THE PLACE OF NARRATIVE

THE PLACE

OF NARRATIVE

Mural Decoration in Italian Churches, 431–1600

Marilyn Aronberg Lavin

The University of Chicago Press

Chicago and London

MARILYN ARONBERG LAVIN, professor of the history of art, has taught at the University of Maryland and at Yale and Princeton. She is the author of *Piero della Francesca: The Flagellation*, also available from the University of Chicago Press.

Publication of this work was made possible in part by a grant from the National Endowment for the Humanities, an independent federal agency, and with the assistance of the Getty Grant Program.

The University of Chicago Press, Chicago 60637
The University of Chicago Press, Ltd., London
© 1990 by the University of Chicago
All rights reserved. Published 1990
Printed in the United States of America

99 98 97 96 95 94 93 92 91 90 5 4 3 2 1

Library of Congress Cataloging-in-Publication Data
Lavin, Marilyn Aronberg.
The place of narrative : mural decoration in Italian churches,
431-1600 / Marilyn Aronberg Lavin.
 p. cm.
 Includes bibliographical references.
 ISBN 0-226-46956-5 (alk. paper)
 1. Mural painting and decoration, Italian—Themes, motives.
2. Mural painting and decoration, Medieval—Italy—Themes, motives.
3. Mural painting and decoration, Renaissance—Italy—Themes,
motives. 4. Christian art and symbolism—Renaissance, 1450–1600—Italy—Themes,
motives. I. Title.
ND2755.L38 1990
751.7′3′0945—dc20

89-49474
CIP

This book is printed on acid-free paper.

"Your highness, ma'am, dear lady," said Macarius. "You really must not expect miracles every day."

"Why not?" said Helena. "There wouldn't be any point in God giving us the cross if He didn't want us to recognize it."

Evelyn Waugh, *Helena*

Contents

Illustrations

DIAGRAMS

Acknowledgments

From the first day I appeared at Princeton University's Computing and Information Technology Services, Shirley K. Robbins, senior statistical programming consultant, took me under her wing. She guided me to the appropriate software; she taught me how to create a database; and as I watched in awe, she set up the program, a job both difficult and tedious. She then stood by with patience and satisfaction as I wandered for several years through the outer spaces of computerland. Always accommodating, she helped me analyze the data I stored and shared with me the joys of discovering new material. Clearly, such forbearance should be memorialized with a monumental cycle depicting the charity and other good works of "Saint Shirley." Douglas L. Mills, statistical programming consultant in the same department, was equally cooperative, once I was able to explain that a fresco cycle was not some kind of outdoor vehicle. These personalities are only two of the myriad helpful technicians in software and hardware at CIT, along with the dozens of students in "the clinic" who never fail to greet a totally stumped user with a smiling "How can I help you?"

To the dean of the faculty, Aaron Lemonick, and the chairman of the Department of Art and Archaeology, Princeton University, William Childs, go my unending gratitude for ensuring sufficient computer time for this project. The Office of Research and Project Administration was more than responsive in replenishing my already generous account for unsponsored research. I was also the grateful recipient of seven annual grants from the departmental Spears Fund for travel and photographs. During the year 1985–86, my work was supported by a grant for independent research from the National Endowment for the Humanities. Many happy hours of productivity were graciously assisted by the staffs of the libraries of the American Academy in Rome, the Research Center for Italian Studies, Harvard University at I Tatti, Florence, and the Marquand Library at Princeton. Susanne Philippson Ćurčić, with painstaking care and skill, executed the diagrams, helping to clarify and articulate the many representational problems involved in this task.

Among the friends, students, and colleagues who gave generously of their thoughts, knowledge, and attention, my special thanks go to Umberto Baldini, Elizabeth M. Bickley, Ornella Casazza, Tracy E. Cooper,

Nicola Courtright, Thomas V. Czarnowski, the late John D'Amico, Lisa Farber, Jack Freiberg, Marc Fumaroli, Meredith Gill, Rona Goffen, Louisa Judge, Herbert L. Kessler, Ernst Kitzinger, Deborah Krohn, Carol Lewine, Steven Nichols, Steven Ostrow, Debra Pincus, Christine Smith, Craig H. Smyth, Susan Taylor, William Tronzo, Michael Vickers, Timothy Wardell, and Wendy J. Wegener, a seminar student who, besides the intellectual acumen she brought to the subject of fresco disposition, demonstrated her outstanding taste for the problem by creating what was probably the only boustrophedonic cake in history!

Introduction: The Place of Narrative

Function and Form

The place of narrative—its didactic role in Western church decoration—has always been recognized. Great cycles of religious stories were spread across the walls of ecclesiastical structures almost as soon as Christianity became the state religion, and they remained a major medium of public communication for over a thousand years. Two main streams of opinion concerning their function can be discerned. One is a tradition, whose starting point is attributed to Pope Gregory the Great (590–604), that assumes an illiterate public to whom pictures provide otherwise inaccessible instruction and models of action.[1] Gregory believed that the mimetic aspects of pictographic forms made stories, and the ideas they conveyed, universally communicable. This attitude became the cornerstone for Western justification of ecclesiastical decoration, and a long series of writers from the time of Charlemagne to well beyond that of Durandus of Mende (d. 1296) continued the Gregorian precept.[2] The other branch of medieval tradition assumed a public at least semiliterate, for whom pictures and *tituli*, or inscriptions, worked together in explanatory symbiosis. This second point of view takes into account the intellectual component involved in learning to interpret paintings.[3] In fact, most medieval visual narratives include *tituli* and labels, making their exposition a combination of pictures and words.[4] As different as these attitudes may seem, their point of departure is the same: that pictorial art illustrates and is inextricably bound to written sources. This point of view has tacitly guided much of the thinking about visual narrative up to the present time.

Art historical discussion of visual storytelling began in earnest in the last quarter of the nineteenth century. Focusing on figure poses, gestures, facial expressions, and psychological interaction, the analysis centered mainly on classical art and illustrations of the ancient myths and epics. Although bibliography on the subject had begun with Gotthold Lessing's influential *Laocoön*, written in the 1760s,[5] Carl Robert was the first scholar to discuss illustration directly.[6] Out of the issues of representation came comments on episodic sequences, where repeated figures represent more than one moment in the story. Continuing the analysis, Franz

Wickoff observed three types of solutions to the problems of representing the passage of time in a static medium, calling them narrative modes.[7] Roughly speaking, the modes are *monoscenic,* in which the main elements of a story are concentrated into one framed scene—the main figures are shown once in a defined space, performing a single action that telescopes much of the story; *polyscenic,* meaning more than one moment is represented—the figures are still shown once but are doing more than one thing, moving the story ahead by more than one episode; and *continuous,* in which the same figure is seen more than one time in a continuous setting, whether landscape or architectural, performing various actions of various episodes of the story.[8] Serial format and extended spatial ambients thus seemed to reinforce the equation between literature and art.

In the twentieth century the discourse became more technical. As George Hanfmann wrote, "Since all human actions unfold in time and are carried out in space, men, time, and space are the three major challenges which the task of story telling presents to a sculptor or painter."[9] Visual artists were called the "thieves of time," spatial tricksters, doing constant battle to overcome the inhibiting limitations of two dimensions and to create a variety of modes of circumvention.[10] Wickhoff's categories were carried forward by Kurt Weitzmann, who developed secondary characteristics of the main modes and applied them to medieval serial manuscript illumination.[11] As the logical conclusion to the "art as illustration" point of view, Weitzmann's categories remain useful, and his methods lie behind much modern analysis.[12] However, his conviction that large-scale narrative painting and other wall decorations essentially adapted illustrational techniques from manuscript illumination[13] inhibits understanding of the different forces at work in the two media.[14] These are differences not only of size but, perhaps more important, of function and finally of effect.

Today there is still surprisingly little consensus on the definition and use of the word "narrative" in the visual arts. At a symposium on the subject held in 1984, the moderator noted "a troubling lack of consistency in terminology [and] at the end of the two-day meeting, no single definition of 'pictorial narrative' had come to be accepted."[15] This gathering put itself in the context of two important earlier symposia on narrative, one held in Chicago in 1955 and another held in Chantilly, France, in 1982.[16] But whereas these earlier discussions had studied the relations between text and illustration with general agreement in granting "primacy and priority to verbal narratives," the Baltimore symposium eschewed such an agreement and focused unswervingly on the "visual aspects of pictorial narrative."[17] There was thus an attempt to differentiate between the capacity of pictures to vivify a literary prototype and the capacity of visual images themselves to serve as the text. In the first case, "narrative" is used as an adjective to modify elements such as poses, expressions, and settings. In the second, "narrative" is used as a noun, meaning the plot as a whole. When the terminology of structuralism was brought into the discussion, it was suggested that the diachronic mode, the succession of images represented one after the other and the synchronic mode, representation in which all parts of the narrative are visible at once, can be combined to move the observer beyond the boundaries of description.[18]

Such redefinitions are important, since they strengthen understanding of the difference between narrative illustrations and narratives that communicate in direct visual terms. As will soon become evident, we will be concerned here with visual narrative as distinct from any literary form, and its place—both its role and its physical location—in the architectural framework that supports it.

The Problem of Disposition

Artistic achievements in monumental wall paintings and mosaics are seen as defining the character and quality of various Western period styles, particularly those of the Middle Ages and the Renaissance. As a result, the genre has received a great deal of attention in the literature that concerns itself with art. Early studies focused on identifying artistic workshops and personalities who created individual cycles, dating the cycles and explicating their subject matter. More recently, interest has turned to problems of structure: on the one hand illusionism, with analysis of the painted architectural settings in relation to real architecture, and on the other the structure of the visual narration in relation to literary theory.[19] Such studies have gone far in articulating the subtle means at the artists' command for communicating to the beholder.

What has not been explored in an organized fashion is the place of narrative in another sense—the disposition of narratives as complete entities within their architectural settings. In studies of individual cycles, schemes are often plotted to aid discussion, and over the years a substantial fund of diagrams and descriptions has accumulated. Yet the overall planning that must have been an essential part of the creative process in the Western ecclesiastical mural tradition has received no coherent survey.[20]

The subject of "narrative disposition" presented itself to me several years ago as a kind of revelation. For most of my professional life I had been engaged in analyzing the paintings of Piero della Francesca, one at a time. I had worked my way through his career and arrived at his frescoes on the subject of the True Cross in the Church of San Francesco in Arezzo. Taking up the study of this remarkable cycle, I had my first surprise. Although some of the best art historical minds of our century had analyzed these paintings, the anomalous arrangement of the episodes of the story, which seems to skip erratically about the chancel area of the church, had never been studied as part of a historical continuum.[21] It struck me that if the mysteries of Piero's "out of order" arrangement were ever to be understood, they would have to be put into such an context. When I found that no such survey existed, I began to gather what I thought would be the pertinent information.

My first decision was to investigate only Italian ecclesiastical cycles in order to remain within the scope of Piero's commission. My plan was to scan a number of cycles dating a few decades before and after Piero's time and representing a limited number of religious stories (the lives of Christ, Mary, and John the Baptist). Despite the small scale of this preliminary sounding, I soon realized that such a study, precisely because of its novelty, faced formidable difficulties. One problem was access to the frescoes through photography. General views are usually too far from the paint-

ings to show them clearly; details are too close to give an idea of the overall arrangement. Moreover, very few cycles have been photographed in their entirety. An even more important difficulty was the sheer quantity of factual material involved. In less than a week, I had collected more information concerning the layout of each cycle than could be efficiently stored and retrieved by hand. Computers, at that time (1982), were just beginning to be used by ordinary mortals like myself, and though I was not yet acquainted with the apparatus, even for word processing, I decided to investigate this possibility as an aid to the storage problem. I was lucky enough to have the Princeton University Computer Center available to me, and with the help of a number of technical advisers, I soon learned that I would be able to devise a storage system to suit my needs. I aimed at compiling information on the arrangement of enough fresco cycles (and some in other media) to see if Piero della Francesca's approach was unique or if, indeed, it could be related to some consistent mode of organization.

My original sample soon proved too restricted. I had only to remember that Piero would have seen, for example, the mosaics and frescoes still extant in the Early Christian basilicas when he worked in Rome in 1458–59. Like the other artists of the Renaissance, Piero had ten centuries of mural decoration to guide him. On this account, I enlarged my survey. Still focusing on Italian ecclesiastical cycles, I began to include those representing any religious subject, from the earliest remaining monuments through those completed about the year 1600.[22] My plan now became the compilation of a large-scale database, which I dubbed NARRART DATA, specifically designed to fulfill the needs of my own individual research project—as far as I know, the first such use of the computer in the field of art history.

The database was structured to document the disposition of narratives in relation to their architectural ambients. The precise location of every scene was noted, with indications of how the individual compositions contributed to the movement of the narrative as it passed over the surfaces of the walls. I continued compiling material until I had logged more than 230 cycles, primarily from Tuscany, Lazio, and Umbria, but including some in the Campagnia, Lombardy, and the Veneto as well. I personally visited every monument to verify and complete the material. By organizing and inputting all the material myself, I retained full responsibility for the descriptions and analyses. In the process, I not only gained understanding of the variety of statistical studies the computer makes possible but, by reviewing familiar works from this fresh point of view, also discovered a new area of the artists' creative activity.[23]

During the inputting, many further revelations occurred. I found that visual reading order rarely (rather than usually) followed literary prototypes without deviation. Therefore "out of order" visual sequence was the rule rather than the exception. Also, visual order was closely related to architectural form. Distributed upon the surfaces of long basilical naves, apses, or private chapels in the aisles, the cycles of stories were usually divided into neatly framed fields that corresponded directly to the basic structural parts of the building. The number and location of surfaces available for decoration often determined the design of the fields as well as the figure compositions. Clearly, one of the main steps in planning

a mural was adjusting the plot to fit and exploit the architectural setting. These adjustments were a matter of objective choice, and the chronological sequence of a given story was often shifted to achieve various kinds of affective power. Thus, before the plot could be divided into visual episodes, and before the episodes were individually designed, the composition of the complete cycle must have been conceived or at least blocked out. Since such preliminary thinking had to come before manual execution, the survey I was conducting would lead to a history of conceptual planning of mural decoration. By the time I had made these observations, I had already answered one question concerning Piero della Francesca's cycle: yes, it's "out of order" narrative sequence did fit into a historical continuum. I now realized that, although Piero's work would remain a focal point of my interest, my survey would of necessity take a broader view of the history of narrative disposition.

The last revelation produced by the database was the most startling: in amassing the descriptive material, I had been able to observe a number of set patterns of arrangement, developed in the Middle Ages and in continuous use through the Late Gothic period, the Renaissance, the time of the Counter-Reformation, and probably beyond. The patterns were formed by rearranging the chronological order of the episodes in familiar stories. In some instances the patterns could be associated directly with particular liturgical practice, providing explanations for what otherwise might seem strange or arbitrary sequences.[24] In other cases the relationship between narrative patterns and religious practice, though logical, lacks real proof.[25] However, the existence of the patterns per se is confirmed by one dramatic case: in the nave of the Upper Church of San Francesco in Assisi, two different systems appear together, and their interlocking is used to prove a theological point.[26] The Franciscans, in fact, will come forth in these pages as among the prime movers in this tradition. Moreover, the patterns themselves show a historical development concomitant with changes in the history of architecture. Although they have remained all but unnoticed in modern times, their ubiquity indicates that the patterns were probably common knowledge, perhaps even part of the professional training of artists.[27]

At the same time, discovery of the patterns raises some interesting questions. If they were ubiquitous, should they not be referred to in written sources? They are not.[28] In fact, written reference to patterns—or any kind of overall planning—whether in fresco or other artistic media, seems to be entirely lacking. Yet this very fact leads me to the following hypothesis: patterns of disposition were known and put into play by patrons and "programmers" as well as by artists. I speculate (in fact, I firmly believe) that all three types of contributor—the patron, the ideologist, and the artist—consulted together to work out the large-scale mural arrangements. According to this view, the usual question of who was responsible for the program of a given work of art is answered "all three." The patron (individual, monastic order, civic organ) would make known his desires, devotion, and financial limitations; the intellectual adviser (theologian, scholar, humanist) would articulate the ideas involved; the artist would craft the thoughts of both in visual form. The first two contributors could be one person or group; the last two could also be one. I see each offering his contribution, bringing his particular expertise to

bear on the project, but working together with the others to generate the finished product.[29]

Perhaps even more important than the discovery of the patterns was the realization that they were not random plot manipulations for the sake of design; nor were they methodological aids to visual storytelling. Rather, narrative units were used as expressive components in patterns developed to broadcast messages of greater than narrational value.[30] Insofar as these messages "go beyond" the familiar stories from the Bible and lives of the saints, speaking to themes of dogma, morality, and political power, I will refer to them as "ulterior arguments." My supposition is that most spectators/worshipers knew the story and interacted with the narrative. When viewers saw that the story was "out of order," they looked for new relationships and juxtapositions of scenes, knowing they would constitute new meanings. To clarify how I believe this interaction operates, I offer a chart (diag. 1).[31]

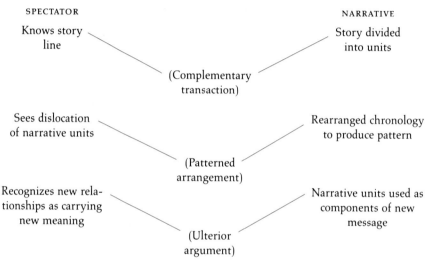

SPECTATOR

NARRATIVE

Knows story line

Story divided into units

(Complementary transaction)

Sees dislocation of narrative units

Rearranged chronology to produce pattern

(Patterned arrangement)

Recognizes new relationships as carrying new meaning

Narrative units used as components of new message

(Ulterior argument)

DIAGRAM 1. Narrative transaction

Recognizing this technique is of some historical moment, since it was used in the major source of public information in Western Europe, the monumental mural cycle, for more than a millennium of Christian history. The study that follows will trace some of the manifestations of this function of narrative.[32]

The Patterns
DESCRIPTIONS

For the convenience of readers, I provide a descriptive list of the patterns of disposition that are a major focus of this book, each illustrated with one or more paradigmatic diagrams (diags. A–K). The generalizations are based on information drawn from the approximately one hundred examples discussed in the text, plus a number selected from other database entries. At the end of the list, a chart (diag. 2) shows the chronological and numerical distribution of the patterns from the sixth century to the sixteenth. The boldface letters preceding the pattern names, which are entirely my own invention, are the keys to the symbols in the chart.

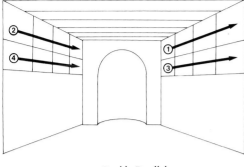

DIAGRAM A. Double Parallel

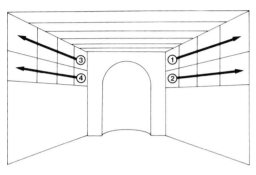

DIAGRAM B. Wraparound

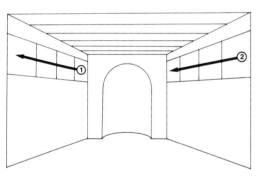

DIAGRAM C. Counterclockwise Wraparound

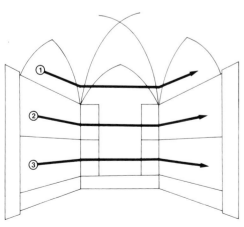

DIAGRAM D. Apse pattern, down

D Double Parallel: The Double Parallel is the prototypical cycle pattern, developed for the Early Christian basilical form. It consists of two parallel streams of narrative that face each other on either side of the nave. Each sequence begins at the apse end of the wall and moves back toward the entrance at the main facade. On the right wall, the sequence reads from left to right. On the left wall, the sequence reads from right to left (diag. A). The narrative can begin at the apse end of either wall, but from the late eighth–early ninth century onward most examples begin on the right wall. This habit may be connected to liturgical practices at the beginning of Holy Mass, but as yet no proof has been found. Eleven Double Parallels are cited in the text.

W The Wraparound pattern: The Wraparound is by far the most widely used pattern in the periods studied. Of the one hundred or so examples analyzed, thirty-seven are in the Wraparound pattern. The narrative begins on the right wall at the apse end of the nave. It moves left to right across the wall. It passes to the left wall at the entrance end, then moves left to right to the apse end (diag. B). The pattern can circle the nave as many as five times. The fully developed Wraparound appeared in the eleventh century. Of the examples tabulated, seventeen are single wraps, seven are doubles, and five are triples.

K The Counterclockwise Wraparound: The Counterclockwise Wraparound is a variation on the regular left-right Wraparound pattern. As the name implies, the movement here is right to left (diag. C). The narrative usually appears on one tier and passes from the apse end of the left wall around the precinct to the apse end of the right wall. This motion has astrological as well as monastic and meditational associations. By the end of the sixteenth century, the Counterclockwise Wraparound was identified with official Counter-Reformation decoration. Eleven examples are discussed here.

A The Apse pattern: A narrative that circles an apse or chancel area on one or more continuous horizontal tiers follows the Apse pattern. The narrative may start on the top tier and move down to the bottom (diag. D). It may start on the lowest tier and move up to the top (diag. E). Seventeen examples, dating from the eighth century to the fifteenth, are discussed in the text.

C The Cat's Cradle: The term Cat's Cradle is taken from the game played with a loop of string that is passed from one finger to another to form various diagonal cross-shaped patterns. In cycle painting I have used the term to refer to patterns shaped like an **X** (actually a Greek chi, the first letter of Christ's name). When the pattern appears in a three-dimensional setting across the space of a chapel, the first arm of the cross is formed by diagonal movement from the end of one tier on one side of the precinct to the opposite end of the same tier on the opposing wall. The second arm is traced from the opposite end of the same tier of the second wall, diagonally back to the opposite end of the first wall (diag. F). This horizontal form of the **X** shaped pattern may be associated with specific liturgical rituals that symbolize the unity of the church. The pattern also appears on single walls where the **X** begins on one tier and proceeds diagonally to a position on a different tier (diag. G). The movement of the diagonals can be either upward or downward. Six examples of the Cat's Cradle appear in the text.

B The Boustrophedon: The Boustrophedon is found on the surface of single walls as well as on one or more opposing walls of a given sanctuary (diags. H and I). The narrative reads on several tiers, first from left to right, then reversing from right to left, or vice versa. The term "boustrophedon" describes this back-and-forth movement literally, meaning "turning like an ox in plow." It is borrowed from epigraphy, where it designates archaic inscriptions that reverse reading directions on each line. Fifteen Boustrophedons, both "linear" and "aerial," are discussed in the text.

S The Straight-Line Vertical: This term refers to narratives in chapels with single-bay side walls, where the major movement is straight down from the top or straight up from the bottom. In spite of the term "vertical," often two scenes are juxtaposed horizontally on one or more of the stacked tiers. In these cases the "on tier" movement can be left-right or right-left. These scenes may or may not be divided by articulated frames (diag. J). Nineteen examples of the Straight-Line Vertical pattern have been isolated.

U The Up-Down, Down-Up pattern: This relatively rare pattern seems to have been developed to position scenes of exaltation (such as the Assumption or Coronation of the Virgin) in the uppermost regions of the wall. The pattern is formed by the narrative starting on the top tier of one wall, moving down to the bottom, and then from the bottom of the opposite wall up to and ending at its top (diag. K). Five occurrences of this pattern were found, two in the fourteenth century and three in the fifteenth.

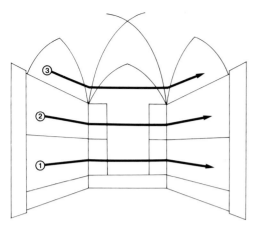

DIAGRAM E. Apse pattern, up

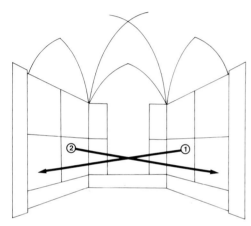

DIAGRAM F. Cat's Cradle, horizontal

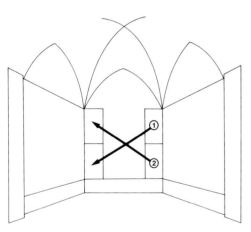

DIAGRAM G. Cat's Cradle, vertical

CHRONOLOGICAL DISTRIBUTION OF PATTERNS

A (Apse) 17	**K** (Counterclockwise Wraparound) 10	
B (Boustrophedon) 13	**S** (Straight-Line Vertical) 19	
C (Cat's Cradle) 7	**U** (Up-Down, Down-Up) 5	
D (Double Parallel) 12	**W** (Wraparound) 37	

500–1000	1000–1200	1200–1300	1300–1400	1400–1500	1500–1600
					W
					W
				S W	S W
				S W	S W
				S W	S W
			B S W	A S W	K W
			B S W	A S W	K W
			B S W	A S W	K W
		A W	B S W	A S W	K W
D		A W	B S W	AB S W	K W
D	W	A D W	B S W	ABC SUW	S W
D	W	A D W	AB SUW	ABCDKSUW	C K W
AB D W	D W	A D W	ABCD SUW	ABCDKSUW	A CDK W

DIAGRAM 2. Chronological distribution of patterns (each letter represents one example).

OTHER OBSERVATIONS

A few observations may be made about the organization of visual narratives that do not concern their physical placement. These general notions seem to have been involved in conceptual planning, perhaps influencing the choice of patterns in certain instances.

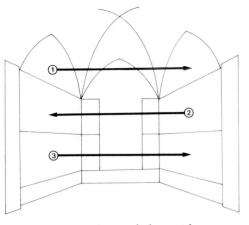

DIAGRAM H. Boustrophedon, aerial

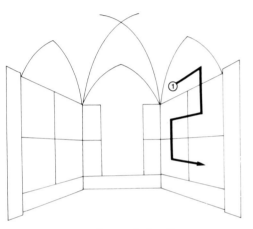

DIAGRAM I. Boustrophedon, linear

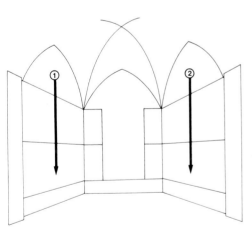

DIAGRAM J. Straight-Line Vertical

The Festival Mode: When the disposition of a cycle emphasizes the liturgical feast associated with the characters in a story more than it stresses the story itself, I designate the cycle as being in the Festival Mode. This consideration, it seems to me, was of major importance in planning fresco cycles at all times, perhaps being a guiding principle more often than can be documented.

The Interlock: Two individual patterns used together in the same cycle are said to be an Interlock. The combination often produces a message larger in meaning than either pattern could imply separately.

The View from the Door: Several examples show that cycles were arranged to give a spectator who stands in the entranceway, without entering a precinct, an encapsulated view of the cycle. This method was often used in places not always open to the public.

Words and Pictures
DEFINITIONS

The few generalizations that have been made about narrative order in Western art seem to have sprung from a body of preconceptions that we are only marginally aware of. For example, it is repeatedly claimed that scenes in a cycle read "automatically" or "normally" or "naturally" from left to right, like lines on a printed page or like comic strips. Scenes stacked in vertical tiers are expected to read in the order the artist worked: if painted or in mosaic, from the top down; if in stained glass, from the bottom up.[33] Comparing these claims with the data, however, shows that they are patently untrue. The assumptions may seem logical, but artists, whatever the medium, rarely followed them. If new generalizations are to be made, they must come from a more accurate study.

Considering the lack of consensus in the terminology of our subject, let me define some of terms I shall use in particular ways. The word *narrative* will be restricted, as far as possible, to its nominative form, referring to a story as a total entity. *Cycle* will mean a number of scenes representing different moments in a story placed in relation to one another and connected in a common theme that progresses from a beginning to an end, passing through a development.[34] A cycle may comprise more than one plot, related thematically or in some other way. To qualify for discussion in this book, a cycle must have more than three episodes.

Individual *episodes* are defined as representing separate actions in the plot taking place in localized settings. The full dramatic situation of a given episode, including the characters, action, and setting, will be called its *inscenation*.[35] I extend the phrase from use as a synonym for mise-en-scène to include psychology and emotion, since in the visual arts everything is created by the artist and is not a matter of interpretation by directors and live actors.

Conventional *left* and *right* are determined by an ideal spectator who stands in an architectural ambient at the entrance facing the altar.[36] The cardinal points will not be used in either the real or the liturgical sense.

The arrangement of episodes in a cycle is commonly called *narrative order.* Most cycles we will encounter are biographies with chronologies that span the subject's life from childhood to death.[37] The term *begin* or *start* will refer to the earliest event depicted and *end* to the latest, no

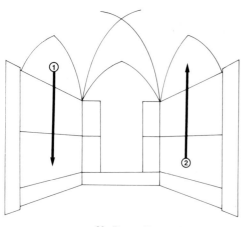

DIAGRAM K. Up-Down, Down-Up

matter where the scenes are placed on the wall. The term *move* will refer to the path the eye must follow to reach the chronologically next scene in the history. I thus separate order from time, reserving the latter for the life-death span of the subject and the former for the visual—that is, physical—placement of the scene.

I will call the physical placement of scenes in a cycle *disposition*, a term I appropriate from the field of rhetoric.[38] Originally it indicated how the learner should organize the set parts of a forensic speech. Later it referred to a set arrangement of parts in a formal oration meant to persuade the audience of the speaker's point of view. Finally it was transferred from speech to literature, where it remained as one of the three principal constituents of the rhetoric of poetics (*invention*, *disposition*, and *elocution*).[39] I have adopted the term disposition because I believe the arrangement of visual elements in a narrative cycle serves a similar persuasive purpose.

ILLUSTRATIONS

The reproductions in this book comprise mainly general views of the monumental schemes (most of which were taken more than seventy-five years ago) and a small number of details. Diagrams, ably executed by Susanne Philippson Ćurčić, are provided for about half the cycles discussed. They were designed to trace the patterns of disposition. In the diagrams, architectural spaces are splayed to exaggerate the visibility of the narrative fields on the side walls, a convention that causes some distortion in the shapes of entrance-wall fields. Architectural structure is simplified graphically and rendered in fine lines. Visual order (chronological sequence of episodes) is indicated with heavy lines that start with arabic numbers and end with arrowheads. The numbers indicate the chronological sequence of the plot; the arrowheads show the direction of narrative movement. The numbers are inscribed in circles, squares, triangles, or octagons, in that order, symbolizing separate plots within the same cycle. Three types of diagrams are employed: frontal views of four-sided precincts showing the exterior of the entrance wall and the interior of the left, center, and right walls; the same frontal view with the entrance wall rendered transparent by dashed lines, to show painting fields on the interior surface; and views from above (or below) with walls drawn up and splayed, to show four-sided chambers more than one bay in length, with paintings on all four walls. Orientation is always from the entrance, facing the altar or the wall opposite the entrance.

As for photographs, readers should be forewarned that illustrating narrative disposition presents unique difficulties. Although general views of architectural interiors may give a sense of the cycle's environment, they do not permit close analysis of the paintings. This problem was recognized years ago and solved when Alinari, Anderson, Brogi, and other commercial art photographers of the nineteenth century introduced the "close-up" of individual scenes. Such detailed photographs became very important for the study of style and iconography. To some extent, however, they created a new problem, for they effectively inhibited the overall perception of the cycles. Often including the painted frames, the close-ups tend to make separate scenes look like easel paintings. Isolated from their context, the episodes lose all sense of scale and all relation to

their surroundings. At the same time, diagrams have their own disadvantages. They are absolutely necessary to make the disposition clear, but numbered or lettered abstractions often flatten the spatial ambient and drain the works of art of their aesthetic and expressive value. The challenge of balancing beauty and information in illustrating visual narrative is thus still largely unresolved.

Partway through this project, I made an attempt to replace still photographs with moving pictures on videodiscs. The idea would have been to include the disc along with the printed text as the actual illustrations. I spent one summer in Italy recording the disposition of narratives in thirty-five chapels on videotape. I then edited the material into a 45-minute videocassette. The trial proved the idea was feasible; not only do moving images give an immediate, full-color impression of an ambient, but the movement itself can help to track the disposition visually. The cost of producing video illustrations, unfortunately, proved prohibitive at this time (1989), and I had to abandon the project.[40] As a result, this book, generated in part with electronic equipment, continues to rely on still photographs and hand-drawn diagrams, in the traditional manner.

THE TEXT

The structure of the text still reflects my particular interest in Piero della Francesca's cycle. Discovering the Story of the True Cross in Arezzo to be part of a lengthy chain in the visual expression of ideas has not dimmed its compelling quality. On the contrary, finding the cycle's place in a new and unexpectedly rich context has sharpened recognition of Piero's originality. For this reason I have dealt at length with the cycle's subject and sources as well as its arrangement, giving them more attention than might be warranted in a well-balanced chronological survey. Readers will find evidence of this distortion in two places in the text, in chapters 4 and 6. Notwithstanding this breach of tempo, my study has addressed the wider range of information offered by the database as an inaugural survey. On one level, it is a history of narrative disposition in Italian ecclesiastical mural decoration from the Council of Ephesus (A.D. 431) to the rebuilding of the Lateran transept in Rome at the height of the Counter-Reformation (A.D. 1600). On another, it is an introduction to the patterns of disposition: how they developed and in what circumstances and for what purpose they were used.

The historical survey begins with an overview of the Middle Ages through the end of the thirteenth century; there follow three chapters on the fourteenth century. The last of these, chapter 4, takes up the medieval history of the True Cross legend and studies Agnolo Gaddi's Florentine cycle of this subject at some length. Chapter 5 deals with the early fifteenth century. Chapter 6 covers the middle decade of that century; it includes an extended study of Piero's Arezzo cycle. Chapters 7 and 8 survey the period from 1470 to 1500. Chapter 9, intended mainly to illustrate the persistence of the patterns in the sixteenth century, is less detailed than the earlier sections; for technical and other reasons, as we shall see, the monuments selected for discussion are restricted to cycles in architectural environments of traditional shape. A final section describes the structure, content, and methodology of the database NARRART

DATA. Appendix 1 reproduces database entries in coded form, covering all the cycles discussed in the text, as well as an example of a processed entry and keys to the codes. Appendix 2 is a list of the one hundred exemplary cycles charted above, arranged chronologically according to patterns of disposition.

In this introductory presentation, I have thus plotted a straight course through uncharted territory, following a chronological narrative of the history of disposition, although my own study demonstrates that strict chronological order is not always the most effective mode of exposition. I hope, nonetheless, that future spectators of monumental narrative cycles will start their own journeys through the churches and chapels of Italy aware that the order of the story must have been the artist's first, and one of his most challenging, creative concerns. [41]

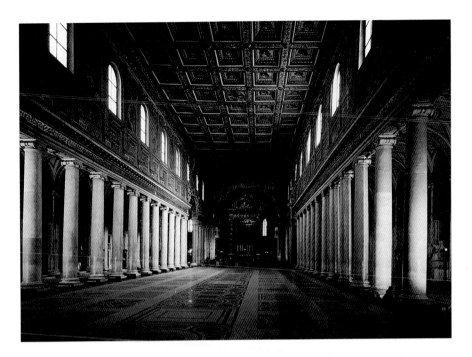

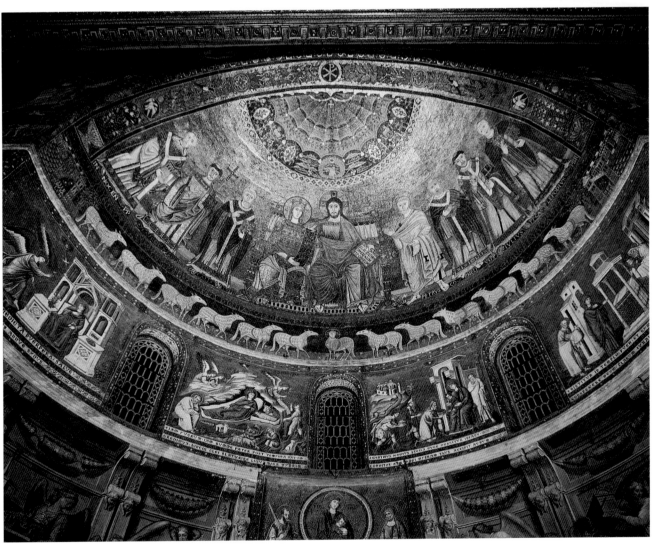

PLATE 3. Assisi, San Francesco, Upper
Church, left transept, Cimabue, *Crucifixion*

PLATE 4 (*facing page*). Florence, Baptistry, in-
terior, view of dome

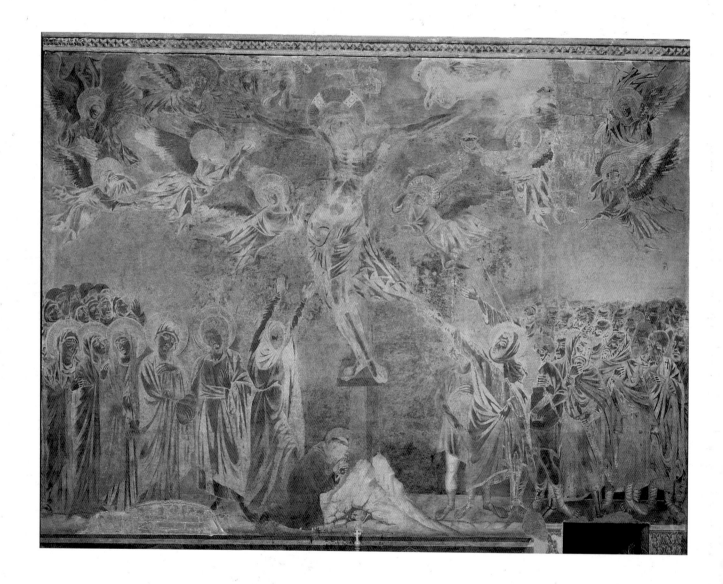

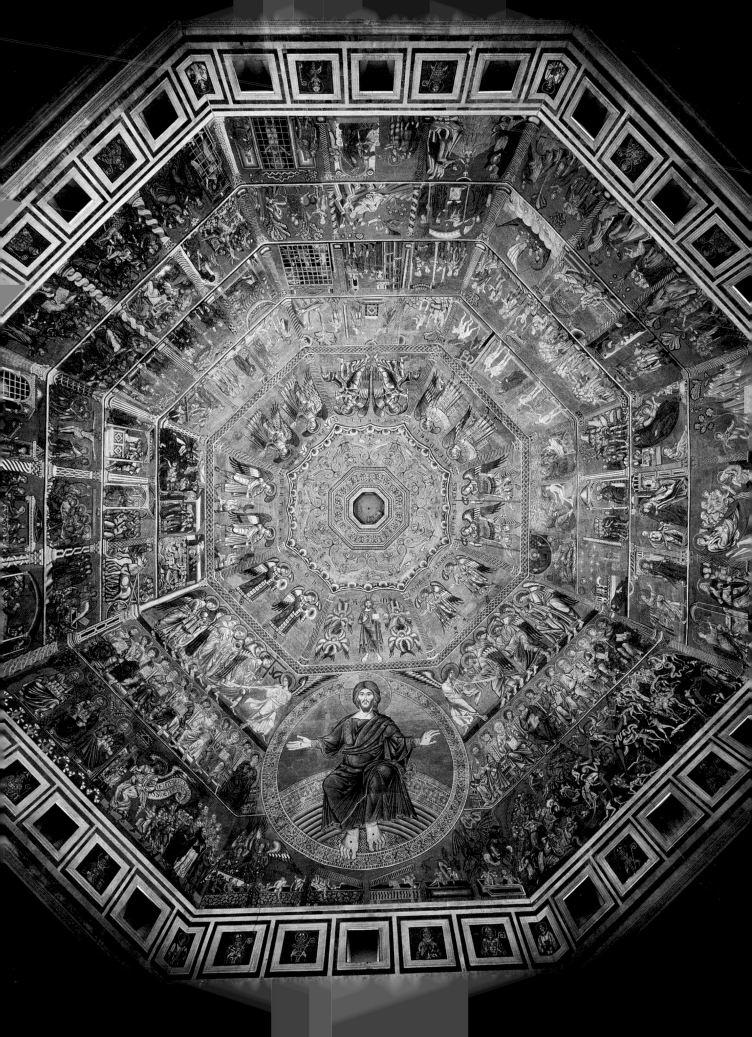

PLATE 5. Padua, Arena Chapel, triumphal arch, Giotto, *The Pact of Judas* and *Architectural View*

PLATE 6 (*facing page*). Padua, Arena Chapel, right wall, Giotto, *The Massacre of the Innocents* and *The Mocking of Christ*

PLATE 7. Assisi, San Francesco, Lower Church, transept, facing Pietro Lorenzetti's *Passion Cycle*

PLATE 8. San Gimignano, Collegiata, right wall, fourth bay, Lippo Memmi (?)

PLATE 9 (*facing page*). Venice, San Marco, Baptistry, interior, view toward apse

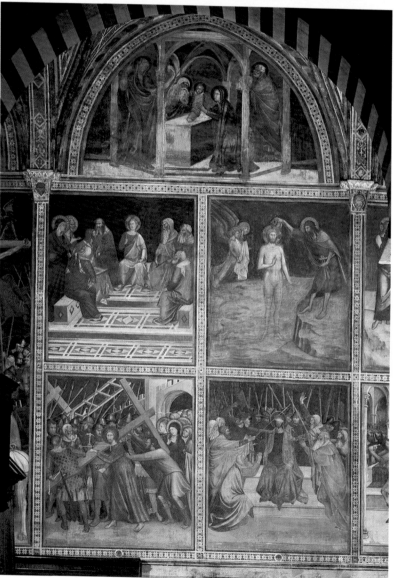

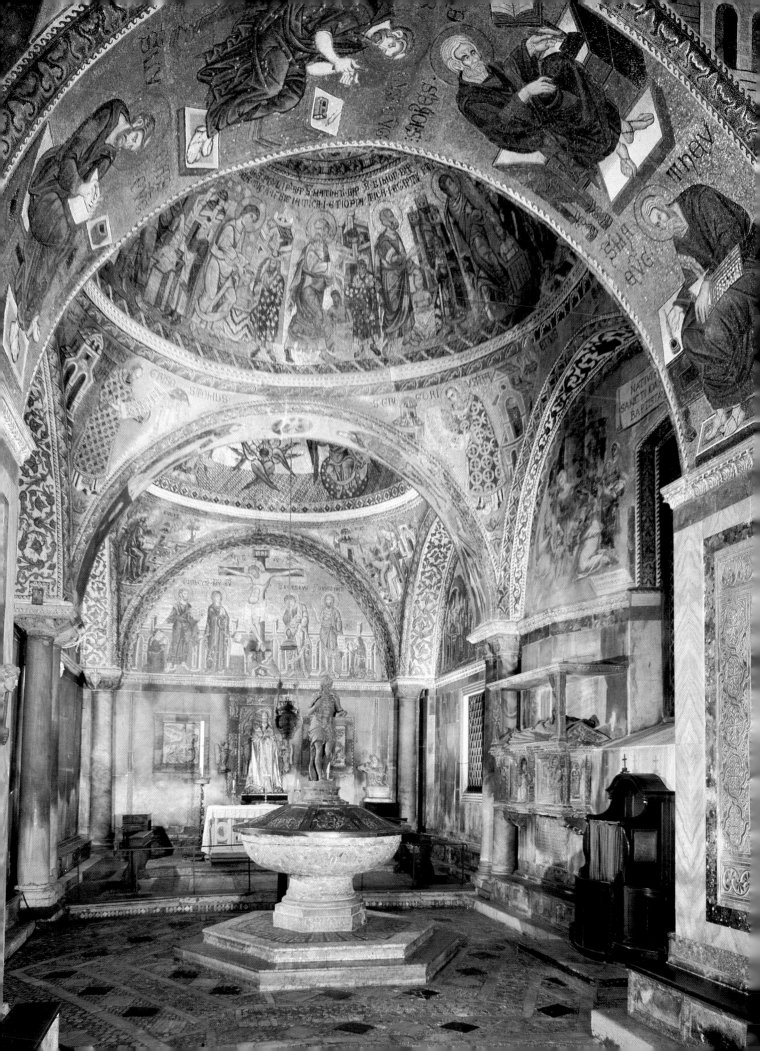

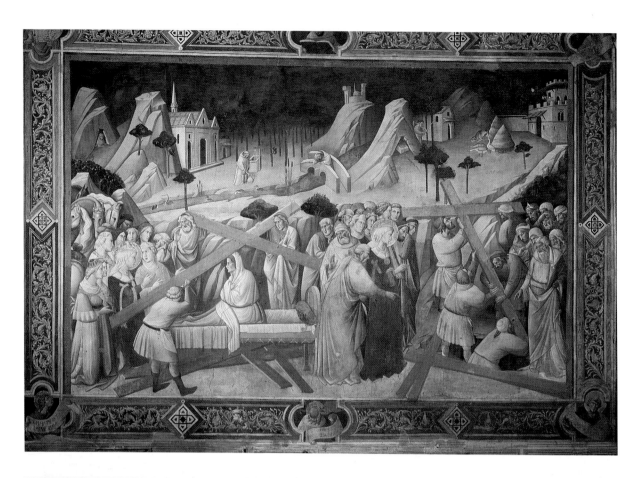

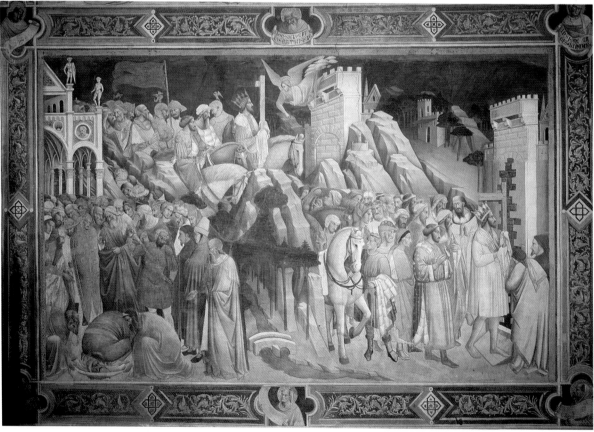

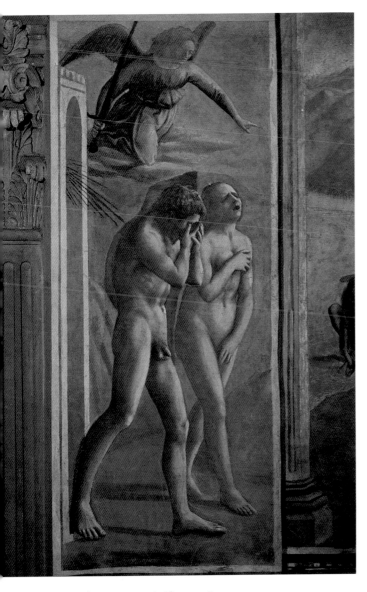

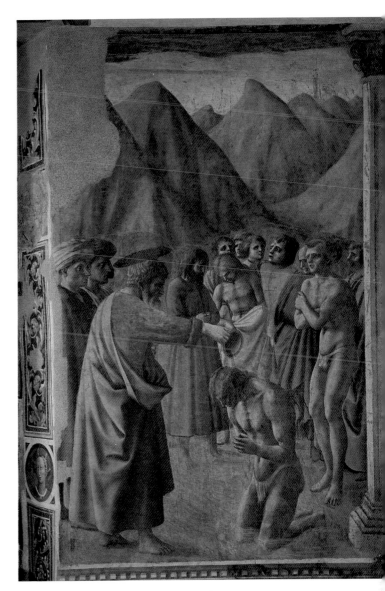

PLATE 10 (*facing page, top*). Florence, Santa Croce, chancel, right wall, lowest tier, Agnolo Gaddi, *Finding and Proofing of the Cross*

PLATE 11 (*facing page, bottom*). Florence, Santa Croce, chancel, left wall, lowest tier, Agnolo Gaddi, *Exaltation of the Cross*

PLATE 12 (*above, left*). Florence, Santa Maria del Carmine, Brancacci Chapel, left wall, second tier, Masaccio, *Expulsion of Adam and Eve*

PLATE 13 (*above, right*). Florence, Santa Maria del Carmine, Brancacci Chapel, altar wall right, second tier, Masaccio, *Baptism of the Neophyte*

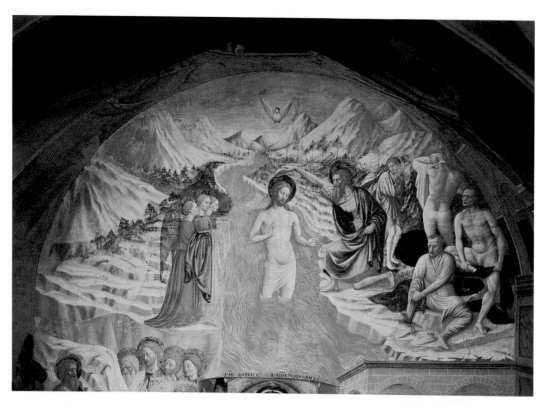

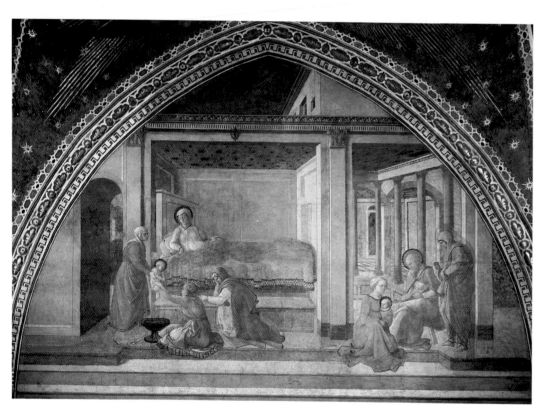

PLATE 14. Castiglione Olona, Baptistry, altar wall, Masolino, *Baptism of Christ*

PLATE 15. Prato, Duomo, chancel, right wall, lunette, Fra Filippo Lippi, *Birth and Naming of the Baptist*

PLATE 16 (*facing page*). Arezzo, San Francesco, chancel, general view, Piero della Francesca, *Story of the True Cross*

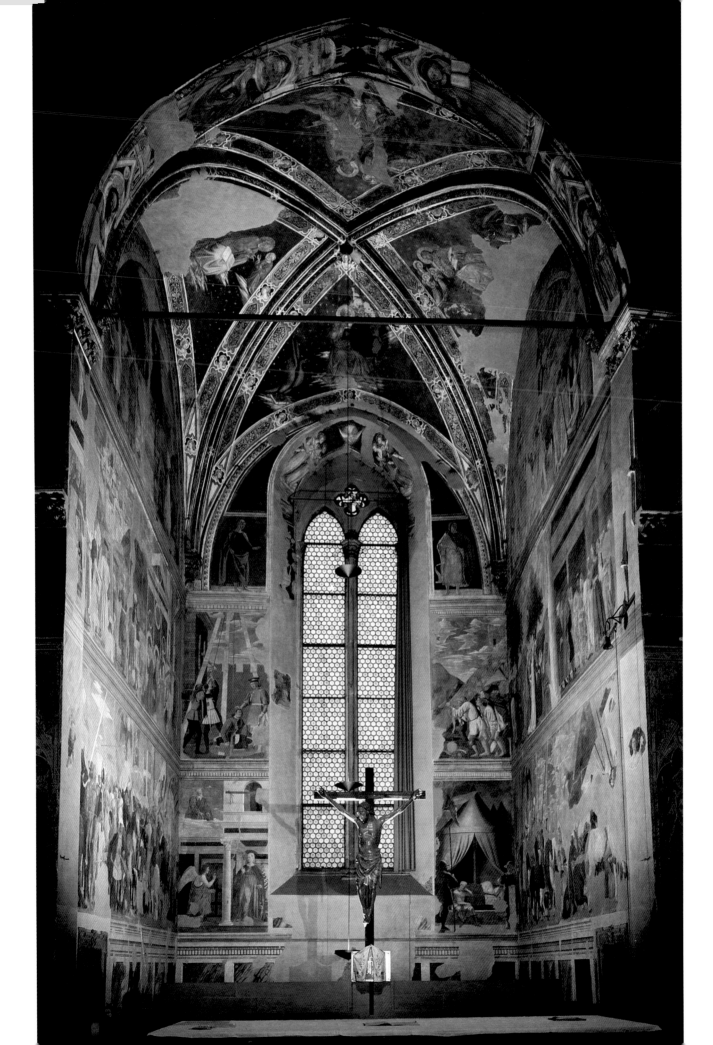

PLATE 17. Arezzo, San Francesco, chancel, right lunette, Piero della Francesca, *Dying Adam and Family*

PLATE 18 (*facing page, top*). Arezzo, San Francesco, chancel, left wall, second tier, Piero della Francesca, *Finding and Proofing of the Cross*

PLATE 19 (*facing page, bottom*). Vatican City, Sistine Chapel, right wall, Cosimo Rosselli, *Last Supper*

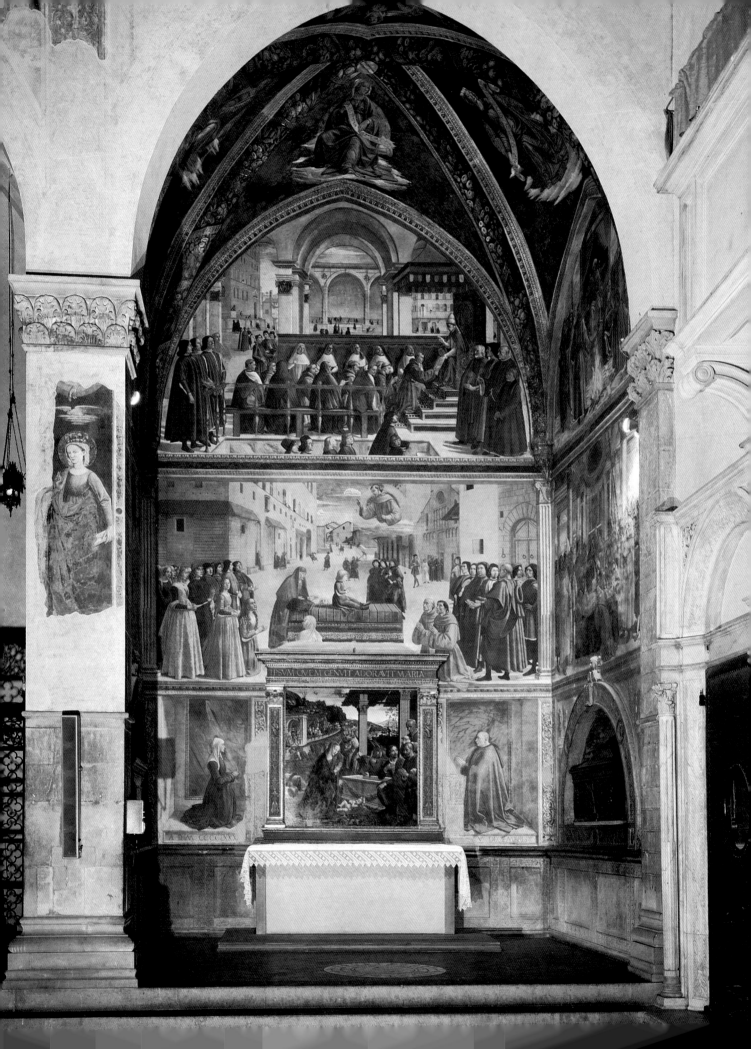

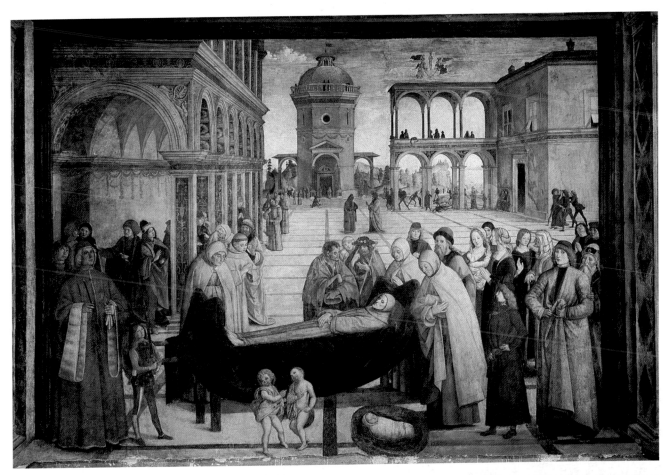

PLATE 20 (*facing page*). Florence, Santa Trinita, Sassetti Chapel, general view, Domenico Ghirlandaio

PLATE 21. Rome, Santa Maria in Aracoeli, Bufalini Chapel, left wall, lower tier, Pintoricchio, *Death of San Bernardino*

PLATE 22. Florence, Santa Maria Novella, Strozzi Chapel, right wall, Filippino Lippi, *Story of Saint Philip*

PLATE 23. Rome, Oratorio del Gonfalone, view toward interior facade, Federigo Zuccari et al.

PLATE 24. Rome, San Giovanni in Laterano, view from nave toward right transept

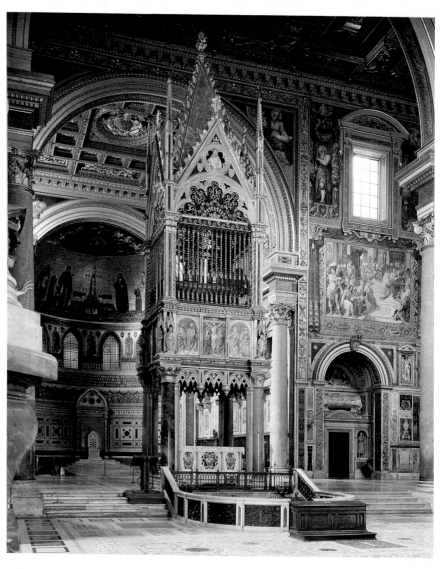

I

1

Medieval Protocols

Several patterns of narrative disposition were established in the basilicas of Rome during the Middle Ages: the "Double Parallel," the "Apse pattern," and the "Wraparound." These developments are surveyed from the time of the decoration of Santa Maria Maggiore in the fifth century through that of the sanctuary of San Francesco in Assisi and other late thirteenth-century monuments in Lazio and Tuscany.

Because the great basilicas of the early Christian church were arenas for public communication and religious instruction, they established certain protocols for arranging narrative cycles that in many ways became the standard. These massive structures followed the plan of Roman law courts, adapting to liturgical use the long, rectangular auditorium as the nave and the projecting semicircular judgment aedicula at one end as the apse where mass was said. As Christian sanctuaries, the apses were decorated with images that tended to be devotional or apocalyptic in nature, usually representing members of the Christian hierarchy in figural or symbolic form.[1] The long nave walls below the windows of the clerestory, in contrast, were decorated with pictorial narratives. Following prototypes developed in the Late Antique period, these monumental narratives became the hallmark of early Christendom's major loci of public activity.[2] At the outset, we must be aware of the difficulties involved in studying these early examples of cycle disposition. Not only has much of the development been lost, but frequently the physical evidence that does remain has been restored, repainted, or recast. The reworkings raise questions whether the locales retain their original dedications, whether the subject matter was repeated or reinterpreted, and most important for our study, whether the original arrangement of scenes and the direction of reading were kept. Clearly we must rely on the current opinions of specialists in this field—the medieval archaeologist, iconographer, and interpreter of style. Should new information become available, conclusions drawn here (and statistical generalizations taken from the database) will have to be modified. Proceeding with all due caution, therefore, this chapter will be devoted to the protocols of Italian monumental narrative as they developed in the Middle Ages.[3]

The Early Middle Ages

Early medieval narrative cycles usually were disposed in superimposed tiers on the long nave walls of the basilicas, in a pattern I will call the Double Parallel Apse-to-Entrance. The narratives begin, almost without exception, at the apse end of the building and progress toward the entrance. The reading order of the two sides is from left to right on the

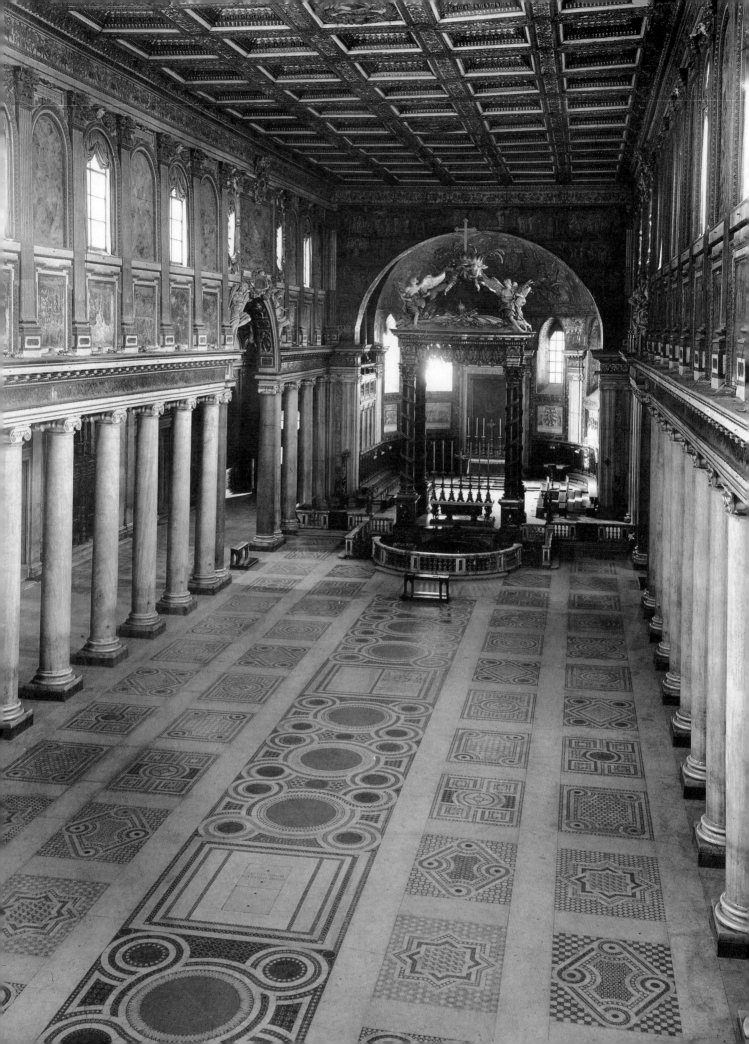

right wall and what we would call "backward" on the left wall—right to left. The remaining evidence suggests that all the Roman Constantinian basilicas followed this pattern, which continued to evolve until it reached its fullest flowering after several centuries. The best preserved of the nave decorations is in Santa Maria Maggiore (fig. 1, diag. 3), transformed into a Christian church in the reign of Pope Sixtus III, A.D. 432–40.[4] In a long inscription on the interior facade wall, the pope dedicates the building to the Mother of God. Because Mary had been given this title only after the Council of Ephesus in A.D. 431, it is often assumed that the building and its decoration were related to that event. Indeed, the scenes of the "Infancy cycle" on the face of the original apsidal arch, in keeping with their proximity to the sanctuary area, place greater emphasis on the theological status of Mary than on descriptive narrative.[5]

The nave decorations, by contrast, include at least forty-two separate narrative scenes. Both sides of the nave carry scenes from the Old Testament, telling the story of the establishment of Israel through the lives of the patriarchs. Their disposition is the Double Parallel Apse-to-Entrance pattern, with the earlier scenes beginning at the apse end on the left wall, followed by later ones on the right.[6] The pictorial fields are generally square in format, divided horizontally into two superimposed zones. The individual scenes are relatively small and, as has often been pointed out, do not seem scaled for distant viewing. Most of all, they resemble illustrations in illuminated manuscripts, as though page decorations had been transferred directly to the wall.[7] A reconsideration of this traditional view, however, reveals that instances of such explicit references to book illumination in monumental decoration are rather rare, and when they do occur there is strong reason to believe that the relationship is intended to carry a specific message. In this case, as Kitzinger has shown, the classicizing style is a programmatic reference to Rome of the Caesars meant to claim effective authority for the bishop of Christian Rome. In like manner, "rearrangements" in chronology of several of the biblical scenes (that of Melchizedek, for example, displaced for liturgical reasons) and emphasis on activities of the patriarchs weight the narrative to express

DIAGRAM 3. Santa Maria Maggiore, nave

FIGURE 2. *Santa Maria Maggiore*, interior, drawing by Sallustio Peruzzi

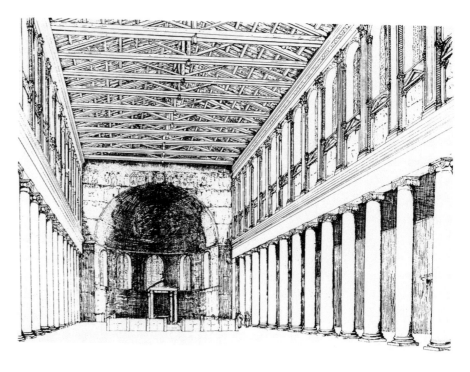

the idea that all the people of Christendom were now recipients of God's promise to the chosen people. Kitzinger further observes that the scenes nearest the apse on both sides are most closely associated in style to the epic mode of the classical prototypes. They are composed with great monumentality and solemnity, and they harmonize fully with the theological mode of the adjacent sanctuary mosaics. As the narrative moves away from the apse toward the entrance, the compositions become progressively quicker in tempo, with smaller figures in more agitated poses.[8] It is interesting that Kitzinger sees this compositional rhythm as a slowing of the action (*ritardando*) as it approaches the sanctuary. From the point of view of narrative disposition, conversely, the cycles begin in slow, ceremonial procession at the apse end of the church, speeding up (*allegrezzando*) as they return in the Double Parallel to the entrance. The overall effect, then, is a long wavelike motion drawing worshipers toward the altar where the newborn Savior is displayed, then returning them with the "glad tidings" to the building's entrance and out to the world at large. Compositional rhythms as well as biblical chronology are manipulated to express the underlying significance of the narrative.

The miniature scale of these mosaics and their placement low on the nave wall raise the question of possible decorations on the upper walls. Some clues to how the upper portions might have been adorned come from the later history of the church. At the end of the sixteenth century, Santa Maria Maggiore was still the center of Marian devotion. Pope Sixtus V, a Counter-Reformation historian of profound learning, undertook a redecoration of the basilica in the spirit of his namesake, Sixtus III, founder of the church. In the same spirit, the archpriest Domenico Pinelli, equally devoted to historical precedence, commissioned (1590–93) the cycle that now decorates the upper clerestory walls, whose subject combines the Life of Mary with that of Christ. A drawing by Sallustio Peruzzi done before the rebuilding, despite incorrect proportions, made

possible a reconstruction of the original nave articulation (fig. 2).[9] There were, above the frieze of the architrave, fourteen tall arched areas including aediculae with alternating pediments framing the extant mosaics in the lower portion. In the upper portion were either fourteen windows or, as most scholars believe, at least seven flat surfaces like the ones now existing.[10] If such "filled in" surfaces did exist, they were likely to have been adorned with monumental representations,[11] aggrandizing and illuminating the dedication of the church. Since the church was dedicated to the Mother of God, it would have been fitting to show Old Testament prophets and forebears of Mary.[12] Such an arrangement would add still another level of possible meaning to the "miniature" style and size of the Old Testament mosaics. Would they not have had the same physically subsidiary, though typologically important, role they have now? That is, the Old Testament scenes would have appeared as the "foundation" for the images that embodied the transition to the New Testament images, functioning as visual footnotes to larger, more monumental forms above.

Both the small scale of the narrative scenes and a wavelike movement from apse to entrance and back can be seen again in the mosaics of Sant'Apollinare Nuovo in Ravenna (ca. A.D. 500; fig. 3). In this case small-scale, framed narrative scenes are placed on the upper register of

FIGURE 3. Ravenna, Sant'Apollinare Nuovo, interior view

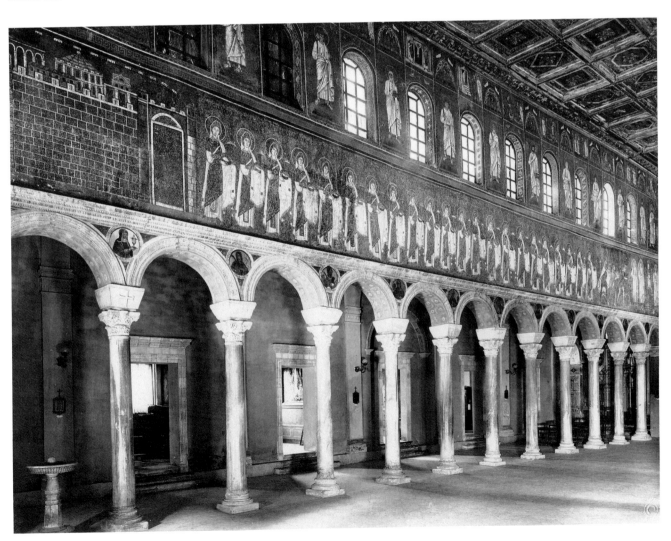

DIAGRAM 4. Sant'Apollinare Nuovo

the clerestory wall, above two other zones containing figures much larger in scale: the second tier shows prophets and saints between the windows, while below are the famous processions of martyrs, females on the left and males on the right.[13] As in Santa Maria Maggiore, the disposition of the framed narratives is the Double Parallel Aspe-to-Entrance, starting on the left wall at the apse end with scenes of Christ's miracles (diag. 4). The sequence then returns to the apse end of the right wall with Passion and post-Passion scenes moving left to right, ending at the entrance. Since the miracles are drawn from different gospels, they cannot be said to follow any exact biblical order; the visual placement, however, generally follows the written chronology.[14] The vast difference from the scenes in Santa Maria Maggiore is in the narrative mode. Despite their small scale, the scenes bear no resemblance to a "miniature" style. Instead, each scene is a human drama with a few powerful figures pressed toward the picture plane and broadly silhouetted against a brilliant gold background. The emphasis is on significant single actions and glances that convey meaning rather than incident. The rectangular framed scenes alternate with a standard motif of a dove-flanked cross surmounting an inverted conch with suspended crown. These emblems place symbolic quotation marks around narratives, adding to the static quality of the scenes and reinforcing the iconic quality of each figure composition in the sequence.[15] The loosely structured narrative, one of the earliest extant ecclesiastical representations of the Life of Christ, combined with a deeply spiritual style, makes clear the Savior's hypostatic state of being.[16]

When we turn to the representations on the lowest zones we find that whereas the Christological cycle moves from the apse to the entrance, the processions of saints move in the opposite direction.[17] The goal of the women martyrs is the enthroned Virgin and Child adored by the Magi; that of the men is Christ enthroned with his angelic entourage. Taking biblical chronology quite literally, we can plot an overall pattern for the full nave.[18] It moves left to right on the bottom tier of the left wall from the entrance to the Adoration of the Magi (Christ's Infancy) at the apse end of the left wall; it moves straight up to the top tier of the same wall (apse end), starting with the scene of the *Wedding at Cana*, Christ's first

public miracle, and moving right to left to the entrance. It jumps back to the apse now on the upper tier of the right, reading left to right from the scene of the *Last Supper* to the *Doubting Thomas* at the entrance end of the nave. It descends straight down to the bottom tier, reversing directions to follow the procession of male saints that leaves the royal palace and moves toward the mature Christ in Majesty at the apse end. The wavelike pattern, only implicit at Santa Maria Maggiore, here becomes overt. It is made up of two zigzags: on the left, starting down, moving left-right, then up, moving right-left; on the right, starting up, moving left-right, then down, moving right-left. As an abstract design, this arrangement has in nucleus an element that was to become a major constituent of cycle design in future centuries: the Boustrophedon.[19]

Another Marian sanctuary whose decorations were carried forward at the beginning of the eighth century by Pope John VII was Santa Maria Antiqua in the Roman Forum. This basilicalike structure, partially built into the natural rock, is too tall and narrow for a unified nave decoration. Perhaps for this reason, for the first time as far as we know, the presbytery was given a continuous narrative cycle.[20] The arrangement, moreover, gives evidence of another pattern of disposition that was to become a well-established formula, identified especially with devotion to the Blessed Virgin Mary. This disposition is the Apse pattern, and it is characterized by scenes circling the apse in a left-right movement on one tier. If the story continues on another tier, it starts again at the left and repeats the same linear progression. Although several scenes are lost at the beginning of the Santa Maria Antiqua cycle, we may assume a Life of Christ that started at the left with childhood episodes and moved across the upper tier (fig. 4); the *Adoration of the Magi* appears in the fifth position, adjacent to the apse. There the narrative is interrupted by a huge devotional scene that has been called the *Adoration of the Crucifixion*. It

FIGURE 4. Rome, Santa Maria Antiqua, drawing

FIGURE 5. *Old Saint Peter's* interior, drawing by Grimaldi

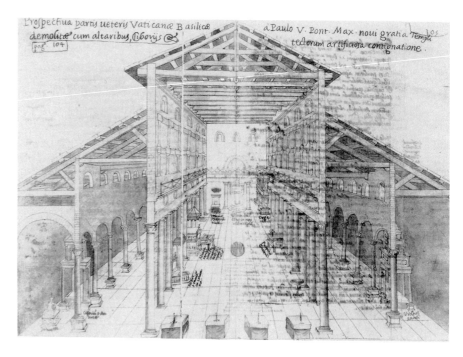

shows the crucified Christ, cherubim, ranks of angels, and liturgical inscriptions, all hierarchically arranged. To the right, the narrative continues on the upper tier with the *Presentation in the Temple,* the *Flight into Egypt,* and three other scenes of Christ's early life. The story returns to the sanctuary's left wall on the next tier down. Again we may assume that there were scenes of the Entry into Jerusalem and the Transfiguration, since the remains of three following scenes indicate the *Last Supper,* the *Betrayal of Christ,* and *Christ Carrying the Cross.* Fragments remaining of the latter scene indicate a compositional movement from left to right, following the progress of the narrative. The oversized Crucifixion, in spite of its nonnarrative aspects, now fits into the sequence as the next phase of the story.[21] The lower tier of the right wall ended the cycle with five post-Passion miracles, of which there are only scant remains. In a very cogent manner, the grouping of the scenes on either side of the building's devotional center moved the narrative along in a logical fashion, using pictures of the Savior's earthly life to frame and emphasize the theological center of his mission.[22]

The full realization of the Double Parallel Apse-to-Entrance disposition occurred, naturally enough, in the main basilicas of Rome. Saint

DIAGRAM 5. Saint Peter's

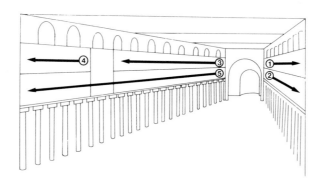

FIGURE 6. *Left Colonnade of Old Saint Peter's,* drawing by Grimaldi

Peter's, San Paolo fuori le Mura, San Giovanni in Laterano, and others, probably decorated by the fifth century, were redone and brought to their most developed forms in the early eighth and ninth centuries. At Old Saint Peter's (fig. 5), on the top tier, huge figures of apostles stood in pairs between the windows.[23] The narrative cycle started on the second tier of the right wall and moved from left to right to the entrance end of the wall (diag. 5). Presumably the story went from Creation through the Life of Isaac. It then returned to the apse end of the same wall, where the reading dropped down one tier and moved again toward the entrance with scenes from the stories of Joseph and Moses, always reading left to right. The narrative then moved to the left wall. New Testament subjects were displayed beginning at the apse end again on the second tier and then on the third, moving toward the entrance, this time reading right to left. Although few of the forty-four subjects of the left wall were recorded, enough evidence remains to verify that the cycle must have been a continuous sequence from the Infancy through the post-Passion miracles, the longest series on this subject before the tenth century.

Placing the Old and New Testament cycles on opposite walls of the nave was meant to convey dogma. Known to have been in use by the fifth century, physical opposition of the cycles was employed to express the concept of typology, whereby events in the Bible of the Jews are shown to prefigure, in a literal way, events in the life of Christ.[24] In this manner the disposition of the cycles and the structure of the mural support were exploited to express theological ideas.

One of the most characteristic features of the Petrine left wall cycle, known from Grimaldi's drawings, is the clearly defined *Crucifixion.* The image encompassed the wall-space allotment of four regular scenes, two on the second tier and two on the third (fig. 6). The scene of Christ's sacrifice stands out, therefore, with special emphasis. An oversized *Crucifixion* (and possibly also the scenes of the Entry into Jerusalem and the Ascension) as a formal manifestation of theological ideas left a long and

impressive legacy throughout the remainder of the Middle Ages and beyond.[25]

Turning to other Constantinian basilicas, we find that San Paolo fuori le Mura (fig. 7) had the same pattern as Saint Peter's: the Double Parallel Apse-to-Entrance, with Old Testament scenes on the right wall and New Testament on the left, in this case, the Life of Paul.[26] The fresco cycle in San Paolo, restored by Pietro Cavallini and his shop (1277–80), remained essentially intact until it was destroyed by fire in 1823.[27] Fairly elaborate drawings and prints had previously recorded the scenes, and unless Cavallini introduced basic changes into the structure of the narrative, we can draw more or less secure conclusions about its organization.[28] The Old Testament scenes follow biblical order rather strictly.[29] The same is true of the Life of Saint Paul, but only up to a certain point, after which the narrative moves up and down from tier to tier and is no longer consecutively arranged. This variation is significant in that it corresponds precisely with a shift of emphasis from the narrative to the didactic and moralizing aspect of the biblical account.[30] As in Santa Maria Maggiore, chronology is disregarded to pursue an ulterior argument. In addition, at least one apocryphal scene, the *Meeting of Peter and Paul,* is added for polemical reasons, symbolizing a carefully orchestrated compromise between rival factions in Rome.[31]

In the case of the Church of San Giovanni in Laterano, traditionally

FIGURE 7. Rome, San Paolo fuori le Mura, drawing by Pinelli, 1823

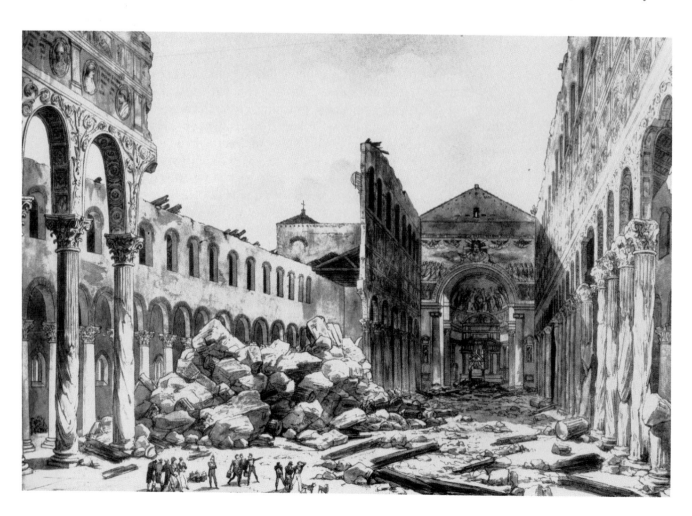

FIGURE 8. Rome, San Giovanni in Laterano, drawing by Borromini school

said to have been founded by Constantine in the winter of 312/13 and decorated by 440–50, there is no direct evidence of the original scheme. A description made in 787 by Pope Hadrian I names scenes then extant but destroyed by an earthquake a century later.[32] In the seventeenth-century reconstruction by Francesco Borromini, this documentation guided the choice of scenes and their typological pairing, which has been called the first one-to-one visual paralleling of New and Old Testament subjects.[33] For example, the scene of the expulsion of Adam and Eve from paradise, first at the apse end of the left nave wall, was placed in relation to the scene of the good thief being welcomed into paradise at the apse end of the right wall. If the baroque reliefs also reflect the original disposition, it was again the Double Parallel pattern, progressing from the apse to the entrance (fig. 8). Here, however, the six Old Testament scenes would have appeared on the left wall, while Christological scenes were on the right, reversing the arrangement both at Saint Peter's and at San Paolo.[34]

This brief, oversimplified survey of early medieval monumental church decoration allows us to make certain generalizations. What I have called the protocols for arranging narrative cycles, though logical within themselves, were not necessarily the only possible choices, or even the most obvious. With no written evidence about why these choices were made, one can only speculate on the reasons behind them. One could assume that the image in the apse, being the focal point of worship and visionary, apocalyptic, or anagogical in nature, was the generating force of the accompanying narratives and hence the starting point at the apse end. One could equally well assume, however, that because of the other-worldly aspect of apse images they represent time beyond time, the goal of worshipers who would enter the church and make their way toward them. Following this concept, it would be logical to arrange the narratives to start at the entrance and move toward the apse. This disposition exists, but it was used rarely and in extraordinary circumstances.[35]

Another factor that might have played a role in shaping the Double Parallel was liturgical practice. Here again we are on shaky ground, for in this realm too we lack documentation. Historians have voiced a considerable range of opinion based mainly on views of the function of the nave. In the East, at least in early times, the nave as a whole was reserved for the clergy. In the West, by the time of Constantine, the clergy had withdrawn to the apse end and the space around the altar; by the mid-fifth century the aisles, and in large part the nave, seem to have been the realm of the congregation, the members being free to walk about. Processions accompanied various ceremonies such as the entrance of bishops and the transport of crosses, gospel books, and elements of the Eucharist, with paths that varied according to local custom.[36] One scenario sees the clergy's solemn entrance through the main portals of the church, a procession through the nave to the apse ending with the singing of the introit, and finally a turn to the right for the reading of the epistle.[37] An architectural feature reinforced this movement: the solea, a raised stone pathway extending precisely from the entrance along the nave to the chancel and serving the bishops and clergy for their processions to the altar.[38] This itinerary takes us, logically at least, to the starting point of the narrative cycles as well. In the case of Sant'Apollinare Nuovo in Ravenna, the

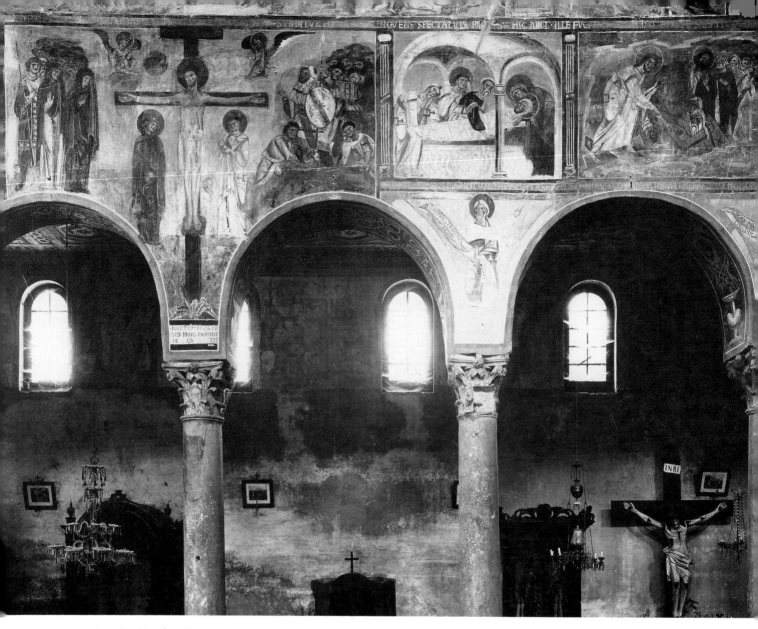

FIGURE 9. Sant'Angelo in Formis, interior

DIAGRAM 6. Sant'Angelo in Formis

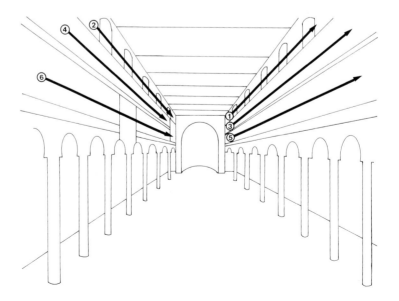

zigzag reading directions may reflect the complex liturgical practice of a town that is often characterized as a crossroads of Eastern and Western ecclestiastical manifestations. In the case of Santa Maria Antiqua, the Apse pattern must reflect the activities of a cult of the Cross. In the central apsidal image, great emphasis is placed on the adoration of the crucifix, in the inscription that flanked the image and in the mass veneration represented visually around it.[39] The "enlarged" *Crucifixion* in the Christological sequence at Old Saint Peter's seems to reflect liturgical practice equally directly. The image has been related to the institution in Rome in the late eighth century of the feast of the Exaltation of the Cross, which involved a special altar and a ceremony that would have taken place beneath the fresco.[40]

Beyond the possible disposition/liturgy rationale, the considerable flexibility in positioning individual units of the narrative also had ideological motivation. "Misplacing" a scene within a given chronology could call attention to general points of dogma, as with the Melchizedek scene in Santa Maria Maggiore. Or the addition of a scene with no chronological grounding could refer to local issues, such as church politics in the *Meeting of Peter and Paul* at San Paolo fuori le Mura. Basic arrangements, which interacted with the linear thrusts of the basilical design, were agents of expression, and variations in those arrangements were equally meaningful. These principles made Christian mural decoration one of the foremost means for communicating with the population at large.

The Later Middle Ages

Sometime before the eleventh century another important type of narrative arrangement came into widespread use. I shall call this pattern the "Wraparound."[41] The Wraparound is seen fully developed in the church of Sant'Angelo in Formis, one of the best preserved churches in Italy of this period until it was damaged by a landslide in 1968 (fig. 9; diag. 6). Built under Abbot Desiderio of Monte Cassino, Sant'Angelo was decorated with Old Testament narratives in the side aisles and a New Testament cycle in the nave.[42] The term Wraparound describes the narrative disposition that reads continuously in one direction, here left to right, wrapping several times around the walls of the nave (diag. 6). The nave walls at Sant'Angelo were decorated with the Life of Christ, beginning, evidently in remembrance of Saint Peter's in Rome, on the top tier at the apse end of the right wall of the nave. Starting with many scenes from the Infancy of Christ (all lost), the narrative proceeds from left to right to the entrance end of the wall. It then continues at the entrance end of the left wall on the same tier, with the preserved scene of *Herod Ordering the Massacre of the Innocents*. The narrative moves again from left to right across the wall to the apse end of the nave, ending with the *Third Temptation of Christ*.[43] The reading continues to wrap around left to right on the second tier of the right wall (starting with the *Calling of the Apostles*); continues at the entrance end of the left wall (with the *Transfiguration*); wraps across to the third tier of the right wall (starting with *Christ and Zaccheus*); and finally moves across to the third tier of the left wall, starting with the *Kiss of Judas* and ending at the apse end with a double-sized vertically oriented scene of the *Ascension*.[44] Although the three tiers

FIGURE 10. Rome, San Giovanni a Porta Latina

FIGURE 11 (*facing page*). Assisi, San Francesco, Lower Church, nave walls, Saint Francis Master, and view into Saint Martin Chapel, Simone Martini

are nearly equal in height, the individually framed scenes vary considerably in width. Three stand out as larger than all the others. These are the *Entry into Jerusalem* (lower tier of right wall), the *Crucifixion*, which descends into the space of the spandrel of the arcade on the left wall, and the *Ascension* noted above. Like the choice of the cycle's starting point, these oversized scenes most likely depend on prototypes established at Saint Peter's in Rome. Recalling the large-scale *Crucifixion* on the left wall there, and looking forward to other instances where the same three scenes are treated in a similar fashion, these analogies may be recognized as not random abberations but deliberate references.[45] The enlargements follow the venerated prototype in giving emphasis to the beginning of Christ's Passion, his sacrifice on the cross, and the end of his earthly life.

The importance of this theological message may be measured by the fact that it is repeated a hundred years later in a church in Rome. At San Giovanni a Porta Latina (1160–91; fig. 10), the *Entry into Jerusalem*, the *Crucifixion*, and the *Ascension* are larger than the other, albeit irregularly sized, scenes.[46] This cycle too is a triple Wraparound starting on the upper tier of the right wall at the apse end and progressing from left to right. Here, however, both Old and New Testament subjects are incorporated into the nave cycle, with scenes from the Creation through the story of Jacob on the top tier and the New Testament sequence appearing on the two lower tiers. If narrative disposition really reflects liturgical function, then the Wraparound pattern implies a processional route that differed from the paths followed in buildings with the Double Parallel.[47]

The persistence and authority of these two basic medieval patterns can be seen with particular clarity in the second half of the thirteenth century, when the great programs of renewal were initiated.[48] One of the most striking demonstrations of this burst of productivity is found at Assisi, where ambitious building campaigns were begun less than a generation after the death of the founder of the mendicant order. The earliest remaining decorations at San Francesco are the frescoes in the nave in the Lower Church, the first foundation of this vast complex. The nave paintings were created by an unknown painter called the Saint Francis Master

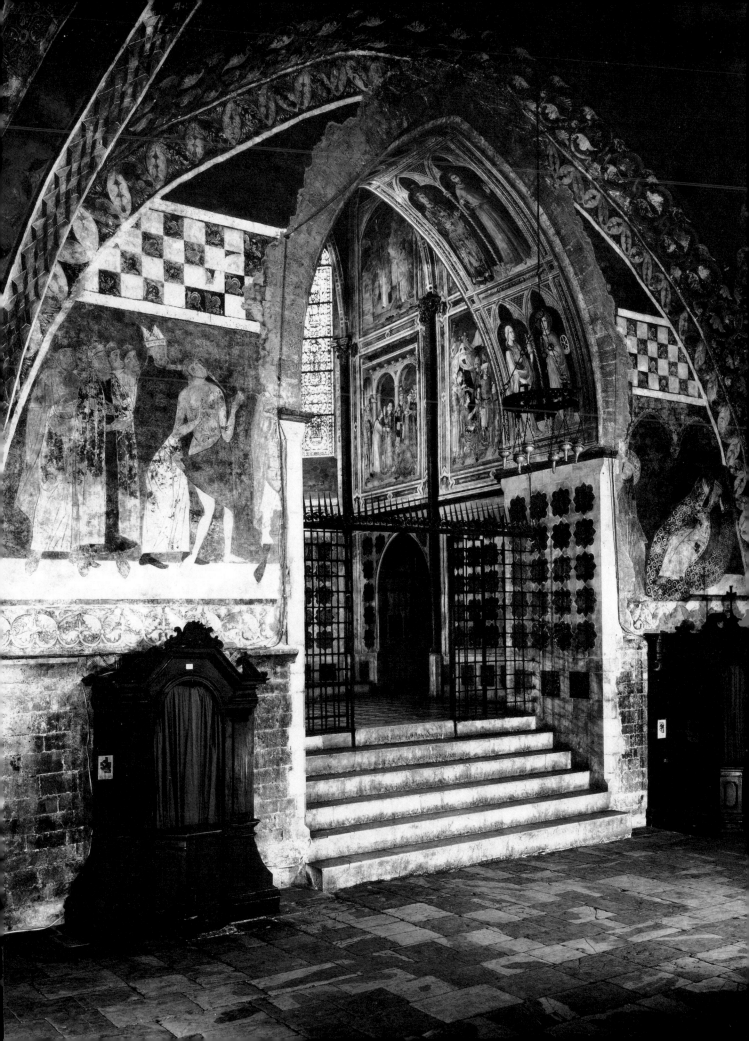

and are now dated 1253–66 (fig. 11).[49] The frescoes are arranged in a way that is important for several reasons. In the Early Christian manner, the episodes on the two sides are confronting parallels: the wall to the right of the apse holds five Christological scenes reading right to left; five scenes from the Life of Saint Francis, reading left to right, are on the left.[50] Using the long-established technique of side-to-side reciprocity, a typology is set up. It is not the standard confrontation of Old and New Testament scenes, but rather a new combination of subjects. Scenes from Francis's life are selected and arranged to mirror those of Christ's Passion. The cycle is one of the first visual allusions to the bold, and highly controversial, theological assertion of the order, *Franciscus alter Christus*, Francis as the new messiah.[51] A detail in one of the Christological scenes illustrates the precision of the pairing. Several rough cloth habits, said to have belonged to Saint Francis and showing the marks of his stigmatization, are kept as relics by the order.[52] It was no doubt in reference to these sacred garments that the extraordinary scene of *Christ Giving up His Robe as He Mounts the Cross* was included.

As the narrative proceeds from the entrance toward the apse, it seems to contradict the history I have been recounting. Recent findings of a team of archaeologists offer an explanation for this apparent anomaly. The evidence suggests that when the Lower Church was first built, the orientation of the nave was the opposite of the present one; that is, the apse was toward the east, the normal orientation for a Christian church.[53] If this reconstruction is correct, the Christological scenes were originally on the left, the Francis scenes were on the right, and the reading sense of the frescoes faithfully followed the Early Christian protocol.

In the Upper Church of San Francesco at Assisi the reference to Rome, augmented by new elements, becomes even more pointed. Saint Francis had taken as his special patrons the Virgin Mary, Saint Peter, and the Archangel Michael.[54] These members of the Christian hierarchy are celebrated in the three main altars of the Upper Church: the apse, now firmly placed at the west end of the building, is dedicated to the Virgin, and the transept wings are dedicated to Michael (left) and Saint Peter (right). In each case the altar is surrounded by fresco cycles with appropriate narratives painted by Giovanni Cimabue and his workshop about 1274–84. In view of their importance and influence, I shall consider these "altar" decorations before turning to the main body of the church, where cycles of the Old and New Testament and the Life of Saint Francis appear.[55]

In the main apse Saint Francis's devotion to the Virgin Mary is dramatized. It is important to recall that Assisi is probably the first of several major apsidal sanctuaries decorated or redecorated with Marian cycles in the decades 1280–1300. Together these works form a tightly knit, interrelated series of variations on a theme.

The arrangement of Cimabue's cycle on the five-sided apse wall at Assisi is a landmark in the visual manifestations of Mariolotry (figs. 12, 13). The subject of the cycle is purely Marian, omitting all those episodes in which Mary figures as a character in Christ's life. There are eight scenes: the first four depict pre-Nativity events, and the last four show Mary's death and glorification.[56] The facets of the wall at either end of the hemicycle have two painting fields superimposed within the lunette area. The horizontal band of four fields forming the lowest tier is inter-

rupted in the center by the altar (diag. 7).[57] The narrative begins at the left on the top tier with the *Expulsion of Joachim*. The second scene, *Mary's Birth*, appears on the same tier at the opposite, right-hand side of the apse. The story then returns to the left lunette, second tier, where the *Presentation* is placed, jumping again to the right lunette with the *Betrothal* on the second tier. The last four scenes recounting Mary's death are disposed consecutively from left to right around the bottom tier. Discounting the architectural differences, the basic arrangement is similar to the one we encountered centuries earlier in Santa Maria Antiqua, which I called the Apse pattern. At Assisi the pattern has a twofold effect. First it draws the full sanctuary into a unity, giving substance to Mary's life as an independent narrative. Then it divides that life into ideological "chapters." The first four scenes, which move back and forth across the space, tell of Mary's life on earth before the Incarnation; they convey the humanity of the Mother of God. The last four scenes flanking the altar describe her glory; they emphasize the reality of her bodily assumption into heaven, where she reigns as Christ's queen.

The mastermind of the program at Assisi has been identified as Jerome of Ascoli, who followed Saint Bonaventure in 1274 as minister general of the Franciscan order.[58] Jerome's personal devotion to the Virgin reflected that of Saint Francis, and he spent much thought and energy in promulgating the still controversial doctrine of Mary's Assumption.[59] The friezelike arrangement of the lower tier of the apse put this major element of Jerome's theological thought into visual form.

Jerome of Ascoli was the first Franciscan to be elected pope. In 1288 he became Nicholas IV.[60] As pontiff he continued his patronage of the mother church in Assisi,[61] and at the same time he turned his attention to the center of Marian worship in Rome, Santa Maria Maggiore. There he built a new apse behind the original apsidal arch, preserving and honoring the ancient mosaics and their theological content. For the new apse he commissioned Jacopo Torriti to make lavish gold-ground mosaics (signed and dated 1295; fig. 14).[62] The main image in the conch is the *Coronation of the Virgin*, shown in a celestial sphere, surrounded by paradisiacal vines and accompanied by the chief apostles, Saint Francis and his follower Saint Anthony, and the pope kneeling in veneration.[63] Running along the base of the conch is a sequence of five scenes, which focus specifically on Mary's role as the Mother of God: the *Annunciation, Nativity, Adoration of the Magi, Presentation in the Temple*, and *Dormition of the Virgin*.[64] The disposition follows the Apse pattern, as at Assisi, with the scenes in a continuous friezelike band along the base of the architectural unit (diag. 8).[65] From the point of view of life chronology the sequence is "out of order." *The Dormition of the Virgin* appears not in its chronological place at the end of the sequence but in the center of the semicircle, directly under the *Coronation*. This manipulation of the narrative order can be said to promulgate a specific theological point. Reading vertically from the bottom up in the center of the conch, the *Coronation of the Virgin* immediately follows her *Dormition* and so implicitly affirms her Assumption as a physical fact.[66] The Franciscan position on the issue of Mary's glorification *in corpo e in spirito* was thus expressed by purely visual means.

Almost simultaneously (1298–1300), Cavallini was commissioned to

FIGURE 12. Assisi, San Francesco, Upper
Church, apse, left, Cimabue

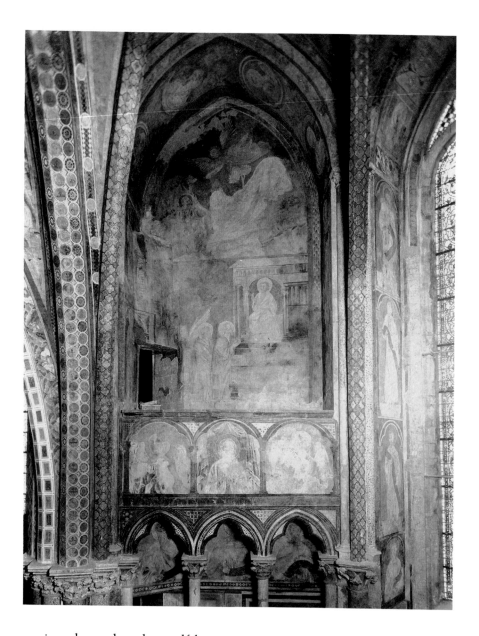

repair and complete the twelfth-century apse mosaic in another great
Marian church in Rome, Santa Maria in Trastevere, and he again em-
ployed the Apse pattern for a narrative of the Life of Mary (fig. 15). A
venerable image in the semidome, preserved from an earlier decoration
dated 1143, shows the Virgin and Christ seated together on a single
throne, with Christ embracing his already-crowned consort/mother. The
theme is that of the Mystic Marriage of Christ and Ecclesia, an idea based
on the Song of Songs, a passage from which appears in an inscription
below the figures. As such, the image shows not a narrative moment but
a mystic state: the king and queen of heaven reigning in perpetuity.[67] To
this purely devotional image, Cavallini adds a friezelike narrative se-
quence at the base of the conch. Mary's own birth scene is introduced on
the left front face of the triumphal arch. The *Nativity, Adoration of the
Magi*, and *Purification* then ring the apse, and the *Virgin's Death* appears
on the right front face. In contrast to Santa Maria Maggiore, the narra-
tive now reads straight through (diag. 9), starting at the left and ending

FIGURE 13. Assisi, San Francesco, Upper Church, apse, right, Cimabue

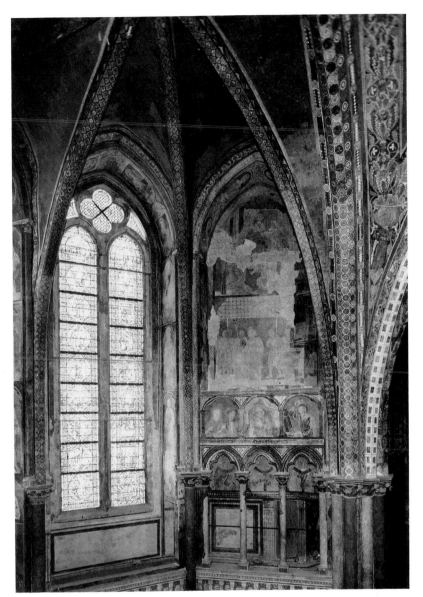

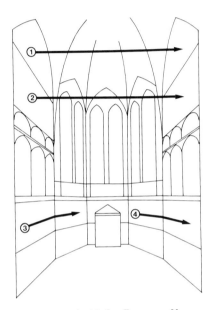

DIAGRAM 7. Assisi, San Francesco, Upper Church, apse

at the right.[68] Here the Apse pattern is used in strict real-life order. With this chronological realism Cavallini describes Mary's entire earthly existence as the preparation for her glorification in heaven above.

In these three Marian monuments, the Apse pattern was firmly associated with devotion to the Mother of God and her bodily Assumption. The Franciscan component in this association is evident, and the Assisi apse, along with its Roman followers, was often emulated as a paradigm of Mariological devotion.[69]

Flanking the apse at Assisi, the wings of the transept are treated as independent chapels, oriented away from the crossing. The left wing, dedicated to the Archangel Michael, is decorated on the wall behind the altar with scenes of the Fall of the Angels, and on the wall to the right with the Apocalypse. The wall to the left is filled with a large *Crucifixion* (fig. 16). The right transept arm is dedicated to Saint Peter, and the fresco cycle shows scenes from his and Saint Paul's lives on the left wall and behind the altar (fig. 17).[70] A second *Crucifixion* fills the wall to the right.

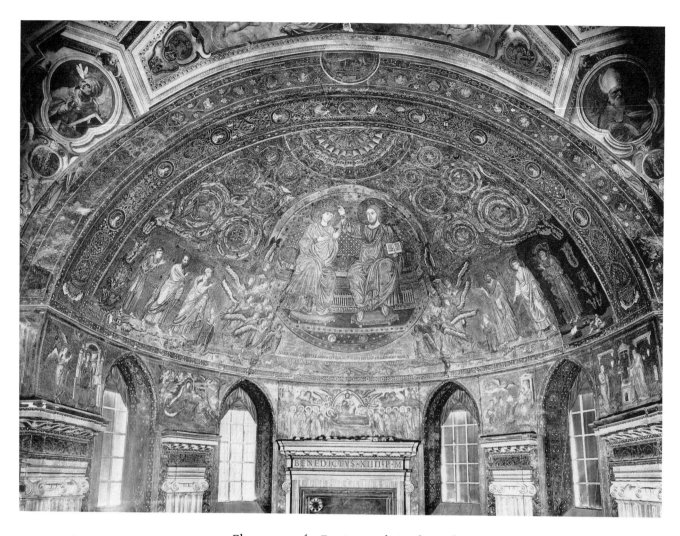

FIGURE 14. Rome, Santa Maria Maggiore, apse mosaic, Torriti

Placement of a Petrine cycle in the right transept arm is in itself a reference to Saint Peter's in Rome, where from at least the ninth century there was a cycle of the apostle's life.[71] This reference is joined with those in the nearby Crucifixions, whose expanded size recalls once more the configuration in the nave of Old Saint Peter's. These images of the Cross, together with those of the Virgin, Michael, and Saint Peter, constitute the chief subjects of Saint Francis's devotion. Moreover, we shall see that the

DIAGRAM 8. Santa Maria Maggiore, apse

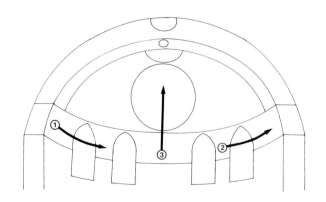

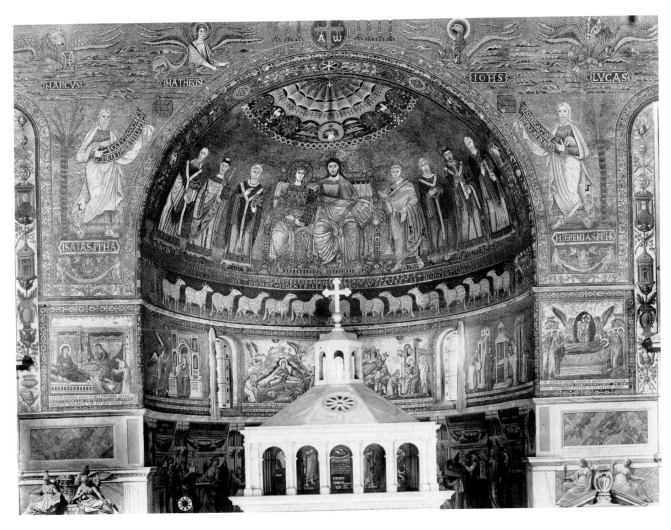

FIGURE 15. Rome, Santa Maria in Trastevere, view of apse (see plate 2)

doubling of the Crucifixion subject and the placement in the crossing (on the walls adjoining the nave in both transept wings) bring an unsuspected unity to the programs of the Upper and Lower churches.[72]

The disposition of the cycles in the nave of the Upper Church (fig. 18; diag. 10) confirms the references to Roman precedents and introduces a major new idea to the tradition we are tracing.[73] The nave of the Gothic building is composed of four huge groin-vaulted bays. The wall surfaces,

DIAGRAM 9. Santa Maria in Trastevere, apse

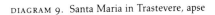

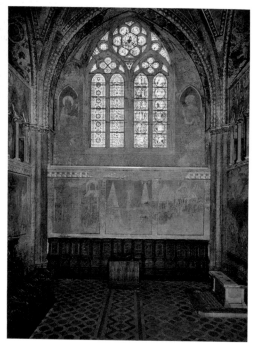

determined by the size of the groins, are divided into bays that are pierced by large windows. The murals appear on the irregular rectangles that flank these openings, following their tall pointed-arch shapes. These fields in turn are divided into two horizontal tiers that span the bays. The disposition of the narrative follows several medieval protocols. The sequence begins at the apse end of the upper tier of the right wall. Reading from left to right, the top right tier contains eight scenes from Genesis, from *Creation* through *Abel's Murder*.[74] The narrative continues by returning to the apse end of the wall, on the second tier, and again reads left to right, with two scenes each from the stories of the patriarchs Noah, Abraham, Isaac, and Joseph. The Old Testament narrative closes with the scene of the *Finding of the Cup in Benjamin's Sack* (fig. 19).[75]

On the upper tier of the left nave wall is a New Testament cycle that begins, again at the apse end, with the *Annunciation to Mary* and proceeds from right to left to the entrance. The eight scenes on this tier end with the *Baptism of Christ*.[76] The second tier follows the same pattern, beginning again at the apse end with the *Wedding at Cana*, reading right to left, and ending with the *Empty Tomb Guarded by Angels*.[77] On this tier the sequence continues across the entrance wall, showing the *Ascension* to the right and finally, to the left, *Pentecost*.[78] Within the structure of a Gothic interior, and excepting the extension onto the interior facade (replacing the more usual Last Judgment), we have the pattern of Old Saint Peter's, including the Old Testament–New Testament, side-to-side typology across the nave.

On the third tier down, the innovative aspect of the arrangement becomes apparent. At this level, forming a monumental continuous band of rectangular fields, there is a cycle of twenty-eight scenes depicting the Life of Saint Francis. It is important to realize that this cycle is the first monumental visualization of the life of a near contemporary, in immediately recognizable settings and costumes.[79] The modernity of painting

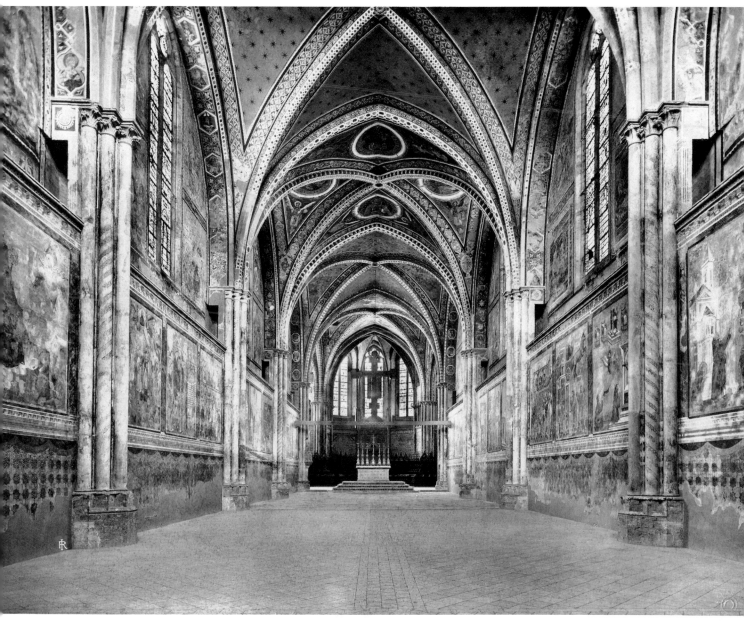

FIGURE 18. Assisi, San Francesco, Upper
Church, nave

DIAGRAM 10. Assisi, San Francesco, Upper
Church, nave

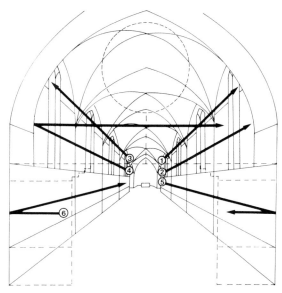

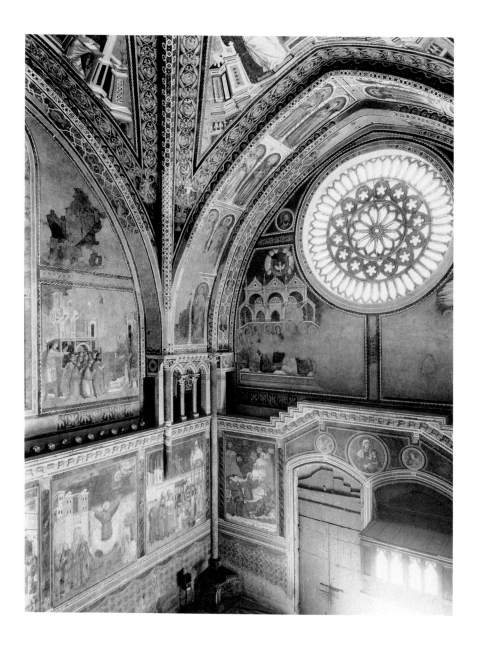

style thus expresses the contemporaneity of the subject. The disposition
serves to exert the ideological force of the theme, calling into service the
alternative medieval pattern I have described as the left-to-right Wrap-
around. The major events of Francis's life, drawn from the "official" biog-
raphy, the *Legenda maior* as it was finally produced by Saint Bonaventure
under strict control and editing by the order,[80] move left-right from the
apse end on the right wall, across the entrance, and continue on the left
wall from the entrance to the apse.

The two major medieval patterns of nave decoration, both identified
with Rome, are thus deliberately contrasted. As they travel separate nar-
rative routes around the nave, the combined systems create a new, higher
unity, in which the life of the modern founder of the order is interlocked
with traditional narratives of the received biblical texts. The Life of Saint
Francis, told with utterly new, explicit, contemporary details, is literally
wrapped around and given status equal to the lives not only of the Old

Testament patriarchs, but of Christ himself. In fact, one of the most effective encounters resulting from this interlocking system is the superimposition of the scene of Christ's death in the *Crucifixion* immediately above the scene of Francis's *Death and Apotheosis* (fig. 20). In this physical intersection of the two narratives, there can be no mistaking the identification of Francis with Christ. Once again the fundamental ideological tenet of the Franciscan order, *Franciscus alter Christus*, is visually, and grandly, expressed.[81] In a remarkably ingenious way, the Assisi planners used narrative disposition to illuminate Franciscan ideas. Their scheme provided an ideological context for the founder's tomb at the same time as it made a vivid statement of the order's allegiance to papal authority. The mystical transfer of efficacy from the center of Christendom to Assisi was manifested through a program of figural decoration that embraced the entire structure.[82]

Two more monuments from roughly the same decade as the Assisi frescos sum up later thirteenth-century developments and point forward to new directions. In the Tuscan basilica of San Piero in Grado, outside Pisa, a long narrative of the Lives of Saints Peter and Paul by Deodato Orlandi, about 1300, is disposed in the Wraparound pattern (fig. 21).[83] The cycle is important historically because many of the compositions follow those of the lost frescoes from the portico of Old Saint Peter's, known from the seventeenth-century drawings of Giovanni Grimaldi.[84] Reference to the Roman prototype lends credence to a local legend. It was at this spot on the Arno River that Saint Peter was said to have landed in Italy, making his way thence to Rome. In memory of these events, Grado became the port of departure for ferryboats filled with pilgrims following

FIGURE 20. Assisi, San Francesco, Upper Church, *Death of Saint Francis*

FIGURE 21. Grado (Pisa), San Piero in Grado, nave

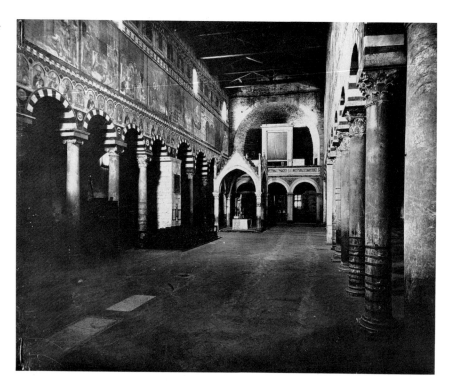

FIGURE 22. Grado (Pisa), San Piero in Grado, Deodato Orlandi, *Founding of Saint Peter's*

the same route.[85] Depictions of the church itself as an architectural portrait and of pilgrims departing for Rome are included in the cycle (right wall, positions 13 and 14). Perhaps for the first time outside Assisi, such local scenes make their appearance in a major hagiographic narrative.[86] Moreover, the story of Peter is here combined with the legend of Constantine, Saint Sylvester, and the founding of the church of Saint Peter's (fig. 22), again relating the present foundation to its prototype in Rome. The scenes and the disposition confirm the authority of the Grado complex and establish its mystical bond with the Eternal City.

The mosaic decoration in the octagonal cloister vault of the Florentine Baptistry probably was created about the same time (fig. 23).[87] The ceiling decoration is organized on several horizontal tiers. Both the plan[88] and the concentric stacking of tiers have their roots in earlier dome decoration.[89] The disposition of the Baptistry decoration, however, falls within the basilical tradition. The apse area of this building is formed by three facets of the wall at the west (known as *la scarsella*), where apocalyptic scenes are represented in a discrete composition. The narrative starts on the top tier to the right of the apse, in the Early Christian manner, and wraps around left to right for five facets of the wall. Four narratives fill one tier each, each beginning to the right of the altar. They describe, in descending order, the passions of Noah, Joseph, Christ, and John the Baptist. Each tier has ten or more scenes divided by elaborately articulated fictive columns (diag. 11). The compositions of the individual scenes clearly reflect their placement in the sequence. The first seven or eight episodes on each tier are designed consistently to be read from left to right. Architectural and landscape elements, as well as figure groups, thrust toward the right, moving the eye in that direction. At the "end" of each tier (the *Flood, Horses of Joseph, Three Marys at the Tomb,* and *Funeral of Saint John*), the compositions straighten up, as it were, often re-

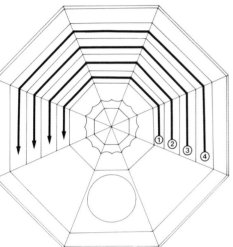

DIAGRAM 11. Florence, Baptistry (see plate 4)

versing the direction of their thrust. A kind of braking mechanism is introduced before the end of the tier, so that the narratives are brought to a close and do not enter the apse area. In this way the tier compositions, while taking cognizance of the centralized scheme of the building, emulate to some extent the narrative movement of the long wall of a basilica.[90] The arrangement seems to express the double status of the building as both centralized baptistry and the *antichissima basilica* of the city's patron.[91]

The truly new aspect of the program, however, and very much a sign of the times, is the introduction of apocryphal subjects, all with local significance for the city of Florence. In the Life of Christ, for example, three full scenes are devoted to the story of the Magi,[92] who were especially venerated in Florence. The Confraternity of the Three Kings was the largest and richest of the town, and their celebration on the Day of Epiphany (6 January) was second only to the feast of San Giovanni (24 June), patron of the city.[93] The story of Saint John the Baptist, patron of

this building, also includes legendary events. In *John Entering the Wilderness*, the portrayal of the saint as a youthful, isolated figure was the progenitor of a major theme in Florentine art. The image of the young Saint John, based on a *sacra storia* probably of Near Eastern origin and newly translated into Italian at this time, came to symbolize the strength, seriousness, and spiritual power of Florence itself.[94] At the beginning of the fourteenth century, monumental cycles were thus being endowed with new significance. Building upon the general doctrinal concerns of the earlier visual tradition, modern versions now adapted program planning to the visualization of civic pride and local devotion.

Surveying the projects of artistic renewal that formed an almost unbroken chain of activity throughout the second half of the thirteenth century, we can see that attention was focused on strengthening continuity with the monuments of Early Christian Rome. Although we know little of the individual painters called to Rome at midcentury to begin this process, they must have been giants in their time, both intellectually and technically.[95] That these unknown artists go largely uncelebrated in our day is primarily due to the opinions voiced in the sixteenth century that have shaped our own. According to Giorgio Vasari, they depicted "at Rome, in Old Saint Peter's, stories that go all around between the windows [as] things that are more like monsters in their lineaments than effigies of that which is, or should be."[96] This dreaded *maniera greca* was wiped away, Vasari goes on to say, by the "progress of the renaissance of the arts, and the perfection to which they have attained in our own time." Vasari's opinion notwithstanding, Italian Late Gothic mural art, through projects of renewal and emulation, in turn was accorded a great measure of authority by the coming generations. Ecclesiastical mural decoration remained the major public voice in the new century, albeit in projects of a different sort. Moreover, neither the artists nor their new lay patrons forgot the original Roman prototypes, exemplars that would provide the structural framework in which the "modern" style was to evolve.

2

The Cycle in the Private Chapel, 1300–1350

New patterns created for the compressed spaces of fourteenth-century private chapels were the aerial and linear Boustrophedon, the Cat's Cradle, the Up-Down, Down-Up, and the Straight-Line Vertical. This development is discussed in the work of Giotto and his contemporaries in Tuscany and Umbria.

The early fourteenth century witnessed a new form of patronage that increased the role of private citizens in the creation of ecclesiastical decoration. Great wealth accumulated through trade and exchange rather than through aristocratic inheritance, accompanied by a change in church policy, made it possible for families and individuals to purchase spaces within monastic or collegiate property for private burial and personal devotion. While most of these burgher-class properties were chapel within the structure of existing churches, one of the earliest such private foundations was an independent building, newly constructed as a small but complete church. The so-called Arena Chapel in Padua was commissioned by Enrico Scrovegni, a second-generation man of wealth, whose assets stemmed from international banking. Placed next to the (now destroyed) Scrovegni dwelling, the chapel was consecrated in 1305. It is now agreed (there are no documents) that the interior (fig. 24) was painted by Giotto di Bondone between that date and 1310.[1]

Along with the private nature of the project and Giotto's spectacular contributions to the development of naturalism, the subject matter of the decoration also qualifies as novel. Perhaps for the first time in Italy a narrative combines and integrates a fully developed story of the Virgin's childhood and youth with an extended Life of Christ. This double narrative reflects, first and foremost, the dedication of the building to Santa Maria della Carità (the Madonna of Charity). This theme represents the institutionalization of Mary's fecundity in the context of the Incarnation of the Savior. The first challenge Giotto was presented with, therefore, was to integrate visually the two stories, one apocryphal, one canonical.[2] Equally daunting was the problem of arranging the double cycle in an asymmetrical structure. For reasons we do not know, the building has six windows in the right wall and none in the left.[3] As a result, it was impossible to arrange the same number of scenes of one size on both side walls. Despite this architectural disunity, Giotto's narrative disposition displays a balance and geometric coherence virtually unprecedented in the history of Christian mural decoration.[4] Moreover, as we shall see, he exploited his own solution, or perhaps even devised it, for iconographic reasons connected to his patron. In this way he refocused expression of civic devotion, developed in the previous decades, toward that of a private indi-

FIGURE 24. Padua, Arena Chapel, interior view

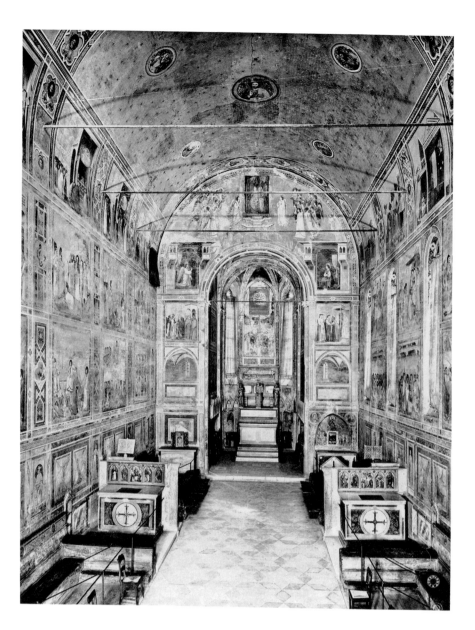

vidual, another original contribution in the history of fresco disposition.

Giotto's model was the protocol I have termed the left-right Wrap-around, with the cycle disposed on three concentric tiers (diag. 12). Within this traditional format, several devices compensate for the asymmetry of the building. The walls are divided horizontally by multicolored bands into three tiers and a dado. They are divided vertically by painted strapwork borders the same width as the strip of wall outside the end windows. The intersections of these two elements plus the windows divide the side walls into thirty-four rectangular painting fields, of equal size throughout the left wall and the top tier of the right. A second, narrower dimension, proportionately related to the first, is introduced for the ten scenes between the windows.[5] At the center and both ends of the walls, the strapwork borders pass up one side and cross the flattened barrel-vaulted ceiling. They continue down through the dado level of the other wall at both ends and to the base of the upper tier at the center of the right wall (diag. 12). By thus tying them together, Giotto unified the

two disparate sides.[6] Beyond the side walls, the narrative covers the whole surface of the triumphal arch: a unified lunette tier and a series of three stacked rectangles on each side of the arched opening.[7] This use of the space on the altar wall to continue the narrative horizontally from the side walls, a major unifying device, occurs for perhaps the first time in the Arena Chapel.[8]

The Marian cycle begins, in the Early Christian manner, on the right wall at the apse end on the upper tier. Twelve apocryphal scenes circle the top tier, moving left to right. With unprecedented rationality, Giotto extends and divides the story into what we might call "chapters," both by the grouping and by the construction of the scenes themselves.[9] Six legendary scenes of the pre-Birth miracles fill the right wall and come to a climax at the entrance end with the *Meeting at the Golden Gate*, traditionally the moment of Anne's conceiving.[10] In terms of inscenation—that is, the internal organization of individual compositions—the first three scenes have left-right compositional thrusts; the next two are centrally balanced; all five show light flowing right to left, as if generated from the real windows. On the other hand the *Golden Gate* scene, last on this tier, is composed in a right-left thrust with light represented as flowing from the front. In effect, Giotto used a compositional "braking" mechanism to emphasize this important moment and bring the chapter to a close at the end of the wall.[11]

Six scenes on the left upper tier show Mary's youth, including her *Birth* and *Presentation* and four scenes related to her marriage.[12] The thrust of the first four scenes on this tier moves left to right with the chronology. The fifth scene, the *Betrothal of the Virgin*, slows the pace with a more central grouping, and the *Cortege* scene moves steadily left-right toward the altar wall where the next, and most important, Marian element in the narrative will appear. On this side there are no windows, and the fictive flow of light accompanies the movement in a different way than on the wall opposite. The first four scenes have left-right light flow; the centralized scene has centralized light; and in the last scene the light continues left to right, reinforcing the directional thrust. The pre-Incarnation story, more extensive than any monumental Life of Mary previously painted, is thus divided into two finite chapters depicted in legato rhythm. The contribution involved here is fundamental. Giotto varied the number of scenes represented to create chapters that isolate parts of the story. He used compositional structure, along with directed sources of represented light, to vary the pace of the narrative. As in no previous cycle, these components of inscenation help to punctuate the narrative and give dramatic impact to special moments.

Having completed a full circuit of the upper tier, the narrative now moves to the face of the triumphal arch. The field here is extended upward to include the full height of the arch. The subject is the *Decision on the Incarnation*.[13] At the highest point on the arch, above two painted steps, God the Father is enthroned, surrounded by a host of angels. Although the ancillary figures are painted in fresco, the deity is painted on a separate panel of wood; the painting is therefore movable. It is possible that the change of medium reflects the *sacra rappresentatione* of the Annunciation, recorded as performed in the chapel and paid for by Scrovegni.[14] The panel may have been swung open during feast times for

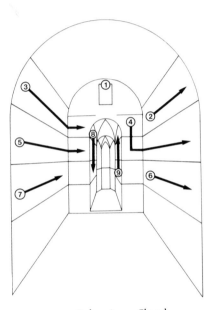

DIAGRAM 12. Padua, Arena Chapel

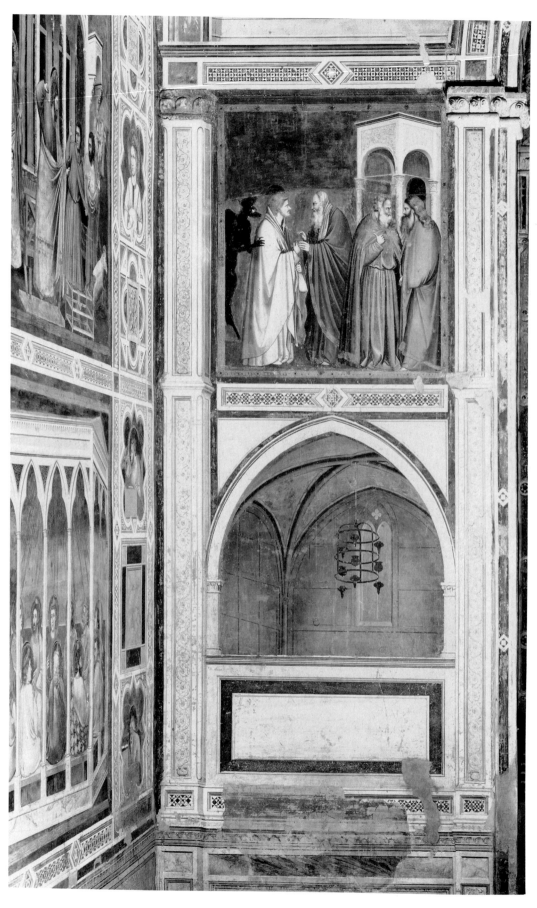

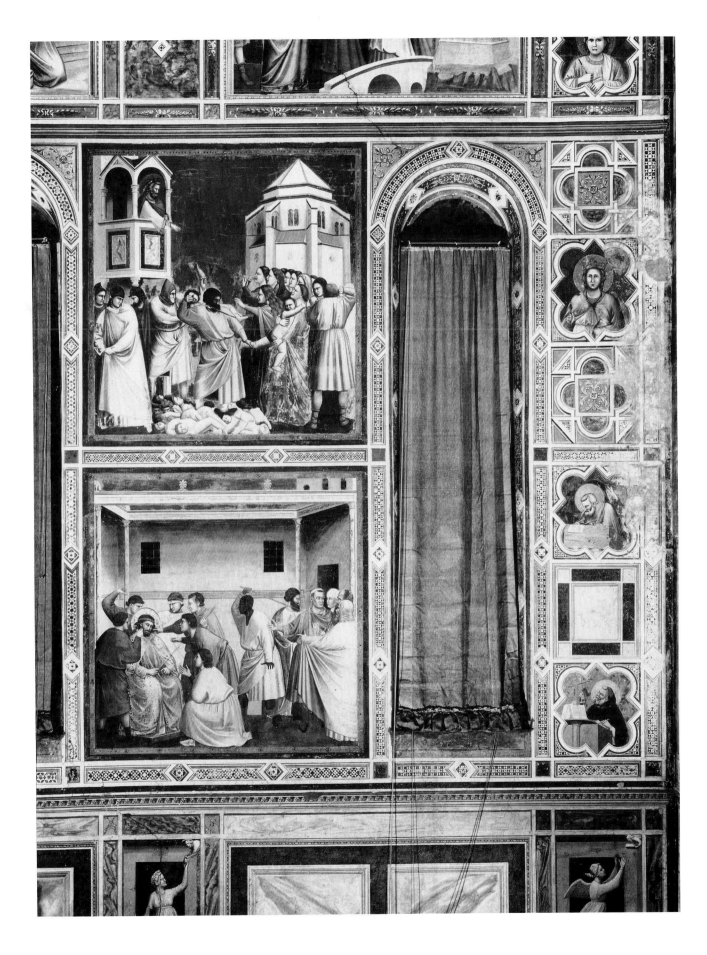

the purpose of lowering a relic or reenacting the Incarnation with lay figures.[15]

The Decision on the Incarnation having been taken after the debate with the angels, God the Father is shown dispatching the Archangel Gabriel on his mission. At the level of the upper tiers on the side walls, the mission is accomplished. Symmetrically placed at both sides of the arch, the *Annunciation* is given great prominence.[16] The idea of splitting the scene of the Annunciation across an architectural opening, with the empty space expressing the miraculous transmission of divine impregnation, has a long history in medieval Western and Byzantine art.[17] To this tradition Giotto adds some remarkable details: the two white veils fluttering from braced poles suspended from the upper porches of the aediculae in which the figures are placed, and the drapes behind each figure, pulled back and wound about columns of precious marble. The fluttering veils refer to the celebratory nature of the day of the Annunciation, 25 March, the day Mary accepted her role as an instrument in the scheme of salvation, the beginning of the New Year. In celebration of such feasts it was common practice to hang finely woven cloths from domestic buildings. The whiteness of these cloths bespeaks Mary's eternal state of purity. The second set of drapes refers typologically to the veils of the tabernacle of the ark, to which Mary is often compared. They have been pulled back along their curtain rods and knotted around a post. Their arrangement is reminiscent of those in many classical and medieval scenes of inspired revelation, as, for example, in a fourth-century ivory diptych showing *A Poet and His Muse* (fig. 27).[18] Here the pulled-back and knotted curtains also reveal a miracle, that of the Incarnation.[19]

Continuing the Wraparound on the right side of the arch, the narrative steps down a tier to the space below the figure of Mary, where the next episode in the chronology is placed. The *Visitation* is represented in a centralized composition with the architecture viewed from left to right. This field is the first in an orderly series of step-downs on the triumphal arch that guides the narrative disposition in a way that is, as far as I know, unique. Isolated on the triumphal arch, the *Visitation* receives prominence as the last episode before the birth of Christ and the first in which his divinity is recognized, in utero (Luke 1:41).

The first chapter of the Life of Christ begins on the same tier at the altar end of the right wall.[20] The opening scene hugs the corner with a right-left composition; the second moves left to right; the third, in the center, has a centralized composition; the fourth, the *Journey* scene, moves stalwartly toward the right; and the last (plate 6) is essentially centralized. All the light again reflects the position of the windows and flows from right to left. On the left wall, the first chapter of Christ's public life is arranged in six compartments, from *Christ among the Doctors* to the *Expulsion of the Moneylenders from the Temple.* The rhythm of thrusting is centered in the first scene, toward the right in the second, centered in the third, and toward to right in the fourth, fifth, and sixth.

The choice of the last episode, *Expulsion of the Moneylenders,* is unusual for a Western cycle of Christ's life. The significance of the choice becomes apparent as the narrative turns the corner to the same tier on the adjacent face of the triumphal arch. There is represented the equally rare scene of the *Pact of Judas* (fig. 25), with its frightening black devil.

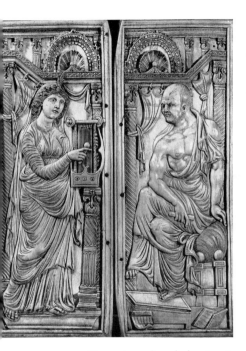

FIGURE 27. Monza, ivory diptych showing *A Poet and His Muse*, Treasury of San Giovanni Battista

Both scenes demonstrate the wickedness of ill-gotten gains and allude, it seems, to the sin of usury. The general disposition was evidently calculated, at least in part, to place these subjects together and emphasize the sin for which the donor of the chapel, as we now know, particularly wished to find absolution.[21] In these scenes, too, the inscenation reinforces the content. The forceful left-right thrust of the *Moneylenders* composition, with the light flow moving in the same direction, drives our attention around the corner toward the *Judas* scene, where the centralized movement and frontal light halt the eye in horrified attention (plate 5).

The placement of the *Judas* scene, isolated and static on the left side of the triumphal arch, also identifies it with the *Visitation*, its opposite number on the right. Without this juxtaposition one would miss the association between the first identification of Christ before his birth and the last before his death. With this juxtaposition we feel the sharp contrast between those who magnify the Lord and those who, for worldly gain, would diminish him.

The narrative now makes its second step down, beyond the *Visitation*, to the third level, where the final Wraparound begins. Here again we are presented with two chapters, five scenes of the Betrayal of Christ on the right and six of the Passion and post-Passion on the left.[22] The character of this tier is one of monumental gravity stemming from repeated use of balanced compositions. The inscenation of four of the five compositions on the right is essentially centralized, with only the last, the *Mocking of Christ* (plate 6), creating a point of stress by thrusting in reverse, right to left, at the corner. The final wall is justly famous for its dramaturgical impact. Compositionally, its six scenes tell their own stories: the *Road to Calvary* moves left to right, reinforced by the light flow. The *Crucifixion* is centralized. The astonishing *Lamentation* breaks this calm with a strong directional impetus back toward the entrance wall. Light falls mystically from above. The degradation of Christ's recumbent body is reinforced by the fall of a rock escarpment thrusting insistently from right to left.[23] The next three episodes return to left-right movement, and the sequence ends with the *Pentecost*, coming to a full stop, centrally organized and frontally lit.

There are several aspects of the Arena Chapel that can be associated with its private nature. Although public mural decoration was the source for the Wraparound disposition, Giotto made the pattern private by modifying it to fit the exigencies of this particular building. He transformed the late dugento idea of local iconographic reference from the civic to the private realm in referring to the moral situation of his patron. In making sacred characters behave like human beings, graver and more serious than ever portrayed before, he gave personal emotions to these lofty figures. Recognized by many scholars as uniquely self-conscious and deliberate, the narrative disposition as well as the naturalistic style of the Arena Chapel expresses the particular aspirations of a private individual through a conceptual unity of form and content.

Yet Giotto was careful not to relinquish his vision of the spiritual world, as the two last pictorial fields in the series attest. On the bottom tier of the altar wall flanking the opening of the arch, two magnificently constructed chambers are represented (plate 5). Suspended from the apex of the cross vault in each chamber is a wrought-iron lantern that illumi-

FIGURE 28. Padua, Arena Chapel, apse, school of Giotto, *Death of the Virgin*

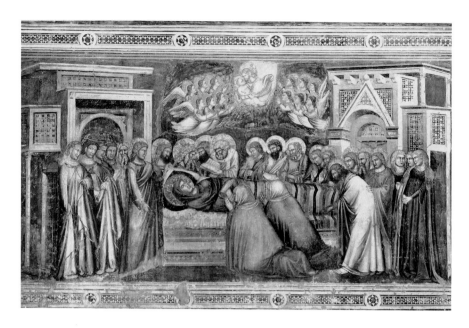

nates the interior space with raking light. These chambers bear a striking resemblance to certain scenes in the Peter cycle at San Piero in Grado (fig. 21), which show similar paired spaces with suspended lamps flanking an altar. In the Grado cycle, itself dependent on lost paintings in the portico of Old Saint Peter's,[24] the scenes represent *Saint Sylvester Founding the Vatican Basilica* and hence the physical establishment of the church as an institution. Giotto's images very likely make the same allusion.[25] Doubled in divine symmetry,[26] they represent the founding of the church, the spirit of Ecclesia, and the dedication of this chapel. For after all, it is as Ecclesia that Mary enacts her charity, and these spaces, pregnant with meaning, place her narrative deep within the theological realm.[27] In these mysterious rooms evoking a mystical marriage of the two narratives linked through the disposition of the cycle, Mary's human frame, touched by God, becomes the body of the church.

The story of Mary's life was completed after a few years (1310–17), in the chancel of the chapel where Scrovegni's tomb was ultimately installed.[28] The area is a single-vaulted bay, with an apse pierced by windows. A self-contained cycle of Mary's Last Days reflects a new narrative concept, in which vertical reading order gains the power to move in either direction.[29] The first scene is at the top of the left wall, filling the lunette with the *Gathering of the Apostles;* the second scene, the *Apostles' Farewell,* occupies the second. On the third tier is the *Koimesis,* or Mary's death, sometimes called the *Dormition* (fig. 28). The story then continues on the right wall, not at the top but on the lowest range, where the *Funeral of the Virgin* is shown. On the second tier is her *Assumption,* and the final scene, the *Coronation,* is in the lunette. The disposition is what I call the Up-Down, Down-Up pattern (diag. 12). The function of this pattern is to put the initial episode and the final denouement on the top tier. In this case the point was to place scenes of Mary's physical death and burial at the bottom and the scene that occurs in heaven, her Coronation, in the uppermost region of the wall. As we shall see, this identity of iconography and organization was soon to become a strong element in the expressive vocabulary of fresco disposition.

Although a few other quite large independent chapels were decorated for single families during the fourteenth century,[30] the grand scale of the Scrovegni remained extraordinary. The norm was a smaller, less pretentious format for the family mortuary, purchased from the administration of the local parish or monastic church.[31] Architecturally, such chapels were most often single (rarely double) bays in the side aisle of the nave or protruding from the transept. In a Gothic building (the norm for most of the fourteenth and fifteenth centuries), the possible areas for narrative painting included an entrance arch, two side walls with lunettes above and two or three tiers of stacked rectangles below, and an altar wall pierced by one or more windows sometimes flanked by the vestigial lunettes and tiers on each side. The webs of the groin vaults, although mostly painted with single figures such as evangelists or prophets, on rare occasions hold narratives. One of the factors that has obscured the continuities in fresco disposition between historical periods, aside from stylistic differences, was this change of format. With fewer fields to paint, the artists, Giotto among them, sought to adapt the protocols evolved for large churches by reducing and excerpting the stories in various ways. One choice might have been to curtail the size of the painting fields, thereby retaining enough space to depict as many episodes as possible. Including all the details of a story did not seem to be a priority, however, and this route was almost never followed.[32] Generally, monumental visibility was the goal, and both iconography and disposition were adjusted accordingly. Although the disposition of cycles in abbreviated ambients may at first seem unrelated to traditional prototypes, it was the way the artists and planners achieved this adaptation that ushered in a new era of monumental wall decoration.

Programs in private chapels within a given church were not as disconnected as they may now appear. By the end of the thirteenth century the Franciscans, in particular, seem to have developed what amounts to an overall church program. Designed to help in spreading their precepts, the unified plan was meant to be followed, at least in outline, in all their new or rebuilt foundations.[33] Certain set scenes from Francis's life were to form a skeleton narrative placed somewhere near or in the apse. Cycles of the lives of other saints closely associated with Francis, such as Anthony of Padua, Louis of Toulouse, and John the Baptist, were then to be carried out in relation to the Francis chapel. The chapels were paid for by private patrons, in agreement with the order. But even though the program was flexible, owing to historical circumstances it was not often carried out. Or if at first the system was followed, the decorations were later changed. Infrequently we catch a glimpse of the underlying plan from the portion that remains. Nevertheless, within the desiderata of the program, the conceptual planning of individual, abbreviated cycles found fertile soil in which to develop.

The Church of Santa Croce in Florence (fig. 29), the main Franciscan friary of the city, was one of the earliest to have such a series of chapels planned to line the arms of both transept wings. One of the first to be decorated was in the place of honor immediately to the right of the apse in the south transept. Owned by the Bardi family, it was decorated with a Life of Saint Francis by Giotto, probably about 1315.[34] Giotto's first encounter with the new spatial environment is remarkable (figs. 30, 31).

FIGURE 29. Florence, Santa Croce, nave, general view

Before he begins the cycle proper, he positions a scene of the *Stigmatization of Saint Francis* above the entrance on the chapel's exterior facade. In spite of some questions of chronology, I am persuaded that this field should be read in concert not only with an *Assumption of the Virgin*, attributed to the Maestro di Figline, in the comparable position on the opposite side of the transept (exterior facade of the Tosinghi and Spinelli Chapel, figs. 75, 76),[35] but also with the great *Crucifix* by Cimabue suspended high above the chancel.[36] The triangulated placement of images of the three patrons of the church appropriately reflects the similar tripartite arrangement of dedications in the apse and transept wings of the Upper Church at Assisi. The prominence and the isolation of the two fresco scenes, moreover, give them a strong devotional character.[37] The *Assumption*, apparently the last scene in a cycle of the Life of the Virgin attributed to Giotto,[38] is almost emblematic in its form. Not only is the *Stigmatization* isolated from the rest of the narrative, but many of the details

of the story are suppressed and the figures are composed in a strongly hieratic manner. Francis kneels on his left rather than the more usual right knee and turns back to look over his shoulder at the seraph. His body as a result is fully frontal and pressed to the picture plane. Through this ingenious device, all five wounds of the stigmata are equally visible. The Stigmatization was installed as a separate feast in 1304, and the iconic quality of the fresco may be a direct allusion to this almost contemporary event.[39]

Inside the Bardi Chapel the story starts on the left wall in the upper lunette with the scene *Francis Renouncing the Wealth of His Father in the Presence of the Bishop of Assisi.* The second scene, *Approval of the Rule by Innocent III,* is in the lunette at the top of the right wall. The third scene, *Proof by Fire before the Sultan of Tunisia,* is on the second tier of the right wall. The fourth scene, *Francis's Appearance at Arles,* is on the second tier of the left wall. The fifth scene is on the third and bottom tier of the left wall: the famous but ruined *Death and Obsequies of Saint Francis,* and the sixth and seventh episodes, the *Visions of Saint Francis's Death to Fra Agostino* (left) and to the *Bishop of Assisi* (right), are together on the bottom tier, right wall,[40] showing that the two episodes took place in different locations but at the same moment.[41]

The narrative sequence thus described is a pattern going from top left to top right, from second right to second left, and from third left to third right (diag. 13). This "reading" pattern recalls that of a relatively small number of ancient inscriptions, early Greek, Etruscan, and early Roman, that move back and forth across the field in precisely this manner. Such inscriptions are termed "boustrophedonic," from the Greek words *bous* (ox) and *strophe,* (turn), meaning to "turn like an ox in plow."[42] As we shall see, the Boustrophedon became a major tool for chapel cycle disposition.[43] Since in Giotto's disposition the narrative also moves across the space of the chapel from one side to the other, I call the organization of the Bardi Chapel an "Aerial Boustrophedon." I believe that Giotto adopted the arrangement for this short cycle to give a sense of Francis's peripatetic life (each scene takes place in a different locale) and to express the simultaneity of the last three episodes, the saint's death and the two visions of his death, seen on opposite sides of the same tier.

The same approach was soon to be seen in another chapel associated with Giotto's name, that dedicated to Saint Mary Magdalene in the Lower Church of San Francesco in Assisi (chapel on the right side of the nave just before the crossing, fig. 32). The similarity of organization adds force to the frequent attribution of this undocumented commission to Giotto himself.[44] The pattern here is what I would describe as a "Linear Boustrophedon," arranged on the lunette level.[45] Each lunette is divided into an upper triangle in the point of the arch and, on the side walls, lower tiers of two fields. The narrative sequence begins with the scene of the *Magdalene Washing Christ's Feet in the House of Simon* at the left side of the left wall on the second tier (diag. 14). On the right side of the left wall on the same level is the *Raising of Lazarus,* brother of the Magdalene. The composition of this scene moves left to right, while the light reflects the position of the oculus in the altar wall, flowing from right to left. The narrative continues on the second tier of the right wall, with the *Noli me Tangere* on the left and the *Magdalene and Lazarus Sailing to Marseilles in*

FIGURE 30. Florence, Santa Croce, Bardi
Chapel, Giotto, left view

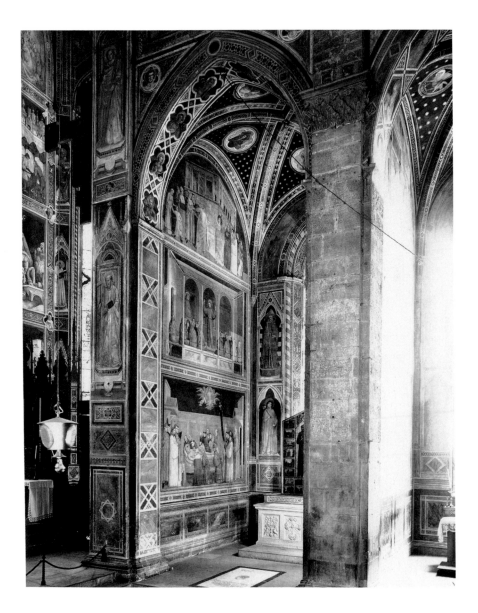

a Rudderless Boat on the right. On the entrance wall, the sequence steps
up to the top tier, with the *Magdalene Dwelling in the Cave of Sozimus.*
The composition of this scene is essentially centered, holding the narra-
tive movement stationary. The reading order now is reversed, wrapping
around the chapel once more but in the opposite direction, from right to
left. The scene on the right wall shows the *Magdalene Carried by Angels.*
Finally, returning to the left where it began, the narrative ends with the
Last Communion and Apotheosis of the Magdalene (fig. 33).[46] In this
chapel neither the compositional thrusts of the various scenes nor the
light flow are as consistent as in the Bardi Chapel. Yet the Boustrophedon
seems to serve an equally meaningful purpose. The scenes in which the
Magdalene is miraculously transported aloft by angelic beings occur high
up on the walls, thereby identifying the physical location of a scene with
its content. In this respect the concept recalls that of the Last Days cycle
in the chancel area in the Arena Chapel, but with an important differ-
ence. There are two scenes of angelic elevation in the story of the Magda-
lene, and the artist has placed them both on the upper tier. His achieve-

FIGURE 31. Florence, Santa Croce, Bardi
Chapel, Giotto, right view

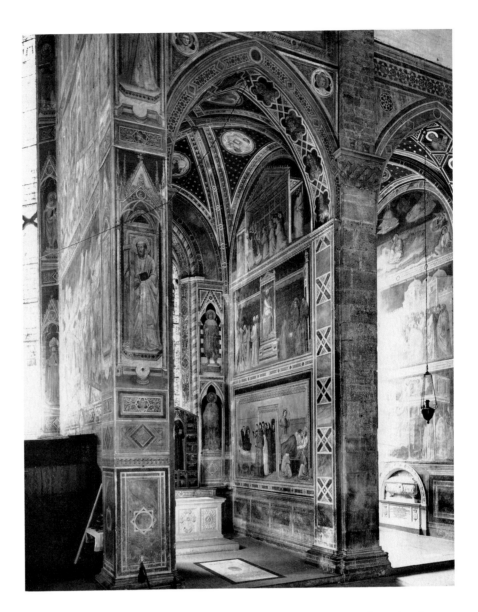

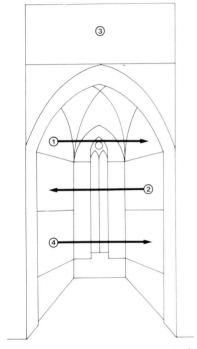

DIAGRAM 13. Florence, Santa Croce, Bardi
Chapel

ment resulted not only from the use of the Boustrophedon but also from
having the whole cycle move upward as it circles the chapel. The Magda-
lene Chapel is one of the first instances of upward narrative movement
used throughout a fresco cycle.

Bottom-to-top reading direction plus the notion of physical placement
imbued with iconographical meaning continues in the Montefiore
Chapel, at the opposite end of the nave of the Lower Church. The chapel
is the first on the left (as one enters today) and was painted by Simone
Martini about 1317–20 (fig. 11). The structure of the architecture is com-
plex. Proceeding up a flight of steps, one enters through a broad, flat-
surfaced arch. The chapel proper is two bays deep; the first bay is vaulted
at a higher level than the entrance, and the second bay is vaulted at a
lower level than the first. The side walls of the first bay slant from floor
to ceiling and are divided into three tiers. The second bay has vertical
walls divided into only two tiers (diag. 15). As a result, the fields for
painting appear on different vertical units, which the artist uses to
dramatize his story.

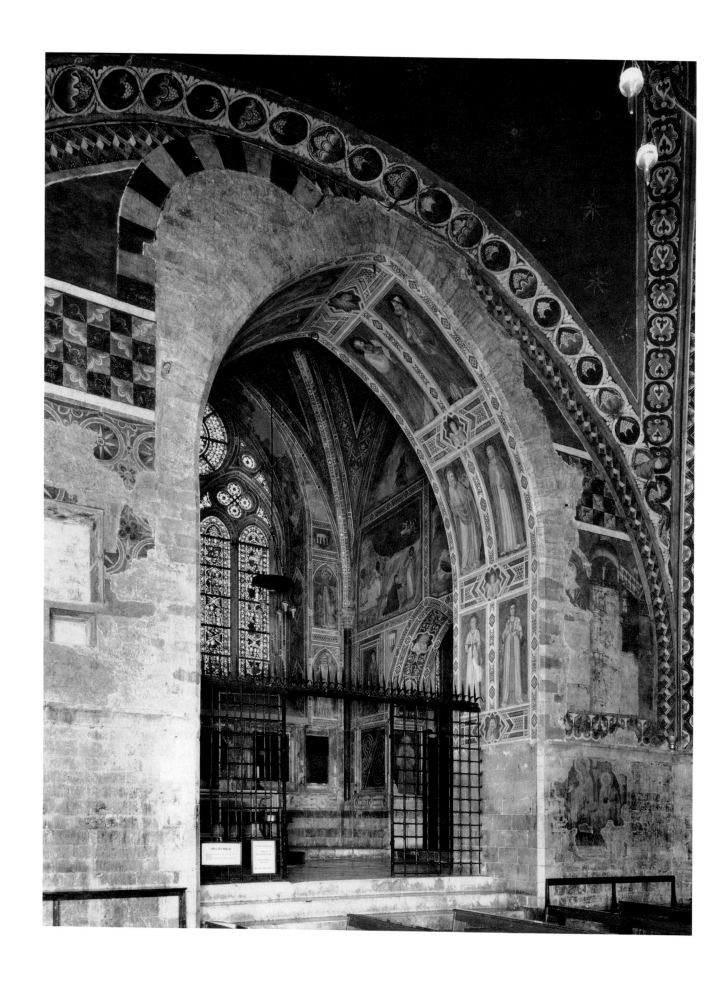

FIGURE 32 (*facing page*). Assisi, San Francesco, Lower Church, Magdalene Chapel, [Giotto?], general view

FIGURE 33. Assisi, San Francesco, Lower Church, Magdalene Chapel [Giotto?], *Apotheosis of Mary Magdalene*

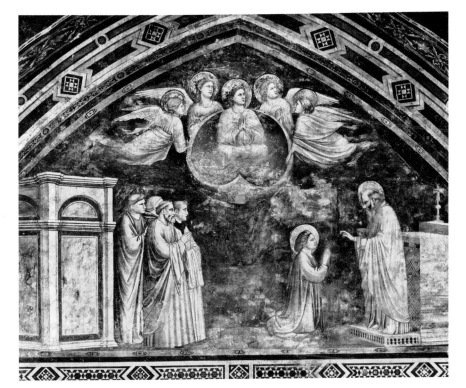

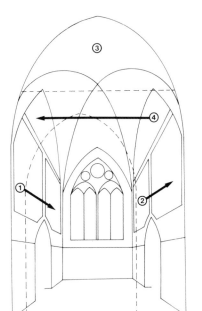

DIAGRAM 14. Assisi, San Francesco, Lower Church, Magdalene Chapel

The chapel is dedicated to Saint Martin of Tours, a fourth-century pagan soldier and member of the imperial guard.[47] After a moral crisis, followed by two visions of Christ, Martin renounced the army, converted, worked miracles, and became one of the patron saints of France. The person commemorated in this chapel was Cardinal Gentile Partino da Montefiore (d. 1298), a powerful Franciscan official who had been titular of the Church of San Martino ai Monti in Rome.[48] It is believed that Montefiore's relation to the Roman church motivated his heirs to order the chapel in this saint's honor.[49]

Following the medieval protocol, the narrative starts at the apse end on the right wall. In this case the earliest episode in the chronology is on the lowest tier. The story opens with the scene of *Martin Invested as a Knight*, justly famous for its elegant poses and splendid chivalric details.[50] The second scene, *Martin Dividing His Cloak at Amiens* (fig. 34), is on the lower tier of the left wall but at the entrance end. This position means that the narrative has moved diagonally across the chapel from the back to the front. The third scene, *A Beggar Appearing to Martin*, remains on the lower tier of the left side in the second bay, next to the altar. The fourth scene again moves the narrative diagonally, this time from back left to right front, where we find the next scene, *Martin Renouncing the Emperor and His Military Responsibility*. The pattern of the narrative thus described is two intersecting diagonals: back right to left front, and back left to right front. I call this pattern a "Cat's Cradle."[51] What it accomplishes is to place scenes of Martin's taking and then rejecting his life in the military side by side on the right, while juxtaposing on the left Martin's two visions of Christ before his conversion. For indeed, the man with whom Martin divides his cloak and the beggar who appears to him are both Christ himself.[52]

The pattern of the Cat's Cradle is not merely a formal arrangement but is intimately linked to liturgical practice. In the ceremony for the dedication of a church or a chapel, the bishop makes a cross on diagonal axes (the Greek letter chi, initial letter of Christ's name) on the floor in ash.[53] With the point of his crosier, he writes first the Greek alphabet, beginning at the left side of the church door and proceeding to the epistle corner near the altar, then the Latin alphabet beginning at the right side of the church door and proceeding to the gospel corner. The intersection of the two lines refers to the Cross, that is, Christ crucified, as the principal dogma of the Christian religion. The Greek and Latin languages represent the Jews and Gentiles respectively, with the Greek alphabet written

FIGURE 34. Assisi, San Francesco, Lower Church, Saint Martin Chapel, Simone Martini, *Saint Martin Dividing His Cloak*

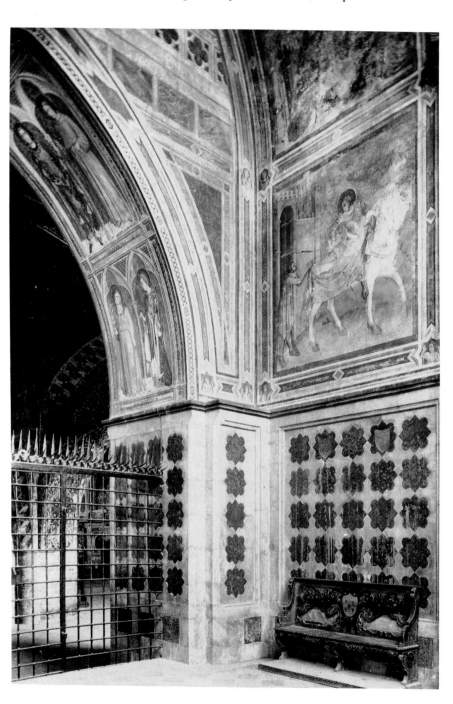

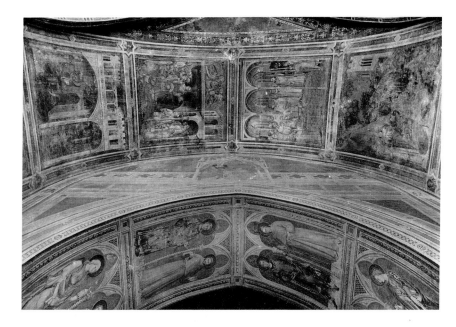

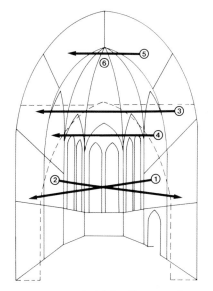

DIAGRAM 15. Assisi, San Francesco, Lower Church, Saint Martin Chapel

first because the Jews were first called to the Christian faith.[54] This ceremony expressed the unity of the new foundation with the central institution of the church. Just before his death, Cardinal Montefiore was on a mission to bring the papal treasure from Assisi to the pope in Avignon. Such close ties with the papal outpost made even the subtlest reference to church unity an expression of prayerful hope for the power of the exiled papacy and for continued good relations between it and the Franciscan order (by no means always the case).[55]

The narrative next moves up a tier as Martin converts, is raised to the bishopric, and works wonders for those he in turn converts (fig. 35). The four scenes on this level represent Saint Martin's miracles in the order of hagiographic chronology: from right front to left front, and from right back to left back. The last of these shows *Saint Ambrose Dreaming of Saint Martin's Death*, in the manner of Saint Augustine's vision of Saint Jerome, placing Martin on a par with a doctor of the church.

The death scene itself and the *Funeral* take us from right to left on the uppermost tier, where, as in the Magdalene Chapel, the saint's ascent to heaven is implied by the physical placement on the range closest to the celestial realm. The disposition of the cycle was thus organized to drive home a theological message, a message that is further emphasized by the placement of the last image in the sequence. On the interior facade, the same uppermost level is occupied by a laterally extended scene with Bishop Martin beneath a celestial ciborium performing his theological function as intercessor; reassuringly, he welcomes the kneeling Montefiore into the ranks of the blessed by grasping his wrist. The location of this scene is a patent reference to the tradition of representing the Last Judgment on the interior facade of churches and reinforces the association of the upper reaches of the chapel with the realm of the saved.[56]

The narrative cycles in the transept of the Lower Church, although not a result of private patronage, clearly correspond to the development now under discussion. In fact, these frescoes represent the next phase in fitting narratives into new spatial ambients.[57] A distinguishing feature here

FIGURE 36. Assisi, San Francesco, Lower
Church, transept (see plate 7)

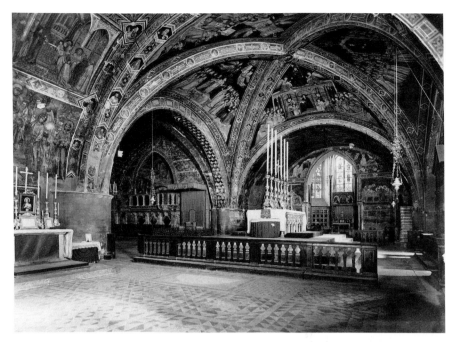

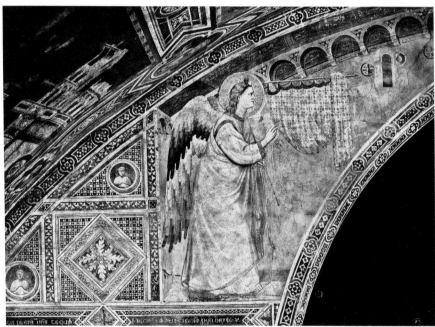

is that the high altar is directly under the crossing, and ideologically
charged figures, normally associated with apse decoration, appear in the
heavily ribbed groin vault (fig. 36). The representations on the webs are
in themselves innovative, replacing the more usual members of the
Christian hierarchy with abstractions of Franciscan doctrine. A figure of
Saint Francis in glory is surrounded by allegories of the main Franciscan
virtues, chastity, poverty, and obedience.

The wings of the transept are made up of broad transverse pointed
arches, whose springing points are close to the floor. A narrative cycle,
divided into thematic chapters on either side of the altar, is arranged in
three tiers on the flat surfaces of these sloping vaults. Each wing termi-

nates with a chapel, whose front facades hold the opening and closing scenes of the cycle on two tiers.[58]

The Infancy chapter of Christ's life, attributed to Maestro delle Vele, is in the right wing, beginning on the chapel facade. The *Annunciation* is "divided" on either side of the arched opening, in the manner of the Arena Chapel triumphal arch (fig. 37, Angel of the Annunciation).[59] Having faced north to see the first scene, the spectator must now turn to the right to read the narrative on the ceiling, starting at the top of the pointed vault and proceeding left-right, two scenes to a tier, down two tiers (fig. 38). In the left half of the third tier is a *Crucifixion Adored by Saint Francis and Other Members of the Order.*[60] One then turns to face the west wall and repeats the sequence, reading left-right from the top down for two tiers. A certain symmetry has been achieved by the addition of a rather rare scene to the Infancy story. After the scene of *Christ Disputing with the Doctors,* the story is stretched and completed with a scene of the *Holy Family's Return from the Temple.* The bottom tier shows two miracles of Saint Francis.

FIGURE 38. Assisi, San Francesco, Lower Church, Maestro delle Vele, Infancy cycle

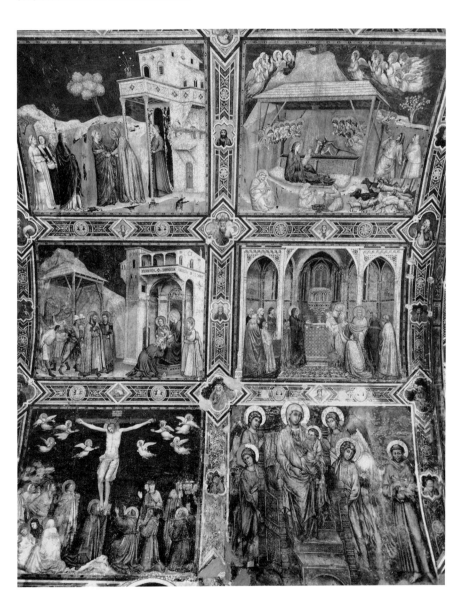

Having completed the Infancy chapter, the narrative now leaps directly to the Passion cycle (fig. 39).[61] To view this sequence one must walk to the opposite side of the altar and again face the west wall. The story begins at the top of the vault with the *Entry into Jerusalem* and repeats the disposition of the opposite wing in reverse order and with two variations. One is that an extraordinary image of *Judas's Suicide* drops the sequence to the third tier on the west wall. It is coupled with a *Stigmatization of Francis* and identified with it thematically. Both scenes are sacrifices for Christ, one sinful and one beatific.[62] In the lowest tiers on the opposite side of the vault, following in proper sequence the *Flagellation* and the *Via Crucis,* is a monumental *Crucifixion,* four times the size of a regular rectangular field. Although the disposition here seems unrelated to the basilical model, the size of the scene is an unmistakable allusion to the Petrine original in Rome.

Finally, the spectator must turn to the right and look toward the facade of the chapel at the end of the transept, where one finds the concluding scenes of the cycle. Four harrowing post-Passion compositions, the *Deposition* (fig. 40), the *Entombment,* the *Descent into Limbo,* and the *Resurrection,* epitomize the power of Pietro Lorenzetti's work. These somber scenes are arranged so that the sequence still progresses left to right in reading order. In this case, however, they move not from the top down, but from the bottom up. This arrangement places the downward-thrusting *Deposition* and *Lowering into the Tomb* on the bottom tier and the rising motion of the *Resurrection* in the upper, more ethereal tier. The Down-Up pattern of this facade should be seen in relation to the pattern of the facade at the opposite end of the transept, which is Up-Down. We may then recognize the Up-Down, Down-Up pattern in the transept as

FIGURE 39. Assisi, San Francesco, Lower Church, Pietro Lorenzetti, *Washing of the Feet*

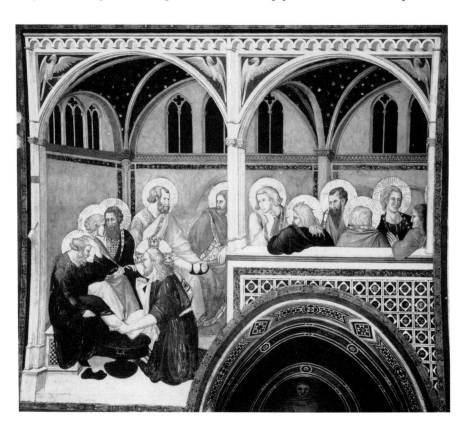

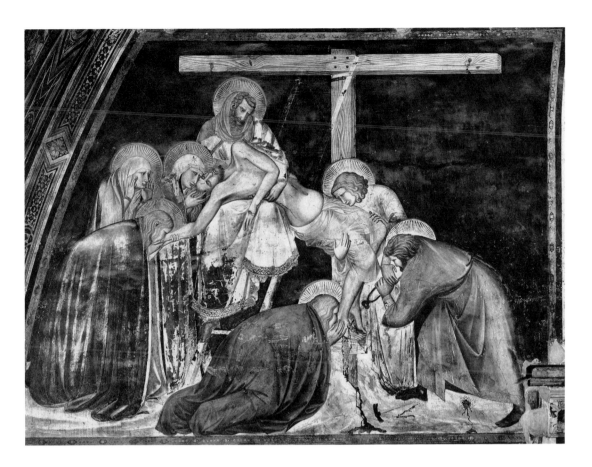

FIGURE 40. Assisi, San Francesco, Lower
Church, Pietro Lorenzetti, *Deposition*

directly expressive of the Descent of the Holy Spirit on the one hand and
the Resurrection of Christ on the other.[63]

The disposition of the transept as a whole creates a general ideological
symmetry that may not be as unified as in the Arena Chapel but is per-
haps more emotionally expressive. A truly grand balance is achieved with
the large *Crucifixion*s on the lower tiers of both sides of the east wall.
These compositions not only balance each other, they also echo the two
*Crucifixion*s, themselves balanced across the space of the nave, immedi-
ately above in the Upper Church.[64] This four-part repetition emphatically
reinforces the core of Franciscan worship, Saint Francis's devotion to
Christ Crucified. Indeed, it is significant that the only one of these im-
ages in true narrative position, that on the east wall of the left lower tran-
sept wing, is also directly opposite the scene of *Francis's Stigmatization* on
the lowest tier of the west wall. The resulting typological relationship re-
peats the convergence of identification of Francis with Christ, found in
the nave of the Upper Church in an even more poignant way.[65] This gran-
diose conceptual plan seems to have been independent of the physical exe-
cution of the frescoes, surviving no matter how many artists were in-
volved, no matter what order they worked in, or how long they worked to
complete the project.

During the two decades between 1330 and 1350, the number and kinds
of patterns of disposition proliferated rapidly. One new departure was the
ancestor of what I shall call the "Expanded Field" when it emerged in its
final form a century later,[66] namely, the use of a large portion of the
chapel side walls for single monumental compositions. Forerunners of

FIGURE 41. Florence, Santa Croce, Velluti
Chapel, Saint Michael scene

FIGURE 42. Florence, Santa Croce, Pulci Ber-
aldi Chapel, Bernardo Daddi

this arrangement are seen in two chapels in the transept of Santa Croce in
Florence: the Velluti Chapel (last on the right in the right transept wing),
dedicated to Saint Michael,[67] and the Pulci Beraldi Chapel (second to the
left of the crossing in the left transept wing), painted by Bernardo Daddi
about 1331. The dedication to one of Saint Francis's patrons in the Velluti
Chapel doubtless was dictated by the Franciscan friars. A large version of
the canonical scene of *Saint Michael Driving out the Rebel Angels* fills the
right wall (fig. 41), while a portrayal of a local Italian legend, *Saint Mi-
chael Slaying the Bull at Monte Galdiano*, fills the left. The Pulci Beraldi
Chapel is dedicated to Saint Lawrence and Saint Stephen, each of whom is
commemorated in a single scene of his martyrdom (fig. 42). Isolated,
monumental martyrdom scenes were rare at this period, and their use
here was perhaps meant to recall decorations in the Sanctum Sanctorum
at the Lateran in Rome, where similarly excerpted martyrdoms are fea-
tured.[68] In the Santa Croce Chapel, the lunettes are filled with repeated
quatrefoil designs that set off and dramatize the single figurative rectan-
gles.

When Giotto returned to Florence from Naples toward the end of his
life and again worked in Santa Croce (1330–36), he established an ar-
rangement that paralleled the lives of two saints and became classic for
the single-bay chapel. He developed this form in the chapel to the right of
the Bardi Chapel, owned by the Peruzzi, a wealthy Florentine banking
family. The dedication of the Peruzzi Chapel to the two Saint Johns, the
Baptist and the Evangelist, may also have been designated by the Francis-
can churchwide program.[69] The association of these two saints goes be-
yond the identity of names and the fact that both men were personally
associated with Christ. As recounted in *The Golden Legend*,[70] the most
important element in their synchronism was that their feast days origi-
nally corresponded: John the Evangelist died on the anniversary of John
the Baptist's birth, 24 June, a feast day of particular importance in Flor-
ence. Both these events are represented in the frescoes. Owing to the im-
portance of both saints, the feasts were arbitrarily separated, and the
Evangelist's death feast was moved to 27 December, the date of the found-
ing of the Lateran basilica in Rome.[71] Another correspondence between
the two saints was that they bracketed Christ's life: the Baptist was

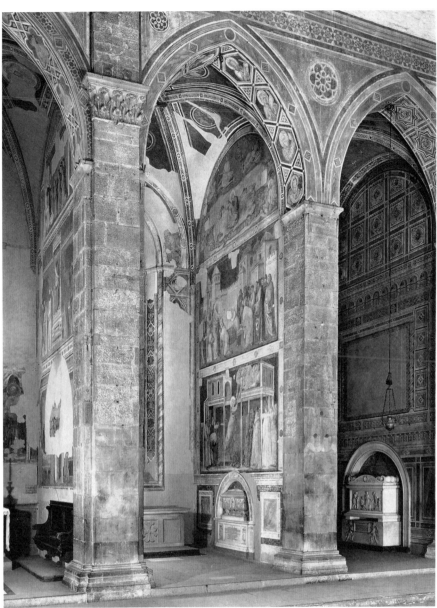

FIGURE 43. Florence, Santa Croce, Peruzzi Chapel, Giotto, right wall

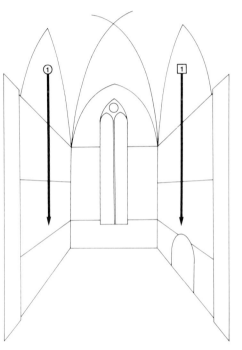

DIAGRAM 16. Florence, Santa Croce, Peruzzi Chapel

Christ's forerunner, while the Evangelist was made his heir when, from the cross, Christ designated him Mary's second son.[72] The Constantinian basilica at the Lateran is dedicated to these two saints together, along with the Savior.

As in the Bardi Chapel, the chronology in the Peruzzi Chapel begins on the left wall toward the chancel area, with the Life of the Baptist, the older of the two saints. Each story is reduced to a few scenes; each wall is assigned to one saint. In vertical stacked tiers, each narrative moves in a straight line from the top of the wall to the bottom (fig. 43). I call this pattern the "Straight-Line Vertical" (diag. 16). In the Peruzzi Chapel there is a thematic correspondence on each tier.[73] In the lunettes are two visions: to the left, the appearance of an angel to Zachariah; to the right, the Apocalypse. On the second tiers are two miracles: left, *Zachariah's Speech Restored*; right, *John Raises the Dead*. On the bottom tiers are the

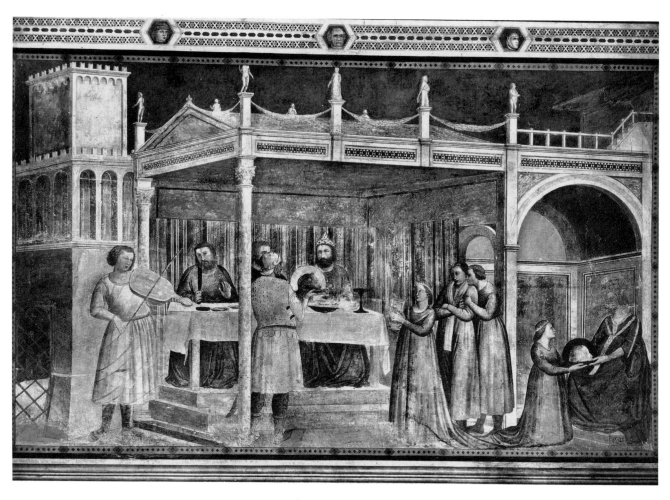

FIGURE 44. Florence, Santa Croce, Peruzzi Chapel, left wall, Giotto, *Banquet of Herod*

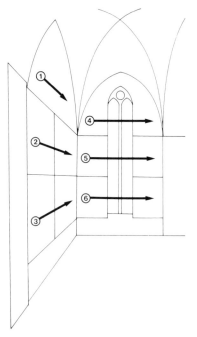

DIAGRAM 17. Florence, Santa Croce, Baroncelli Chapel

two extraordinary deaths: left, *Salome Shows the Baptist's Severed Head* (fig. 44), right, *Christ Takes the Evangelist to Heaven*. The classic simplicity of this arrangement persuades one that it represents the "logical" and "right" way to decorate a single-bay chapel. Yet in fact Giotto seems to have conceived this disposition to express a particular set of ideas. Earlier he had employed, perhaps invented, other patterns for other reasons: the Aerial Boustrophedon moving from the top down in the Bardi Chapel; the Linear Boustrophedon moving from the bottom up in the Magdalene Chapel. In the Peruzzi Chapel, the Straight-Line Vertical not only illustrates the thematic unity of the two lives, it also calls attention to the historical synchronism of the two feasts. Moreover, the downward-moving direction of the narrative represents visually a theological link between these saints. The descending movement alludes to the soul of John the Baptist, which after death descended into limbo.[74] The Evangelist's death, which occurred in old age and, unlike that of most martyrs, from natural causes, was nevertheless also marked in a special way. At the moment of John's passing, as a sign of his great love, Christ descended from heaven and transported John directly to paradise. Giotto designed the architecture in the fresco with an opening for this passage. The reality of Christ's condescending to have John at his side is reinforced by the placement of the scene at the bottom of the wall.

The last two commissions for Santa Croce in the first half of the fourteenth century followed the Peruzzi Chapel in the use of the Straight-

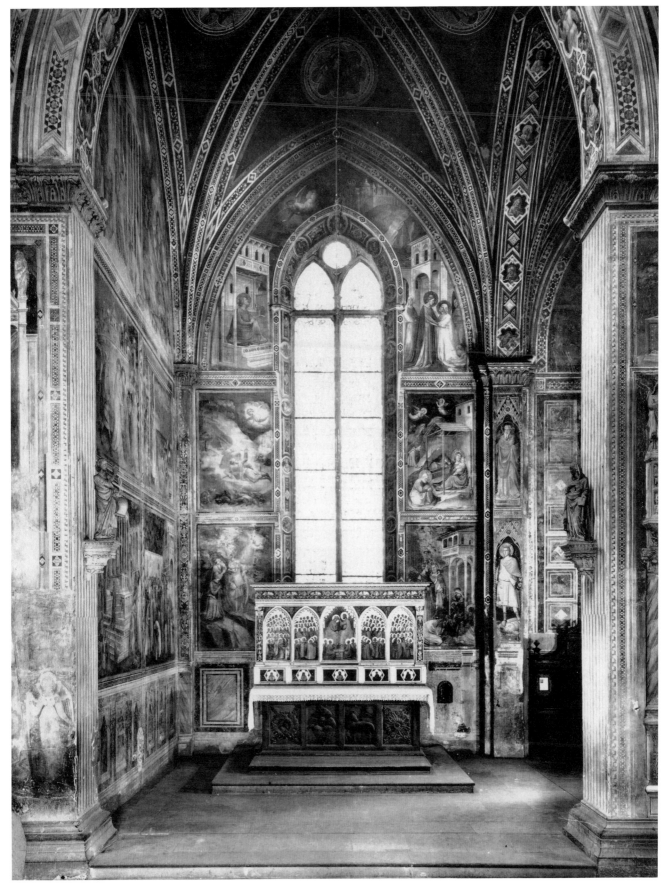

FIGURE 45. Florence, Santa Croce, Baroncelli
Chapel, Taddeo Gaddi, general view

FIGURE 46. Florence, Santa Croce, Baroncelli Chapel, Taddeo Gaddi, *Vision of the Magi*

FIGURE 47. Florence, Santa Croce, Bardi di Vernio Chapel, Maso di Banco, general view

Line Vertical. Both were painted by close associates of Giotto, Taddeo Gaddi and Maso di Banco, who benefited from the master's intellectual guidance during many years of their careers. At the same time, both artists moved ahead vigorously on their own separate paths, making contributions that depart in distinctive ways from Giotto's humanistic ethos. Taddeo Gaddi, Giotto's assistant for twenty-four years, painted the Baroncelli Chapel at the end of the south transept wing (fig. 45) about 1330–34 (contemporary with the Peruzzi Chapel).[75] The Baroncelli Chapel was originally a much larger ambient, comprising two full bays perpendicular to the transept end; in the fifteenth century it was curtailed by the building of the Pazzi Chapel directly behind it, toward the cloister. Although fragmentary, the narrative of Mary's life, like that in the Arena Chapel, is divided into two chapters: the pre-Incarnation period, placed on the wall to the left as one enters the chapel, and the Incarnation and Birth cycle on the adjacent altar wall.[76]

The reading order on the side wall is left-right from the top down, two episodes appearing on each of three tiers (diag. 17). In the lunette, *Joachim's Expulsion from the Temple* and the *Annunciation to Joachim in the Wilderness* appear together in continuous mode. Taddeo employs the braking device we met in Giotto's work, arranging the second scene with the thrust both in figure grouping and in flow of light reversed and moving right to left. The composition is thereby held in the corner. The same principle is used in each of the right-hand scenes on tiers two and three (*Birth of the Virgin* and the *Betrothal*). Yet the differences from Giotto's method are fundamental.

In the second chapter, which appears on the altar wall, Taddeo uses the art of disposition to create strikingly new dramatic effects. In the sense of literal chronology, the episodes still proceed from left to right from the top down, though they must jump across the window to do so. The main issue is that, in a most logical manner, Taddeo has placed a sequence of mystical annunciations in a vertical column, one below the other. Seated on the ground, Mary hears the words of Gabriel as he floats above to the right, brilliantly illuminated in an aureole of light. On the second tier, the shepherds on the ground sleeping with their flock are informed of the Messiah's birth by an incandescent messenger floating in a blaze of light on their right. At the bottom, the traveling Magi (fig. 46) kneel on the ground to heed their shared vision of the radiant infant floating in a blaze of light above to their right.[77] Clearly, Taddeo repeated the Straight-Line Vertical on the altar wall not only to retain literary reading order but also to superimpose three ideologically related scenes. He suggests the origin of the light of revelation by identifying it in each case with light flowing down from heaven through the adjacent window.[78] Although dependent on Giotto's plot periodization and manipulation of light, such effects reach beyond Giotto's expressive intensity to make an additional level of religious meaning explicit and visible.

Maso di Banco used his inheritance from Giotto to create a new style of robust solidity, evident in the Bardi di Vernio Chapel at the far end of the north transept wing (fig. 47). The dedication is to Saint Sylvester, and the story is that of the emperor Constantine's conversion to Christianity. Maso adheres rigidly to the chronology recorded in the literary sources. In spite of the intrusion of two wall tombs, the narrative proceeds down

the left wall, then to the altar wall, and finally down the right wall (fig. 48).[79] This strict top-down, left-right pattern clearly means to establish the historicity of the narrative. The story traces events from the time of Constantine's conversion to the cleansing of the Roman Capitol on the authority of the princes of the apostles. In the scene of *Constantine's Vision of Saints Peter and Paul* an astonished bystander peeking in from the right corner of the room bears witness to the event. In the scene on the Campidoglio, the power and corruption of ancient Rome are made visible through the works of ancient architecture shown, perhaps for the first time, in decay. The eradication of pagan superstition is literally in the hands of the official Roman pontiff who, wearing a historically correct single tiara, throttles the dragon of religious ignorance.[80] By composing his visual narrative in three Straight-Line Verticals and following chronological order, Maso digested his irregular architectural ambient and displayed the Christian *istoria* as the simple truth.

In designing schemes for private chapels, the fourteenth-century artists were never far from their historical precedents. Protocols developed

in the early centuries of Christianity, though sometimes difficult to recognize, frequently determined important aspects of the new arrangements. Inspired in part by the smaller scale of the private chapels, the patterns—the Boustrophedon, the Cat's Cradle, the Up-Down, Down-Up, the Straight-Line Vertical—became recognized vehicles in their own right. Responding to the intimate devotional function of their surroundings, these new conceptual structures permitted a concomitant coherence of meaning, reflecting or perhaps even calling forth a new coherence of the architectural space. At the same time, retaining the monumental mode preserved a continuity with the respected medieval protocols that were always to remain a major factor in the artistic and religious consciousness.

3

Narrative in the Public Domain, 1340–1400

Early trecento chapel patterns were employed throughout the century, singly and in "interlock" combinations. The discussion follows the phenomenon through Tuscany to the Veneto, Avignon, and Umbria.

For reasons not altogether clear, in the middle decades of the trecento more public commissions than private were produced. Accordingly, I shall consider first the large ecclesiastical projects dating from the 1340s and 1350s, returning to private commissions at the time they regained historical prominence.[1]

In the early 1330s, the citizens of Florence began a project to decorate the exterior of their Baptistry that was to last more than a hundred years. The first commission was for a set of bronze doors with a cycle of the Life of John the Baptist carried out by Andrea Pisano between 1332 and 1336 (fig. 49).[2] In the history of medieval bivalve bronze portals, artists were confronted with problems of narrative disposition deeply akin to those I have been discussing. Monumental in scale, the portals were frequently divided into large numbers of square or rectangular pictorial fields stacked vertically and juxtaposed horizontally in tiers. The chronological reading order seems to have been as often from the bottom to the top as from the top to the bottom.[3] The most important Tuscan commission before that in Florence had been the Porta di San Ranieri on the Duomo of Pisa (fig. 50). Created by Bonanno Pisano in 1186 and depicting the Life of Christ, the Pisan narrative is disposed on six tiers of four scenes that read horizontally left to right across both valves of the doorway. The narrative starts on the lowest tier and moves up to the top, where there are two devotional compositions, *Christ in Glory* centered over the left valve, and the *Virgin Enthroned* over the right.[4] The disposition of the Florentine cycle is quite different. Within strongly accented rectangular frames, each episode is enclosed in a quatrefoil molding. The story starts at the top on the left valve and moves left to right for two scenes, that is, the width of only one valve. This arrangement of paired scenes continues down for five tiers of the left valve. The narrative then returns to the top of the portal, now on the right valve, moving left to right for two scenes, and proceeds down again for the same number of tiers. Below these parallel narrative columns, two horizontal tiers of seated allegories read across both doors horizontally.[5] The aim of this new arrangement seems to have been to infuse the miniature figure scale inherent in the portal format with the power due a public monument. The goal was accomplished by exploiting the contributions of contemporary avant-garde

fresco painting.[6] The disposition of the doors has its closest parallel in the almost exactly contemporary Baroncelli Chapel at Santa Croce, where the narrative movement of the paintings is across two scenes horizontally, with Straight-Line Vertical stacking from top to bottom on two adjacent bays.[7] As has frequently been noted, the shape of the quatrefoils on the doors seems directly related to the same decorative motifs in the lunettes of the Pulci Beraldi Chapel.[8] The inscenation of the individual scenes, with restricted numbers of figures and miniaturized architectural props, is often said to depend on that used in the Arena Chapel. The division of the story into chapters likewise follows Giotto's lead. The first chapter includes John's mission from the *Annunciation to Zachariah* through the *Baptism of Christ*; the second on the right valve includes John's passion from his *Preaching to Herod* through his decollation and burial. A result

FIGURE 49. Florence, Baptistry, Andrea Pisano, bronze doors

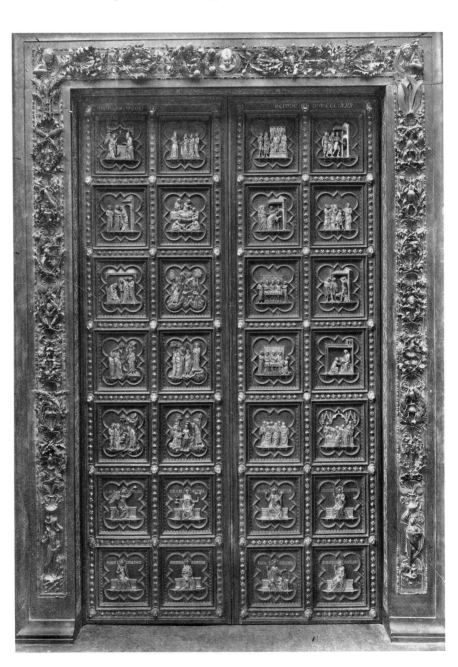

of this division is that when the doors stand open, they retain integrity as independent units.

There is one anomaly in the Life of John in terms of order and another in narrative detail. The *Ecce Agnus Dei* scene is unconventionally separated from the *Baptism of Christ* by a scene of the *Baptism of the Multitude* (fig. 51). This temporal reversal serves as a reminder not to mistake these scenes for mere illustrations. Like the account in the fourth Gospel (John 1:15 ff.), where the sequence is not chronological but reports the Baptist's bearing witness to Jesus as the Messiah, the order here is ideological.[9] On the fourth tier John preaches on the left, and the content of his preaching, the *Ecce Agnus Dei*, is visualized on the right. On the fifth tier John baptizes the people on the left and baptizes Christ on the right, both scenes being models for the function of the Baptistry. In chapter 2

FIGURE 50. Pisa, Duomo, bronze doors of San Ranieri, Bonanno Pisano, 1186

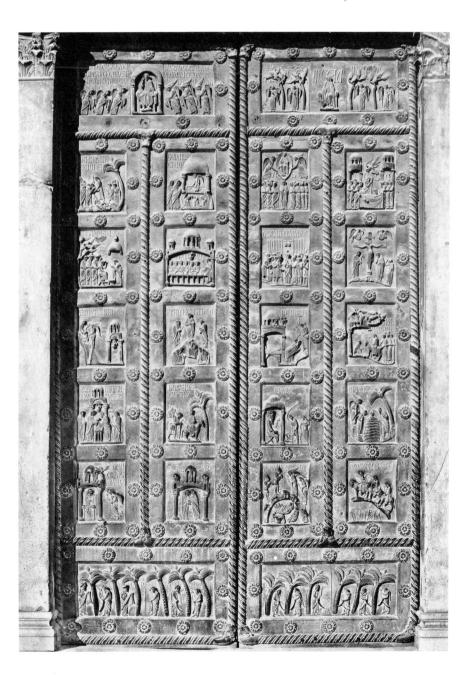

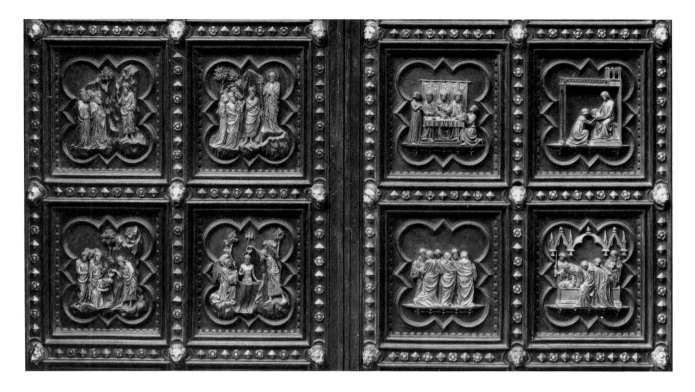

the Baptist's head is brought to Salome at Herod's table on the left, and Salome takes the head to her mother on the right. John's body is carried on the left; it is placed in the tomb on the right. The final four scenes in both chapters should thus be read not as episodes in a chronological sequence but as sets of pairs. The rare extension of John's burial into two scenes in fact fulfills the apparent need for this narrative symmetry.[10]

The superimposition of the narrative above tiers of allegories is similar to the pattern of many earlier bronze doors and, as has often been observed, the Arena Chapel. Here the personifications of eight virtues, each identified with a large inscription, are placed on the two bottom tiers of each valve.[11] The poses of the figures on the outer edge thrust toward the center; the figures toward the center face forward, making closure at the outer ends. The lions' heads at the corners of the plaques reinforce this rhythm. This symmetry is the concluding element in a self-conscious design that imbues the structure of the portal as a whole with an abstract stability quite new to the history of art.

A prime public commission was carried out in the 1340s in the town of San Gimignano, south of Siena, in the Church of the Collegiata, a Romanesque foundation refurbished in the fourteenth century and again in the fifteenth. In the early trecento, the orientation of the church had been completely turned around by moving the facade from the northwest to the southeast.[12] When the interior was ready for decoration, a design must have been drawn up that included Old and New Testament cycles in typological opposition on the walls of the side aisles. An Old Testament cycle by Bartolo di Fredi on the left wall was not carried out until 1367. The New Testament cycle on the right wall was finished earlier and, on the basis of remarks by Lorenzo Ghiberti, has long been attributed to an otherwise unknown artist called "Barna da Siena." A consensus is now building toward attribution to Lippo Memmi and his shop, with a date

between 1333 and 1350, probably about 1343.[13] Both of these nave cycles start at the entrance end of the building and proceed toward the apse, contrary to hoary tradition. To explain this "reverse" movement I suggest that the reading matches the Early Christian Double Parallel but "remembers" the previous orientation of the church by starting from the position of the original apse. The building's two facade entrances, known as the Porta delle Donne on the left and Porta degli Huomini on the right, are in their places at the sides of the old apse, apparently again remembering an arrangement in the previous structure.[14] Worshipers enter through these doors and start "reading" the frescoes as soon as they move inside. The Old Testament narrative on the left wall proceeds from left to right for six bays on three tiers, moving from the top down. The scene of the *Crossing of the Red Sea* on the lowest tier is four times the size of the other rectangular scenes, perhaps in imitation of a scene in the lost cycle in Old Saint Peter's in Rome.[15]

The disposition of the New Testament cycle on the right wall is quite different. It is one of the clearest, most deliberate monumental Boustrophedons ever created (diag. 18). The Life of Christ, again divided into chapters, starts on the lunette level, just inside the Porta degli Huomini (fig. 52). This upper tier shows the Infancy (the *Annunciation* through the *Flight into Egypt*) and reads right to left.[16] Following a balanced composition at the opening scene,[17] all the other five scenes on this level thrust emphatically right to left in terms of their figure groupings, encouraging the spectator along the narrative progression. The narrative continues on the second tier in the fourth bay from the entrance; this chapter deals with Christ's public life, *Christ among the Doctors* through the *Entry into Jerusalem*.[18] On this tier the narrative direction is reversed and reads back to the entrance, moving left to right. The first two scenes are essentially centralized compositions drifting slightly toward the right. The next four scenes, the *Calling of Peter and Andrew* through the *Raising of Lazarus*, exercise the beaking mechanism by standing upright or thrusting to the right. The last episode, *Christ's Entry*, exhibits some remarkable elements. It is double size, taking up the space of two full scenes, their frames included. Our attention is called to this oddity by the figure of a young man spreading his coat to honor Christ's path: half his body appears in one framed area and half in the other, with the painted frame dividing him down the middle (fig. 53).[19] The field on the left shows Christ riding toward the right. The larger field with a view of Jerusalem brings the movement to a close at the end of the tier. Expanding the size of the *Entry* scene recalls the arrangement I have signaled as having its origin in Old Saint Peter's, perpetuated throughout the Middle Ages.[20] But in this case the emphasis came from more than size. The artist alludes to his Early Christian source by giving a prominent place, quite extraordinarily, to the figure of Saint Peter holding symbolic keys.

In the last chapter of Christ's life on the third tier, the reading direction reverses again, becoming once more right to left. The opening scene, the *Last Supper*, is centralized and balanced. The *Pact of Judas* has a perverse thrust left to right, against the grain of the narrative movement. Then the scene at *Gethsemane*, the *Betrayal*, *Christ before Caiaphas* (again like Giotto's Arena cycle, there is no Pilate scene), and the *Flagellation* are all composed to follow the chronology inclining toward the left. The

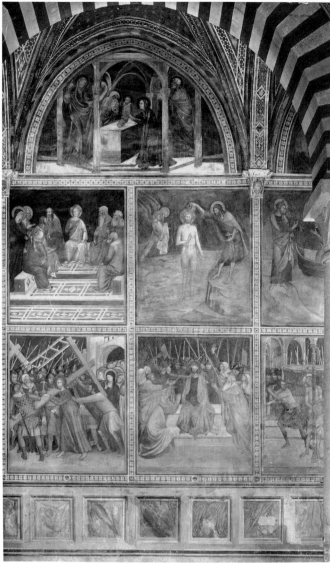

FIGURE 52 (*above and facing page*). San Gimignano, Collegiata, right wall [Lippo Memmi?], Life of Christ

Mocking scene is centralized; the *Road to Calvary* again moves to the left with the chronological progress. Following this strongly thrusting composition, the *Crucifixion* is frontal, balanced, and stationary. It is the largest, most elaborate narrative representation of this subject up to this time, something over seven and a half meters high.[21] But the issue is

DIAGRAM 18. San Gimignano, Collegiata, right wall (see plate 8)

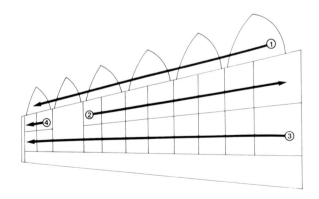

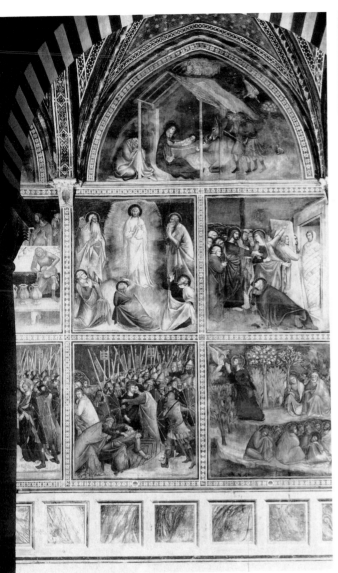
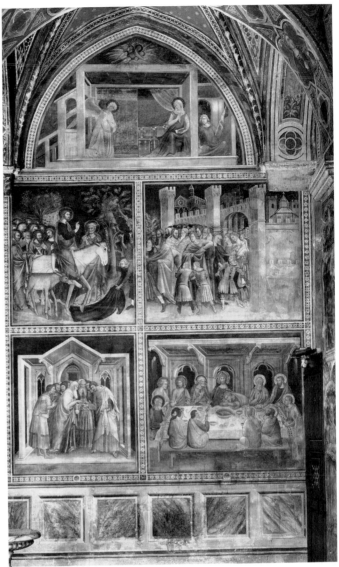

that, being four times the size of a regular scene, the *Crucifixion* confirms the reference to Old Saint Peter's in Rome. When we remember that in these years Cola di Rienzo was calling loudly for a renaissance of Rome as a Christian city and insisting that the pope return (from France), the importance of such visual references to the authority of Saint Peter cannot be underestimated.[22]

The last four scenes form a kind of unit unto themselves, repeating the notion of topographic symbolism we found at Assisi and elsewhere. Although they are all now badly damaged, one can tell that the earthbound scenes of the *Entombment* and the *Descent into Limbo* are on the bottom tier and the soaring miracles of the *Resurrection* and the *Ascension* are placed on high.

If the cycle is indeed by Lippo Memmi, known traditionally for his contribution to the great 1333 *Annunciation* made with Simone Martini for the Siena Cathedral, with this cycle he emerges as an independent creative mind of the first order. His use of the Boustrophedon on a monumental scale is unprecedented. Frequently the many small scenes on

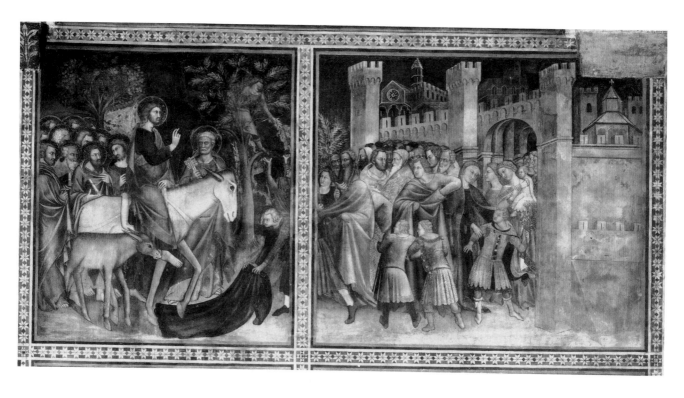

large-scale stained glass windows are arranged boustrophedonically in complex vertical columns; an example of an upward Boustrophedon is seen in the Charlemagne Window at Chartres.[23] Two orderly Boustrophedons moving downward are found on the Paschal Candelabrum of Gaeta of about 1260.[24] The two Giottesque examples of Boustrophedons I have discussed, the Aerial in the Bardi Chapel and the Linear in the Magdalene Chapel, are monumental but have relatively few scenes. At San Gimignano there are twenty-six episodes besides the oversized *Crucifixion*, and the excursion of right-left, left-right, right-left reading is longer and more sustained than ever before. The constant sense of movement, the diversified groupings of scenes, vertical as well as horizontal, the shifts of scale, enliven the long, flat wall in an exhilarating manner.[25] If it is true that the organization is related to the back of Duccio de Buoninsegna's *Maestà*, as is often suggested.[26] Lippo has added a sense of grandeur that far surpasses the model.

In the same decade of the 1340s another public commission was carried out in Venice: the interior of the Baptistry at San Marco in Venice was being embellished with a sumptuous mosaic cycle (fig. 54).[27] Although immediately adjacent to the main church, the Baptistry is a separate building and, as such, joins a tradition that is particular to Italy. What is remarkable in this case is the association of this strictly Western ecclesiastical building type with what is essentially a Byzantine style of church. Although this combination has often been discussed in terms of architecture and mosaic figure style,[28] what has not been noted is that the disposition of the narrative cycle shows the same impulse in bringing Eastern and Western characteristics together to create something new. In plan, the Baptistry is a longitudinal rectangle, its axis parallel to that of the main church, with its altar at the east. Given this basic format, however, many elements imply contraction into a central plan. One entrance is

through a small narthex and portal at the west. Another is found at the center of the nave through the left side wall at the level of the baptismal font. Although the altar is at the east, the hexagonal baptismal font, the main functional element of the building, is at its geometric center. Although the nave is longitudinally extended, it is divided into three autonomous sections: the westernmost, covered by a transverse barrel vault; the central baptismal section, covered by a dome; and the eastern section, crowned by a smaller dome. The ceilings of these sections are covered with mosaics in self-contained compositions. But in spite of the divisive elements, the iconography of the ceiling, taken as a whole, shows a unified theological progression moving without interruption from west to east.[29] The cycle, placed at the level of the springing of the vaults, shows the same combination of elements.

The subject of the wall cycle combines the Life of John the Baptist and the Infancy of Christ.[30] The narrative begins in the Western medieval

FIGURE 54. Venice, San Marco Baptistry, interior, view toward apse (see plate 9)

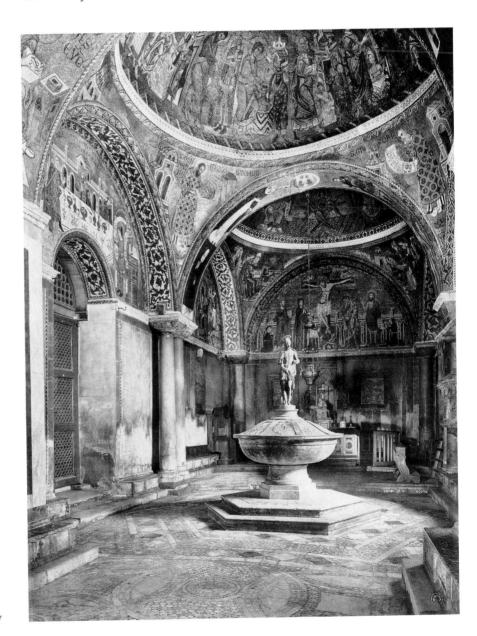

DIAGRAM 19. Venice, San Marco, Baptistry

FIGURE 55. Venice, San Marco Baptistry, mosaic, *Adoration of the Magi*

manner, on the right wall at the apse end (diag. 19). The first lunette-shaped field holds three episodes one next to the other, reading left to right. The scenes are the *Annunciation to Zachariah; Zachariah Mute* (he demonstrates his condition to the three men by pointing to his mouth); and the *Meeting of Zachariah and Elizabeth.* The latter is an episode apparently transposed from the apocryphal life of Mary, the Meeting of Joachim and Anne, and perhaps is meant to have the same meaning, namely the actual moment of conception. It elongates John's pre-Birth story to complete a triadic composition. A single scene of the *Birth of John* apparently filled the second bay; the original mosaic was destroyed when a window was added, and a painted scene of this subject with the date 1628 was substituted.

The cycle next moves to the entrance area and begins a series of episodes in continuous mode that follows the transverse vault on two tiers across the interior facade. The upper tier is, in fact, a curved surface on the springing of the vault. The narrative now shifts to the Life of Christ with the scenes of the *Magi Speaking to Herod,* the *Adoration of the Magi,* and *Joseph's Second Dream* in the far right corner (fig. 55). The sequence then jumps to the upper tier of the east side of the barrel vault, where the lives of Christ and John begin to interlock. Still moving left to right, the

first image is the *Flight into Egypt,* with the infant facing his mother and clinging to her. The *Massacre of the Innocents* that follows introduces an episode rarely represented in Western art. Hiding in the mountains, safe from Herod's murderous soldiers, Saint Elizabeth holds her infant son. Having been warned by an angel, they have escaped to the desert.[31] The narrative wraps around to the west side of the barrel vault, now on the lower tier. The first scene is an apocryphal episode of the *Infant Saint John Led into the Desert by the Archangel Uriel;* they progress from left to right, the angel pointing forward in the same direction.[32] In an irregularly shaped field within the entrance arch area, there is a scene of the *Vocation of John,* another episode with Eastern apocryphal roots. The hermit saint, his hair and beard now streaked with gray, receives his camel's hair cloak from an angel.[33] The last scene on this wall, in the spandrel at the right end, shows the saint, now in his traditional haggard and emaciated condition, *Preaching to the Pharisees.* The composition slows the left-right movement of the narrative, thrusting right to left.

The ritardando of the *Preaching* episode prepares for the crucial scene of the series. The *Baptism of Christ* is isolated on the lower tier of the adjacent left wall. The portrayal is essentially Byzantine in form, frontal and strictly symmetrical, with personifications in the River Jordan, alluding to typological parallels in the Psalms.[34] Scenes of John and his disciples (somewhat damaged) on the spandrels of the western membrane arch complete the second circuit of the narrative around the barrel-vaulted area.

The narrative now progresses left to right along the left nave wall, that is, the arches of the central and easternmost sections. In the lunette-shaped field of the first arch is a spatially unified scene matching the *Birth* scene opposite. It represents the *Feast of Herod,* with Herod and Herodias, seated at the table, giving orders to their servants. The famous red-clad figure of Salome dances at the left, holding aloft the Baptist's severed head. Not only is the compositional thrust here reversed (right to left), the episode itself is anachronistically placed. Only on the next architectural unit is the *Beheading of John* represented. By isolating Salome's dance before her lustful stepfather, the artist dramatized the story's maximum sin precisely in the section of maximum redemption, where the baptismal font is placed. The final lunette holds another triad, balancing the three pre-Birth scenes on the opposite side of the nave. It includes the *Beheading of John* before the prison, the *Delivery of the Head to Herodias,* and the *Burial of the Headless Body,* ending the cycle at the corner of the altar wall.

Among the many unique aspects of the disposition, perhaps the most arresting is the way it responds to the architecture. Basically the disposition is a Wraparound. But reciprocating and reinforcing the structure, it is extended to include a second loop around the barrel vault (diag. 19). This visual circuit makes a bond between the lives of John and Jesus stronger than any verbal description could achieve. It binds the separate sections of the building together as well, reinforcing the centralized pull on the baptismal font within the longitudinal plan. The goal of all these expressive agents is in the lunette on the altar wall, where a monumental *Crucifixion* takes a mystical form that includes the figures of John the Baptist, the Magdalene, and two magistrates of Venice.[35] In this way the

building and its decoration are coordinated to make visible the meaning of John the Baptist's mission as precursor of the Savior, as well as the universal significance of baptism within the life of a Christian city.

Our first encounter with the use of an interlocking system was with the important triple cycles in the Upper Church of Assisi.[36] As we have just seen, the Venetian Baptistry demonstrates the same idea achieved with another kind of disposition. We shall now look at two more cases where Interlocks are used to make other theological points.

Orcagna's rectangular Tabernacle of the Virgin in Orsan Michele, Florence, done between 1352 and 1359, was the first major cyclical commission in sculpture after Andrea Pisano's Baptistry doors. On the lower tier of the marble structure, a Life of Mary is represented in eight hexagonal reliefs, two on each side of the rectangle (fig. 56).[37] Each scene is treated as a revelation, with tiny tabernacle drapes pulled back to reveal a miracu-

FIGURE 56. Florence, Orsan Michele, Orcagna, tabernacle

FIGURE 57. Padua, Santo, "San Felice
Chapel," Altichiero

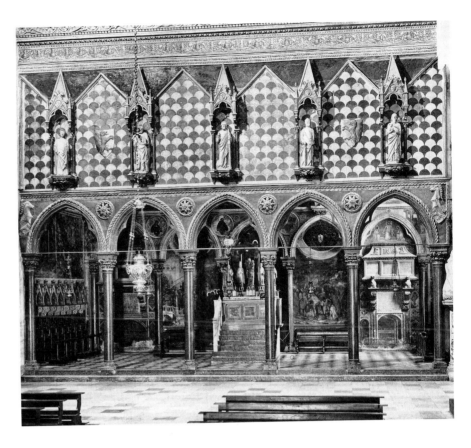

lous event. The sequence begins at the left side (facing the altarpiece) and
moves in a Wraparound left to right. The order and placement of scenes
synchronizes with the devotional images on the front and back of the tab-
ernacle. On the front is a much-venerated panel of the *Madonna and
Child*, embraced by two scenes pertinent to the Incarnation, the *Marriage*
and the *Annunciation*.[38] Centralized on the lower register of the back is a
large-scale relief of the *Dormition of the Virgin*; it is surmounted by an
even larger image of the *Assumption of the Virgin*. The double scene is
flanked by the *Purification* on the left and the *Annunciation of the Death*.
Narrative order here is anachronistic: the *Death* comes before the an-
nouncing of it, again reminding spectators that what they see is not a
story, but a theological exposition of the Virgin's life. The superimposi-
tion over Mary's death of her elevation repeats the dogmatic arrangement
at Santa Maria Maggiore in Rome, replacing the Coronation image with
the Assumption, including the figure of Saint Thomas receiving the holy
belt to emphasize further the palpability of the miracle. This narrative
cycle embraces, quite literally, the devotion to the Virgin that the spon-
soring guild wished to promulgate.[39]

 To pursue the Interlock, we skip ahead to the so-called San Felice
Chapel in the Santo in Padua, painted by Altichiero da Zevio and his shop
between 1372 and 1379. The chapel in the right aisle of the church is
actually dedicated to Saint James the Greater and is decorated with a cycle
of his life (fig. 57).[40] The disposition here is a Wraparound that binds the
life of the saint to that of Christ. The story begins on the left wall on the
upper tier and reads left to right around the chapel. When the sequence
completes one circuit and arrives again at the left wall, it drops down a

tier, crosses the wall, and ends as it reaches the altar wall. Only this arrangement places the martyrdom of James on the top tier directly in the center of the altar wall. A gigantic *Crucifixion* (fig. 58) fills the three arched fields in the lower portion of this wall, and the cross of Christ is placed immediately under the figure of Saint James. The scene of the saint's death is thus visually identified with that of Christ, clearly stating through the superimposition the relation between the first of the apostles to be martyred and the Savior he followed.[41] Although portraits of contemporary Paduans included in the scenes augment the content of the cycle with current political allusions,[42] the Interlocking Wraparound lifts the actual narrative to a higher devotional plane.[43]

Political implications of a broader nature had become an evident factor in religious cycles a few decades earlier. A most pertinent case in point is

FIGURE 58. Padua, Santo, "San Felice Chapel," Altichiero, altar wall

found in Avignon where, though the city is in southern France, an Italian artist was hired to justify in visual terms the schism with the Roman papacy. By the 1340s a new Avingian papal palace, begun in the early years of the century, was complete, and lavish decorations were under way.[44] Among the wall paintings in the many public and private spaces that were decorated in the palace, those in two chapels built one above the other in the Tour Saint Jean were heavily charged with political meaning. It may not be without significance that Matteo Giovannetti, who was from Viterbo, a city that boasts a papal palace, was especially imported for the job. Even though these chapels are relatively small in scale (6 × 5.25 meters) and therefore conceived for a restricted audience, together they make strong claims for both the religious and the political potency of the French popes. The political statement begins with the chapels' dedications. Adjacent to the great Consistory Hall, the lower chapel is dedicated to the two Saint Johns.[45] It thereby refers to the Lateran Cathedral in Rome. The upper chapel, approached through the Festival Hall (Grand Tinel), is dedicated to Saint Martial, patron of the Limousin, home of the reigning pope, Clement VI. In fact, at this time Clement was promoting Saint Martial as a national patron, in the hope of replacing the more "royalist" Saint Denis. For this reason and others in the story of Saint Martial's life, he was also known as the "Saint Peter of France."[46] A chapel dedicated to him therefore would refer to the church of the Vatican in Rome. Taken together, the chapels recreate the two main foundations of Roman ecclesiastical power on French soil. For Clement VI they signified authority as bishop of the capital and apostolic vicar of Christ on earth.

The double narrative in the lower chapel of the two Saint Johns is disposed in two rather loosely structured Boustrophedons starting on the altar wall and moving, albeit irregularly, in opposite directions (fig. 59). As in the Peruzzi Chapel in Florence a decade earlier, the Life of the Baptist is on the left and that of the Evangelist is on the right. The scene of *John at the Porta Latina*,[47] considered the martyrdom of the saint, is "out of order" on the lower tier of the entrance wall and thus identified with the *Crucifixion* that fills the upper part of the same lunette.

In the chapel on the upper floor the disposition of the cycle of Saint Martial is altogether different. Most striking is that it is partly painted on the ceiling (fig. 60).[48] The general arrangement is a familiar one, a left-right Wraparound bent to fit a groined vault's webs. Yet this unorthodox placement at first makes the cycle difficult to follow. The story begins in the web to the left of the entrance and oscillates loosely up and down along the ribs of the vault as it moves left to right. The vault surface is treated as a star-studded blue firmament, on which as many as eight narrative episodes appear, two in each web. Having circled the ceiling, the narrative moves down to the left vertical wall and circles the chamber two more times in a left-right Wraparound including all four walls. Decorated ground lines divide the major tiers and include one-line written captions.[49] The individual episodes on each tier have no frames; each flows into the next against an unbroken background of architecture and landscape. The concept of surface continuity across the wall is so firm, in fact, that even the embrasures of the windows are used as pictorial fields. Though not carrying major narrative events, these slanting surfaces

FIGURE 59. Avignon, Papal Palace, Chapel of Saint John, Matteo Giovannetti, view

FIGURE 60 (*facing page*). Avignon, Papal Palace, Chapel of Saint Martial, Matteo Giovannetti, ceiling view

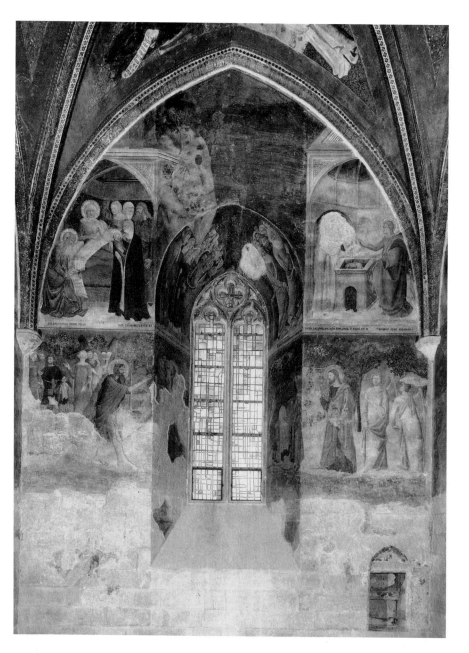

(where the frescoes are particularly well preserved), contain some very original, stylish, and highly individualized figures.[50]

One of the most interesting elements in this chapel is the special instructions given for reading the narrative. Perhaps as much because of the rarity of the subject as because of its unusual placement, the artist employed a system of alphabetic numbering, painted in the ground of each scene: A through H appear on the scenes of the ceiling; I, L, M, N, O, P, and Q circle the walls.[51] What is important about the disposition, however, is that it ensures the placement of crucial episodes in significant locations. Positioning scenes of the interaction of Saint Peter and Saint Martial in the honored upper regions of the chapel establishes the direct line of descent from the apostle to the patron. By ending the cycle next to the altar, Saint Martial's Peterlike role as church founder is further

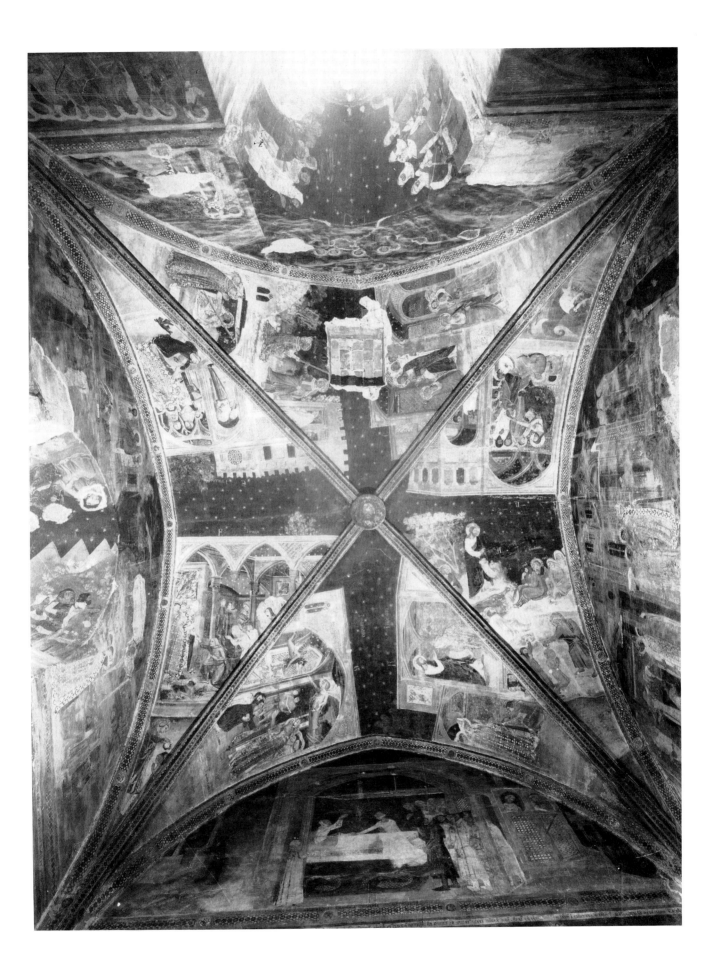

FIGURE 61. Avignon, Papal Palace, Chapel of Saint Martial, Matteo Giovannetti, *Church Scene*

FIGURE 62 (*facing page, top*). Florence, Santa Maria Novella, "Spanish Chapel," Andrea di Firenze, view of ceiling

FIGURE 63 (*facing page, bottom*). Florence, Santa Maria Novella, "Spanish Chapel," *Crucifixion*

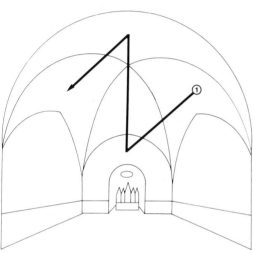

DIAGRAM 20. Florence, Santa Maria Novella, "Spanish Chapel"

affirmed. The last scene in the sequence, one of the most elaborate architectural landscapes remaining from this period (fig. 61), shows thirteen churches founded in France by Saint Martial, eight of which are dedicated to Saint Peter.[52] Outstanding in itself, this impressive image affirms the supreme authority of Saint Martial as papal advocate. Disposition and subject matter here form a richly textured narrative that combines with the cycles in the chapel on the lower floor to recreate the major Roman centers of papal authority and insist on Avignon as the true seat of Christian power.[53]

The use of narrative ceiling decoration for self-promotion on an even larger scale was to be seen in the following decades back in Italy. The great vault in the "Spanish Chapel"—the chapter house of the Dominican convent at Santa Maria Novella in Florence—was painted by Andrea da Firenze between 1366 and 1368.[54] The large-scale webs of a four-part vault are treated as separate fields, each web containing a continuous narrative with several related episodes placed before a unified background (fig. 62). Within this structure the disposition is relatively complex, the Wraparound used at Avignon being abandoned for the ideologically richer Boustrophedon (diag. 20). The subjects include the *Miraculous Draft of Fishes,* the Passion and the post-Passion of Christ, and two non-narrative images promulgating Dominican doctrine.[55] The earliest in the chronology, the *Miraculous Draft,* is in the web on the right as one enters. Although on the ceiling, this starting point carries reference to the basilical churches of the past. From there the sequence moves down to the lunette-shaped altar wall. the story moves left to right from the *Via Crucis* through the *Crucifixion* to the *Descent into Limbo* and covers the entire arch (fig. 63). The *Resurrection* and other scenes attendant on that subject appear on the vault web immediately above. The *Ascension* is placed in mirror position on the web over the entrance, and final contact with Christ on earth, the scene of the *Pentecost,* is on the web to the left.[56] The disposition of the upper realm is thus a diagonal Aerial Boustrophedon magnified by use of the ceiling to create an upper "superior" realm. With the inclusion of the *Miraculous Draft* scene, a subject that confirms Petrine authority, the frescoes promulgate the world rights of the Dominican order within the *Ecclesiastical Establishment,* which is represented on

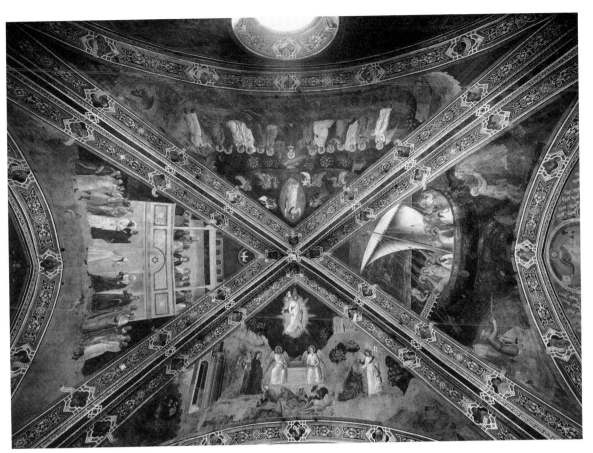

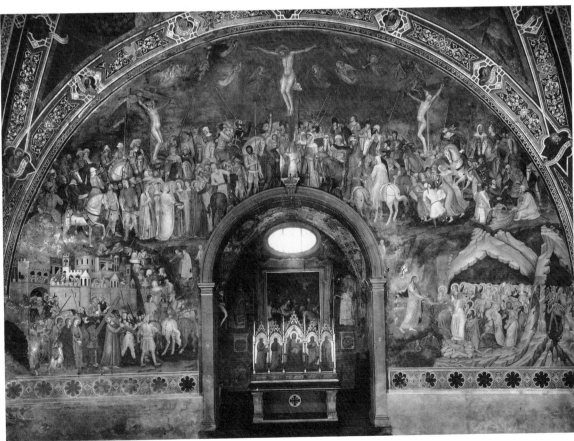

the right wall, and under the intellectual leadership of Saint Thomas Aquinas, whose *Glorification* is represented on the left.

In the last third of the century, private commissions again become the norm, and it seems not by chance that several recapitulate formats developed earlier in the century. Although dispositions, and actual inscenations in some cases, copy older models, many innovations that carry the development of chapel decoration along new paths can also be discerned.[57] An instance of what we might call progressive revivalism can be seen the so-called Rinuccini Chapel, adjacent to the sacristy in Santa Croce, Florence (fig. 64). It is now known that this chapel was started by the Guidalotti family and painted up to a certain point by Giovanni da

FIGURE 64. Florence, Santa Croce, sacristy, Rinuccini Chapel, Giovanni da Milano and Master of the Rinuccini Chapel, left wall

Milano between 1365 and 1369. The property was taken over by the Rinuccini family, and a second painter carried the lowest tiers on both walls to completion.[58]

References to the Baroncelli Chapel of thirty years earlier were the guiding principle. Like the side walls of the Baroncelli, the facing bay walls are each divided into five fields: the lunette and two stacked tiers of two rectangles each (fig. 65). The reading sense is generally from left to right and from the top down. A number of individual compositions follow those in the Baroncelli Chapel very closely. For example, the scene of the *Meeting at the Golden Gate* repeats many aspects of Taddeo's scene, particularly in the addition of the moody shepherd who follows Joachim.

FIGURE 65. Florence, Santa Croce, sacristy, Rinuccini Chapel, Giovanni da Milano and Master of the Rinuccini Chapel, right wall

DIAGRAM 21. Florence, Santa Croce, Rinuccini Chapel

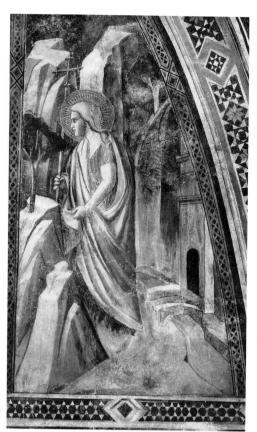

FIGURE 66. Florence, Santa Croce, Castellani Chapel, Starnina, *Saint John the Baptist Enters the Desert*

The scene of Mary's *Presentation in the Temple* follows the great architectural structure in the composition of the earlier cycle. However, there are also major differences. The areas of the lunettes are now conceived as monoscenic units, each containing a single unified episode designed with monumental architectural settings that enlarge and dramatize the scenes. This element of expansion was to be an important legacy at the end of the fifteenth century. Here the enlarged space allows the figures to be multiplied into ritualized and balanced groups. Moreover, the compositions of the individual rectangles on each tier, whether monoscenic or continuous, create echoing rhythms across the chapel that, in spite of the somewhat disjointed additions by the Rinuccini Master on the lowest range, give the chapel an unexpected formal coherence.[59] It is possible that the effect was somewhat muted by the change of artist, since the scenes by the Rinuccini Master are less abstract, with less compositional force and less emotional intensity. However, though he may have felt constricted in working with someone else's idea, he nevertheless carried on the program with a good measure of consistency.

Cycles of the Virgin and the Magdalene face each other on either side of the windowed altar wall; to the left is the "first chapter" of the Life of the Virgin, from the *Rejection of Joachim's Sacrifice* to the *Marriage* scene. On the right is the first chapter of the Life of Mary Magdalene, from the *Feast in the House of Simon* through the Magdalene's own first miracle (*Resuscitation and Conversion of the Prince and Princess of Marseilles*).[60] In spite of a change of patron and artist halfway through the project, a coherent scheme was carried out. The rhythmic patterns take the following form: compositions in both lunettes point toward the altar; on the second tiers, the compositional thrust is generally away from the altar wall; on the third tiers, the scenes thrust generally toward the altar wall. Iconographically also, the two sides correspond. Pairing the women who were closest to Christ, and who were both patrons of Saint Francis, the Virgin Mary and Mary Magdalene are shown in episodes before their saintly functions began. The scenes of the Virgin's life are from before the birth of Christ; scenes of the Magdalene are from before her isolated life of abnegation in imitation of Christ. Both chapters technically are times of preparation.

Beyond this thematic statement, the Rinuccini Chapel demonstrates two separate realms of patterning, that of reading order, and that of compositional thrust, showing how they can operate separately or together (diag. 21). In this case, the Rinuccini Master scenes on the lowest tier of the left wall move from left to right both compositionally and narratively. On the lowest tier of the right wall, the two fields as a narrative unit move chronologically from left to right: first the continuous narrative in the left-hand field (*Marys at the Tomb* and *Nolime Tangere*), followed by the *Princess of Marseilles* scene. However, in the left field as a separate unit, chronology is reversed. Christ appeared to the Magdalene after the *Visit to the Tomb*, and thus the narrative movement is right to left. On the other hand, the compositional thrust of both fields is also right to left, that is, toward the altar. The thrust therefore coincides with the narrative direction in the left rectangle. The result is that there is visual movement toward the altar on both sides of the chapel, a pattern we shall see more than once in the years to come.[61]

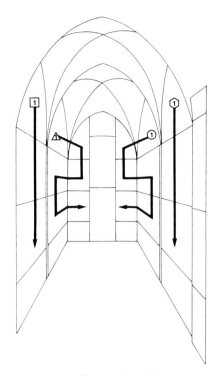

DIAGRAM 22. Florence, Santa Croce,
Castellani Chapel

Another example of progressive revivalism is seen in the two-bay Castellani Chapel, also in Santa Croce.[62] On the west side of the south transept, this chapel, like the Rinuccini Chapel, had more than one artist participating in creating cycles of the lives of more than one saint. Major parts of the chapel were painted by Agnolo Gaddi, one of Taddeo's sons, with the intervention perhaps of Gherardo Starnina and a third hand. Although it cannot be claimed that the chapel's design is wholly consistent, the arrangement can be characterized as follows: incorporating all four walls, each bay displays the lives of two saints, one on each side. In the first bay as one enters, the life of Saint John the Evangelist is on the left, and Saint Nicholas of Bari is on the right. The entrance and side walls are arranged essentially in Straight-Line Verticals (the interior facade is somewhat irregular), recalling the Peruzzi Chapel across the transept. The new contribution comes in the second bay at the altar end, where the Life of Saint John the Baptist is represented on the right and Saint Anthony is on the left. The progression is in matching Boustrophedons that turn the corners and include the altar wall (figs. 66, 67, diag. 22). With only the smallest discrepancies, the cycles start at the top, move toward the altar and onto the altar wall, descend to the second tier, reverse and return to the side walls, descend to the third tier, reverse again, and move toward the altar and around the corners, ending on the altar wall. The loosely constructed double Boustrophedons including the altar wall in the Saint Johns Chapel at Avignon can be cited as precedents. What is new here, however, is a rhythmical balance and integration of the three-wall disposition that puts the saints' lives into the literal embrace of the architecture. The team of artists who cooperated on the Castellani commission not only worked from a preconceived plan, but understood perfectly the goals of the overall design.

Reference to earlier formats is quite programmatic in a lengthy and complex public cycle in the chancel of Santa Maria della Stella, the

FIGURE 67. Florence, Santa Croce, Castellani Chapel, Starnina, *Baptism of Christ*

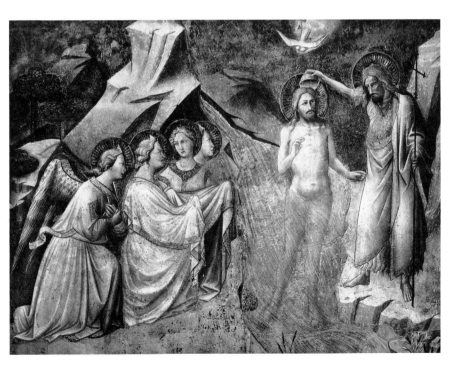

Duomo of Orvieto (fig. 68). This great building, founded in the 1270s,[63] was carried forward by Nicholas IV, the Franciscan pope who, as we have seen, was deeply dedicated to the Virgin and was one of the great promulgators of the dogma of the Assumption. At Orvieto he seems to have made expression of the ideological bonds between Santa Maria della Stella and Santa Maria Maggiore in Rome a sine qua non for the design and decoration.[64] More than a century later, his mandate was carried forward when the chancel cycle of the Life of the Virgin was given the Apse pattern, also reflecting the disposition of the apse at Santa Maria Maggiore. The Orvieto cycle was carried out between 1357 and 1364 by a team of artists, chief among whom were Ugolino di Prete Ilario, Pietro di Puccio, and Cola di Petruccioli.[65] Rendered in discursive and anecdotal detail, each episode accompanied by a narrative caption, it is longer (thirty-two episodes) than any large-scale version of the Marian legend before or

FIGURE 68. Orvieto, Duomo, interior view

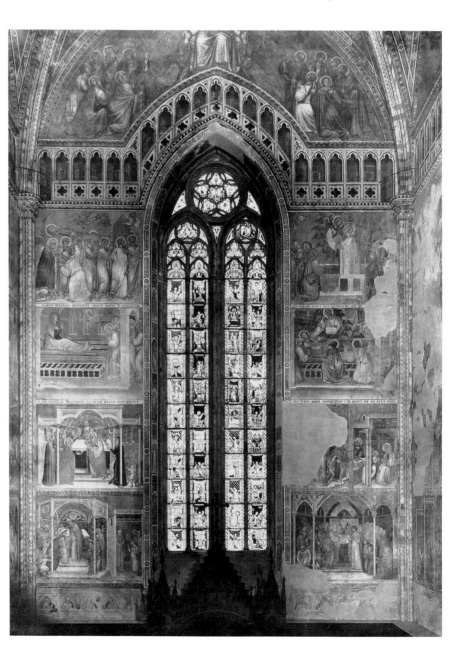

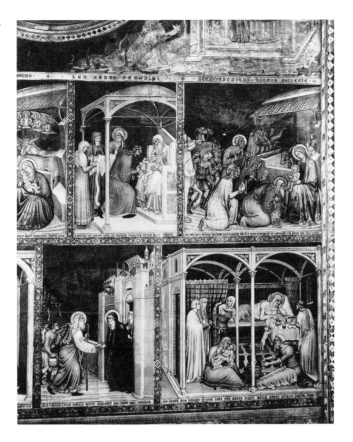

after this period. Modernity here lies precisely in the great elaboration of the narrative. Many scenes of activities not previously associated in visual terms with the idealized life of the Virgin are represented, such as sewing, eating, arguing, hesitating, and so on (fig. 69).[66] The desire to glorify Mary's physicality seems to have motivated this expansion of visual vocabulary. As in the model church in Rome, the disposition in the apse moves upward, here in parallel tiers, from left to right across three walls of the apse (diag. 23).[67] It starts on the lower tier at the left and circles the apse for two tiers (Mary's youth and married life are described). It then moves to the altar wall on the third tier, where a cycle of Mary's death is placed as a unit. Progressing left to right, scenes of the Last Days[68] flank the top of the central window. The *Assumption* fills the huge space of the lunette at the top, and the *Coronation* takes its superior place in the web of the great vault crowning the chancel area (diag. 23). As in few other monumental cycles, the Orvieto frescoes combine the descriptive style of illustration with the eloquence of dogmatic disposition, designed to promulgate the ideas of the church.

The paintings in the side-wall lunettes are in a different vein; they are nonnarrative in mode and polemical in content. At this crucial point in history, just before the start of the Great Western Schism, they express a fervid fealty to the papacy of Rome. In contrast to the descriptive style of narrative below, these nonnarrative scenes of ideology are painted in abstract grisaille against flat red backgrounds. On the right are the Old Testament patriarchs who established lands and family lines at the beginning of monotheism. On the left is the *Baptism of Constantine by Pope*

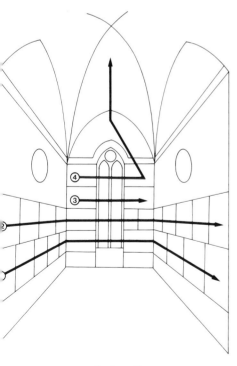

DIAGRAM 23. Orvieto, Duomo, apse

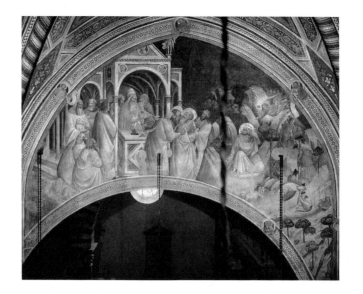

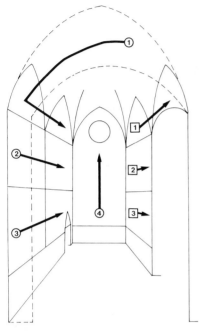

DIAGRAM 24. Prato, Duomo, Cappella del Sacro Cingolo

FIGURE 71 (*left*). Prato, Cappella del Sacro Cingolo, Agnolo Gaddi, *Nativity*

FIGURE 72 (*right*). Prato, Cappella del Sacro Cingolo, Agnolo Gaddi, *Assumption of the Virgin*

Sylvester, representing the historical figures who established papal lands and Roman jurisdiction over them. These inaugural characters are supported on both sides by Old Testament prophets, New Testament evangelists, martyrs, and fathers of the Western church. On the groins above all the scenes, Christ in the western web blesses and is adored by the hierarchy of angels as described by Dionysius the Areopagite, who appears within the scene of the Coronation. At this period, Dionysius was thought to have been an early and strong backer of the Assumption dogma, and his figure may have been included here for that reason.[69] The grandiose composition of the apse should be understood as giving proof of Mary's glory with visual documentation, whose authority rises as the narrative disposition proceeds upward. The humility and simplicity of the homely apocrypha of Mary's life are surmounted by the verities of Christian history. The whole is finally crowned by the visionary exegesis of a venerated churchman.

The tendency to emphasize ever more strongly the palpability of Mary's physical survival, seen in the Orvieto frescoes, reached a climax in

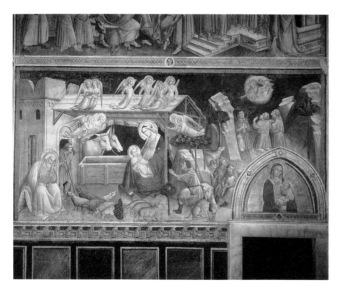

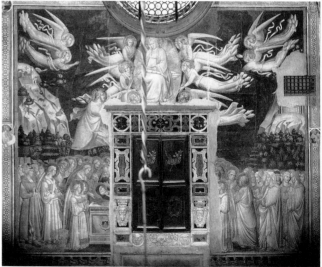

FIGURE 73. Siena, Palazzo Pubblico, Cappella dei Priori, Agnolo Gaddi

the second half of the fourteenth century with the translation of the relic of her girdle to the Duomo of Prato. A story relates that when Mary was assumed, all but one of the apostles were present; Saint Thomas, who had doubted Christ's resurrection in the flesh, was absent from the Assumption and therefore also doubted this event. To reassure him, Mary graciously dropped her belt, or *cingolo*, thereby giving tangible evidence of her physical presence in heaven. According to legend, Saint Thomas gave the belt over to the care of a holy man in Jerusalem, where it remained for centuries. In the twelfth century, Michele Dragomari from Prato received the girdle during a trip to the Holy Land and brought it back to be enshrined in the Duomo of Prato.[70] The Cappella del Sacro Cingolo, founded in 1365, was painted by Agnolo Gaddi in 1393–95.[71] To promote Prato as a major shrine, the Dragomari story was included as part of a double cycle on the wall opposite (on the right) the Life of the Virgin.[72] In a variation on the Apse pattern, Mary's life begins over the entrance (fig. 70, diag. 24) and moves to the left wall, reading left to right on three tiers in descending order. The final scenes occupy the single bay of the altar wall, where the *Death, Assumption* (with Saint Thomas), and *Coronation* appear in one continuous, upward-moving sequence (fig. 72).[73] The arrangement places Saint Thomas's scene directly over the

altar. It also places the *Nativity of Christ* precisely adjacent to the Death/ Koimesis scene. This juxtaposition is found frequently in Byzantine art, where it expresses the words in a sermon by Germanos, spoken by Christ to his mother: "I wish to . . . give back to you . . . the full payment for your affections."[74] In the heavenly *Coronation* scene, Mary is returned to the same youthful beauty as in the nearby *Nativity* scene (fig. 71).[75]

A cluster of cycles around the turn of the century focused on the same theme of the Virgin's physical survival after death. The didactic purpose was to assure the worshiper, through demonstration in Mary as the representative of all humanity, of the resurrection of the body at the time of the Second Coming. Two cycles by Taddeo di Bartolo exemplify this point. One is in Pisa: the Sardi Campigli Chapel in San Francesco, 1397–98, where the five scenes are arranged in an Aerial Boustrophedon, starting on the altar wall and ending on the lower tier of the right wall.[76] The other is in the Palazzo Pubblico of Siena, in the Cappella dei Priori, 1407, which adds a separate scene of the Virgin's Resurrection (fig. 73).[77] Although the arrangement recalls that of the Cappella del Sacro Cingolo in Prato for authentication, additional theological authority is added visually in the first bay with representations of the main teachers of the church, including Saint Jerome and Saint Augustine, who were thought to be among the main promulgators of the dogma of the Assumption.[78] As the title suggests, the Cappella dei Priori was a devotional precinct within the hall of government, where administrators of the Commune were meant to seek divine guidance in their civic work. The same relationship is found in the Palazzo Trinci, in Foligno in the chapel adjacent to the council hall, where Ottaviano Nelli painted an elaborate Life and Death of the Virgin, dated 1424, following a grand Wraparound starting in the groin vault and ending on the lower tier with a mystical scene of Christ and Mary together in heaven.[79] Nowhere is the public function of religious narrative clearer than in these chapels within civic buildings. The theological message of eternal survival and salvation made explicit within the domain of government confirms the definition of the state as the institutional remedy for original sin.

4

Nationalism and the Festival Mode:
The Legend of the True Cross

The theme of the True Cross often served to elucidate the politics of liturgy in promulgating crusades and other wars of faith. With Agnolo Gaddi's Santa Croce cycle as the centerpiece, this chapter examines the theme from its Byzantine manuscript beginnings through Masolino's monumental 1424 version of the story.

FIGURE 74. Giovanni Villani, *Chronicle*, illuminated manuscript, later fourteenth century, *Founding of Santa Croce*

The refounding of Santa Croce in Florence in 1294 was an event so important in the city's history that it received a place in the *Chronicle* of Giovanni Villani (fig. 74). When the friary church had to be rebuilt after a serious fire, a new foundation stone was inscribed as follows: "Dì di S. Croce, 3 Maggio."[1] This date refers to the Invention of the Cross, one of two annual feast days celebrating the relic of Christ's crucifixion, the other being the Exaltation of the Cross held on 14 September. When the chancel was finally decorated with frescoes by Agnolo Gaddi nearly a century later (1388–92; figs. 75, 76), the subject of the cycle honored these feasts and the dedication of the church with a monumental cycle of the Legend of the True Cross on the two single-bay walls that face each other on either side of the chancel.[2] The patrons of this grand enterprise were members of the Alberti family, prominent participants in the political life of Florence.[3] As the benefactors, they doubtless played a role in approving the subject of the cycle, but it was the friars of Santa Croce who made the choice. The theme of the Cross, parallel to the dedication of the church, brings the expression of Franciscan ideology in the transept to a fitting climax.[4] Of profound historical importance in the greatest of the Tuscan Franciscan buildings, Gaddi's cycle became a point of authority for a coherent tradition of representations of the story that continued until well into the sixteenth century. Because of its pivotal place in the history of the theme that was one of the starting points of this study, I shall slow the pace of the survey to analyze this cycle in greater depth than usual. Moreover, this chapter will include accounts of further visual manifestations of True Cross subject matter through the first quarter of the fifteenth century. Later examples will be discussed in chapter 6 when we arrive chronologically at Piero della Francesca's version of the legend in his cycle in Arezzo.

Because the Story of the True Cross is complex and is unfamiliar to twentieth-century viewers, it may be useful to sketch some of its details. Based partly on fact and partly on apocryphal tales that developed separately in the early Middle Ages, the legend follows the wood of the cross from the time of Adam to the seventh century A.D.[5] It begins when a branch or some seeds from the tree of knowledge are planted over the body of Adam, and it continues with Solomon's attempt to use planks

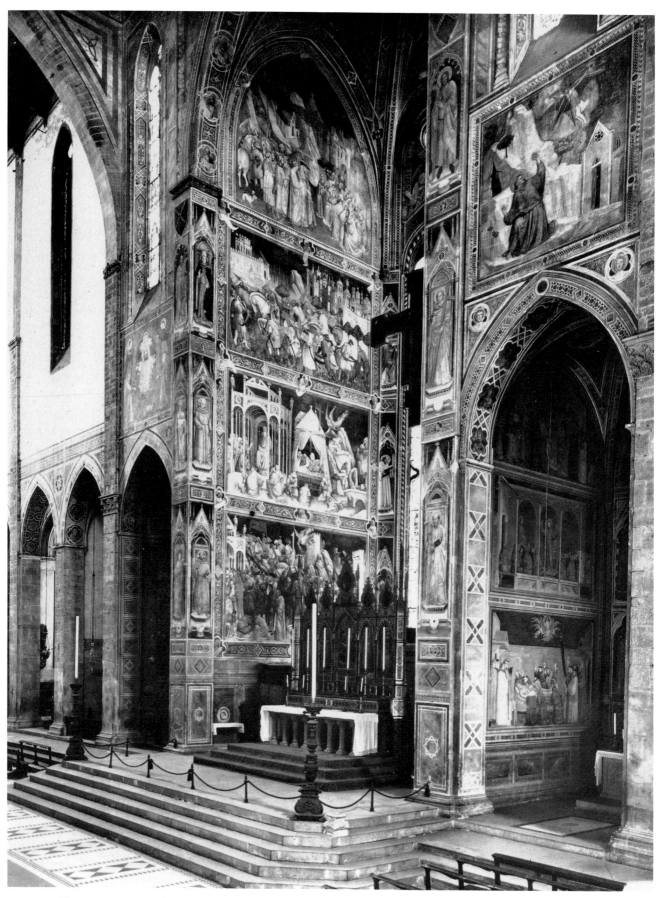

FIGURE 75. Florence, Santa Croce, chancel, Agnolo Gaddi,
Story of the True Cross, left wall view

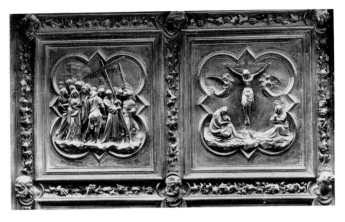
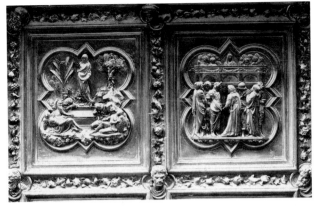

FIGURE 98 (*facing page*). Florence, Baptistry, Ghiberti, north doors, general view

FIGURE 99. Florence, Baptistry, Ghiberti, north doors, upper tier

His format had to be precisely the same as that used by Andrea Pisano more than seventy years earlier—twenty-eight plaques set in quatrefoil moldings in seven tiers of two on each of two valves. Thus, it was the way he used this formula to tell his stories with classical forms and motifs that constituted the newness of his style. Not only did he model the figures after antique statuary, but he constructed the architectural settings with elegant classical details on the principles of mathematical perspective, diminishing or projecting according to newly developed rational schemes.[2] But antique references were only part of his innovation. The other part lay in the conceptual planning (fig. 98).

Ghiberti's commission was for a Life of Christ. Five upper tiers again held the narrative cycle; the two lowest tiers have nonnarrative figures, in this case the four evangelists and the four fathers of the Western church.[3] As we recall, Pisano had arranged his scenes in two separate "bays" from the top down on each valve.[4] Ghiberti changed all that. He started his narrative at the bottom and moved to the top, and he made the episodes proceed from left to right all the way across both valves on continuous tiers. Although his sculptured forms resonate with classicizing naturalism, his disposition pays homage to a medieval past. His scheme echoes most closely that of the twelfth-century doors of Bonanno Pisano on the Duomo of Pisa where, as we have seen, the monoscenic reliefs read across both valves, four to a tier, and proceed from the bottom to the top.[5]

As a story, the cycle has it idiosyncrasies. It is compressed in certain aspects: there is no *Presentation, Flight into Egypt, Deposition, Entombment,* or *Descent into Limbo.* It is expanded in others, with the inclusion of the fairly rare *Expulsion of the Money Changers* and a scene of *Christ Calming the Storm on the Sea of Tiberias.* In the choice of the last two episodes, it could be said that the *Expulsion* scene is again an admonition to bankers, this time Florentine, in the manner of the Arena Chapel, while the *Storm* is a political pledge of allegiance (in the manner of Giotto's *Navicella*) by the Guelph party as well as by religious leaders to the newly reinstalled authority of the Roman papacy in the face of consular pressures.[6] The doors were being worked on throughout the time of the Council of Constance (1414–18). When the antipope John XXIII visited Florence, he won the favor of the city in the face of controversies with the cardinals—so much so that when he died he was, quite extraordinarily, given burial in the very building on which the relief appears.[7]

The inscenation of scenes on the doors shows a new self-consciousness

in planning. The first three episodes on each tier thrust compositionally from left to right, and the last episode stops the motion. Each of the scenes in the right-hand vertical column either has a centralized organization or actually thrusts back toward the left (as in the *Storm* scene). In harmony with the technique used for the mosaics inside the Baptistry,[8] here too a strong braking mechanism has been employed on every level, holding the scenes at the edge of the door. On the uppermost tier (fig. 99) the rhythm takes on a new legato pace. All four episodes are centralized images, effectively bringing the narrative to a ritualistic halt. Even the *Way to Calvary*, which logically moves to the right, is composed of backwardbending linear rhythms that stop the flow. Again there is a reference to the Bonanno doors. There Christ and the Virgin rise above the narrative and sit in glory at the highest point of each valve. Ghiberti's top-level reliefs achieve a similar iconic power, yet they remain within the realm of

FIGURE 100. Urbino, Oratorio di San Giovanni Battista, Salimbeni brothers, general view

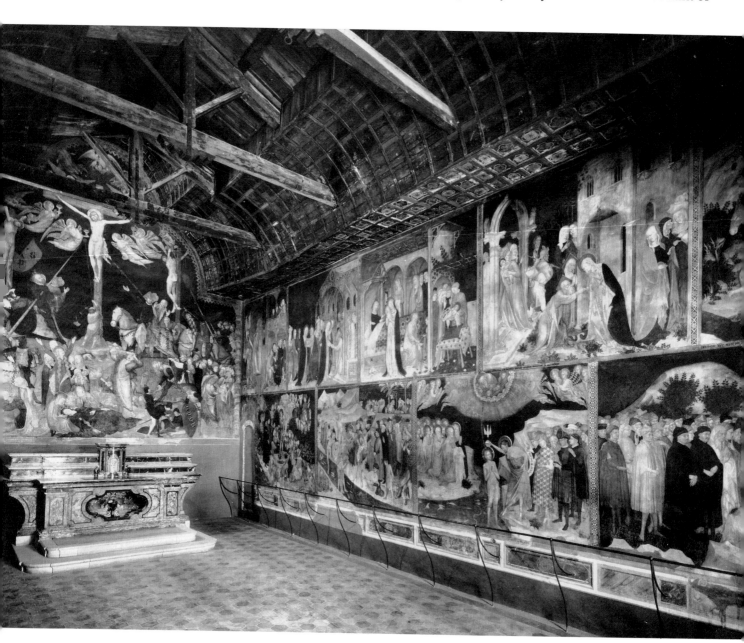

narrative continuity. By combining the traditional format and organizational principles of his medieval sources with the formal contributions of his own classically idealized style, Ghiberti set a new tone for religious art that became a model in the decades that followed.

The combination of narrative and icon is less unified but even more specific in a cycle of frescoes by the brothers Jacopo and Lorenzo Salimbeni in the Oratorio di San Giovanni Battista, Urbino; the paintings are signed and dated 1416. The subject is the Life of the Baptist as recounted in the apocryphal *Vita*, which by this period had become a major source for artists.[9] Never before, however, had so many episodes and so many details of this story been given visual form. The disposition is unique (fig. 100): it is a combination of the Double Parallel and Wraparound patterns. The arrangement starts in the now familiar position on the top tier, right wall, at the altar end.[10] It progresses horizontally along the right wall on the upper tier, then returns to the apse end and again moves left to right along the lower tier. The story must have continued on the inside facade, though no paintings are now visible; the scenes of John's Arrest and Decollation were probably on the lower tier. The movement then wraps around to the left wall, where elements of *Herod's Banquet* and the *Burial of John* remain and move from left to right.

At first glance the cycle seems to be purely illustrative, even anecdotal in its approach to storytelling. It teems with details of daily life, essays in human anatomy, and awkward but strangely moving psychological interactions. The pictorial fields are irregular in size and do not line up between tiers. These shifting, almost fluid dimensions seem to add to the picturesque, episodic character of the narrative. But at the same time one finds aspects of both inscenation and disposition that create unexpected effects of mysticism and personal devotion.

Scenes on the upper tier of the right wall emphasize the Virgin's role in John's early life and establish his preternatural origins. The opening chapter comes to a close at the right end of the wall with one of the first representations of the *Meeting of John and Jesus in the Desert* (fig. 101), a scene that was to play a major role in proximate developments of the iconography of the Infant Saint John.[11] This scene brings the chapter to an end rhythmically as well, for it reverses the narrative thrust of right to left.

Returning to the altar end on the second tier, John's public life is given four scenes, again of varying size. The figures are portrayed in exotic costumes and extravagant poses, and there are several truly audacious representations of male nudes (in the *Baptism of the Neophytes*). Compared with the swiftly moving left-to-right scenes on the top range, the four compositions on the lower tier, though still proliferating detail, tend to be more unified and static. Indeed, the largest and most centralized, the *Baptism of Christ* (fig. 102), has a cast of characters not fully explained by the apocryphal legend. The image can only be described as a vision, filled with heavenly presence, beautiful souls, and hortatory inscriptions.[12] This otherworldly intrusion is complemented on the right wall, where, without a change of medium, there appear three large-scale framed votive paintings juxtaposed to the final narrative scenes. The first, representing *Saint John and Beato Pietro Spagnuoli da Urbino* (a local patron), focuses on the oratorian devotion. The next frame, by Lorenzo Salimbeni, known

FIGURE 101. Urbino, Oratorio di San Giovanni Battista, Salimbeni brothers, *Meeting of John and Jesus in the Desert*

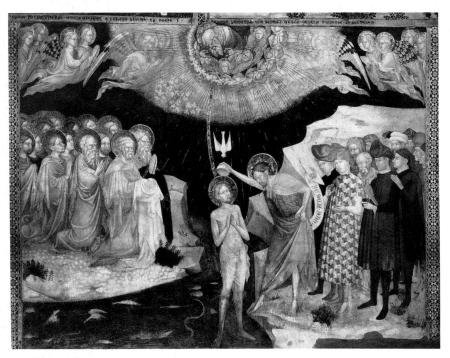

as the *Madonna del Paradiso*, is a Madonna of Humility seated on the
ground with a sleeping child in her lap (fig. 103);[13] she is accompanied by
Saint John and Saint James the Greater. The third shows the *Madonna
and Child Enthroned*, this time with Saint Sebastian at a column and once
more Saint John the Baptist. Together the three icons make a sequence in
devotional mode, first to the patron intercessors, then to the Virgin in her
most human form, speaking directly from earth to the worshiper as a
member of humanity, and finally to Mary as queen of heaven, in the next
world, responding to the oratorian prayers to a higher authority.

On the adjacent altar wall a great *Crucifixion*, filled with narrative details, is also highly symbolic. In the true climax of Saint John's mission as
nexus between Christ and man, human emotion is the point of this image, with the Madonna lying flat upon the ground in her sorrow and the
cross of the bad thief, attacked by devils, turned backward to the picture
plane. As a result of the narrative disposition, this cycle is a matrix for
extended exposition, transformed before our eyes into a sustained drama
of Christian mysteries, finally becoming at the end a paradigm of procedures for the expression of Christian faith.

A few years later, Lorenzo Monaco completed this idea by actually incorporating the devotional image in an altarpiece into the narrative cycle
that surrounds it. He took his step in the Bartolini Chapel in Santa Trinita, Florence (fig. 104), completed in 1420–25.[14] The subject of the cycle
is the Life and Death of the Virgin, to which is added her miraculous appearance in Rome at the founding of Santa Maria Maggiore. The narrative starts on the upper tier of the left wall with the two scenes of *Joachim's Expulsion* and *Dream in the Desert* in continuous mode. The
Meeting at the Golden Gate (fig. 105) fills the lower tier (diag. 27). The
significance of this meeting as the moment of Saint Anne's miraculous
conceiving is expressed in the form of a *pro nuba* angel who flies above
the couple and touches their heads. The next scene turns the corner on

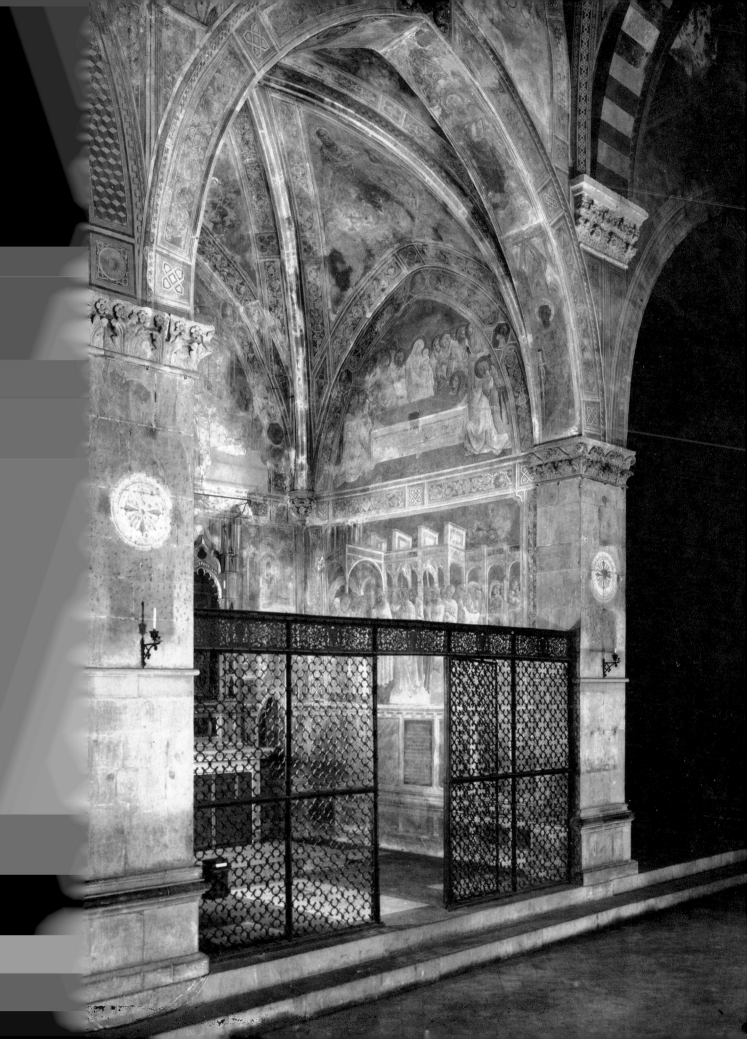

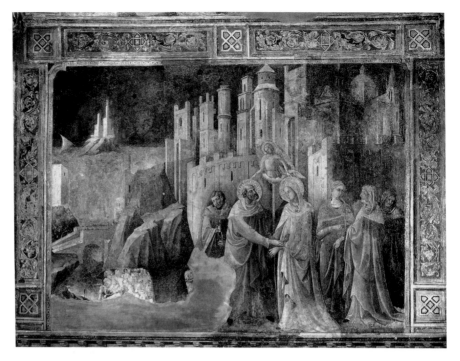

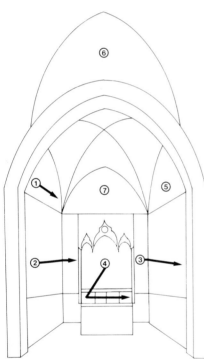

the same (lower) level to the left side of the altar wall; it represents the *Birth of the Virgin*. The *Presentation* is on the right side of the same wall. The sequence then moves to the right wall, where the *Marriage of the Virgin* occupies the whole lower field. Two scenes of marriage thus face each other across the space of the chapel in thematic harmony.[15]

It is the next step in the narrative sequence that gives the Bartolini Chapel its place in history: the sequence is taken up by the image on the painted panel of the altarpiece (fig. 106), framed in wood but set into the wall. The panel, also by Lorenzo Monaco, represents the *Annunciation*, a scene that had already played an important role in the emergence of narrative subjects in devotional images.[16] The organic role of the altarpiece in the narrative progression is continued in the rigorous regularity with which the story continues in the predella panels below, moving left to right.[17] As if to integrate the altarpiece further into the fresco cycle, Monaco painted an *inquadratura* in fresco surrounding and interlocking with the panel's gold carpentry frame.[18]

Following the episodes on the predella, the Death chapter begins: the *Koimesis* scene is on the upper tier of the right wall. Thus while the overall scheme has something of the character of an Aerial Boustrophedon, the walls follow the Up-Down, Down-Up pattern established in the Life of the Virgin in the Arena Chapel apse. The *Assumption* appears in the by now usual upper tier, but placed on the exterior of the chapel's entrance arch.[19] And the final scene of the *Miracle of the Snow*, referring again to the source of Marian worship in Rome,[20] receives the place of honor on the upper tier above the altar.[21]

Almost as soon as Ghiberti had finished his first set of bronze doors for the Florentine Baptistry, he was commissioned to prepare a second set, this time with scenes from the Old Testament, completing the standard typology for church decoration.[22] A written program of subjects was composed by the humanist Leonardo Bruni, one of the earliest docu-

ments of its kind, but not followed exactly in the final execution.[23] In the end this cycle displaced the doors with the Life of Christ, which were moved to the north side of the building. Facing the entrance to the Duomo, the new doors became known as the "Gates of Paradise," as much for their beauty as for their position on the eastern facade (fig. 107).

One of Ghiberti's first steps in this commission was to create a new format. He eliminated the almost-square plaques with their restrictive quatrefoil molded frames, and with them the staccato stability of the monoscenic mode. He banished the array of nonnarrative figures in the lower tiers and freed the whole area of both valves for narrative episodes.[24] The portal as a whole was divided into ten large horizontal rectangles arranged in five stacked and framed panels on each valve. With these changes, the artist embarked on an entirely new realm of inscenation that might be described as an experimental version of the continuous mode.[25] Exploiting the narrative continuity of this time-honored mode, he created complete chapters within each plaque. He drew out the spatial

FIGURE 106. Florence, Santa Trinita, Bartolini Chapel, Lorenzo Monaco, altar wall

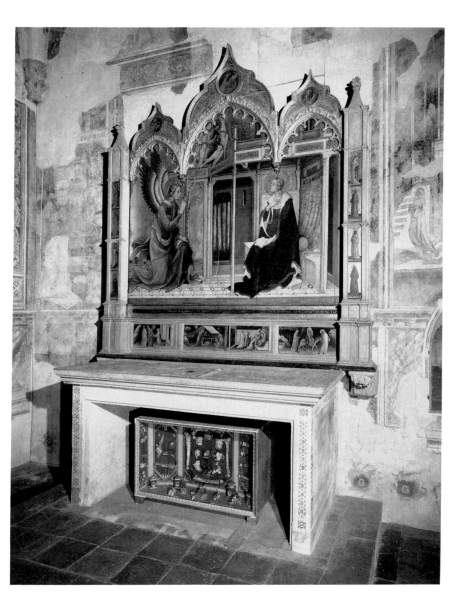

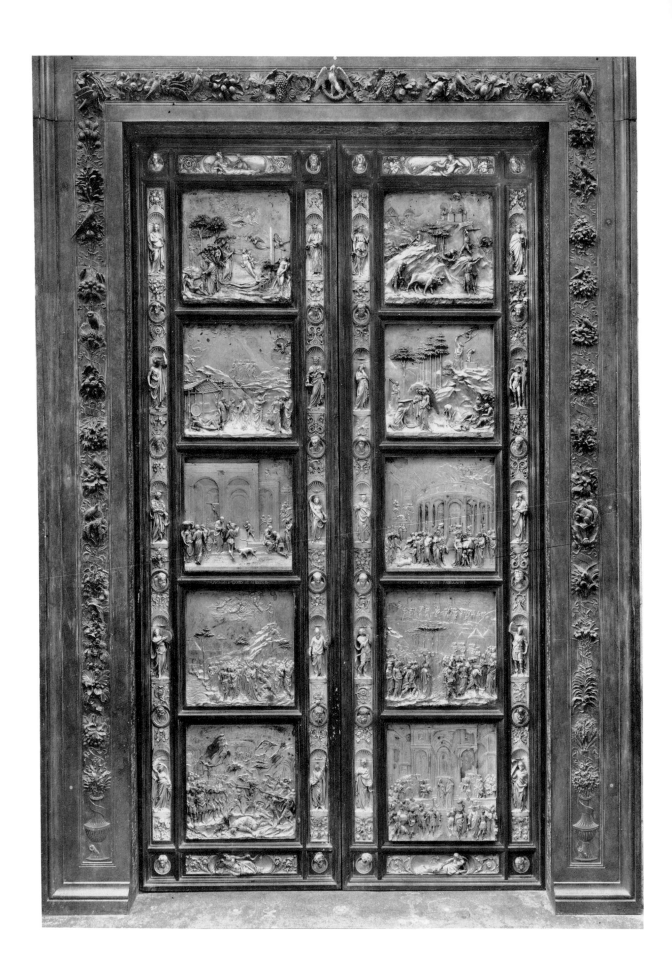

FIGURE 107. Florence, Baptistry, Ghiberti, east doors

implications of the many small episode spaces, or *effetti*, by rationalizing them separately in an "open" ambient. He then brought them together in the unity of a general compositional thrust. Seen together on the doors, the individual plaques made an overall pattern that unites the two valves in a single pictorial and iconographic harmony. Thus again Ghiberti used a traditional form, in this case the continuous mode, to achieve something new.[26]

Dedicated to the Old Testament, the cycle runs from the *Creation of Adam and Eve* (Genesis) through the *Meeting of Solomon and Sheba* (Kings). The disposition reads chronologically from left to right across both valves, and from the top to the bottom (thus reversing the stacking of the north doors). The two upper tiers form a compositional unit. Their pattern is two matching chevrons. Diagonal thrusts move from upper left to lower right on the left plaque of both tiers, and from upper right to lower left on the right, making two broad superimposed Vs. The next three tiers are a unit of a more complex nature. Thickly populated and increasing in number of episodes as they move down, the two compositions on each tier are matched in another way: on tier three the *Story of Isaac* and the *Story of Joseph* are both architectural; on tier four, the *Story of Moses* and the *Story of Joshua* are both landscapes. Of the two compositions on tier five, the *Story of David and Goliath*, left, a rural setting with townscape background, and the *Meeting of Solomon and Sheba*, right, a completely urban, architectural scene, are both strongly centralized and balanced. The final plaque is unique on the doors in being treated with the monoscenic mode. The subject is also special in having a deep and specific typological meaning of its own: the *Meeting of Solomon and Sheba* refers to the Marriage of Christ and Mary-Ecclesia.[27] I believe this theme provides a key to meaning of the portal and to a program for the building as a whole. Iconographically, the subjects in the top unit—that is, the two top tiers—cover the first twenty-one generations of Christ, from Creation through Abraham the patriarch. They thus form an ideological as well as a compositional unit. The subjects of the second unit (tiers three through five) represent the next group of fourteen generations (Rebecca thorough David). The last scene, the *Meeting of Solomon and Sheba*, starts the third group of forty-two generations that leads directly to the family of Mary.[28] By alluding to the advent of Mary on portals placed opposite the facade of the Duomo, long since dedicated to Santa Maria del Fiore, the doors that give access to baptism truly are the Gates of Paradise.

During the middle years of the 1420s, when the style of painting in the city was in great ferment, an interesting phenomenon took place within the walls of Santa Maria del Carmine in Florence. Two fresco cycles were produced almost simultaneously: one, the Life of Saint Cecilia in the sacristy, summed up a number of trends from the past; the other, the Life of Saint Peter in the Brancacci Chapel in the right transept wing, broke fresh ground. The Brancacci Chapel was painted in the late 1420s by Masolino and Masaccio; the frescoes in the sacristy still have not been attributed or dated with any certainty, although Lorenzo di Bicci and the pseudo-Ambrogio di Baldesi are the main nominees and 1420–30 the proposed dates.[29] The Life of Saint Cecilia is told in twenty episodes of continuous narrative on three tiers of the three-sided sacristy apse

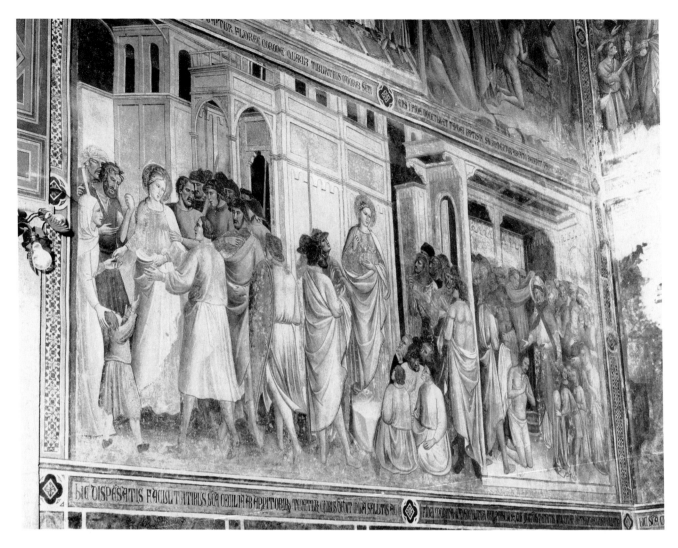

FIGURE 108. Florence, Santa Maria del Carmine, sacristy, view of left wall

FIGURE 109 (*facing page*). Florence, Santa Maria del Carmine, sacristy, view of right wall

(figs. 108, 109). The disposition is what I have called the Apse pattern, running left to right in parallel rows, reading from the top down (diag. 28). The episodes are differentiated by architectural units and landscape settings, which carve out cubicles of shallow space for each moment. The tiers are bound by painted frames that carry long explanatory inscriptions, reinforcing the narratives; some figures are named in labels. There are no new elements in the disposition; rather, familiar elements are rendered with splendid self-confidence and suavity. Figures garbed in high pastel colors, posed with superb poise,[30] present a new equilibrium between straightforward visual exposition, verbal explication, and aesthetic refinement. It is perhaps this unproblematic sense of consummation that has left this cycle somewhat overlooked in recent research.

Just the reverse is true of the Brancacci Chapel (figs. 110, 111). The cycle on the Life of Saint Peter has been studied and analyzed more than almost any other in Florence for over a century. Following Varsari's lead,[31] most scholars in the first three-quarters of the twentieth century focused on distinguishing the work of the youthful Masaccio from that of Masolino, his ostensible master.[32] Only in the 1970s did the theological content of the cycle become an issue of scholarly interest, and important advances were made in recognizing the essentially ideological nature of

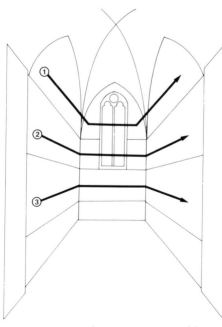

DIAGRAM 28. Florence, Santa Maria del Carmine, sacristy

the antic array of subjects.[33] Owing to the lack of emphasis on problems of disposition, however, this aspect of the chapel has never been given its historical footing.[34] Through all the vicissitudes and changes the chapel has undergone, I believe that the disposition currently visible has enough thematic consistency to suggest that the original scheme, in general terms, might not have been too far from what we now see.

In strictly chronological terms, the sequence begins not with the Peter scenes, but with those from Genesis.[35] The Old Testament scenes are reduced to two and are placed in narrow fields on the second tier at the entrance end of the chapel.[36] The sequence thus begins in the Early Christian manner on the right wall with Masolino's scene of the *Temptation*. It moves to the left, on the second tier, with the *Expulsion* (plate 12), whose compositional thrust is into the space of the chapel. Even with nothing more than these two excerpts, the combination of Old Testament scenes with the life of an apostle recalls the original arrangement of Old Saint Peter's as well as the setting of San Paolo fuori le Mura, both still visible in Rome at this time.[37] In fact, placement of a petrine cycle in the right transept wing is itself reminiscent of a Petrine cycle in the right transept wing is itself reminiscent of Old Saint Peter's where, as we have seen, the Life of Saint Peter was in the transept on the right of the high

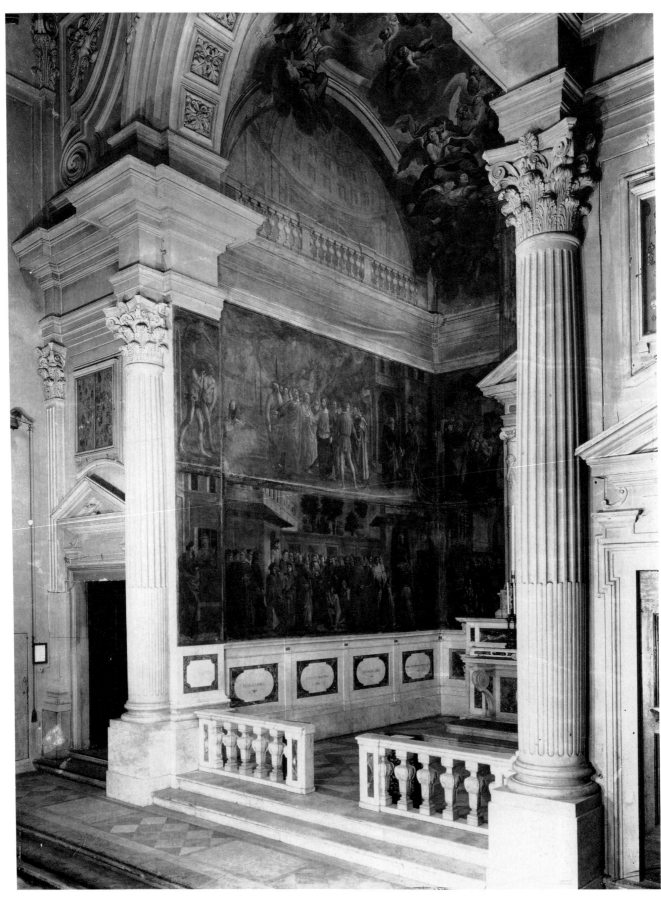

FIGURE 110. Florence, Santa Maria del Carmine,
Brancacci Chapel, Masaccio and Masolino, left wall

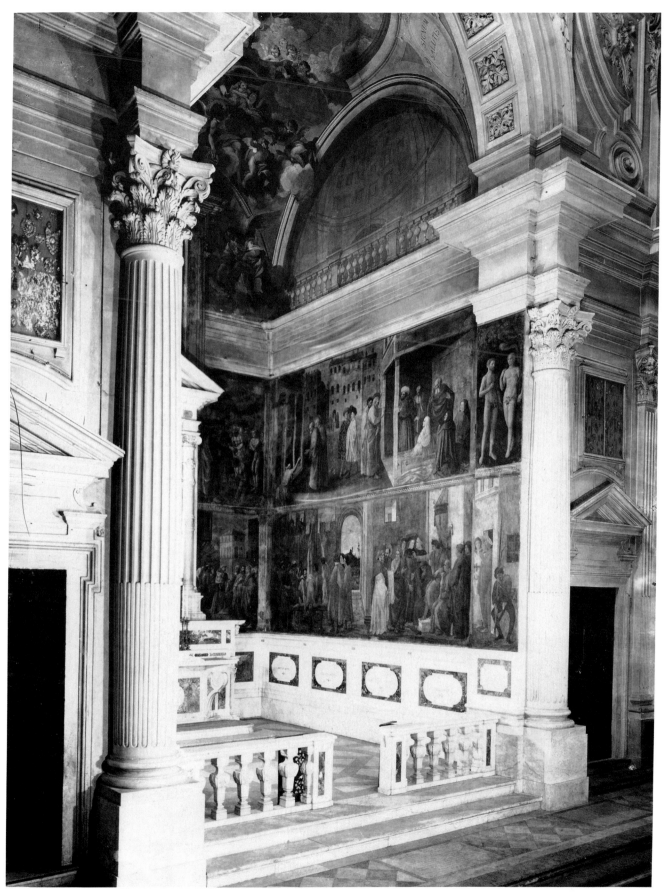

FIGURE 111. Florence, Santa Maria del Carmine,
Brancacci Chapel, Masaccio and Masolino, right wall

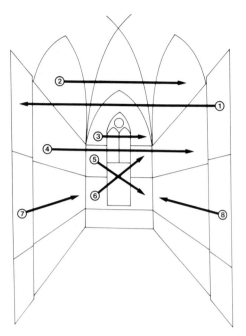

DIAGRAM 29. Florence, Santa Maria del Carmine, Brancacci Chapel

altar.[38] The location seems to have become traditional: the Saint Peter cycle is found, for example, in the right transept wing in the Upper Church of San Francesco at Assisi.[39]

Combining Vasari's description with information provided by the newly discovered *sinopie*, we find that the Life of Saint Peter, which generally moves from the top down, was arranged thematically with scenes that match across the space on every tier (diag. 29). All scenes on the lunette level illustrated the Gospels. Those on the side walls, the *Calling of Peter and Andrew* (Matt. 4:18) on the left and the *Storm at Sea* (Matt. 14:24) on the right, are paired by the theme of Peter the Fisherman.[40] The half-lunettes on the altar wall held images of faith: on the left, Peter's loss of faith in his *Denial of Christ* (Matt. 26:70), and on the right, Christ's faith in Peter in the *Pasce Oves Meas* (John 21:17).[41]

All the scenes on the second tier show Peter's power to work miracles. In the *Tribute Money*, where Peter's first miracle is guided by Christ, the narrative mode is continuous and the pacing is slowed by emphatic division of the story into three separate parts; starting in the center, it moves first to the left and then to the right.[42] The separate episodes are thus comparable to Ghiberti's multiple *effetti* on the east doors, in the designing stage at this date. The focus on monetary concerns in the subject is parallel to the choice of the *Money Changers* on the recently set up north doors, and perhaps was chosen for similar reasons.[43] The corresponding scenes on the second tier of the right wall show Peter performing his first miracles after Christ's death. Again in continuous mode, Peter is shown twice working miracles in two different places, as described in the Acts.[44] The style is less taut and the pace of the narrative quickened, and therefore the composition is given to Masolino. The inscenation, nevertheless, responds to the *Tribute Money* with a similar centralized, unified spatial ambient, the deepest projection in the middle, and porticoed structures articulating the altar-side edge.

All the scenes on the altar wall illustrate the Acts of Peter (fig. 112). When read in the order of the texts, they form a Cat's Cradle: the pattern starts with the scene of *Peter Preaching* (Acts 3:12) on the second tier to the left and descends to the *Death of Ananias* (Acts 5:1) on the bottom tier to the right (another scene focusing on monetary issues). This diagonal is followed by *Peter Healing with His Shadow* (Acts 5:15), on the bottom to the left, and finally *Peter Baptizing the Neophyte* (Acts 10:48) on the second tier to the right. The "order" thus inscribes an X, as we have seen it before. The earlier examples at Assisi and Volterra, however, were on a horizontal plane, following the path of the liturgical inscription. Here the pattern is taken over but is raised to the vertical surface of the altar wall and immured as the visual focus of the chapel. The result is another gain in thematic unity: two scenes of conversion on the upper tier and two scenes of public beneficence below. The scenes further match topographically: both upper scenes are landscapes, equated with the deep vistas on the side walls of this tier, while the lower scenes are structured architecturally. Moreover, the spatial projections of all four scenes are unified; they all thrust into the center of the wall as a whole, with the perspective of the architectural scenes ending in a joint vanishing point at the center of the field originally below the window (of which I will speak in a moment).

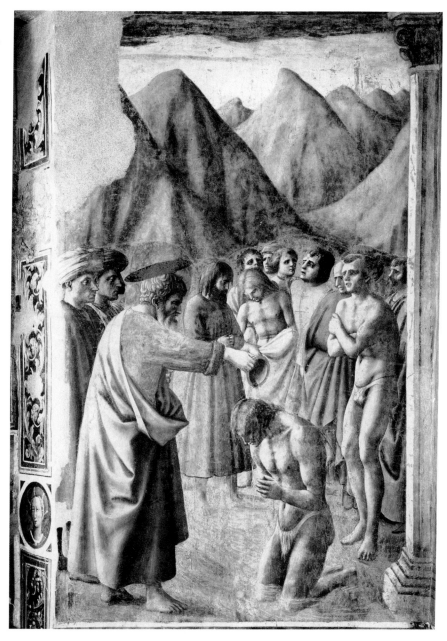

Another system of disposition is used on the lowest tier of the side walls, where there is again a unity of composition. The settings on both sides are continuous narratives, each with multiple episodes that move essentially in Parallels from entrance to altar wall. Both sides are urban views with shallow foregrounds where the action takes place. These narrow spaces recede to screenlike architectural backdrops, pierced at one interval toward the center. None of the scenes on this tier come from the Bible; their sources are all apocryphal, but from apocrypha of the most authoritative sort. In fact, the lowest tiers are in what I have called the Festival Mode: all the episodes represented are celebrated on feast days of Saint Peter. The tier on the left presents *Peter Freed from Jail through Paul's Persuasion*, *Peter Raising the Son of Theophilos*, and *Peter Made Bishop*. These events all took place in Antioch, and they are all celebrated on 22 February, the feast of the Chairing of Saint Peter. The scenes on the

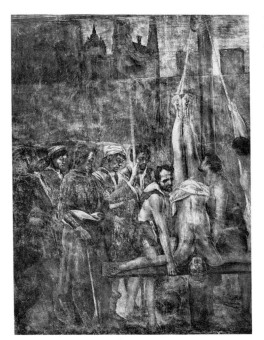

FIGURE 113. Florence, Santa Maria del Carmine, Brancacci Chapel, Filippino Lippi, *Crucifixion of Saint Peter*

lowest tier of the right wall take place in Jerusalem and in Rome, the New Jerusalem. They refer to the other two feasts of Saint Peter, that of 1 August, the Liberation of Peter, represented at the right end of the wall, and the feast of 29 June, the Martyrdom of Peter in Rome (fig. 113).[45] The current disposition of the lower tiers thus follows the innovation of Agnolo Gaddi in Santa Croce, where the festival scenes are arranged to move from the nave toward the altar of the sanctuary to emphasize their liturgical import. This effect was originally even stronger, when the disposition found its focus in the *Crucifixion of Peter* placed in the position of prominence in the center of the altar wall, below the window. Situated behind the altar, there was no mistaking its liturgical meaning, and the martyrdom of Peter was physically identified with the sacrifice of Christ at the climax of the mass.

The organization of the Brancacci Chapel was thus highly experimental: like the ancient prototypes in Rome, it rearranges biblical order for the purpose of ideological expression. At the same time, in the manner of medieval typology, it plays one side wall off against the other. But unlike the early models, it matches themes within a single life and thereby establishes its own authority. In spite of the chapel's complex physical history and the three artists who worked at different times, the conceptual planning of the narrative disposition shows the same surge of creative energy and risk taking that have long been associated with the paintings in the realm of style.

The experimental quality of the Brancacci Chapel was immediately carried forward by the same artists in Rome. In 1427 Masolino and Masaccio began the Chapel of Saints Catherine and Ambrose in San Clemente, commissioned by the wealthy and influential Cardinal Branda Castiglione.[46] The chapel is a broad, groin-vaulted single bay with lunette-shaped walls, on the left side of the entrance end of the basilica (fig. 114). The iconographic scheme begins on the entrance arch exterior,

FIGURE 114. Rome, San Clemente, Branda Chapel, Masolino (and Masaccio), general view

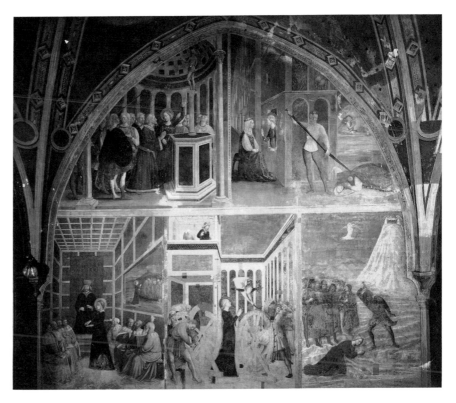

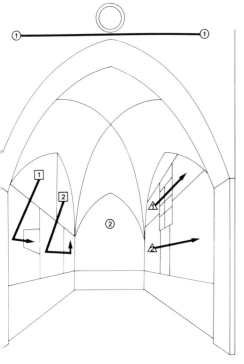

DIAGRAM 30. Rome, San Clemente, Branda Chapel

where the *Annunciation* is depicted.[47] Although the scene takes the traditional split form, with Gabriel in the left spandrel and Mary in the right, the surface of the arch is treated in an unprecedented way. The whole area is rendered as a single portico with thin, classicizing colonnettes, semicircular arches, and an almost transparent coffered ceiling. God the Father appears in a rondel at the apex. The high placement of the portico is emphasized by the perspective, which creates the illusion of a view *di soto in sù*. Through this ethereal structure, one sees the Christological cycle completed by a huge *Crucifixion* on the altar wall within the chapel.[48] A Life of Saint Catherine is on the left wall, matched by a Life of Saint Ambrose on the right. The contrast between the approach to inscenation on the altar wall and in the side-wall cycles in instructive. The *Crucifixion* (usually associated with the hand of Masaccio) is a great unified space, defined by single-point perspective. Although the general composition suggests registers, the crosses and ladders establish orthogonals, and the panoramic view focuses on the central figure of Christ, the highest physical and most lofty theological element. In contrast to their topographically unified and psychologically concentrated drama, the saints' lives seem hyperactive and congested, rather irrational in their spatial malleability. It is only when we look at the scenes in detail that we understand their new and very sophisticated rationale.

The side-wall lunettes are divided into five sections each by thin, barely noticeable frames. Horizontally, the fields are divided into two tiers, the upper with two sections, the lower with three. Both sides generally read from left to right (fig. 115, diag. 30). Within the divisions, patches of space proliferate into secondary regions. Although few of these areas are geometrically shaped, each has its own individual structure.[49] Further episodes are represented in the newly formed spaces. For

FIGURE 116. Rome, San Clemente, Branda Chapel, Masolino (and Masaccio), right wall

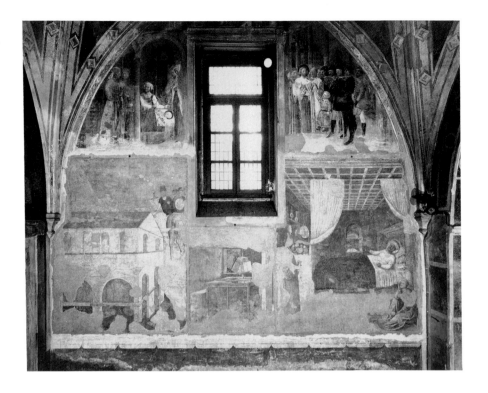

example, the scene of *Saint Catherine with the Philosophers* is shown in a hall with multicolored marble revetted walls and coffered ceiling. The room diminishes consistently toward a single vanishing point. On the right of the hall, we see what purports to be a rectangular window, correctly diminished. But within the space created by this "opening" we see the next scene in the story, *Saint Catherine Giving Solace to the Philosophers* martyred by fire, the same men she had converted with her religious logic in the previous scene. At the altar end of this wall, the spatial units are defined by landscape elements, rocky cliffs carved out to designate different time zones. The narrative progression here becomes a function of the unframed, slightly melting spatial creations that carry the story along.

Although the narrative motion of the right wall continues a general left-right Wraparound begun on the left, in a number of instances the compositions directly across from each other on the two side walls match their opposite numbers (figs. 115, 116). For example, opposite the covered room of *Catherine's Debate,* the scene of the *Death of Saint Ambrose,* placed on the lower tier of the right wall at the entrance end, is set in a similar room. The exterior settings and distant views at the altar end also match on the top tiers of both sides. Thus, in spite of its somewhat fluid surface quality, harmonious pairing of inscenation gives the chapel a strong underlying cohesiveness.

Left on his own after Masaccio's death, Masolino developed the melting tendency to an even higher degree. His next commission was again for Cardinal Branda, at Castiglione Olona, the cardinal's Lombard property north of Milan. Masolino and new members of his shop[50] created lengthy cycles in the Collegiata and the baptistry there between 1432 and 1435, the year shown in an inscription. Particularly in the baptistry, where a detailed cycle of John the Baptist's life was carried out, the spatial

illusionism is almost exaggeratedly fluid.[51] Pouring across the surfaces and around corners, the seamless narrative covers all the available wall surface above the dado, including the ceiling over the altar wall (fig. 117). On the second tier of this wall the frontally composed *Baptism* rises up and spreads without interruption onto the ceiling where the figure of God the Father blesses from the celestial realm. The way the painted space negates the actual structure of the walls serves to express the mystical content of the narrative. Masolino here seems to give his experimental tendencies free rein, using the methods of mathematical perspective aggressively to carve undulating surfaces that project from and recede into the walls. The narrative itself moves in a fairly regular Wraparound sequence, starting to the left of the entrance and progressing to the right around the centralized building.[52] But the individual scenes, including one all but unique apocryphal episode,[53] flow from one to the next, spilling across walls, supports, and window embrasures. The closest parallel for such a fluid conception would be the frescoes of Matteo Giovannetti in the papal palace at Avignon of nearly a hundred years earlier, where the narrative also passed across architectural barriers without interruption.

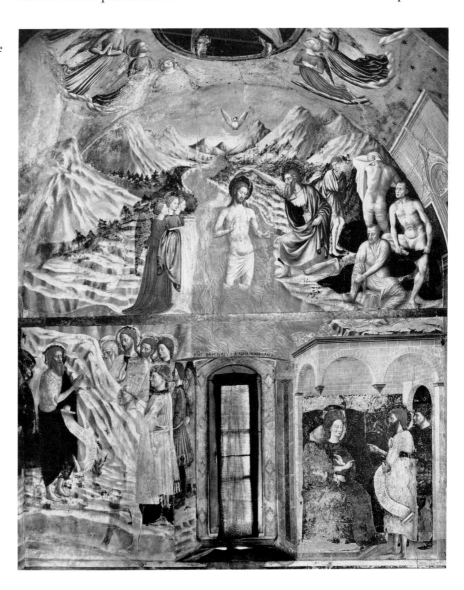

FIGURE 117. Castiglione Olona, Baptistry altar wall, Masolino, *Baptism of Christ* (see plate 14)

Interestingly enough, Branda himself had close political ties with Avignon and vigorously expressed his desire to emulate that papal grandeur in his private provincial retreat.[54] Some of the progressive aspects of this apocryphal narrative style were soon to be taken up by Fra Filippo Lippi.

Vasari lets us speculate on the disposition of the Life of the Virgin in the chancel of the hospital church of Sant'Egidio (Santa Maria Nuova, Florence, destroyed in 1594), where three young men of the new generation worked side by side. Domenico Veneziano, Andrea del Castagno, and Piero della Francesca are documented as the team in 1439; Alessio Baldovinetti was engaged some years later to complete unfinished scenes. The arrangement seems to have been a Straight-Line Vertical in three tiers, reading from the top to the bottom on both sides.[55] From the documents, the six subjects seem to have been painted in literary order; that is, Veneziano was paid for the *Meeting at the Golden Gate*, then the *Birth of the Virgin*, and then the *Marriage of the Virgin*, which he left unfinished in 1445. Afterward Castagno painted the *Annunciation*, the *Presentation*, and finally the *Death of the Virgin*.[56]

FIGURE 118. Florence, Santa Maria Novella, Chiostro Verde, Uccello, first bay, *sinopia*

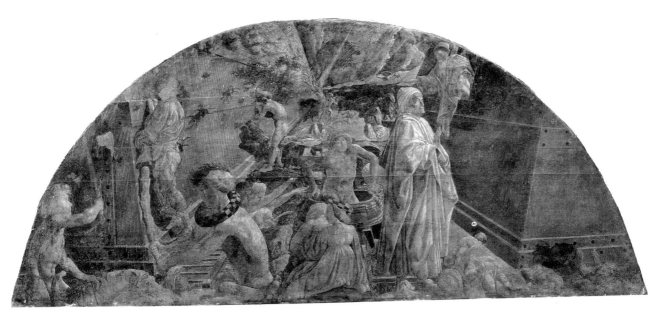

FIGURE 119. Florence, Santa Maria Novella, Chiostro Verde, Uccello, *Deluge*

We can judge the importance the cycle must have held for our subject from the nearly contemporary contributions by the same artists in other monuments. Paolo Uccello, for example, painted a number of scenes in the "Chiostro Verde" at the Dominican monastery of Santa Maria Novella in these same years. The design of the cycle was probably set in the 1420s, when work on the cloister was started presumably under Dello Delli, who is responsible for most scenes.[57] The cloister, which parallels the left aisle of the church, can be approached from the church as well as from the public courtyard, entered from the main piazza. The area in turn gives access to the chapter house on its east side.[58] The other three sides, all six bays in length, are painted with scenes from Genesis. Each bay is divided into two tiers, the upper one in the curve of the lunette. There are two, sometimes three or four, scenes in continuous mode on each tier. The reading order within the bays, quite consistently, is from left to right on the top tier and then left to right on the bottom. The general disposition, beginning to the left of the door from the church aisle, is left to right clockwise around the cloister.[59]

The Genesis cycle is divided into clear chapters, one on each wall. The south wall contains episodes from Creation through the generations of Noah (Genesis 1–11). The west wall contains scenes of the generations of Abraham (Genesis 12–25). The north wall contains episodes from the generations of Isaac (Genesis 25–35). The cloister thus is specifically dedicated to the first three patriarchal periods and the theme of the establishment of inheritance and property lines.[60]

Within the first chapter, Uccello painted two separate bays. About April 1430 he did the first bay: on the upper tier, the *Creation of the Animals* and the *Creation of Adam*; on the lower tier, the *Creation of Eve*, and the *Fall* (fig. 118).[61] Two decades later he continued to paint in the fifth bay. Here, however, he molded the rather old-fashioned organization into a modern idiom. The famous scenes of the *Story of Noah* should be understood first in the context of the cycle. Some writers have puzzled over finding more than one figure of Noah in this space and have further wondered at seeing two versions of the ark. There is nothing untoward

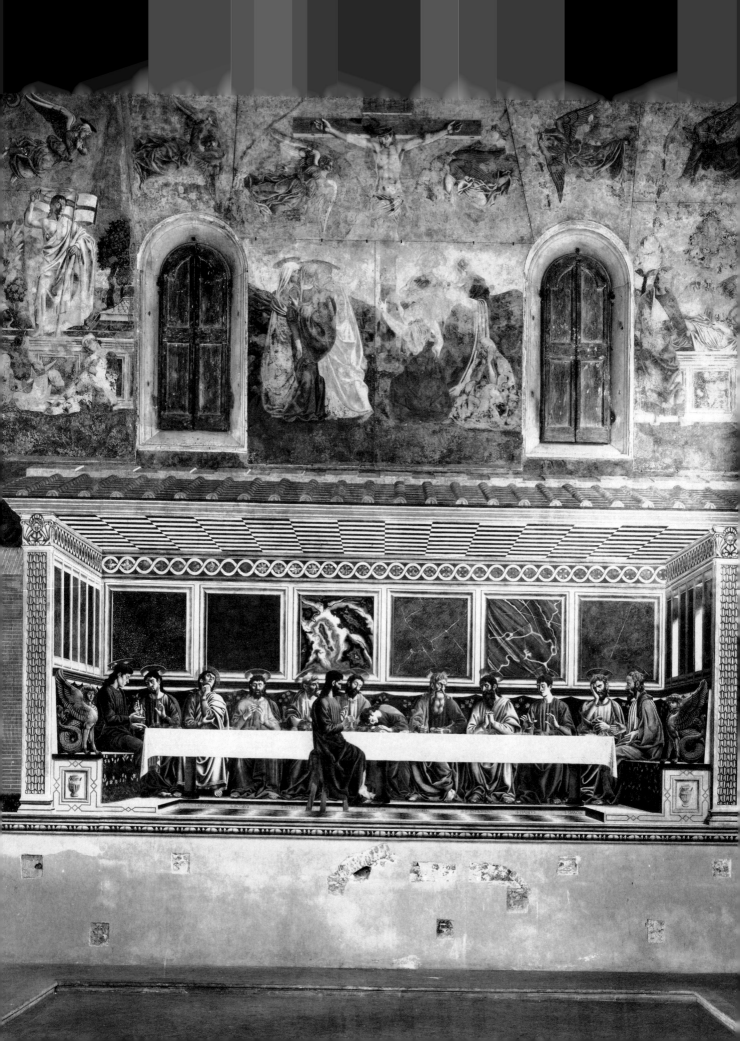

FIGURE 120 (*facing page*). Florence, Sant-'Apollonia, refectory, Castagno, end wall, general view

FIGURE 121. Florence, Sant'Apollonia, refectory, Castagno, landscape detail

about these features, remembering the norms of the continuous narrative mode in use here. The two episodes on the top tier are the *Deluge* itself and the *Recession of the Waters*, or *Noah's Conversation with the Lord* (fig. 119). What is out of the ordinary is the spatial construction that unifies the two moments into one visual experience.[62] The artist has used the newly invented technique of perspective not to create a semblance of reality, but rather to exaggerate the already mythological proportion of the occurrences represented. To underscore this idea, he has tilted the perspective, raising the vanishing point almost to the top of the lunette, thereby charging the painted space with the power of an explosion. In the perspective on the lower tier, the line of sight is geared to more normal eye level. In effect, the perspective constructions recognize the difference in the heights of the two zones. The calmer perspective is also appropriate to the devotional scene of the *Sacrifice* on the left and the tragic *Drunkenness* scene on the right. Where Uccello's experimental personality still bursts through is in the figure of God in the sacrifice scene, blessing from on high with his head projecting into (not out of) the painted space.

Andrea del Castagno's commission to decorate the refectory of the monastery at Sant'Apollonia in Florence cannot rank as a full-scale narrative cycle. Yet in representing four scenes of Christ's Passion and hence the cycle of his death in abbreviated form, it too shows the inventive force of this generation (fig. 120).[63] Covering the narrow wall at one end

of the room, the disposition is again on two tiers, though not divided by any sort of arbitrary molding or cornice.[64] The chronology starts at the bottom with the scene of the *Last Supper* focused on an off-center figure of Christ seated behind the table.[65] Outside the oblique antis walls that close off the room at either side are small patches of grassy lawn, green and well tended. These fertile areas are defined at the back by a high, neatly constructed wall, parallel to the picture plane, made of carefully laid brick. This unusual feature may remind us of other garden walls,[66] over which we are often given a glimpse of paradisical beauty. Here, however, we are shown nothing but horrible black rocks and crags, a devastated landscape, charred and ugly like a volcanic crater (fig. 121). With the wretched real world thus kept out, Castagno has turned the pictorial convention around and placed paradise inside the walls with the holy figures.

The chronology now moves to the upper tier, where the final three scenes are represented in continuous mode. The landscape that passes behind the episodes is uninterrupted and spatially consistent. All the geometric elements, the cross, the sarcophagus, and so on, diminish toward a single, central vanishing point.[67] But within this unified space the artist creates a new visual anomaly. The chronology begins in the center with the *Crucifixion*, moving to the *Deposition* on the right and finally to the *Resurrection* on the left. The movement traces a kind of "sign of the cross," or "center, side, side" pattern before the unified landscape that should remind us of Masaccio's *Tribute Money*. The truly astonishing part of the disposition is that as time moves forward in the story, Christ becomes younger and younger: he appears first as a black-bearded adult, then as a fallen youth, and finally as a vigorous boy. The centralized perspective of both tiers signals the identity of Christ's sacrifice above and the Eucharist below, while the diminution of Christ's age makes the Resurrection palpable as a metaphor for rebirth. Here we have an eloquent demonstration, if one is needed, of the use of narrative disposition for the expression of theological content.

During these same years, Fra Angelico was making his contributions to the field of narrative painting. His work at the convent of San Marco in Florence (1440–45) can be seen only as a cycle of sorts.[68] Various episodes from the Life of Christ, painted in fresco, appear in isolation in the separate monastic cells; they are not arranged in narrative order, nor are the scenes purely narrative in character. On the contrary, each scene includes the figure of a Dominican friar, who meditates on the religious event represented. The contemplative mode of these painted witnesses has a strong effect on the narrative. Joined with compositional centralization and narrative simplification, the contemplative figures raise the episodes to a devotional level. The scenes leave the realm of narrative and become models of contemplation. In fact, the separate frescoes are visible evidence for the transformation of narrative units into devotional images that was one of the major accomplishments of the second half of the fifteenth century.[69]

In 1447–50 Fra Angelico, assisted by Benozzo Gozzoli, executed a true cycle for Pope Nicholas V in his Vatican chapel known as the Niccolina.[70] Though it is a tiny chamber, the disposition of the frescoes treats this private sanctuary with the grandeur of a medieval basilica (fig. 122). The

lives of the two protomartyrs are disposed in a double Wraparound, with the life of Saint Stephen above and that of Saint Lawrence below. The chronology starts in the usual place, on the top tier at the apse end of the right wall, and circles the walls to finish on the left at the apse end. Not only do these frescoes recall the protocols of the great historic past of the church in their disposition, but in the ecclesiastical settings of the scenes they apparently also reflect the grandiose plans Nicholas V had for rebuilding Saint Peter's.[71] Continuing ideas suggested by Lorenzo Ghiberti, Fra Angelico depicts many rationally constructed ambients within a single pictorial field, each providing an autonomous spatial unit. Each unit contains the finite moment of an episode. For example, in the opening scene of the Life of Saint Stephen, the lunette on the right wall shows a heavily vaulted church. On the left side, it recedes to the upper left, and in the interior we see the ordination of the saint (as deacon) at the hands of Saint Peter. To the right, on the steps of the same building but outside the portal, the saint distributes alms to the poor. Dividing the two scenes

FIGURE 123. Montefalco, San Francesco, chancel, general view

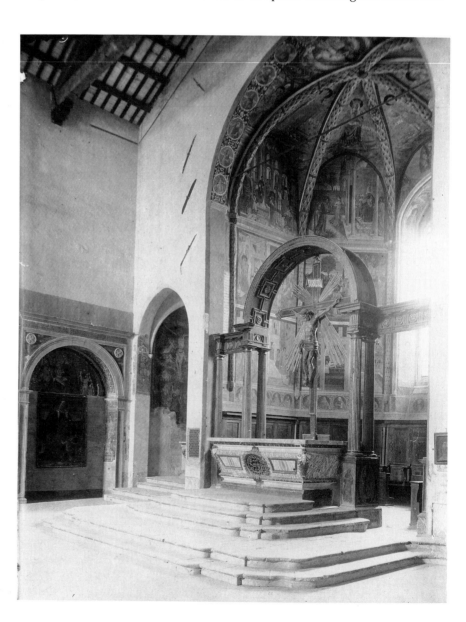

is the wall of the church, drawn up to the picture plane, ending *in antis* and effectively making a vertical frame for both scenes. Only the tiers on the entrance wall are divided by an arbitrarily constructed cornice. In every other instance the episodes are separated by the members of the painted architecture. Although painted in fantastic colors of pink-gray, blue, and gold, the broadly proportioned architecture is constructed to perform this task.

This ultramodern version of continuous narrative had a lasting effect on Fra Angelico's students and colleagues.[72] Benozzo Gozzoli, in particular, elaborated the approach almost immediately in a cycle he did for the church of San Francesco in Montefalco (Umbria), where by 1452 he had signed and dated a Life of Saint Francis that covers the walls of the polygonal apse (figs. 123, 124, 125).[73] Not only did Gozzoli carry forward the inscenation techniques of his master, he also modernized a traditional pattern of disposition to make social and historical statements about the Franciscan order. He began by placing an array of small portrait busts of historical characters around the base of the narrative scenes and across the entrance arch of the chapel. The busts are in rondels framed by rinceaux alluding to the Franciscan text of the *Arbor vitae* by Ubertino da Casale.[74] The roster of named personalities moves chronologically upward from thirteenth- and fourteenth-century temporal rulers, religious leaders, and early churchmen around the dado, the sainted heroes of Franciscanism above. As we shall see, this focus on historicity reflects similar themes embedded in the narrative.

The disposition of the cycle is essentially the Apse pattern (diag. 31), that is, concentric horizontal bands moving from left to right across the polygonal apse. In this setting we cannot ignore the reference to the "mother" church; it was in the apse of San Francesco in Assisi, as we have seen, that the association of the Apse pattern with the Franciscan order was established. The difference in Montefalco is that the vertical movement, which in the prototype descends from the top tier, here moves from the bottom to the top. This shift again places in the upper regions of the chapel (the lunettes on the right) those episodes with celestial connotations (the *Stigmatization* and the *Death and Apotheosis of Francis*), near the figure of the saint in glory.

Within the basic pattern, however, chronology is rearranged to create important thematic confrontations. After progressing from left to right for three fields showing scenes from Francis's early life, the bottom tier ends with an event that occurred in Francis's maturity, the *Meeting of Saint Francis and Saint Dominic*.[75] This jump in time pairs an image of the *Birth of Saint Francis* in the first field on the left with the *Meeting* in the last. Neither episode had ever before appeared in monumental art. Both demonstrated the perfection of Saint Francis's saintliness. The former shows Christ (disguised as a pilgrim) confirming Francis's sainthood at his "Christlike" birth.[76] The latter is a scene of Christ of the Last Judgment persuaded that saintly monasticism will repair the world (*proreparatione mundi*). Thomas of Celano claimed, in a separate chapter of his *Second Life of Saint Francis*, that following their embrace Dominic said, "In truth, I say to you, all other religious ought to follow this holy man Francis, so great is the perfection of his sanctity."[77]

The *Miracle at Greccio* is in the first position on the top tier. The

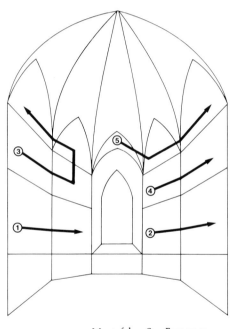

DIAGRAM 31. Montefalco, San Francesco, apse

FIGURE 124. Montefalco, San Francesco, chancel, Benozzo Gozzoli, Life of Saint Francis, left view

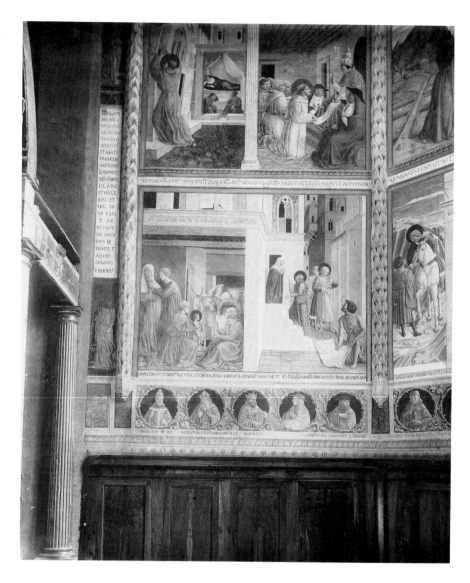

Apotheosis is the last. Both scenes associate Francis directly with Christ, the first when Francis acts out the Nativity and the lay infant miraculously becomes Christ, and the second when the soul of Francis rises to heaven in the manner of Christ's Ascension. On the second tier flanking the window, in positions of great prominence, are scenes that pair civic miracles: *Arezzo Cleansed of Devils* (left), and the *Sermon to the Birds at Bevagna* and the *Consuls of Montefalco Blessed* (right). They all emphasize Francis's political role as peacemaker in affairs of state.

One of the most important results of the disposition is the placement of the *Stigmatization* episode. This miracle is shown in two compartments: the seraph appear in a rocky, otherworldly landscape in the small lunette above the altar, while the kneeling saint is shown in the next facet to the right, raising his eyes to the light-shot seraph across the corner outside the frame. The searing rays enter the scene at a sharp descending angle, crossing the space between the two separate compartments.[78] This arrangement isolates the seraph-clad crucifix as a sacramental image by aligning it vertically with the altar. Moreover, in this position it is trian-

FIGURE 125. Montefalco, San Francesco, chancel, Benozzo Gozzoli, Life of Saint Francis, right view

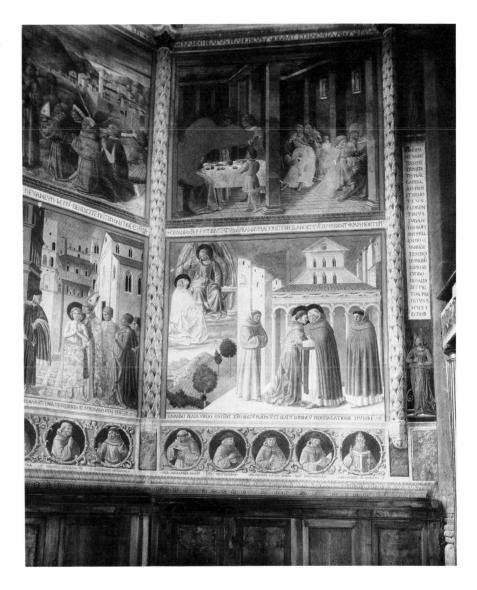

gulated with the other two representations of Christ in the cycle at the beginning and end of the bottom tier[79] and is linked horizontally with the benign, seated figure of Saint Francis, blessing from his place in the upper circles of paradise, at the apex of the ceiling, his head projecting into the space of the chancel.[80]

The internal organization of compositions continues ideas initiated by Fra Angelico in the Niccolina Chapel: well-rendered classicizing architectural members, porticoes, and pedimented facades define separate units of space in which different episodes take place, sometimes as many as three in a field. A further ramification of this idea is the use of relative placement in depth to indicate time sequence. On the second tier, first facet to the left, for example, the *Dream of Innocent III*, in which the pope sees Francis supporting the Lateran, is placed deeper in space—that is, farther away in time—than the *Confirmation of the Rule by Honorius III*, a later pope,[81] which is close to and parallel with the picture plane.

Benozzo's rendition of the architectural narrative components is coloristically less lyrical and ethereal than in the Niccolina Chapel. It is crisper

and more matter-of-fact, and this new pragmatic character communicates information in an efficient and forceful way, much in harmony with the forthright theological points made by the disposition. Benozzo used the same approach on several other occasions where theoretical and dogmatic statements are made in an equally declarative manner.[82] This expository style in many ways set the stage for three other great cycles produced in the decade 1450–60: by Fra Filippo, Piero della Francesca, and Andrea Mantegna, each of which shares essential features with Benozzo's work while adding dramatically to the tradition in its own way.

6

Disposition as a Theopolitical Tool:
Fra Filippo, Mantegna, Piero della Francesca

Three major cycles, contemporary in date—Fra Filippo Lippi's in Prato, Mantegna's in Padua, and Piero della Francesca's in Arezzo—share many elements of symbolic naturalism. Together they characterize the communicative power of patterns of disposition in the mid-fifteenth century. Piero's frescoes, studied at greater length than the others, stand alone in raising cycle painting to the level of epic.

In the decade between 1450 and 1460, the creative forces of Fra Filippo Lippi, Andrea Mantegna, and Piero della Francesca converged in the realm of conceptual planning when almost simultaneously they all took commissions for large-scale fresco cycles. Although the three painters were at different stages in their careers and were working in different towns (Prato, Padua, and Arezzo), they produced narrative cycles that have major features in common. All three are painted on single-bay walls facing each other on opposite sides of the altar. Each wall is divided into three tiers.[1] All three cycles involve some form of balance between scenes in corresponding positions on the opposite walls; all three interrupt strict narrative chronology to produce this balance. In two, Fra Filippo's and Piero's, the rearrangement makes use of boustrophedony. The same two follow medieval protocols by starting chronologically on the right wall. Two others, Fra Filippo's and Mantegna's, parallel the lives of two saints in typological fashion. All three emphasize church festivals of importance in the particular locale. All three rely on the recently introduced architecturally divided time units within continuous landscape, each elaborating its elements of rationality and expressiveness. While it might be fairly said that by the middle of the fifteenth century these features had become the common coin of fresco disposition, in the hands of these particular artists they became the tool for articulating historical, theological, and political ideas with unprecedented clarity. In fact, what is new about these cycles is the use of visual narrative to rise above the story and express what I have called the "ulterior argument." Since all three cycles were being worked on simultaneously, the order of discussion is entirely arbitrary. I have chosen to end with Piero's Arezzo cycle because it was the starting point of this survey, and I shall discuss it at somewhat greater length than the other examples.[2]

Fra Filippo Lippi

The Pieve di Santo Stefano in Prato (after 1653, the Duomo) became a pilgrimage site of outstanding importance when the large chapel housing the relic of the Virgin's girdle was opened.[3] The overflow crowds that convened annually on the feast of the Assumption of the Virgin (15 August),

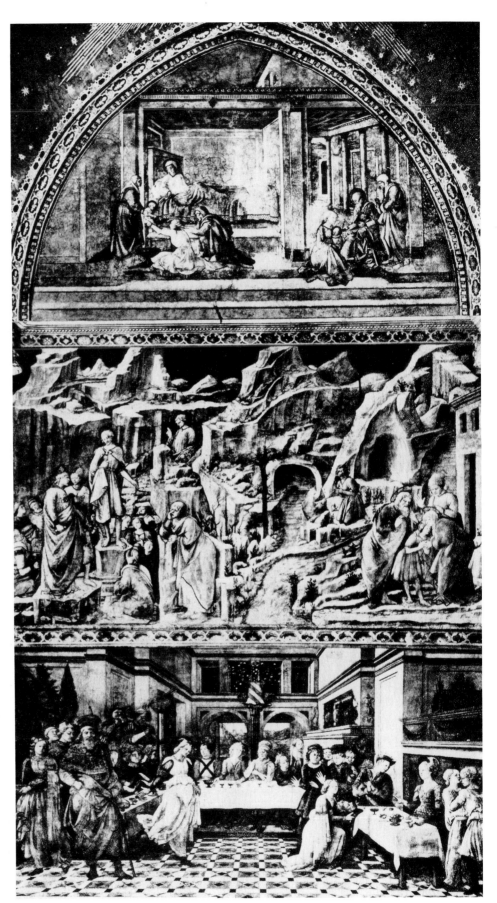

FIGURE 127. Prato, Duomo,
chancel, Fra Filippo Lippi, right wall,
general view

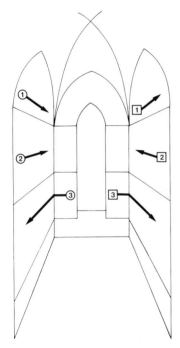

DIAGRAM 32. Prato, Duomo, chancel

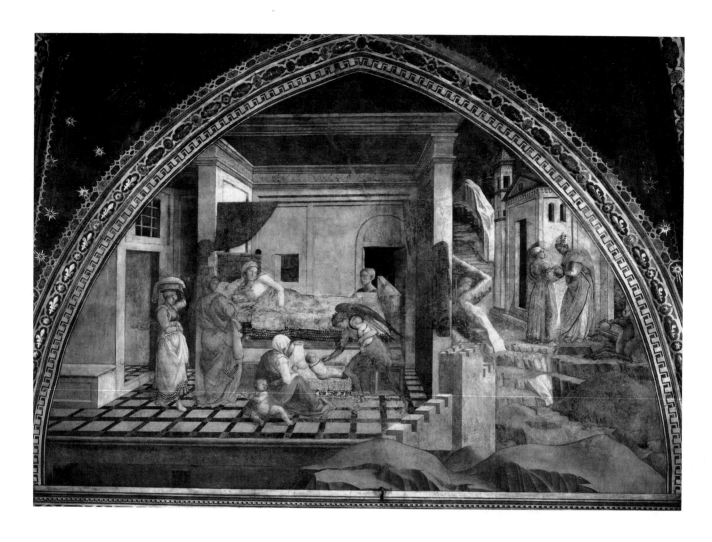

FIGURE 128. Prato, Duomo, chancel, Fra Filippo Lippi, *Birth of Saint Stephen*

were accommodated in the piazza outside the church where, on the right corner of the facade, a pulpit was erected for displaying the relic.[4] The entire entrance end of the church was thus dedicated to this cult.

From earliest times the church had possessed other esteemed relics: one of the stones with which Saint Stephen was martyred, hence the primary dedication of the building, and the stone on which John the Baptist was decapitated, hence the second dedication.[5] The mid-fifteenth century commission to celebrate the two Early Christian patrons in the chancel of the church may indeed indicate the church fathers' desire for a certain adjustment in thematic emphasis at the opposite end from the Virgin's sanctuary. After much negotiation, Fra Filippo started work in 1452 and completed the job in 1464.[6]

The sequence follows medieval protocol by starting on the wall to the right of the altar; it begins with the life of the Baptist,[7] whose birth preceded Saint Stephen's by half a generation (figs. 126, 127, diag. 32). In the very first scene, the artist establishes a ritualistic mode. The *Birth of Saint John the Baptist* takes place high in the lunette (fig. 129), where tilted perspective exaggerates the apparent distance from the spectator's eye. The main action is further removed by being set on a three-step platform that raises the figures almost beyond the reasonable limits of sight. Far from creating an analogue for domesticity, Fra Filippo renders a

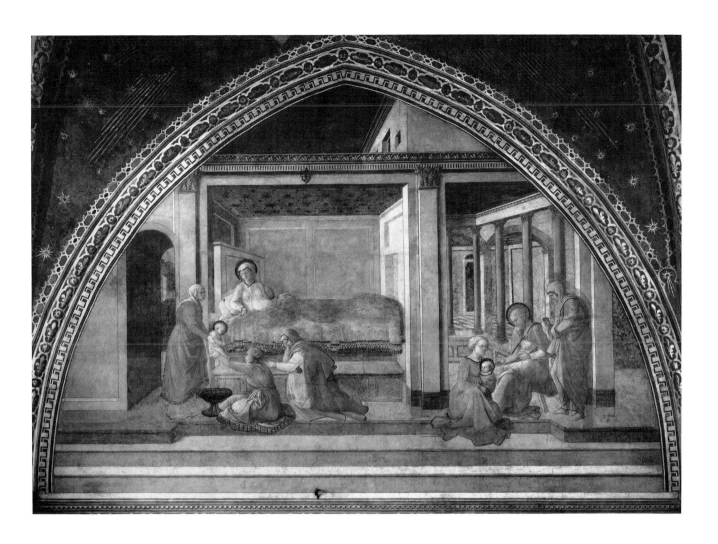

FIGURE 129. Prato, Duomo, chancel, right wall, lunette, Fra Filippo Lippi, *Birth of Saint John the Baptist* (see plate 15)

windowless room, cut away in the front, and fills it almost completely with the birthing bed. Saint Elizabeth sits up and leans on one elbow in the position of "royal birth without pain"; she is young and beautiful, not the old hag of the biblical account.[8] The miracle of her conceiving is thus suppressed in favor of emphasizing the destiny of her newborn child. One of the women in attendance holds the babe suspended over a font-shaped basin, symbolic of John's future mission.[9] The *Naming* episode takes place to the right in an architectural unit suggestive of a columned sanctuary. This pompous background gives eminence to Zachariah, the high priest, who writes his son's name while sitting with his legs crossed in the pose of an evangelist or a prophet. The portent of his message is again confirmed by the women at his side: the one who holds the child defers to his great wisdom in the pose of humility. Clearly what we witness is not a simple story but the ritual celebration of the feast of the Baptist's Birth.[10]

Although the birth of Saint Stephen has no comparable feast day,[11] there is thematic matching of the opening scenes of his life with those of Saint John, as has often been pointed out (fig. 128). The composition of the left lunette analogously moves from left to right; the bedroom is again a cutaway box with antis wall, again set on a kind of inaccessible platform. Both newly delivered mothers rest on their elbows, and both

infant scenes take place on the floor in front of the beds. The sanctity of Stephen's pre-Christian household is expressed by the miniature crenelations that surround the socially organized space. The great difference in the two lunettes is the action itself, Stephen's story being the veritable reverse of John's. Instead of the contemplative calm of John's first moments, the infant Stephen is wrenched from his crib by a devil who places a changeling, less-than-holy child in his stead. The bemused air of most of the ancillary figures shows their ignorance of the proceedings. Only the agitated infant scrambling away on the tile floor sees the devilish action. The second episode again takes place to the right, in a rocky landscape where the child has been left to die. Instead he is fed by a friendly doe, ancient symbol of eternal life. Finally he is saved by Bishop Julian, who places him in the care of a nurse at the door of the church. Thus both lunettes show similar auspicious nativities and the safeguarding of the infant protomartyrs.

The narratives on both sides drop down a tier, and both chronologies read from the nave back toward the altar. The result for the John story is a Boustrophedon on tiers one and two. The scenes of John's childhood on the right move to his maturity on the left before a continuous rock-hewn setting (fig. 130), faceted cliffs and shadowy caves providing the various episodes with integral spaces.[12] Judging from the somber character of expressions and gestures, this stony setting (and that of the first tier of the Stephen story) alludes to the material of the precious relics housed in the church.

In the left half of the zone the scene of *John Preaching in the Wilderness* is ritualized by the curious placement of the figures on outcroppings that act as pedestals. John has interrupted his exhortation to stand silently, eyes lowered. He points with his right hand to the blessing figure of the "Agnus Dei," whose graceful body rises behind a pulpitlike stone parapet. A youth in the center foreground leans with his elbow on a rough pillar, head in hand in philosophic contemplation in the antique manner. Two richly garbed publicans gesture in contestation. They too are elevated on a faceted stone base. Again, in spite of the narrative elements from popular legends, the scene is clearly ritualistic, with the entire composition dropping away on the foreground plane in a shelf of jagged rocks, as though it were an artificial stage.[13]

The second tier of the Stephen story likewise shows the young saint leaving his childhood home and traveling through an adventure-filled land.[14] At the altar end of the zone in a setting like a casual amphitheater, this youth too disputes with protesting disbelievers.

On the third tier, the narrative progression on both sides moves from the altar toward the nave. This reversal produces a third turn of the Boustrophedon on the right and establishes a two-tier Boustrophedon on the left. The compositions on both lowest tiers are again matching: each presents an architectural structure receding deeply into space: the corniced dining hall of Herod's palace on the right and a great basilica with archivolted colonnade on the left. Each has an image of the dead saint (only the head in the case of Saint John) in the area toward the nave. Each shows the scene of the saint's martyrdom not merely at the apse end of the tier but, having turned the corner, on the face of the altar wall (figs. 131, 132).[15] These are not simply two scenes juxtaposed on adjoining

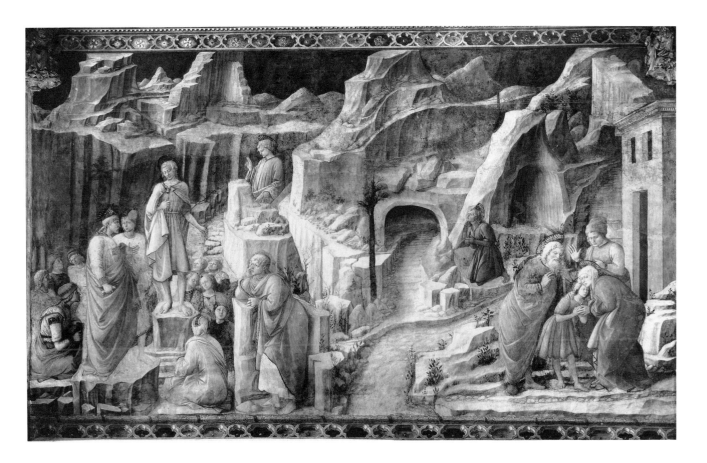

FIGURE 130. Prato, Duomo, chancel, Fra
Filippo Lippi, *Youth of Saint John the Baptist*

walls at forty-five-degree angles. They are single episodes with their
space literally bent around the corner. In the *Stoning of Saint Stephen*,
the enraged killer's stone will fly across the intervening space; in the *De-
collation of Saint John the Baptist*, the executioner's arm actually turns the
corner so that John's severed head is on the side wall near Salome's basin,
waiting to receive it. When seen from directly in front, the figures of the
dying saints are lifted out of the narrative and isolated on the altar wall,
where they take on iconic power. When seen diagonally, from the en-
trance to the chancel, the unnatural bending produces a powerful other-
worldly effect commensurate with the enormity of the action repre-
sented.[16]

Even more significant, through this arrangement Fra Filippo achieved
the overall thematic balance in the building that was perhaps the point of
his commission. His outrageous visual device emphasizes the two major
relics of this church other than the sacred belt. In so doing, the artist bal-
anced the veneration of the foundation relics in the apse with the more
famous relic of the Virgin at the entrance end of the building, and the
whole church, front and back, could serve the pilgrimage crowds as a
sacro monte in their devotional peregrinations around the full expanse of
the ecclesiastical space.

Mantegna

In the same years when Prato was negotiating with Fra Filippo, the Ove-
tari family was making arrangements for decorating its chapel in the

church of the Augustinian hermits in Padua (figs. 133, 134). The commission was let by Imperatrice, widow of Antonio Ovetari,[17] with no fewer than six artists under contract at different times. A team of four began in 1450: Antonio Vivarini and Giovanni d'Alemagna from Venice, the youthful Andrea Mantegna, and Niccolò Pizzolo from the shop of Donatello in Padua. Giovanni d'Alemagna died soon after the signing, and Vivarini withdrew almost immediately. Soon after completing a terra-cotta altarpiece in 1453, Pizzolo was killed.[18] These events left Mantegna the sole survivor of the original commission. In 1454 a new contract was drawn up with him, Asuino da Forlì, and Bono da Ferrara. The last two painted and signed scenes on the right wall, then they too withdrew, leaving Mantegna once more alone to finish the job, which he did about February 1457. When we now consider the many elements that bring the two walls into visual unity, we can safely say that, in spite of

the seemingly large cadre of workers on the project, a single mind—Mantegna's—must have guided the conception from the beginning.

The double dedication of the chapel, to Saint James the Greater, whose life appears on the left wall, and to Saint Christopher, whose story is on the right, was already designated in 1372.[19] In terms of disposition, the arrangement is straightforward: each side has six monoscenic episodes, two to a tier reading left to right, on three tiers moving from top to bottom (diag. 33).[20] Both side walls are outlined and overlaid with a network of painted moldings that frame the individual scenes, including the two irregular triangles on the lunette tier. These out-of-the-ordinary triangular fields can be related to the Cappella Maggiore of this church, where the artist Guariento had arranged the lunette register in a similar way a century earlier.[21]

At first glance the lives of James and Christopher seem to have little in

FIGURE 133. Padua, Eremitani, Ovetari
Chapel, general view, left wall

FIGURE 134. Padua, Eremitani, Ovetari
Chapel, general view, right wall

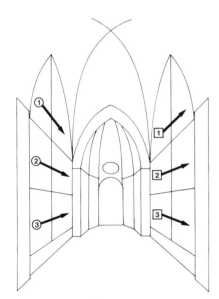

DIAGRAM 33. Padua, Eremitani, Ovetari
Chapel

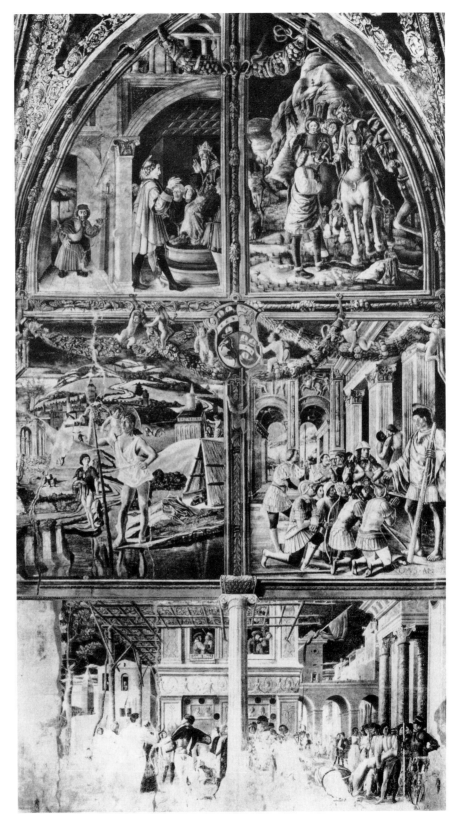

FIGURE 135. Padua, Eremitani, Ovetari Chapel, left lunette, Mantegna, *Calling of Saint James, Debate with the Devil*

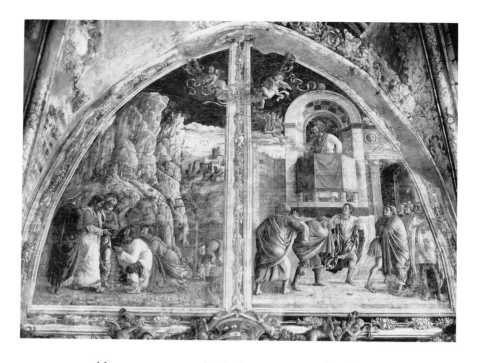

common and hence to present limited opportunity for thematic pairing. Only the martyrdom actually match, each on the bottom tier, placed appropriately on the side of the tier toward the altar. Yet by matching the designs of comparably placed scenes throughout the cycle, the artist defines the similarity between the two holy men on a level that is deeper than narrative. In the lunettes, for example, the scenes toward to the nave (the *Calling of James* on the left and *Saint Christopher Refusing to Follow the Devil* [note the horns on the helmet of the rider in the background] on the right; figs. 135, 136) are both set in open landscapes, framed on their respective nave sides with high, rocky outcroppings and showing deep vistas on the sides toward the altar. The compositional thrust on the left is from the right; on the right it is from the left. These mirror-image compositions call attention to the fact that the scenes are also related thematically, in this case through opposition: the *Calling* is a scene of adoring acceptance, while the *Refusal* is one of skeptical rejection. On this same tier the scenes toward the altar, *James's Debate with Devils Sent by Hermogenes*, left, and *Christopher Seeking the Most Powerful King*, right, both have architectural settings with paved floors, are restricted at the back by masonry walls, and are articulated by arches and open passageways.

In the right lunette, a long-robed dwarf knocks on the portal of the king's audience hall. Such a character, as far as I have been able to discover, is not to be found in the literary sources on Christopher's life. *The Golden Legend* mention a minstrel (they were often jesters and dwarfs) whose song, naming the devil several times, caused the king to make the sign of the cross and thus reveal his "weakness" to Christopher. The dwarf outside the door perhaps refers to such an entertainer. Moreover, it is important to observe that, visually, he opens the story on the note of physical scale, one of the main issues of Saint Christopher's persona, as we shall see.

Similar compositional echoing is found on the other two tiers. The two

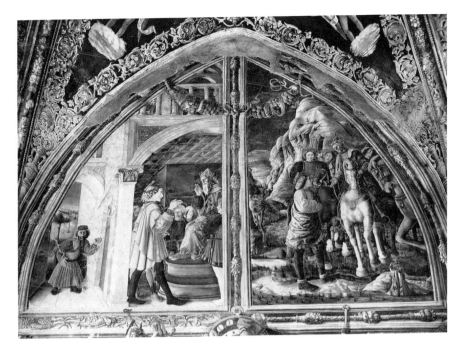

scenes on the nave sides of tier two have architectural settings that, in spite of grave differences in quality of execution, are almost identical. Mantegna's scene of the *Baptism of Hermogenes* and the *Preaching of Christopher*, signed by Asuino da Forlì, on the right, both show paved open areas enclosed in receding rows of square pillars and ending at the back with double arches. Even Mantegna's famous trial scene, *James before Herod Agrippa*, though conceptually different from the continuous narrative of the scenes opposite (*Saint Christopher with the Hermit* and *Saint Christopher Carrying the Christ Child across the River*, signed by Bono da Ferrara),[22] share with it the plowed and planted hills visible through the opening of the background triumphal arch. The bare-legged youth carrying a basket in the Christopher scene repeats, in a less stalwart mode, the postural rhythms of the pensive, accusatory soldier in the Trial scene. Similar also are the hip-shot pose of Saint Christopher himself and that of the halberdier in the center of the Trial scene, both in turn echoing antique figures of Poseidon or Zeus in the way they hold their staves.[23]

In the written story of Saint James, the Trial scene is not described in much detail. The episode appears in the cycle by Agnolo Gaddi (or Starnina) in the Cappella Manassei, Duomo, Prato, as part of a continuous narrative, along with the *Beheading*.[24] By giving the episode a full unit of space in the Padua cycle, besides "slowing down" the narrative, Mantegna makes a striking parallel with the life of Christ. Through this reference to the more familiar Christological scene (Christ before Pilate), James becomes the surrogate of the Lord and Herod Agrippa the surrogate of Pilate. The calm inevitability expressed by the mood of the scene seems to illustrate James's own words as given in *The Golden Legend:* "Let us follow the example of Christ and return good for evil."[25]

The perspectives of both scenes on both sides on this tier share vanishing points. These points of convergence are subtly concealed by the frames between the scenes. On the bottom tiers, the vanishing points slip

below the lower edges of the fields. This drop creates the *di sotto in sù* viewing point, slicing off the pictorial space and forcing a dramatic oblique view of the scenes that end the narratives. The visual effects on the bottom tiers were fully controlled by Mantegna, who painted both sides and used perspective to drive home the message. On the left, in the scene of *James Healing the Paralytic on His Way to Execution,* we see the underside of a soldier's foot as it projects from the space. The angle of vision seems to draw out the irony of the sick man saved by the man condemned, framed by an arch of triumph. The image appears as an emblem of humility in contrast to the angry soldiers at the right, who struggle together under a prideful flag. In the final scene the saint is fully humiliated, manacled and prone on the ground. A grotesque executioner, sleeve ripped and genitals exposed, swings his deadly mallet.[26] The horror of the killing is intensified by the impassivity of the assembled military company and by the illusion that the head of the apostle could drop off the fictive ledge, over the painted precipice, and land at our feet.

The final episodes of the Christopher story are in continuous mode, arranged in two separate units and brought together by the perspective construction. The division is marked by a painted Ionic column that masks the vanishing point. We see an arbor-covered piazza, a centrally placed palace, and exterior spaces balanced at both sides of the background. At least three different moments appear. The *Shooting of Christopher,* matching the martyrdom on the opposite wall, is placed toward the altar. The wicked king of Lycia stands at a window of the palace in the background, struck in the eye by an arrow meant for the saint that has magically turned back on him.[27] On the side toward the nave, men struggle with the saint's huge body; as with James's death, the event is proclaimed by the furling of a flag. Decapitation has taken place, and Christopher's head (destroyed) is positioned like James's, on the front plane of the painting, for our immediate contemplation.

As the story of Saint Christopher unfolds, his size increases. He begins as a normal man in contrast to the size of the dwarf. As the story progresses he grows larger with each scene; at his martyrdom he stretches up into the vertical dimension of the register. As he is hauled away, his huge foot, worn with calluses, held aloft for our viewing, contrasts strikingly in scale to the heads with which it is juxtaposed. The final flourish of this visual progression comes at the close of the sequence. At the extreme right of the tier the sharp-featured halberdier looks pointedly down at a little boy, beautifully dressed and perfectly formed, as if to call our attention to the contrast he makes to the misshapen dwarf with whom the sequence began.[28]

The concept of progress toward a final goal draws the lives of these two saints together. James, the first apostle to be sacrificed, becomes progressively meeker as his story unfolds, to emphasize his Christlike actions. Saint Christopher becomes progressively more heroic, growing in scale as he grows in spiritual understanding and dies as a miracle-working giant for Christ. The disparate narratives are thus unified through progression toward a more perfect imitation of Christ.

In spite of our being able to name the true argument of the cycle, the reason for drawing these particular stories together remains to be asked. Surprisingly enough, the answer comes from the painted decorations that

frame the scenes, usually counted among the many classicizing details that characterize Mantegna's work. As part of the meticulous illusionism, these painted moldings are gaily hung with fruits and flowers twisted together in leafy clusters. At the top of each bay there are heavy swags of the same materials, further decorated with ribbons that curl and flutter.[29] Climbing, flying, and standing on the garlands are putti who look into the scenes with rapt attention. Their glances and pointing gestures give verification, if it is needed, to the separation in levels of reality between the decorations and the scenes. The swags and festoons deny the scenes their historical perspective and declare, in the most direct visual terms, that they are not narrative but celebratory. The anniversary of James's martyrdom is 25 March,[30] but the liturgical feast in his honor has been shifted by four months to the day of the translation of his relics to the pilgrimage site of Santiago di Compostella in Spain—25 July. The anniversary of Saint Christopher's death and the day his martyrdom is celebrated are the same day, 25 July.[31] The chapel is thus festooned in ritual garb in perpetuity to celebrate the liturgy of the two saintly "imitators of Christ." Mantegna's Festival Mode calls attention to itself with rare strength, informing the eye to look beyond the surface of his classical realism into the realm of miracles.[32]

Piero della Francesca

Piero's now famous cycle of the True Cross in San Francesco in Arezzo was rediscovered as an object of artistic merit only in the mid-nineteenth century (fig. 137). From that time on the frescoes have presented a number of intriguing puzzles, the first concerning their date. Since Piero's style in general is deemed curiously uniform throughout his career, and since there is a general paucity of documents,[33] his chronology has remained a matter of opinion.[34] The Arezzo frescoes are placed between 1452 and 1466 on the basis of circumstantial evidence. We know that the commission came from the Bacci family of Arezzo, who had owned the chancel property since the early fifteenth century.[35] As was not uncommon, after the first burial (of Baccio di Magi in 1417), the promise of funds to the church for further decoration was not fulfilled by the family until more than thirty years later. In 1447 Bicci di Lorenzo was awarded the commission and went to work on the ceiling; in 1452 he died. Presumably Piero took over sometime after that.[36] As in the case of the cycle in Santa Croce, Florence, the subject of the True Cross had probably been chosen by the friars of San Francesco for its pertinence to the titular of the church. Saint Francis had spent a good deal of time at Arezzo where, moreover, one of his most impressive miracles had occurred.[37]

The problem concerning the Arezzo frescoes that has caused the most discussion is their disposition. And in fact, it was in confronting this problem that I entered into the subject of this book. Although Piero's cycle occupies all three walls of the chancel area in a not unusual way,[38] the chronological arrangement of scenes on these surfaces is extraordinary. The reading order is consecutive in neither the vertical nor the horizontal sense: it does not progress in the Straight-Line Vertical (in the manner of Agnolo Gaddi's or Masolino's cycle on the same subject), nor does it follow the Apse pattern around the chancel. It does not move con-

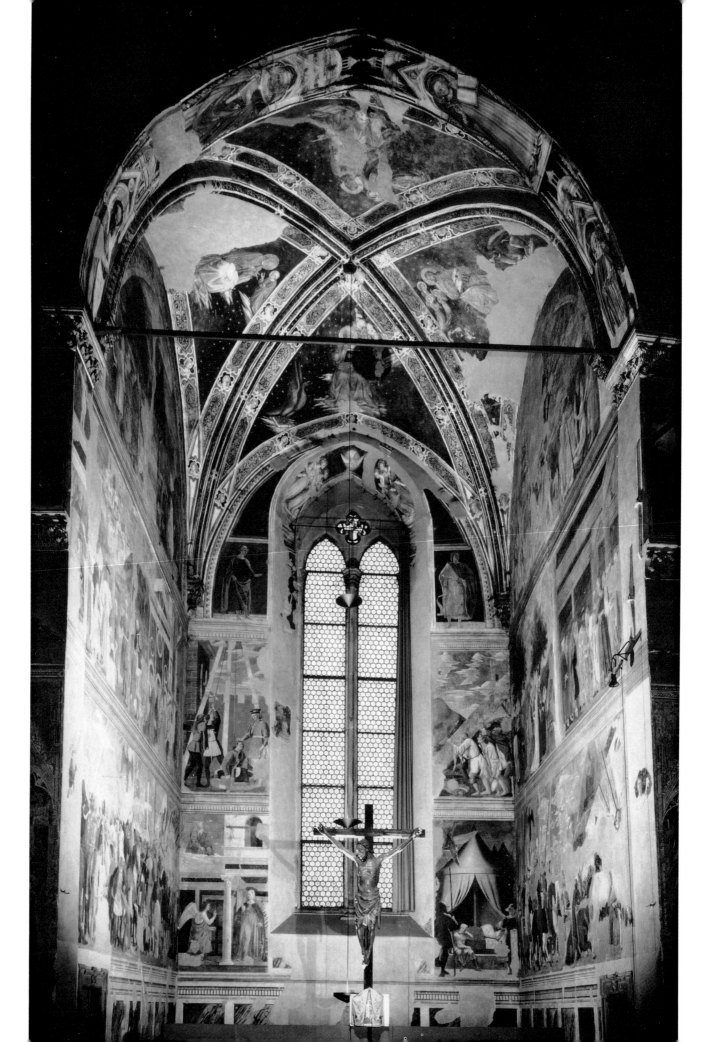

FIGURE 137. Arezzo, San Francesco, chancel, general view (see plate 16)

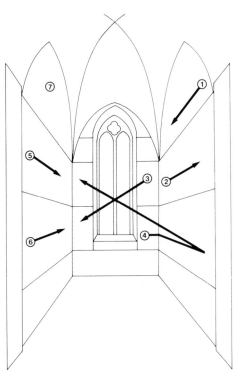

DIAGRAM 34. Arezzo, San Francesco, chancel

sistently either left to right or right to left. It does not move consistently from top to bottom or from bottom to top. Skipping and jumping from wall to wall, reading now down, now up, now to the right, now to the left, its "out-of-order" narrative order has fascinated and challenged scholars since the day it was first mentioned in the literature (diag. 34).[39] Observing another kind of order, scholars soon posited that in his sovereign quest for classical harmony Piero had "rearranged" the scenes so that similar subjects would appear in similar positions on the opposing walls.[40] The first interpretation of this visual symmetry placed it squarely in the tradition of Christian typology.[41] But soon this interpretation seemed too old-fashioned for such an avant-garde Renaissance artist. And thereafter nearly every author who discussed the cycle included another interpretation—historical, religious, or aesthetic—of what was called "an uncommon effect on symmetry and balance."[42] By the mid-1970s, Piero's motivation in giving up narrative order to achieve visual symmetry had become the focus of repeated analyses and was ultimately subjected to semiological criticism.[43] In restoring the discussion to its art historical context and placing the cycle within the history of narrative disposition, my aim is to seek a more accurate assessment of its contributions in this area than has hitherto been possible.

We have already learned that Piero's use of rearranged chronology and thematic pairing of scenes was part and parcel of tradition. At the same time, it is clear that these elements in Piero's work have been correctly singled out, because in his case they are exaggeratedly visible in both subject and inscenation. In the history of distribution of scenes for ideological purposes, Piero's rearrangement is more "rearranged" than usual. In the history of the pairing of scenes to magnify a theme, it is the consistency and strictness of the symmetry he achieved at Arezzo that is novel. I believe that these exaggerations are meaningful and that their purpose is to signal the ulterior argument. In pursuing this hypothesis we shall find the argument to be the establishment of a foundation myth for Christianity expressed for the first time in an epic mode.

In the three earlier monumental cycles of the True Cross already discussed, the episodes chosen for representation were highly consistent.[44] The cycles in Florence and in Empoli, in their side-to-side Straight-Line Vertical disposition, exhibit the Festival Mode, 3 May to the right, 14 September to the left. In many ways Piero's cycle is heavily indebted to the authority of these earlier examples,[45] and like them he follows the medieval protocol by starting the chronology on the right. However, there are also differences, and the differences are profound. Although the festival subjects play a major role in Piero's murals, they lack the requisite side-to-side confrontation for the festival argument, being placed together on a single wall (the left). On the other hand, Piero evokes the Festival Mode through the very essence of his style. I take the scene of *Sheba Venerates the Wood* (fig. 140) as one example for all. As is commonly observed, Piero's rendering of the human form reflects his interest in mathematics. Solid bodies are perfected to their geometric ideals: legs are shown as cylinders; each head is a perfect sphere; the log of holy wood is represented as a finished parallelopiped.[46] He thus denies his forms as merely palpable. The inscenation suggests a journey from the distant hills through a broad and empty valley. At the turning on the left,

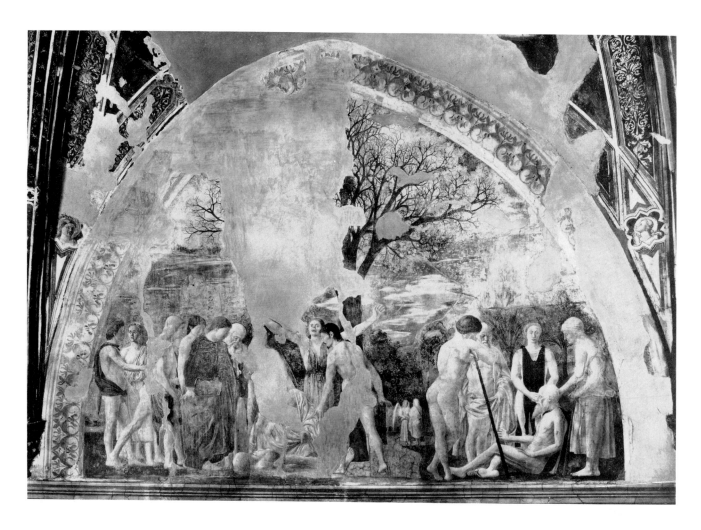

FIGURE 138. Arezzo, San Francesco, chancel, right lunette, Piero della Francesca, *Story of Adam, Quest of Seth*

the group of travelers comes to rest. Two grooms attending sturdy mounts are paradigms of symmetry, one seen from the front, one from the back, one in gray and red, one in red and gray.[47] Two leafy trees create a hypaethral sanctuary where the queen has dismounted to venerate the wood. Her entourage of women surrounds her, gesturing in amazement at the miracle. In his mode of representation, Piero brings form and space to abstract perfection and time to an absolute standstill.[48] In so doing, he makes the action of the episode into ritual and its meaning that of holy celebration.

Aside from drastically rearranging the narrative sequence, Piero's cycle deletes a number of the traditional episodes[49] while introducing others, many of which have no precedent in any cycle of this subject.[50] Because the scene choices and some of the details render Piero's cycle so radically different in subject from its immediate predecessors, I will discuss the innovations in some depth. In what follows I shall point out only those elements I have found to be idiosyncratic, without elaborating on how Piero treated the traditional aspects of the narrative.[51]

RIGHT LUNETTE

The opening scene of the story on the right of the lunette, *The Dying Adam*, is without precedent in the visual arts (figs. 138, 139). The ancient

patriarch reclines on the ground, supported from behind by his equally aged consort; he lifts his hand in declamation to members of his family who surround him. At 930 years of age, Adam is dying; his living children are unfamiliar with suffering and death, and he explains those mysteries to them. The image is again related to the legendary Life of Adam and Eve attached to the Story of the True Cross and represented in Gaddi's cycle.[52] In contrast to this prototype, where the first scene shows Seth's colloquies with an apparition of the Archangel Michael (which Piero reduces to a distant and therefore small, grounded background scene), Piero's cycle is launched with a visual meditation on man's physical mortality. He introduces a figure of Eve, represented as the monumentally flaccid-breasted mother (according to the legend, mother of thirty sons and thirty daughters) expressing her dual role as temptress and support to Adam, to be replaced by the Virgin Mary at the proper time.[53]

In the next episode the figure of the dead Adam lies prone to the left of center, at a diagonal to the picture plane.[54] The dress of the figures in the three episodes, *Adam Speaking to His Children, Seth Speaking to the Archangel Michael,*[55] and *Seth Planting the Branch over Adam at His Funeral,* range from complete nudity, to clothes of animal skins, to woven drapes,

FIGURE 139. Arezzo, San Francesco, chancel, right lunette, Piero della Francesca, *Dying Adam and Family* (see plate 17)

to full-scale colored togas, as though showing the evolution of society that took place during the near millennium of the patriarch's life. The blond youth, second to the end on the left, seems to concentrate on the figure of a prophet standing across the corner on the altar wall, who foretells the miraculous future that awaits the heirs of this primitive race.[56]

In spite of the linear progression of the human drama from right to left, the true subject of this painted field stands stationary in the center of the composition. A huge tree spreads its branches over most of the lunette. It now appears lifeless and black; originally it was covered with masses of green leaves.[57] This tree is the generating force of the legend; reappearing as it does outside paradise, it universalizes the locale of the scenes.[58] That the great tree rises in triumph over Adam's death is emblematic of a concept fundamental to Christian thought—"the paradox of the fortunate fall." As expounded in the Easter Exultet hymn, without the *felix culpa* of Adam and Eve, the advent of the glorious Savior would never have taken place, and man would be diminished thereby.[59] Because of sin the old Adam dies, the root of the cross is planted, and the scheme of salvation begins. In the first composition of his cycle, Piero thus alerts the worshiper to read each parcel of the narrative as part of a larger mosaic of significant Christian ideas.

RIGHT WALL, SECOND TIER

One of the points of the Sheba/Solomon episodes (fig. 140)[60] is the duping of the Old Testament king known for his wisdom. Centuries after its planting, the tree is seen by Solomon, who admires it so much he wishes to incorporate it into the palace he is building. The tree is felled, but because it magically keeps changing size, the workmen find it impossible to use. In desperation, the king has it thrown across a stream to serve as a footbridge. It is this log that Sheba venerates at the water's edge. In the story Sheba returns to her home in the Orient, and she writes to tell Solomon that a man who will bring an end to his kingdom will hang from the wood she has seen. The frightened king then has the beam buried.

The second tier on the right wall contains two scenes from the Sheba/Solomon episode that reverse the reading direction and move from left to right. On the left is the Veneration scene I have already described.[61]

After this ritualistic image, on the right Piero departs from the story to introduce the *Meeting of Solomon and Sheba*, a scene from the traditional repertory but never before included in a cycle of the True Cross.[62] In effect, Piero returns to the original source for Sheba's visit to Solomon, namely the Bible: 1 Kings 10 and 2 Chronicles 9, according to which she comes to prove the wisdom of the king with hard questions. When she is convinced that his wisdom and prosperity exceed his fame, and when they have exchanged gifts of great value, she returns to her home. Their meeting took on great significance in Christian theology because Christ himself interpreted the encounter as a figure of the pagan world's recognition of his own divine wisdom. "The queen of the south shall rise up in the judgment with this generation, and shall condemn it: for she came from the uttermost parts of the earth to hear the wisdom of Solomon; and, behold, a greater than Solomon is here" (Matt. 12:42). Saint Ambrose, in the fourth century, carried the thought further to include a fig-

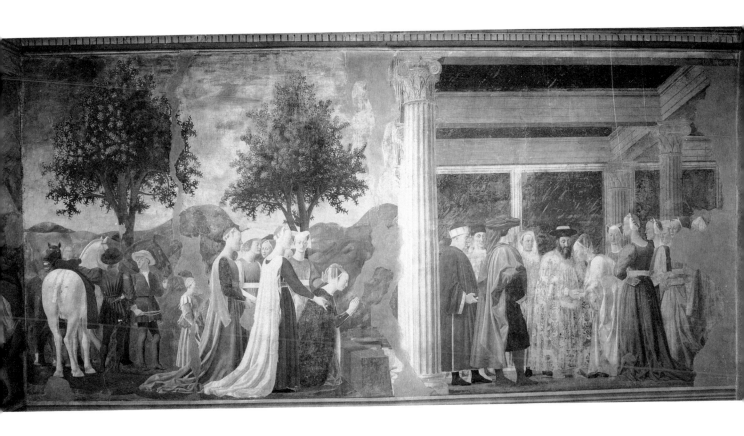

FIGURE 140. Arezzo, San Francesco, chancel, second tier right, Piero della Francesca, *Sheba Venerates the Wood, Meeting of Solomon and Sheba*

ure of the Marriage of Christ and Ecclesia.[63] It seems not by chance that at Arezzo Saint Ambrose is represented (along with the other three fathers of the church) on the intrados of the triumphal arch, on the lower range to the right, closest to the Meeting scene. In his scene, Piero shows the monarchs clasping hands within a portico of Solomon's palace. He has used the technique of architectural structure to frame this new narrative moment. A sense of mythological grandeur emanates from the vast hall with its heroic fluted supports, great marble slab ceilings, and unnaturally long lintels and roof beams.[64] The conception emphasizes neither Solomon's wealth nor his powers of judgment, and certainly not his gullibility. Rather, at the moment of handfasting, a sign of equality among monarchs,[65] Sheba bends forward to place her head below Solomon's in recognition of his superior wisdom. In this way Piero ensures Solomon's proper role as an antetype of Christ, again raising the historical-theological level of the scene beyond narrative. The inscenation sets off the two central figures while also very subtly reversing the rightward thrust, in preparation for the next move in the sequence to the altar wall.

ALTAR WALL, SECOND TIER, RIGHT

In this position on the second tier, the *Burial of the Wood* (fig. 142, detail) keeps its relation to the Sheba/Solomon episodes but is as far as possible from the figure of the noble king. In fact, besides having lost all the usual courtly witnesses, the scene gives evidence of a complete change of mood. Along with its opposite number on the left side of this tier (to be discussed below), both of which are painted in a somewhat crude style,[66] the Burial scene offers the cycle what I shall classify as "comic relief." The

action of burying the wood is carried out by three lowbrow ruffians, earnest but disheveled in varying states of disarray. They labor together to upend a knotty plank into a red-rimmed pool.[67] The struggle causes them to sweat: the first has loosened his shirt; his genitals are shamelessly exposed; his *calzoni* fall below his knees. The second, barefoot and bare chested, hoists the plank with the aid of a strut, biting his lower lip with the effort. With his shirttails bagging out, the third pushes forward and

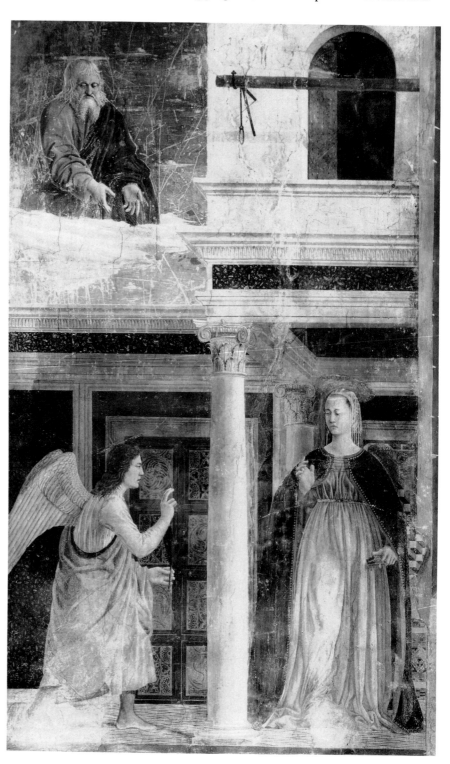

FIGURE 141. Arezzo, San Francesco, chancel, lower tier altar wall left, Piero della Francesca, *Annunciation*

FIGURE 142. Arezzo, San Francesco, chancel, second tier altar wall right, Piero della Francesca [Giovanni dei Piamonte?], *Burial of the Wood*

down with his bare hand. This workman wears a wreath of berries and leaves suggesting pagan drunkenness and lack of wit.[68] If this unseemly action has typological value,[69] it is in a paradoxical way, demonstrating the innocence of stupid men who know not what they do. The compositional thrust of the scene follows the descent of the wood from upper right to lower left, directing the eye to the next episode diagonally below.

ALTAR WALL, LOWEST TIER, LEFT

The *Annunciation,* chronologically speaking, is the next scene in the sequence (fig. 141). Even though the Old Testament and medieval parts of the True Cross story are implicitly connected by the Life of Christ, there are no texts that bring the two together. The moment of the Incarnation is crucial to the logic of the legend, yet no other cycle of the True Cross includes the scene. As a result, its presence here has been the subject of numerous discussions.[70] In the Cappella della Croce in Volterra, as we have seen, a cycle of the True Cross is combined with a short Mariological cycle that includes an Annunciation (fig. 93). Here as well as in Piero's scene, the angel offers the Virgin a palm frond.[71] The Volterra composition therefore is often cited as a precedent for Piero's scene. Actually the two represent different moments in the story. Since in Volterra Mary is shown as a mature woman wearing a wimple, not as a young girl, the subject is an annunciation of her death.[72] Yet there is still a relation between the two. In Volterra the episode is juxtaposed on the right by the *Nativity* and on the left by the *Death of the Virgin.*[73] It thereby expresses simultaneously two aspects of Mary's character: her virginal motherhood and her person as a guarantor and model of mankind's salvation. Piero's scene not only conveys the same combined message by using the proleptic palm frond, but also conveys her role in the scheme of salvation through reference to a whole spectrum of Marian epithets.

In Piero's scene, Mary is placed in a portico of encrusted marble, close in form to a number of tabernacles built to hold miraculous images of the Annunziata.[74] In rational terms, Mary is much too large for this structure, being nearly as tall as the column that supports the porch. The reciprocity of the swelling entasis in the body of the column and in that of Mary, pillar of the church, has often been noted. Behind her massive silhouette, a partial view of her bedroom appears. The fancy room with diaper-pattern inlay wall and bowerlike vaulted ceiling suggests the marriage chamber. Two epithets are involved here: one is Mary as Ecclesia, the other is Mary as Sponsa. The oversized body stands for Ecclesia, the institutional body of the church. She is veiled in preparation for the wedding taking place before our eyes. The intricately carved door depicted in the forecourt behind Gabriel refers to Mary as Porta. With its patterns of geometric perfection, it alludes to the words of Ezekiel (44:1–3), who speaks of the closed eastern door through which only God can enter. This metaphor is understood as a prophecy of Mary's virginal conceiving; she is therefore known as the Janua Coeli.

The window depicted on the second story of the portico represents another epithet for Mary: the Fenestra Cancellata—the barred window described by Jeremiah (10:21).[75] On a more mundane level, the bar across the window represents a support for drapes and tapestries hung from

buildings along outdoor processional routes on feast days and celebrations. The metal strut that terminates in a ring serves, in fact, for fixing the tapestries and other linens with string or leather thongs.[76] The placement of these accoutrements is comparable to that of the paired veils in Giotto's *Annunciation* in the Arena Chapel and surely carries the same reference to the Annunciation feast.[77] That here the bar is ostentatiously empty, however, shows that Piero's point is not to celebrate the feast, but to represent the moment of the Incarnation, nexus between the Old Testament preparation for the veneration of the cross and its exaltation as a relic. Reference to the cross, moreover, is explicit in the structure of the composition as a whole, divided into quadrants by the columnar central

FIGURE 143. Arezzo, San Francesco, chancel, lower tier altar wall right, Piero della Francesca, *Dream of Constantine*

FIGURE 144. Arezzo, San Francesco, chancel, lower tier altar wall right, Piero della Francesca, *Angel with Golden Cross*, detail

FIGURE 145. Venice, San Marco Baptistry, mosaic, *Joseph's Second Dream*, detail

vertical and the horizontal crossbar of the variegated marble frieze. Again, this horizontal accent guides the eye to the field that holds the next scene, as we shall see in a moment.

First I must point out what is perhaps the most important factor in the inclusion of an image of the Madonna in this cycle. Among the documents recording the early history of the church, one states that "[in 1298] . . . frater Mattheus Portuensis et Sancte Rufine episcopus, legatus apostolice Sedis," conceded forty days of indulgence to those who "ecclesiam fratrum Minorum frequenta in festivitatibus beate Maria Virginis, beati Francisci, beati Antonii et sancte Clare."[78] The indulgence in favor of the Madonna would have made a representataion of her or a reference to one of her feasts virtually mandatory in the decoration of the apse and may account in a fundamental way for the presence of the *Annunciation* in Piero's cycle.[79] If a representation of the Virgin was called for by the friars to make visible this remission, Piero again performed his duty in his characteristic manner by universalizing the inner relevance of the subject to his cycle.[80]

ALTAR WALL, LOWEST TIER, RIGHT

After the *Annunciation*, the narrative returns to the right side of the altar wall on the lower tier, crossing the altar area where a crucifix would always have been placed.[81] This progression placed the Crucifixion in its "correct" chronological position after the *Annunciation* and before the *Dream of Constantine*. The latter is the first of two Early Christian episodes introduced here for the first time in monumental art. I shall speculate in a moment on the possible Franciscan allusions in their presence.

Scenes of the *Dream of Constantine* have a long history in medieval small-scale art, both Eastern and Western. On the eve of battle with Maxentius, fellow Roman contender for the title of emperor, a mystic visitor announces impending victory to Constantine under a sign in the shape of a cross. The meaning of the cross is not explained. As we have seen, in earlier monumental cycles of this story the configuration of a sleeping general's vision had been transferred to Heraclius in a comparable composition.[82] Piero not only reintegrates the vision into Constantine's story, he also gives the scene a drama it never had before (fig. 143). In a blaze of light, an angel streaks in from on high (fig. 144),[83] holding before him a tiny golden cross.[84] Emanating from this little emblem is a radiance that fills the night and brings the visionary scene into view.[85] The compositional thrust of the angel's flight from upper light to lower right repeats and harmonizes with the path marked by the descent of the Holy Spirit from God the Father's hands toward the Virgin in the Annunciation scene. The air of mystery engendered by the light is augmented by other factors. Two stalwart guards positioned at the sides of the tent hide the lacings of the flaps with their bodies. As a result, the flaps seem miraculously suspended. Through this device, the scene becomes a revelation. The emperor sees his vision in a dream, with his eyes closed. He reclines at the foot of the tent pole like the symbolic dead Adam, who often lies at the foot of the cross.[86] On the platform of his bed a body servant, resting head on hand, looks out at us with an air of melancholy mourning.[87] Superseding the narrative, these elements make

FIGURE 146. Rome, San Clemente, Branda Chapel, Masolino, *Death of Saint Ambrose*

the message clear: as in a revelation, we witness the death of paganism on the eve of Christian victory and the coming of the new age.[88]

RIGHT WALL, LOWEST TIER

To the right of the dream scene the *Victory of Constantine* springs to life. Portions of soldiers and horses in poses of fast action seem to emerge from a long stream hidden behind the corner of the wall (fig. 147). This detail points up the lack of vertical framing devices that might arbitrarily separate the scenes. Throughout this cycle, as we see it here, compositions stop where the wall support ends, but the episodes continue on their own in another, invisible realm beyond the painting fields. This technique is related to illustrations in contemporary romance literature, as we shall see.

As it moves toward the right the army calms into an organized march against the enemy (fig. 148). On the second range of the tightly knit column, behind his armed guards, Constantine holds the tiny cross as a talisman above the head of his magnificent white horse. Behind him the Tiber winds its way through the Tuscan countryside, a few ducks floating on its surface. Maxentius, the Roman pretender, flees the charm led by a naked barbarian accomplice riding bareback. The routed troops have fallen into their own river trap and retreat under the flags of the wicked basilisk and the evil Moor. To call this scene a battle is a misnomer, since no fighting is taking place. In spite of gloriously detailed trappings, weapons, and armor both contemporary and classical in style, Constantine's victory, for the first time in visual history, comes as a miracle.[89] The Constantinian chapter ends with the exodus of the enemy troops up the

FIGURE 147. Arezzo, San Francesco, chancel, lower tier, right corner, Piero della Francesca, *Soldiers and Horses*

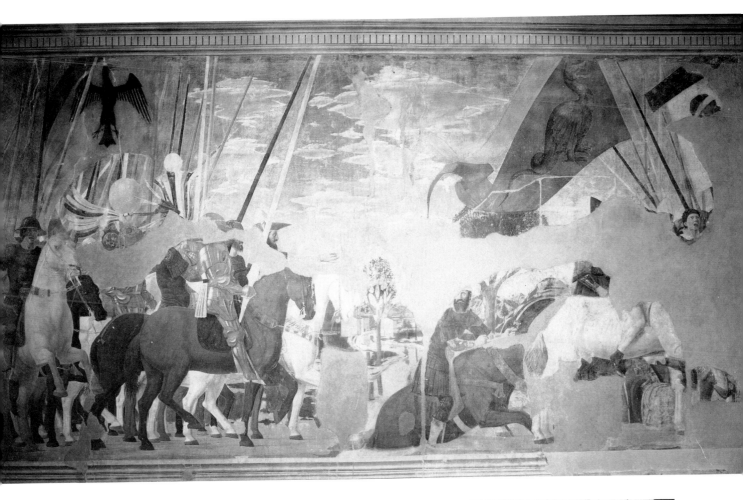

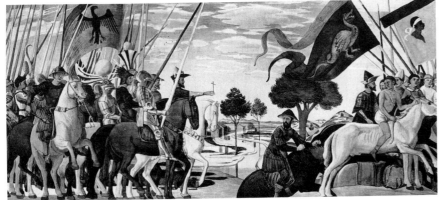

FIGURE 148 (*above*). Arezzo, San Francesco, chancel, lower tier right, Piero della Francesca, *Victory of Constantine*

FIGURE 149 (*right*). Watercolor, A. Ramboux, copy of Piero della Francesca's *Victory of Constantine*

banks of the river and out of the pictorial field toward the right.[90]

The historian Bishop Eusebius (264?-349?) had written of the salvific quality of Constantine's battle in his biography of the emperor. He compared the victory at the Milvian bridge to Moses' victory over the Egyptians at the Red Sea. He thereupon described Constantine as the new Moses, saving his people from the pagan pharaoh and leading them on to the Promised Land of Christianity.[91] For similar reasons, Saint Francis was also called the new Moses and, as we shall see, the order itself was likened to a new Exodus.[92] Thus not only did the scene of Constantine's

FIGURE 150. Arezzo, San Francesco, chancel, Piero della Francesca, *Victory of Constantine,* detail of figure of Constantine

FIGURE 151. Florence, San Miniato, sacristy, Spinello Aretino, *Totila before Saint Benedict,* detail of figure of Totila

Vision give resonance to Francis's own vision of cross-emblazoned armor, but the bloodless victory at the river also foreshadowed Francis's victory in the cross.[93]

This battle scene is often said to refer specifically to the fall of Constantinople in 1453, primarily because the profile of Constantine is visually so similar to an earlier medal by Pisanello of John Palaeologus, last of the Byzantine emperors. Palaeologus had visited Ferrara and Florence for the council between the Eastern and Western churches in 1438–39,[94] where aside from pursuing theological questions he had sought badly needed Western aid to ward off the invading Turks.[95] Help was not forthcoming, and in 1453 the Turks took Constantinople and the empire was lost. The downfall of Byzantium meant ever greater threats to Italy itself, and there were many calls for renewed crusades. These calls came from papal circles and from among the Franciscans, who had a vested interest since, as we have seen, they were stationed in Jerusalem as protectors of various holy sites. With these current events very much in the air, visual allusions to such matters in this cycle could not be avoided. In fact, I have been at pains to emphasize that all True Cross subject matter, from the time Islam began to pose a threat to Christianity, had undertones of crusade propaganda. By the fourteenth century and beyond, reference to problems with the Turks was practically endemic to the subject and would have been a starting point for any artist given the assignment. In a place of worship in the fifteenth century, however, the first level of recognition would remain on the theological plane.

The proximity to a secular prototype in this case, nevertheless, calls for further comment. The salient feature in identifying the mounted figure with a portrait of the emperor has always been his high peaked hat with characteristic long, pointed visor (fig. 150). Palaeologus's hat was described by eyewitnesses at the council some twenty years earlier not only as having this shape, but also as being snow white with a huge ruby atop its crown.[96] Constantine's hat in Piero's fresco has a red crown, a green visor, and no jewel. A similar high-topped hat with pointed brim, moreover, was already a favorite in Tuscan painting long before Piero's time. Spinello Aretino, about 1390, had put it on the head of Totila, "the Scourge of God" who was converted by Saint Benedict (fig. 151), in the cycle on the life of that saint in Florence at San Miniato al Monte; Agnolo Gaddi used it too in the frescoes of Santa Croce, on a man in the *Retrieval of the Wood* (fig. 82), on another in Sheba's train (fig. 83), on Saint Helena's first lady-in-waiting as she exalts the cross (fig. 84), and on the warrior-knight walking behind Heraclius (fig. 87). Ghiberti's queen of Sheba in her *Meeting with King Solomon* on the Gates of Paradise (fig. 107) wears the same hat. Piero himself used this headgear more than once: not only on Constantine, but also in different hues on his enemy Maxentius in the same composition. Saint Helena's dwarf wears this hat (fig. 152), and the Jerusalemite on the right in *Exaltation of the Cross* (fig. 153) carries one in his hand. Clearly, the haberdashery was not exclusively Palaeologan property. What is important to observe in this context is that Piero put contemporary Constantinopolitan costumes on many figures in this cycle, carefully reserving the clothing style for scenes portraying late antiquity and early medieval periods.[97] I conclude, therefore, that it is unlikely Piero meant to "represent" the emperor.

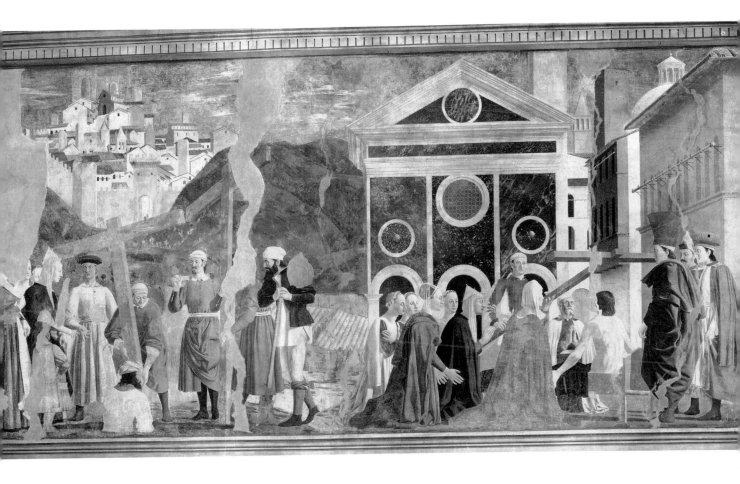

Rather, with eminent appropriateness, he alluded visually to the living heir to the Roman empire in a scene of imperial battle.[98]

ALTAR WALL, SECOND TIER, LEFT

The narrative now takes up the "Helena chapter" of the story on the left side of the chapel. It begins on the second tier of the altar wall, with the scene of *Judas Freed from the Well* (fig. 154).[99] The compositional thrust of this scene, like that of its partner on the altar wall, depends on strong diagonals. Matching the plank in the *Burial of the Wood*, in this case the supporting blocks of a single-fixed pulley extend beyond the margins on two sides of the painted field. Scenes of *Judas Thrown into the Well* and *Judas Freed* had long histories in manuscript illustrations of the story of the Cross but had not before appeared on a monumental scale. Piero makes two major contributions to this tradition, on two levels of significance. The first is in a comic vein and drawn, surprisingly enough, from illustrations to the *Decameron* of Boccaccio. In the hilarious story of Andreuccio da Perugia, the fifth story of day the second, the "hero" goes to Naples to buy a horse and gets into all kinds of trouble. At one point he is in need of serious washing off.[100] He is helped by two tomb robbers to a well where there had always been a rope, a pulley, and a great bucket. Finding the bucket gone, they tie Andreuccio to the rope and let him down into the well. Guards of the watch who come to the well for water mistakenly pull Andreuccio up and cause quite a stir (fig. 155). The

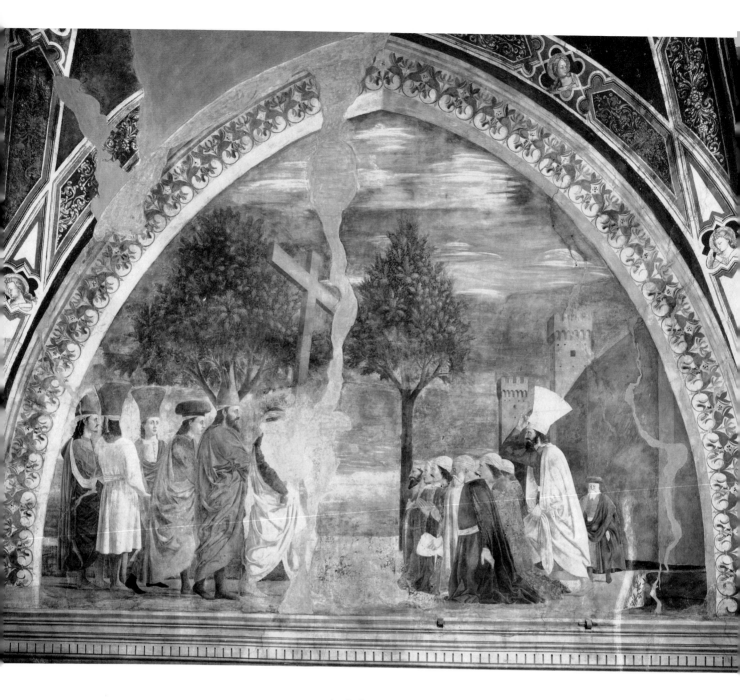

FIGURE 153. Arezzo, San Francesco, chancel, left lunette, Piero della Francesca, *Exaltation of the Cross*

mismatched characters then continue on their adventures.[101] Surely, in Piero's version, the dandified boys pulling on the rope of a pulley with a young man attached recall this lowbrow comic situation. The painted scene thus joins its counterpart to the right of the window on the level of comic relief.

At the same time a more serious note is struck.[102] The more official-looking participant holds a covered baton and has a ticket in his hat inscribed with a word resembling "prudence" (fig. 156).[103] He grasps Judas by the locks and hauls him from the well. This manner of extrication is reminiscent of the means by which the prophet Habakkuk was taken by an angel where he did not wish to go. Like Habakkuk, Judas does not yet understand that he is taken by force for a higher good.[104] As opposed to

FIGURE 155. Venice, Stampa di Gregori, 1492, woodcut illustration, Boccaccio, *Decameron, Story of Andreuccio*

FIGURE 156. Arezzo, San Francesco, chancel, Piero della Francesca, *Judas Pulled from the Well*, detail

his evil namesake, the new Judas soon shows his prudence in a change of heart, becoming Helena's confidant and leading her to the cross. He thereafter is ordained, later becoming bishop of Jerusalem with the name Cyriacus.[105]

LEFT WALL, SECOND TIER

The two-part composition of the *Finding and Proofing of the Cross* (fig. 152), except for differences in style, has much in common with the earlier representations of the same episodes.[106] The order is reversed and brings the *Proofing* to the altar end of the wall. As usual, Piero has added several elements. One is an elegantly dressed dwarf who observes the progress of the digging. He is not the low-class freak we met outside the door of the first Christopher scene in the Ovetari Chapel. Rather, he is clearly a part of the royal entourage. He joins a long array of precedent dwarfs, buffoons, and jesters whose role, it seems, defines their highborn patrons' status.[107] Helena's fellow throws her conversation with the foreman into high relief, lending the party an air of regal grandeur. There even seems to be some precedent for his presence within the liturgical context of this subject. In the Hainricus Missal (Morgan 711, second quarter of the thirteenth century) a digging scene is portrayed in the initial for the liturgy for the feast of the Finding of the Cross (fig. 157). The queen enthroned watches Judas dig; behind her, bending with the shape of the letter D, is her jester in fool's cap and cape.[108]

Another element new to such episodes is the representation of a specific city in the background: an image of Arezzo, walled and nestling in the saddle of the Tuscan hills (fig. 158). At the top of the town is the *nuova cattedrale* and lower down the tower of the church of San Francesco itself. Localized cityscapes were nothing new to the pictorial arts at this date,[109] but here, as we shall see, the vista has special meaning for the story at hand. The view forms a backdrop to the episode on the left where, in the presence of Macarius, bishop of Jerusalem (his head is destroyed), and members of the court, Judas indicates to Saint Helena where the crosses will be found. The episode on the right takes place in an urban setting: the third cross proves true when its touch raises a dead youth on his bier.[110] The queen and her ladies fall to their knees at the sight. In written versions of the legend, at this moment the devil is heard to cry out.[111] It is this narrative detail that elucidates the presence of the image of Arezzo and brings it into unity with the foreground scenes.

One of the most important miracles carried out by Saint Francis took place at Arezzo during a time of bitter intestine fighting. On one of his many journeys through Umbria and Tuscany, he approached Arezzo with a companion named Brother Sylvester (fig. 159). He was greatly dismayed as he looked down on the town from a nearby hill, for he saw demons exulting at the internal warring they had engendered. He called his traveling companion and told him to go to the Porta di Borgo and "in the name of almighty God command the devils in virtue of obedience to go away immediately." This Sylvester did, and the devils fled screaming from the town.[112] The same Sylvester had earlier had a Constantinelike vision of Francis himself, with a cross of gold coming from his mouth: "The top of it reached up to heaven and its arms stretched far and wide

FIGURE 157. Hainricus Missal, fol. 101v

and seemed to embrace the whole earth." As with Constantine, the vision had caused Sylvester to "convert" to the order of the Friars Minor.[113] I propose that the conjunction of Franciscan cross imagery with the exorcism of screaming devils motivated the identification of the environs of Jerusalem with the outskirts of Arezzo.

This same conjunction, not incidentally, is the element that gives the final explanation for the inclusion of an image of the Annunciation in this cycle. There is one important source that binds Saint Helena to the Virgin in the most explicit manner possible. Saint Ambrose, whom we have met before within the confines of the chapel, is the earliest source to describe Saint Helena's finding of the cross, writing at the end of the fourth century, some fifty years after Saint Helena's death. Having described her arrival in Jerusalem and her mission, Ambrose recounts Helena's thoughts as she draws near the burial place of the cross:

> (No. 44) "I see what you did, O devil, in order that the sword by which you were destroyed might be walled up. . . . Why did you labor to hide the wood, O devil, unless that you may be vanquished a second time? You were vanquished by Mary, who gave the Conqueror birth. She without detriment to her virginity, brought forth him to conquer you by his crucifixion, and to subjugate you by his death. Today also you shall be conquered when a woman discovers your snares. (Quoth Helena,) As that holy one bore the Lord, I shall search for his cross. She showed him created; I, raised from the

dead. She caused God to be seen among men; I shall raise from the ruins the divine standard as a remedy for our sins. . . ." (No. 46) . . . The wood shone and grace flashed forth. And as before Christ had visited a woman in Mary, so the spirit visited a woman in Helena. He taught her those things which as woman she knew not, and led her to the way which no mortal was able to know. . . . (No. 47) . . . Mary was visited to liberate Eve; Helen was visited that Emperors might be redeemed.

Thus the words of Saint Ambrose, as we have seen in the earlier context where they link Sheba to Mary, here link Mary to Eve and, on this mystical level, Helena to Mary.[114]

LEFT WALL, LOWEST TIER

There are several new aspects in the episodes that follow on the lowest tier of the left wall (fig. 160). Chosroes' theft of the cross and his blas-

FIGURE 160. Arezzo, San Francesco, chancel, lower tier left, Piero della Francesca, *Battle of Heraclius*

phemy are omitted, and the remedy for his crime is represented directly without interval. The remedy in the form of a Christian military victory is given an entirely new shape. The *Battle of Heraclius* had never before been shown as a mass conflict. Rather than two knights clashing on a bridge, as the story goes, Piero fills the long rectangular area with a clangorous melee between calvary, foot soldiers, officers, mercenaries, and slaves, armed both in classical leather and in trappings of contemporary manufacture. The battleground is, as on all other tiers in the cycle, compressed into the frontal plane.[115] Rather than a directional thrust, this composition has a tightly woven fabric, full of dead stops and impenetrable masses. Like its opposite number on the right wall, it has lateral extension behind the wall surface, particularly at the far left, where half a body and a severed head are lying on the ground.[116] In contrast to earlier Heraclius battles, the skirmish is complex and without a preordained winner. In fact the victor is quite impossible to recognize.[117] Yet in spite of specific weaponry and physiognomic types, in spite of spurting blood and casualties, it is not a convincing battle. The poses are hieratic; figures do not express emotions; the atmosphere is universalized. Piero alludes neither to an orderly chivalric encounter nor to a more contemporary rough-and-tumble clash. Instead, his use of motifs from specific imperial monuments—battle scenes on the arch of Constantine and the drawing of an equestrian statue perhaps representing Heraclius himself—identi-

fies his battle with historical events.[118] In this way he made his scene "authentic" and placed it squarely in the official realm of the early centuries of Christendom.

By also revamping the *Execution Scene* to show Chosroes still alive but just before his execution, Piero is able to make several points about him. The star-studded celestial canopy covering his throne alludes to his attempts to rule the workings of the universe.[119] Even more poignant is the reference to the substance of his blasphemy, stated visually through the physiognomic identification with the lofty face of God the Father, juxtaposed around the corner on the altar wall. The evil Eastern king is furthermore judged not only by his seventh-century contemporaries, but by all the ages to come, represented by the witnesses surrounding him, who include three members of the Bacci family, patrons of the cycle.[120] Here is the reference to contemporary fears and a pledge to keep the infidel enemy at bay.

LEFT WALL, LUNETTE

The same telescoping of events is found in the final scene of the cycle, which skips to the lunette high up on the left-side wall (fig. 153). Heraclius has already been admonished by Zacharias, the current bishop of Jerusalem, who is at his side. He is told to imitate Christ more closely and heeds the words. "Then Heraclius, taking off his ceremonial robes and his shoes and putting on a poor man's garment, easily went the rest of the way and placed the Cross on that same spot on Calvary from which it had been taken by the Persians" (lesson 6 in the Breviary, reading on 14 September). As opposed to many manuscript illustrations of this passage where entering the Jerusalem gate is a major issue, Piero's scene is set far outside the town and the gate is omitted. A group of Jerusalemites have hurriedly come out: one man is doffing his spectacular hat, and another older gentleman is still rushing along the road. The distance they have traveled is suggested by the huge walls casting a dark shadow behind them. Representing the episode in this way, as an isolated scene, Piero has alluded to the ancient protocol of *adventus,* wherein the farther the greeting is from the city, the greater respect is shown.[121] Concentrating their gaze on the relic Heraclius carries, the townspeople transfer their reverence for the emperor to the cross. Showing Heraclius simply dressed and barefoot, moreover, makes his act a premonition of discalced poverty, chief among Franciscan virtues. Finally, by matching the last scene of the cycle with the opening in the opposite lunette, he performed the ultimate exorcism. In the words of the Preface of the Cross (also read on 14 September): "We should . . . give thanks unto Thee, O holy Lord . . . who didst establish the salvation of mankind on the tree of the Cross; that whence death came, thence also life might arise again, and that he, who overcame by the tree, by the tree also might be overcome [. . . et qui in ligno vincebat, in ligno quoque vinceretur . . .]."

"OUT OF ORDER" ORDER

When we now follow the chronology of the story with our increased knowledge of the history of disposition, we find that the rearrangement is

FIGURE 161. *Kaiser Heinrichs VII Romfahrt,* manuscript illumination, about 1350

not as haphazard as it seems at first. It is made up of several of the traditional patterns we have met before. The order of the first two tiers on the right (*Story of Adam* and *Story of Sheba and Solomon,* figs. 138, 140), is a Boustrophedon. Besides expressing the queen's long journey, this arrangement places Sheba's Recognition of the Wood directly opposite that of Helena on the left wall. The order on the altar wall, again seen as a unit, is a Cat's Cradle. The pattern is formed of intersecting diagonals from upper right to lower left and from lower right to upper left.[122] As usual, the pattern functions to create unity in diversity, here tying scenes from the Old Testament to the New and scenes from Roman history to medieval legend. Finally, the general arrangement of the facing walls (with the interruption of the left wall starting in the middle) is what I have called the Up-Down, Down-Up pattern, found first in the apse of the Arena Chapel and in the transept of the Lower Church of Assisi where, as here, it sets the opening scene and the final exaltation on upper tiers.[123]

Combining these patterns creates what might be characterized as a type of "gothic" order: many separate parts, consistent within themselves, brought together in a group but not unified. The result of combining the patterns, however, is the side-to-side coupling of scenes, which can be characterized as a type of "classic" order. The physical locations that match and mirror each other contain rigorously paired thematic facets of narrative. Together the lunettes display the beginning of the cycle and its end: the planting of the wood on the right and its exaltation on the left. The parallel is carried out on the compositional level as well: both landscape backgrounds have orthogonally arranged paths to the right of center that help to focus on the wood. Both have small-scale figures in the background.[124] On the second tiers, the pairing operates with even stronger symmetry. Both sides shows divinely inspired queens. In the scenes toward the nave, the queens resolve hard questions, guided by their male companions. Sheba bends to the superior wisdom of Solomon; Helena finds the crosses on the advice of Judas. In the scenes toward the altar wall, both queens recognize the True Wood and kneel in veneration to adore it. The two episodes on each side are likewise evenly divided; one appears before a rolling landscape, the other uses classicizing architectural units to indicate a new time and space. On the second tier of the altar wall the lowering of the wood is matched by the raising of the Jew; on the right the wood is hidden, on the left its position is revealed. As we have seen, both scenes involve diagonal wooden planks, and both are in small areas hemmed in at the back by stony structures. On the lower tier, divine annunciations are paired: on the left the Incarnation is announced, beginning the cycle of salvation; to the right Constantine's victory is foretold, beginning the institutional salvation of mankind and the creation of the Christian state. Both these scenes are based on left-to-right descending diagonals and take place in semiopen structures with central columnar supports. The lowest tiers on the side walls pair the two battle scenes, each a Christian victory under the Cross: on the right is Constantine's bloodless defeat of paganism, snared by its own wiles; on the left is the bloody defeat of the blasphemous infidel and death of the false god. Both battles have friezelike compositions, extending laterally beyond the field.[125]

As we have seen, pairing tiers thematically was by no means novel. We

met the same elements of inscenation, balance, and reciprocity of themes
in work at Prato and Padua, and we may confidently claim it to be charac-
teristic of fresco designing at this midpoint in the century. What is new
in Piero's cycle is the emphasis placed on symmetry, whose strength
fairly invites the semiological analysis it has received. No other artist had
gone to such extremes of "out of order" order; no one had so thoroughly
worked out the symmetry of the compositions or had so ritualized the
action of the figures. Although the symmetry and balance are beautiful
and moving as artistic components, in a religious work it is not likely that
they are the final goal. We may still ask, in this case, What is the ulterior
argument?

A clearly visible tension between the "out of order" order and the the-
matic pairing is what started the discussion of Piero's cycle, and for all

our historical and visual analysis, this tension unquestionably remains. As a result, we must consider the tension itself as a possible guide to further meaning.

The fundamental connection between the Story of the True Cross and crusade propaganda puts the Arezzo frescoes into a long tradition of art with political content. In fact, a reference to the current conflict with Islam was so much to be taken for granted that it cannot be called "ulterior."[126] What has not been observed is that the inclusion of two battle scenes (those of Constantine and Heraclius) together in a monumental cycle of the Cross is unprecedented.[127] The scenes of Constantine, his vision, and his battle are, in fact, reintroduced into the visual tradition of Arezzo after an absence of more than three hundred years and introduced to monumental art for the first time. It was precisely during these centuries that, as we saw in chapter 4, aspects of the Legend of the Cross had been absorbed into the myth of Charlemagne and the troubadour tradition.[128] We have seen how important this tradition was for the Florentine cycle of the True Cross at Santa Croce. Between the end of the fourteenth century and Piero's time, moreover, we have evidence that large-scale mural decorations illustrating these romance tales had developed their own rules and habits of disposition.[129] Mostly they reflected their literary prototypes in rhythm and pace, often moving across walls unchecked by architectural framework. Episodes clash and interpenetrate; active figures fight, play games, and wear exotic clothes in spaces that are loose and fluid.[130] Perhaps the greatest surviving example in the tradition is the fresco by Pisanello in the *salone* of the Palazzo Ducale in Mantua (fig. 162), painted for the Gonzaga family in 1447–48.[131] As Piero's narrative moves about in raucous rhythms, with episodes in frameless scenes that disappear behind the walls, it recalls the halting twists of such picaresque decorations. Their subjects too, in the end, are all but identical: tales of knightly battles, devout ladies, and the recovery of the sacred relic. One of the points of Piero's disposition is thus to evoke the Franco-chivalresque mode of storytelling. In Florence, as we have seen, these Francophile allusions had strong political overtones, whose force remained fundamental throughout the fifteenth century.[132]

What was true for Florence, however, was not the case in Arezzo. For centuries the towns had been at war; battles raged back and forth throughout the Middle Ages.[133] A problem in Arezzo, as we know from the anecdote of Saint Francis related earlier, was that the proud and haughty Aretine families, and then the papal and imperial factions within the city, could never work together; a papal interdict in 1234–36 and further internal strife weakened the community in the face of outside pressure. By the early fourteenth century the city was split into two factions: the Verdi and dei Secchi (the Tarlati family), who were in constant conflict. In 1337 the latter sold the town to Florence. Twenty years later (1354) the adventurer Fra Morial stole it back. It was taken again in 1368 by Giovanni Acuto, the English mercenary, and again in 1381 by Alberico da Barbiano. As we have seen, in the late fourteenth-century wars with the French, Arezzo was put under siege and then occupied.[134] The final degradation came in 1385, when the French sold Arezzo to its old enemy. Henceforth Arezzo had lost its autonomy and would be ruled by a Florentine governor. The warring ended, but hard feelings between the towns

were never assuaged.[135] Even seventy-five years later, in the 1450s, it could not be imagined that the Florentine hero Carlomagno would have been a favorite with the Aretine Franciscans or their devotees.

Thus, on the one hand, while the picaresque chronology summons up visions of the French romances, at the same moment the harmonious classicism of the thematic pairing countermands the Franco-Florentine ideal. Charlemagne and his knights are replaced by Constantine and his army, poised not at the Milvian bridge but at the Tuscan Tiber (fig. 163).[136] As Saint Francis brought the cross of Christ to Italy engraved upon his body in the Stigmata, so Constantine in modern dress returns the Imperium of Holy Rome to Tuscan, even Aretine, soil.[137]

The local importance of this point can be found in the fact that the ancient Roman stronghold of Arretium counted itself uniquely blessed for having been an early convert to Christianity. Indeed, part of its basic self-image takes shape from the fact that the first bishop of Arezzo was nominated by Pope Sylvester during the reign of the emperor Constantine. The city therefore saw itself as benefiting from the virtues of its classical past, greatly augmented by the spiritual riches of the new faith.[138]

In this light the exaggerated symmetry takes on an almost patriotic air. It is but one of a series of classicizing elements that characterize the cycle. They may be described as follows: the argument is based on historical events and truths. The inscenation is grave and dignified; the figure

compositions are relatively isocephalic and held close to the picture plane; the figures are posed with decorum; their emotional expression is strong but reserved and unified psychologically. The battle scenes are filled with variety but are not cluttered. The spatial construction is rationally controlled and has proportional harmony. Some elements—like Helena's dwarf, the seminude ruffians, and the overdressed dandies on the altar wall—blend the serious and the humorous without disgrace. In sum, Piero has given us to understand that he has followed the principles laid down by Horace in his *Ars poetica* and has consciously translated them into visual form in order to paint a narrative in epic mode.[139]

At this very moment, Florentine humanists were attempting to revive the classical epic in literary form, and they were doing so, not surprisingly, by using as their subject the theme of Charlemagne and the Holy Defense. In a double twist of history, it was to flatter the French king and offer him a model for giving help in time of need that the nascent epic was launched. On 30 December 1461 at Tours, after Filippo dei Medici, bishop of Pisa, and two other Italian emissaries to the coronation of Louis XI had set the stage in their peroration, a then-young Florentine, Donato Acciaiuoli, read a Life of Charlemagne he had composed for the occasion. The *Vita Caroli* was written and presented in elegant Ciceronian style as praise for the new king.[140] Twenty years later, Acciaiuoli's friend Ugolino Vernio followed the same mode in his *Carliade*, now praising Charles VIII through the greatest of compliments, his likeness to the "French" king Charlemagne.[141] In both of these poems Charlemagne is drawn as the champion of the faith, rebuilder of Jerusalem, restorer of Christian Florence. He is called "Pius Aenea"; his son Orlando is called "Francorum magnus Achilles," and Rinaldo is "un altro telamonious Aiax." Both authors strive for Latin poetic form, and though their stories are identical with those of the "chanson" tradition, they make important strides toward a full-blown classical revival style. Their steps were the first in the development that led to Pulci,[142] Ariosto, Tasso,[143] and later in the seventeenth century, Francesco Bracciolini. All these authors objectively sought to compose the "modern epic," by which they meant "Christian."[144] In theme, their works are identical—the rescue of Jerusalem and finally, with Bracciolini, the actual story of Heraclius and the True Cross.[145]

I assert that Piero had already moved toward this goal in visual terms. To achieve these ends, content as well as form had to be reshaped: all editorializing episodes were removed, and only proofs of the efficacy of Christ's sacrifice were shown.[146] With his "festival" style and "classic" disposition, Piero bent the erratic serial fable into a heroic myth of Christianity's foundation and displayed it with the grandeur of the *Iliad* or the *Aenead.* His purpose was to represent the founding facts of early Christendom, preparation for the Messiah in patriarchal times, official conversion of the pagans, establishment of the cult of relics, suppression of heresy, and the liberation and protection of the Holy Land. By inventing visual equivalents for the classical "poetic arts," Piero placed the moral strength of classical theory at the service of Christian institutions. He satisfied the Franciscans with a cycle celebrating the Cross, fulfilling the words of Saint Bonaventure that paired Francis and Constantine: "God revealed the sign of the cross . . . to two members of Christ's mystical

body: to Emperor Constantine I and to St. Francis. . . . As he chose to imprint the sign of victory on Constantine, so he chose to imprint the sign of penance on St. Francis."[147] He also gave them reference to one of their own political preoccupations, the Turkish threat to their custodial domain. By doubling the battle scenes and representing Constantine along with Heraclius, he purged the story of its latent French accretions and made a stand for Aretine independence with the Bacci as the leading citizens. But most important, by calling attention to the compelling strength and universality of the Story of the True Cross as religious history, he grasped the potential of fresco disposition as a theopolitical tool and showed his ulterior argument to be a definition of the modern epic.[148]

7 Consolidation of Tradition: The Sistine Chapel and Beyond

Modernizing many of the traditional patterns of disposition, the Sistine, Sassetti, and Tornabuoni chapels joined narrative with theology, politics, and monastic allegiance. Leonardo da Vinci challenged the irrationality of stacked, perspectivized narratives at a moment when the conventions of narrative and architecture were undergoing reevaluation.

Piero's presentation of Christian theopolitical history created a new intellectual framework for Italian mural decoration that was to have an important legacy. In fact his contributions were soon carried forward in logical progression in the frescoes commissioned by Pope Sixtus IV for the walls of the Sistine Chapel. In that august sanctuary, some of the ideas developed at Arezzo were expressed within the now firmly reestablished Roman papal capital.[1] Sixtus's campaign of decoration formally began in 1481. Pietro Perugino headed a team of prominent Tuscan and Umbrian painters including Bernardino Pintoricchio, Domenico Ghirlandaio, Sandro Botticelli, Cosimo Rosselli, and Luca Signorelli, who finished the task in the astonishingly short span of less than three years.[2] By 9 August 1483, anniversary of his own coronation, Sixtus attended vespers in the chapel, and on 15 August, feast of the Assunta, to whom the chapel is dedicated, mass was said there for the first recorded time.[3]

Although the chapel was probably dedicated to the Virgin before this,[4] Sixtus reaffirmed the dedication with a new altarpiece.[5] Executed by Perugino, the composition showed Mary elevated above a landscape in a mandorla supported by angels. Below her were apostles and a kneeling figure of Pope Sixtus presented by Saint Peter, his papal forerunner.[6] With no sarcophagus or any other mundane detail, it did not depict "an Assumption" but was a strictly devotional image, polemical in nature. It represented an apostolic vision of Mary assumed in the flesh and confirmed Sixtus's belief in her incorruptibility. As a Franciscan friar, Sixtus directed much of his private devotion to the advocacy of the Virgin; as a theologian he was an avid promulgator of the dogma of her Assumption.[7] The altarpiece thus reflected his personal religious dedication as well as his official position on questions of doctrine. It was a bold statement, being over six meters high. It was executed in fresco and, along with its frame, was fully integrated into the design of the chapel. Although the subject had iconic rather than narrative value, the arrangement could be said to follow the tradition of integrated altarpieces established in the Bartolini Chapel sixty years earlier.[8]

All four walls were divided into four horizontal tiers by projecting cornices.[9] The narrative scenes of the cycle are on the third tier down, set out in large rectangular fields framed at the sides by painted heavy, flat

FIGURE 164. Vatican City, Sistine Chapel, reconstruction drawing

pilasters. These fictive supports are classical in style and decorated with acanthus scrolls emerging from voluted urns. Behind the pilasters are further classical moldings that frame the sides and top of the scenes. The painting fields are thus more elaborately articulated as separate units than in any previous cycle.[10]

The narratives consist of matching Lives, of Moses on the left and of Christ on the right (fig. 164). The disposition is the Double Parallel Apse-to-Entrance, with the two lives clearly set in typological relation to each other.[11] The arrangement has always been recognized as emulating that of Old Saint Peter's[12] and therefore as expressing ideological continuity with the primitive church. Various unusual choices of scenes and "out of order" placement of a number of episodes have been shown to express theological arguments.[13] The raised and gilded *tituli* found during the partial cleaning of these frescoes in the 1970s helped greatly in verifying these interpretations: in every instance, statements of promise in the Old Testament and fulfillment in the New echo each other verbatim across the nave.[14] Even before the inscriptions were found, Ettlinger's work revealed the expressive depth of the narrative components. He articulated with clarity and precision the theopolitical statement of apostolic succession and *primatus papae* that Sixtus IV had orchestrated in visual terms in this, the ceremonial center of the church of Rome.[15] Our particular task is to put these analytical accomplishments into the context of the history of fresco disposition. And when we do so, surprisingly enough, another important level of interpretation, to be discussed in a moment, is suddenly revealed.

Originally, the disposition was not a simple Double Parallel. Both sequences began on the altar wall (the *Finding of Moses* on the left, the *Nativity* on the right) and immediately turn the corners. Only then did the progression right-left on the left and left-right on the right proceed toward the ceremonial entrance of the chamber.[16] At the entrance end the

sequence again turns the corner, finally ending on the inside facade (diag. 35). We have seen earlier cycles that extend around corners[17] and many similar pairings of two lives, but no previous case worked precisely as it does here. The disposition was made to bend symmetrically at both ends, resulting in a harmonious bracketing effect. The traditional Double Parallel was thus modernized to embrace the full circuit of the room. The disposition of the papal portraits on the tier above adds another element to this unity. Grouped in pairs and arranged in chronological order, this sequence too starts at the altar end of the chapel. The chronology proceeds, however, not in the Double Parallel but moving across the nave in a zigzag from right to left and back again. The arrangement of the popes is thus a Boustrophedon. As part of an interlocking system, the disposition of these standing figures reinforces the side-to-side movement of the typology in the narrative fields they accompany.

In the context of typology, it is important to note that the locations of Old and New Testament types do not follow those of Old Saint Peter's. As we have observed, the most usual Early Christian arrangement put the chronologically earlier scenes from the Old Testament on the right wall and the later New Testament cycle on the left. This was the case not only at Saint Peter's but also at San Paolo fuori le Mura and the many churches that reflect their schemes.[18] The Sistine arrangement, in contrast, follows the less frequent Early Christian prototype that started the chronology on the left wall. The major remaining example of this type is Santa Maria Maggiore,[19] where the earliest scenes (from the Life of Abraham) start at the altar end on the left wall and the following sequence in the chronology begins again at the altar end of the right wall (with the later stories of Moses and Joshua). From the point of view of biblical chronology, therefore, the Sistine disposition follows not Saint Peter's but the mosaics in the lower register of the nave at Santa Maria Maggiore. We shall see that this allusion to the historical center of the cult of Mary was one of several in the Sistine Chapel.

The selection of Moses as a typological parallel for Christ was not unusual. Along with David and Solomon, Moses was one of several Old Testament personalities the church fathers deemed forerunners or antetypes of the Messiah. As we have seen, portions of their lives were often

DIAGRAM 35. Vatican, Sistine Chapel

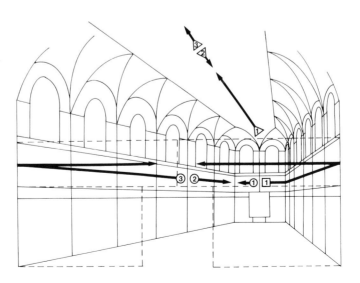

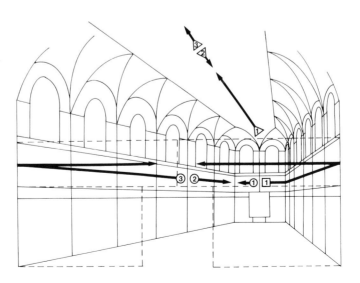

grouped together and placed in typological opposition to cycles of Christ's life. There are relatively few remaining cases, however, where one of these men is singled out for a full-scale, monumental cycle of his own.[20] And before the Sistine Chapel there are none that focus only on the Life of Moses.[21] Thus in presenting an isolated life of this particular Old Testament hero, with as many as twenty-six episodes, the Sistina is without precedent.[22] In these circumstances it is of great moment that many of the same subjects, as well as some of the actual figural arrangements in the scenes of the Sistina, find their source in, or at least some correlation to, the same subjects in the longest precedent Moses cycle, that at Santa Maria Maggiore.[23] This double dependence on Santa Maria Maggiore in both disposition and subject matter has not previously been observed. Yet it is precisely this relationship that, in my opinion, reveals a new level of meaning in the Sistine decorations—a heavy charge of Franciscanism.

It was immediately after Mary was declared the "Mother of God" at the Council of Ephesus (A.D. 431) that Sixtus III began the first great campaign in the decoration of Santa Maria Maggiore. Toward the end of the thirteenth century, Nicholas IV initiated the second, this one to promote worship of the Virgin in the context of doctrinal concerns of the Franciscan order. At the election of Francesco della Rovere to the pontifical seat in 1471, his papal name Sixtus IV was imposed because the conclave began on the feast day of Saint Sixtus II (6 August). It seems evident, however, that a nominal reference to Saint Sixtus III, his predecessor in devotion to the Virgin, was not a negligible factor in the choice. The cycle disposition was thus a visible reference to the initiator of the Marian cult. It also alluded to the work done in the same sanctuary by his one Franciscan papal predecessor Nicholas IV;[24] the polemical point of Torriti's apse mosaic was repeated, after all, in Sixtus's *Assunta* altarpiece. In this manner Sixtus IV put his own devotion and doctrinal stance in the same Franciscan context.[25]

The representational mode of the scenes in the Sistine Chapel is another element that seems to connect it to the mosaics in the venerable Marian prototype. The many *effetti* found in each large rectangular field are not differentiated from each other by the individually constructed architectural units found in earlier fifteenth-century inscenation.[26] On the contrary, all but one of the episode groups take place in open landscapes, which are loosely subdivided by folds of land, promontories, or bodies of water.[27] In terms of their large scale and deep spatial projection, these continuous landscape compositions may be described as "heroic." In this characteristic they again recall the mosaics of Santa Maria Maggiore in the narrative mode of the episodes at the apse end of the nave.[28] The purpose of this grand mode in the case of the Sistine scenes was to give each field its own fully developed *historia* showing motivation, action, and results. Though selected for their typological value, the episode clusters are made into "miniepics" in the history of the church, each complete within itself yet taking its place in the larger ideological sequence.[29] The figures of contemporary church officials and laymen depicted in most of the compositions may be thought of as choruses of witnesses who reap the benefit of the action in the scenes. That the typological parallels do not match the standard handbooks of the later Middle Ages is part of the cycle's modernity, reflecting the newer method of "internal typologies" I have de-

scribed as created for particular ideological content. The significance of these types was not so obvious, however, as to make verbal identification and confirmation unnecessary. Thus the function of the *tituli*, set out in *pastiglia* and gleaming gold. The complete combination of word and image carries the message of the ecclesiastical foundation of Rome and the ultimate authority of its God-given priesthood. The authority in the Old Law is consummated in the scene of *Michael Defending the Body of Moses* on the entrance wall to the left[30] and confirmed in the evangelical church by the image of the *Resurrected Christ* on the right.[31] The message is echoed in the altarpiece, in the figure of the Assumed Virgin, a guarantee of humankind's own resurrection at the end of time.

Understanding these guarantees makes it all the more imperative, it seems to me, to ask what was the specific impetus for breaking with tradition and choosing to represent, in this unprecedented way, a long cycle of the Life of Moses. The answer, I suggest, lies again in Sixtus's Franciscan roots.

Soon after Francis of Assisi died on the night of 3 October 1226, Brother Elias of Cortona composed a document that announced to the world the miracles of Francis's last days. It described for the first time the Stigmata and laid the foundation of what was to develop into the public image of the modest and private man. This letter included the following words: "Vos, ergo, carissimi fratres, ad quos litterae praesentes pervenerint, Israelitici populi sequentes vestigia, deplorantis Moysen et Aaron inclytos duces suos, viam demus lacrimis, tanti patris solatio destituti."[32] The Franciscan order is thus said to be the new Exodus, and the Chosen People are to be led by Saint Francis, who is both Moses and Aaron. Already during his lifetime Francis referred to himself as Moses, and the notion was made ever more explicit by his early biographers, particularly Bonaventura.[33] Some of the most obvious parallels drawn between Francis and Moses concern their similar roles as lawgivers. As Moses climbed Mount Sinai to receive the laws from God, so Francis retreated to Mount Alverna to consider the rule for his followers. Bonaventura says, "He came down from the mountain bearing in himself the form of Jesus Crucified, not portrayed upon tables of stone or wood by the hands of an early craftsman, but drawn upon his flesh by the figure of the living God."[34] Ubertino da Casale, the controversial fourteenth-century Franciscan author, made the connection between Moses' direct contact with the deity on Mount Horeb, when he removed his shoes, and the barefoot apostolate of Franciscan poverty.[35]

In the fifth fresco on the left wall of the Sistina, Botticelli's *Punishment of Corah* (fig. 165), the remarkable portrait of the Arch of Constantine in the central background brings up again the issue of Christianity's beginning as a state religion. Inscribed on the arch is a command to accept leadership only from him who is appointed by God, as Aaron was. The image performs as a *typus* to *Christ's Charge to Peter* directly opposite.[36] Ettlinger describes the argument as proving that Moses was ordained as a priest by God and that he vested his sacerdotal powers in Aaron. The exhortation on the arch confirms the action of Christ in vesting Peter, and thereby the Roman papacy in perpetuity. We are thus meant to see a threefold function of the two leading characters in the frescoes, Moses and Christ, as teacher, priest, and ruler, in the overall context of their

roles as forerunners of Saint Peter, the vicar of Christ on earth.[37] What we may now add to this interpretation is that both these characters, Moses and Christ, were reborn, according to Franciscan doctrine, in the figure of Il Poverello. In 1482, while the decoration of the Sistine Chapel was in progress, Pope Sixtus IV oversaw the canonization of Bonaventura and the Franciscan martyrs, bringing "victory to a cause and official sanction to the cult of Francis." Near the same moment, the first edition of Ubertino da Casale's treatise, *Arbor vitae crucifixae Jesu* (1485, Venice), became available in printed form. In the writings of this author, Francis's role is also described as threefold: he is identified as the reincarnation of the angel of the sixth seal, as *alter Christus*, and as *alter Moisè*.[38]

By introducing the fact that Saint Francis of Assisi was identified with Moses, I do not wish to imply that the scenes on the left wall of the chapel secretly represent the thirteenth-century saint. I do suggest that, given the notion of a double cycle renewing visual protocols of the early church, expressing the synchronous preparation for and founding of the True Apostolic Church, and affirming the *primatus papae* of the ruling pope, the choice of Moses as the antetype for Christ had a profoundly Franciscan thrust. Only with an understanding of the figure of Saint Francis as the unique tertium quid do the choice of cycle disposition, the choice of a long Life of Moses as a parallel to that of Christ, and a dedication to the Virgin Mary all come together as necessary components of a unified idea.[39] That Sixtus IV, along with his Franciscan contemporaries, championed the doctrine of the Immaculate Conception of Mary cannot be discounted as one of the strongest of all the motivating factors for the chapel's decoration. This doctrinal point was utterly rejected by the Dominicans of the time. Vincenzo Bandelli, a leading Dominican spokesman, made public statements to the effect that those who declared the conception of the Blessed Virgin to have been immaculate were guilty of heresy and, accordingly, or mortal sin. The dispute was finally so violent that Sixtus IV issued the bull *Grave nemis* specifically to deny the claims of the Dominicans.[40] The chapel and its mural decoration seem to stand in answer to the same claims.

FIGURE 166. Vatican City, Sistine Chapel, right wall, Cosimo Rosselli, *Last Supper* (see plate 19)

While we have seen the use of fresco cycles to communicate ideas from the very inception of Christian art, the argument of the Sistine Chapel in itself makes overt allusions to this practice. It seems not by chance that Piero's cycle, precedent to the Sistina and with similar Constantinian themes, should have been for a Franciscan patron in a region where the anti-Florentine sentiment was just as strong, if surreptitious, as it was under the Franciscan pope. The war between Sixtus and the Florentines came precisely one hundred years after a similar struggle between the city and the papacy.[41] If we find the paintings in the Sistine Chapel burdened with the weight of multiple levels of ideology, it is because Sixtus IV had discovered in his own Franciscan roots the potential and the power of the public visual image.[42]

Most of the artists who shared in the commission of the Sistine Chapel were fairly young, and the experience helped to shape their futures. For Cosimo Rosselli, the oldest of the group, it was a kind of swan song, perhaps the major contribution of his career. According to Vasari, Rosselli was singled out for praise by Sixtus IV and asked to add still more rare and costly blue and gold to his compositions.[43] Though the scenes of the *Red Sea, Sinai,* and *Sermon on the Mount* may look somewhat cluttered and anatomically weak, they seem to have pleased the pope. Where Rosselli achieved real pictorial stature, however, was in the final scene in the sequence, the *Last Supper* (fig. 166), in the last position on the right wall. There he condensed the whole of Christ's Passion into a single spatial unit, making one of the most ingenious compositions in the series. In representing the Upper Room, Rosselli created an architectural space that extends laterally behind the two decorated pilasters framing the field; two contemporary spectators stand at either side of this area, giving reality to the corridor of space between the standard frame and the scene. He then constructs a polygonal refectory, supported at the front by two square pilasters decorated with running palmettes and seen in perspective. The plan of the room is emphasized by a five-sided dining table, the decoration of the pavement, and the trabiated structure of the ceiling. The upper part of the back wall is a three-faceted portico supported by six small

FIGURE 167. Florence, Santa Trinita, Sassetti
Chapel, general view, Domenico Ghirlandaio
(see plate 20)

pilasters decorated in harmony with those in the foreground as well as
with the larger outer frames. In turn, they frame three openings in the
back wall. In each of these smaller rectangular openings we see a separate
scene continuing the narrative.[44] The time sequence moves from front to
back and from left to right, with the earliest scene in the main space
(*Christ and the Apostles at Table*); the second is on the left in the back-
ground (the *Agony in the Garden*), and the third is in the center (the *Ar-
rest of Christ*). The last scene on the right, the *Crucifixion*, is dramatized
by an innovative oblique view of the subject. Each of the final scenes of
Christ's life is thereby uniquely (in the chapel) isolated and dignified
within a separate architectural frame. We shall see that the use of per-
spectivized pilasters as framing devices will have a long and impressive
life in chapel decorations of the later 1480s and 1490s.

Domenico Ghirlandaio was one of the first artists to put his experience
in the Sistine Chapel to use. After he returned to Florence in 1482 he
gave his full attention to a commission he must have been considering all
the while he worked in Rome. Even before 1479, at least two years before
the papal commission, he had begun sketching scenes for the burial
chapel of Francesco Sassetti and his wife in the right transept wing of
Santa Trinita in Florence; the project was finished in 1486.[45] Although it
is justly famous for its innovations in the realm of classical revival,[46] the
Sassetti Chapel (fig. 167) should be thought of first as the direct descend-
ant, on a small, private scale, of the public message-bearing cycle in the
papal chapel.

The earliest episode of the sequence, which is on the exterior face of
the entrance arch,[47] is not ordinarily associated with the life of Saint
Francis. The *Vision of Augustus and the Tiburtine Sibyl* (fig. 168, diag. 36)
is an apocryphal episode usually connected to the Life of Christ.[48] Not
only does it at first glance seem out of place, it also does not have its usual
form. The two leading characters with their entourages face each other
across a narrow, stagelike parapet, observing with amazement an airborne
vision at the apex of the pointed arch. What they see is not the traditional
image of the Virgin and Child seated on an altar, characteristic of this
scene, but the flaming trigram of Christ (YHS), emblem of the Francis-
can Observant reform. Thus, even before entering the precinct we are
alerted that a guiding principle of the chapel will be Franciscan thought in
the particular self-abnegating form promulgated by San Bernardino of
Siena.[49] Behind the figures at some distance is an astonishing panoramic
vista of Rome. The bird's-eye view tells us that the figures are "correctly"
placed where the vision occurred, high on the brow of the Capitoline Hill,
location of the "future" church of Santa Maria in Aracoeli. At the same
time we see that the image of the Eternal City is anachronistically por-
trayed in its "future" Christian form.[50]

The prediction of the sibyl is fulfilled in the scene of the *Nativity of
Christ* represented below in the altarpiece. Signed and dated 1485 by
Ghirlandaio, the panel is "incorporated" into the wall as part of the dispo-
sitional scheme; the classical style of the carved frame matches the
painted architecture of the chapel. In this characteristic it is reminiscent
of Perugino's earlier altarpiece for the Sistine Chapel and also of Lorenzo
Monaco's altarpiece in the Bartolini Chapel, just across the transept,
where the tradition began.

DIAGRAM 36. Florence, Santa Trinita, Sas-
setti Chapel

FIGURE 168. Florence, Santa Trinita, Sassetti Chapel, entrance arch, Domenico Ghirlandaio, *Vision of Augustus and the Tiburtine Sibyl*

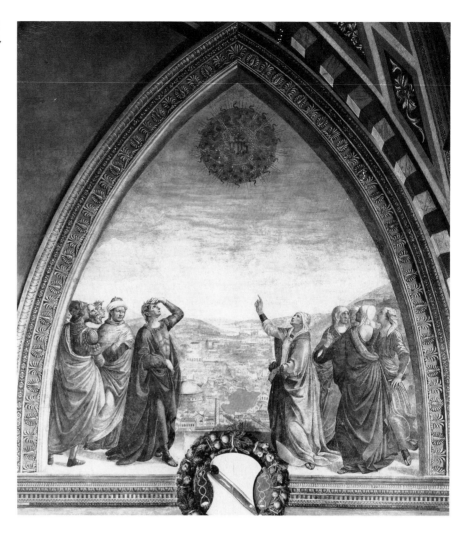

The Francis cycle, which cover the three inside walls of the chapel, is disposed in the Apse pattern. The chronology proceeds from left to right and from the top down in two concentric tiers.[51] In this manner it recalls, with all possible directness, the Franciscan mother church in Assisi and the archetypal disposition of its Marian apse.[52] However, a second organizational motif is also evident: this is a Straight-Line Vertical, top to bottom, that intersects the Apse pattern at the center of the altar wall. Since this secondary axis involves what has often been described as a puzzling irregularity in the narrative order, some further analysis will be useful.

Long ago, Aby Warburg demonstrated Sassetti's desire to commemorate personal and professional events in his life by nesting them within the life of his religious patron. Among the events of great importance was the untimely death of his oldest son Teodoro at the age of eighteen. The young man had been working in Geneva as manager of one his father's banks, and his career seemed headed for success when death overtook him. A visual reference to this sad occasion may be found in the first frame of the cycle, *Saint Francis Renouncing His Patrimony*. The figure of the disapproving father in the scene is more severe than most comparable characters; he holds a whip and seems viciously angry.[53] The city on the lake in the background is recognizable as Geneva and hence is connected

to Teodoro. But such an explicitly cruel interpretation of the event may indicate Sassetti's guilt at somehow having helped bring about his son's death. The standard episode is thus given particular meaning for the donor, who thereby locks his destiny with that of Saint Francis.

In life this tragedy was followed, in May 1479, by the birth of another male child whom Sassetti named Teodoro II. Warburg's proposal was to identify this happy event with the scene on the second tier of the altar wall, the *Resuscitation of the Notary's Son*.[54] In the Franciscan incident, a child has been killed by jumping out a window. He is restored to life when his father answers yes to the question, "Do you believe Saint Francis can raise your child from the dead because of the love he had for Christ, who gave life back to men by his crucifixion?"[55] Paternal affirmation of faith, followed by a pledge to serve Francis for the rest of his life if he is found worthy of such compassion, is seen as Sassetti's own. While this interpretation has been universally accepted, the placement of the scene is still considered problematic. Being a posthumous miracle, it should have come after the saint's own death. Instead, following the logic of the Apse pattern, it comes before. As we have seen, it was common practice to make such rearrangements in visual order to express an "ulterior argument." Thus laying the ghost of irregular placement, we move on to discover what the deeper implications may be.

A second problematic area has been the setting of the scene. According to the story, the episode occurred near the Piazza San Marco in Rome, whereas in the painting the background is Florence. The view shows specifically the piazza outside the Church of Santa Trinita.[56] This transfer of locale, moreover, is matched in the scene directly above, where the *Confirmation of the Rule*, which took place before the pope in Rome, is represented in the fresco as happening in Florence, near the Piazza della Signoria.[57] In fact, these localized settings develop the cityscape conceits in the altarpiece below[58] and are the final link in defining the secondary axis in the chapel's overall organization.

The ulterior argument begins to unfold when we see that the scenes on this axis are united under two rubrics. The first is one of locale: as the Tiburtine sibyl prophesies world peace under Franciscan Observantism, she and Augustus stand in the locale that will become the church of Santa Maria in Aracoeli, Observant center in Rome.[59] Behind them, the view includes Old Saint Peter's, where Francis's rule was accepted, the historical locale of the top-tier scene, and Piazza San Marco, where the posthumous resuscitation miracle, represented in the lower tier, took place.

The other rubric is thematic: the *Rule* scene represents the birth of the order under Saint Francis himself; the *Revival* scene represents the rebirth of a son, with pointed significance for Sassetti; and finally (or first) the *Nativity* is the birth of the Savior, as prophesied by the pagans (the sibyl).[60] These scenes are arranged in one vertical column that descends from the entrance arch to the altarpiece, intersecting the Apse pattern at its center. Furthermore, the two patterns are bound together by the mortuary theme of the chapel. The scene of the *Funeral of Saint Francis* is immediately above and therefore associated with the tomb of the donor.[61] The tombs of the two Sassettis, like loculi filling the lowest tiers of the side walls,[62] join with the antique sarcophagus represented in the altarpiece to create a horizontal group of three. The final effect of these

interlocking patterns is an ideological grid that clarifies the ulterior argument: as Francis is the new representative of Christ on earth, so the individual's experience is interlocked with his devotional paradigm. Sassetti has linked his personal destiny to that of his patron saint in a profoundly new fashion.[63]

Our discussion up to this point has not repeated the facts concerning Sassetti's relation to Lorenzo de' Medici or the humanist framework of these monumental decorations,[64] but it recognizes the important role these modern innovations played in reinforcing the profound religiosity involved. It might be said, in fact, that Francesco Sassetti here gives thanks to three patrons: to Lorenzo de' Medici, who saves him professionally and literally stood by him in opposition to his banking enemies, helping to preserve his patrimony;[65] to the Virgin and her son, patrons of the Observant Franciscans, who delivered a new Teodoro; and to Saint Francis, Sassetti's sponsor and advocate, who gave him consolatory support and faith in the ultimate regeneration of his lost son and his own immortal soul.[66]

Further evidence for this argument lies within the details of the altarpiece, where, as I have said, the architectural landscapes complete the Florence/Rome conceit. The notion of identifying Florence with Rome within the political and cultural context of the 1480s[67] should be placed within a much older tradition. The founding myth of the city claimed that Christian Florence was constructed in the image of Early Christian Rome. Villani's *Chronicle* describes in full how the Florentine churches were topographically disposed to imitate the great pilgrimage churches of Rome. Among other churches with prototypes in Rome, Villani identifies the church of San Pier Scheraggio (seen next to the town hall in the *Rule* scene) with Old Saint Peter's.[68] The family of Sassetti's wife, Nera Corsi, were Fiesolani (that is, born in Fiesole), and thus by birth among the warlike neighbors who had destroyed Roman Florence in the distant past. As we have seen, in the founding myth,[69] when the Christian city was refounded by Charlemagne, the Fiesolani were subdued forever. The happy marriage of Sassetti and Corsi, recorded here in the funeral inscriptions,[70] represents the harmony in which ancient factions had lived together for centuries under Christianity. Moreover, their companionship is made visible in the foreground of the altarpiece. A chunk of white marble representing the husband (*sassetto* means stone) and a pile of brick referring to the wife (in the sense that bricks are laid in courses, *corsi*),[71] lie together just below the newborn Savior. They are the building blocks of the new renewed Christian religion, expressed in the syncretism of classical purity, Old Testament heroism, and *Franciscus alter Christus* in its modern, Observant formulation.[72]

In contrast to the downward movement of the narrative, the painted scaffold that supports this ideological grid rises upward in a hierarchy of ever-decreasing weight. Above the marble dado circling the chapel and defining the height of the altar table, classicizing pilasters support the realm of the tombs. Fluted Corinthian columns sustain the second tier, beyond which the narrative fields open out into fictive space. The crossribs of the vault are painted as a bower of fruit and flowers. The artist has defined a world of spatial unreality in which landscape and architectural settings from a variety of worldly locales are represented with new ele-

ment of realism but are revealed as having significance far beyond the simple recounting of narrative history.[73]

These innovations should be kept in mind as we analyze Ghirlandaio's next (and last) major commission, the double cycle of the Virgin and Saint John the Baptist, painted for Sassetti's archrival, Giovanni Tornabuoni, in the chancel of Santa Maria Novella (1485–90). In contrast to the previous commission, the organization here is so rigorously correct in chronology and so smoothly ordered in disposition that it is often mistaken for being obvious and inevitable (figs. 169, 170). It is even possible that many widely held preconceptions about mural arrangements are unconsciously based on its formulation. But in fact the final disposition was a hard-won classic statement, subtle in concept and suave in execution. Unlike Sassetti, Tornabuoni had excellent rapport with the Dominicans of Santa Maria Novella, and he seems to have embraced straightforward religious values in an almost antihumanist way.[74] Many family members, citizens, and prelates are included in the scenes, but little or no reference is made to private feelings or experiences.[75]

For this commission there exists a contract that contains a passage of great importance for our subject. This contract not only includes the titles of the scenes to be portrayed but also indicates how they were to be disposed.[76] It spells out seven subjects each for the two Lives, implying one scene in the lunette and two on each of three tiers. It then goes on to say: "Incipiendo in parte inferiori, ascendendo ad superiorum partem." Thus we have in writing that the narrative is to "start" on the bottom and "move" to the top. As far as I have been able to discover, this document is unique in referring to even one element of disposition.

When the frescoes were executed, however, the number of scenes and the subjects mentioned in the contract were changed.[77] In the Marian cycle on the left, the *Purification of Mary* and *Christ among the Doctors* were dropped and three new scenes were added: the *Expulsion of Joachim*, the *Presentation of the Virgin*, and an almost battlelike scene of the *Massacre of the Innocents*.[78] In the John cycle, the *Naming of John* was inserted and treated as a monumental monoscenic composition. It has been suggested that the addition of this episode responded to the birth of a grandson to Giovanni, who indeed was named for him, Giovanni di Lorenzo di Giovanni Tornabuoni.[79]

An even more important change was on the level of the second tier of each story, where a third episode was added in a smaller field on the adjacent altar wall. Following the scene of the *Marriage of the Virgin*, the *Annunciation* (fig. 171) appears on the altar wall to the left. After the *Naming of John*, we find the *Young Saint John Departs for the Desert* (fig. 172) on the right (diag. 37). Both these scenes had been placed on the altar wall before.[80] But here the turning of the corner serves to isolate and emphasize scenes in each Life, in contrast to the larger fields, that the characters experience alone and that represent major turning points in their physical existence.[81] Equating the energetic figure of Saint John, who rushes forward to his new life, with the Annunziata visually elevates the apocryphal image, by this time almost a hallmark of the city of Florence, to the status of dogma.

The result of these readjustments is a completely harmonious arrangement. For the first time in the history of monumental wall decoration, all

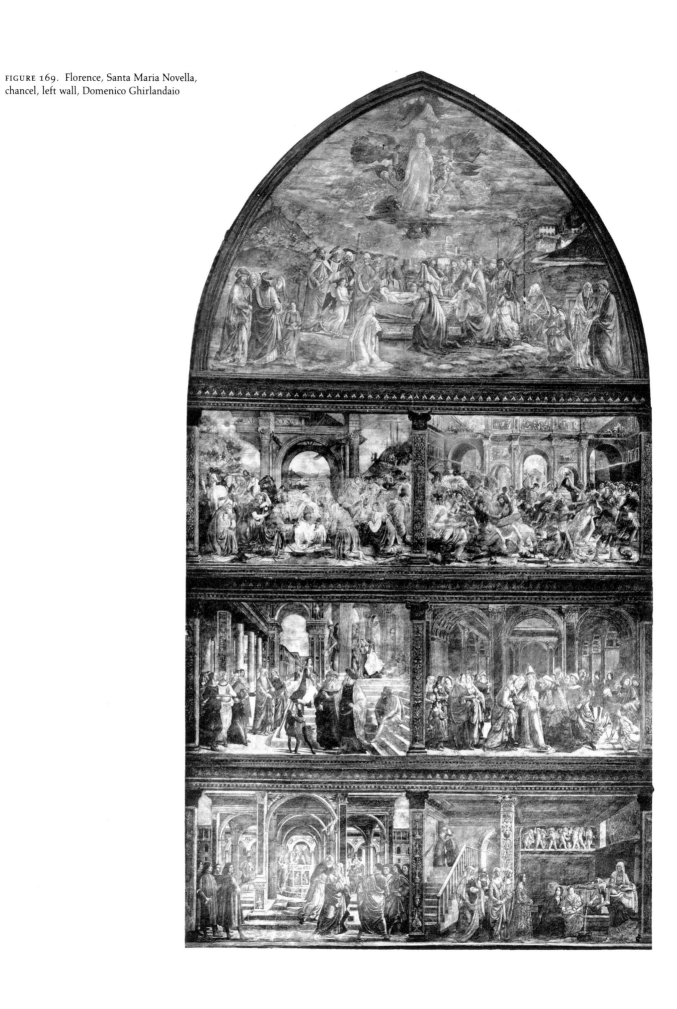

FIGURE 170. Florence, Santa Maria Novella, chancel, right wall, Domenico Ghirlandaio

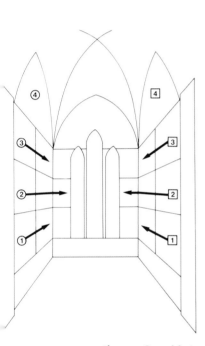

DIAGRAM 37. Florence, Santa Maria Novella, chancel

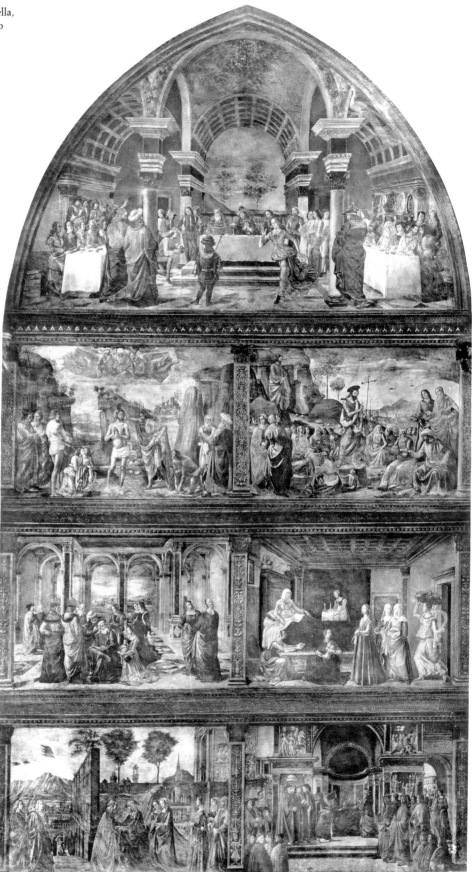

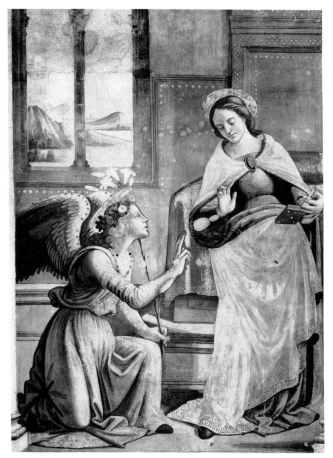

FIGURE 171 (*left*). Florence, Santa Maria Novella, chancel, altar wall left, Domenico Ghirlandaio, *Annunciation*

FIGURE 172 (*right*). Florence, Santa Maria Novella, chancel, altar wall right, Domenico Ghirlandaio, *Saint John Departs for the Desert*

the scenes move smoothly from the nave to the altar wall on every tier. That is, they read from left to right on the left wall and right to left on the right wall, both sides ending with a single episode in the lunette. The two sides mirror each other; with no issue of chronological precedence, the two Lives are meant to be read in concert. The almost geometric matching of scene placement has its counterpart in the internal organization of the scenes themselves. Each rectangular tier is divided into two fields by a central flat pilaster painted with classical grotesques. The same motif frames the scenes on the lateral limits. The framing devices, in turn, form part of the settings, casting shadows on the ground and adding to the depth of the represented spaces. Perspective is used with accomplished understatement, the viewpoint becoming slightly more oblique as the tiers rise. The result is the perception that, although the scenes are high above one's head, the action nonetheless seems relatively easy to view. The light in all the scenes on both sides works against the narrative emanating from the direction of the real window on the altar wall. Architecture, all represented in grand classical style, is for the most part centralized and frontal. With few exceptions (the *Birth of the Virgin* and the *Visitation*), asymmetricality is used to reinforce the movement of the narrative. The landscapes in *Saint John Preaching* and the *Baptism of Christ* work so that the cliffs at the sides come together at the center to unify the tier as a whole. Figure groupings are also centralized, with the main figures clearly outlined in the center of the represented space. The

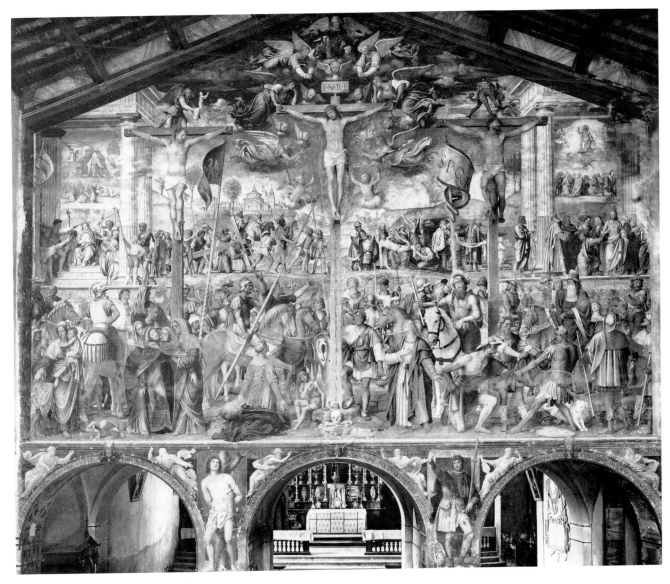

FIGURE 173. Lugano, Santa Maria degli
Angeli, altar wall, Bernardo Luini, *Story of
the Passion*

DIAGRAM 38. Ivrea, San Bernardino, choir
screen

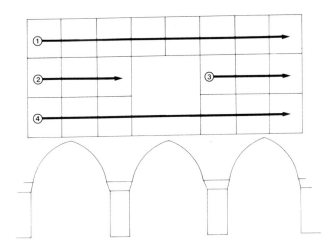

portrait spectators in the lower, more accessible tiers[82] add their presence to the scenes unobtrusively and without interrupting the narrative flow.[83]

The chapel thus presents a double cycle that reads in continuous, unbroken rhythmic continuity, in such a simple pattern that one tends to overlook the fact that it is absolutely without parallel in the history of art. We might say that in this cycle fifteenth-century freedom in visual order is replaced by an equal measure of carefully prepared "visual balance." What started as a signpost of ulterior information in Piero della Francesca's cycle in Arezzo here becomes a soothing reassurance of doctrinal stability. For this achievement in classical equilibrium, so well realized as to go almost unnoticed, Domenico Ghirlandaio remains largely unsung. Moreover, his contributions were not carried forward directly because of the introduction of new architectural forms and, as we shall shortly see, of a new conception of the wall as a field for painting.

For a time, however, stacking lived on in a rather coherent tradition that developed in Lombardy in direct relation to the Franciscan Observant movement as it flourished there late in the century.[84] Many original choir screens, or *tramezzi*,[85] survive in these Lombard churches, possibly because they are structurally rather permanent. They consist of solid walls not only extending the full width of the nave but also reaching to the ceiling. Preaching was done from a pulpit that ordinarily stood close to and at a height level with the solid part of this transverse wall. These walls were regularly painted with elaborate Passion cycles, which apparently functioned as exempla in the preaching of the Observant mission. The earliest and most famous of these cycles (now destroyed) was in San Giacomo in Pavia, painted by Vincenzo Foppa and others about 1480–85. The many extant exampled dating over the next fifty years[86] all seem to follow the same pattern. The uninterrupted surface of the membrane wall is divided into as many as twenty vertical rectangles (diag. 38). The story generally reads left to right across three or more stacked tiers, starting on the left at the top of the wall and moving down to the bottom right corner. Within a straightforward sequence of narrative illustrations, usually lacking illusionism or elaborate framing devices, the *Crucifixion* is centrally placed and enlarged to four times the size of the other scenes. As we have seen, this manner of singling out the Crucifixion for emphasis depends on the Early Christian protocol established at Saint Peter's at least by the ninth century. Its use in these *tramezzi* decorations reflects the fundamentalist ideology of the order at this time, emphasizing the values of the primitive church: dedicated allegiance to Rome and unwavering Franciscan devotion to the Cross.

Leonardo da Vinci made his second trip to Lombardy in the early 1490s and perhaps had these very walls in mind, along with examples in Tuscany, when discussing the matter of stacking scenes in the notes for his treatise on painting. In no uncertain terms, Leonardo states that he finds this habit absurd: "There is a universal custom followed by those who paint on the walls of chapels which is much to be deplored. They make a composition with its landscape and buildings on one plane, then go higher and make a composition in which they change the point of view, and then paint a third and a fourth, so that one wall has four points of view. That is utmost stupidity on the part of those masters."[87] To Leonardo, the unity of space, time, and action and the rejection of illusion-

ism suggesting things not possible in nature seemed self-evident.[88] For him the goal of art was successful re-creation of terrestrial space with the new pictorial tool of perspective. He therefore considered fools those artists who continued to use stacking when it caused them to pierce the wall over and over again.[89] If we continue his logic we must then assume that as Fra Angelico, Masaccio, Piero della Francesca, Perugino, and others became more and more skilled they became more and more compromised by the old-fashioned approach that inhibited their progress toward the ultimate simulacrum. However, these very artists, from Masaccio to Fra Filippo, from Piero to Ghirlandaio, made no effort whatever to dissimulate their superimposed spatial fields. In most cases, in fact, they called attention to their perspective impossibilities by painting heavy frames around their spatial illusions and meticulously detailing the severed edges of earth, water, and man-made constructions sliced off by the picture plane. They continued to use gold for details and modeling and *pastiglia* for further richness, insisting with these techniques that their products should not be thought of as imitating what was real. Rather than making mistakes, these masters took full advantage of stacking to unify the space of the total ambient and carry their mix of rationally delineated forms in unnatural relationships expressively as far as it would go. That the great artists of the Early Renaissance persisted throughout the fifteenth century in using these devices, even after Leonardo's admonitions, demonstrates not a willingness to be coerced by inhibiting forces but rather an objective choice intended to achieve certain strongly prized goals.

Although Leonardo never participated in the execution of an extended narrative, he did not stop with criticizing the methods of others but went on to describe how he would handle a cycle if called upon:

> If you ask me how shall I paint on one wall the life of a saint which is divided into may incidents? My answer is that you must place the first plane at the eye-level of the beholder of the scene and on that place represent the first scene in large size, and then diminishing the figures and buildings on the various hills and planes, as you go on, make the setting for the whole story. And as to the remainder of the wall, fill it with large trees in relation to the figures, or with angels, if they fit the story, or perhaps birds or clouds. If you do otherwise you will exert yourself in vain and all your work will go awry.[90]

In this context Bernardino Luini's large Passion cycle in Santa Maria degli Angeli, Lugano (fig. 173), takes on fresh interest.[91] We have seen how this work falls within the local northern Italian *tramezzo* tradition in its location in the church and in its subject matter. Yet in disposition it seems to follow Leonardo's precepts precisely. Luini places the large *Crucifixion* "on the line of sight" in the foreground, as the focus of attention. Then, without dividing the rest of the field by any sort of framing, he creates architectural platforms on each side and behind Golgotha, where the rest of the episodes of the Passion are represented more or less sequentially across the lower part of the background. Symmetrical aediculae on either side house two scenes each and a third outside, from the *Agony in the Garden* (left) through the *Ascension* in the upper part of the right aedicula.[92] The part of the background behind the figural scenes is then filled with sky and clouds. Whether this updated version of the continuous narrative mode achieved the "elemental situational coherence"

that has been described as Leonardo's aim better than other types of narrative procedure, I leave to readers to decide,[93] observing only that it persisted a much shorter time than did the stacking system. Interestingly enough, the early mural landscapes by Polidoro da Caravaggio, a native of northern Italy, in San Silvestro al Quirinale in Rome (about 1518–24?) follow the idea of multiple scenes in a unified space (Lives of Saint Catherine and the Magdalene), set among the natural plateaus of dwellings and hills, in large vistas arranged with utmost coherence.[94] Thus this particular northern Italian development, if it can be counted as such, was perfected and delivered to Rome in very short order.

Nevertheless, it is important to realize that Leonardo was not alone in having new attitudes toward the wall in the fourth quarter of the fifteenth century. The old methods he was so eager to reject were already being enthusiastically replaced, in the realm of architectural structure as well as the structure of narrative, in the repertories of the upcoming younger generation.

8

The Expanded Field and Its
Narrative Implications

In the later fifteenth-century expansion of the fresco painter's format from a series of stacked lateral rectangles to a single, unified lunette-topped field, the traditional patterns of disposition were given new trajectories. In this new format the "Boustrophedon" and the "Up-Down, Down-Up" patterns served to aggrandize metaphorical levels of cycle content. Signorelli introduced a new form, the "Counterclockwise Wraparound." In the Sistine Chapel Michelangelo recast the "Double Parallel" and the "Cat's Cradle."

Niccolò di Manno Bufalini di Castello Bufalini, a consistorial lawyer and *imbreviatore de parco majori* in Rome, commissioned a fresco cycle for his mortuary chapel in Santa Maria in Aracoeli in the early 1480s, while the Sistine Chapel decoration was still in progress. The subject of the cycle was a Life of the fifteenth-century Franciscan friar Bernardino da Siena, who died in 1444 and was already sainted in 1450. During his lifetime San Bernardino had acted as peacemaker between the Bufalini family and their Perugian enemies the Baglione, and he remained thereafter the Bufalini patron. As leader of the Observant reform and vicar-general of the Franciscans (1438), Bernardino himself had placed the Church of Santa Maria in Aracoeli under the authority of the Observant friars. The subject of his life for a fresco cycle in this locale could not have been more appropriate.

Bernardino Pintoricchio, then in his mid-twenties, was given the commission, and his results immediately give evidence of a major departure in the field of mural disposition.[1] In a quite novel manner, Pintoricchio divided the side wall surfaces into two tiers rather than the more usual three. These tiers consist of a lunette and one large rectangle, separated by a heavy cornice. He framed each wall for its entire height with a monumental order of pilasters depicted in perspective.[2] Pintoricchio's innovation surely developed out of Cosimo Rosselli's *Institution of the Eucharist* in the Sistine Chapel, where perspectivized classicizing pilasters define the space of the scene. Pintoricchio reinterpreted the device by moving the pilasters forward to the surface of the field and transforming them into a frame for the whole area. He thereby integrated the painted space with the real architecture as had never been done before.[3] The result of this new treatment is most clearly visible on the left wall, where both the lunette area and the rectangular field below assume proportions (no matter what the actual dimensions) more grandiose than in earlier chapels. This opening up of the pictorial format is what I call the "Expanded Field," and its implications for the expression of new complexities in religious devotion, as well as penetration into new depths of psychological experience, were to characterize cycle painting for the next two decades.[4]

Since the chapel is immediately adjacent to the entrance of the church at the top of the steps, the right wall is the actual interior facade of the

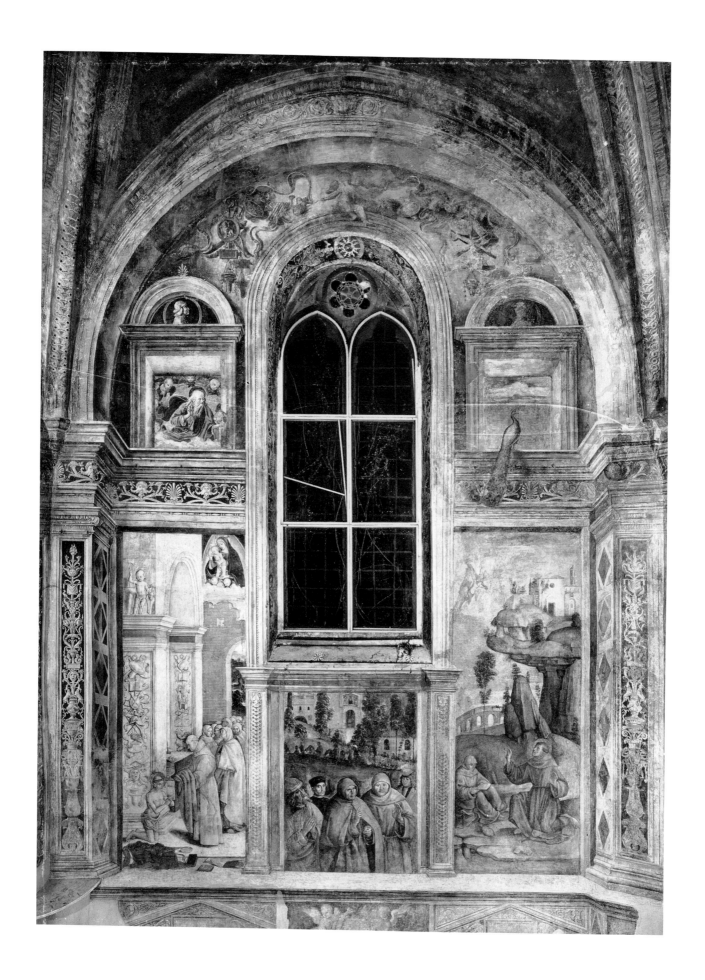

building (fig. 174). It has the same division into only two tiers as the left wall, but it is pierced by a real opening that starts in the lunette and breaks through the painted cornice into the space of the field below. Flanking this real window are two painted windows with perspectivized jambs that rest illusionistically on the painted cornice. Each is topped by a lunette holding a profile bust. On the left a representation of God the Father surrounded by cherubim looks into the space; a splendid peacock sits on the sill of the painted window on the right. The result is a series of openings in the lunette tier through which appears the celestial realm high above Rome. The lower tier holds three scenes, spatially quite separate from each other, yet bound together by the line of sight of God the Father, who gestures down diagonally to the right toward an image of the Stigmatization. The altar wall is more genuinely unified, with the cornice omitted altogether (fig. 175). San Bernardino is shown standing before a panoramic landscape flanked by two Franciscan saints, Louis of Toulouse and Anthony of Padua. He displays a book and points to Christ, who

FIGURE 175. Rome, Santa Maria in Aracoeli, Bufalini Chapel, altar wall, Pintoricchio, *San Bernardino in Glory*

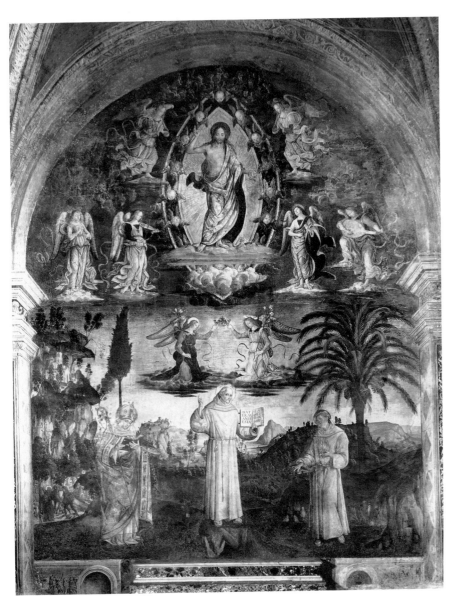

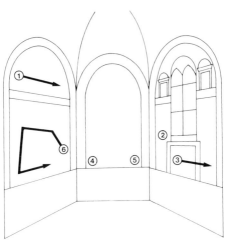

DIAGRAM 39. Rome, Santa Maria in Aracoeli, Bufalini Chapel

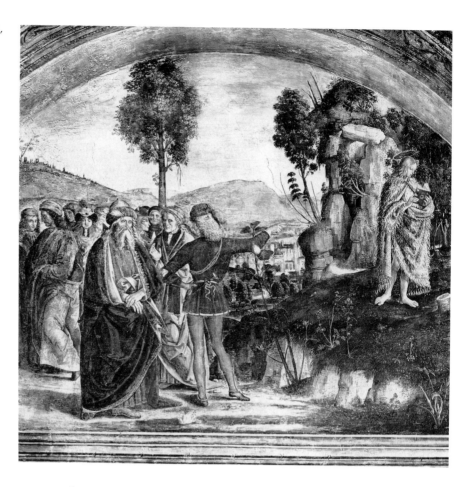

appears above in a mandorla. The great, lunette-topped image is thus not
narrative but devotional. And indeed its scale and format depend without
doubt on the fresco altarpiece Pintoricchio knew in the Sistine Chapel.[5]

In the Life of San Bernardino, which begins chronologically on the up-
per tier of the left wall (fig. 176), the narrative technique is as new as the
setting (diag. 39). Rather than particular events, the artist has depicted
visual sermons. Almost every episode alludes to Bernardino's commen-
taries on his own life as he used them in preaching.[6] Reading left to right
in the lunette, a group of Sienese citizens engage in heated discussion.
An elegantly dressed young man points at the object of their consterna-
tion: a beautiful youth, wrapped rather ostentatiously in the goatskin of
a pilgrim, standing in the wilderness reading a small book. The boy is
Bernardino Albizzeschi, a wealthy young student of jurisprudence and
the classics, who has entered the "desert" outside the city to follow the
teachings of Saint Jerome. The focus of the scene is the interplay between
the two boys. The pointing youth turns his voluptuous back to the pic-
ture plane and the branch of a fig tree passes across his arm. The young
Bernardino ignores him as he meditates; there is a jack-in-the-pulpit be-
low his feet. The fig is the biblical symbol of lust (Gen. 3:7);[7] the jack-in-
the-pulpit, *arisaro* in Italian, is a floral indication of Bernardino's future
as a preaching friar.[8] San Bernardino was to recall such a Sienese "sod-
omite" who made advances toward him in his youth in the sermon,
"L'abominabile peccato della maladetta soddomia," and the painting is a
visualization of this lesson.[9]

The narrative continues on the right wall, lower tier at the left, with the *Vesting of Bernardino.* Like that of Saint Francis, his nakedness signifies utter rejection of his family's worldly goods to take the friar's robe. In contrast to his elegance in the earlier scene, he now embraces the Observant Franciscan rule of total poverty.[10] The scene includes references to other acts of his early religious dedication. He once carried a cross to Seggiano in the heat of summer, and his nakedness could refer to that occasion. The Virgin and Child appear over an archway in the background, as in a vision on clouds. The saint speaks of inspiration received from such an image of the Virgin (in glory, surrounded by angels) on the Porta Camollia.[11]

Leaving the life of the saint, a remarkable scene composed of what look like contemporary portraits is framed in the next space to the right. Under the window just over the patron's sarcophagus,[12] five figures, Franciscan friars and laymen, are shown close up and three-quarter length (fig. 177). The two hooded friars display their rosaries; one points to the

FIGURE 177. Rome, Santa Maria in Aracoeli, Bufalini Chapel, right wall, Pintoricchio, *Walking Friars*

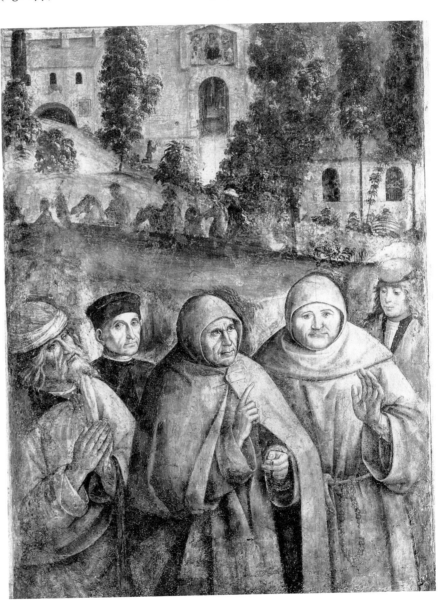

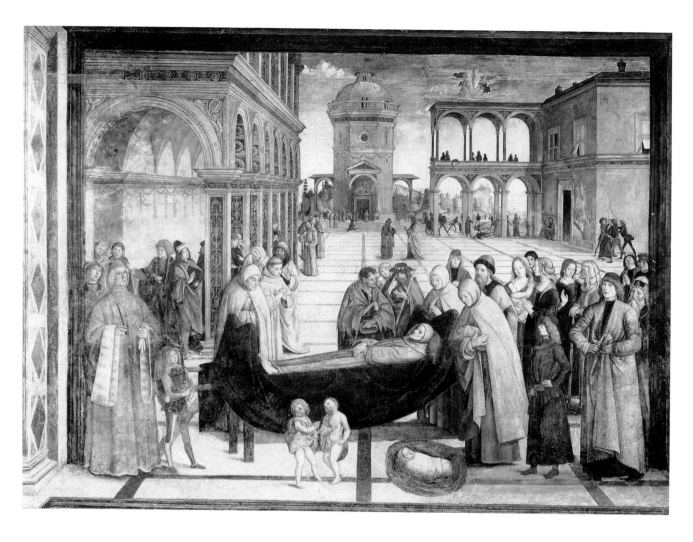

FIGURE 178. Rome, Santa Maria in Aracoeli, Bufalini Chapel, left wall, lower tier, Pintoricchio, *Death of San Bernardino* (see plate 21)

next scene on our right, the image of *Saint Francis Receiving the Stigmata*.[13] These friars demonstrate Observant devotion to the Virgin with their rosaries while pointing to the source of one of Bernardino's most famous preaching courses: the forty Latin sermons he delivered in Padua in 1443, called collectively *Seraphim*.[14] Their message draws together the images on the rest of this wall: prayer and meditation on the Stigmata, Francis's supreme act of devotion and the order's central God-given miracle, the friars seem to say, will help the donor buried below—and the worshiper in the chapel—achieve Christian immortality, symbolized by the peacock in the painted window above.

The sequence now returns to the left wall on the lower tier, where the large rectangular field holds a complex array of Bernardine miracles. Taken from many different moments in the saint's life, they are set in a unified perspective as though part of a continuous narrative (fig. 178). The action starts in the right middle ground and progresses to the left in a wide arc from the right-hand two-story pavilion, where the saint drives out evil spirits and saves a boy from Prato who was gored by a bull. It moves to the fabulous octagonal building in the left background, modeled on Perugino's temple in the Sistina but transformed into a pagan building by the statues at its cardinal points. The building refers to Bernardino's many exorcisms of classical gods, as at the Fonte Teca outside Arezzo in

1440.[15] The sequence continues through the left-hand portico, finally ending in the foreground funeral scene. The overall inscenation is that of a fifteenth-century *sacra rappresentazione* moving through "mansions," or *luoghi deputati,* set up around a town piazza.[16]

In the *Obsequies of San Bernardino,* the catafalque is surrounded by the halt, the lame, and the poor who were cured by the saint in posthumous miracles,[17] while contemporary members of the Bufalini family stand guard on both sides of the body. The inclusion of contemporary characters, reminiscent of the Sistine Chapel, is here given an added dimension of real participation, stimulated perhaps by the topicality of the subject. A controversy had arisen immediately after San Bernardino's death in the town of L'Aquila concerning his final resting place. Originally his body was claimed by the Conventuals of that town and buried in their church. The local Observants contested this claim on the basis of the saint's own affiliation, and after a long trial they won the right to his relics and built a new church for this purpose. The solemn translation took place in 1472.[18] The painted image documents the success of the Observant by representing their patron's funeral in their own church in Rome. With this telescoping of time and place, the impact of the final scene combines historicity and political authority.

Progressing from the upper left to the lower right and back to the lower left, the disposition of the cycle is an Aerial Boustrophedon. This pattern harks back, even in some specific details, to the authoritative cycle on the Life of Saint Francis by Giotto in the Bardi Chapel in Santa Croce of nearly two centuries earlier.[19] In this way Pintoricchio identifies the modern saint directly with his predecessor and model. At the same time, he opens the narrative to the grand sweep of the final episodes, where the Expanded Field provides the capacity for rendering temporal elasticity and a fuller exploitation of the devotional uses of narrative.

The final step was to extend the iconic image with a narrative dimension. On the altar wall, in a subject usually called *San Bernardino in Glory* (fig. 175), the realistic portrait of the saint shows him frontally, standing on an earthly "statuary base." In the landscape to the left behind the figure of Saint Louis of Toulouse, the historical San Bernardino quells the controversy between the Bufalini and their enemies. To the right, behind Saint Anthony, he burns worldly "vanities" and heretical books. Though these views characterize Bernardino's role as peacemaker and scourge of sinners,[20] the heart of his theology is defined in the central image. The book he holds toward the spectator is open to a legible inscription, "Pater manifestavi nomen tuum omnibus" (Father, your name is manifest in everything), the opening phrase of the Magnificat antiphon for the feast of the Ascension.[21] San Bernardino died on the feast of the Ascension (20 May 1444), as this anthem was being recited. The image is thus liturgical, devotional, and didactic. Even in death Bernardino continues to preach, demonstrating in this case that the "name" he invokes is the name of the Lord; the words are those of Christ as he returned to the right hand of the Father at the beginning of ecclesiastical time. This moment is pictured above in a "mystical Ascension," which appears as a visualization of the sermon. In recognition of this power to preach theological wisdom, Bernardino is crowned by two angels with the golden aureole of a church doctor.[22] As he had modernized the Aerial Boustrophedon of primitive

Franciscanism by expanding the spatial format, so Pintoricchio extends the spiritual range of the altar wall image with narrative events and theological lessons and creates what amounts to a mural altarpiece.[23]

The advantages of this new format were immediately recognized and taken up by Filippino Lippi in major commissions in Rome and Florence. The first of these was for Cardinal Oliviero Carafa in his funerary chapel in Santa Maria sopra Minerva, the main Dominican church in Rome.[24] Dedicated to both the Virgin Annunciate and Saint Thomas Aquinas, the subject matter includes scenes from both Lives (fig. 179). As in the Sistine and Sassetti chapels, a framed altarpiece is integrated into the overall scheme.[25] In this case the frame is made of marble, carved with classicizing grotesques and built into the wall and altar table; the fresco on the altar wall creates the illusion of a baldachin suspended over the whole altar area. The subject of the altarpiece demonstrates the dual dedication of the chapel: it represents a scene of the *Annunciation*, with the donor presented to the Virgin by his patron Saint Thomas Aquinas. Carafa kneels

FIGURE 180. Rome, Santa Maria sopra
Minerva, Carafa Chapel, right corner,
Filippino Lippi

to the Virgin, who in a polyscenic gesture responds both to the angel Ga-
briel and to the donor. Further, there is depicted a barrel-vaulted chamber
to the left representing the decorated tomb of Carafa as actually built at
the left of the chapel.[26] As in the Bufalini chapel, the altar wall has no
dividing cornice (although it is visually cut by the painted baldachin); it is
thus again a through-running vertical field with arched top. The *Assump-
tion* scene unifies the wall around the altarpiece, with the Virgin in the
zone above and the apostles on the ground at either side of the altarpiece
(fig. 180).

Again like the Bufalini chapel, the side walls are divided by a heavy
cornice into only two tiers (fig. 181) and bounded by giant pilasters simi-
larly treated in massive classical style with grotesques and other classical
details.[27] However, in this case they are not neutral supports but play
roles in the iconography, with many details in the grotesques charged
with meaning relevant to the rest of the chapel.[28] Scenes from Thomas's
life appear in the right lunette, where the sequence moves generally from

FIGURE 181. Rome, Santa Maria sopra Minerva, Carafa Chapel, right wall, Filippino Lippi, detail of right wall

FIGURE 182. Florence, Santa Maria Novella, Strozzi Chapel, altar wall, Filippino Lippi

right to left in several scenes arranged at various depths in space to express different times in the saint's life. The lower field again has the expanded format in which the subject matter moves easily from narrative to moral content. *Saint Thomas's Triumph over Heretics* places the glorified saint in a central position on an elevated architectural throne,[29] before a detailed vista of contemporary Rome.[30] The inscenation is both local and universal: while it shows specific Roman details, it also shows Saint Thomas's dominion over adversaries who are exotic racial types from all over the known world.

Returning to Florence in 1493, Filippino brought the same expanded format to his design for the Strozzi Chapel in Santa Maria Novella.[31] The altar wall is again a single conceptual unit but now is pierced by a window. The glass centerpiece is flanked by some of the most elaborate classical grotesque decorations produced up to this time, painted in grisaille (fig. 182). The narratives on the side walls again appear in only two tiers (diag. 40). The whole wall area is again framed by classicizing, grotesque-encrusted pilasters.[32] Unlike their predecessors in the Bufalini and Carafa

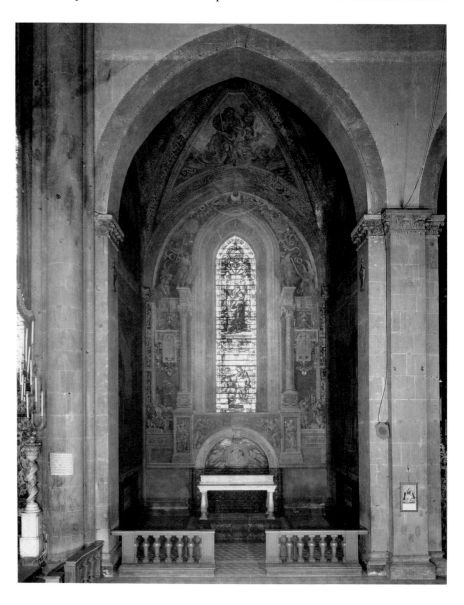

chapels, however, these pilasters are not outside the space of the scenes. In fact, figures from the scenes overlap their edges and bring the pictorial illusion up to the picture plane. This change in the framing structure is related to another shift in attitude toward the narrative itself. Here the narrative is reduced from a series of several episodes to succinct excerpts, one to each tier. Pressed toward the picture plane, the figures are strongly emphasized. The backgrounds, on the other hand, are sketchy and inarticulate, without deep vistas. Clearly we are not meant to be drawn into the distance but are to concentrate on the foreground tableaux and the messages they carry.

The scenes are from the Lives of Saint John the Evangelist and Saint Philip the Apostle, patrons of the donor.[33] Two martyrdoms are paired in opposing lunettes, creating what I have called the Festival Mode.[34] Recalling the technique of the Ovetari Chapel in Padua, the classically festooned and beribboned grotesque decorations on the altar wall carry out the celebratory theme.[35] Further allusions to Mantegna's work have been noted in the composition of the Strozzi altar wall stained-glass window:

FIGURE 183. Florence, Santa Maria Novella, Strozzi Chapel, left wall, Filippino Lippi, scenes of Saint John the Evangelist

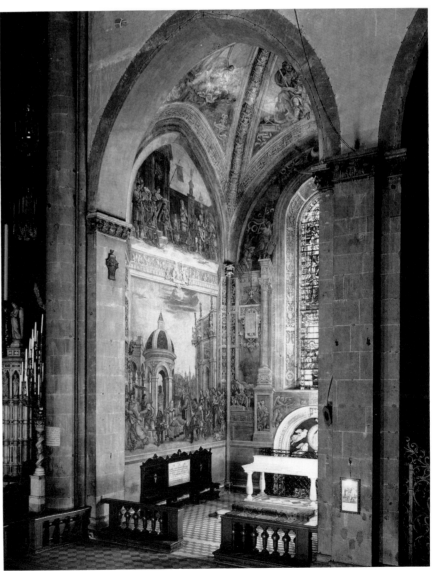

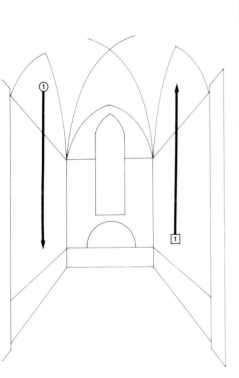

DIAGRAM 40. Florence, Santa Maria Novella, Strozzi Chapel

both are tall, thin vertical fields with elevated images of the Madonna and conversing apostles below.[36] Since this entire wall, including the window, is cast in the form of a triumphal arch, Strozzi's tomb immediately below[37] is transformed into more than a statement of hope.

Differences from the Ovetari Chapel in disposition are significant. Whereas Mantegna moved his narratives from top to bottom on both sides, Filippino moves the Life of Saint John on the left from the top down (fig. 183) and that of Saint Philip on the right (fig. 184) from the bottom up. The Strozzi disposition is thus the Up-Down, Down-Up pattern.[38] Only with this disposition could he achieve the side-to-side matching of miracles of the saints overcoming evil and death in the large rectangles[39] and martyrdoms in the lunettes.[40] It is in the context of historicity that we may understand the profusion of pagan details: they help to give substance to the apostles as historical persons and to present the scenes without anachronisms. In the Strozzi Chapel, the Expanded Field became synonymous with the isolation and magnification of significant events from Christianity's illustrious past.

The scenes of the martyrdoms in the lunettes are shown sharply *di sotto in sù*, with very stilted floor lines. The technique serves two purposes: one is to give the illusion that, although far above our heads, the stagelike space is still completely visible. The other is to carry the eye up to the ceiling, where we find figures representing an aspect of the pre-Christian past. The choice of the patriarchs Adam, Abraham, Isaac, and Jacob for the webs of the cross vault, part of the same Early Christian revival we saw at the Sistine Chapel, is meant to establish the lineage of Christianity in the usual typological fashion.[41] Here it combines in synchronism with the carefully studied classical elements on the walls of the chapel to foreshadow the present state of grace.[42]

Although up to a certain point the concept of the Expanded Field evolved in essentially Gothic structures, the implications of the new pictorial space were also related to the development of new architectural forms. In the programs of architectural modernization that took place in the second half of the fifteenth century, pointed vaults gave way to semicircular arches, and church walls themselves took on new shapes. If the days of stacking were not over, at least they would never be the same. One wonders if Leonardo's prophetic complaint inaugurated or reflected the new departures.

One of the most prominent of the new narrative formats is what might be called an "independent lunette"; that is, large semicircular fields above a dado made up complete walls.[43] The use of this format for further spatial and psychological penetration into the ideological content of narrative can be seen as the logical extension of the enlarged side-wall rectangle. Considering his innovations in the Bufalini Chapel, it is not surprising to find that Pintoricchio was one of the first artists to work with this format. He did so at the Baglione Chapel in the Collegiata di Santa Maria at Spello (fig. 185, 1501).[44] The cycle is on the Infancy of Christ and consists of three monoscenic compositions on large lunette-shaped walls chronologically disposed from left to right in a chapel that is almost square. The episodes represented are the *Annunciation*, the *Nativity*, and *Christ Disputing with the Doctors*.[45] In each case the single incident is made into a public celebration by its aggrandized size and setting.

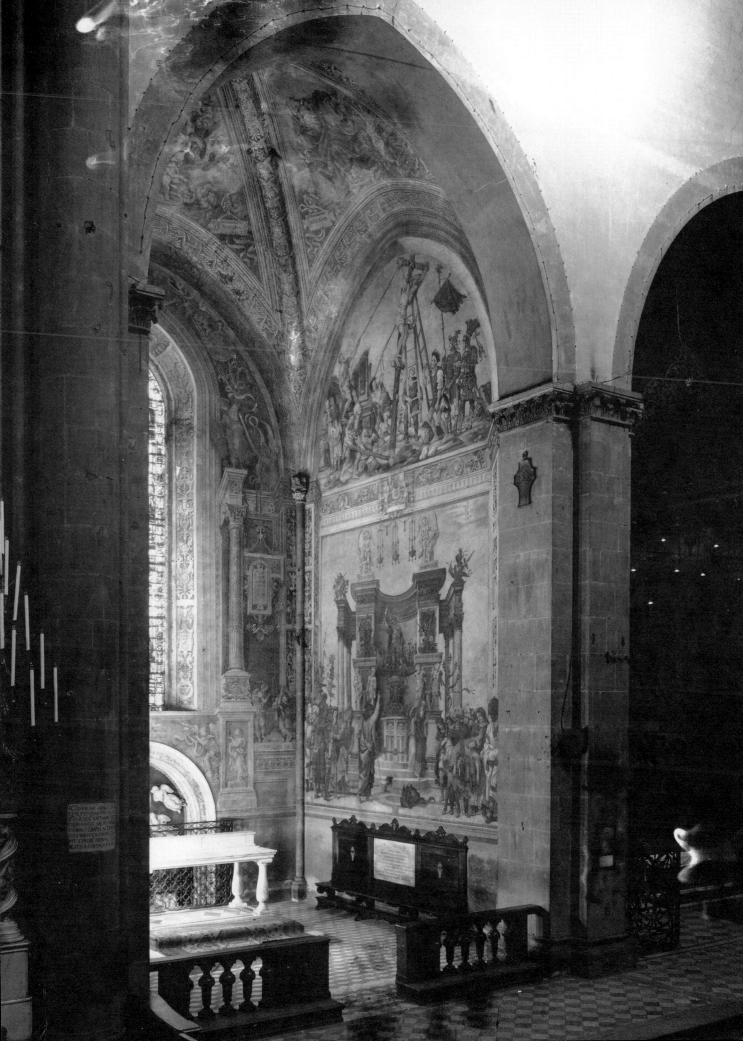

The *Annunciation*, for example, takes place in an urban square that makes Nazareth into a heavenly metropolis, with Spello pictured in the distance. Christian symbols appear quite naturally within the spacious settings: the *hortus conclusus* behind the piazza of the *Annunciation*, a cross of two fallen logs in the foreground of the *Nativity*. The perspective in each lunette is perfectly centered. A spectator standing in the exact middle of the chapel sees each of the expanded spaces as a self-sufficient composition. From the vantage point of the chapel's entrance, however, one has a different perception. From there the cycle appears as a gigantic three-part devotional image, with the *Nativity* as the main image seen frontally in the center and the two side-wall scenes appearing as obliquely folded "wings." In either case, the overall effect is no longer that of a running narrative. Rather, the independent lunettes present related but separate parts of a grand static ensemble, meant to serve mainly for devotional contemplation.

At the same time as the Spello frescoes were in progress, Luca Signo-

FIGURE 185. Spello, Santa Maria Maggiore, Baglione Chapel, right wall, Pintoricchio, *Christ Disputing with the Doctors*

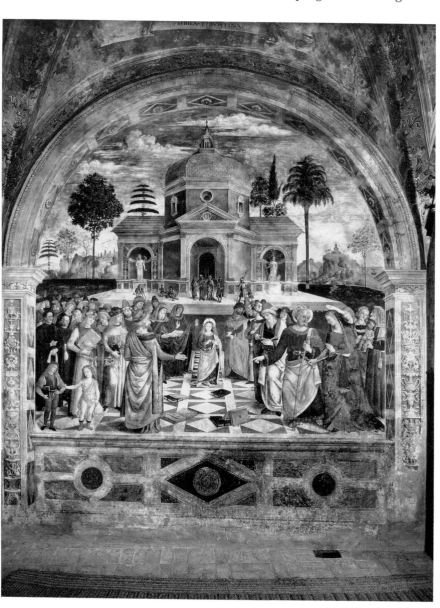

relli was painting in the San Brizio Chapel in the Duomo of Orvieto (1499–1502).[46] Although the architecture still has the pointed arches of the Gothic style, the painting fields are six huge independent lunettes, two on each side wall and one at each end broken into two narrow halves by the entrance and the altar. The original commission much earlier in the century was to Fra Angelico, who completed the painting of the vault. Christ of the Second Coming is over the altar; patriarchs, apostles, doctors, martyrs, and virgins, in hierarchical order, cover the rest of the ceiling from the altar to the entrance.[47] Since the disposition of Signorelli's frescoes depends in great measure on the position of the figure of Christ, it is possible that much of the planning was complete in Fra Angelico's time. In any case, when Signorelli took over at the end of the century, he eagerly embraced the new mode of the Expanded Field.[48]

The subjects of the six compositions of this remarkable cycle, which might be called an "Apocalyptic Last Judgment," depend on passages in *The Golden Legend* and the then recently published "Vision of Saint

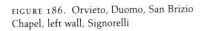

FIGURE 186. Orvieto, Duomo, San Brizio Chapel, left wall, Signorelli

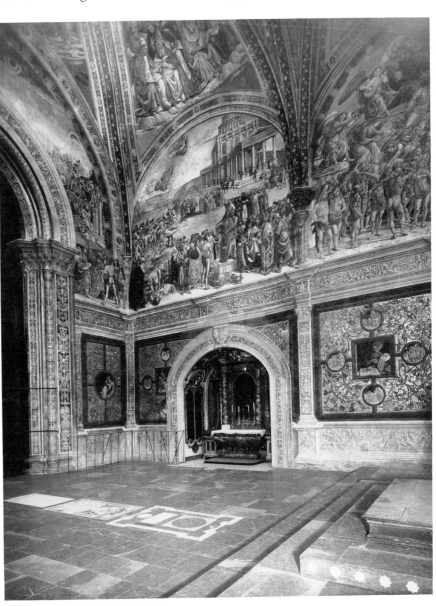

Bridget of Sweden."[49] The chronology begins in the first bay on the left wall with the *Preaching of the Antichrist* (fig. 186). The inscenation, interestingly enough, is quite similar to that of the final scene in the Bufalini Chapel (fig. 178);[50] that is, the action starts in the right background and moves to the foreground on the left. In this case the right-to-left movement signals a major innovation. The disposition is a traditional Wraparound, but for the first time in a religious cycle, the direction is counterclockwise (diag. 41).[51] Its first step turns the corner to the interior facade wall, where the subject is the *Destruction of the World.* Lightning and flames fall from on high and strike the representatives of mankind in the lower levels of both sides of the doorway. Turning the corner again, the progression continues on the right wall, first the *Resurrection of the Flesh* (fig. 187) and then, next to the left, a horrific scene of the *Damned Souls* (fig. 188). In both scenes, human bodies are packed into a vast level, stagelike space, unadorned and abstracted from all details of setting. Compositionally, each scene is frontal and centralized, with light

FIGURE 187. Orvieto, Duomo, San Brizio Chapel, right back corner, Signorelli

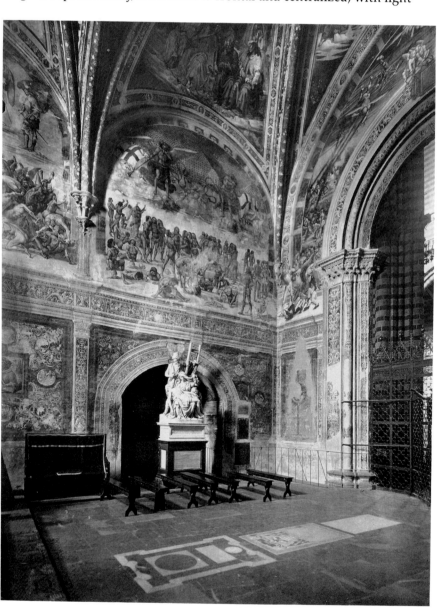

painted as though streaming from the window over the altar. This same window also motivates the painted light flow in the scenes on both sides of the altar. To the right, near the *Damned Souls,* are *Souls Entering Hell;* on the left are *Souls Entering Heaven.* This arrangement leads to the final scene of the sequence (in the second bay on the left wall), showing a beatific vision of *The Elect in Heaven.* Again, as in the other postmundial scenes, a concentrated mass of expressive nudes is arranged in a stable, centralized composition, with light flowing from the right as if lit from the altar window.[52]

The result of the disposition is that a worshiper looking into the chapel has a global view of Christian destiny: even without entering the precinct, one is confronted with a view of the altar wall and the choice between heaven and hell as they bracket the altar. The "view from the door" to show the conceptual point of a cycle finds its source in the late trecento, in chapels like the sacristy at San Miniato, Florence, for example. There the cycle on the Life of Saint Benedict by Spinello Aretino

FIGURE 188. Orvieto, Duomo, San Brizio Chapel, right wall and altar wall, Signorelli

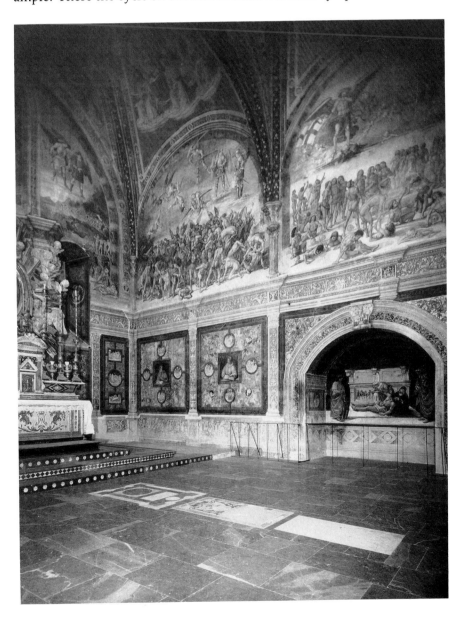

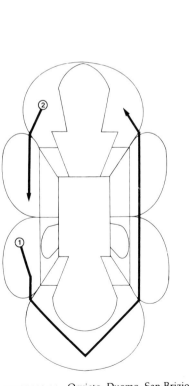

DIAGRAM 41. Orvieto, Duomo, San Brizio Chapel

(1387–90) starts precisely opposite the entrance from the nave of the church, that is, the second position on the upper tier of the right wall. The disposition moves in a double Wraparound, left to right, and ends at the second position on the right wall on the tier immediately under the place it began. This arrangement provides a "view from the door" of the birth of the saint together with his apotheosis, a statement of the model life in encapsulated form.[53] By presenting the main issues of the Christian scheme of salvation in this manner, Signorelli carries the idea a significant step forward. And by setting the cycle as a whole into the Counterclockwise Wraparound he reinforces the notion still further. Among the phenomena of the visible world that rotate in the right-left direction, the most fundamental is the movement of the heavens. The planets actually move counterclockwise, and the representation of zodiacal motion is always plotted right to left on astrological spheres.[54] This convention is frequently followed in works of art concerned with astrological matters, as for example, the frescoes in the Sala dei Mesi in the Villa Schiffanoia in Ferrara, which are disposed around the rectangular audience hall in precisely this manner.[55] Although direct astrological meaning in the program of the San Brizio Chapel may be minimal, the apocalyptic and prophetic nature of the subject matter alludes more to the celestial realm than to the terrestrial. The counterclockwise disposition had the unique result of ensuring expression of the cycle's spiritual locale.[56] Concomitantly, the enlarged format I have called the Expanded Field here suggests the endless spaces of eternity. Signorelli intensified the reality of the anatomy of the individual bodies he portrayed, but he set them in bulging domes of otherworldly firmaments. He thereby used the modernized format to expand the moral dimension of his subject.[57]

Readers will have realized that in defining the "independent lunette" I have described the format of the Vatican Stanze. Since they are not ecclesiastical in nature, analysis of these rooms lies outside the scope of this study. Let me point out, however, that the four great hemicycles of the Stanza dell'Incendio, the Stanza d'Eliodoro, and the Stanza della Segnatura, though not linked as portions of sequential narratives, are conceived as spatially unified realms wherein representations of psychologically interacting human beings express visually weighty ideological messages.[58] They are therefore nothing more or less that the fully developed versions of the Expanded Field concept.

Just before Raphael and his school executed the paintings in the Stanze, Michelangelo's labors on the Sistine ceiling took place.[59] I close this chapter on the Expanded Field with a brief discussion of this portentous work, which brings full circle the innovations in monumentalized, spatial abstractions we have been discussing by returning them to profoundly traditional disposition and subject matter. That is to say, the narrative on the Sistine ceiling represents conventional subjects from the Book of Genesis (Creation through the Story of Noah); the disposition on the mural surface is a stacked arrangement of the time-honored Early Christian Apse-to-Entrance protocol.[60] As has often been noted, the subject of the cycle completes the typological sequence of the fifteenth-century murals below by adding to the *sub legem* period of Moses and the *sub gratiam* period of Christ the *ante legem* period of Genesis. In disposi-

tion it follows not only that of the fifteenth-century frescoes but, of course, that of Old Saint Peter's as well.[61]

The ceiling is divided into nine rectangular narrative fields lined up along the central axis of the vault (figs. 189, 190). The fields alternate in size, beginning and ending with one of the five smaller rectangles. The four larger fields tend to house subjects of larger scope: the *Creation of the Stars and the Planets* is a continuous narrative, with the figure of God shown twice; the *Creation of Adam* brings the celestial and terrestrial worlds into contact for the first time; the *Fall* and *Expulsion from Paradise* are again two episodes shown in continuous sequence. The chronology of the next two scenes is reversed: the *Sacrifice of Noah* (Gen. 8:20) is placed before the *Deluge* (Gen. 6:5–8:19), shown in a spatial vista, panoramic in scope. Scholars have discussed this departure from biblical order at length, dividing opinions between matters of artistic license and design and theological considerations.[62] We have seen repeatedly that chronological order was changed or manipulated when ideology took precedence, and that may be true in this case. The explanations offered up to now, however, seem so tortured that I venture the opinion that here the decisive factor was the desire to give the public subject the larger theater of expression while placing the more intimate scene of the *Sacrifice* in the smaller format.

More anomalous is the relation of the disposition to an element not yet discussed in this book—that of orientation. In scenes placed on a vertical plane, there is no question what is the top and what is the bottom. But on the ceiling there are several choices, depending on which way the spectator stands in relation to the front, back, or sides of the architectural ambient. The scenes of the Sistine ceiling, from a certain point of view, are stacked in a traditional manner, being lateral rectangles with their long sides juxtaposed. But from another viewpoint they are unique. Their disposition and their orientation work in precisely opposite directions. To see the scenes right side up, one must stand at the entrance and face the altar. To follow the chronology, one must start at the altar and move to the entrance at the east end of the building. To have both aspects work properly, one must walk backward, looking up, from the altar to the entrance, an operation not many are likely to perform.

Below the ceiling in the corner spandrels are four narrative scenes, *Triumph of the Brazen Serpent, David Killing Goliath*, the *Execution of Haman*, and *Judith and the Slain Holofernes*, all clearly chosen for their symbolic and typological value.[63] Of interest in our context is that these scenes are arranged in a Cat's Cradle. The earliest in biblical chronology (the Brazen Serpent) is at the altar and on the right; the next (David), is in the left corner at the entrance end; the third (the Haman scene from the Book of Esther) is at the altar end in the left corner; and the last (from the Apocrypha of Judith) is in the right corner at the entrance end. The pattern is used in the usual way, to tie together across the space the disparate parts of a unified theme: victories of the forerunners of Christ in the first instance, and deaths of the enemies of the Chosen People in the second.

In the fifteenth century the ceiling of the chapel had been conceived as the conventional celestial firmament, painted with a field of blue in which stars were arranged in more or less regular patterns (fig. 164).[64] With the

FIGURE 189. Vatican City, Sistine Chapel,
view from entrance

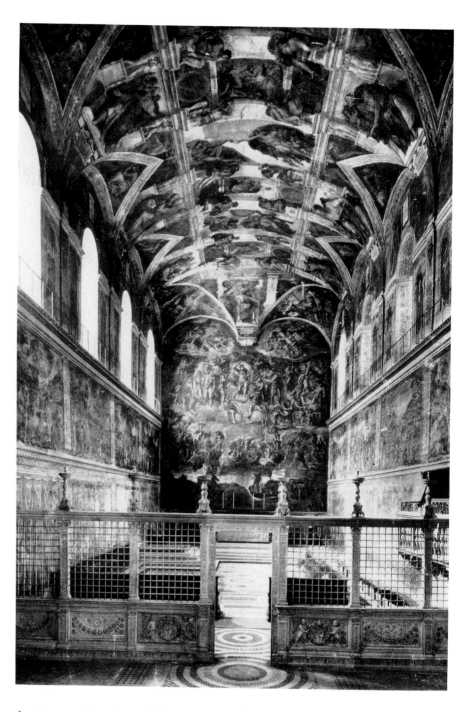

decision to place figural decoration on the ceiling, the issue moved to an-
other line of tradition, that of painted ecclesiastical vaults. Although few
examples of such decoration have survived the frequent fires, collapses,
and rebuildings of the Middle Ages, enough evidence exists to make some
tentative generalizations. An example of one major type is found in
France, in the eleventh-century frescoes at Saint-Savin sur Gartemps.[65]
The barrel vault surface there is divided into two parts by a continuous
spine painted along the center of the vault. The fields on either side of the
spine are subdivided in tiers, two on each side. The Old Testament narra-
tive begins at the apse end on the tier closest to the spine at the left. With
some variations,[66] it moves left to right from the apse to the entrance. It

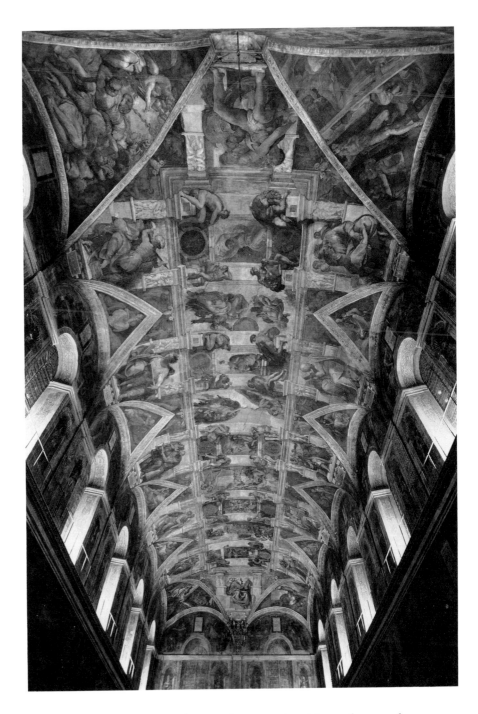

passes across the spine to the "top" tier on the right and moves boustro-phedonically right to left, back to the apse. The "bottom" tiers on both sides of the spine then read in the standard Parallel Apse-to-Entrance, first on the right, then on the left. The issue of orientation is solved by setting the scenes side by side along the vault, viewed correctly by turning first toward one side of the building and then toward the other.

Between this organization and the treatment of the barrel vault as a celestial realm, there were several intermediate forms. There are cases with pictorial fields that crawl up from the walls, as in the Arena Chapel, where top-tier scenes bend from the wall onto the vault, intruding some-what into the broad field of celestial blue.[67] There are others where ceiling

scenes slip down from the ceiling onto the wall, as in the Oratorio della Maddalena, painted by Andrea di Giovanni about 1400 in the Franciscan monastery at Belverde (Città di Pieve). Here a figurated barrel vault is divided, like that at Saint-Savin in France, by a painted center spine. The orientation again is toward the worshiper who stands facing first one side wall and then the other. In a Wraparound disposition starting at the entrance on the left side, the scenes begin on the ceiling but slip down to overlap the tops of the side walls.[68] A different set of problems is present when groin vaults are used for narratives, which was probably more frequent than one would expect. We have seen one solution in the Chapel of Saint Martial in Avignon,[69] where the orientation follows in a Wraparound directed by letters of the alphabet. The "Spanish Chapel," as we saw, made each web into an independent field of continuous episodes on a single theme, each requiring a different orientation for the spectator. The scenes in an Aerial Boustrophedon are organized with their tops at the crossing of the vault and ground lines placed along the springing of the arches. This treatment was still used in the sequence of Old Testament narrative groin vaults by Guglielmo de Marcillat (1511–25, finished in the seventeenth century) in the Duomo Nuovo, Arezzo.[70]

Michelangelo returned to the Saint-Savin tradition by bisecting the vault with a central spine,[71] but he revolutionized the tradition by using the median divider in an entirely new way. Instead of leaving the spine inert and flanking it with figural scenes, he activated this very area and made it the arena for the narrative action. With the issue of orientation, he again departed from tradition. He set the scenes at right angles to the spine and thereby ended their traditional implicit adherence to side-wall emulation. Instead he chose to identify the orientation with the end walls. His choice of the entrance end as the "right-side-up" viewing station was by no means arbitrary. In fact, he emphasized the heavy symbolic value of this entranceway by placing an image of Zechariah, prophet of Christ's Entry into Jerusalem, on the spandrel immediately above the door. There were indeed always two doors into the Sistine Chapel, one at the east, approached from the Scala Regia and used for ceremonial occasions, and another at the west, used as the liturgical entrance for the officiating participants in the Holy Mass.[72] Thus, by making the chronological sequence follow the prototypical Apse-to-Entrance disposition but orienting the scenes in the opposite direction, Michelangelo not only exploited the "view from the door" for its expressive value but unified the liturgical and ceremonial functions of the room in a way that would otherwise have been impossible.[73] In the context of liturgy and ceremony, moreover, it seems likely that the *ignudi* bearing garlands, who frame the narratives along the length of vault, are only adult, monumentalized versions of the putti in the frames of the Ovetari Chapel.[74] Like them, the gorgeous youths in the Chapel of the Popes make the Festival Mode into a perpetual state of being. Further, by changing the inscenation of the individual episodes from the epic abstraction of the *Creation* scenes at the apse end to the narrative velocity of the more discursive episodes at the entrance, Michelangelo recalled the change of tempo from legato to allegro at Santa Maria Maggiore and, as in the fifteenth-century frescoes below, revealed that a reference to that venerated prototype was part of his original conception.[75]

III

9 New Continuities: Narrative Disposition in the Sixteenth Century

In the new foundations of the sixteenth century, narrative cycles in fresco and those made up of separately framed paintings were typically in the Wraparound pattern, the traditional left-right "Wraparound" for lay oratories and the "Counterclockwise Wraparound," identified with monastic cloisters, for monasterylike oratorian churches. By century's end, the Counter-Reformation had established its own protocol: the papal "Counterclockwise Wraparound," employed for the new decorations in the Cathedral of Rome.

In the varied and complex historical and art historical events that took place in Italy during the sixteenth century there was no dearth of narrative. On the contrary, although mural disposition as such was not mentioned when the uses of the visual arts were codified during the sessions of the Council of Trent,[1] narrative as an effective tool for communicating religious ideas remained a factor of major importance. Yet I will omit almost half of the monuments from this period that are worthy of study. The problem stems from my methodology. By the second half of the sixteenth century, many new forms of wall and ceiling articulation had come into use. Stucco work applied to walls, window embrasures, spandrels, vaults, and domes created narrative fields of circular, oval, and other less regular configurations. Below, above, and at the sides of major episodes, smaller-sacle, irregular medallions and cartouches were introduced, often housing further narrative scenes on a minor scale. As a result, the tracking of narrative sequences ceased to follow the simple left-right, right-left, and diagonal progressions familiar in earlier periods. It was no longer an easy matter to describe what was above or below or to say what came before or after in a series of painting fields. To some extent these changes were stylistic, signaling a major shift in the framework of monumental narrative art. In other ways they inaugurated new techniques for recombining narrative components into statements of current theological importance. But the fact is that for the more "modern" ambients my original computer variables were no longer adequate. Since I started my study with a cycle in a late fourteenth-century architectural ambient, the architectural model I had unconsciously adopted for the database was Late Gothic in style. As I expanded my exploration to include earlier and later examples, most of the buildings involved had similarly shaped painting fields, and I continued to fill the same computer structures with the same kinds of data. But for many sixteenth-century buildings, new variables are needed. I am sure that with the help of specialists in post-Renaissance art, such variables could easily be developed and the database carried forward. In fact, I feel that doing so is imperative, for although little studied as a general rule, mannerist and baroque cycle programs and schemes of disposition had a life as rich and varied as those of the earlier periods.[2] Our knowledge of the important role that conceptual planning

FIGURE 191. Monte Olivetto, monastery,
cloister, Signorelli

of large-scale narratives played in the creative process will be incomplete
until we are able to survey the full range of its history.

Meanwhile, I could see certain continuities stretching out through the
century in the conceptual planning for buildings that remained in the di-
rect line of traditional architecture.[3] From analysis of these monuments,
which makes up the bulk of this chapter, it is clear that narrative disposi-
tion can be counted among the proofs for historical continuity within the
Reform itself.

For efficiency's sake, I have arranged the discussion according to archi-
tectural types: cloisters, oratories, and finally public churches.

Monastic Cloisters

In this survey I have had occasion to mention cycles carried out on the
walls created by the vaulted arcades that surround monastic courtyards.

The discussion of the Chiostro Verde at Santa Maria Novella, Florence (fig. 119), focused on the practice of placing several scenes within a single bay that was divided into two tiers with continuous compositions of multiple episodes on each tier. The disposition reads from left to right, starting in this case at the exit from the right side of the main church at the transept wing.[4] A later version of the same disposition guided the cloister cycle of the Life of Saint Benedict at the monastery of Monte Olivetto, started by Signorelli (1497–98, fig. 191) and continued by Il Sodoma (1505–8) and Il Riccio (1534).[5] Here the episodes, still frequently continuous in mode, were expanded to fill each lunette-topped bay with a single composition, broadly enriched with anecdotal details. Essentially, the compositions are made to thrust with rhythmic variations to move the viewer from the entrance at the right transept wing of the main church to a clockwise circuit around the cloister.

Such left-to-right movement, however, seems to have been in the minority. As far as I can judge, in fact, most cycles in Italian monastic cloisters move in precisely the opposite direction; that is, right to left, or counterclockwise. For example, in the Life of Saint Benedict at the Florentine Badia in the Chiostro degli Aranci, the narrative moves right to left.[6] The painting fields are single-tier lunettes, with continuous-mode episodes in each bay. When Bronzino made his additions about 1525,[7] his compositions were designed to follow this progression (fig. 192). The cloister at Sant'Onofrio in Rome, 1510–20, depicting the saint's life in lunette-shaped fields, has the same disposition,[8] and a later example, from the seventeenth century, is the Old Testament cycle in the Grand Cloister of Santa Chiara in Naples, which again moves counterclockwise.[9]

These observations give a context for the arrangement of Jacopo da Pontormo's remarkable Passion cycle at the Carthusian monastery of San Lorenzo al Monte at Galluzzo outside Florence, 1523 to 1525.[10] The slightly elongated lunettes he painted on were detached in 1956 from the walls of the large cloister. There is still some discussion concerning their correct placement, since they were not in consecutive bays but were dispersed in pairs at the corners of the rectangle. However, there is no question that the general order was counterclockwise, starting at the left of the entrance with the *Agony in the Garden* and reading back around the corner right to left. The other scenes included a *Christ before Pilate*, the *Via Crucis* (fig. 193), a *Nailing to the Cross*, possibly a *Crucifixion*,[11] the *Lamentation* (fig. 194), and finally a *Resurrection*. The compositional thrust of the first four subjects is strongly directed toward the left, whereas the *Lamentation* and the *Resurrection* are centralized, slowing the movement and finally bringing the cycle to a close. It is not easy to divine why here, as in other monastic settings, the counterclockwise movement was employed. I feel sure that the disposition reflects in some way paths prescribed for the monks in moving about the cloister while meditating, reading the breviary, or performing other devotional acts not generally known to the public.[12] In this case the path is clearly following the Way of the Cross, a characteristic devotion of the Carthusian order.[13] As we shall see, whatever its genesis in the monastic setting, the counterclockwise disposition became a major element in later sixteenth-century counterreformatory ecclesiastical decoration.

FIGURE 192. Florence, Badia, cloister,
Bronzino, *Story of Saint Benedict*

Oratories

The late medieval development of charitable societies, called confraternities, reflected an increase in lay participation in religious activities and services. These brotherhoods had meeting halls that were either independent structures or additions made to particular church buildings. We have seen one such example in Tuscany, the Oratory of the Cross attached to San Francesco in Volterra, a rare case that has retained its mural decoration.[14] Although quite a number of Tuscan altarpieces and painted standards owned by the confraternities have come down to us, much less is known about the permanent mural decoration of the early meeting-houses in that region.[15] Perhaps owing to circumstances of preservation, we have more evidence from Venice in this case. Not that there were more such societies (called *scuole*) in the Veneto than in Tuscany or Rome. But since the damper atmosphere in the north made frescoes less

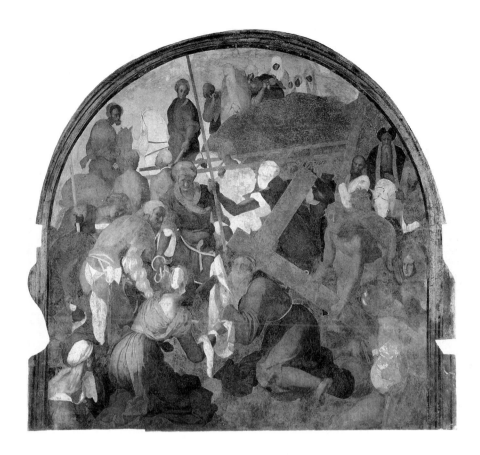

FIGURE 193. Galluzzo, Monastery of San Lorenzo al Monte, cloister, Pontormo, *Via Crucis*

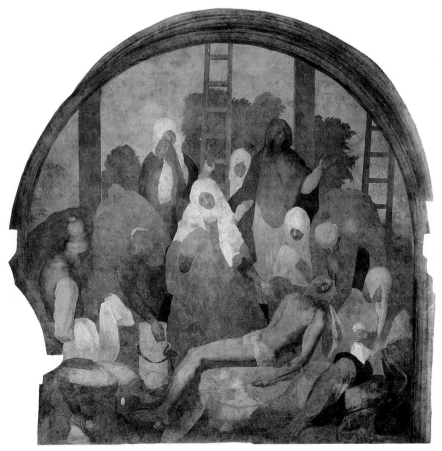

FIGURE 194. Galluzzo, Monastery of San Lorenzo al Monte, cloister, Pontormo, *Lamentation*

practical, narrative cycles often took the form of panel paintings, later canvases, and many of these survived even when their architecture was remodeled or replaced. From these paintings we can often judge the cycle disposition from compositional thrusts, light flow, or the figure grouping in the individual compositions. What is said to represent one of the earliest remaining Venetian "panel" cycles is known from a few paintings of the Life of the Virgin by Jacopo Bellini.[16] Another is known only from documents: it was for the small chapel of the Scuola di San Gerolamo in Cannaregio, painted by Giovanni Bellini, Alvise Vivarini, and Lazzaro Bastiani, dated 1464. The description makes it clear that the disposition was a Wraparound starting at the entrance on the left.[17] From later extant examples it seems this pattern was the one most commonly used in the Scuole Piccole. For example, a left-right wrap starting on the right wall at the altar end is seen in Vittore Carpaccio's three-part cycle of separate panels in the Scuola di San Giorgio degli Schiavoni (later 1490s; now on the ground floor, though originally the cycle was on the floor above). This artist had already employed the same disposition in his canvas cycle of Sant'Orsola from San Zanne Pollo, starting on the right at the apse in the familiar late medieval manner.[18] A counterclockwise Wraparound can be seen in the Life of Saint Anthony at the Scoletta del Santo in Padua, where the young Titian painted at least three of the fields in 1510–11.[19] Here, as in the later fifteenth-century decoration of the Scuola Grande di San Giovanni Evangelista—the cycle of Miracles of the Cross by Gentile Bellini and others[20]—emphasis fell not on disposition but on the interpretation of history, the expressive phrasing of scenes, and the psychological interaction of the figures.[21] From our point of view the Venetian cycles were important in establishing separate cycle episodes as physically independent units, first on panels and later on canvas, made to work harmoniously together in sequence.[22]

From the sixteenth century in Tuscany, many more meeting rooms and chapels still bear their mural paintings. These statistics may not reflect the state of preservation alone; they also demonstrate the Reform church's seeking to increase lay participation in the religious life of the community.

One of the first of the sixteenth-century Tuscan confraternity cycles to have survived is in the upper level of the Oratory of San Bernardino, adjacent to the Church of San Francisco in Siena (1518–32). The cycle is a Life of the Virgin, patroness of San Bernardino, who preached on this spot. The commission was carried out by a team of artists: Sodoma, Domenico Beccafumi, and Gerolamo del Pacchia.[23] The disposition of the eight scenes of Mary's life is a left-right Wraparound beginning at the entrance end of the left wall (fig. 195). Even though the designing of the individual scenes is not particularly unified, the reading order is highly consistent. The interesting aspect of the ensemble is that, though painted in fresco, each episode is set within an elaborate, classicizing painted frame, more like picture frames than arbitrary divisions between the fields. In this way the series resembles Venetian "panel cycles" and the pictorial autonomy they represent.

A different source inspired the more-or-less contemporary cycle made for the Florentine flagellant Compania di San Giovanni Battista, called Lo Scalzo.[24] The assignment went to Andrea del Sarto, a member of the

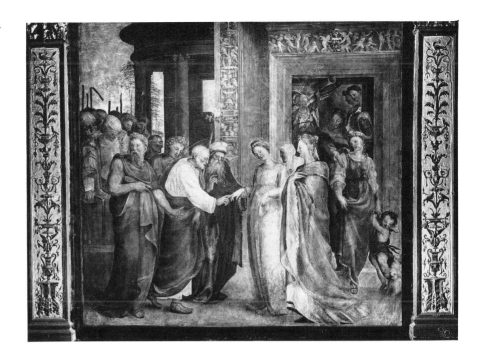

company, for a cycle on the life of the patron, Saint John the Baptist. It was to go not in the meeting hall but in the courtyard outside the oratory, and perhaps on this account the disposition reflects those found in monastic cloisters.

Andrea seems to have begun his work in 1510, quite early in his career.[25] He had painted only a small part of the cycle by 1518, when he left for France. He stayed away for six years, and during his absence Francesco Franciabigio painted two of the large fields on the right wall. Andrea continued the project when he returned to Florence in 1522, finally finishing in 1526. The placement of scenes in the cycle was obviously worked out before the painting began, since in spite of these interruptions and changes of hands the thread was never lost. The order of the execution (and Andrea's stylistic development) is so far from the chronology of the narrative that the conceptual planning involved has been all but overlooked.[26]

Entering the precinct from the street, one passes through an *ingresso* and then the portal of the courtyard; a second portal at the opposite end originally gave onto the oratory proper. Before an eighteenth-century rebuilding, the courtyard was a simple structure, open to the sky, with wooden columns and wooden benches attached to the walls. It is possible that these benches, besides offering rest and giving the members an opportunity to socialize, were also related to ritual reading or meditation that might have taken place routinely in the court. The entrance portal is flanked by personifications of Hope and Faith, two states of Christian virtue proper for starting a worshipful journey. The narrative begins immediately to the right of the entrance and follows around the yard in a Counterclockwise Wraparound (fig. 196, diag. 42). By thus recalling the arrangement of most monastic cloisters, the disposition elevates the lay organization to a higher devotional status.[27] At the same time, the compositions are monumentalized in large-scale expanded rectangles, richly framed as independent units.[28]

FIGURE 196. Florence, Lo Scalzo, Andrea del Sarto, corner view

The first three scenes in the chronology, biblical in source, were actually painted last.[29] They are eloquently simplified, with a few figures centrally composed, portentous in their stillness. The two legendary scenes that complete the right wall were painted during Andrea's absence.[30] The second of these shows *John's Meeting with the Holy Family in the Wilderness*, at which time, according to the legend, the full implication of John's mission is explained to him and he becomes a penitent. The scene was thus included as a crucial expression of the nature of the commissioning organization.

The back wall of the cortile is given over to John's mission. Within the logic of the Wraparound, the canonical chronology is reversed: the *Baptism* comes first, to the right of the doorway, and the *Preaching* second, to the left. Encircled by paradigmatic groups of listeners in the center of the field, in the latter John preaches from atop a hillock, pointing into the background (into the oratory) while looking across to the opposite side of the wall. There the scene at the Jordan appears like a vision, isolated from the crowd, attended only by angels. On this account the biblical source seems to be not the temporal episodes from Mark or Luke but the more mystical text of Saint John the Evangelist (John 1:29–36, 3:24–29), where there is no narrative. The Baptist is questioned about his identity,

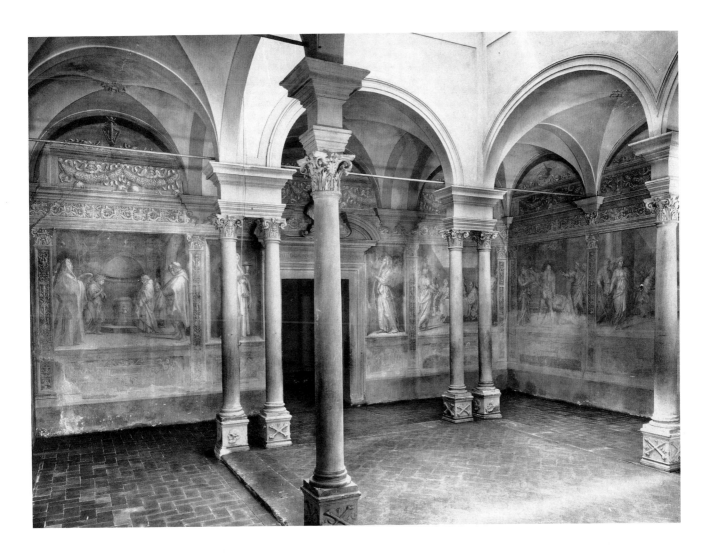

FIGURE 197. Florence, Lo Scalzo, Andrea del Sarto, view toward scene of the *Death of the Baptist*

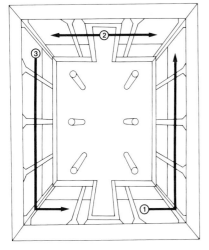

DIAGRAM 42. Florence, Lo Scalzo, courtyard

and in his own words he tells what has already occurred.[31] The scenes on the back wall represent this bearing of witness. What the technique of rearranged chronology achieves in this specific instance, aside from drawing out the mystical implications of the subject, is to give the spectator an immediate vision of the crux of the cycle. It is thus the arrangement I have called the "view from the door."[32] Entering and arriving at the center of the courtyard, the visitor sees all the images of Christ in the cycles, with the central scene of his Baptism in the place of honor to the right of the portal. It was this dispositional concept that caused the *Baptism* to be painted first. Its position obviously had the highest priority, if not actual function, determining the rest of the placement of scenes from the very inception of the commission.

As if to move the narrative back into its right-left flow, there is a tiny reprise of the group discussion in the right background of the *Baptism of the Multitudes* around the corner on the left wall. This group is almost identical to the one in the Preaching scene, with John now pointing forward to another figure of himself pouring the sacramental water on a devotee.[33]

The final four scenes of the sequence, three on the left wall and one on the entrance wall right of the door, were done in Andrea del Sarto's

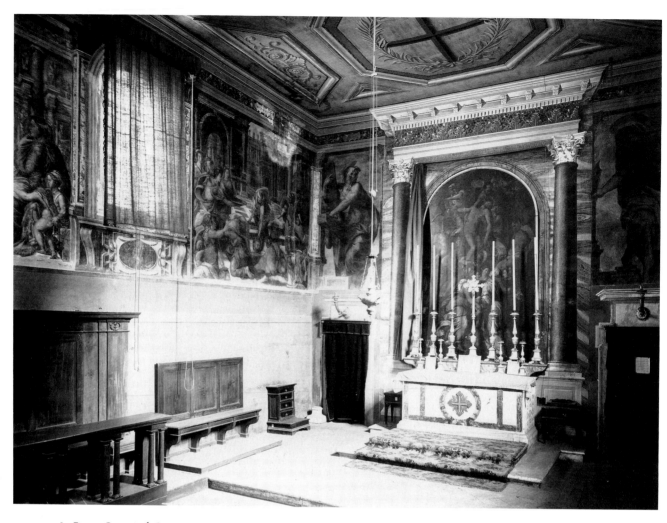

FIGURE 198. Rome, Oratorio di San Giovanni
Decollato, general view

FIGURE 199. Rome, Oratorio di San Giovanni
Decollato, assistant of Francesco Salviati,
Decollation of the Baptist

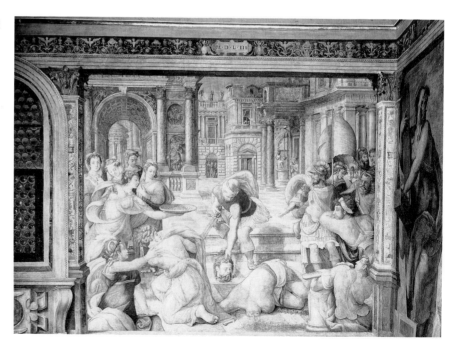

second campaign (fig. 197). The way he divided the episodes solve a chronological anomaly that had appeared in almost every earlier cycle of John's life. The Banquet, Dance, and Delivery of the Head previously had almost always been put together in a single composition. Andrea conceived them as independent scenes, each having its own expanded field. First there is the *Arrest of John*, with Herod repeating John's forward-pointing gesture from the previous scene, and the prison with a disciple's visit in the background. Then there is the *Dance*, a dance without movement, where Salome shows her body in a ritually frontal stance. The *Decollation* follows, with the executioner a faceless murderer turned backward, cutting the space with his body and his sword and masking John's severed head. He looks to the right and delivers the head to the left, moving the narrative in that direction. The last scene, the *Delivery of the Head*, like the other scenes, is an unbloody ritual in a separate space. All these scenes are slowed to a halt, centralized, and made static, each a ceremony in itself. In the scene next to the doorway the story ends, and the modicum of narrative thrust is reversed to left-right, bringing the cycle to a close. As members of the society leave the precinct, the figure of Hope is their last visual impression. Although placement of the scene of the *Baptism* generated the disposition of the cycle as well as the division of the scenes, the shifting of rhythms from description to ritual goes beyond stylistic development and enters the realm of conscious search for affective power, a mystical concomitant to the idealized naturalism that characterized the High Renaissance.

Parallel in dedication to Lo Scalzo, the Confraternity of San Giovanni Decollato in Rome, a few decades later, also commissioned a Life of Saint John the Baptist, this time for the walls of the oratory itself (fig. 198). Situated closer to the source of religious renewal, the Roman group chose a disposition strictly dependent on medieval church protocol: a simple Wraparound starting on the right wall at the apse end of the chamber but including gilded cartouches with miniature classical scenes below some of the elements. Again the cycle was painted by a number of different artists over a rather long period.[34] In this case the disposition was used by the artists to integrate their work in a meaningful way. The mission of the confraternity was concentrated on the spiritual well-being of condemned criminals, counseling them, seeing that they received last rites, and providing for their burial after execution. These preoccupations are reflected in the heavily populated "orchestra space" before and below the space of the scenes, filled with portraits of members of the organization who witness both *Saint John's Arrest* and his *Decollation* (fig. 199).[35] The positioning of John's decapitation on the steps in the foreground presents an unrelenting view of the bloody neck stump. It is one of the most explicit representations of dissection in pictorial art up to this time.[36] The identification between iconography and function is taken one step further in the altarpiece, a *Deposition* by Jacopino del Conte.[37] In a manner quite out of the ordinary for this subject, the image includes not only an angel bearing the eucharistic chalice, but also the figures of the two thieves.[38]

The consistency with which the Wraparound pattern was followed in other Roman oratories of the period makes it unlikely that there was no concerted effort to recall high medieval protocols. Even when the style of painting seems provocatively far from the simplicity of the early periods,

FIGURE 200. Rome, Oratorio del Gonfalone,
Passion cycle

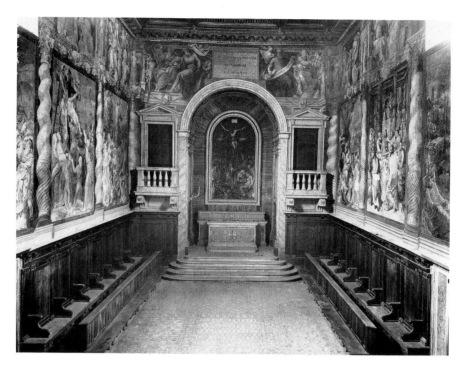

the similar disposition was enough to make the identification with the
earlier, theoretically more pure, period of the church.[39] Such is the case in
the Oratorio del Gonfalone (fig. 200), another flagellant society in
Rome.[40] The chapel near the Via Giulia was decorated with a Passion
cycle in 1556–57 and 1568–76 by a large group of painters headed by
Federico Zuccari.[41] Once again the narrative moves from the altar end on
the right wall around the chamber, ending with the *Resurrection* at the
altar end on the left (diag. 43). A major interruption of the sequence oc-
curs in the center of the entrance wall, where a devotional image of the

FIGURE 201. Rome, Oratorio del Gonfalone,
back wall (see plate 23)

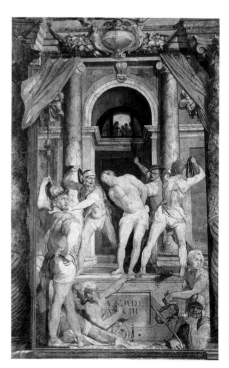

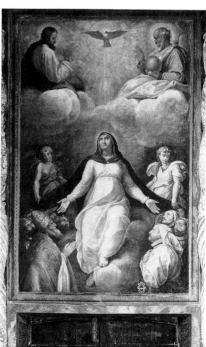

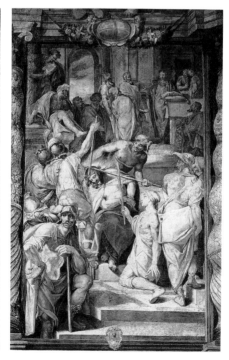

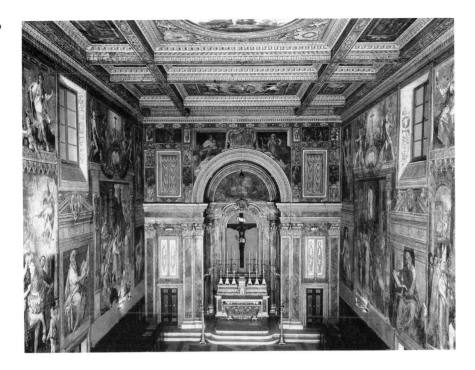

Madonna with the Trinity is inserted (fig. 201). This static interposition
serves to highlight the flanking fields, a rare doubling of the phases of
Christ's torture, the *Flagellation* (by Zuccari) on the left and the *Mocking
of Christ* (by Cesare Nebbia) on the right. The purpose is to reflect and
emphasize the penitential activities of the society.

The founding of the Oratorio del Santissimo Crocifisso in Rome was
occasioned by the survival of a miraculous and highly venerated cross
after a fire at San Marcello al Corso. Several scenes depicting this miracle
were painted at the entrance end of the chapel. Another team of painters
(Cesare Nebbia, Pomarancio, Niccolò Circignani, Baldassare Croce, Paris
Nogari, and Giovanni de' Vecchi) completed the work between 1578 and
1587.[42] The monumental part of the cycle is dedicated to episodes in the
Story of the True Cross (fig. 202). As in the wall organization of the
Gonfalone, there is an oblique reference to stacking, with emblematic
representations of Constantine's Vision of the Cross alternating with fig-
ures of virtues on the tier above the large-scale episodes. These latter, on
the second tier, are treated as independent compositions with painted ar-
chitectural frames and flanked by sibyls and prophets. The episodes are
grouped in the Festival Mode: three scenes of the Finding of the Cross
(fig. 203) are on the right wall and three of the Exaltation are on the
left.[43] In terms of chronology, however, the overall disposition again pro-
ceeds from the right of the altar, wrapping left to right around the nave of
the chapel in a linear movement.

The Wraparound pattern was thus used by the lay organizations with
great potency to identify their goals with the medieval period of the
Church Triumphant. In a moment we shall see that this practice charac-
terized large-scale Roman church decoration as well. It was outside
Rome, however, that the traditions of the Wraparound pattern and cycles
made up of individual easel paintings came together in a new departure in
Counter-Reformation decoration.

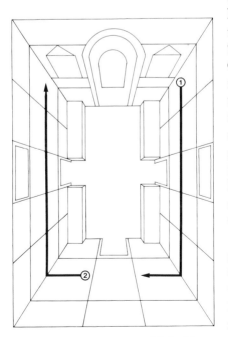

DIAGRAM 43. Rome, Oratorio del Gonfalone

Churches and Chapels

In redesigning the nave of Santa Croce in Florence, Giorgio Vasari—who by his own proclamation was an enemy of everything Gothic—[44] created a cycle of Christ's Passion in a monumental Wraparound composed of twelve separate, framed paintings. After more than three hundred years, in this venture Vasari finally achieved the unified program envisioned by the friars of Santa Croce of the High Gothic period. Like most of the churches in Italy in the early sixteenth century, Santa Croce still had its heavy *tramezzo*, an architectural structure that closed off the choir from the public part of the nave.[45] It was a two-story construction, half a bay deep and about sixteen feet tall, with a superstructure almost fifty feet high.[46] As a result, in the nave of the church there was no view of the high altar and no unobstructed entry into the transept arms. In 1565 Vasari received a mandate to tear the *tramezzo* down and begin redesigning

the nave.[47] The high altar was moved forward into the crossing, and the nave took on the sweeping view from entrance to apse that we see today (fig. 29). Initiated by Cosimo de' Medici, the project involved at least fourteen families, most of whom were connected to the court in some capacity. A few of the people already owned property in the church; others bought space for tombs or chapels on this occasion.[48] Vasari not only made the new architectural design and painted three of the huge altarpieces, but also acted as an entrepreneur. Through sheer force of will, he got the cooperation of all the patrons involved. He engaged the services of Don Vincenzo Borghini as collaborator on much of the iconography, drew together the owners of the chapels and the artists they commissioned,[49] and brought to completion what must have been one of the most elaborate communal artistic projects of the sixteenth century.

Vasari's architectural scheme is one of great power. It consists of a series of chapels without side walls, articulated with massive architectural frames of alternating designs that hold large-scale altarpieces representing scenes of the Passion. The remarkable thing is that though the project took almost forty years to complete, the monumental altarpieces join together as coordinated components in a unified Wraparound pattern that circles the nave almost without skipping a beat (diag. 44). In the Early Christian fashion, the cycle begins at the altar end of the right wall with a scene by Ludovico Cigoli of the *Entry into Jerusalem*,[50] the opening feast of Holy Week. The scenes on the right wall then move left to right: the *Agony in the Garden* by Andrea del Minga (1574–75), the *Flagellation* by Alessandro Barbiere (1575), *Ecce Homo* by Jacopo Coppi (1576), and the *Way to Cavalry* by Vasari (1572), ending with the *Crucifixion* by Santi di Tito (1588). In the first three of these altarpieces[51] the light flows from the left, the direction of the windows in the transept, while in the last three[52] it flows from the right, the direction of the windows on the façade.[53]

The lighting in the altarpieces on the left wall varies the rhythm but is equally preconceived. The first four, Battista Naldini's *Laying on the Ground*, Santi di Tito's *Resurrection* and *Supper at Emmaus* (both 1574), and Vasari's *Incredulity of Thomas* (fig. 204, 1572), all have left-to-right light flows. Giovanni Stradano's *Ascension* (1569) reverses the flow to right-left, and the last altarpiece in the sequence, Vasari's *Pentecost*,[54] is lighted by a beam that shines from the front, high above the pictorial space. This visual device effectively brings the Wraparound movement to a standstill and the cycle of Christ's Passion to an end.[55]

The scheme of Santa Croce is reminiscent of the northern Italian tradition of panel cycles in that the units are joined in a Wraparound pattern. Aside from the great enlargement of scale, what is new in Florence is that the paintings serve a dual purpose: as altarpieces, they function as isolated devotional images to be contemplated during the liturgy of the Mass. At the same time, as narrative components they perform as episodes in a continuous sequence.[56] What has been called a "shift in interest . . . away from the titular event"[57] is really part of a concerted effort to create a narrative of images showing moments in a story that are venerable and efficacious within themselves. This ideal is achieved through artistic means. Most of the compositions are centered, with only ancillary objects making thrusts in the direction of the narrative sequence.

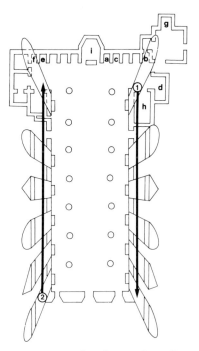

DIAGRAM 44. Plan, Florence, Santa Croce: a, Bardi Chapel; b, Velluti Chapel; c, Peruzzi Chapel; d, Baroncelli Chapel; e, Pulci Beraldi Chapel; f, Bardi di Vernio Chapel; g, Rinuccini Chapel (sacristy); h, Castellani Chapel; i, Alberti Chapel (chancel). Nave wall chapels designed by Giorgio Vasari.

Most are tightly packed with static forms pressed against the frontal plane. All are suffused with otherworldly, unreal light. In every case emphasis on the incidental or anecdotal aspect of the episode is removed and the festival or celebratory quality is drawn out. In sum, the paintings are iconic in character with a new theological dimension bespeaking the Counter-Reformation spirit. In the series of private chapels owned by wealthy patrons yet open to all worshipers, didactic purpose is wedded to liturgical function in settings that harmonize the whole nave. As in the cycles of old, the story marches around the space in the manner of a reli-

FIGURE 204. Florence, Santa Croce, Giorgio Vasari, *Incredulity of Thomas*

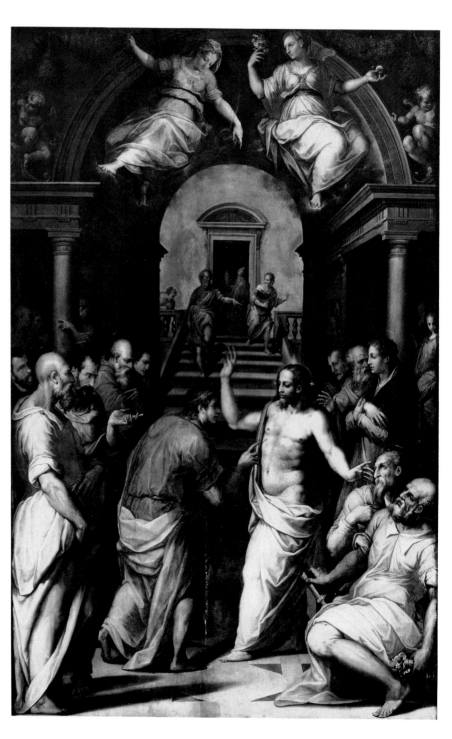

gious procession, glorifying the Cross, instrument of Christ's sacrifice, and thereby the titular of the building.

The tendency to isolate the narrative episode in a separate painting also influenced the decoration of the more usual private aisle chapels. Merging easel painting with the late fifteenth-century "Expanded Field" concept that gave the full side wall of a chapel an uninterrupted painting surface produced what are called "laterals," or framed paintings inserted in the walls, flanking or surrounding the altar. The Serlupi Chapel in Santa Maria in Aracoeli, for example,[58] has various apocalyptic subjects promulgating the Immaculate Conception as dogma in this form on the walls, with Old Testament typological narratives frescoed in the lunettes and on the ceiling. In the Mattei Chapel in the same church, painted in 1586–89 by Girolamo Muziano, the Life of Saint Matthew is reduced to four oil paintings, semicircular lunette-shaped frames above and large rectangular "laterals" inserted in the walls below.[59] The strong possibility that the positions of these paintings have been changed in the intervening centuries again underscores the secondary nature of chronology in disposition once the fields became independent units.[60]

The scheme Vasari introduced in the nave at Santa Croce, with a major variation, entered the mainstream of church decoration in Rome almost immediately. In the newly rebuilt church of Santa Maria in Vallicella (1575), however, the overall planning was not a matter of corporate coordination but was in the hands of a single man. San Filippo Neri planned a series of coordinated altar dedications reflecting his devotion to the rosary that circle the entire building and form one coherent program.[61] Long before any property was let for public use, all the altars in the apse, the transepts, and the five chapels on each side of the nave were dedicated, in the words of San Filippo himself, to the mysteries of the Virgin (diag. 45).[62] Altarpieces were commissioned from a number of painters to carry out the themes of the dedications. The high altarpiece is literally a reliquary, a painting of saints and angels by Peter Paul Rubens encasing a much older miracle-working image of the *Madonna and Child*. Then starting in the left wing of the transept with a scene of the *Presentation of the Virgin* by Federigo Barocci, a unified narrative proceeds right to left toward the entrance of the church, along the five chapels on the left side of the nave (fig. 205). It passes to the right wall and moves from the entrance toward the apse, ending with the *Coronation of the Virgin* in the transept's right wing.[63] That this prescription resulted in a unified sequence of altarpieces has been called innovative, and indeed it is. It is probably the first remaining instance of such a unity planned from the beginning and carried out without change. But what has not been recognized is that this arrangement fits into the history of cycle disposition. What San Filippo did was to wed the newly invented basilical altar cycle in the Wraparound pattern to the monastic counterclockwise devotional narrative order. I suggest that San Filippo Neri not only was aware of these traditions but consciously chose them to reinforce the devotional mode of his own new confraternal order.

San Filippo founded the Oratorians (1575) as a kind of lay apostolate administered by the members of the confraternity as well as by clerics. The devotional principles adopted were totally democratic, based on a system of common prayer and singing, preaching, and discussion. The de-

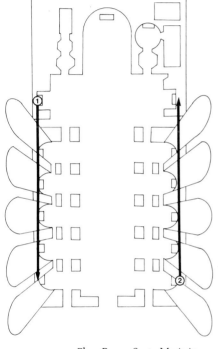

DIAGRAM 45. Plan, Rome, Santa Maria in Vallicella

votion to the rosary, always considered a popular form of worship, was one of his main concerns.[64] Rosaries are made of graduated beads and used to count off prayers—one Pater Noster, ten Ave Marias, and one Gloria Patri—between pious meditations on the fifteen mysteries of the Virgin. Divided among a number of individuals, these prayers become a shared spiritual experience.[65] San Filippo said he wanted the tour around the church, with the worshiper passing from chapel to chapel, from altarpiece to altarpiece, to be used specifically for such contemplative experience.

It is at this juncture that narrative and mystery interpenetrate. The

FIGURE 205. Rome, Santa Maria in Vallicella, second chapel, left side, Barocci, *Visitation*

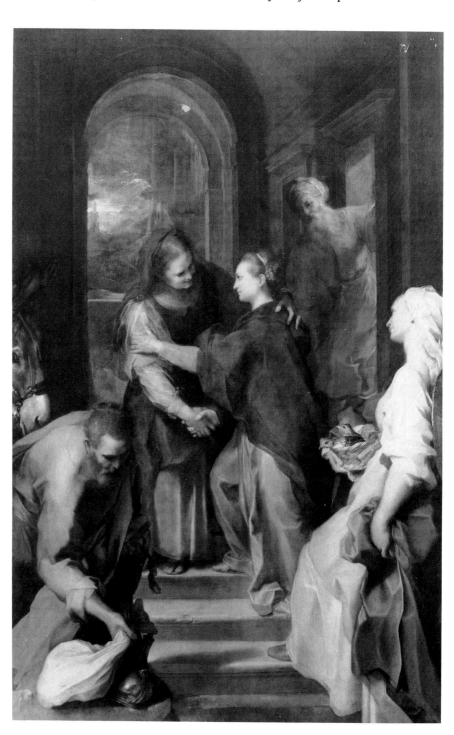

rosary mysteries are divided into three parts: the Incarnation (Annunciation, Visitation, Nativity, Circumcision, and Christ among the Doctors); the Passion (Agony in the Garden, Flagellation, Crowning with Thorns, Carrying of the Cross, and Crucifixion); and the Glory (Resurrection, Ascension, Descent of the Holy Ghost, Assumption, and Coronation). If one reads these feasts back into their narrative sources, it is easy to see that they form the combined Lives of the Virgin and Christ, as we have seen in various cycles. The difference at the Chiesa Nuova is that the cycle is made up of individual feast paintings, related in the sense of narrative sequence but composed independently to be contemplated as separate devotional units. I propose that San Filippo appropriated Vasari's somewhat earlier accomplishment for the Florentine Franciscans and reversed the direction of reading to the counterclockwise motion for at least two reasons. Not only does the order of the altarpieces allude to the disposition of cycles in monastic cloisters and their association with perambulatory meditative contemplation, but it also follows the counterclockwise movement of the rosary as the fingers pass from bead to bead in prayer.[66] In this way San Filippo was able to bring the spirit of monastic, solitary devotion in the cloister into the body of the church, where it could be shared by the Oratorians as they processed in groups around the church.[67]

This complex of devotional allusions was shortly raised to official status in the efflorescence of ecclesiastical renewal that took place in Rome in the last decades of the sixteenth century. A concerted effort to refurbish Early Christian foundations throughout the papal city demonstrates how medieval patterns of disposition were used as a major element in the reaffirmation of pristine Christian values. The campaign of Clement VIII (1592–1605) was particularly energetic as he took up the task of remaking the basilica of San Giovanni in Laterano. In the first of the Constantinian foundations and the cathedral of the capital, it was not the nave that was refurbished (that project would come later in the seventeenth century), but the transept. Clement's idea was to transform this space into what amounted practically to a new church intersecting the orientation and the meaning of the old. The area was given its own entrance and its own high altar with its own dedication and a series of important relics.[68] The decorative scheme is a unified achievement centered on a fresco cycle of Constantine the Great (fig. 206). The historical implications of the Constantinian foundation myth are presented as an official statement of the church's new triumph in the very building where the events took place. Chiefly designed by the Cavaliere d'Arpino,[69] the episodes represented are from the Life of Constantine, his conversion at the hands of Saint Sylvester, his founding of the Lateran, and his donation of properties to the new church. The pattern of disposition is a Wraparound with the variable that became one of the hallmarks of the sixteenth century: counterclockwise movement (diag. 46).[70] Eight large scenes, four on each side, are painted with a double illusion that makes them look like framed paintings represented on fluttering tapestries.[71] The conceit thus interlocks allusions to the Festival Mode in the temporary tapestries and the liturgical "altar cycle" with the fresco mural tradition. On the lowest tier are emblems of the Cross, the only remnant of Constantine's vision,[72] and nine white marble angels representing the nine choirs of heaven.

FIGURE 206. Rome, San Giovanni in Later-
ano, transept, general view (see plate 24)

DIAGRAM 46. Rome, San Giovanni in Later-
ano, transept

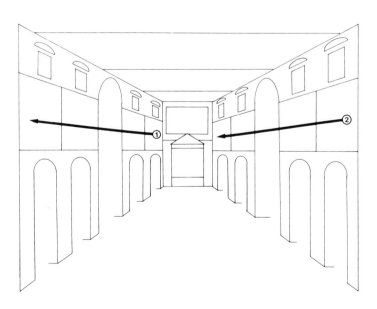

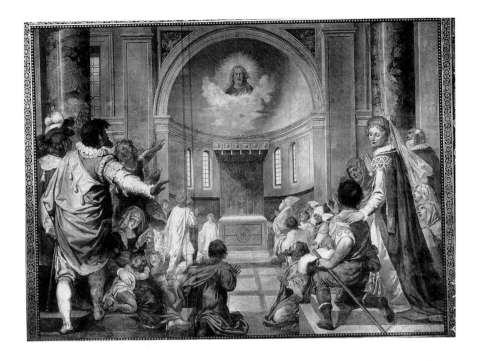

The use of the counterclockwise progression in this case takes on a fundamental meaning of its own. The first chapter of the cycle consists of the four scenes on the left wall; it deals with Constantine's Conversion: his *Triumphal Entry* on his return from the divinely guided battle, his *Illness and Dream*, the *Discovery of Saint Sylvester*, and the *Baptism of Constantine* accompanied by a mystical flash of light. The second chapter on the left wall concerns the Founding of the State Religion, all the scenes of which take place at the Church of San Giovanni itself. Beginning at the right there is the *Foundation of the Lateran*, with excavations being dug. The second scene is the *Consecration of the High Altar*, the third is the *Apparition of the Volto Santo in the Apse* (fig. 207), and the last is *Constantine's Donation to the Lateran* (fig. 208).[73] The second and third of these compositions appear at the sides of the actual apse, where pictured in mosaic is a vision of the bust of Christ, who appeared in this spot on the day the church was dedicated.[74] The counterclockwise arrangement—and only this arrangement—made it possible to juxtapose the two scenes representing the altar/apse of the host basilica with the actual altar/apse and to integrate the important image represented there into the painted cycle. The counterclockwise progression thus provided a new level of veracity for the presence of the miraculous image and for the epic nature of the history of the church.[75]

The decorative programs created under the strong control of Sixtus V, Gregory XIV, and Clement VIII in the closing years of the sixteenth century involved an almost pedantic degree of a archaeological precision. Use of the hoary tradition of fresco disposition, however, should not be counted merely as an element of this revival. Over the centuries, the patterns of disposition became a fundamental part of artistic knowledge and planning and, as we have seen, were never set aside. They were changed and modified, and sometimes reinterpreted, but always with the goal of making them more coherent and specific to their own time and locale.

FIGURE 208. Rome, San Giovanni in Later-
ano, transept, view of *Constantine's Donation
to the Lateran*

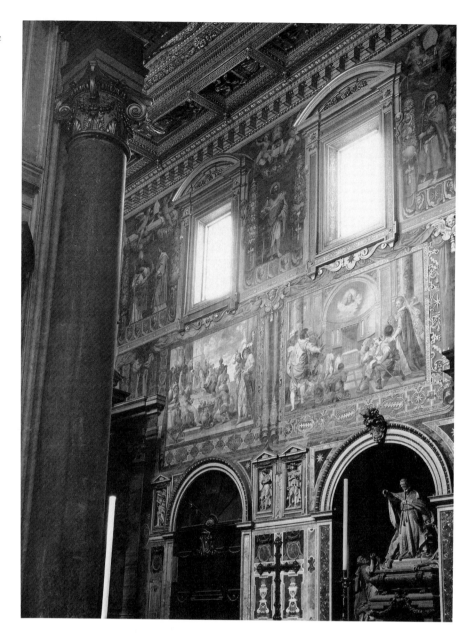

Expression of basic theological ideas remained their function, and there-
fore their recognizability remained imperative. Rather than revival, the
issue was what might be called "historic continuity," which at the height
of the Counter-Reformation was sought more objectively than ever be-
fore. Indeed, it is amply clear that though I bring the discussion to a close
at the year 1600, fresco disposition as part of mural decoration was to
retain its place in the expression of major public ideas for many centuries
to come.[76]

The Computer Database: NARRART DATA

What follows is an account of the structure, content, and function of NARRART DATA, the computer database into which I have entered most of the factual information I gathered concerning some 230 Italian medieval and Renaissance monumental ecclesiastical cycles. The discussion is aimed primarily at readers who are not particularly computer literate, in the hope of encouraging them to try the methods I have found fruitful. For those who have grown up with computers, this narrative will probably seem quaint. I include it, however, to document the formation of a private research database designed to deal efficiently with what previously would have been an unmanageable amount of historical information.

I started (in 1982) by assembling the kinds of facts I thought would be appropriate for computer processing: a meticulous list of the cycles I had studied up to that point, with their names, dates, artists, and subjects. Armed with these notes, I went looking for expert help at Computing Information Technology Services (CIT), the then relatively new computer center at Princeton University. There I met Shirley K. Robbins and Douglas L. Mills, programming consultants, who told me that because a computer is run by a program, or software package, in setting up a database one must choose a program appropriate to the problem at hand. In this light, they asked what I planned to do with the material once it was in a database. Because I had thought that storage and retrieval by mechanical means was an end in itself, I had no ready answer. The consultants advised me to break my subject down, so far as was possible, into smaller component parts. Using just one cycle this time, I made a new outline, focusing on the narrative itself. Besides identifying the cycle, I named each episode and indicated where each scene was on the wall. This operation made me feel rather anxious. The cycles I was going to deal with were all highly individual, with different scenes in different sequences, placed in different parts of the architecture. If I had to make such an outline for every cycle, how was the computer going to save me time? Besides, it worried me to think of the great monuments of medieval and Renaissance painting as parts of faceless lists forced into a machine. However, when I saw the consultants seriously considering the new outline, I began to feel encouraged. After a period of contemplation,

they started asking me questions: Do you want to know where the story starts in all your cycles? Do you want to know what scenes are represented? Do you want to know where each scene is on the wall? Do you want to know how many stories start in the same location? Do you want to know how many cycles have the same scenes? Do you want to know how many times they have the same scenes and how many times they do not? Do you want to know how often scenes of a certain subject are on left walls? How many stories start on the top tier? How many read from left to right? How many read from bottom to top? And so on. Robbins and Mills had generalized from my outline and were asking questions the computer could handle. They both agreed that since I would be dealing with many examples of the same genre and wanted to know how their characteristics compared in a quantitative sense, my problem was statistical.[1] On the basis of this observation, they could now suggest the proper program.

From my point of view, their questions had provided an important insight. I would not be forcing "examples" into the machine. A computer after all is nothing but a piece of electronic equipment operating on the binary system. That is, the only thing it can do is transmit electrical charges that are positive or negative; it can turn on and turn off. However, it can do that very fast. Each pulse of energy can, moreover, house a unit of information that has been deposited there. To get a full description of a work of art, one must separate the parts, deposit the units in specified places in the computer, and reassemble them in one's own mind. In other words, I could not tell the machine that Piero's cycle is painted in a three-sided chapel; that the story starts on the top tier of the right wall; that it reads first from the right to the left and then from the left to the right. I would have to make a place in the machine (one or more bytes) designated as "the right wall" and another designated as "the top tier."[2] Then I could assume the machine was asking me, "Does the cycle begin on the right wall?" And I could answer yes by typing 1 in the proper place. When the machine then asked me, "Does the cycle begin on the top tier?" I could answer yes again with a 1 in its proper place.[3] In like manner, I could not "tell" the computer that the scenes were stacked in three superimposed tiers—one lunette and two rectangles. But I could make a place for the characteristic "rectangle" and empower the machine to ask: Are there rectangular fields? (yes/no), then make a place for the quantity of such a feature, with the machine asking: How many rectangular fields? In this case the answer would take the form of an uncoded number that retained its own quantitative value. That is, in this case a 2 would not mean no but would mean *two* rectangles. With a series of such questions, the description of a fresco cycle could be "reconstructed."

My thinking had been turned around. I was no longer *telling* the computer what I knew. I was arranging station points in the computer so that it could *ask* me what I knew. I was not tampering with the quality of the work of art; I was simply organizing its salient physical characteristics in a way that would permit rational comparisons with other works.

The next mission was to get characteristics of fresco disposition into "machine readable" form for storage. This step meant choosing what are called the "variables" in my investigation. Variables may be defined as the constant components of any investigation; they are always the same

in type, but they vary in detail. For example, in a study to ascertain the average weight of children in a kindergarten class, the variables might be each child's name, age, height, weight, and quality of appetite. All the children would have all five of these characteristics, but each characteristic, or variable, would vary according to the child being tabulated. By now I had understood that I would not be able to elicit a description of the fresco's narrative disposition without first describing the architectural ambient in which it was housed. The variables therefore would comprise two groups, one for the architecture—that is, the actual surfaces on which paintings could be executed—and one for the disposition of scenes on those surfaces.

A number of preconceptions guided my choices in the first group of variables. Since my starting point had been frescoes in medieval and Renaissance buildings, the architectural model I followed in choosing the variables was unconsciously based on buildings of these periods. In such architectural ambients, the painting fields tend to have predictable shapes in relatively standard juxtapositions. The churches and chapels are generally rectangular, composed of bays, and covered with pitched ceilings or vaults. The upper tiers, flat topped, pointed, or semicircular in form, are often pierced by clerestory windows. Top-tier painting fields, therefore, are either vertical rectangles, lunettes, or smaller irregular triangles flanking a window. Below this level, most walls are divided into two or three horizontal rectangular tiers, stacked one above the other. I did not consider the more irregular shapes of later, post-Renaissance buildings. As a result, the variables I chose in this category were lunettes, clerestories, windows, rectangles, number of rectangles, barrel vaults, groin vaults, and domes.

The second group of variables addressed the heart of my problem: the physical location of each scene on the architectural support, regardless of its relation to literary order. Applied to the wall structures I had described, medieval and Renaissance narrative sequences follow linear movements with clearly defined relationships, and again the definitions took the form of questions eliciting positive/negative answers: Does the cycle start on the left wall? (yes/no). Does it move from the left to the right? Does it move from the top down? Does it move horizontally by bays? Does it move vertically by tiers? Is the movement diagonal? Is the movement irregular? And again by assembling the answers a description, in this case of the narrative disposition, is formed.

The Software

The software selected was Statistical Analysis System (SAS), a system for data analysis created to handle large-scale projects in fields ranging from census taking and demography to physics, forecasting, and financial reporting.[4] Although it was more powerful than necessary for my needs, SAS could be adapted to problems of any size or subject. Although later deemed relatively difficult to run, it was the best management program available in 1982, when I began this project. The compact storage format, moreover, proved highly valuable in a practical sense, as we shall see in a moment.

The SAS system requires a database of a particular form. It calls for the data to be arranged in what are called "records," which take the shape of one horizontal line on a computer screen. There are eighty characters, or bytes, on each line, numbered 1 to 80 from left to right. In SAS a byte, or a group of bytes, can be designated as a storage place for particular information. Once those bytes are designated by the program, they remain unique and constant and are "readable" by the machine. Three bytes at the end of each record are reserved to identify that record. They must be filled by one letter and two numbers. For example, I call one of my records "T01." T is an arbitrary character that I chose; the number 01 identifies the line as the first of the T-record.[5]

The data in SAS records can be composed of what are called "mixed strings"; that is, the records can receive a combination of letters and numbers used to spell words or give dates, and of letters or numbers, or both, that have been coded to symbolize larger amounts of information. As we have seen, a number such as 1 can be used to mean yes; it can be used to mean the quantity one; or it can mean 1 as in 1492. In particular locations I have coded 1 to mean "seen from the left"; in other locations I have coded it to mean "monoscenic narrative mode, or a scene with one representation of each figure performing one narrative action." Obviously such "coded" numbers and letters, storing much material in a compact space, require relatively small amounts of memory, one of the objectives in creating a database.

The efficiency of the SAS format is easy to observe. For example, all the variables necessary to identify a particular cycle—the country, city, church, location in the church, dedication of precinct, and name of the artist—fit on one record. Again, all the variables describing the architecture and the disposition of a cycle, plus its date and the title of its subject, are stored on another single record. NARRART DATA has six types of records and a total of ninety-one variables, and it can store enough information for a very well-rounded view of each cycle.

When the database is processed by the SAS program, the coded material is translated into English and printed out for users with no computer skills. Sample pages of the processed database are reproduced below in appendix 1. In its entirety, this printout is very large and can be consulted only as a reference document. When the database is printed out directly in its coded form, it is still very useful. One of the guiding principles of my design for NARRART DATA was to use real words and numbers as often as possible. For example, I wrote out the names of all the artists and the scene titles and put them, along with dates, in highly visible locations for easy scanning. This approach makes it possible for any reader to consult portions of the coded database directly. Nevertheless, there are many coded numbers and letters that must be deciphered before they can be understood. The principles I used in setting up the codes, however, are so simple that they quickly become part of one's vocabulary. For example, in certain set locations, 1 always means "from the left," 2 always means "centered" or "balanced," and 3 always means "from the right."[6] In its coded form, NARRART DATA prints out in a relatively short, lightweight, portable format. Although it is considered very large in terms of the amount of data for a single subject, its printed form is the equivalent of only sixty-five typed pages. One can therefore carry the entire data-

base to libraries and sites for editing and correcting and use it as a guide when surveying the cycles in situ.

Structure and Content of NARRART DATA

For those interested in the exact content of the database, I give the following description. In reading this section, one should consult appendix 1, where the data's physical appearance on the computer screen is reproduced.

NARRART DATA consists of a vertical list of Italian fresco cycles arranged chronologically from top to bottom. A description of each cycle is contained in a block of six types of records, separated from other blocks by a number of blank lines. Information in each block is of four types: identification, description, iconography, and incidental details. The six types of records that house the data are called T-record, O-record, S-record, I-record, A-record, and F-record.

T-record. This record stores the information necessary to identify a cycle with its geographic location, attribution, date, and subject matter. Placed as the first line of a block, it identifies the group of records that pertain to one particular cycle. The record is initialed T because it contains topographical information. The country, city, and church in coded letters fill in the first twenty-nine spaces (or bytes) starting at the left. *Country code* is in one byte, in this case I, which stands for Italy (others would be F for France, G for Germany, and so on). The next two letters are the *city code*—in this case, initials following the conventions of Italian automobile tags. The next five letters code the name of the *church* in which the cycle is found.[7] The next twenty spaces name the cycle's *location* within the church. The name of the artist(s) to whom the cycle is attributed appears toward the end of this line. Byte 75 asks whether the primary artist was assisted by helpers, answered by 1/2 = yes/no.

O-record. This record contains descriptive information concerning the organization of the architecture and the narrative. The descriptions required the use of some conventions to ensure consistency. The walls of a given precinct are always numbered from the point of view of a spectator standing at the entrance and facing the altar. Starting s36the left, the walls are numbered consecutively around the chamber from left to right. Wall 1 is on the left; wall 2 is the altar wall; wall 3 is on the right; and wall 4 is the entrance wall. Horizontally stacked tiers are always numbered starting at the top with tier 1 and are counted down to the bottom. The positions on each tier are numbered from left to right, counted straight through on a long nave wall, and started anew with each wall when the walls have no more than two bays. These conventions are always followed in describing an architectural ambient, regardless of how the narrative moves upon the surfaces. The presence and number of lunettes, windows, clerestory walls, rectangular fields, and roofing types are noted in coded form in bytes 31–52. The chronological order of the narrative on the wall is noted with coded numbers indicating where it begins (on which wall and tier) and in what direction it moves (up, down, or sideways; horizontally, or vertically by bays or walls; from left to right or right to left or irregularly), bytes 53–76.[8] This record also includes the

(approximate) dates of the cycle, in real numbers in the first nine spaces on the left.

S-record. The subject, or iconography, of every episode represented in the cycle is listed with a standardized title twenty-eight bytes long.[9] Each episode is named separately, whether it appears alone within a frame or together with other scenes. The record contains two titles to a line; it is repeated as many times as called for by the number of episodes represented.

Following each title are eight coded numbers, the first four indicating the exact physical location of the scene.[10] The four numbers in the second group might be considered "analytical" in an art historical sense. They designate the character of the inscenation of the scene by describing four major compositional elements: represented architecture, landscape, light flow, and figure groups, in that order. The mission of this data group, which is perhaps more interpretive than most in the database, is to show how the elements described slow or speed the narrative movement by remaining upright and static or by thrusting in a particular direction and guiding the eye from scene to scene.[11] Again the codes used here define 1 as left, 2 as center, 3 as right, and 0 as an absence of the element.

I-record. This unstructured record, initialed I for inscriptions, indicates whether the cycle includes inscriptions: dates, signatures, labels, tituli, or quotations of any sort. Where possible, the inscriptions are quoted.

A-record. This record was left unstructured to receive prose descriptions of anomalous characteristics (A for anomaly) of a given cycle. It is multiplied as many times as necessary. SAS will sort from this record, listing the whole record (of several lines) or any words or phrases from within the record.[12] The names of the patterns of disposition, discovered in the working process, are placed in this record.

F-record. The last two lines of each block contain information about altarpieces and figural representations that are nonnarrative on architectural elements other than the main fields (pilasters, borders, dados, stained glass, ceilings, and floors) in the same precinct. The final entry on record "F02" (bytes 36–76), is a bibliographic reference chosen to lead to publications containing further bibliography on the cycle.

NARRART DATA is currently stored on disk in the Princeton University main frame IBM 3081 computer; it contains some 230 cycles and is constantly being expanded and edited.

Use of the SAS Program

The SAS program can list, count, sort, compare, and otherwise process every one of the ninety-one variables in NARRART DATA with any or all of the others in all of the cycles in the database. Every factual unit in the database can be located electronically. Operating the SAS program can produce statistics on gross questions: for example, listing all cycles on the life of a given saint. It can help to analyze issues of a more complex nature: for example, listing factors that affect the design of individual scenes, such as the location on the wall or relation to a window, proximity of a scene to entrances and corners, juxtaposition above, below, and beside other scenes. It can track iconographic features, such as episodes

chosen for representation (and by implication, those left out) or follow the frequency of various subjects and their narrative modes.

The following is an example of a simple statistical problem that was run on SAS. It is used as a demonstration partly because it produced a clear set of statistics; more important, however, it led to the formulation of further scholarly problems.

In compiling the database, I observed some correlation between the direction of light flow in a scene and the scene's location within the architectural ambient. I speculated that the illusion of painted light as emanating from the source of real light in the church interior—that is, from windows—might have a history beginning much earlier than is ordinarily assumed.[13] As a trial, I programmed SAS to array all the frescoes in the database from the fourteenth century that have scenes with light painted as flowing from the right that are on the left walls of chapels that have windows only on the altar wall. The question looked like this:

```
IF WALLOC = 1 & LGT = 3 & WIN2 > 0 THEN OUTPUT;
FORMAT: .CHURCH .LOCAT .SUBJECT .DATE .ARTIST; END;
```

The results are charted in diagram 47, as an array of examples and as a bar chart showing visually the chronological distribution by twelve-year intervals. The same question was posed for scenes on right walls during the same period, with the same results. My original question was thus answered: yes, naturalistically represented light was already related to fenestration in the trecento.[14]

The statistics, however, give more than an answer, for beyond the accumulated data new questions now arise. The bar chart showed a heavy concentration between the years 1320 and 1332, the years Giotto was at work (d. 1337), followed by a couple of decades with no examples. A quick check of the database showed that plenty of cycles were painted in that interval, but none used light in this fashion. Then, late in the century there seemed to be a renewal of the usage. Was the clustering of instances of naturalistic light geographically localized? Why did it start, stop, and then start again? What is its historical significance? How did it affect the meaning of the paintings? What are its implications for the style of each work?[15] I consider this kind of unfolding of further questions—a typical effect of statistical answers—one of the computer's chief contributions to scholarly activity.

The statistical implications of NARRART DATA remain largely unexploited at this point. In discovering the patterns of disposition while preparing the material for entry into the database, and in recognizing their historical importance, I essentially put aside working with the database as a statistical tool. That challenge therefore still lies ahead.

DIAGRAM 47. Scenes with painted light coordinated with light from windows, 1320–68

	CHURCH	LOCATION	SUBJECT	DATE	ARTIST
1	SCRC	BARDI CHAPEL	SFRAN RENOUNCES FATHER	1315–20	GIOTTO
2	SCRC	BARDI CHAPEL	SFRAN DEATH & APOTH	1315–20	GIOTTO
3	SFRAN	MAGD CHAPEL	MAGD DRIES X FEET	1320–21	GIOTTO ATT
4	SFRAN	MAGD CHAPEL	X RAISES LAZARUS	1320–21	GIOTTO ATT
5	SFRAN	MAGD CHAPEL	MAGD LAST COMMUNION	1320–21	GIOTTO ATT
6	SFRAN	SMARTIN CHP	SMART DIVIDES CLOAK	1320–28	SIMONE MART
7	SFRAN	SMARTIN CHP	SMART X APPEARS BEGGAR	1320–28	SIMONE MART
8	SFRAN	SMARTIN CHP	SMART RAISES BOY CHARTRE	1320–28	SIMONE MART
9	SFRAN	SMARTIN CHP	SAMBROSE DREAMS SMART	1320–28	SIMONE MART
10	SFRAN	SMARTIN CHP	SMART FUNERAL SING	1320–28	SIMONE MART

11	SCRC	BARONCELLI	JOACHIM IN WILDERNESS	1330–34	TADDEO GADDI
12	SCRC	BARONCELLI	BMV BIRTH OF MIDWIVES	1330–34	TADDEO GADDI
13	SCRC	BARONCELLI	BVM PRESENTATION STEPS	1330–34	TADDEO GADDI
14	SCRC	BARONCELLI	BVM BETROTHAL GARDEN WALL	1330–34	TADDEO GADDI
15	SCRC	PERUZZI	ZACHARIAH ANNUNCI MUSIC	1330–36	GIOTTO
16	SCRC	PERUZZI	JBAPT BIRTH NAMING	1330–34	GIOTTO
17	SCRC	PERUZZI	HEROD FEAST DANCE	1330–34	GIOTTO
18	BARG	CHAPEL	PRINCE MARSEILLE WIFE	1336–38	GIOTTO FOL
19	BARG	CHAPEL	JBAP NAMING OF	1336–38	GIOTTO FOL
20	SCRC	RINUCCINI CHP	JOACHIM EXPLUSION	1365–69	GIOV MILANO
21	SCRC	RINUCCINI CHP	JOACHIM IN WILDERNESS	1365–69	GIOV MILANO
22	SCRC	RINUCCINI CHP	GOLDEN GATE MEETING	1365–69	GIOV MILANO
23	SCRC	RINUCCINI CHP	BVM BIRTH MIDWIVES	1365–69	GIOV MILANO
24	SCRC	RINUCCINI CHP	BVM PRESENTATION STEPS	1365–69	GIOV MILANO
25	SCRC	RINUCCINI CHP	BVM BETROTHAL RODS	1365–69	GIOV MILANO
26	SGIOR	ORATORIO DI	SGEORGE B4 DECAPIT	1377–84	ALTICHIERO
27	SCRC	CASTELLANI CHP	SANTHONY BEATEN DEVILS	1385–90	AGNOLO GADDI

FREQUENCY BAR CHART

FREQUENCY

```
10  +            *****
 :            *****
 :            *****
 :            *****
 :            *****
 9  +            *****
 :            *****        *****
 :            *****        *****
 :            *****        *****
 :            *****        *****
 8  +            *****        *****                              *****
 :            *****        *****                              *****
 :            *****        *****                              *****
 :            *****        *****                              *****
 :            *****        *****                              *****
 7  +            *****        *****                              *****
 :            *****        *****                              *****
 :            *****        *****                              *****
 :            *****        *****                              *****
 :            *****        *****                              *****
 6  +            *****        *****                              *****
 :            *****        *****                              *****
 :            *****        *****                              *****
 :            *****        *****                              *****
 :            *****        *****                              *****
 5  +            *****        *****                              *****
 :            *****        *****                              *****
 :            *****        *****                              *****
 :            *****        *****                              *****
 :            *****        *****                              *****
 4  +            *****        *****                              *****
 :            *****        *****                              *****
 :            *****        *****                              *****
 :            *****        *****                              *****
 :            *****        *****                              *****
3:  +            *****        *****                              *****
 :            *****        *****                              *****
 :            *****        *****                              *****
 :            *****        *****                              *****
 :            *****        *****                              *****
 2  +            *****        *****                              *****
 :            *****        *****                              *****
 :            *****        *****                              *****
 :            *****        *****                              *****
 :            *****        *****                              *****
 1  +            *****        *****                              *****
 :            *****        *****                              *****
 :            *****        *****                              *****
 :            *****        *****                              *****
 :            *****        *****                              *****
           _____       _____       _____       _____       _____
            1320         1332         1344         1356         1368
```

Appendix 1: Selected Cycle Entries

```
IROSMM  NAVE                          BVM                ROMAN SCHOOL    1        1 T01
0431-0440OT&NT                        158 211         211        111      4113    O02
ABRAHAM AND MELCHISEDEK        11  0212    ABRAHAM AND 3 ANGELS OAK     31  0111S01
ABRAHAM ENTERTAINS 3 ANGELS 31  1111       ABRAHAM AND LOT PARTING OF   11  1112S02
DESTROYED                     1            DESTROYED                    1      S03
DESTROYED                     1            ISAAC BLESSES JACOB          11  3113S04
DESTROYED                     1            RACHEL ANNOUN ARRIV JACOB    31      S05
JACOB AND LABAN MEET LOWER   1             JACOB HAND OF RACHEL LABAN   11   022S06
JACOB REPROACHES LABAN       11  1213      JACOB LABAN EMBRACE          31  3211S07
JACOB LAMENTS W UNCLE        11  3111      JACOB AND RACHEL MARRIAGE    31  2212S08
JACOB ASK LABAN PAY SERVANT 11  3212       JACOB DIVIDES FLOCK          11  0212S09
JACOB COMMANDED TO LEAVE GOD11  0232       JACOB DEPARTURE TELLS RACHEL 11  1112S10
JACOB ESAU MEETING           31  2212      JACOB BUYS CAMP              11  3111S11
DINA RAPE OF                 11  0313      DINA MARRIAGE SICHEM ELDER   12  3212S12
DESTROYED                    1             DESTROYED                    1      S13
DESTROYED                    1             DESTROYED                    13     S14
MOSES PHARAOHS DGTR TAKEN BY13  1011       MOSES DISPUTE WITH ELDERS    13  2012S15
MOSES ZEPPORAH MARRIAGE      13  0212      MOSES GUARDING SHEEP         13  0212S16
DESTROYED                    3             DESTROYED                    3      S17
DESTROYED                    3             RED SEA CROSSING DOUBLE SIZE 13  1333S18
ISRAELITE COMPLAINT MOSES    33  0233      QUAILS FALL OF DESERT        13  0113S19
MOSES SWEETENS MARAH WATER   33  0213      MOSES AMALEKITE PRINCES      13  1212S20
MOSES ON MOUNT               33  0212      BATTLE AMALE KITE DOUBLE SC  33  3112S21
SPIES RETURN FROM PROMIS LD 13  1212       MOSES BRINGS LAWS PEOPLE STON13  3111S22
MOSES DEATH OF               33  0211      JOSHUA AND ARK JORDAN        13  0111S23
JORDAN CROSSING WITH ARK     13  0313      SPIES GO TO JERICO           13  3211S24
JOSHUA AND ANGEL             13  0111      SPIES RETURN TO JOSHUA       13  1313S25
MARCHING TO JERICO           13  3212      JERICO WALL DOWN TRUMPETS    13  0113S26
AI ASSAULT ON                13  1313      AI ASSAULT ON                13  0313S27
JOSHUA CONQUERS AMORITES     13  0211      JOSHUA CONQUERS AMORITES     13  0111S28
JOSHUA STOPS THE SUN         13  0213      JOSHUA ORDERS REGULI         13  02 2S29
SOME NAMES INSCRIBED                                                          I01
DOUBLE // APSE-ENTRANCE START RIGHT OT SCS IN TWO VERTICAL TIERS ORIG 43      A01
NOW 37 ALWAYS COMPARED TO MSS ILL APSE DESTROYED REDONE 1295 PTGS 1590-95     A02
                                       C CECCHELLI MOSAICI BASIL SMM TURIN 1954 F02

IRASAN   NAVE              SAPOLLINARE       BYZANTINE ARTISTS          T01
0504    X MIRACLES&PASSION  1283211         3211       11      4113    O01
X CANA MARRIAGE WATER WINE  1113 3 1    X FEEDS MULTITUDES LVS & FISH1112 2 2S01
X CALLING PETER & ANDREW    1111 1 3    X HEALS BLINDMEN TWO         1110   2S02
X HEALS ISSUE OF BLOOD      1119   1    X & SAMARITAN WOMAN AT WELL  1118   2S03
X RAISES LAZARUS            11171  3    PHARISEE & PUBLICAN          11162  2S04
X PARABLE OF WIDOW'S MITE   11153  3    X SEPARATING SHEEP FROM GOATS1114 2 2S05
X HEALS RICH SON CAPERNAUM  111311 1    X HEALS POSSESSED OF GERASA  1112 1 1S06
X HEALS PARALYTIC BETHESDA  1111 1 3    LAST SUPPER                  13112  1S07
X AGONY IN GARDEN           1312 2 2    KISS OF JUDAS                1313   1S08
X ARREST LED AWAY           1314 2 1    X B4 CAIAPHAS                13153  1S09
X PROPHESIES SPET DENIAL    13163  1    SPET DENIAL 1                13172  1S11
JUDAS REPENTANCE OF         13183  1    PILATE WASHES HANDS          13193  1S12
CALVARY ROAD TO             1310 1 1    X TOMB MARYS 2 AT            13112  2S13
X EMMAUS ROAD TO            131233 3    DOUBTING THOMAS              13132  2S14
MAGI ADORATION BVM ENTHRONED113 2  1    X ENTHRONED HOLDING DBL VIAL 133    2S15
```

```
BOUSTROPHEDON (EARLY)    STARTS LEFT (SMM & JLAT) NARMOVE OPPOSTE PROC STS   A01
FEMALE SS RIGHT MIRACLES OVER CITY-IMAGE PASSION OVER PALACE-IMAGE           A02
                              BOVINI G SANT'APOLLINARE NUOVO 1961            F02

IROSMA  PRESBYTERY          BVM                 ROMAN-BYZ ARTISTS           T01
0705-0707X LIFE             121                                             O01
LOST                        111     LOST                     112           S01
LOST                        113     X NATIVITY              1114           S02
MAGI ADORATION W ANGEL    11153001  CRUCIFIXION ADORATION OF  42100002     S03
X PRESENTATION            13112001  FLIGHT INTO EGYPT       13120101        S04
LOST                        313     LOST                     314           S05
LOST                        315     LOST                     121           S06
LOST                        122     LOST                    1123           S07
KISS OF JUDAS   EAR?       1134     X CARRYING CROSS       11250101         S08
CRUCIFIXION ADORATION OF  42200002  APOSTLES AT SEPULCHRE   1321        3  S09
DOUBTING THOMAS           13223002  X APPEARANCE ON LAKE TIBERIAS13230202  S10
X APPEARANCE TO ELEVEN APSTL13240202 EMMAUS ROAD TO         13240101       S11
APSE PATTERN 1ST EX OF DOUBLE SIZE CRUCIFIXION BUT DEVOTIONAL CF SPET      A01
                    NORDHAGEN,PJ FRESCOES OF JOHNVII SMA 1968              F02

ISFSAFORNAVE                SMICHAEL            ROMAN SCHOOL               T01
1072-1087X LIFE&OT          1677 11    7 11 3 111     131     113131314    O01
BVM ANNUN (LOST)            1311     VISITATION (LOST)         1312        S01
X NATIVITY (LOST)           1313     SHEPS ANNUNCIATION (LOST) 1314        S02
MAGI ADORATION (LOST)       1315     X PRESENTATION (LOST)     1316        S03
JOSEPH SECOND DREAM?(LOST)  1317     EGYPT FLIGHT TO (LOST)    1318        S04
HEROD ORDERS MASSACRE       11111    INNOCENTS MASSACRE        1112        S05
X AMONG DOCTORS             1113     JBAP PREACHING IN WILDERNESS 1114     S06
X BAPTISM                   1115     X TEMPTATION IN DESERT    1116        S07
X TEMPTATION AT TEMPLE      1117     X TEMPTATION ON MOUNTAIN  1118        S08
X CALLING APOSTLES          1321     X CANA MARRIAGE           1322        S09
X HEALS LEPER               1323     X STILLS TEMPEST GALILEE  1324        S10
X HEALS PARALYTIC           1325     X ISSUE OF BLOOD WOMAN    3326        S11
X RAISES JAIRUS DGTER       3326     X HEALS BLINDMEN TWO      1327        S12
X FEEDS MULTITUDES LVS FISH 1328     X CANAANITES DGTR         1329        S13
X TRANSFIGURATION           1121     X TRIBUTE MONEY           1122        S14
X WIDOWS MITE JUDGE         1123     X & UNGRATEFUL SERVANT    1124        S15
X GOOD SAMARITAN  WOUNDED   1125     X SAMARITAN PARABLE       1126        S16
X SAMARITAN HELPS TRAVELER  11273 1  X RICH YOUNG RULER        1128        S17
X RICH YOUNG RULER PARABLE  1129     X BOY POSSESSED PARABLE   1120        S18
X ASCENSION                 1121     X & ZACCHEUS IN TREE     1331 131     S19
X & WOMAN OF SAMARIA WELL   1332 333 X ADULTERY WOMAN TAKEN    1333313     S20
X HEALS BORN BLIND          3334  1  X RAISES LAZARUS         133531 1     S21
X VISITS MOTHER JOHN & JAMES13361  3 X SUPPER SIMON HOUSE WASH FT 13373 3  S22
ENTRY INTO JERUSALEM        1338 1 1 LAST SUPPER CIMA TABLE    13393 3     S23
X WASHES APOST FEET         1330   2 X AGONY IN GARDEN        3131 3 3     S24
X ARREST KISS OF JUDAS      31321 1  X MOCKED (SANHEDRIN)      1133 3      S25
PILATE WASHES HANDS  VIA CRU31343 1  CRUCIFIXION ALIVE         1135 2      S26
X DEPOSITION ARCHED TOMB    11361  1 X DESCENT INTO LIMBO      1137 2 2    S27
X TOMB MARYS AT    ONE ANGEL 11381 1 X EMMAUS ROAD TO 2 DISCP  1139   1    S28
X APPEARS     SEA OF GALILEE 1130 1 1 X DOUBTING THOMAS        11312 2     S29
ASCENSION X (BOTTOM HALF)   1132     LAST JUDGMENT             402  2      S30
EXPULSION OF ADAM & EVE     1411   1 CAIN & ABEL SACRIFICE     412         S31
GIDEON INCREDULITY WITH ANG 3413   2 CAIN KILLS ABEL          3413 1       S32
CAIN CONDEMNATION OF        3414   1 NOAH TOLD CONSTRUCT ARK  3415 1       S33
S PANTALEONE MARTYRDOM      142  2 2                                      S34
TRIPLE WRAPAROUND   TOP RANGE W3 (IE BEGINNING OF NARR) X INFANCY DESTROYED A01
IRREGULAR RECTANGLES SEVERAL POSTPASSION SCS CRUX PIERCES BOTTOM SPANDREL  A02
ASCENS 2 TIERS VERT ENTRY JERU 2RECTS HORZ REFER TO SPET ROME             A03
OT IN AISLE STS PROPHETS  LAST JUDGMENT INTERIOR FACADE  VERY BAD DAMAGE   A04
                 1    MORISANI 1962 BOOK AFFRES D SAFOR                    F02

IASSFRANLOWER NAVE SEMIDESTR SFRAN&X          SFRANCIS MASTER         2 T01
1253-1366LIVES SFRAN & X PASS210 122     122     4 4 33      4131        O01
                                              FRANCISCAN               O02
X GIVES UP CLOAK AT CROSS   13150 13 CRUCIFIXION WOMEN         13140011 S01
DEPOSITION JOE HOLD HAMMER  13130111 LAMENTATION THRENOS COMPASSIO131201 S02
EMMAUS SUPPER THOUGHT TO BE 11111032 SFRAN RENOUNC BISH COVERSCLOA111100 S03
SFRAN INNO III VISION LAT HD111220 3 SFRAN BIRDS PREACHING TO  11130213  S04
SFRAN STIGMATIZATION SERAPH 11140111 SFRAN DEATH HD LEFT       111500    S05
ORIG THREE BAYS EACH W CENTRAL WINDOW PERHAPS 4TH BAY AT ENTRANCE END LOST A01
ALL BAYS CUT OPEN IN CENTER AS ENTRANC TO NEW CHAPELS SIDES OF EACH SCENE LTA02
LAST HALF OF BAYS AT ALTAR END MAY NOT HAVE HAD SCS DECOR NOW EARLY SFRAN CCA03
ORIG ORIENTATION REVERSED WAS TAU SHAPE   DOUBLE // APSE-ENTRANCE         A04
EARLY VERY STRONG FRANCISCUS ALTER CHRISTUS PROMULGATION  CF OLD SPET     A05
                    RUF GERHARD 1981      GRAB DES HEIL FRF02
```

```
IASSFRAN UPPER APSE          BVM SPET MICHAEL    CIMABUE                    1 T01
1274-1284BVM LIFE  & DEATH    2 8 12133      1213      131 31199131312123     O01
                                                           FRANCISCAN         O02
JOACHIM EXPULSION            1110        BVM BIRTH                    1310    S01
BVM PRESENTATION            1120        BVM MARRIAGE  (BETROTHAL)     1320    S02
BVM APOSTLES GATHERING OF   114020 3    BVM DEATH OF KOIMESIS       124100 2S03
BVM ASSUMPTION X EMBRACING  124302 2    BVM ENTHRONED W X           134020 3S04
POLYGONAL APSE JUMPS L-R TIERS 1&2 CONT L-R SEQUENCE TIER 4 DEATH&MYSTIC MARA01
APSE PATTERN      CF ALSO STAINED GLASS SEQUENCES                             A02
                              11 HBELTING   1977BOOK   DIE OBERKIRCHE         F02

IROSMM  APSE                BVM             TORRITI                    1 T01
1295    LIFE BVM             1 8    02217        42          112             O01
BVM CORONATION              1210   2    TWO KNEELING B4 POPE       12213031S01
BVM ANNUNCIATION           12122011    X NATIVITY SHEP ADORATION   32131111S02
BVM DEATH DORMITION        12142022    MAGI ADORATION             12151011S03
X PRESENTATION             12161032    APOSTLES SPEAKING TO MEN?  12171022S04
SIGNED AND DATED 1295                                                        I01
SCS 1 & 7 ON FRONT FACE OF TRIUM ARCH L-R APSE PATTERN       MOSAIC          A01
                                                                            F02

IROSMTRAMAIN APSE MOSAIC    BVM             CAVALLINI                  1 T01
1298-1300BVM LIFE           1 6    11116        1 42       11               O01
BVM BIRTH    ANNE ON LFT    12312011   BVM ANNUN THRONE GABLELFTSTAN12321111S01
X NATIVITY CAVE  RECLIN SHEP223300111   MAGI ADORATION JOE BEHIND   12341111S02
BVM PURIFICATION IN TEMPLE  12351012   BVM DEATH KOIMESIS HEAD RGT  12362012S03
3LINE HEXAMETER VERSE UNDER E SC INTERNAL INSC NATIV     CONCH 1143          I01
DONOR PANEL BVM & X & DONOR SAME SCALE CORONATION ABV CANTICLE QUOTE         A01
APSE ARRANGEMENT CF ASSISI REALISM IN PLACEMENT MYSTIC CONCH 1ST LJ W4 IN ITA02
                              P HETHERINGTON 1979 BK    P CAVALLINI          F02

IASSFRAN UPPER NAVE         SFRAN        GIOTTO ATTRISCECIL MS      1 T01
1295-1297GEN&EXO X LIFE&POST 16331113     311131122 4 41331 4131341331143499O01
                                                           FRANCISCAN        O02
CREATION FIRST DAYS         23110212   ADAM CREATION              1312022 S01
EVE CREATION FR ADAM        13130211   TEMPTATION FIG LEAVES      131402 2S02
ADAM & EVE EXPULSION        131502 1   ADAM & EVE AT WORK(DESTROYED)1316   S03
CAIN & ABEL SACRIFCE(DESTRD)1317       CAIN KILLS ABEL            131802  S04
NOAH GOD SPEAKS & BUILDS ARK33210131   NOAH FAM IN ARK ANIMALS ENTER1322   S05
ABRAHAM ISAAC SACRIFICE     13233111   ABRAHAM AND 3 ANGELS       13240 13S06
ISAAC & JACOB BED HEAD LEFT 13251033   ISAAC & ESAU REJECTED      13261013S07
JOSP SOLD BY BROTHER WELL   232701 2   BENJAMINS CLOAK REFOUND    13283031S08
X BAPTISM JBAP RGT 2 ANGELS 111102 2   X AMONG DRS IN TEMPLE      11122022S09
EGYPT FLIGHT TO  (DESTROYED)1113       X PRESENTATION             11142012S10
MAGI ADORATION              11151  1   X NATIVITY WITH SHEPS      11160313S11
VISITATION (DESTROYED)      1117       BVM ANNUNCIATION           11181022S12
X TOMB ANGEL ON SARC        1121 12    LAMENTATION                11220113S13
CRUCIFIXION                 11230232   CALVARY ROAD TO            11240 33S14
X FLAGELLATION (DESTROYED)  1125       KISS OF JUDAS PETER CUTS EAR 31260222S15
X RAISES LAZARUS            1127       X CANA MARRIAGE  CROWN BRIDE 11282022S16
ASCENSION                   12130211   PENTECOST HG BVM           12112022S17
SFRAN SIMPLE MAN HONORS SCEL13311012   SFRAN GVS CLOAK POOR KNIGHT 13321112S18
SFRAN VISION PALACE & ARMOR 13331011   SFRAN PRAYS IN SDAMIANO    13341031S19
SFRAN RENOUNCES FATHER&BISH 13351032   SFRAN INNO III VISION LATERAN13361033S20
SFRAN RULE INNO III APPROVES13371032   SFRAN FIERY CHARIOT VISION 13383031S21
SFRAN VISION THRONES HEAVEN 13391031   SFRAN AREZZO DEVILS EXPELLED 13303131S22
SFRAN SULTAN TRIAL BY FIRE  13312032   SFRAN TRANSFIGURATION      13323031S23
SFRAN GRECCIO NATIVITY      13332023   SFRAN MIRACLE OF SPRING    14310111S24
SFRAN BIRDS PREACHING TO    14330211   SFRAN CELANO KNIGHT DEATH OF 11313011S25
SFRAN PREACHING TO HON III  11322011   SFRAN ARLES APPEARANCE     11331013S26
SFRAN STIGMATIZATION X NUDE 11341111   SFRAN DEATH & APOTHEOSIS   21350012S27
SFRAN DEATH VISION FR AUGUST31361013   SFRAN DEATH VISION BISH ASSIS31373013S28
SFRAN OBSEQUIES JEROME TESTI11382012   SFRAN SCLARE GRIEVING OVER  11391112S29
SFRAN CANONIZATION          11303012   SFRAN POPE GREG VISION OF   11312011S30
SFRAN HEALS ILERDO MAN      11322032   SFRAN RESUS WOMAN CONFESSION 11331032S31
SFRAN LIBERATES HERETIC    ·11342032                                        S32
SFRAN27-30WL 1 BY MST SCECILIA SHADOWS PERSPECTIVE ANTIQUES                  A01
TRS 1&2 OT-NT DOUBLE // TR 3 SFRAM WRAPAROUND W4 INC START W3 INTERLOCK       A02
X CRUCIFIXION ABOVE SFRAN DEATH SC LOOK FOR TYPOLOGY NO MOSES OR AARON       A03
PARALLEL MOVEMENT FROM APSE TO ENTRANCE CF LOWER AS AND OLD SPET NAVE MODE   A04
                          222212MEISS&TINTORI 1962BOOK   PTGLIFE SFRAN       F02

IFIBAPT  DOME               JOHN THE BAPTIST   ANON MOSAICIST          1 T01
1290-1299OT& X& JOHN BAPT   2590               7515 7        115             O01
```

```
CREATION                      171102 2   CREATION OF ADAM              171202 2S01
CREATION OF EVE               171302 1   TEMPTATION OF ADAM & EVE      171402 2S02
GOD REPRIMANDING ADAM EVE     171500 1   EXPULSION                     171610 1S03
ADAM & EVE WORKING GOD N SKY171701 1     SACRIFICE OF CAIN & ABEL      171822 2S04
CAIN KILLS ABEL TREE          171903 1   LAMECH KILLS CAIN             171001 1S05
GOD COMMANDS NOAH ARK          17110 3   NOAH BUILDS ARK SAWING        171210 1S06
NOAH FAMI ANIMALS ENTER ARK   171310 1   DELUGE DOVE BODIES UND WATER   17143 1S07
JOSP DREAM OF                   17213 1   JOSP TELLS PARENTS OF DREAM    17222 1S08
JOSP TELLS BROTHERS OFDREAM   172301 1   JOSP SOLD BY BROTHERS         172420 1S09
JOSP ANNUN OF DEATH FALSE     172530 1   JOSP JOURNEY OF             17260101S10
JOSP POTIPHAR B4              172710 1   JOSP ACCUSED BY POTIPHAR WIFE172820 1S11
JOSP IN PRISON                172920 3   DREAM OF PHARAOH              172020 3S12
JOSP INTERPRETS PHARAOH DREA172120 3     JOSP VICEROY OF PHARAOH       172220 2S13
JOSP STORING GRAIN            172310 3   JOSP BROTHERS VENERATED BY    172430 3S14
JOSP FATHER HORSES            172500 3   ANNUNCIATION BVM DOVE RAYS    173110 1S15
VISITATION                    173210 2   NATIVITY X ANNUN SHEPS        373322 2S16
MAGI ADORATION                173430 2   MAGI DREAM OF ANGEL SKY       173520 1S17
MAGI RETURN BOAT              173620 1   PRESENTATION X PRIEST HOLDS   173730 2S18
JOSEPH SECOND DREAM  LNDSCP 173803 1     FLIGHT INTO EGYPT ONE SON     173901 1S19
INNOCENTS MASSACRE HEROD      173030 1   LAST SUPPER SOP TO JUDAS      173120 3S20
KISS OF JUDAS MALCHUS EAR     173200 2   CRUCIFIXION SWOON LEFT        173332 2S21
LAMENTATION HEAD LEFT         173430 3   X TOMB MARYS 3 AT 1 ANGEL     173533 3S22
ZACHARIAH ANNUNCIATION        174130 2   JBAP BIRTH NAMING             374203 1S23
JBAP INF DEPARTS FOR DESERT   174301 1   JBAP YOUNG PREACHING 5 MEN    174401 2S24
JBAP BAPTIZING MULTITUDES     174502 2   ECCE AGNUS DEI X RGT          174601 1S25
X BAPTISM TWO ANGELS          174702 2   JBAP BERATING HEROD&HERODIAS 174820 2S26
JBAP IN PRISON                174920 2   JBAP SENDS DISCIPS TO X 2     174021 1S27
X WORKS MIRACLE B4 JOHN DISC174100 3     HEROD FEAST OF DANCING PRES   174200 3S28
JBAP DECOLLATION SALOME PRES174330 3     SALOME DELIVERS HEAD JBAP     174420 2S29
JBAP FUNERAL HEAD ON           17453002                                       S30
4TIERS 4PASSIONS MUCH APOCRY EMPHAS MAGI COSMOLOGY LJ IN APSE DIETY  ANGELS A01
NB NB NUMBERING OF TIER POSITION START RGT OF ALTAR SIDE 6 OF OCTAGON NB   A02
// (4 TIER PARALLEL) BRAKING MECHANISM AT END OF EACH TIER                 A03
                            IRENE HUECK  1962 DISS DAS PROGRAMM DER F02

IGDSPET NAVE                  SPET        DEODATO ORLANDI              T01
1300     SPET SYLV CONSTANT 130 11     11      13      1131      1131 O01
CALLING OF SPET X            1321 3 3   ON WATER SEA OF GALILEE SPET 1312 1 1S01
TRIBUTE MONEY SPET X         232322 2   SPET X GIVES KEYS TO (DESTROY)324  S02
PASCE OVES MEAS SPET         132511 3   SPET HEALS CRIPPLE IN TEMPLE 13262 3S03
SPET HEALS W SHADOW AC5       13271 1   SPET ENTHRONED ANANIAS SAPHIR33282 1S04
SPET RAISES TABITHA           13293 1   SPET IN CHAINS LIBERATED ANGE13202 1S05
SPET DEDICATES ANTIOCH CHURC13212 2     SPET SAILS FR ANTIOCH TO ROME13223 33S06
BASILICA SPET GR ARCHITEC      3232     PILGRIMS AT SPET GRADO LOCAL  324 2S07
SPET & PAUL ROME RECONSTRUC   1121      SPET & MAGUS B4 EMP NERO      1222 1S08
FLIGHT OF SIMON MAGUS        112311 1   DOMINE QUO VADIS              11241 1S09
SPET CRUCIFIXION OF          1125 2 2   PAUL BEHEADED SOUL RGT        3125 1 1S10
SPET BURIAL                   11262 1   BURIAL OF PAUL                11272 1S11
DEATH OF EMP NERO SOLD DOGS 112831 1    BODIES SPET PAUL STOLEN       31281 1S12
BURIAL OF SPET PAUL SSEBAST 112922 1    CONSTANTINE DREAM P&P HEAD R  11202 1S13
SYLVESTER SHOWS CONSTANT ICO11212 1     CONSTAN BUILDS SPETS          31222 1S14
SYLVESTER DEDICATES SPETERS   11232 2   SYLVESTER DRAGON MIRACLE CAP  11242 1S15
ELABORATE DESC        TITULI                                               I01
TOP TIER PTD WINDOWS W ANGELS LOOKING OUT BOTTOM TIER PORTS OF POPES LOCAL A01
CF OLD SPET PORCH LOST  GRIMALDI DRAWINGS  WRAPAROUND                      A02
                            WOLLESEN J  1977 BK    FRESKEN VON SDG F02

IPDARENA NAVE                 BVMDELLA CARITA    GIOTTO                  2 T01
1303-1310BVM LIFE X LIFE      241 221 12146211 1122      221    112312314 O01
JOACHIM EXPULSION OF          13113031   JOACHIM IN WILDERNESS SHEPS  13121131S01
ANNE ANNUNCIAT SPINDLE        13131031   JOACHIM SACRIFICE ANGEL BLESS13141132S02
JOACHIM ANGEL APPEARS SHEPS  13151332   GOLDEN GATE MEETING AT KISS  13161023S03
BVM BIRTH OF 2BABES ANNE RED31113013    BVM PRESENTATION TEMPLE STEPS11121011S04
BVM RODS PRESENTED JOS LEFT  11132011    BVM RODS WATCHED MEN KNEEL   11142011S05
BVM MARRIAGE BETROTH  RGTHND11152022     BVM NUPTIAL CORTEGE MUS TREE 11161011S06
X GABRIEL MISSION  GTF ANGEL121000 2     BVM ANNUNCIA GABRIEL KNEELS  12213011S07
BVM ANNUNCIATION KNEELING    12231011    VISITATION ELIZ BENDS        12331032S08
NATIVITY BVM RECLINS 2SHEPS  13211133    MAGI ADORATION ANGELS CAMELS 13221122S09
X PRESENTATION OF ANNASCROLL13233032     EGYPT FLIGHT TO 4 SERVS ANGEL13240131S10
INNOCENTS MASSACRE OF HEROD  13252032    X AMONG DOCS BVM & JOE TEMPLE11212022S11
X BAPTISM OF 4ANG GTF 4SHORT11220222     X CANA MARRIAGE BRIDE CROWN  11232022S12
X RAISES LAZARUS DOOR TOMB   11240131    ENTRY INTO JERUS BOYS IN TREE11251111S13
EXPULSION FROM TEMPLE MERCH  11263011    JUDAS PACT OF DEVIL BEHIND   12311012S14
LAST SUPPER XLFT 5APOS BKSTR13313022     X WASHES APOST FEET B4 PETER 13323032S15
KISS OF JUDAS TORCHES        13330232    X B4 CAIAPHAS TEARING CLOTHES13342022S16
X MOCKED    SEATED THORNS    13352033    CALVARY ROAD TO X CARRIES CRO11313111S17
```

```
CRUCIFIXION SKULL MAGD 2GRPS11320212    LAMENTATION PIETA ANGELS AIR 11330333S18
  TOMB ANGELS ON SARCOPHPINK31340132    NOLIME TANGERE MAGD KNEELS   31350111S19
X ASCENSION BVM APOSTL KNEEL11360211    PENTECOST NO BVM FISTULAE    11371022S20
LAST JUDGMENT W DONOR & MONK24100222                                         S21
INSCRIPTIONS ON VIRTUES & VICES DAGO                                         I01
VAULTED CHAMBERS WL2 TIER4 JUDAS EMPH ELABORATED LIFE BVM 4 MARRIAGE SCS     A01
NO TEMPTATIONS NO TRANSFIGURATION NO AGONY IN GARDEN DRAMATIC EVENTS MORALS  A02
RATIONALLY ADJUSTED ASYMMETRY NARRA ALWAYS STARTS W2 DROPS ONE TIER TO W3 &  A03
TRIPLE WRAPAROUND NOTHING OUT OF PLACE ONLY EMPHASIZED                       A04
CF N.29 SPET GRADO SSYLV FNDS SPET EMPTY CHAPELS WITH LANTERN VAULTS         A05
1INSITU CF ARENA CHOIR                                                       F01
                       011212JSTUBBLEBINE  1969 GIOTTO ARENA FRESCOES F02

   IPDARENASCROVEGNI CHOIR      BVM              FOLLOWER   OF GIOTTO    1 T01
   1317-1320BVM DEATH OF     2 6 12131    1213    1111313 13 12          99O01
   BVM APOSTLES GATHERING OF   111030 3  BVM APOSTLES FAREWELL       112010 3S01
   BVM DEATH KOIMESIS HEAD LFT 113020 2  BVM FUNERAL HEAD LEFT       133001 1S02
   BVM ASSUMPTION STHOM GETSBEL132002 1  BVM CORONATION AIRBORNE     131002 2S03
   START LFT MOVE DWN JMP RGT MOV UP HEAVEN SCN IN AIR DEATH CYC NR TOMB     A01
   UP-DOWN, DOWN-UP                                                         A02
   1INSITU    GIOVANNI PISANO   1310      BVM & X W 2 STS MARBLE            F01
                            HUECK  SCROV VERANDER MITT.FLOR'73 277-94F02

   IFISCRC BARDI CHAPEL 1ST STR SFRANCIS            GIOTTO            2 T01
   1315-1320 LIFE OF SFRAN    2 8 121211212 1212    111 311 2122122      O01
                                                    FRANCISCAN          O02
   SFRAN RENOUNCES FATHER&BISH 11102032    SFRAN RULE INNO III APPROVES13102013S01
   SFRAN SULTAN TRIAL BY FIRE  13202012    SFRAN ARLES APPEARANCE      11202032S02
   SFRAN STIGMATIZATION        14101312    SFRAN DEATH & APOTHEOSIS     11342032S03
   SFRAN DEATH VISION FR AUGUST33313013    SFRAN DEATH VISION BISH ASSI33330133S04
   AERIAL BOUSTROPHEDON TOP DOWN START LEFT ZIGZAG 1331 TIER 3 SIMUL         A01
   STIGMAT ON EXTERIOR WALL RGT OF APSE FUNCTIONS AS MAIN IMAGE OF CHURCH    A02
   MONASTIC THEME ROME AUTHORITY BEGIN END BISHASSIS STANDARD LOCA RGT OF ALTARA03
   1LUGANOTHYSUGOLINOATTR     AFT1310    CRUCIFIXION BVMJOHNSFRAN & FEMALE STF01
                            222222BORSOOK RIVISTA D'ARTE 1961-2 PP 371FF   F02

   IASSFRAN MAGD CHAPEL LOWER   MAGDALEN           GIOTTO ATTR        1 T01
   1320-1321MAGD LIFE      2 8012122    01212012111111313    4113431   99O01
                                                    FRANCISCAN          O02
   MAGD DRIES X FEET SIMON    11211031    X RAISES LAZARUS            11230131S01
   NOLIME TANGERE            13210331    MAGD LAZARUS RUDDERLESS BOAT 33233111S02
   PRINCE MARSEILLE WIFE ISLAND33233111  MAGD IN CAVE ZOSIMUS ROBE    14100112S03
   MAGD CARRIED UP BY ANGELS  13100211    MAGD LAST COMMUNION CLIPEATA 11101031S04
   TIER2 MOVES LEFT TIER1 MOVES RGT AIRBORNE SCS AT TOP LINEAR BOUSTROPHEDON  A01
                            221022SCHWARTZ L   WESTERN ILLINOIS UNIV DISS  F02

   IASSFRANLOWERSMARTIN CHAP    ST MARTIN BSH CONF  SIMONE MARTINI      2 T01
   1317-1320SMART LIFE&DEATH    211 221332222 2213 122 2321332   41313131499O01
                                                    FRANCISCAN          O02
   SMART INVESTED AS KNIGHT    23311013    SMART DIVIDES CLOAK AT AMIENS11313333S01
   SMART X APPEARS TO AS BEGGAR11333031    SMART REFUSES JULIAN'S MONEY 23330111S02
   SMART APPEARS TO EMP        13231011    SMART RAISE DEAD BOY CHARTRES11211332S03
   SMART CELEB MASS ANGELS DRES13213013    SAMBROSE DREAMS SMARTS DEATH 21233032S04
   SMART DEATH SOUL ABOVE      23132012    SMART FUNERAL HEAD LFT SING  11112032S05
   SMART RECEIVES GMONTEFIORE  14102002                                      S06
   TRAVELING HAT INVESTURE SC  EARLY SCENES LOW HEAVENLY TOP   SIDE TO SIDE SEQ A01
   ON SECOND TIER NARR BEGIN NAVE MODE BUT BOTTOM TIER CAT'S CRADLE  PATTERN  A02
   BEGIN&END MILITARY LOW WL3 XMIRACLE LOW WL1 MIRACLES TIER2 SEQUENCE MOVES UPA03
   SAMBROSE DREAM LIKE AUGUSTINE/JEROME                                      A04
                            122122BORSOOK E 1980 23FF      MURAL PTRS    F02

   IASSFRANLOWER TRANS NORTH    JBAP             MAESTRO DELLE VELE       T01
   1315-1320X INFANCY     214   17 1 2    16   111 221  231 41231        O01
                                                    FRANCISCAN          O02
   BVM ANNUN BVM RGT OF DOOR  13102 2    VISITATION SAME HEIGHT       14111131S01
   SUESSA BOY DEAD HOUSE COLLAP13213221  SFRAN REVIVES SUESSA BOY     13233023S02
   X NATIVITY ANNUN SHEPS BATH 34131331  MAGI ADORATION 2 ANGELS STAND14211311S03
   X PRESENTATION           142320 2    CRUCIFIXION W FRANCISCANS    14300232S04
   EGYPT FLIGHT TO BENDING PALM12112231  INNOCENTS MASSACRE  HEROD    12132011S05
   X AMONG DOCTORS          12212022    X RETURN FROM TEMPLE         12233031S06
   SFRAN MIR FALL SPERELLI BOY 12312123  SFRAN WITH SKELETON          123300 2S07
   NARR ON BARREL VAULT DIVIDED AT CENTER TOP  EACH SIDE MOVES DOWN AND L TO R A01
   STRAIGHT-LINE VERTICAL    PLUS TOP DOWN CF PIETRO LORENZETTI PASSION      A02
                            KLEINSCHMIDT DIE WANDMALEREIEN SFRAN 1930F02
```

```
IASSFRANLOWER TRANS SOUTH    JBAP                PIETRO LORENZETTI        1 T01
1315-1320X PASSION           214    13 3  12   14    111  31  312         O01
                                                          FRANCISCAN      O02
ENTRY INTO JERUSALEM WELL DR121111 1   LAST SUPPER KITCHEN SC     12133  3S01
X WASHES APOST FEET          12213 1   KISS OF JUDAS             1223 1  1S02
JUDAS HANGED                 12311 1   SFRAN STIGMATIZATION       1233   S03
X FLAGELLATION PILATE BHD CO14111 1    CALVARY ROAD TO CITY GATE 14131  1S04
CRUCIFIXION CITY GATE        1420 2 2   BVM & X SFRAN & JEVAN     4430   S05
X DEPOSITION X BENDS BCKW    1121 3 3   ENTOMBMENT BVM KISS HEAD LEFT1123 1 3S06
X DESCENT INTO LIMBO         111111 1   X RESURREC FT ON RIM 5 SOLDR 111311 3S07
EMOTIONAL INTENSITY GEOMETR RIGOR ODD ARCHIT DETAIL SYMBOLIC GENRE        A01
STRAIGHT-LINE VERTICAL    PLUS BOTTOM UP CF VELE LIFE X    ART BUL 1984 MAG A02
PART OF UP DOWN,DOWN UP PATTERN WITH OPPOSITE END WALL                    A03
                                   MAGINNIS ZEITSCHRIFT F KUNST 1976 208  F02

IFISCRC PERUZZI CHAPEL       SS JOHN BAPT & EVAN GIOTTO              1 T01
1330-1336JBAPT & JEVAN       2 6 121211 2  1 12   11113111 13  4213      O01
ZACHARIAH ANNUN   MUSICIANS 11103 32   JBAPT BIRTH NAMING        11223 33S01
HEROD FEAST DANCE SALOMEHEAD31303 31   JEVAN ON PATMOS APOC AROUND 1310 212S02
JEVAN RESURR OF DRUSIANA      13201 11   JEVAN ASCENSION X DESC    13301 11S03
MUSIC AT BIRTH SENSE OF HEARNG  PATTERN VISION MIRACL DEATH              A01
REFERENCE TO LATERAN TWO ST JOHNS STRAIGHT-LINE VERTICAL                 A02
          GIOTTO PERHAPS   1330CA    X IN GLORY                         F01
2    2                     1  1  BORSOOK TINTORI 1961 BK  GIOTTO PERU CHAPF02

IFISCRC BARONCELLI CHAP STR   BVM ANNUNCI      TADDEO GADDI           2 T01
1330-1334BVM LIFE            212 12141114     11  311 212  1111        O01
                                                     FRANCISCAN       O02
JOACHIM EXPULSION OF         31112103   JOACHIM ANNUN IN WILDERNESS 31130333S01
GOLDEN GATE MEETING EMBRACI11211023   BMV BIRTH OF MIDWIVES BATHING11231033S02
BVM PRESENTATION OF STEPS    11311033   BVM BETROTHAL OF GARDENWALL  11331232S03
BVM ANNUNCIA ANGEL IN AIR RT12111031   VISITATION ELIZ KNEELS FIGS 12133131S04
SHEPS ANNUNCIATION BRGT LIGT12210132   X NATIVITY CARPENTRY CAVE    12333112S05
MAGI VISION  VIS SWADDLED X 12310131   MAGI ADORATION OF            12331012S06
BETROTHAL LARGE CROWD GARDEN WALL  ANNUN BVM & ANNUN SHEPS & ANNUN MAGI  A01
VISION WITH BRIGHT LIGHT FROM REAL WINDOW  WEST END DESTROY FOR PAZZI CHAP A02
2 SCENE STRAIGHT-LINE VERTICAL  TWO PART STIGMATA IN WINDOW SFRAN LEFT    A03
1INSITU    ATTR SGN GIOTTO  1327-33?  CORONATION OF BVM W SAINTS        F01
                           111112J GARDNER 1971 89-117  ZEITSCHRIFT F KUNSF02

IFIBAPT SOUTH DOOR BRONZE    JOHN BAPTIST      GIOVANNI PISANO         1 T01
1332-1336LIFE OF JOHN BAPT   128    1            11 2   111            O01
ZACHARIAH ANNUNCIATION       11113  2   ZACHARIAH AND ELDERS       1112   1S01
VISITATION EQUAL EMBRACE     11211  2   JBAP BIRTH                 11221  2S02
JBAP NAMING BVM BRINGS       11313  2   JBAPT INF ENTERS DESERT    11321  1S03
JBAP PREACHING IN WILDERNESS1141 1 3   ECCE AGNUS DEI             1142 1 1S04
JBAP BAPTIZING MULTITUDES    1151 1 2   X BAPTISM                  1152 2 2S05
JBAP BERATING HEROD          11131  1   JBAP ARREST  2 SOLDIERS    11141  1S06
JBAPT IN PRISON VISITED DISC11231  3   JBAPT PREACHING TO STORPI  1124   2S07
SALOME IMPLORES HEROD TABLE 11331  1   JBAPT DECOLLATION          11341  3S08
JBAPT HEAD BANQUET HEROD     11431  1   SALOME DELIVERS HEAD JBAPMOTH11443 1S09
JBAP FUNERAL BODY CARRIED    1153 1 1   JBAP BURIAL WITH HEAD      1154   3S10
HOPE (SPES)                  161    1   FAITH (FIDES)              162    2S11
FORTITUDE CLUB R SHIELD L    171    1   TEMPERANCE SWORD INTO HILT 172    2S12
CHARITY HEART                163    2   HUMILITY  CANDLE VEIL      164    3S13
JUSTICE SWORD SCALE          173    2   PRUDENCE                   174    3S14
VIRTUES NAMED IN LATIN                                                   I01
JOHN KEEPS HEAD NO HALOS XCEPT BVM&X LIONS RVRS MOVEMT OF VIRTUES  SC 2-4ODDA01
2 SC STRAIGHT-LINE VERTICAL EACH VALVE                                   A01
                 11    TOESCA I ANDREA & NINO PISANO FLOR 1950        F02

IFISCRC BARDI DI VERNIO CHAP SSYLVESTRO        MASO DI BANCO            T01
1335-1341CONSTANTINE CONVERSI2 6 1 121   1 12    111  311 13  1      99O01
                                                     FRANCISCAN       O02
CONSTANTINE REFUSES BLOODBAT111130 3   CONSTANTINE DREAM P & P SYLV 11201031S01
SYLVESTER SHOWS CONSTANT ICO33113011   CONSTANTINE BAPTISM IN FONT  33132011S02
SYLVESTER BULL MIRACLE ZAN   13202012   SYLVESTER DRAGON MIRACLE CAPI33303211S03
TOMBSW1TIER3 STRAIGHT-LINE VERTICAL 3 WALLS  HISTORICITY RUINS OR ROME  A01
TRANSFER POWER TO SYLV=ROME PAPACY DREAM OF CONST HERE NOT IN CHANCEL   A02
CF D WEBB THE TRUTH ABOUT CON  RELIGION & HUMANISM OXFORD 1981 P85F     A03
SYLV AT SORACT OR JOURN TO WL 2 SYLVT JOURN TO ROME LOWER WALL 2 SUGGESTED A04
                           WILKINS D    1969        DISS U MICH       F02
```

```
IVESMRC BAPTISTRY              BAPTIST            BYZANTINE MOSAICIST        T01
1343-1354LIFE OF X&BAPT     1181122 0122 2122 112183131231      113441     99O01
ZACHARIAH ANNUNCIATION      13112  2    ZACHARIAH ELIZ MEETING OF    13212  2S01
ZACHARIAH MUTE              1312        JBAP BIRTH  REDONE 1628      1313    S02
MAGI SPEAK TO HEROD         34111  1    MAGI ADORATION DREAM OF JOE  34133  1S03
EGYPT FLIGHT TO             12111  1    INNOCENTS MAS FLGHT ELIZ JBAP3213   1S04
JBAP INF ANGEL LEADS DESERT 1421 1 1    JBAP VOCATION OF             1423 1 1S05
JBAP PREACHING TO PHARISEE  14242  2    X BAPTISM PERSONIFICATIONS   1120 2 2S06
JBAP W 2 DISC MAN ON ROCK   1221        HEROD FEAST OF SALOME DANCE  11122  2S07
JBAP DECOLLATION HEAD BASIN 31131  1    SALOME DELIVERS HEAD JBAP    31141  1S08
JBAP FUNERAL WOUT HEAD      31153  3    CRUCIFIXION W DOGE & MAGISTR 1210 2 2S09
WESTERN LONGITUDNL PLAN EASTERN DOMES SECTIONS  WESTERN WRAPAROUND   XTR LOOPA01
BARRELV HOLDS PRT UPPER TIER NAR CF ARENA&MASCOLI 3PRT CEIL PROGR THEOLOGY  A02
BARRELV OT GOD PROPH CENDOME XGLORY APOS BAPT EDOME X2ND COMING ANGELS HEIR A03
ARRANGEMENT EXPRESSIVE OF INTERWEAVING LIVES OF JBAPT AND X INTERLOCK       A04
ALL SCS HAVE TITULI ALL FIGURES HAVE LABELS      DATED                      I01
                    11 1  TOZZI R        1933 PP418 BOLL D ARTE             F02

ISGCOLG  RT AISLE                        LIPPO MEMMI (?)          1 T01
1340-1343X LIFE             230        1  1    6   31   413           99O01
BVM ANNUNCIATION SPINDLE    13162 22   X NATIVITY SHEPS ADORATION   13151323S01
MAGI ADORATION              13141 33   X PRESENTATION TEMPLE        13132  3S02
INNOCENTS MASSACRE          13122  3   EGYPT FLIGHT TO              1311   3S03
X AMONG DOCTORS             13241 21   X BAPTISM ANGELS TWO FLYING  1325 1 1S04
X CALLING SPET              1326 1 3   X CANA MARRIAGE              13273 23S05
X TRANSFIGURATION           1328 2 2   X RAISES LAZARUS             13291  1S06
ENTRY INTO JERUSALEM SPET   3320 1 1   ENTRY INTO JERUSALEM PEOP GAT33211  3S07
X LAST SUPPER               1331 2 2   JUDAS PACT OF                13302  1S08
X AGONY IN GARDEN           1339 323   KISS OF JUDAS MALCHUS EAR    1338   3S09
X B4 CAIAPHAS TEARS CLOTHES 13372  3   FLAGELLATION BEHIND COLUMN   13361 33S11
X MOCKED                    13352  2   CALVARY ROAD TO              13341  3S12
CRUCIFIXION 3 CROSSES       132302 2   CRUCIFIXION 3 CROSSES        132302 2S13
CRUCIFIXION SWOON           133302 2   CRUCIFIXION SOLDIER LONGINUS 133302 2S14
X ENTOMBMENT SEMIDESTROYED  1332       DESCENT INTO LIMBO(SEMIDESTR)1331    S15
X RESURRECTION SEMIDESTROYED1322       X ASCENSION SEMIDESTROYED    1321    S16
NEW ATTRIBUTION BY GAUDENZ FREULER DOCUMENT  CF ARTE CHRISTIANA 1986        A01
XFIXION 4SQRS ENTRY 2SQRS W SPET CALL OF SPET ROME NO APPEAR BOUSTROPHEDON  A02
FORMER ATTRI TO BARNA DA SIENA FROM GHIBERTI                                A03
                    222   CECCHINI CARLI   1962     SGIMIGNANO              F02

IFIORSM TABERNACLE STONE    BVM              ORCAGNA                    2 T01
1352-1359BVM                110   11   11   11   11    1        111432      O01
BVM BIRTH UNDER TENT        11113003   BVM PRESENTATION STEPS       11132002S01
BVM MARRIAGE BETROTH BRK ROD14112002   BVM ANNUNCIATION             14130002S02
X NATIVITY SHEPS ANNUN      33110202   MAGI ADORATION X IN STAR     13132002S03
X PRESENTATION X OVER FIRE  12112003   BVM DEATH ANNUNCIATION       12132003S04
BVM DEATH KOIMESIS          32220202   BVM ASSUMPTION STHOM BELT    32120002S05
VIRTUES HOLD INSCRIPTIONS ON BANDEROLES                                    I01
BVM OVERSIZE BVM ANNUN   BLUE BCKGRD SCS HEXAGONAL DRAPE TABERNACLE SETTINGSA01
EARLY REP STHOM DEATH & ASSUMP LARGEST RELIEF TO DATE PALEOLOGAN HAT SELF P?A02
WRAPAROUND                                                                 A02
2REPLACED BERN DADDI3RD VERS 1347     BVM & CHILD CHINCHUCK GOLDFINCH      F01
                 112000FABBRI&RUTENBU1981385-405ART BULLETIN              F02

FAVPAPPACHAP SMARTIAL       SMARZIALE      MATTEO GIOVANNETTI          T01
1346-1349LIFE SMARTIAL      132112141121411214012  1111 66111612341       O01
02218                                                                     O02
X PREACHES MARTIAL & FAM  A 36110111   SPET BAPTIZES MARTIAL   A   3621 2 2S01
X SEATED BLESS YOUNG MARTIAL361230 1   MAN IN CAVE             B   362201 3S02
X SPEAKS TO SPET KNEEL  C   36131013   SPET SPEAKS TO APOST    C   362310 1S03
SPET GVS MAGIC CRS MARTIAL D36141211   SMARTIAL REVIVES AUSTRICLI D 36243011S04
SMARTIAL EXORC GIRL TULLE E 361510 2   SMARTIAL RAISES SON NERVA F 36163013S05
SMARTIAL EXORC STATUE JUPI G36171033   X BLESSES SMARTIAL BISH H   36183012S06
SMARTIAL HEALS NEOPHYTE  I  311110 2   SMARTIAL HEALS CRIPPLE I    311210 1S07
DECAPIT SVALERIE LOST       3211       EXECUTIONER KILLED BY ANG RES3212   1S08
EXECUTIONER REVIVED RESPOND 3213  3    SMARTIAL CONVER DUC ETIENNE L321410 1S09
ETIENNE ROME SPET ABSOLVE M 331120 1   SMARTIAL REVIV SN POITIERS   3313    S10
BODY CHOPPED UP   O         341131 3   SMARTIAL HEALS CNT BORDEAUX O341220 3S11
SMARTIAL STOPS CITY FIRE O  341333 3   SPET SPAUL MARTYRDOMS P     342222 2S12
AURELIEN REC ORDERS LIMOGE Q312120 2   CHRCHS 13 FOUNDED MARTIAL  Q 12223  S13
X ANN DEATH SMARTIAL KNLING 322110 1   SMARTIAL SOUL TAKEN 2 ANGELS 3223   S14
SMARTIAL FUNERAL            321  1     SMARTIAL MIRACLE OF SHROUD   323   1S15
X ANN TO SMARTIAL IN VISION 3423                                    323    S16
SCS LETTERED A-Q CF SSTEF ROTONDO SCESARIO  SINGLE BAND INSCRP EACH FRAME  I01
WRAPAROUND START CEILING  FULL PAINTED RESPOND CF LORENZETTI               A01
```

```
STORY IN GAUL TULLE D'AGEN LIMOGES KNOWN AS 'FRENCH SPET' PATRON OF LIMOGES A02
1INSITU    SCH GIOVANETTI    1342-1346  CRUCIFIXION                          F01
                                     M PLANT DISS MELBORNE 1980 FRESC N ITALY F02

IFISCRC RINUCCINI CHAP SACRISBVM              GIOVANNI DA MILANO          2TO1
1365-1369BVM & MAGD       112 12121    1212    1111311 213  411133         O01
JOACHIM EXPULSION         11102031   JOACHIM IN WILDERNESS      31210131S01
GOLDEN GATE MEETING       31211032   BVM BIRTH MANY MIDWIVES    11233033S02
BVM PRESENTATION STEPS    11311031   BVM MARRIAGE BETROTH BRK RODS11331031S03
MAGD DRIES X FEET         13101013   MAGD & MARTHA X AT HOUSE OF  13213011S04
X RAISES LAZARUS          13233311   X TOMB MARYS (2)AT 3 ANGLES  33321011S05
NOLIME TANGERE            33313112   MAGD PROTECTS PRINC MARSEILLE13330313S06
FRAME OF LUNETTE WLS 1&3 PTD PLAQUE WL 3 TIER 3 STRAIGHT-LINE VERTCAL 2 SDS I01
NOLI ME & MARYS AT TOMB REVERSED DEVILS IN DRIES SC LARGE SHEP W DOG IN MGT A01
JEWISH RITUAL DIVIS MEN & WOMEN JOACHIM SC BVM & JOE BACKS TURNED IN BETRO  A02
1INSITU    GIOVAN DEL BIONDO 1379       BVM & CHILD                        F01
1    1    STIGFRAN MAGDANGELS122212MEISS      1951 13FF  BLACK DEATH       F02

IFISMN  SPANISH CHAPEL                        ANDREA DA FIRENZE            T01
1366-1368X PASSION DOM THEOL 11301    1    1   11  661        426413  99O01
02214                                         DOMINICAN                   O02
X DRAFT OF FISH SPET WATER  3613    CRUCIFIXION CALVARY RD LIMBO 32102 22S01
RESURRECTION ANGELS 2       1612 2 2   ASCENSION APOST KNEELING    1614 2 2S02
PENTECOST W MARY PETER STAND16112   2  PETER VERONA RECEIVES HABIT   421    S03
PETERMARTYR PREACHES PIASMN  422    PETERMARTYR MARTYRDOM           423    S04
PETERMARTYR CURE OF RUFINO   424    PETERMARTYR CURE OF AGATHA      425    S05
PETERMARTYR SICK CRIPPLESTOMB426    STHOMAS AQ ENTHRONED            120    S06
CHURCH MILITANT             320                                           S07
NARRAT SCENES IN WEBS GROIN VAULTS BOUSTROPHEDON  WALLS THEOLOGICAL       A01
SCS LATERAL WEBS EMPHASIZE PETER APOST ROME AUTHORITY ECCLESIA            A02
1INSITU    BERNARDO DADDI            MADONNA X STS (CORPUS DOMINI DED)     F01
2    2                     1 GARDNER J ART HISTORY 1979    107FF          F02

IORDUOMOCHANCEL           BVM              UGOLINO DI PRETE ILARIO  1 T01
1357-1364BVM LIFE      132412131121641213    1111312    41123123299O01
JOACHIM EXPULSION FROM TEMPL11411  1   JOACHIM IN WILDERNESS ANGEL  1142   3S01
ANNE ANNUN RGT PINK STONE   11431  1   GOLDEN GATE MEETING SHEPHERD 114422 2S02
BVM BIRTH HEAD RGT EATING   1145      BVM PRESENTATION DISPUTE DRS 32412  1S03
BVM MARRIAGE                1243      BVM ANNUNCIATION AEDICULA    13413  1S04
JOSEPHS FIRST DREAM         1342      BVM NUPTIAL CORTEGE JOY CONSU13431  1S05
X NATIVITY CHILD NAKED GRND 1131 1 1   SHEPS ADORATION BVM HUMILITY 1132   3S06
X CIRCUMCISION NO BVM MOIL  11331  1   MAGI ADORATION               1134  1S07
X PRESENTATION PURIFICATION 12312     EGYPT FLIGHT TO SEMIDESTROYED12331  1S08
HOLY FAM AT HOME WORK COAT  12343     DESTROYED(X TAKEN TO TEMPLE) 1331   S09
X W PARENTS THRESHOLD TEMPLE1332   1   X LOST PARENTS DISRAUGHT LDSC 333  S10
X AMONG DOCTORS  PARENTS LF 1334   1   X DRS PARENTS DISCUSS PROWESS1335  S11
BVM DEATH ANNUNC PALM HEAD L1221   3   BVM DEATH KOIMESIS           1223  1S12
BVM FUNERAL IDOLS FALL      1211   1   BVM RESURRECTION X CHERUB JEW12132 1S13
BVM ASSUMPTION 4 ANG APOST  1210      BVM CORONATION EAST GROIN    1620  S14
PENTECOST SOUTH  GROIN      1630      ANGEL HIERARCHY NORTH GROIN  1610  S15
X TRIUMPHANT WEST GROIN     1640      CONSTANTINE BAPTISM SYLVESTER 11   S16
ALL SCS HV NARRATIVE INSCRIPT INSIDE PTD FRAMES NOT SURE DATES DOCUMTD    I01
STARTS BOTTOM L-R MOVE UP 2T THEN W2T2&MOVES UP POST DEATH SCS ON CEILING A01
DIDACTIC UPPER SIDES APSE PATTERN BOTTOM-UP LIKE WINDOW AND FACADE CF     A02
                        LEXIKON CHRIST IKONOGRIII, BASEL 1971 223F02

IPDSANTOSFELICE CHAPEL    SJAMES MAJOR     ALTICHIERO            T01
1372-1379SJAMESMSTORIES CRUCI224 1 11 12  11 11 1   131331399   11212341 99O02
BVM ANNUNC BVM RGT         2202  2   CRUCIFIXION 3 SPACES SWOON   123022 2S01
ENTOMBMENT MAN OF SORROWS  2212  2   RESURRECTION RT FT OVER 2 ANG12232 2S02
HERMOGENES SENDS FILETO TO S31111  1  FILETO DISPUTES W SJAMESM    31122  1S03
HERMOGENES EVOKES DEVILS   31132  1  HERMOGENES TRANSPT BY DEVILS 3211   1S04
HERMOGENES BAPTISM BKS BURNT32122  3  SJAMESM  DECOLLATION MIRACLE 3213   S05
ANGELIN BOAT SJAMESM BURIED 32142331  SJAMESDISC PETITION QUEENLUPA32152 1 S06
SJAMESMDISC B4 KNG OF SPAIN 13113  1  SJAMESM DISC IN PRISON       13131  1S07
SJAMESMDISC LIBERATED BYANGE3411   1  SOLDIERS HORSES BRIDGE FALL  34121  1S08
HERMOGENES BAPTISM BKS BURNT32122  3  MIRACLE DRAGON & BULL        3414 3 3S09
SJAMESMDISC RECALLBY KGSPAIN3413 1 1  BAPTISM QUEEN LUPA           34162  3S10
QUEEN LUPA DONATES  CASTLE  34172  1  DREAM OF RAMIRO              31213  1S11
RAMIRO COUNCIL OF           31221  1  BATTLE RAMIRO SJAMES MIRACLE 3123 1 1S12
RAMIR-KNG LOUIS HUNGARY HELPED PD AGAINST VE DEATH ST OVER CRUCIFIX CROWD  A01
GOOD VIRTUOUS BATTLE FIGHTING OVER CONTEMPLATIVE NARRAT FOR POLITICS CURRENTA02
VOTIVE FRESCO W3T2 BVM&X BONIF LUPI (CF QUNLUPA)FL ARMOR WIFE CATHER ECCLESIAAO3
DOUBLE WRAPAROUND    INTERLOCK                                            A04
                        PLANT MARG    1981 406FF ART BULLETIN             F02
```

```
IFISCRC CASTELLANI CHAP RTRA SACRAMENT          AGNOLO GADDI (STARNINA)  1 T01
1385-1390JEVANANTAB NIC JBAPT22901212112120121202112121331  321242      99O01
                                                        FRANCISCAN       O02
JEVAN ON PATMOS APOC ISLAND 11110232    J EVAN BAPTIZES CRATO PHILOS 31212032S01
JEVN TURN STICKS STONE 2GEMS31223132    ACTEUS EUGEN B4 GOLDSMITH DES313110 1S02
JEVN ACTEUS EUGEN KNEEL DEST3133 1 1    SANTHONY HEARS GOSPEL ALTAR  31123033S03
SANTHONY DISTRIBUTES FORTUNE31131031    SANTHONY YOUNG IN DESERT     12110113S04
SANTHONY BEATEN BY DEVILS    31231131   SANTHONY X APPEARS TO IN BED 31243323S05
SANTHONY MEETS CENTAUR DESER12210131    SANTHONY MTS PAUL 1ST HERMIT 12310132S06
SANTHONY DEATH & BURIAL LOST 133        SNICHOLAS GOLD BALL 3 MAIDENS13121011S07
SNIC STOPS EXECUTION PRINCE 14210331    SNIC REVIVES 3 DEAD YOUTHS   14311023S08
BAD DEBTOR STAFF JEW B4 JUDG33241012    SNIC BAD DEBTOR CHARIOT KILL 33233013S09
BAD DEBTOR REPAY JEW CONVERT33251012    SNIC RESTORES DROWNED CHILD  33333113S10
ANNUNCIATION ZACHARIAH       13112013   YOUNG JBAPT IN DESERT        12131313S11
JBAPT PREACHING PHARISEE     12230113   JBAPT OF MULTITUDES STARNINA 33213112S12
X BAPTISM 4 ANG CRANE STARNI13220112    JBAPT IN PRISON DISCIPLES    13321011S13
JBAPT DISCIPLES TO CHRIST?   33313011   JBAPT DECOLLATION TOWER       123310 S14
SLUCY MARTYRED WITH DAGGER  143220 1                                        S15
LIVES4STS 1STBAYS R&L MONEY GOOD&BAD QUAL 2NDBAY&ALTARW HERMIT LIFE DOUBLE  A01
BOUSTROPHEDON   2ND BAY W ALTAR WALL 1ST BAYS TOP DOWN W VARIATIONS        A02
COLE B FINDS3 HANDS GADDI JOHN MASTER NICHOLAS MASTER CF                   A03
SCS W MIXED LIGHT    SOURCES GOLDEN LEGEND FEAST OF ANTHONY & PAUL HERMIT  A04
                 11 11 COLE B  1977 BK 78-79      AGNOLO GADDI           F02

IFISCRC CHANCEL          TRUE CROSS        AGNOLO GADDI              T01
1388-1393TRUE CROSS LEGEND  216 1 1332220 1 13    13113311 31  4
TRC SETH & MICHAEL GARDEN   33120212   TRC ADAM DEATH SETH PLANT   33120212S01
TRC SHEBA VENERATES WOOD    33210111   TRC WOOD BURIAL             33231111S02
TRC FINDING WOOD PROBATICA  33311301   TRC FABRICATION OF C HOSPITAL33333011S03
TRC HELEN FINDING CROSS     33433113   TRC HELEN PROOFING C KNEELS 33413133S04
TRC HELEN RETURNS C TO JERUS11102332   TRC CHOSROES STEALS C FR JERU11202333S05
TRC HERACLIUS DREAM OFHELMET31322031   TRC HERACLIUS BATTLE CHOS SON313303 1S06
TRC CHOSROES ENTHRONED AS GD31311033   TRC CHOSROES EXECUTION OF    31413101S07
TRC EXALTATION ANGEL STOPS  31421131   TRC EXALTATION RETRN CR HALF 31431131S08
NO CONSTANTINE CF BARDIVERNIO CHAPEL WALL3 CEN LF LF RGT WALL1  CEN RGT LFLFA01
STRONG LATERAL MOTION MOVING BEYOND FRAME LAST MOVE INTO ALTAR LEFT        A02
FIRST MONUMENTAL COMBO HELEN AND HERACLIUS LEGEND SCRC FOUNDED 3 MAY 1294  A03
FESTIVAL MODE  STRAIGHT-LINE VERTICAL                                      A04
1INSITU    UGOLINO                                                         F01
                 11 11 COLE B AGNOLO GADDI BOOK 1977                     F02

IPODUOMOCAP DI CINTOLA      BVM             AGNOLO GADDI              T01
1393-1995BVM LIFE         216012141    01 1201   2121341 2412311          O01
JOACHIM EXPULSION          34120      JOACHIM ANNUN WILDERNESS    34130113S01
GOLDEN GATE MEETING       11111002    BVM BIRTH HD RGT JOAC TALKING11123003S02
BVM PRESENT TEMPL GARDEN WAL11211201  BVM MARRIAGE BETROTH SUITORS 11221201S03
BVM ANNUNCIATION SEATED RGT 11311001  X NATIVITY BVM HUMILITY SHEPS31323333S04
BVM DEATH                 32302002    BVM ASSUMPTION STHOMAS      32200003S05
BVM CORONATION            32102002    STHOM GIVES BELT TO PRIEST  33113103S06
DRAGOMARI MICHELE MARRIAGE 33123001   BELT ARRIVES IN PRATO       33211101S07
DRAGOMARI MOVED BY ANGELS  33221003   DRAGOMARI DEATH OF          33313002S08
BELT GIVEN TO PRATO DUOMO  33323001   DRAGOMARI VOYAGE OF         14110101S09
2TIERS STHOMAS W3 START ABOVE ENTRANCE ARCH BEAR & DOG  DCTORS & EVANGS    A01
APSE PATTERN IN PART                                                       A02
                 B COLE AGNOLO GADDI BK 1977                             F02

IPISFRANSARDI-CAMPIGLI CHAP  BVM          TADDEO DI BARTOLO          T01
1397-1398BVM LAST DAYS     2 5 121111211 1211    111 311   4 21313         O01
                                                      FRANCISCAN           O02
ANNUN OF DEATH OF BVM PALM  210       GATHERING OF APOSTLES        111010 1S01
BVM FUNERAL               131031 1    BVM DEATH KOIMESIS           112020 2S02
BVM ASSUMPTION           132002 2                                         S03
APSE OF SACRISTY  ABBREV AERIAL BOUSTROPHEDON    SAME YR AS BAPT AT TROIA?A01
                           E CARLI PITTURA POSANA DEL TREC II 27F   F02

IBVMAGD CEILING MAGDCHAP     MAGDALEN       ANDREA DI GIOVANNI        T01
1400-1402 LIFE OF MAGD     2 6               5        41          99O01
02216                                                 FRANCISCAN         O02
MAGD DRIES X FEET HS SIMON 1511  3    MAGD LAZARUS RUDDERLESS BOAT 15121  S01
PRINCE MARSEILLE WIFE ISLAND15132 2   PRINCE MARSEILLE RETURNS WIFE15141 1S02
MAGD CARRIED UP ANGELS     1515  2    MAGD LAST COMMUNION HAIR     1516 2 2S03
SCS ON CEILING BARREL VLT 2 ROWS FACE DOWN WRAPAROUND START LEFT ENTRANCE  A01
                           E CARLI BELVERDE EREMO 1977              F02
```

```
IVOSFRAN CONF CHAP        TRUE CROSS          CENNI DI FRANCESCO      1 T01
1410      X INFANCY TR CROSS 124012142121411212 12112121333    413341143  O01
                                                        FRANCISCAN         O02
TRC SETH & MICHAEL           33130121   TRC ADAM DEATH PLANT BRANCH 33141313S01
TRC SHEBA VENERATES WOOD     34111101   TRC WOOD BURIAL (POOR CONDIT)3412  S02
BVM ANNUN DEATH(?) WIMPLE    12132001   X NATIVITY BVM KNEELS       13111011S03
SHEPS ANNUNCATION TO         13120313   X PRESENTATION IN TEMPLE    12232002S04
INNOCENTS MASSACRE           13213111   EGYPT FLIGHT TO (POOR CONDIT)12211 3S05
BVM ENTHRONED MAGI ? POOR CO1211        BVM DEATH HEAL LEFT POOR    1212   1S06
TRC FINDING OF WOOD PROBAT 13141 1      TRC FABRICATION OF CROSS    31121101S07
TRC HELEN FINDING CROSS      31140101   TRC HELEN PROOFING CROSS    311302 1S08
TRC HELEN RETURNS CROSS JERU11232311    TRC CHOSROES STEALS CR HALF 11213133S09
TRC CHOSROES ENTRHONE GODFAT34213001    TRC HERACLIUS DREAM NO HELMET32222001S10
TRC HERACLIUS BATTLES BRIDGE32222202    TRC CHOSROES EXECUTION OF    33220103S11
TRC EXALTATION ANGEL STOPS   33230101   TRC EXALTATION HERAC BAREFOOT33241111S12
X INF APSE END WLS 323 BOUSTROPHEDON  PERHAPS MAGI ABV FLGT BVM DEATH    A01
PERHAPS ANNUN OF DEATH OR ALLUDING TO BOTH ANNUNS THRU LOCATION?         A02
SEE FIRST&LAST SCS TRCR ENTERING BOUSTROPHEDONIC WLS32123  SFRAN JBAP&RHODESA03
XNAT OPP REBIRTH BOY MASSINN DIAG COS STEAL W HORS HEL RETURNS DIA OPP HERACA04
INTERNAL TYPOLOGY AREAL CAT'S CRADLE CORSINI DONAT CRUSADE CONNECTED     A05
SIGNED AND DATED CEILING BY OTHER ARTIST                                 I01
2 LOST                                  CRUCIFIXION                      F01
                        PHLEGER S RASSEGNA VOLTERRANA '83/4 PP172F02

IURSGIOVORATORY OF       JOHN BAPTIST       L & J SALIMBENI         1 T01
1416      LIFE OF JBAP    12102216012110221922211 1    31    1133412  99O01
ZACHARIAH ANNUNCIATIONN TO 33111 1      JBAP NAMING                 33121  1S01
VISITATION BVM ARRIVES       33131 1    BVM GREETS ZACH             33141  1S02
JBAP BIRTH BVM PRESENT NAME 33151 1     JBAP CIRCUMCISION           33161  1S03
BVM DEPARTURE                13173  3   JBAP & X MEET IN DESERT BVM 13183  3S04
JBAP   PREACHING YOUNG       1321 1 1   JBAP BAPTIZING MULTITUDES UND1322 1 1S05
X BAPTISM MYSTIC CITIZENS    1323 2 2   JBAP BERATES HEROD          1324   3S06
JBAP ARREST (LOST)           41         JBAP DECOLLATION (LOST)     41     S07
SALOME DELIVERS HEAD JBAP    11111 1    JBAP FUNERAL                11121  1S08
JBAP BODY BEMOANED BY DISCIP11131 1     JBAP B PIETRO SPAGNUOLI BVM X4114  S09
MADONNA OF HUMILITY X ASLEEP4115   2    MADONNA X ENTHRONED         4116   2S10
CRUCIFIXION 3 CROSSES L BACK1210   2                                      S11
SIGNED AND DATED                                                          I01
W3-1 CONT MOVEMENT  W3-2 MORE STATIC & CENTRALIZED W1-VOTIVES JUMPS BACK  A01
WRAPAROUND DOUBLE ON W3                                                   A02
                        ROSSI   A       1976BOOK  I SALIMBENI       F02

IFISTRN BARTOLINI CHAPEL   BVM ANNUNCIATE    LORENZO MONACO         2 T01
1420-1425BVM LIFE         214012110121201211012 1111313    1  12323299O01
                                                        VALLOMBROSANA      O02
JOACHIM EXPULSION OF         31111011   JOACHIM IN WILDERNESS       31130313S01
GOLDEN GATE MEET PRO NUBA AN11201111    BVM BIRTH                   122110 3S02
BVM PRESENTATION IN TEMPLE   12232033   BVM MARRIAGE OF PRIEST TURK 13203033S03
BVM ANNUN ALTARPIECE MAIN RT12221012    VISITATION PREDELLA 1       12311122S04
X NATIVITY PREDELLA 2        12323312   MAGI ADORATION PREDELLA 3   12332011S05
EGYPT FLIGHT TO PREDELLA 4   12340331   BVM DEATH KOIMESIS HEAD RGT 13102032S06
BVM ASSUMPTION               14103232   MADONNA OF THE SNOW         12102012S07
MOVES L DOWN ACROSS R BACK TO ALTARPIECE W PREDELLE JUMPS TO TOP R JUMPS  A01
TO OUTER ENTRANCE ARCH JUMPS TO LUNETTE OVER ALTAR NEW USE ALTARPIECE     A02
PTD (ARCH) FRAME AROUND RECT OF REAL ALTARP PERHAPS SMTHG ON TOP CENTER   A03
AERIAL BOSTROPHEDON   ALTARPIECE INCLUDED IN NARRATIVE SEQUENCE           A04
1INSITU    LORENZO MONACO   1420        ANNUNCIATION                     F01
2    2    INFANCY OF X          1 DEBOLDVON KRITTER 1975 BRANCACCI KAPPELL F02

IFISMCARBRANCACCI CHAPEL   ASCENSION           MASOLINO MASACCIO F LIPPI T01
1423-1428 OT LIFE SPET    219012141121401214    1111431    41312313 99O01
                                                        CARMELITE          O02
TEMPTATION OF ADAM & EVE     1323 312   EXPULSION OF ADAM & EVE     11213 31S01
SPET & ANDR CALLING  LOST    1110       NAUFRAGIO MT 14:22-23  (LOST)1310  S02
SPET DENIAL LK 22:54-62 SINO1211        PASCE OVES MEAS JN 21:15 SINO1213  S03
TRIBUTE MONEY SPET LAKE PAYM31221333    SPET PREACHING ACTS 2       1221 333S04
SPET HEALING W SHADOW ACTS 512311 33    SPET DISTRIB GDS ANANIAS DEAD12331313S05
BAPTISM OF NEOPHYTES SPET    12230113   SPET HEALS CRIPPLE          13121313S06
SPET REVIVES TABITHA         31231011   SPAUL VISITS SPET IN PRISON 11313031S07
SPET RAISES THEOPHILUS SON   31323032   SPET CHAIRING OF ANTIOCH    31331033S08
SPET LIBERATION ANGEL ROME   13331013   SPET B4 NERO IDOL ON FLOOR  31321011S09
SPET CRUCIFIXION OF          3133321                                      S10
UPPER TIER LOST FESTIVAL MODE & TOPOGRAPHICAL ARRG JUNE 29 FEB 22 AUG 1   A01
```

```
LOVE X AUTHORITY POWER MIRACLES SEMIPATTERNED NONNARRATIVE SEQUENCE FESTIVALA02
CLEANING1983 FOUNDW2 SINOPIE ABOVE & SMALL CRUCIFIX SPET UNDER WINDOW       A03
COVERED BY NEW ALTAR & ICON DEL POPOLO  AUTOGRAPH HEADS ON RESPONDS         A04
ALTAR-WALL CAT'S CRADLE FILIPPO LIPPI COMPLETION CA 1487 4 EVANS ON VAULT   A05
1INSITU              13TH C    MADONNA & CHILD                              F01
2   2    DELIVERY OF KEYS         DEBOLDVON KRITTER 1975 115F BRANCACCI KAPF02

IEMSTOSTSTACROC CHAP DESTR   ST HELENA           MASOLINO                   T01
1424     TRUE CROSS          21301212     01212    3 1  31 131   4          O01
TRC SHEBA VENERATES WOOD  3311 1 1    TRC BURIAL WOOD  (DESTROYED)3313      S01
TRC FINDING OF WOOD PROBAT 3321 3 3   TRC FABRICATION OF CROSS       33233 3S02
TRC HELEN FINDING  CROSS   3333   1   TRC HELEN PROOFING CROSS       3331  3S03
TRC HELEN RETURNS C TO JERUS3110   3  TRC CHOSROES ENTHRONED GODFA3121     3S04
TRC HERACLIUS DREAM OF     3123   1   TRC CHOSROES EXECUTION OF      3131  3S05
TRC EXALT HERAC BAREFOOT   3133   1   PORTRAITS CONFRATERNITY LOGG340       S06
PORTRAITS CONFRATERN LOGGE  140                                            S07
DESTR1792 SINOPIA ONLY UNIFIED RHYTHMIC FLOW PULL OPP DIR HAD FRAMESBTWNTIERA01
REF TO GADDI BUT NO  ADAM SCENES OTHERS REDUCED CF LAZZARONI BUL ST EMPOLESEA02
FESTIVAL MODE STRAIGHT-LINE VERTICAL                                        A03
                         COLE B       1968 289F  MITT KUNST INST F02

IFIBAPT NORTH DOORS BRONZE   JOHN BAPTIST      L GHIBERTI           1 T01
1410-1425LIFE OF X           228        1         32      113         O01
ST AUGUSTINE              1371      ST JEROME               1372     S01
ST GREGORY               1373      ST AMBROSE              1371     S02
ST JOHN EVAN             1361      ST MATTHEW EVAN         1362     S03
ST LUKE EVAN             1363      ST MARK EVAN            1364     S04
BVM ANNUNCIATION         1351   1  X NATIVITY B4 1417      1352    3S05
MAGI ADORATION    B4 1417 13532  1  X AMONG DOCTORS   B4 1417  13542 2S06
X BAPTISM               134130 1  X TEMPTATION OF         1343 1 1S07
EXPULSION FROM TEMPLE    1343   1  X WALKS ON WATER STORM B414191344 3 3S08
X TRANSFIGURATION  B4 1419 1331 2 2  X RAISES LAZARUS     1332 3 3S09
X ENTRY INTO JERUSALEM   13331  2  LAST SUPPER            13342  2S10
AGONY IN GARDEN         13211  1  KISS OF JUDAS X ARREST   332202 2S11
FLAGELLATION            13232  2  X B4 PILATE HAND WASH B4 1418132410 1S12
CALVARY ROAD TO (VIA CRUCIS)131131 1  CRUCIFIXION          131202 2S13
RESURRECTION            131302 2  PENTECOST             131420 2S14
NO X PRES NB MONEYCHANGERS STORM  NO JUDGMENTS NO DEPOSIT NO ENTOMBMENT     A01
LEFT-RIGHT // BOTTOM-TOP                                                    A02
                    11    KRAUTHEIMER R   1956 LORENZO GHIBERTI           F02

IFISMCARSACRISTY           SCECILIA          LORENZO DI BICCI/BALDES1 T01
1420-1430LIFE OF SCECILIA  122012121121401212   1111 11     111231231  O01
                                           CARMELITE                  O02
SCECILIA & VALERIAN MARRIAGE31113031   SCECI EXHORTS VAL TO CONTINEN31123033S01
VALERIAN MTS X AS BEGGAR   32110132   PP URBAN LIVING AMNG TOMBS   32130113S02
VAL SEES OLDMAN W CREED WHIT33110111  VALERIAN BAPTIZED BY URBAN   33131112S03
SCEC VAL ANGE PRNUBA WREATHS31213032  VAL BRO TIBURTIUS WITH X     31223032S04
TIBURTIUS BAPT BY URBAN EXT 31233131  VAL GIVES MART TOMB TO POOR  12211233S05
VAL ARRESTED B4 ALMACHIUS   32233013  MAXIMUS BAPTIZED BY URBAN    33213011S06
VAL PREACHES TO 2 PRISONERS 33223011  EXECUTION VAL & TIBURT VISION33233011S07
SCECI DISTRIBUTING ALMS    31331033  SCECI PREACHING TO PAGANS    31323032S08
PPURBAN BATIZ 400 CHLD UNDRS31331033  SCECI KILLED IN HOUSE (LOST) 231   S09
SCECI BURNT SWORD    LOST    233      SCECI MUTILATED ASK CONS HOUS33313013S10
BURIAL OF SCECI HD LFT     33321313  SCECI HOUSE CONSECRATED PASQU33333113S11
BALANCED PATTERN 2 SCS EACH LUNETTE 3 SCS EACH RECTANG ORDER LOGIC POISE    A01
EMPHASIS PREACHING XTIAN IDEAS HIGH PASTELS OUTLINES DARK SHADE LOCAL COLOR A02
APSE PATTERN TOP TO BOTTOM       DADO PASTEL MARBLE SLABS FREEMANTLE 849 A03
LONG EXPLANATORY INSCRIPTIONS IDENTIFY SCENES LATIN  SOME NAMES            I01
                    1 MOSSAWKOWSKI S ZEIT F KUNST XXI '68 1-26 F02

IROSCLM BRANDA CHAP        SACRAMENT         MASACCIO MASOLINO             T01
1428-1431 X SCATH SAMBRO   213012130122 111130122 1111343      4213    99O01
BVM ANNUNCIATION          14102 32   X CRUCIFIX  SWOON 3 CROSSES 1210 2 2S01
SCATH REFUSES WORSHIP IDOLS 11111 31  SCATH DEBATES W PHILOSOPHERS 31211 32S02
BURNING OF PHILOSPHERS SCATH3122 111  SCATH VISITED FAUSTINA BEHEAD311211313S°3
SCATH WHEEL SAVED FROM    11231 32   SCATH BEHEADING ANGELS BURY  3124 111S04
SAMBROSE IN CRIB         33112 31   SAMBROSE DESIGNATED BISHOP    33131 11S05
SAMBROMIRAC RICH HOUSE FIRE 13213331  SAMBROS STUDIOS NONNARRATIVE 13221 1 S06
SAMROSE DEATH OF         13232 12                                          S07
EXPERIMENTAL PERSPECTIVE SCS MATCH ACROSS SEMI PATTERNED CONTINUOUS RAT SPACA01
LUNETTE-SHAPED WALLS 2 TIERS 2 SCS TOP 3 BOTTOM WRAPAROUND                 A02
                    VAYER L      1962 BK   MASOLIN ES ROMA F02
```

```
IFIBAPT EAST DOORS              JBAPTIST           GHIBERTI L              1 T01
1425-1451OT              232    15        15       11      41         O01
CREATION OF ADAM         3111         CREATION OF EVE          3112    S01
TEMPTATION OF ADAM AND EVE 3111   2   EXPULSION OF ADAM & EVE    31133 1S02
ADAM & EVE HOME W CHILDREN 331133 2   ABEL TENDS FLOCKS         3311 1 3S03
CAIN  PLOWING            3311 1 1     SACRIFICE OF CAIN & ABEL  3313 2 2S04
CAIN KILLS ABEL          3313 1 3     CAIN CURSED BY GOD        3313 1 1S05
NOAH FAMILY ANIMALS LV ARK 3122 2 2  NOAH SACRIFICE OF         3123 1 1S06
ISAAC SPEAKS TO JACOB    31322  3     ISAAC BLESSES JACOB       31331  3S10
JOSP SOLD BY BROTHERS ISHM 3333 3 2  JOSP GIVES GRAIN TO BROTHERS 33322 2S11
JOSP CUP DISCOV BENJ SACK 33313 2    JOSP REVEALED TO BROTHERS 33313  3S12
MOSES RECEIVES LAWS MT SINAI3143 1 2 MOSES & CHILDREN OF ISRAEL 3141 1 3S13
JOSHUA ARK ARRIVE AT JORDAN 3341 1 1 CARRYING STONES AT JORDAN 3143   1S14
JOSHUA PROCESSION TO JERICHO31423  3 DAVID SLAYS GOLIATH IN BATTLE3152 1 2S15
DAVID CARRIES HEAD TO JERUS 3152 1 1 SOLOMON SHEBA MEET WRIST GRSP13522 2S16
TOP 2 TIERS CHEVRON DIAGS CREAT THRU ABRAHAM 1ST 14 GENERATIONS THRU ISAAC A01
BOTTOM 3 TIERS COMPLEX MATCHING JACOB THRU SOLOMON 2ND 14 GENERA GENEAL BVM A02
GROSS PATTERN ARRANGEMENT TO EXPRESS PARALL SOLOM BUILDER OF TEMPLE  &     A03
SOLOMON & SHEBA FIGURE FOR MARRIAGE OF X AND ECCLESIA BVM                  A04
                        11    KRAUTHEIMER R 1956       LOR GHIBERTI    F02

ICGCOLGEBAPTISTRY              JBAPTIST           MASOLINO               1 T01
1432-1435LIFE OF JBAPT     1130122 1122 0122 0122    34      114123   99001
ZACHARIAH ANNUNCIATION    14112 32    VISITATION                 1413    S01
JBAP BIRTH               3111         JBAP NAMING              3113      S02
JBAP RECEIVE RAIMENT FR ANGS121 1  1 JBAP PREACHING IN WILDERNESS 3221 331S03
X BAPTISM UNDRESS CATECU 3212 2 2    JBAPT BERATING HEROD      32231 32S04
JBAPT IN PRISON          1224        JBAP DECOLLATION          32251 11S05
HEROD FEAST OF SALOME B4 33213 13    SALOME DELIVERS HEAD JBAP 32231 31S06
JBAP BURIAL     BCKGRD   3212 1 2                                        S07
WRAPAROUND,     UP ONTO BACK WALL, AND CEILING, DOWN, OUT ONTO FACE OF ARCH A01
FLUID SPACE POUR OVER CORNERS ALL SP ABOVE DADO CARVED PITS CHANCEL W2 APOCRA02
                        1 VAYER L     1962 BK    MASOLINO ES ROMEF02

IROVAT  NICCOLINA CHAPEL      SSSTEPH & LAWRENCE  FRA ANGELICO         1 T01
1446-1450LIVES SSSTEPH&LAWR  112122140222 2221302213    131    11341341  O01
SSTEPH REC DECANATO SPET 33111 13    SSTEPH DISTRIBUTES ALMS   33131 11S01
SSTEPH PREACHING         34111 11    SSTEPH DISPUTES SANHEDRIN 34132 13S02
SSTEPH EXPELLED F JERUSALEM 31111 31 SSTEPH STONED PAUL PRESENT 31131 31S03
SLAWRENCE ORDAINED       13202 12    SLAWRENCE REC TREASURE CHURCH34211 11S04
SLAWRENCE DISTRIBUTES ALMS 34232 12  SLAWRENCE B4 VALERIUS      31212  1S05
SLAWRENCE JAIL  CONV HIPPOLI31222 32 SLAWREENCE ON GRILL EMP ABOVE31231 31S06
DADO GREEN TXTIL NEW MONUMENTALIZED GRAND ARCHITCTR OF FUTURE PERSPEC FLOOR A01
TINY ACTUAL SPACE EARLY XTIAN ARRANGMNT WRAPAROUND COMPROMISE FRAN & DOMIN  A02
SS IN CORNERS WL1 RG BNAVTR LF CHRYSOS WL3 LFT ANASTAS RGT THOM AQUIN E & W A03
1LOST       FRA ANGELICO      1447         DEPOSITION                    F01
2    2                        1  1 POPE-HENNESSEY J       FRA ANGELICO  F02

IFISAPOLREFECTORY                             CASTAGNO                   T01
1447-1450X PASSION         2 40222 022122222     22      4         99001
LAST SUPPER AEDICULA     12202233    X CRUCIFIXION 1+ YNG X STABAT3212 232S01
DEPOSITION HD RT         32132231    X RESURRECTION YOUTH SOLD SLP32112232S02
GARDEN OUT LS BRICKWALL UGLY LDSC BEHIND YOUTHFUL X LADSCP UNIFIED SP EASTERA01
X GETS YOUNGER AS TIME GOES FORWARD ARRANGEMENT MAKES SIGN OF THE CROSS    A02
                        VERTOVA L I CENACOLI                              F02

IPDEREMIOVETARI CHAPEL                    MANTEGNA BONO DA FERRA  1 T01
1450-1457SSJAMES & XTOPHER  112012143222 01214    1 1 111    11133    O01
                                          AUGUSTINIAN                   O02
SJAMES CALLING OF AND JOHN 1111 331   SJAMES DEVILS SPEAKING TO  11132 33S01
HERMOGENES BAPTISM        11213 31    SJAMES B4 HEROD AGRIPPA    11231 31S02
SJAMES LED TO MARTYRDOM   11313 31    SJAMES BEHEADED NAKED EXECU 1313 333S03
SXTOPHER B4 KING ASUINO   13111111    SXTOPHER REFUSES SERVE DEVIL 1313 113S04
SXTOPHER CARRIES X REFLECT 3321 113   SERMON OF SXTOPHER         13231 11S05
SXTOPHER MARTYRDOM KING SHOT13311 11  REMOVAL OF BODY SXTOPHER   3333 13 S06

TEAM ARTISTS SCS ON SAME TIER UNIFIED IN PERSPECTIVE VP HIDDEN BY FRAME    A01
STRAIGHT-LINE VERTICAL FESTIVAL MODE                                       A02
SCS ON LOWEST TIER DI SOTTO IN SU W SOME FEET DISAPPEARING NOVIOL REAL SPACEA03
CF PDF NAKED EXECU & PRONE FIG SJAM ADAM BOMBED MUCH DESTROYED  PHOTOS ONLY A04
SXTOPHER GROWS IN SIZE AS SCS MOVE DOWN & BECOMES MORE X LIKE DWARF STARTS  A05
SIGNATURE ASUINO AND PERHAPS OTHERS                                        I01
1INSITU    MANTEGNA         1454         ASSUMPTION BVM                    F01
2    2    0                   11111 G FIOCCO FRES OF MANT IN EREMI 1947 1978 F02
```

```
IMFSFRANCHANCEL              SFRANCIS        BENOZZO GOZZOLI        1 T01
1452    LIFE SFRANCIS        118     11218        5 322 5     112      99O01
                                                        FRANCISCAN        O02
SFRAN BIRTH OX & ASS      32311031   SFRAN SIMPLE MAN HONORS    32322032S01
SFRAN GVS CLOAK HORSEBACK  3233 132  SFRAN VISION PALACE & ARMOR 32343013S02
SFRAN RENOUNCES FATHER WEALT12352 11 SFRAN SDOM MTG VISION X LFT 22362112S03
SFRAN INNO III VISION LAT  32211133  SFRAN RULE HONORIUS APPROVES 32221 31S04
SFRAN AREZZO DEVILS EXPELLED12231231 SFRAN BIRDS PREACHING TO    32240111S05
SFRAN BLESSES MONTEFALCO BVG32251113 SFRAN PROPH&CELANO KNGT DEATH32261013S06
SFRAN GRECCIO NATIVITY     12113033  SFRAN SULTAN TRIAL BY FIRE  12121232S07
SFRAN SERAPH W X CRUCIFIED  3213 2 1 SFRAN STIGMATIZATION W LEO  32141113S08
SFRAN DEATH & APOTHEOS HD LF22152012 SFRAN IN GLORY            1411    2S09
POLYG APSE BOT UP 2SEPAR SPACES STIG SERAPH OUTSD  AREZZO STORY CF ASSISI A01
APSE PATTERN  BOTTOM-TOP     CF SFRAN AS CONSTANTINE HD              A02
LONG NARRATIVE INSCRIPT  DATE IN WORDS NOVEL SCS IDED HONORIUS NAMED     I01
                            1  11 BOSCHETTO A  1961 18F   BG CHIESA SFRMTFF02

IARSFRANCHANCEL HIGH ALTAR  SFRANCIS      PIERO DELLA FRANCESCA    1 T01
1452-1466TRUE CROSS    2150121211214012120222 1111333    43323211199O01
                                                        FRANCISCAN        O02
TRC ADAM FAMILY MISSION SETH33130212 TRC SETH & MICHAEL OIL     33120313S01
TRC ADAM DEAD PLANT BRANCH 33120111  TRC SHEBA VENERATES WOOD   33210111S02
TRC SHEBA SOLOMON MGT      33233012  TRC WOOD BURIAL SEMINUDEWKMAN12230113S03
BVM ANNUN GOD FA ABOVE LFT 12311031  TRC CONSTANTINE DREAM ANGEL 12331011S04
TRC CONSTANTINE BATTLE MAX 13300111  TRC JUDAS DRAWN OUT OF WELL 12213011S05
TRC HELEN FINDS CROSS DWARF 31210132 TRC HELEN PROOFS CR BOY    31231033S06
TRC HERACLIUS BATTLE CHO SON31310032 TRC CHOSROES EXECUTION BACCI 31333032S07
TRC HERACLIUS BAREFOOT     11103232                              S08
NONNARRATIVE PATTERN MATCHING THEMES TIERL3 & 1SECT1 & 3WL2 XIAN EPIC MODE A01
AREZZO-FRANCIS-DEVILS OUT RF IN FINDING SC  UNIQUE COMBO CONSTANT HERAC BAT A02
UNIQUE MTG SOLOM & SHEBA  TRC UNIQUE ADAM DYING  DWARF UNIQUE BVM-HELEN // A03
BOUSTROPHEDON CAT'S CRADLE EARLY XITAN PROTOCOL UP-DOWN, DOWN-UP PATTERN   A04
                            1250-1275  CRUCIFIX W STFRANCIS KISSING FEET   F01
2    2                      112112GINZBERG C  INDAGINE SU PIERO 1981      F02

IPODUOMOCHANCEL             BVM CINTOLA       FRA FILIPPO LIPPI      1 T01
1452-1464LIVES SSJBAP & STEPH219 1 121  14 1 12    111 331  31  31323121 99O01
JBAP BIRTH ELIZ HEAD LEFT   33112 13  JBAP NAMING                33133 11S01
JBAP INFANT PARENTS FAREWELL33231312  JBAP YOUTH IN WILDERNESS    3323 113S02
ECCE AGNUS DEI             3321 112   JBAP DECOLLATION ARND CORNER 32333111S03
SALOME RECEIVES JOHNS HEAD 3331  11   SALOME DANCE OF BANQUET     33322 11S04
SALOME DELIVERS HEAD JBAP   33331 11  SSTEPH  BIRTH HEAD LF BABYXCH31112 31S05
INFSTEPH LEFT TO DIE IN WILD3112 331  INFSTEPH DELIVERED TO JULIAN 31131 31S06
SSTEPH ORDAINED BISH JULIAN 31231332  SSTEPH EMBRACES RELATIVE    31221332S07
SSTEPH EXORCIZES MAN CHAIN 31233 31   SSTEPH DISPUTES W PHARISEE  31241 33S08
SSTEPH STONED             3231 331    SAUL WATCHES STONE THROWER  3333 131S09
SSTEPH OBSEQUIES           31322 32                              S10
NB SPACE TURNS CORNERS TIERS3 BOTH SIDES APOCRYPHA IRREG PRGRESSION OF TIME A01
DOUBLE BOUSTROPHEDON                                            A02
                            1    1 BORSOOK E FLOR MITTEILUNGEN XIX 1975 ALL F02

IROSIST NAVE               ASSUNTA       PERUG GHIRL SIGNOR ROSEL1 T01
1481-1483MOSES&X       11931111022113111101212    22    41214234    O01
FINDING OF MOSES LOST      211      CIRCUMCISION MOSES SONS ANGEL3116 131S01
MOSES EGYPT & MIDIA BURNBUSH311533 3 CROSSING RED SEA            3114 332S02
MOSES SINAI GOLDEN CALF BRK 3113 1 1 PUNISHMNT CORAH & AARONS SONS311222 2S03
MOSES TESTAMENT DEATH      31112  2  SMICHAEL DEFENDING MOSES BODY1411 311S04
X NATIVITY LOST           213       X BAPTISM OF              33112 12S05
X TEMPTATIONS 3 OT SACRIFICE33122212 X CALLING PETER & ANDREW   3313 212S06
X SERMON ON MOUNT HEALING  3314 113  X DELIVERY OF THE KEYS SPET 13152222S07
INSTITUTION OF EUCHARIST    33162 12 AGONY IN GARDEN            3316 313S08
X ARREST KISS            3317 112   X CRUCIFIXION 3 CROSSES     3318 111S09
RESURRECTION & ASCENSION  3213 111                             S10
TYPOLOGY INTERNAL ELAB CONTINUOUS NAR UNIFIED LDSCP TEAM ART GOLD PASTIGLIA A01
RF OLD SPET DOUBLE // APSE-ENTRANCE START RIGHT REF SMM FESTIVAL LECTIONARY A02
BUILDING STARTED COMMEMORATE 100 ANNIV END OF BABYLONIAN CAPTIVITY 1477   A03
ELABORATE TYPOLOGICAL TITULI                                    I01
1LOST      PERUGINO SCH FRSC1483     ASSUMPTION BVM               F01
                            111 ETTLINGER L  1965 SISTINE CHAPEL B4 MICF02

IFISTRN SASSETTI CHAPEL     SFRANCIS        GHIRLANDAIO             T01
1482-1486SFRAN         2 701 1101 1101 110 111111311    11123    O01
                                                     VALLOMBROSANA       O02
SFRAN RENOUNCES FATHER WEALT11101112  SFRAN RULE INNO III APPROVIII12102 31S01
```

```
SFRAN SULTAN TRIAL BY FIRE  13102 32    SFRAN STIGMATIZATION          1121 213S02
SFRAN RAISING SPINI CHILD   12202 32    SFRAN DEATH OF OBSEQUIES    13202232S03
AUGUSTUS & TIBURTINE SIBYL  1410   2                                       S04
APSE PATTERN TOP-DOWN AND STRAIGHT-LINE VERTICAL INTERLOCK                 A01
TWO FLORENTINE SCENES LINED UP ROMAN NOTARY MIR ACROSS VIA TORNABUONI      A02
UNITY NARR & ALTAR & AUGUST MOD ROME SUBJ ADOR OF SHEP LIKE PRESEP GRECCIO A03
SIGNED & DATED                                                            I01
1INSITU    GHIRLANDAIO      1485      ADORATION SHEPS                      F01
                            1    BORSOOK JOFFERHAUS FR SASSETTI GHIR 1981 F02

IROSMAC BUFALINI CHAPEL          SBERNARDINO SIENA   PINTORICCHIO          T01
1485-1486LIFE SBERNARDINO   1 801 1101 1111 11     1111311     1 1313      O01
                                                    FRANCISCAN             O02
BLESSING GODF W ANGS WINDOW 13113011    PEACOCK SEATED B4 FRAMED WIND13131211S02
SBERNARDINO YOUTH IN PENET  3110 131    SBERNARDINE VESTING OS     13213033S03
BUFALINI CHIERICO CAMERA PNT13221331    SFRAN STIGMA VIS LEO       13132333S04
SBERNARD FUNERAL OF MIRA BDG31202 33    SBERNARDINE IN GLORY X ABOVE 210 2 2S05
SPACE USE TO TELLS STORY BK TO FRT PERSPEC&ARCHIT VY SOPHIS PLUS MYSTIC SC A01
FRANCISCAN IDEALS CONTEMP PAPAL BACKING  AERIAL BOUSTROPHEDON EXPANDED FIELDA02
                              CARLI E      1960 23F   IL PINTORICCHIO F02

IROSMSMNCARAFA CHAPEL         BVM ANNUN THOMAS AQ FILIPPINO LIPPI          T01
1488-1493STHOMAS AQUINAS    1 6112140121101211022201111334                99001
                                                    DOMINICAN              O02
STHOMAS SPEAKING CRUCIFIX   33112031    STHOMAS DEPART FAMILY       33132233S01
STHOMAS TRIUMPH OVER HERESY 13202232    BVM ANNUN W CARAFA FRESCO FRM22221012S02
ASSUMPTION OF BVM APOST BLW 12102112    VIRTUES OVER VICES          1      S03
MORALISTIC USEF NARRAT NB ANN & BLESS FRESC ALTARP W FRAME ENLARGED SPACES A01
EAST WALL DESTROYED 1566 HAD TRIUMPH OF VIRTUE WINDOW DOOR TO TOMB         A02
CROSSVAULT CEILING WITH SIBYLS ANGELS INSCRIPTIONS STRAIGHT-LINE VERTICAL  A03
1INSITU    FILIPPINO LIPPI  1488-1493 ANNUN FR LEFT W CARAFA & STHOM       F01
                            111 1 GEIGER G 1975 DISS C BERTELLI BOLL D ARTEF02

IFISMN  CHANCEL               ASSUNTA         GHIRLANDAIO           1 T01
1486-1490BVM LIFE JBAP      217012134111201013    111 313  1123241232      O01
                                                    DOMINICAN              O02
ZACHARIAH ANNUN IN TEMPLE   33432012    VISITATION                 33411312S01
JBAP BIRTH BED LFT          13332013    JBAP NAMING                13312313S02
JBAP INF DEPARTS FOR DESERT 12330313    JOHN PREACHING ECCE AGNUS DEI33230311S03
X BAPTISM   W MULTITUDES    13210112    HEROD FEAST OF             13122112S04
JOACHIM EXPULSION           11412031    GOLDEN GATE MEETING BVM BIRTH31431031S05
BVM PRESENTATION SEATEDNUDE 11311031    BVM MARRIAGE               11332032S06
BVM ANNUNCATION  BACKHANDED 12311031    MAGI ADORATION ENTR LFT    11212232S07
INNOCENTS MASSACRE          11332031    BVM DEATH OBSEQUES HEAD LEFT 31120232S08
BVM ASSUMPTION LOOKS UP     31120232                               S09
STRAIGHT-LINE VERTICAL BOTTOM UP MOVE TWO APSE CONTRACT CALLS FOR BOTTOM UP A01
SUBJECTS CHANGED FM CONTRACT W2 DOCTRINAL SCS TIER2 DONORS TIER4 MALES LEFT A02
NAR TURNS CORNER TIER 3 BOTH SIDES CF CASTELLANI CHAPEL AIRBORNE SCS TOP   A03
1MUNIBERLINGHIRLANDAIO      1490      BVM IN GLORY SS RESURRECTION BACK     F01
2        LOST               1  11 DAVIS G  DOCS 1909  BOOK  GHIRLANDAIO    F02

IFISMN  STROZZI CHAPEL        SPHILIP          FILIPPINO LIPPI      1 T01
1487-1502SPHILIP            1 4 1 111     1 11    111 3121 13             O01
                                                    DOMINICAN              O02
JEVAN RAISING DRUSIANA      11211033    JEVAN MARTYRDOM            11113031S01
SPHILIP B4 ALTAR MARS DRAGON13212011    SPHILIP  CRUCIFIXION OF    13110311S02
DI SOTTO IN SU NO DEPTH SPACE UNIFIED EXCERPTED NAR CLEAR SILHOUETTE CLASSICA01
PATRIARCH ADAM (62) NOAH (61) ABRAHAM (63) JACOB (64) VAULT CF CLOISTER SMN A04
UP-DOWN, DOWN-UP EXPANDED FIELD                                           A03
                            11 11 SALE J R  STROZZI CHAPEL DISS U PENN 1976F02

ISLSMM  BAGLIONE CHAPEL                        PINTORICCHIO               T01
1501-1503INFANCY X          1 301   01   01       111131    1 123          O01
BVM ANNUNCIATION            11101112    NATIVITY MAGI SHEPS ANNUN SHE12101312S01
X DISPUTES WITH DOCTORS     131022 2                                      S02
HUGE PERSPECTIVES AS THO SEEN FR ENTRANCE RATIONALIZED SPACE SIBYLS ON CEIL A01
WRAPAROUND EXPANDED FIELD                                                 A02
                              E CARLI IL PINTORICCHIO                      F02

IORDUOMOCHAPEL S BRIZIO                        SIGNORELLI                 T01
1499-1500LAST JUDGMENT      1 70122 1122 0122 01   212131     3114321      O01
PREACHING OF ANTICHRIST     31121233    END OF THE WORLD           34100232S01
```

```
RESURRECTION OF FLESH        13120012   CONDEMNATION OF WICKED      13110012S02
SOULS ENTERING HELL          12130111   SOULS ENTERING HEAVEN       12110131S03
THE ELECT IN HEAVEN          11120032                                       S04
COUNTERCLOCKWISE WRAPAROUND STARTS LEFT  EXPANDED FIELD                     A01
VIEW FROM THE DOOR VISION HEAVEN & HELL BRACKETING ALTAR                    A02
                            111 1 CHASTEL A                                 F02

IROSIST CEILING              ASSUNTA            MICHELANGELO            T01
1508-1512GENESIS             210311110221131111101212  22      41214234   O01
CREATION LIGHT & DARK        16100012   CREATION OF SUN MOON & PLANTS36200012S01
CREATION WATER FISH & BIRDS 16300012   ADAM CREATION               16400313S02
EVE CREATION                 16500112   FALL     I                  16610311S03
EXPULSION                    36720211   NOAH SACRIFICE              16802012S04
DELUGE                       16902113   NOAH DRUNKENNESS            16002012S05
ANTELEGEM ALTAR ENTRANCE DISPOSITION EAST-WEST ORIENTATION ACTIVATED SPINE A01
ALLEGREZZANDO RHYTHM OF SMM                                                A02
                       TOLNAY THE SISTINE CEILING PTN 1959                 F02

IFILOSC CORTILE              JBAPT            ANDREA DEL SARTO          1 T01
1510-1523LIFE JBAPT          12                                             O01
ZACHARIAH ANNUNCIATION       14112021   VISITATION SHOP             13142012S01
JBAP BIRTH & NAMING  SHOP    13133011   JBAP INF DEPARTS  PARENTS    33123232S02
MBAP INF MEETING W INFX      13110333   MBAP BAPTIZING MULTITUDES    31140112S03
JBAP PREACHING  X BCKGD      32110121   X BAPTISM TWO ANGELS  SHOP   12140211S04
JBAP ARREST B4 HEROD         11132013   SALOME DANCE OF              11121012S05
JBAP DECOLLATION             11112033   SALOME DELIVERS HEAD JBAP HER14142013S06
NAR READ COUNTERCLOCKWISE PREACHING ECCE AGNUS DEI  OUT OF ORDER           A01
ARRANGEMENT PUTS BAPTISM WALL OPPOSITE ENTRANCE BASED ON JOHN 1:29, 2:23-29 A02
COMPOSIS BECOME MORE CENTRALIZED LESS NARRATIVE MORE EMBLEMATIC DEVOTIONAL A03
                       FREEDBERG SJ             ANDREA DEL SARTOF02

IGZCERTOCHIOSTRO                          PONTORMO                     T01
1523-1525PASSION X           5                                              O01
                                         CARTHUSIAN                    O02
X AGONY IN GARDEN            11113333   X B4 PILATE                 13122013S01
CALVARY ROAD TO             0313        LAMENTATION                           S02
RESURRECTION                2                                                 S03
CF I MORENO ART BULLETIN 1981 308F CRUCIFIX REPRESENTED BY CROSS ON WELL   A01
COUNTERCLOCKWISE WRAPAROUND CLOISTER MODE                                  A02
                       J REARICK PONTORM HARVARD 1967                      F02

IROSGDT ORATORY              JBAPT            SALVIATI JAC DEL CONTE   1 T01
1536-1553LIFE JBAPT          832213022122221302211   13       11341   O01
ZACHARIAH ANNUN   JD CONTE   13112 31   VISITATION SALVIATI 1538     12123013S01
JBAP  BIRTH OF SALVIATI 155113132013   JBAP YOUTH PREACH JD CONTE 3714110232S02
X BAPTISM RIVER GOD JDC 41  14120232   JBAP ARREST  BAT FRANCO      1111 213S03
SALOME DANCE OF LIGORIO      11121 13   JBAP DECOLLATION SALVIATI AS 11131 12S04
WRAPAROUND STARTS RT ALTAR FLANKED BY SS ANDREW BARTOLO GRIS BACCHIC RLFS  A01
NO RESURR IN COMPLEX NO JOY PENITENTIAL B4 DESCT LIMB & FREEING OF JBAP    A02
GRAY & GOLD GRISAILLE SMALL SCENE CLASSICAL SUBJECTS MANDRAKE IN BAPTISM   A03
1INSITU   JAC DEL CONTE      1555       DEPOSITION ANGEL W CHALICE         F01
                       111   KELLER R 1976 ORATORIO VON SGIOV DECOLLAF02

IROORSCRNAVE                 TRUE CROSS       NEBBIA POMARANCIO D VEC O1 T01
1578-1587TRUE CROSS          10222130222 2221322212    13     41323212199O01
TRC HELENA DIRECTS SEARCH    13221031   TRC HELENA FINDING C BISHOP 13243133S01
TRC HELENA PROOFS C BOY FRT 13261033   DOCUMENT PRESENTED CARDINAL  1327    S02
PLAGUE 1592 MIRAC CRUCIFIX   1221       MIRAC CRUCIFIX IN TACT FIRE191223   S03
GREGXIII PERMIS FND SCHIARA  1121       TRC HERACLIUS BATTLE BRIDGE 31222223S04
TRC EXALTATION ANGEL STOPS  11243111   TRC EXALTATION BAREFOOT JERUS11261111S05
TR1 PROPH VISION OF C VIRTUES TR2 SIBYLS & PROPH ALTERNATE W SCS WRAPAROUND A01
FESTIVAL MODE WRAPAROUND  WL 3 PROPH CROSS LEGS  BARE FOOT PROTRUDES       A02
                       HENNEBERG JOSEPHINE VON ORATORIO 1974              F02

IROGNF  ORATORY              STA LUCIA        ZUCCARI NEBBIA AGRESTI    T01
1556-1576PASSION X           1144122150222 1221512213   13      11341  O01
X ENTRY INTO JERUSALEM       13210111   LAST SUPPER                 33222012S01
X WASHES APOST FEET BACKGRD 33222012   X AGONY IN GARDEN            13230231S02
X ARREST                     13241111   X B4 PILATE                 13251011S03
X FLAGELLATION 3 BEATERS     14212032   MADONNA W TRINITY           44220012S04
X MOCKING OF                 14231011   ECCE HOMO                   11213033S05
```

```
X CALVARY VIA CRUCIS VERONIC11220311   CRUCIFIXION                        11230212S06
X DEPOSITION FR CROSS       11241011   X RESURRECTION                     11250212S07
HAEC OPORTUIT PATI CHRISTUM ET ITA INTRARE IN GLORIA SUAM LUKE 24:26            I01
EARLY XTIAN ARR PROPH SIBYLS GOLD VIRTUES DAVID TR1 OVER BVM  WRAPAROUND        A01
1INSITU    NEBBIA            1573       CRUCIFIXION SWOON RGT CONFRAT BKGD       F01
   2    2    0                          212222WOLLESEN-WISCH, B DISS UC BERKELEY 1985  F02

IFISCRC NAVE                      TRUE CROSS          GIORGIO VASARI         1 T01
1565-1572PASSION X                                                            O01
                                                             FRANCISCAN       O02
ENTRY INTO JERUSALEM (CIGOL)13113013   SFRAN & SDOM EMBRACE (CAVALC)1312    2S01
X AGONY IN GARDEN (MINGA)    13130113  FLAGELLATION (BARBIERI 1575) 13143011S02
ECCE HOMO (COPPI 1576)       13152032  CALVARY ROAD TO (VASARI 1572)13160031S03
CRUCIFIXION (S D TITO 1588)  13170332  DEPOSITION (SALVIATI 1548)MUS14110011S04
DESCENT LIMBO (BRONZINO 52)  14130232  LAYING ON GROUND (NALDINI 83)11110311S05
RESURRECTION (S D TITO 1547) 11120012  X EMMAUS SUPPER (S D TITO 74)11131111S05
DOUBTING THOMAS (VASARI 72)  11142012  ASCENSION (STRADANO 1569)    11150233S06
TWO MONKS EMBRACING DOOR     1116    2 PENTECOST (VASARI 1568)      11170022S07
NARRATIVE COMPONENTS SEPARATE ALTARPIECES DEVOT IMAGES NAR SUBJ IN CYCLE        A01
ALTARS COMPLETE ICONOG OF CH W MEDIEVAL WRAPAROUND  VASARI ENTREPRENEUR MED     A02
MEDICI PROJ  15 FAMILIES INVOLVED TOTALLY PREPLANNED OVER 12+ YR PER            A03
                          HALL M RENOVATION & COUNTERREFORM OX 1979F02

IROCHNOVNAVE ALTARS              BVM                  MANY ARTISTS            TO1
1582-1605BVM LIFE                12                                           O01
BVM PRESENT (BAROCCI 1594)   1161    2 BVM ANNUN RGT (PASSIGNANO)   1151   3 S01
VISITATION (BAROCCI 1583)    1141    3 NATIVITY ADOR SHEPS         1131      S02
MAGI ADORATION               1121      PRESENTATION (LOST)         1111      S03
CRUCIFIXION (PULZONE)        1311    2 PIETA (DEPOSITION CARRAVAGIO)1321    3S04
ASCENSION (MUZIANO)          1331    2 PENTECOST                   1341    2S05
ASSUMPTION (AURELIO LOMI)    1335      CORONATION (CV D'ARPINO 1593)1361     S06
UNIFIED ALTARS ARRANGED COUNTERCLOCKWISE WRAPAROUND                             A01
DESIGNED BY FILIPPO NERI DEVOTION TO ROSARY CF VASARI & COUNTERREFORM           A02
1INSITU    RUBENS                       MADONNA & CHILD                         F01
                          ZUCCARI ALES STOR D'ARTE 1981 77 / 171               F02

IROJLAT TRANSEPT              SACRAMENT           CAV D'ARPINO  NEBBIA     1 T01
1599-1601LIFE OF CONSTANTINE 2 8221140222 0211402211    11      1113         O01
CONSTANT TRIUMP GREETS HELEN11242333   CONSTANT ILL VISION SSPET &PA11232033S01
SSYLVES CALLED FR SORATTE    11220111  BAPTISM OF CONSTANTINE       11212032S02
CONSTANTINE FOUNDS LATERAN   13243112  CONSECRAT LATERAN ALTAR ANOIT13233011S03
VOLTO SANTO APPEARS APSE LAT13222012   CONSTANT GIFTS FESTIGIUM VESS13212013S04
COUNTERCLOCKWISE WRAPAROUND FRAMED SCS & 'FINTO' TAPESTRIES ALTER W APOSTLESA01
SCS ON RGT ALL IN LAT SC FLANK APSE ABOUT APSE REASON FOR R-L MOVEMENT          A02
NINE SCULPTURED ANGELS ALSO PROGRESS TO ALTAR OF SACRAMENT                      A03
1INSITU    CAV D ARPINO       1592      SACRAMENT ASCENSION                     F01
   2    2    0                 112112FREIBERG J NEW YORK UNIV IFA DISS 1988    F02
```

One Database Cycle Block Processed by SAS

COUNTRY:	ITALY
CITY:	AREZZO
CHURCH:	SAN FRANCESCO
DATE:	1452–66
CYCLE:	TRUE CROSS LEGEND
LOCATION:	CHANCEL
DEDICATION:	SFRANCIS
ARTIST:	PIERO DELLA FRANCESCA
ASSISTED:	YES
INSCRIBED:	NO
NUMBER OF SECTIONS:	15

Organization of Walls

	WALL 1 (LEFT)	WALL 2 (ALTAR)	WALL 3 (RIGHT)	WALL 4 (ENTRANCE)	CEILING
WINDOWS	NO WINDS	ONE WIND	NO WINDS	NO WINDS	•
LUNETTE	YES	YES	YES	NO	•
CLERESTORY	NO	NO	NO	NO	•

RECTANGULAR	YES	YES	YES	NO	•
NUMBER OF REC	2	4	2	•	•
NUMBER BAYS	1	1	1	•	•
CEILING TYPE	GROIN VAULT				

Organization of Narrative

STARTING WALL RIGHT OF ALTAR

VERTICAL MOVEMENT MIXED

NUMBER OF BAYS
IN VERT MOVEMENT

VERTICAL MOVEMENT
WALL SEQUENCE

HORIZONTAL MOVEMENT

NARRATIVE READS MIXED

HORIZONTAL MOVEMENT
WALL SEQUENCE RIGHT RIGHT ALTAR RIGHT ALTAR LEFT

HORIZONTAL SEQUENCE IS IRREGULAR. SEE ANOMALY.

Subjects of Scenes

TRC ADAM DYING FAMILY
 NARRATIVE MODE: CONTINUOUS
 LOCATED ON WALL: RIGHT OF ALTAR
 LOCATED ON TIER: 1
 POSITION ON TIER: ON RGT OR 3FR LFT
 ARCHITECTURE: NONE
 LANDSCAPE: CENTERED
 LIGHT FLOW: COMING FROM LEFT
 MAIN FIGURES: BALANCED

TRC SETH & MICHAEL OIL
 NARRATIVE MODE: CONTINUOUS
 LOCATED ON WALL: RIGHT OF ALTAR
 LOCATED ON TIER: 1
 POSITION ON TIER: CENTER ON 2NDFR LEFT
 ARCHITECTURE: NONE
 LANDSCAPE: MASSED TWD LFT
 LIGHT FLOW: COMING FROM LEFT
 MAIN FIGURES: MV TWD LFT

TRC ADAM DEAD PLANTING BRANC
 NARRATIVE MODE: CONTINUOUS
 LOCATED ON WALL: RIGHT OF ALTAR
 LOCATED ON TIER: 1
 POSITION ON TIER: CENTER OR 2NDFR LEFT
 ARCHITECTURE: NONE
 LANDSCAPE: MASSED TWD RGT
 LIGHT FLOW: COMING FROM LEFT
 MAIN FIGURES: MV TWD RGT

TRC SHEBA VENERATES WOOD
 NARRATIVE MODE: CONTINUOUS
 LOCATED ON WALL: RIGHT OF ALTAR
 LOCATED ON TIER: 2
 POSITION ON TIER: ON LEFT OR 11THFR LEFT
 ARCHITECTURE: NONE
 LANDSCAPE: MASSED TWD RGT
 LIGHT FLOW: COMING FROM LEFT
 MAIN FIGURES: MV TWD RGT

TRC SHEBA SOLOMON MGT
 NARRATIVE MODE: CONTINUOUS
 LOCATED ON WALL: RIGHT OF ALTAR
 LOCATED ON TIER: 2
 POSITION ON TIER: ON RGT OR 3FR LFT
 ARCHITECTURE: SEEN FR RIGHT
 LANDSCAPE: NONE
 LIGHT FLOW: COMING FROM LEFT
 MAIN FIGURES: BALANCED

TRC WOOD BURIAL SEMINUDEWKMAN
 NARRATIVE MODE: MONOSCENIC
 LOCATED ON WALL: ALTAR WALL
 LOCATED ON TIER: 2
 POSITION ON TIER: ON RGT OR FR LFT
 ARCHITECTURE: NONE
 LANDSCAPE: MASSED TWD RGT
 LIGHT FLOW: COMING FROM LEFT
 MAIN FIGURES: MV TWD LFT

BVM ANNUNCGOD FATHER ABOVELF
 NARRATIVE MODE: MONOSCENIC
 LOCATED ON WALL: ALTAR WALL
 LOCATED ON TIER: 3
 POSITION ON TIER: ON LEFT OR 11THFR LEFT
 ARCHITECTURE: SEEN FR LEFT
 LANDSCAPE: NONE
 LIGHT FLOW: COMING FROM RIGHT
 MAIN FIGURES: MV TWD RGT

TRC CONSTANTINE DREAM ANGEL
 NARRATIVE MODE: MONOSCENIC
 LOCATED ON WALL: ALTAR WALL
 LOCATED ON TIER: 3
 POSITION ON TIER: ON RGT OR 3FR LFT
 ARCHITECTURE: SEEN FR LEFT
 LANDSCAPE: NONE
 LIGHT FLOW: COMING FROM LEFT
 MAIN FIGURES: MV TWD RGT

TRC CONSTANTINE BATTLE MAX
 NARRATIVE MODE: MONOSCENIC
 LOCATED ON WALL: RIGHT OF ALTAR
 LOCATED ON TIER: 3
 POSITION ON TIER: FULL OR 10THFR LEFT
 ARCHITECTURE: NONE
 LANDSCAPE: MASSED TWD RGT
 LIGHT FLOW: COMING FROM LEFT
 MAIN FIGURES: MV TWD RGT

TRC JUDAS DRAWN OUT OF WELL
 NARRATIVE MODE: MONOSCENIC
 LOCATED ON WALL: ALTAR WALL
 LOCATED ON TIER: 2
 POSITION ON TIER: ON LEFT OR 11THFR LEFT
 ARCHITECTURE: SEEN FR RIGHT
 LANDSCAPE: NONE
 LIGHT FLOW: COMING FROM LEFT
 MAIN FIGURES: MV TWD RGT

TRC HELEN FINDS CROSS JUDAS
 NARRATIVE MODE: CONTINUOUS
 LOCATED ON WALL: LEFT OF ALTAR
 LOCATED ON TIER: 2
 POSITION ON TIER: ON LEFT OR 11THFR LEFT
 ARCHITECTURE: NONE
 LANDSCAPE: MASSED TWD RGT
 LIGHT FLOW: COMING FROM RIGHT
 MAIN FIGURES: BALANCED

TRC HELEN PROOFS CR BOY
 NARRATIVE MODE: CONTINUOUS
 LOCATED ON WALL: LEFT OF ALTAR
 LOCATED ON TIER: 2
 POSITION ON TIER: ON RGT OR 3FR LFT
 ARCHITECTURE: SEEN FR LEFT
 LANDSCAPE: NONE
 LIGHT FLOW: COMING FROM RIGHT
 MAIN FIGURES: MV TWD LFT

TRC HERACLIUS BATTLE CHOSSON
 NARRATIVE MODE CONTINUOUS
 LOCATED ON WALL: LEFT OF ALTAR
 LOCATED ON TIER: 3
 POSITION ON TIER: ON LEFT OR 11THFR LEFT

 ARCHITECTURE: NONE
 LANDSCAPE: NONE
 LIGHT FLOW: COMING FROM RIGHT
 MAIN FIGURES: BALANCED

TRC CHOSROES EXECUTION BACCI
 NARRATIVE MODE: CONTINUOUS
 LOCATED ON WALL: LEFT OF ALTAR
 LOCATED ON TIER: 3
 POSITION ON TIER: ON RGT OR 3FR LFT
 ARCHITECTURE: SEEN FR RIGHT
 LANDSCAPE: NONE
 LIGHT FLOW: COMING FROM RIGHT
 MAIN FIGURES: BALANCED

TRC HERACLIUS BAREFOOT
 NARRATIVE MODE: MONOSCENIC
 LOCATED ON WALL: LEFT OF ALTAR
 LOCATED ON TIER: 1
 POSITION ON TIER: FULL OR 10THFR LEFT
 ARCHITECTURE: SEEN FR RIGHT
 LANDSCAPE: CENTERED
 LIGHT FLOW: COMING FROM RIGHT
 MAIN FIGURES: BALANCED

ANOMALY: MED PROTOCOL START BOUSTROPHEDON CAT'S CRADLE UP-DOWN, DOWN-UP

ANOMALY: CHIVAL IRREGULAR CHRONOLOGY PAIRED THEMES EPIC MODE

ANOMALY: UNIQUE COMBO CONSTANT & HERACLIUS BATTLES UNIQUE MTG SHEBA-SOLOMON

ANOMALY: UNIQUE ADAM DYING COMIC RELIEF AREZZO-FRANCIS-DEVILS OUT FINDING

ALTARPIECE:
 LOCATION OF ORIGINAL:
 PAINTER:
 DATE: 1250–75
 SUBJECT: CRUCIFIX W SFRANCIS KISSING FEET

 NARRATIVE ON: WINGS: NO
 PINNACLES: NO
 PREDELLA:

 FIGURES ON: PILASTER: BORDERS: YES
DADO: NO
WINDOW: NO
CEILING: YES
FLOOR: NO

BIBLIOGR: BATTISTI. E PDF MILAN 1971

Codes

City Names

AA = ANTELLA
AB = ALBI
AI = ANAGNI
AN = ANCONA
AO = AOSTA
AP = ASCOLI PICENO
AQ = L'AQUILA
AR = AREZZO
AS = ASSISI
AT = ASTI
AV = AVIGNON
BA = BARI
BG = BERGAMO
BL = BELLUNO
BN = BENEVENTO
BO = BOLOGNA
BR = BRINDISI
BS = BRESCIA
BV = BELVERDE
BZ = BOLZANO
CA = CAGLIARI
CE = CASERTA
CG = CASTGL OLONA
CO = COMO

CR = CREMONA
CS = CASTEL SEPRIO
CT = CATANIA
EM = EMPOLI
FE = FERRARA
FG = FOGGIA
FI = FLORENCE
FO = FORLI
GD = SPIERO GRADO
GE = GENOVA
GR = GROSSETO
GV = SGIOV VALDARNO
GZ = GALUZZO
LG = LUGANO
LI = LIVORNO
LO = LORETO
LT = LATINA
LU = LUCCA
MC = MACERATA
ME = MESSINA
MF = MONTEFALCO
MG = MONTEGIORGIO
MI = MILANO
MN = MANTOVA

MO = MODENA
MR = MONREALE
MV = MTE OLIVETTO
NA = NAPLES
NO = NOVARRA
OR = ORVIETO
PA = PALERMO
PC = PAGANICO
PD = PADUA
PE = PESCARA
PG = PERUGIA
PI = PISA
PM = POMPOSA
PN = PORDENONE
PO = PRATO
PP = POPPI
PQ = PARIS
PR = PARMA
PS = PESARO
PT = PISTOIA
PV = PAVIA
PZ = PIACENZA
RA = RAVENNA

RI = RIETI
RO = ROME
SA = SALERNO
SF = SANGELOFORMIS
SG = SAN GIMIGNANO
SI = SIENA
SL = SPELLO
SP = LA SPEZIA
SV = SAVONA
TI = TIVOLI
TN = TRENTO
TO = TURIN
TR = TERNI
TS = TRIESTE
TU = TUSCANIA
TV = TREVISO
UD = UDINE
UR = URBINO
VE = VENICE
VI = VICENZA
VO = VOLTERRA
VR = VERONA
VT = VITERBO

Church Names

BAPT = BAPTISTRY
BARG = BARGELLO
CERT = CERTOSA DI SLORENZO
CHNOV = CHIESA NUOVA
COLG = COLLEGIATA
CPSTO = CAMPO SANTO
EREM = EREMITANI
GNF = GONFALONE
JLAT = LATERAN
LOSC = LO SCALZO
MLOR = STA MARIA DI LORETO
MTOL = MTE OLIVETTO MAG
ORSCR = ORATORIO D SCROCE
ORSM = OR SAN MICHELE
PAMED = PALAZZO MEDICI
PAPPA = PAPAL PALACE
PLPUB = PALAZZO PUBBLICO
PZDUC = PALAZZO DUCALE
QCORO = SSQUATTRO CORONATI
SAFOR = SANGELO IN FORMIS
SANAS = SANT ANASTASIA
SAPOL = SANT APOLLONIA
SBERN = SAN BERNARDINO
SCATH = STA CATERINA
SCECI = STA CECILIA
SCLM = SAN CLEMENTE
SCRC = STA CROCE
SCRGE = SCROCE GERUSALEM
SCSTO = SCUOLA DEL SANTO

SCT = SANCTUM SANCTORUM
SEGID = SANT' EGIDIO
SFRAN = SAN FRANCESCO
SGDT = SGIOVANNI DECOLLATO
SGI = SCUOLA DI S GIORGIO
SGIOV = SAN GIOVANNI
SIST = SISTINE CHAPEL
SLOR = SAN LORENZO
SMA = STA MARIA ANTIQUA
SMC = STA MARIA COSMEDIN
SMDA = SMARIA D ANGELI
SMAC = SMARIA IN ARACOELI
SMCAR = SMARIA IN CARMINE
SMLLO = SMARCELLO AL CORSO
SMM = STA MARIA MAGGIORE
SMN = STA MARIA NOVELLA
SMRC = SAN MARCO
SMSC = SMARIA D SCALA
SMSMN = SMARIA S MINERVA
SMTO = S MINIATO AI MONTI
SMTRA = SMARIA TRASTEVERE
SMV = STA MARIA IN VESCOVIO
SONO = SANT' ONOFRIO
SPAOL = SPAOLO F L MURA
SPT = SPIETRO IN TUSCANIA
SSYL = SAN SILVESTRO
STRN = STA TRINITA
VAT = VATICAN

Descriptive Codes

WALL IDENTIFICATION

1 = WALL LEFT OF ALTAR
2 = ALTAR WALL
3 = WALL RIGHT OF ALTAR
4 = WALL OPPOSITE ALTAR

POSITION OF SCENE ON TIER

0 = FILLS WHOLE TIER OR 10TH FROM LEFT
1 = ON THE LEFT OR 11TH FROM LEFT
2 = CENTER OF TIER OR 2D FROM LEFT
3 = ON THE RIGHT OR 3D FROM LEFT
4 = 4TH FROM LEFT, etc.

DIRECTION NARRATIVE READS

1 = FROM LEFT TO RIGHT
2 = CENTERED
3 = FROM RIGHT TO LEFT
4 = MIXED

VERTICAL MOVEMENT OF NARRATIVE

1 = FROM TOP TO BOTTOM
2 = FROM BOTTOM TO TOP
3 = MIXED

CEILING TYPES

1 = SADDLE ROOF
2 = BARREL VAULT
3 = GROIN VAULT
4 = DOME
5 = BARREL VAULT WITH NARRATIVE SCENES
6 = GROIN VAULT WITH NARRATIVE SCENES
7 = DOME WITH NARRATIVE

NUMBER OF WINDOWS

0 = NONE
1 = ONE WINDOW
2 = TWO WINDOWS
3 = MORE THAN TWO WINDOWS
4 = ROSE WINDOW

NARRATIVE MODES

1 = MONOSCENIC
2 = POLYSCENIC
3 = CONTINUOUS
4 = DEVOTIONAL

VIEW OF ARCHITECTURE

0 = NONE
1 = SEEN FROM LEFT (EXTERIOR OF LEFT WALL;
INTERIOR OF RIGHT WALL)
2 = SEEN FROM FRONT
3 = SEEN FROM RIGHT (EXTERIOR OF RIGHT WALL;
INTERIOR OF LEFT WALL)

COMPOSITION OF LANDSCAPE

0 = NONE
1 = MASSED TOWARD THE RIGHT
2 = CENTERED
3 = MASSED TOWARD THE LEFT

DIRECTION OF LIGHT FLOW

0 = NONE
1 = COMING FROM LEFT
2 = FRONTAL
3 = COMING FROM RIGHT

ARRANGEMENT OF MAIN FIGURES

0 = NONE
1 = MOVING TOWARD THE RIGHT
2 = BALANCED
3 = MOVING TOWARD THE LEFT

Column Designations

T-Records

Variables	Format Names	Columns
COUNTRY	$CTRY.	1
CITY	$CNAME.	2–3
CHURCH	$CHNAME.	4–8
LOCAT	—	9–29
DEDIC	—	30–49
ARTIST	—	50–69
ASSIST	YESNO.	75

Oo1-Records

Variables	Format Names	Columns
DATE	—	1–9
CSUBJ	—	10–29
WRITING	YESNO.	30
NSECTS	—	31–32
WALL 1	XWALL1.	33–37
NWIN1	WIND.	33
LUNI	YESNO.	34
CLER1	YESNO.	35
RECT1	YESNO.	36
NRECS1	—	37
WALL2	XWALL2.	38–42
NWIN2	WIND.	38
LUN2	YESNO.	39
CLER2	YESNO.	40
RECT2	YESNO.	41
NREC2S	—	42
WALL3	XWALL3.	43–47
NWIN3	WIND.	43
LUN3	YESNO.	44
CLER3	YESNO.	45
RECT3	YESNO.	46
NRECS3	—	47
WALL4	XWALL.4	48–52

Variables	Format Names	Columns
NWIN4	WIND.	48
LUN4	YESNO.	49
CLER4	YESNO.	50
RECT4	YESNO.	51
NRECS4	—	52
BAYS1	—	53
BAYS2	—	54
BAYS3	—	55
BAYS4	—	56
CEILING	CTYPE.	57
START	XWALL.	58
UPDOWN	VERT.	59
VBMOVE	—	60–61
VWSEQ1	VERMOV.	62
VWSEQ2	VERMOV.	63
VWSEQ3	VERMOV.	64
VWSEQ4	VERMOV.	65
NAREAD	NREAD.(1–4)	66
HORMOVE	YESNO.	67
HWSEQ1	HORSEQ.	68
HWSEQ2	HORSEQ.	69
HWSEQ3	HORSEQ.	70
HWSEQ4	HORSEQ.	71
HWSEQ5	HORSEQ.	72
HWSEQ6	HORSEQ.	73
HWSEQ7	HORSEQ.	74
IRSEQ	99	75–76

Oo2-Records

VAULT	—	1–5
NWINV	WIND.	1
LUNV	YESNO.	2
CLERV	YESNO.	3
RECTV	YESNO.	4
NRECV	—	5
ORDER	ORDER.	60–70

S-Records

Variables	Format Names	Columns
SUBJECTI	—	1–28
MODE1	—	29
WALLOC1	XWALL.	30
TIERLOC1	—	31
TIERPOS1	TPOS.	32
ARCH1	ARCHITEC.	33
LANDS1	LAND.	34
LIGHT	LIGHT.	35
MAINFIG1	MAINFIG.	36
ETC 2,3,4		

I-Records

INSCRIP-TIONS	—	1–76

A-Records

ANOMA-LIES	—	1–76

Fo1-Records

Variables	Format Names	Columns
ORIGALT	YESNO.	1
PLACE	—	2–11
PAINTER	—	12–29
TIME	—	30–38
ICONOG	—	41–76

Fo2-Records

NARWING	YESNO.	1
NARPINN	YESNO.	6
PREDELLA	—	11–29
PILASTER	YESNO.	30
BORDERS	YESNO.	31
DADO	YESNO.	32
GLASS	YESNO.	33
ROOF	YESNO.	34
FLOOR	YESNO.	35
BIBLIOG	—	36–76

Appendix 2: List of Cycles by Patterns of Disposition

Apse Pattern

705–7	Rome, Santa Maria Antiqua
1274–84	Assisi, San Francesco, Upper Church, apse
1274–84	Assisi, San Francesco, Upper Church, left transept
1274–84	Assisi, San Francesco, Upper Church, right transept
1295	Rome, Santa Maria Maggiore, apse
1298–1300	Rome, Santa Maria in Trastevere, apse
1357–64	Orvieto, Duomo, chancel
1393–95	Prato, Duomo, Cappella del Sacro Cingolo
1407	Siena, Palazzo Pubblico, Cappella dei Priori
1420–30	Florence, Santa Maria del Carmine, sacristy
1422–27	Gubbio, San Agostino, chancel
1427–28	Gubbio, San Francesco, right apsidal chapel
1452	Montefalco, San Francesco, chancel
1461–65	San Gimignano, San Agostino, chancel
1482–86	Florence, Santa Trinita, Sassetti Chapel
1492	Rome, Santa Croce in Gerusalemme, apse
1586–87	Rome, Santa Maria Maggiore, Sistine Chapel

Boustrophedon

504	Ravenna, Sant'Apollinare Nuovo
1308–11	[Duccio, *Maestà*]
1315–20	Florence, Santa Croce, Bardi Chapel
1315–20	Assisi, Lower Church, Magdalene Chapel
1334–43	San Gimignano, Collegiata, right wall
1346–48	Avignon, Papal Palace, Chapel of Saint John
1366–68	Florence, Santa Maria Novella, "Spanish Chapel"*
1383–95	Florence, Santa Croce, Castellani Chapel
1397–98	Pisa, San Francesco, Sardi Campigli Chapel
1410	Volterra, San Francesco, Cappella della Croce
1420–25	Florence, Santa Trinita, Bartolini Chapel
1452–66	Arezzo, San Francesco, chancel*
1482–85	Rome, Santa Maria in Aracoeli, Bufalini Chapel

Cat's Cradle

1317–20	Assisi, San Francesco, Lower Church, Saint Martin Chapel*
1410	Volterra, San Francesco, Cappella della Croce

1425–28 Florence, Santa Maria del Carmine, Brancacci Chapel*
1452–66 Arezzo, San Francesco, chancel*
1505–6 Siena, Duomo, Arringhieri Chapel
1508–12 Vatican, Sistine Chapel
1546–54 Florence, San Lorenzo, chancel (lost)

Double Parallel

432–40 Rome, Santa Maria Maggiore
446–507 Rome, San Giovanni in Laterano, nave
801–50 Rome, San Paolo fuori le Mura*
891–96 Vatican, Saint Peter's*
1100–1149 Ferentino, San Pietro*
1253–66 Assisi, San Francesco, Lower Church, nave
1280–1300 Assisi, San Francesco, Upper Church, nave (top two tiers)*
1295–1300 Santa Maria in Vescovio*
1367 San Gimignano, Collegiata, left wall
1423–32 Rome, San Giovanni in Laterano, nave
1481–83 Vatican, Sistine Chapel
1515 Vatican, Sistine Chapel, tapestries

Counterclockwise Wraparound

1436–39 Florence, Badia, Chiostro degli Aranci
1499–1502 Orvieto, Duomo, San Brizio Chapel
1509–23 Florence, Lo Scalzo
1510 Rome, Sant'Onofrio, cloister
1511 Padua, Oratorio dello Santo
1523–25 Galluzzo, San Lorenzo, cloister
1572 Rome, Santa Maria in Vallicella
1599–1601 Rome, San Giovanni in Laterano, transept
1600–1601 Rome, San Cesareo
1600–1605 Rome, Santa Prassede

Straight-Line Vertical

1330–34 Florence, Santa Croce, Baroncelli Chapel
1330–36 Florence, Santa Croce, Peruzzi Chapel
1332–36 Florence, Baptistry, south doors
1335–41 Florence, Santa Croce, Bardi Chapel di Vernio
1340 San Gimignano, San Agostino, Chapel of the Blessed Virgin Mary
1343 Pistoia, San Francesco, Cappella Grande
1365–69 Florence, Santa Croce, Rinuccini Chapel
1377–84 Padua, Oratorio di San Giorgio
1388–93 Florence, Santa Croce, chancel*
1395–98 Prato, San Francesco, Capitolare
1410–25 Florence, Baptistry, north doors
1424 Empoli, Santo Stefano, Cappella della Croce*
1425–40 Florence, Santa Maria Novella, Chiostro Verde
1425–51 Florence, Baptistry, east doors
1433–38 Prato, Duomo, Bocchineri Chapel
1450–57 Padua, Eremitani, Ovetari Chapel
1452–64 Prato, Duomo, chancel
1486–90 Florence, Santa Maria Novella, chancel
1488–93 Rome, Santa Maria sopra Minerva, Carafa Chapel

Up-Down, Down-Up

1310–11 Padua, Arena Chapel, chancel*
1320–30 Assisi, San Francesco, Lower Church, transept
1420–25 Florence, Santa Trinita, Bartolini Chapel
1452–66 Arezzo, San Francesco, chancel*
1487–1502 Florence, Santa Maria Novella, Strozzi Chapel

Wraparound

830–34 [Müstair, Saint John]
1072–87 Sant'Angelo in Formis*
1130–54 Monreale, Duomo*
1160–91 Rome, San Giovanni in Porta Latina*
1246 Rome, Santi Quattro Coronati
1260–70 Parma, Baptistry
1287–88 Rome, Santa Maria in Aracoeli, nave
1290–99 Florence, Baptistry, mosaics*
1295–97 Assisi, San Francesco, Upper Church, nave (bottom tier)*
1300–1350 Pomposa, Abbey*
1300 San Piero in Grado*
1303–10 Padua, Arena Chapel
1341–42 Pisa, Campo Santo*
1343–54 Venice, Baptistry
1346–49 Avignon, Papal Palace, Chapel of Saint Martial
1352–59 Florence, Orsan Michele, tabernacle
1372–79 Padua, Santo, San Felice Chapel
1387–90 Florence, San Miniato, sacristy
1400–1405 Belverde, San Francesco
1416 Urbino, Oratorio di San Giovanni Battista*
1424–25 Foligno, Trinci Chapel
1424–28 Siena, Baptistry, baptismal font
1428–31 Rome, San Clemente, Branda Chapel
1432–35 Castiglione Olona, Baptistry
1446–50 Vatican, Niccolina Chapel*
1459 Florence, Medici Palace, chapel*
1490–95 Venice, San Giorgio degli Sciavone
1498–1508 Monte Olivetto, cloister
1518–32 Siena, Oratorio di San Bernardino
1519–24 Vatican, Sala di Costantino
1536–53 Rome, Oratorio di San Giovanni Decollato*
1565–72 Florence, Santa Croce, nave*
1567–71 Parma, Duomo, nave
1573 Rome, Oratorio del Gonfalone*
1578–87 Rome, Oratorio del Santissimo Crocifisso*
1590–93 Rome, Santa Maria Maggiore, nave

*Cycles following the Early Christian protocol (starting on the right at the apse end).

Notes

INTRODUCTION

1. Although Gregory thought cult images should be forbidden (cf. on this subject Edwyn Bevan, *Holy Images* [London, 1940]), he said that painting was "admissible in churches in order that those who are unlettered may yet read by gazing at the walls what they cannot read in books" (Idcirco enim pictura in ecclesiis adhibetur ut hi qui litteras nesciunt saltem in parietibus videndo legant quae legere in codicibus non valent; letter to Bishop Serenus of Marseilles; lib. 9, ep. 105, Migne, *P.L.*, vol. 77, cols. 1027–28). He says further that the function of paintings was, for persons "though ignorant of letters, to learn what had been done . . . by turning their eyes to the story itself" (Nam quod legentibus scriptura, hoc idiotis praestat pictura cernentibus, quia in ipsa etiam ignorantes vident quid sequi debeant, in ipsa legunt qui litteras nesciunt. Unde et praecipue gentibus pro lectiones pictura est; lib. 11, ep. 13 ad eumd. Seren., *P.L.*, vol. 77, col. 1128). Translations in P. Schaff and H. Wace, eds., *A Select Library of Nicene and Post-Nicene Fathers of the Christian Church* (New York, 1898), 13:53 ff. Cf. the discussion in Herbert L. Kessler, "Pictorial Narrative and Church Mission in Sixth-Century Gaul," in *Pictorial Narrative in Antiquity and the Middle Ages*, ed. Herbert L. Kessler and Marianna Shreve Simpson, vol. 16 of *Studies in the History of Art*, Center for Advanced Study in the Visual Arts Symposium Series 4 (Washington, D.C., 1985), pp. 75–91. (Hereafter cited as *Pictorial Narrative*.)

2. The "Libri Carolini," published in 791, says that pictures are not to be compared with books as sources of edification, yet they are worth having for their commemorative and decorative value. Thomas Aquinus (d. 1274) says art is to instruct the ignorant, render sacred miracles visible so as to be better committed to mind, and excite devotion (*Summa Theologica* 2.2, q. 94, art. 2); Durandus of Mende says, "Pictures are the letters and scriptures of the laity. For deeds are placed before the eyes in paintings, and so appear to be actually carrying on. But in description, the deed is done as it were by hearsay. In churches we pay less reverence to books than to images and pictures" (*Rationale divinorum officiorum*, trans. J. M. Neale and B. Webb as *The Symbolism of Churches and Church Ornaments* (Leeds, 1843), lib. 1, cap. 3, no. 1, 4). Louis Gougaud, "Muta praedicatio," *Revue Bénédictine* 42 (1930): 168–71, collects more than a dozen quotations from throughout the Middle Ages on this point. The concept is evoked again by members of the trecento Sienese painters' guild, who professed themselves "by the grace of God, the expositors of sacred writ to the ignorant who know not how to read." (Breve dell'arte de' pittori senesi dell'anno mccclv: . . . Imperciochè noi siamo per la gratia di Dio manifestatori agli uomini grossi

che non sanno lectera, de le cose miracolose operate per virtù et in virtù de la santa fede; Gaetano Milanesi, ed., *Documenti per la storia dell'arte senese* [Siena, 1854], 1:1 ff.). For the extension of these ideas into the sixteenth century, see the remarks of Paolo Cortese, *De cardinalatu* (Castro Cortese, 1510), fol. liiiv, where "the ancient tradition that sacred histories in church instruct and inspire the faithful" is repeated in the context of the Sistine Chapel, according to John K. G. Shearman, *Raphael's Cartoons in the Collection of Her Majesty the Queen and the Tapestries for the Sistine Chapel* (London, 1972), pp. 44 n. 1. See also Kathleen Weil-Garris and John D'Amico, "The Renaissance Cardinal's Ideal Palace: A Chapter from Cortese's *De Cardinalatu*," in *Studies in Italian Art and Architecture, Fifteenth through Eighteenth Centuries*, ed. Henry A. Millon, pp. 45–123 (Cambridge, Mass., 1980), esp. pp. 92–93, for Cortese's remarks on chapel decoration.

3. Bishop Paulinus of Nola (early fifth century), said it would be useful to embellish the Church of Saint Felix "all over with sacred paintings in order to see whether the spirit of the peasants would not be surprised by this spectacle and undergo the influence of the colored sketches which are explained by inscriptions over them, so that the script may make clear what the hand has exhibited" (*S. Paulini Nolani opera, pars I epistulae*, ed. G. de Hartel, Corpus Scriptorum Ecclesiasticorum Latinorum 29 [Vienna, 1894], pp. 285–91). See also Robert W. Gaston, "Studies in the Early Christian 'Tituli' of Wall Decoration in the Latin West (The Tituli of St. Paulinus of Nola)" (Ph.D. diss., University of London, 1969); and Cäcilia Davis-Weyer, *Early Medieval Art, 300–1150* (Englewood Cliffs, N.J., 1971), pp. 17–18.

4. Dale Kinney made this point in "Words and Pictures in Medieval Italian Art," a public talk given at the American Association of University Professors of Italian, annual meeting, J. Paul Getty Museum, 21 November 1981, as does Lawrence G. Duggan, "Was Art Really the 'Book of the Illiterate'?" *Word and Image* 5(1989): 227–51. See also Kessler, "Pictorial Narrative." Examples of literary inscriptions concomitant with, but not explanatory of, adjacent scenes are found in the cycles of Santa Maria Maggiore in Rome (Cavallini, chap. 1 below) and Pomposa Abbey on the Adriatic coast, dated about 1300. Oddly, it was during the Renaissance, when literacy was on the rise, that inscriptions became rare in monumental narrative art. But see below, chap. 7, on the Sistine Chapel.

5. Gotthold E. Lessing, *Laocoön*, trans. Ellen Frothingham (Boston, 1898). Originally published 1766.

6. Carl Robert, "Die Entwicklung des griechischen Mythos in Kunst und Poesie," in *Bild und Lied: Archaeologische Beitrage zur Geschichte der griechischen Heldensage* (Berlin, 1881).

7. Franz Wickoff, *Die "Wiener Genesis"* (Vienna, 1895); translated by E. Strong as *Roman Art: Some of Its Principles and Their Application to Early Christian Painting* (New York, 1900).

8. I use these three categories for indicating how many episodes appear within one frame.

9. George M. A. Hanfmann, "Narration in Greek Art," in *Narration in Ancient Art: A Symposium*, ed. Carl Hermann Kraeling et al. (1957). Reprinted in *American Journal of Archaeology* 61 (1961): 43–91.

10. Etienne Souriau, "Time in the Plastic Arts," *Journal of Aesthetics and Art Criticism* 7 (1949): 294–307; Henrietta A. Groenewegen-Frankfort, *Arrest and Movement: An Essay on Space and Time in the Representational Art of the Ancient Near East* (Chicago, 1951); Otto Pächt, *The Rise of Pictorial Narrative in Twelfth-Century England* (Oxford, 1962); Sven Sandström, *Levels of Unreality: Studies in Structure and Construction in Italian Mural Painting during the Renaissance* (Uppsala, 1963).

11. Kurt Weitzmann, *Illustration in Roll and Codex* (Princeton, 1947).

12. An important discussion of fifteenth-century narrative composition was initiated by John Pope-Hennessy, "The Sixth Centenary of Ghiberti," in *The Study and Criticism of Italian Sculpture*, pp. 39–70 (New York, 1980), esp. pp. 51 ff. The author suggests that clichés about "continuous" narrative as being "more primitive" than the single, focused image have blinded us to the true relation of narrative techniques to the development of Renaissance perspective. Cf. below, chapter 5.

13. For example, the remarkable instance of the Cotton Genesis and its relation to the mosaics of San Marco in Venice; cf. Kurt Weitzmann and Herbert L. Kessler, *The Cotton Genesis: British Library, Codex Cotton Otho B VI* (Princeton, 1986).

14. Cf. Ernst Kitzinger, "The Role of Miniature Painting in Mural Decoration," in *The Place of Book Illumination in Byzantine Art*, ed. Kurt Weitzmann et al., pp. 99–142 (Princeton, 1975).

15. *Pictorial Narrative*, introduction, p. 8.

16. See above, note 9, and *Texte et image: Actes du Colloque International de Chantilly* (13–15 October 1982), Centre de Recherches de l'Université de Paris 10 (Paris, 1984).

17. *Pictorial Narrative*, introduction, p. 8.

18. Richard Brilliant, *Visual Narratives: Storytelling in Etruscan and Roman Art* (Ithaca, N. Y., 1984), pp. 18 ff.

19. Eve Borsook, *The Mural Painters of Tuscany, from Cimabue to Andrea del Sarto* (Oxford, 1980); Sandström, *Levels of Unreality*; Rudolf Kuhn, *Mittelitalienische Freskenzyklen, 1300–1500: Zur erzählenden Malerei* (Munich, 1984).

20. Preliminary steps in this direction were taken by Herbert L. Kessler, "Pictures as Scripture in Fifth-Century Churches," *Studia Artium Orientalis et Occidentalis* 2 (1985): 17–31, where sources, function, and disposition of Early Christian fresco cycles are commented upon and studied in some detail. See also Luba Eleen, "The Frescoes from the Life of St. Paul in San Paolo fuori le Mura in Rome: Early Christian or Medieval?" in *The Roman Tradition in Wall Decoration*, vol. 12 of *Canadian Art Review* (Quebec, 1985), pp. 251–59. Wolfgang Kemp treats problems of planning in a more general sense in his *"Sermo Corporeus": Die Erzählung der mittelalterlichen Glasfenster* (Munich, 1987).

21. Figure 137 and diagram 34; the bibliography on Piero's cycle appears with the discussion below in chapter 6, notes 34 ff.

22. The decision to stop at the end of the sixteenth century was made not because the importance of cycle painting diminished, but because of the radical changes in architectural forms that occurred during the period of Mannerism. See the opening passage of chapter 9 below.

23. The structure, contents and technical aspects of the database are reviewed below in The Computer Database: NARRART DATA.

24. See below, the discussion of Simone Martini's Saint Martin Chapel, chapter 2.

25. Cf. the discussion in chapter 1, below. Tracing the correlation between liturgy and fresco design in many individual cases must await further study.

26. See discussion below chapter 1. Patterned narratives have been proposed for other media; see Ernst Kitzinger, "Christian Imagery: Growth and Impact," in *The Age of Spirituality: Late Antique and Early Christian Art, Third to Seventh Century*, ed. Kurt Weitzmann et al., pp. 141–63 (New York, 1980), esp. p. 152.

27. See the next section of this chapter for a descriptive list of the patterns.

28. For what may be a unique reference in an artist's contract to narrative disposition, but only by implication, see below, chapter 7 (Ghirlandaio).

29. See the various articles on this subject in F. W. Kent, Patricia Simons, and J. C. Eade, eds., *Patronage, Art, and Society in Renaissance Italy* (Oxford, 1987).

30. Obviously, patterned narratives were not the only means used to express

such ideas; the choice of scenes for inclusion or omission, with episodes arranged in "simple" reading order, was frequently employed to great effect. Cf. Kurt Weitzmann, *The Fresco Cycle in Santa Maria in Castelseprio* (Princeton, 1951).

31. The structure of the diagram is based on the ideas of Eric Berne *Transactional Analysis in Psychotherapy* (New York, 1961) and *Games People Play: The Psychology of Human Relationships* (New York, 1964), esp. pp. 33–34. Berne introduces the term "ulterior" to mean an activity involving more than two ego states simultaneously. As opposed to his negative use of the term, meaning psychologically "dishonest," I shall use it positively, referring only to the duplex activity of the narrative components as parts of the story and parts of a new whole that conveys a larger meaning.

32. I have published a few preliminary statements concerning the database and my findings: See Marilyn Aronberg Lavin, "Monumental Narrative Cycles," in *Census: Computerization in the History of Art*, ed. Laura Corti, Scuola Normale Superiore, Pisa, and the J. Paul Getty Trust (Los Angeles, 1984), 1, 142:343–44; "Italian Narrative Fresco Cycles," in *Automatic Processing of Art History Data and Documents (September 24–27, Pisa, 1984): Papers*, ed. Laura Corti, 2, 48:387–401 (Florence, 1984); "Patterns of Arrangement in Italian Fresco Cycles: A Computer Database," in *The Roman Tradition in Wall Decoration*, vol. 12 of *Canadian Art Review* (Quebec, 1985), pp. 209–14; "Computers and the Private Scholar," *AICARC* 14–15, 25–26 (1986–87): 54–55; "Computers and Art History: Piero della Francescsa and the Problem of Visual Order," *New Literary History* 20, 2 (1988–89): 1–22.

33. Cf. e.g., L. D. Ettlinger, *The Sistine Chapel before Michelangelo: Religious Imagery and Papal Primacy* (Oxford, 1965), p. 35, where "problematic" compositions on the left wall are discussed in the light of their right-to-left (i.e., reversed) reading order. We find the same presumption concerning the reading of individual images, as in the following passage: "In scanning [a] picture, the eye normally moves from left to right, with the result that forms shown as moving from right to left . . . appear to come against the viewer's eye-motion, while forms directed from left to right appear to run with it"; Lorenz Eitner, *Gericault: His Life and Works* (London, 1983), p. 32. See also Otto Demus, *Romanesque Mural Painting*, trans. Mary Whittall (London, 1970), pp. 13 ff., esp. p. 24, where narrative order that reads first from left to right and then right to left is treated as an inconvenience to the observer (who must walk about to see the paintings) but as a convenience to the painter once the scaffolding was built. Demus also contrasts the Western and Byzantine fresco organization in *Byzantine Mosaic Decoration* (New Rochelle, N.Y., 1976), pp. 16–29. Guy Metraux observed (in a public talk at the American Academy in Rome, June 1984) that consonantal languages read left-right or right-left, from top to bottom or bottom to top, whereas syllabic languages read left-right, a fact related to synapses in brains and neurological controls. On the basis of studies by Dierik de Kerkove, of the Marshall McLuhan Center for Communications, University of Toronto, Metraux suggested it might be fruitful to analyze visual scenes and sequences in these terms. See G. T. Buswell, *How People Look at Pictures* (Chicago, 1935); John Kennedy, *The Psychology of Picture Perception* (San Francisco, 1974); and Hayden B. J. Maginnis, "The Role of Perceptual Learning in Connoisseurship: Morelli, Berenson and Beyond," *Art History* 13 (1990): 104–17, all of whom discuss patterns of eye movement responding to certain visual stimuli in the field of art. I thank Professor Maginnis for the last three references.

34. Cf. the definition by a semiologist: "Il ciclo è provvisto di una linearità temporale che è isomorfa a quella della storia che vi si racconta dentro [The cycle follows a temporal linearity that is isomorphic to that of the story it tells]"; Omar Calabrese, "Note sul dispositivo formale della 'Storia della Vera Croce' di

Piero della Francesca ad Arezzo," in *La macchina della pittura: Pratiche teoriche della rappresentazione figurative fra Rinascimento e Barocco*, pp. 241–63, Biblioteca di Cultura Moderna Laterza 917 (Rome, 1985).

35. From the German *Inszenierung*, first used in English about 1895.

36. One might call this point of view "secular" as opposed to the earlier convention of describing an ecclesiastical ambient in liturgical terms. Throughout most of the Middle Ages, the position of the crucifix on the altar (facing the nave with its back to the apse) determined which was right and left. As far as I can judge, Vasari's descriptions followed this precept, speaking of left and right from the point of view of the figures represented in a painting; Giorgio Vasari, *Le vite de' più eccellenti pittori, scultori ed architettori*, ed. Gaetano Milanese (Milan, 1878) (hereafter cited as Vasari, *Vite*). The same is true for most of the nineteenth-century descriptions I have analyzed. On the quite ambivalent or even "multivalent" theological symbolism of right and left (and liturgical south and north), see Erwin Panofsky, *Early Netherlandish Painting* (Cambridge, Mass., 1953), pp. 416–17, 147 n. 2; and below, chapter 7.

37. A life story, whether written or painted, may begin at any point, with flashbacks to earlier days and prophecies of future moments. The variations in simple chronological order are described generally as prolepsis, analepsis, or anachrony; see Gérard Genette, *Narrative Discourse* (Oxford, 1972), pp. 33–85, esp. 72–78. Cf. the survey of the problems of literary order and "narratology" in Terry Eagleton, *Literary Theory: An Introduction* (Minneapolis, 1983), pp. 103 ff. For discussion of the early development of hagiographical lives and their illustrations as imitations of Christ, and therefore following the narrative structure of his life, see Cynthia Hahn, "Narrative and Liturgy in the Earliest Illustrated Lives of the Saints" (Ph.D. diss., Johns Hopkins University, 1982).

38. One of the first authors I know to have discussed the problem of order in the visual arts is Florens Deuchler, first in a brief article, "Le sense de la lecture, à propos du boustrophedon," in *Etudes d'Art médiéval offertes à Louis Grodecki*, ed. Sumner McK. Crosby et al., pp. 251–58 (Paris, 1981), and later in his monograph *Duccio* (Milan, 1984), pp. 57 ff.

39. Cf. Horace, *Ars poetica*, ed. Charles D. N. Costa (Boston, 1973), ll. 42–118; C. O. Brink, *Horace on Poetry*, vols. 1 (1963) and 2 (1971). See also Quintilian, *Institutio oratoria* 3.3.1–10, 7.1.1; cf. Michael Baxandall, *Giotto and the Orators* (Oxford, 1971), pp. 101, 103 (123). Vitruvius discusses *dispositio* in book 1.2.

40. The editing, financed by the Spears Fund, Department of Art and Archaeology, Princeton University, was carried out in collaboration with Glenn Picher, a graduate student in media arts. I will continue trying to develop ways to illustrate the history of mural disposition using analog or digital imaging as the quality of resolution improves, shelf-life lengthens, and production costs decrease.

41. The notes to this study were effectively complete in December 1987. In an attempt to keep the Bibliography up to date, I have added references that came to my attention after that date (generally dating 1986 through 1989), whether or not the texts were available to me.

CHAPTER ONE

1. I will use the adjective "devotional" to designate works of art characterized by their inspirational function and lack of storytelling or anecdotal value. Such apse decoration will be omitted from the discussion on the grounds that the representations are rarely cyclical in character; but see below, note 18.

2. In the ancient world, monumental narrative seems to have been executed primarily in sculptural form, with sequential framed reliefs epitomizing histori-

cal and mythological events as on the exterior friezes of Greek temples, or sculptured continuous narratives as on the spiral columns, or excerpted scenes as on triumphal arches and sarcophagi in Roman art. Cf. the important discussions in *Narration in Ancient Art: A Symposium*, ed. Carl Hermann Kraeling et al. (1957), reprinted in *American Journal of Archaeology* 61 (1961): 43–91. Large-scale narrative painting seems to have developed toward the end of the Empire; an example dated A.D. 300–309 is the monumental procession of figures in a room dedicated to the imperial cult at Luxor, Egypt (known mainly from nineteenth-century watercolors); cf. Johannes G. Deckers, "Die Wandmalerei des tetrarchischen Lagerheiligtums im Ammon-Tempel von Luxor," *Römische Quartalschrift für Christliche Altertumskunde und Kirchengeschichte* 68 (1973): 1 ff., and Ioli Kalavrezou-Maxeiner, "The Imperial Chamber at Luxor," *Dumbarton Oaks Papers* 29 (1975): 227 ff. Relatively small Early Christian narratives in the catacombs most likely adumbrated the arrangements of larger, public images. Cf. Aldo Nestori, *Repertorio topografico delle pitture delle catacombe romane*, Roma Sotterranea Cristiana 5 (Vatican City, 1975). See also the analytical study of William Tronzo, *The Via Latina Catacomb: Imitation and Discontinuity in Fourth-Century Roman Painting* (University Park, Pa., 1986).

3. The content and arrangement of Byzantine mural decoration over the same centuries were highly codified; cf. Demus, *Byzantine Mosaic Decoration*, pp. 16–29. A corpus of Byzantine fresco painting is now in preparation under the direction of Manolis Chatzidakis, Athens. Entry of this material into a database similar to mine would be highly desirable.

4. Heinrich Karpp, ed., *Die frühchristlichen und mittelalterlichen Mosaiken in Santa Maria Maggiore zu Rom* (Baden-Baden, 1966); Beat Brenk, *Die frühchristlichen Mosaiken in S. Maria Maggiore zu Rom* (Wiesbaden, 1975).

5. Cf. Ernst Kitzinger, *Byzantine Art in the Making: Main Lines of Stylistic Development in Mediterranean Art, Third–Seventh Century* (Cambridge, Mass., 1977), p. 143 nn. 20–21.

6. To the left, scenes from the histories of Abraham, Isaac, and Jacob; to the right, Moses and Joshua. Twenty-seven surviving panels are in situ. See appendix 1, p. 269, for a list of the subjects and their locations.

7. For a review of this much-discussed issue and the mosaics' relation to the Vatican Virgil, the *Itala*, and the Quedlinburg manuscripts, see Kitzinger, *Byzantine Art*, pp. 67 ff.

8. Kitzinger, *Byzantine Art*, pp. 72 ff.; see also another version of this material in Ernst Kitzinger, "The Role of Miniature Painting in Mural Decoration," in *The Place of Book Illumination in Byzantine Art* (Princeton, 1975), pp. 99 ff.

9. Uffizi dis. arch. 66or; Richard Krautheimer, "The Architecture of Sixtus III: A Fifth-Century Renascence?" in *De Artibus Opuscula XL: Essays in Honor of Erwin Panofsky* (New York, 1961), pp. 291 ff., fig. 6, with additions in Richard Krautheimer, *Studies in Early Christian, Medieval, and Renaissance Art* (New York, 1969), pp. 181 ff.

10. Other scholars claim that these surfaces were created in Domenico Pinelli's campaign.

11. As in the Church of Sant'Apollinare Nuovo, which I shall discuss next.

12. Or (less likely for the period) scenes from Mary's life, as it does now.

13. Kitzinger, *Byzantine Art*, pp. 62 ff., with bibliography.

14. See appendix 1, p. 269, for a list of the subjects and their locations.

15. As Kitzinger has pointed out, the conch motif also functions in the vertical reading of the wall, providing niche canopies for the large-scale figures below.

16. Christological cycles seem to have existed already in the previous century in Eastern Christian art, as is implied by Saint Nilus of Sinai, who recommended such a scheme to his friend, Olympiodorus, prefect of Constantinople; Migne,

P. G., 79, col. 577; and *Epistolarum libri IV, interprete Leone Allatio* (Rome, 1668), book 4, let. 61, p. 491.

17. The processional aspect of this arrangement has been associated with the fact that the building had been the chapel of Theodoric's palace and the figures originally were his courtiers. The composition remained essentially the same when the figures were changed to saints by Archbishop Agnellus (app. 556); cf. Kitzinger, *Byzantine Art*, pp. 62 ff. See also Otto von Simson, *Sacred Fortress: Byzantine Art and Statecraft in Ravenna* (Chicago, 1948), pp. 49 ff., 69 ff.

18. It has been suggested that the apse mosaic was an Infancy cycle, perhaps with a large figure of the Virgin in the center with narrative scenes either at her sides or below her feet (see below, reference to the shrine of Pope John VII, note 22). Cf. Friedrich Wilhelm Deichmann, *Ravenna: Haupstadt des spätantiken Abendlandes*, vol. 1, *Geschichte und Monumente* (Wiesbaden, 1969), pp. 158 ff.; vol. 2, *Kommentar* (Wiesbaden, 1974), pp. 61 ff.; vol. 3, *Frühchristliche Bauten und Mosaiken von Ravenna*, 2d ed. (Wiesbaden, n.d.), pls. I, 1–31. If this were the case, the Christological chronology would flow from the apse to the left wall.

19. See discussion below, chapter 2.

20. Per Jonas Nordhagen, *The Frescoes of John VII (A.D. 705–707) in S. Maria Antiqua in Rome*, Acta ad Archaeologiam et Axtium Historiam Pertinentia 3 (Rome, 1968).

21. See discussion of the various aspects of the Crucifixion image in Nordhagen, *Frescoes of John VII*; cf. also William Tronzo, "The Prestige of Saint Peter's: Observations on the Function of Monumental Narrative Cycles in Italy," in *Pictorial Narrative*, pp. 93–112, esp. 98 ff. and notes.

22. John VII built another sanctuary to the Virgin using a disposition something like the Apse pattern: the Oratorium Johannes VII (or Santa Maria ad Praesepe), founded in 706, was built against the flat interior facade wall of Old Saint Peter's. Seven rectangular fields holding thirteen episodes of Christ's life surround a monumental figure of the Madonna orant. Fields one through three form a frieze across the top, with the scenes in chronological order left to right; four and five read across as a second tier, passing over the Madonna; six and seven do the same. Cf. Giacomo Grimaldi, *Descrizione della basilica antica di S. Pietro in Vaticano, Codice Barberini Latino 2733*, ed. Reto Niggl, Codices ex Vaticanis Selecti 32 (Vatican City, 1972). The large figure of Mary at the center of a narrative composition may provide a clue to the appearance of contemporary apse decorations, now lost. One of the few extant apse decorations to include narrative is the extraordinary cycle at Santa Maria in Castelseprio, near Milan (ca. A.D. 790–950). An Infancy cycle is disposed in two tiers, left to right, not only around the ring of the apse but also across a wall that closed the apse off from the nave. The focus of the apse decoration is a representation of Christ Blessing in a medallion over the central window and two medallions, one on either side, now lost. The narrative flanks these medallions as it travels around the hemicycle. In the center of the wall closing the apse, facing the bust of Christ, is a medallion with the "Hetiomasia." Cf. Weitzmann, *Fresco Cycle in Santa Maria*, and Paula Leveto-Jabr, "Carbon-14 Dating of Wood from the East Apse of Santa Maria at Castel Seprio," *Gesta* 26 (1987): 17–18.

23. Recall that under Pope Julius II (1503–13) the decision was finally made to tear down the crumbling Old Saint Peter's to make way for a new building. Bramante was commissioned to design and begin the new structure in 1505–6. The western half of the Early Christian nave, including the transept and the apse, was razed, and the building remained in this condition for more than a hundred years; cf. Richard Krautheimer, Spencer Corbett, and Alfred K. Frazer, *Corpus Basilicarum Christianarum Romae: The Early Christian Basilicas of Rome (IV–IX Cent.)* (Vatican City, 1977), 5: 163–279. See especially the drawings by

Heemskerck, ca. 1535, figs. 202–5. With a temporary wall at the west end, the front part of the old church functioned as the whole until the early seventeenth century. What we know of the decoration of Old Saint Peter's depends on the chronicle of Giacomo Grimaldi, who recorded what was left of the eastern half of the church just before it too was razed. In a new spirit of historicity, Cardinal Barberini (later Pope Urban VIII) ordered Grimaldi to record the architectural aspects of the remaining building, including its decorations and furnishings, in a series of elaborate colored drawings. They are probably among the earliest (ca. 1620) documents of their kind. Cf. Grimaldi, *Descrizione della basilica*, esp. fols. 108v–109r and 113v–114r. It is believed that originally the left wall held a Life of Saint Peter, titular of the basilica, and that in the late seventh, eighth (under John VII, 705–7), or late ninth century (under Formosus, 891–96), a cycle of the Life of Christ was introduced. The cycle of Saint Peter was probably moved to the right transept at this time. Cf. Tronzo, "Prestige of Saint Peter's," and the bibliography cited there. The nave frescoes are believed to have been restored about 1280 by Pietro Cavallini and his shop, but no documents or drawings remain.

24. See above, note 16, reference to Saint Nilus of Sinai, who mentions the use of typological pairing.

25. For the possible meaning of the enlargement in this location, see below, and also chapter 3.

26. Krautheimer, Corbett, and Frazer, *Corpus*, 5:1–92.

27. Cf. Paul Hetherington, *Pietro Cavallini: A Study in the Art of Late Medieval Rome* (London, 1979), pp. 82 ff.; John White, "Cavallini and the Lost Frescoes of S. Paolo," *Journal of the Warburg and Courtauld Institutes* 19 (1956): 84 ff. See also Luba Eleen, "The Frescoes from the Life of St. Paul in San Paolo fuori le Mura in Rome: Early Christian or Medieval?" in *The Roman Tradition in Wall Decoration*, vol. 12 of *Canadian Art Review* (Quebec, 1985), pp. 251–59, who is studying some of the same problems discussed in this chapter and who plans to publish her results soon.

28. Cf. Stephan Waetzoldt, *Die Kopien des 17. Jahrhunderts nach Mosaiken und Wandmalereien in Rom* (Vienna, 1964), 58, 60–1.

29. On the top right tier, from Creation through Jacobs' Dream; on the second tier, the stories of Joseph and Moses through the seven plagues.

30. Kessler, "Pictures as Scripture," pp. 23–26.

31. Herbert L. Kessler, "The Meeting of Peter and Paul in Rome: The Emblematic Narrative of Spiritual Brotherhood," in *Studies in Art and Archaeology in Honor of Ernst Kitzinger on His Seventy-fifth Birthday, Dumbarton Oaks Papers* 41 (1987): 265–75. Cf. idem, "'Caput et Speculum Omnium Ecclesiarum': Old St. Peter's and Church Decoration in Medieval Latium," in *Italian Church Decoration of the Middle Ages and Early Renaissance*, ed. William Tronzo (Bologna, 1989), pp. 119–46, who distinguishes between the artistic heirs to the cycle in Saint Peter's and to that in San Paolo.

32. Krautheimer, Corbett, and Frazer, *Corpus*, 5:1–92. Also Richard Krautheimer, *Rome: Profile of a City, 312–1308* (Princeton, 1980), pp. 54–55.

33. Alessandro Algardi seems to have designed the reliefs about 1646–50; they were carried out in stucco by a number of contemporary sculptors. Under the direction of Annibale Albani, librarian of the Vatican and director of the program at San Giovanni, a choice was made to have the chronology of the Old Testament scenes (rather than the Life of Christ) determine the order. Cf. Jennifer Montagu, *Alessandro Algardi* (New Haven, 1985), vol. 2, cat. no. 35, pp. 343–44.

34. The starting point of the chronology on the left wall is the same as that of Santa Maria Maggiore. See below, chapter 5, for mention of the fifteenth-century repainting of the nave cycle.

35. Perhaps in the nave of Santa Maria Antiqua; and see below, discussion of the Lower Church at Assisi and in chapter 3, discussion of the Collegiata at San Gimignano.

36. Richard Krautheimer, *Early Christian and Byzantine Architecture* (Harmondsworth, 1965), pp. 76 ff. For a discussion of Eastern practice, see Thomas F. Mathews, *The Early Churches of Constantinople* (University Park, Pa., 1971), pp. 117–37, with much further bibliography; see also Robert F. Taft, *The Great Entrance . . . the Rite of the Liturgy of St. John Chrysostom* (Rome, 1975). Dorothy Glass, "Papal Patronage in the Early Twelfth Century: Notes on the Iconography of Cosmatesque Pavements," *Journal of the Warburg and Courtauld Institutes* 31 (1969): 386–90, and *Studies on Cosmatesque Pavements*, BAR Intern Series 82 (Oxford, 1980), discusses aspects of this subject in the West. A very useful survey is given by Marcello Fagiolo, "Chiesa Celeste, Chiesa Umana, Chiesa di Pietra," *Chiese e Cattedrali* (Touring Club Italiano), 1978, pp. 46–47. See also Von Simson, *Sacred Fortress*, passim, for discussion of this subject in Byzantine practice.

37. For the sources of liturgical practice see S. J. P. Van Dijk and J. Hazelden Walker, *The Origins of the Modern Roman Liturgy: The Liturgy of the Papal Court and the Franciscan Order in the Thirteenth Century* (Westminster, Md., 1960), bibliography, pp. xiii–xxv; H. A. Wilson, ed., *The Gelasian Sacramentary: Liber Sacramentorum Romanae Ecclesiae* (Oxford, 1894); Michel Andrieu, *Les ordines romani du Haut Moyen Age*, 5 vols. (Louvain, 1931–61); Antoine Chavasse, *Le sacramentaire gélasien*, Vaticanus Reninensis 316 (Tournai, 1958). Although the "starting side" for narrative cycles alternated in the Early Christian period, after the eighth century by far the majority of cycles began on the right.

38. The solea in San Giovanni in Laterano was long known from literary descriptions but was discovered archaeologically only in the 1934–38 excavations; Krautheimer, Corbett, and Frazer, *Corpus*, 5:87. The solea at Aquileia, in the North Basilica (eleventh-century rebuilding), is particularly well preserved; cf. Giovanni Brusini, "Un grande edificio culturale a monastero di Aquileia," *Bolletino d'Arte* 34 (1949): 351–57. Professor Kitzinger guided me to this information.

39. Cf. Per Jonas Nordhagen, "John VII's *Adoration of the Cross* in S. Maria Antiqua," *Journal of the Warburg and Courtauld Institutes* 30 (1967): 388 ff.

40. Tronzo, "Prestige of Saint Peter's," pp. 99 ff.

41. The workings of this pattern were foreshadowed by such Carolingian frescoes as those at Saint John, Müstair, in southeastern Switzerland, not far from the Italian border: cf. Joan S. Cwi, "A Study in Carolingian Political Theology: The David Cycle at St. John, Müstair," *Riforma religiosa e arti nell'Epoca Carolingia*, ed Alfred A. Schmid, Atti del XXIVe Congresso Internazionale di Storia dell'Arte 1979, 24:1–2, (Bologna, 1983), pp. 117–28; cf. n. 2 for bibliography. See also Beat Brenk, "Müstair and Artistic Centers in Italy: Milan, Verona and Rome," paper presented at symposium on Italian Church Decoration of the Middle Ages and Early Renaissance: The Problem of Regional Traditions, Johns Hopkins University, Villa Spelman, Florence, March 1987.

42. Franz Xaver Kraus, "Die Wandgemälde von Sant'Angelo in Formis," *Jahrbuch der Preussischen Kunstsammlungen* 14 (1893): 3–21, 84–100; Ottavio Morisani, *Gli affreschi di Sant'Angelo in Formis* (Cava dei Tirreni, 1962); Anita Moppert-Schmidt, *Die Fresken von S. Angelo in Formis* (Zurich, 1967); Demus, *Romanesque Mural Painting*, diag. A, 296.

43. An apocalyptic vision of Christ fills the well-preserved apse. The interior facade is covered with a representation of the *Last Judgment*.

44. See appendix 1, p. 270, for a list of the subjects and their locations.

45. Another example of this reference is in the cycle in the small eleventh-century church of Sant'Urbano alla Caffarella outside Rome, disposed in a Wrap-

around with some irregularities, with an oversized *Crucifixion* in sequence over the entrance; cf. Alexandru Busuioceanu, "Un ciclo di affreschi del secolo XI: S. Urbano alla Caffarella," *Ephemeris Dacoromana* 2 (1924).

46. The implied reference to the earlier Middle Ages in these distinctive formats has been noted before. Cf. Ernst Kitzinger, "The Arts as Aspects of a Renaissance, Rome and Italy," in *Renaissance and Renewal in the Twelfth Century*, ed. R. L. Benson and Giles Constable, pp. 637–70 (Cambridge, Mass., 1982), esp. 649; See also Guglielmo Matthiae, *Pittura romana del medioevo* (Rome, 1966), 2:102–19; Margaret Manion, "The Frescoes of S. Giovanni a Porta Latina in Rome" (Ph.D. diss., Bryn Mawr College, 1972), cited in Tronzo, "Prestige of Saint Peter's," n. 99.

47. See below, chapter 2, note 54, documenting a triple Wraparound procession as part of the ceremony at the dedication of a church.

48. Along with the large basilicas, the Sanctum Sanctorum received painted decorations at this time carried out under the orders of Pope Nicholas III; cf. Julian Gardner, "Nicholas III's Oratory of the Sancta Sanctorum and Its Decoration," *Burlington Magazine* 115(1973): 283–94; and Jens T. Wollesen, "Die Fresken in Sancta Sanctorum," *Römisches Jahrbuch für Kunstgeschichte* 19 (1981): 35–84.

49. Beda Kleinschmidt, *Die Basilika San Francesco in Assisi* (Berlin, 1915–28); Gerhard Ruf, *Das Grab des hl. Franziskus: Die Fresken der Unterkirche von Assisi* (Freiburg im Breisgau, 1981); Joanna Cannon, "Dating the Frescoes by the Maestro di S. Francesco at Assisi," *Burlington Magazine* 124(1982): 65–69; Silvestro Nessi, *La Basilica di S. Francesco in Assisi e la sua documentazione storica* (Assisi, 1982); Ludovigo da Pietralunga, *Descrizione della Basilica di S. Francesco e di altri santuari di Assisi*, commen. Pietro Scarpellini (Treviso, 1982); Joachim Poeschke, with Stefan Diller, Luigi Artini, and Gerhard Ruf, *Die Kirche San Francesco in Assisi und ihre Wandmalereien* (Munich, 1985), catalog of documents, plans, and diagrams, pp. 59–120, bibliography pp. 131–34, and many previously unpublished photographs.

50. See appendix 1, p. 270, for a list of the subjects and their locations.

51. The idea that Francis was the Savior revivified was fundamental to Franciscan doctrine. See the essential study by Stanislao da Campagnola, *L'angelo del sesto sigillo et l'"Alter Christus": Genesi e sviluppo di due temi francescani nei secoli XIII–XIV* (Rome, 1971); see also John V. Fleming, *From Bonaventure to Bellini: An Essay in Franciscan Exegesis* (Princeton, 1982), pp. 129–57, and Henk Van Os, "St. Francis of Assisi as a Second Christ in Early Italian Painting," *Simiolus* 7(1974): 115–32.

52. Including the tattered relics at Assisi and at Santa Croce and the Chiesa di Ognissanti in Florence; cf. Ruf, *Grab*, fig. 3. See Rosalia B. Fanelli et al., eds., *Il tesoro della Basilica di San Francesco ad Assisi*, (Florence, 1980), p. 15 and pl. III.

53. Giuseppe Rocchi, *La Basilica di San Francesco ad Assisi: Interpretazione e relievo* (Florence, 1982). Rocchi's interpretation of the evidence is not universally accepted. See also idem, "La più antica pittura nella Basilica di S. Francesco ad Assisi," in *The Roman Tradition in Wall Decoration*, vol. 12 of *Canadian Art Review* (Quebec, 1985), pp. 169–74.

54. Peter represents the apostolic mission on earth taken up by Francis, and Michael symbolizes the escatological aims for saving man's eternal soul; cf. Charles Mitchell, "The Imagery of the Upper Church at Assisi," in *Giotto e il suo tempo: Atti del congresso internazionale per la celebrazione del VII. centenario della nascita di Giotto* (Rome, 1971), pp. 121 ff. Saint Francis honored the Virgin above all others, and it was to her he dedicated himself during his forty days' retreat on Mount Alverna. Moreover, it was she who appeared to him in the miracle of the Porziuncola just before he died. He designated the Virgin as advocate of the order. Cf. Raphael Brown, *Our Lady and St. Francis: All the Earliest*

Texts (Chicago, 1954); cited (p. 1730) in Marion A. Habig, ed., *St. Francis of Assisi, Writings and Early Biographies: English Omnibus of the Sources for the Life of St. Francis* (Chicago, 1983); hereafter cited as Habig, *Omnibus*, with English titles of sources.

55. Hans Belting, *Die Oberkirche von San Francesco in Assisi* (Berlin, 1977); Irene Hueck, "Cimabue und das Bildprogramm der Oberkirche von San Francesco in Assisi," *Mitteilungen des Kunsthistorischen Institutes in Florenz* 25 (1981): 280–324; John White, "Cimabue and Assisi: Working Methods and Art Historical Consequence," *Art History* 4 (1981): 355–83.

56. See appendix 1, p. 271, for a list of the subjects and their locations.

57. The upper portions of the middle three facets of the apse are filled with two-light stained glass windows decorated with scenes of Christ's life; cf. E. Giusto, *Le Vetrate di S. Francesco in Assisi* (Milan, 1911); Gerhard Ruf, *Christ ist erstanden: Eine Betrachtung der Bildes des rechten Chorfensters der Oberkirche von S. Francesco in Assisi* (Basel, 1983).

58. Hence the approximate starting date assigned to the frescoes. Jerome held this office until 1279; cf. Mitchell, "Imagery." Under Gregory X, he was legate to the Patriarchate of Byzantium; he was bishop of Palestrina, and he advocated a crusade against Islam. As minister general (elected in February 1279), he reintroduced pictorial decoration, banned in Franciscan churches by the chapter at Narbonne in 1260, declaring that "the Church Militant must appear as the new holy Jerusalem, sent and beautified by the Lord, like the bride going forth to her spouse" (cited by Eugenio Battisti, *Cimabue* [Milan, 1963], pp. 38–39).

59. Saint Bonaventure describes Francis's devotion to the Virgin and to her Assumption; cf. Habig, *Omnibus, Major Life,* chap. 9, sec. 3, p. 699.

60. It was a sign of the incredibly swift success of the Franciscan movement that the order could produce a pope within sixty years of the patron's death; Nicholas died in 1292.

61. It is assumed that Nicholas subvented some of the cost of the further decorations of the transept and nave; cf. Mitchell, "Imagery."

62. See H. Henkels, "Remarks on the Late Thirteenth-Century Apse Mosaic in Santa Maria Maggiore," *Simiolus* 4 (1971): 128–49.

63. In the same period, Nicholas commissioned the apse mosaic in San Giovanni in Laterano, where the two main Franciscan saints again flank the main image; Nicholas IV kneels at their side. See chapter 9.

64. See appendix 1, p. 271, for a list of the subjects and their locations.

65. A precursor in subject and format perhaps may be provided by the lower lintel composition on the portal of Saint Anne at Nôtre Dame de Paris (thirteenth century), where two apocryphal scenes of Joachim and Anne before Mary's birth are represented along with others that continue around the arch. Compressed cycles of the end of Mary's life were frequently carved on French Gothic churches (Notre-Dame, Chartres, Amiens, Sens, to name a few), but they are arranged in superimposed tiers on exterior lintels, not in bands along the interiors of sanctuaries; cf. Emile Mâle, *The Gothic Image: Religious Art in France of the Thirteenth Century* (1913), trans. Dora Nussey (New York, 1972), pp. 235 ff.

66. This point was made by William Tronzo, "Reform and the Apse of S. Maria Maggiore in Rome," College Art Association Meeting, (Abstracts, p. 55), Los Angeles, 1985. Cf. "De Assumptione beatae Virginis Mariae," sermo I, Saint Bonaventure (agreeing with Albertus and Saint Thomas); the discussion was carried forward by Matteo di Aquasparta (d. 1302), François de Mayron (ca. 1328 +), Nicolaus of Lyra (d. 1349), and Thomas d'Argentina (d. 1357); cf. Martin Jugie, *Le mort e l'assomption de la sainte Vièrge,* Studi e Testi 114 (Vatican City, 1944), p. 400 ff.; V. Bennett and R. Winch, *The Assumption of Our*

Lady and Catholic Theology (London, 1950); G. A. Wellen, *Theotokos: Eine ikonographische Abhandlung über das Gottesmutterbild in frühchristlicher Zeit* (Utrecht, 1960), chap. 3, Santa Maria Maggiore, pp. 93–138; cf. also Belting, *Oberkirche*, p. 56. (See Rona Goffen, *Piety and Patronage in Renaissance Venice: Bellini, Titian, and Franciscans* [New Haven, 1986], pp. 91–94, for a summary of the order's attitude toward the doctrine through the fifteenth century.) Nicholas IV's preoccupation with the mother church of Marian devotion is visible at the Cathedral of Orvieto, which he also sponsored. He orderd images on the facade of Santa Maria Maggiore to be repeated in similar places on the facade in Orvieto. Cf. Luigi Fumi, *Il Duomo di Orvieto e i suoi restauri* (Rome, 1891), p. 175, 2 (3 March 1285); cf. also Julian Gardner, "Pope Nicolas IV and the Decoration of Santa Maria Maggiore," *Zeitschrift für Kunstgeschichte* 36 (1973): 1–50.

67. See Tronzo, "Reform and the Apse"; Ernst Kitzinger, "A Virgin's Face: Antiquarianism in Twelfth-Century Art," *Art Bulletin* 62 (1980): 6 ff.; Dale Kinney, "Santa Maria Maggiore from Its Founding to 1215" (Ph.D. diss., New York University, 1975).

68. See appendix 1, p. 271, for a list of the subjects and their locations.

69. See below, chapters 3, 5, and so on.

70. White, "Cimabue and Assisi," points to a steady left-to-right progress of execution around the left transept end, the apse, and through the right end, with scaffolding that spanned the full width at one time. This fact is one of many that prove the existence of an overall plan long before the painting began.

71. Above note 23; at Monreale outside Palermo, a Peter cycle is also placed to the right of the main altar. See chapter 5, discussion of the Brancacci Chapel.

72. See below, chapter 2.

73. The bibliography on the attribution and dating of the nave frescoes is vast, and the problems are little resolved. Compare, for example, Leonetto Tintori and Millard Meiss, *The Painting of the Life of St. Francis in Assisi, with Notes on the Arena Chapel*, 3d ed. (New York, 1967), and Alastair Smart, *The Assisi Problem and the Art of Giotto: A Study of the Legend of St. Francis in the Upper Church of San Francesco, Assisi* (Oxford, 1971), with James H. Stubblebine, *Assisi and the Rise of Vernacular Art* (New York, 1985). No documents identify the painters, and attributions for the Old Testament cycle include, besides Cimabue, Torriti and the young Giotto. See the review of the attribution problem in Laurie Schneider, ed., *Giotto in Perspective* (New York, 1974), pp. 15 ff.

74. *First Days of Creation, Creation of Adam, Creation of Eve,* the *Temptation,* the *Expulsion, Adam and Eve at Work, Sacrifice of Cain and Abel, Cain Kills Abel.* The similarity to, if not absolute dependence on, the same scenes in San Paolo fuori le Mura in Rome has often been pointed out; cf. Belting, *Oberkirche,* pp. 155 ff.

75. Cf. Carlo Volpe, "La formazione di Giotto nella cultura di Assisi," in *Giotto e i Giotteschi in Assisi,* intro. Giuseppe Palumbo (Rome, 1969), pp. 15–59, for other illustrations.

76. The others are the *Visitation, Nativity, Adoration of the Magi, Presentation, Flight into Egypt,* and *Christ among the Doctors.*

77. The others are the *Raising of Lazarus, Kiss of Judas, Flagellation, Road to Calvary, Crucifixion,* and *Lamentation.*

78. The irregularly shaped fields of these two scenes, not represented in the diagram, accommodate the large oculus window in the facade.

79. See Belting, *Oberkirche,* pp. 139 ff.; and Hans Belting, "The New Role of Narrative in Public Painting of the Trecento: *Historia* and Allegory," in *Pictorial Narrative,* pp. 151–68.

80. Habig, *Omnibus, Major Life,* pp. 627–787.

81. See above, note 51. I emphasize here, once and for all, that all large-scale Franciscan projects represent sponsorship of the Conventual faction of the order.

The opposing faction, the Spirituals or Observants, bitterly objected to the ownership of property and to ostentation of any sort.

82. See Mitchell, "Imagery," and Belting, *Oberkirche*, pp. 27 ff. See also the brief remarks of Leone Brancaloni, *L'arte francescana nella vita e nella storia di settecento anni* (Todi, 1924), p. 114 n. 2.

83. From the same period is the Wraparound Old Testament/New Testament/Apocalypse cycle at the Adriatic coast Benedictine monastery of Pomposa; cf. Mario Salmi, *L'Abbazia di Pomposa* (Milan, 1966). The strict Double Parallel Apse-to-Entrance pattern is also in force as a direct reference to Saint Peter's in Rome. See, for example, the Old Testament/New Testament cycle in this form at Santa Maria Vescovio (Sabina); Allesandro Tomei, "Il ciclo vetero e neotestamentario di S. Maria in Vescovio," in *Roma Anno 1300* (Rome, 1983), pp. 355–66.

84. Jens T. Wollesen, *Die Fresken von San Piero in Grado bei Pisa* (Bad Oeynhausen, 1977).

85. Ibid., p. 7 n. 7 citing Ferdinando Ughelli, *Italia sacra* (Venice, 1717–22), col. 862.

86. Ibid., figs. 18, 19. See appendix 1, p. 272, for a list of the subjects and their locations.

87. Cf. Irene Hueck, *Das Programm der Kuppelmosaiken im Florentiner Baptisterium* (Mondorf, 1962). Cf. also Penelope A. Dunford, "A Suggestion for the Dating of the Baptistry Mosaics at Florence," *Burlington Magazine* 116 (1974): 96–98.

88. The one earlier centrally planned Italian baptistry that retains its decoration, that in Parma (cf. Pietro Toesca, *Il Battistero di Parma* [Milan, 1960]), includes one tier of consecutive narrative. The Life of Saint John the Baptist on the fourth tier down begins to the left of the west door (present but not original entrance) and circles once from left to right. The arrangement places the scene of the Baptism of Christ directly over the altar. The scenes include the *Annunciation to Zachariah, Birth of the Baptist, Infant Baptist Led by Uriel into the Desert, Baptist Preaching in the Wilderness, John Baptizing the Multitudes, Ecce Agnus Dei, Baptism of Christ, John Berating Herod, John Sending His Disciples to Christ, Christ's Miracle before John's Disciples, Decollation of John,* and *Feast of Herod.*

89. Cf. the mosaic dome in a tomb at Centcelles, near Tarragona, Spain (finished by 1154), divided into three tiers, the second holding a cycle of sixteen Old and New Testament scenes, framed by spiral columns that alternate the direction of twist to form pairs; see Helmut Schlunk and Theodor Hauschild, "Informe preliminar sobre los trabajos realizados en Centcelles," *Excavaciones Arqueologicas en España* 18 (1962). I thank Professor Kitzinger for this reference. Cf. the fourteenth-century mosaic dome with Creation cycle in the vestibule of San Marco, Venice, also divided into a number of stacked rings; see Otto Demus, *The Mosaics of San Marco of Venice,* vol. 4 (Chicago, 1984), fig. 107.

90. Cf. Hueck, *Programm,* pp. 16–20; Borsook, *Mural Painters,* p. xxiii.

91. Walter Horn, "Das Florentiner Baptisterium," *Mitteilungen des Kunsthistorischen Institutes in Florenz* 5 (1938): 100–151; Walter Paatz and Elizabeth Paatz, *Die Kirchen von Florenz* (Frankfurt am Main, 1955), 2:172–271.

92. *Adoration,* the *Magi's Dream,* and the *Magi Return Home by Boat.*

93. Rab Hatfield, "The Compagnia de' Magi," *Journal of the Warburg and Courtauld Institutes* 33 (1970): 107–61.

94. Marilyn Aronberg Lavin, "Giovannino Battista: A Study in Renaissance Religious Symbolism," *Art Bulletin* 37 (1955): 85–101, and idem, "Giovannino Battista: A Supplement," *Art Bulletin* 43 (1961): 319–26.

95. Josef Garber, *Wirkungen der frühchristlichen Gemäldezyklen der alten Peters- und Pauls-basilika in Rom* (Berlin, 1918), pp. 16–19, 57 ff., demonstrated from Grimaldi's early seventeenth-century copies that Cavallini, Cimabue, and

their colleagues left intact the style of the Early Christian originals they found extant.

96. "Ed in Roma, in San Pietro, nel vecchio, storie intorno intorno fra le finestre: cose che hanno più del mostro nel lineamento, che effige di quel che e' si sia." Of contemporary sculpture he says it could not be worse, being "così goffe e sì ree, e tanto malfatte di grossezza e di maniera, che par impossibile che immaginare peggio si potesse." Vasari, *Vite*, 1:242–43, "Proemio delle Vite."

CHAPTER TWO

1. The construction of this chapel caused some consternation to the Augustinian Eremitani, whose property and church are adjacent; see Sergio Bettini and Leonello Puppi, *La Chiesa degli Eremitani di Padova* (Vicenza, 1970), pp. 17 ff. Quite early in its history, the Scrovegni Chapel was opened to pilgrims; cf. Ursula Schlegel, "Zum Bilderprogramm der Arena Kapelle," *Zeitschrift für Kunstgeschichte* 20 (1957): 125–46; Borsook, *Mural Painters*, pp. 7–14; also Margrit Lisner, "Farbgebung und Farbikonographie in Giottos Arenafresken," *Mitteilungen des Kunsthistorischen Institutes in Florenz* 29(1985): 1–69. See Anna Maria Spiazzza, "Giotto a Padova: Studi sullo stato di Conservazione della Cappella degli Scrovegni in Padova," *Bollettino d'Arte*, ser. 2, 63 (1978; published 1982): 13–55, for a survey of known facts and bibliography. Michel Alpatoff, "The Parallelism of Giotto's Paduan Frescoes," *Art Bulletin* 29 (1947): 149–54, though taking into account only two of the cycle's three tiers, was prescient in recognizing the importance of the disposition. His analysis pointed out the vertical alignment of scenes from Christ's life to produce pairs, sometimes thematic and sometimes visual, adding meaning beyond the straightforward narrative.

2. The main bibliography in the sources for Mary's life before the Incarnation will be found in Jacqueline Lafontaine-Dosogne, *Iconographie de l'enfance de la Vièrge dans l'empire byzantin et en occident*, Mémoires de l'Académie Royale de Belgique, Classe des Beaux-Arts 11 (Brussels, 1964).

3. It is possible that the chapel was built into a solid wall, contiguous with Scrovegni's new palace; but see Cesira Gasparotto, "Critica della cronologia tradizionale della Cappella degli Scrovegni," *Padova e la Sua Provincia* 12, 10(1966): 3–9; 12, 11(1966): 3–12.

4. Compare the following discussion with Roger Fry's statement that "essentially the design is made up of the sum of a number of separate compositions. The time had not come for co-ordinating these into a single scheme"; *Vision and Design* (New York, 1921), pp. 164–65.

5. The pictorial surface plus the interior painted frame of the smaller fields equals the pictorial surface of the larger fields.

6. Cf. the discussion by Borsook, *Mural Painters*, p. 10, concerning Giotto's use of geometry in organizing the ceiling decoration.

7. The large unified space matches that of the *Last Judgment* in the traditional location on the interior facade wall at the opposite end of the nave. See chapter 8 for discussion of the "Expanded Field."

8. Related to but differing from earlier corner turning, as in Santi Quattro Coronati in Rome, and at the facade end of the Francis cycle in the Upper Church of Assisi, neither of which involves the altar wall. See below, chapter 3, discussion of the Castellani Chapel, and chapter 6, on the chancel of the Duomo in Prato.

9. A better term might be "sequence" as it is used for film, deemphasizing the literary parallel.

10. See appendix 1, p. 272, for a list of the subjects and their locations.

11. This braking mechanism is the similar to the one we found in operation in the mosaics of the Florentine Baptistry.

12. *Presentation of the Rods, Watching the Rods of the Suitors, Betrothal of the Virgin,* and *Nuptial Cortege.*

13. This subject is drawn from the introduction to the *Meditations of the Life of Christ,* the Franciscan devotional text coming into wide circulation at this time; ed. Rosalie B. Green and Isa Ragusa (Princeton, 1961), pp. 5–8.

14. Cf. Rizieri Zanocco, "L'Annunciazione all'Arena di Padova (1305–1309)," *Rivista d'Arte* 19(1937): 370–73.

15. Andrew Ladis suggested the same function for the panel, "The Legend of Giotto's Wit and the Arena Chapel," *Art Bulletin* 68 (1986): 595 n. 45. Just this kind of wooden door is found high on the wall of the crossing in the Duomo of Milan. It serves in the celebration of the feast of the Exaltation of the Cross (14 September). A priest is lifted by a pulley to the door, which he opens to retrieve relics of the Crucifixion. After he and the relics are returned to the floor, a procession begins. This liturgical practice began in the fourteenth century and was revived first by San Carlo Borromeo in the later sixteenth century and again in the 1980s. My thanks to Edith W. Kirsch for giving me this information before the publication of her article, "An Early Reliquary of the Holy Nail in Milan," *Mitteilungen des Kunsthistorischen Institutes in Florenz* 30 (1986): 569–76. Another example occurs at Notre-Dame, Les Saintes Maries de la Mer (Camargue, France), where the relic of the Magdalene's boat is lowered from a paneled doorway in the triumphal arch and carried in procession each 24 May. Andrew Ladis informs me there is a panel of the *Annunciation* in the center of the triumphal arch at San Zeno, Verona, that may have a similar function.

16. The placement of the angel on the left and Mary on the right obviously depends on the narrative movement of the cycle and has nothing to do with the right or left hand of God; for discussion of such considerations see Don Denny, "The Annunciation from the Right: From Early Christian Times to the Sixteenth Century" (Ph.D. diss., New York University, 1965; reproduced by Garland Press, New York, 1977).

17. Gertrude Schiller, *Iconography of Christian Art,* 2 vols., trans. Janet Seligman (London, 1972), 1:33–55.

18. Cf. Margaret Frazer, *Monza, Il Duomo e i suoi tesori* (Milan, 1988), p. 38, cat. no. 34.

19. For the motif of Mary revealed, cf. Yiro Hirn, *The Sacred Shrine* (London, 1912), pp. 214–49. For further examples of the knotted drapery motif, see Peter Lasko, *Ars Sacra, 800–1200* (Baltimore, 1972), figs. 38, 39, 115, 116, and David Diringer, *The Illuminated Book: Its History and Production* (New York, 1967), pls. IV–12, IV–17. For discussion of the *revelatio* motive, see Johann Konrad Eberlein, *Apparitio Regis—Revelatio Veritatis* (Wiesbaden, 1982); the same author discusses the postmedieval use of symbolic drawn drapes in "The Curtain in Raphael's Sistine Madonna," *Art Bulletin* 65 (1983): 61–77, and in a letter to the editor, *Art Bulletin* 66 (1984): 330–31.

20. Five scenes represent Christ's childhood, from the *Nativity* to the *Massacre of the Innocents;* see appendix 1.

21. Cf. Schlegel, "Zum Bilderprogramm"; see other references in Borsook, *Mural Painters,* p. 13 nn. 37 ff. Side-by-side placement of these two scenes, in fact, has precedents in medieval wall decoration. See, for example, the fresco cycle in the church at Chalivoy-Milon, France; cf. Marcia Kupfer, "Les fresques romanes de Chalivoy-Milon: Iconographie religieuse et iconographie politique," in *111ᵉ Congrès Nationale des Sociétés Savantes,* pp. 147–69 (Poitiers, 1986), who relates the juxtaposition to contemporary problems with simony.

22. See appendix 1, pp. 272–73, for a list of subjects and their locations.

23. As David Wilkins has observed, the impact of the scene comes as much from the juxtaposition with the adjacent scenes as from the emotional expres-

sion within the scene; see his review of James Stubblebine, *Giotto and the Arena Chapel Frescoes, Art Quarterly* 34 (1971): 114.

24. Wolleson, *Fresken von San Piero in Grado bei Pisa,* p. 97, no. 29, fig. 48.

25. Cf. Durandus of Mende (1296), *Rationale divinorum officiorum,* bk 1., chap. 7, "De altaris consecratione."

26. Doubled like the symbolic veils in the *Annunciation* above, the painted chapels resemble the pastophoria, or liturgical chambers, that flank the sanctuary in Byzantine churches.

27. Cf. Henri de Lubac, *The Splendour of the Church,* trans. Michael Mason (New York, 1956), pp. 238–89; Gertrude Schiller, *Ikonographie der Christlichen Kunst,* 4 vols. (Kassel, 1976) 4, 1:84–89, figs. 205–34.

28. Irene Hueck, "Zu Enrico Scrovegnis Veränderungen der Arenakapella," *Mitteilungen des Kunsthistorischen Institutes in Florenz* 17(1973): 277–94.

29. A similar arrangement was introduced in the Magdalene Chapel at Assisi, to be described below, at just about the same time; the concept, if not the execution, can also be attributed to Giotto, who surely oversaw both projects.

30. For example, the San Giorgio Chapel, also in Padua, by Altichiero (ca. 1370), to be discussed in chapter 3.

31. Although lacking a coherent tradition, small-scale chapels for special use had a history stretching back to earliest Christian times. What changed in the trecento was that ownership could be bought by individuals and passed through the family by inheritance. The spaces served also for privately conducted masses, and their performance could be influenced by the current owners. Cf. Annegret Höger, "Studien zur Entstehung der Familien Kapelle und zu Familienkapellen und -altären des Trecento in Florentiner Kirchen" (Ph.D. diss., Universität Bonn, 1976). See below, chapter 9, for discussion of *tramezzi,* or *ponti,* which also held family burials and consecrated altars.

32. But see below, description of the apse of the Cathedral of Orvieto, chapter 3.

33. Dieter Blume, *Wandmalerei als Ordenspropaganda, Bildprogramme im Chorbereich franziskanischer Konvente italiens bis zur Mitte des 14. Jahrhunderts,* Heidelberger Kunstgeschichtliche 17 (Worms, 1983). But see the review by Joanna Cannon, *Burlington Magazine* 127 (1985): 234–35.

34. The commission is undocumented. Cf. Eve Borsook, "Notizie su due cappelle in Santa Croce a Firenze," *Rivista d'Arte* 36 (1961–62): 98–106; Rona Goffen, *Spirituality in Conflict: Saint Francis and Giotto's Bardi Chapel* (University Park, Pa., 1988). See appendix 1, p. 273, for a list of the subjects and their locations. For color photographs of the Bardi Chapel and many other ambients in this church, see Umberto Baldini et al., eds., *Il complesso monumentale di Santa Croce: La basilica, le cappelle, i chiostri, il museo* (Florence, 1983).

35. Cf. Julie Gy-Wilde, "Die Stellung der 'Himmelfahrt Maria' und der 'Stigmatisation des Hl. Franziskus' in Giottos Werk: Giotto-Studien." *Wiener Jahrbuch für Kunstgeschichte* 7 (1930): 45–94. It is often suggested that although the framing of the compositions and other devices on the triumphal arch were planned earlier, the actual painting dates from the 1380s; see, e.g., Robert Oertel, *Early Italian Painting to 1400* (London, 1968), p. 188; Paatz and Paatz, *Kirchen von Florenz,* 1:570.

36. Before its partial destruction in the 1966 flood; usually dated ca. 1285–88. Cf. Eugenio Battisti, *Il crocifisso di Cimabue in Santa Croce* (Milan, 1967), and Umberto Baldini, *Le crucifix de Cimabue* (Vienna, 1982).

37. In the suppressed *Life of Francis* by Thomas of Celano, it is implied that the Stigmata occurred when Francis was keeping a fast between the feast of the Assumption and that of Saint Michael; Habig, *Omnibus,* Celano 2, chap. 149, p. 520.

38. Cf. Giuseppe Marchini, "Gli affreschi perduti di Giotto in una cappella di

S. Croce," *Rivista d'Arte* 20 (1938): 215–41; the paintings inside the chapel were destroyed and replaced in the nineteenth century.

39. Luke Wadding, *Scriptores ordinis minorum quibus accesit syllabus illorum qui eodem ordine . . .* (Rome, 1654), vol. 6, sec. 14, p. 39. See also the forthcoming publication of Chiara Frugoni concerning elements in representations of the Stigmata, perhaps introduced in this fresco, that deepen Francis's identification with Christ. The image would also have been read in direct relation to the chapel's own altarpiece, described by Vasari as a crucifixion by Ugolino di Nerio. Hayden B. J. Maginnis convincingly argues that this panel, which he dates 1310–15, is now in the Thyssen-Bornemisza Collection, Lugano, still very large in scale although cut down at the bottom; see "The Thyssen-Bornemisza Ugolino," *Apollo* 114(1983): 16–21. Maginnis shows further that it is an example of a previously unidentified new type of Tuscan altarpiece displaying abbreviated scenes of the Crucifixion, noting the implications in this observation for future altarpiece subject matter. See my remarks about narrative altarpieces, chapter 9.

40. Saint Bonaventure declares that his account of Francis's life in the *Legenda maior* "does not always follow chronological order. Instead, in order to avoid confusion, I chose to be more systematic and group together events which happened at different times but concerned similar subjects while separating others which occurred at the same time but concerned different subjects." See Habig, *Omnibus*, pp. 633–34. Nevertheless, a sequence is established by the *Legenda* and by the cycle in the Upper Church at Assisi; cf. above, chapter 1.

41. Cf. Barbara B. Walsh, "Giotto's 'Visions' of Brother Agostino and the Bishop of Assisi, Bardi Chapel, S. Croce, Florence," *Art Bulletin* 62(1980): 20–23. I should point out that the light flow of all the scenes on the left wall comes from the right, that is, the direction of the altar wall, where there is a real window, and in all the scenes on the right wall it comes from the left in a highly consistent manner.

42. In plowing, the farmer goes up one furrow and then down the next (he does not return to the starting point and begin again, which would be inefficient). See Hugh Blair, *Lectures on Rhetoric* (1783) (Brooklyn, N.Y., 1812), 1.7.155; see also Lillian H. Jeffery, *The Local Scripts of Archaic Greece* (Oxford, 1961), pp. 43–50 (I have profited from discussions with Homer Thompson and William Childs on this point). Incidentally, "boustrophedonic" is now the technical term used to describe the motion of a computer printer head.

43. The layout of medieval inscriptions has been little studied, although the Boustrophedon most likely plays a role here too; see a rare analysis, in this case of runic inscriptions, by Paul Meyvaert, "An Apocalypse Panel on the Ruthwell Cross," *Medieval and Renaissance Studies* (Duke University), 1982, pp. 3–32, esp. p. 23, appendix. I am grateful to Lawrence Nees for this reference. Deuchler, in "Sens de la lecture" and *Duccio*, calls attention to the boustrophedonic arrangement in the visual arts and makes the very important observation that relaxing rigid ideas about "correct narrative order" and accepting the boustrophedonic "reading sense" as an objective choice on the part of the artist and the programmer helps explain many apparent anomalies in the disposition of frescoes as well as other narrative genres.

44. Or to an immediate follower who knew his ideas well. Borsook, *Mural Painters*, pp. 14 ff., calls the artist an "anonymous follower of Giotto." Cesare Gnudi, *Giotto* (Milan, 1958), pp. 180–86, claims the frescoes are by Giotto himself. Lorraine Schwartz, "The Franciscan Character of the Fresco Decoration of the Magdalene Chapel in the Basilica San Francesco at Assisi," public talk, College Art Association Annual Meeting, 1982, Abstracts, p. 42 (Ph.D. diss., Western Illinois University), relates the frescoes to the importance of the Magdalene in the devotion of Saint Francis and in Franciscan ideology. See appendix 1, p. 273, for a list of the subjects and their locations.

45. All the walls of the chapel other than the altar wall have arched entrance-ways flanked by symbolic and decorative painted panels, standing saints, and the donor, who is shown twice: as a friar kneeling to the Magdalene, and dressed in a bishop's robes before San Rufino, first bishop of Assisi. Cf. Aldo Brunacci, *Leggende e culto di S. Rufino in Assisi* (Perugia, 1955); until the first half of the eleventh century, the Cathedral of Assisi was dedicated to this saint.

46. Cf. the discussion of these scenes in Avigdor W. D. Poseq, "The Lunette: A Study in the Role of the Arch-Outlined Format in the Design and Content of Italian Murals of the Renaissance" (Ph.D. diss., Hebrew University, Jerusalem, 1974), pp. 381–414.

47. Of either the emperor Constantius or Julian. See the accounts of Sulpitius Severus and Gregory of Tours, whose stories vary to some extent the order of events in Martin's life; cf. *Bibliotheca sanctorum* (Rome: Grottaferrata di Roma, 1967), vol. 8, cols. 1248–91.

48. The full dedication of that church is to Santi Silvestro e Martino ai Monti.

49. Ferdinando Bologna, *Gli affreschi di Simone Martini ad Assisi* (Milan, 1965); also Joe Brink, "Sts Martin and Francis: Sources and Meaning in Simone Martini's Montefiore Chapel," in *Renaissance Studies in Honor of Craig Hugh Smyth*, ed. Andrew Morrogh et al., 2:79–96 (Florence, 1985).

50. Brink, "Sts. Martin and Francis," suggests that this subject contains a metaphorical reference to the knight's baptism. Adrian S. Hoch, "St. Martin of Tours: His Transformation into a Chivalric Hero and Franciscan Ideal," *Zeitschrift für Kunstgeschichte* 50 (1987): 471–482, does the same, pointing out, further, the typological relation of the young Saint Francis to the prototypical saintly knight Martin. Claiming the scene literally represents a baptism, Hoch reads the cycle's narrative sequence on the lower tier as a Wraparound starting on the left at the entrance. This author does not discuss the sequence in the upper two tiers.

51. Recalling the children's game played with crossed strings.

52. Rarely has this pattern been recognized; e.g., Belting, "New Role of Narrative in Public Painting," *Pictorial Narrative*, pp. 153–54, speaks of Simone's scenes as lacking "the sequence and continuity of the traditional narrative cycle" and says he "lost hold of the 'law of series.'" See appendix 1, p. 273, for a list of the subjects and their locations.

53. The rest of this description is based on the account in the *Catholic Encyclopedia*; see next note.

54. A full description of the ceremony for a large church is presented in the twelfth-century pontificals: the ritual opens as the bishops and clerics march in procession three times around the exterior of the church, then enter and proceed to the space before the high altar. The Latin is cited in Glass, "Papal Patronage," p. 388; cf. also the *Catholic Encyclopedia* (New York, 1908), 4:280–82. This observation was kindly brought to my attention by John Onians, who in his own work on the history of architecture has found this pattern in the placement of certain structural members; see his *Bearers of Meaning: The Classical Orders in Antiquity, the Middle Ages, and the Renaissance* (Princeton, 1988), pp. 102–5. See also a review of various rituals involving marking the church floor with an X in Fagiolo, "Chiesa Celeste, Chiesa Umana, Chiesa di Pietra," pp. 47–49.

55. Cf. Borsook, *Mural Painters*, p. 23, who also refers to various questions that still surround the circumstances of Montefiore's finances at the time of his death.

56. As has been noted, the unusual equality in scale between saint and mortal is another visual expression of this idea; cf. John Pope-Hennessy, *The Portrait in the Renaissance* (New York, 1966), p. 257, and Marilyn Aronberg Lavin, "Pi-

ero della Francesca's *Fresco of Sigismondo Pandolfo Malatesta before St. Sigismund . . . ,"* *Art Bulletin* 56 (1974): 348.

57. As we will see, the execution falls into two clearly marked campaigns, both completed before 1320; cf. Hayden B. J. Maginnis, "Pietro Lorenzetti and the Assisi Passion Cycle" (Ph.D. diss., Princeton University, 1975); idem, "The Passion Cycle in the Lower Church of San Francesco, Assisi: The Technical Evidence," *Zeitschrift für Kunstgeschichte* 39 (1976): 193–208; idem, "Pietro Lorenzetti: A Chronology," *Art Bulletin* 66 (1984): 183–211. We must note that in the Lower Assisi complex, during the fifteen years between ca. 1315 and 1330, there must have been scaffolding everywhere, with activity taking place in several areas at once. If the artists—Giotto, Simone Martini, Pietro Lorenzetti and the Vele Master—were not actually working and planning together, they must have been fully conscious of the innovations coming forth from moment to moment.

58. To the right (north), is the Orsini Chapel dedicated to Saint Nicholas, and to the left is the chapel of Saint John the Baptist.

59. Repetition of Giotto's motifs of the hanging veils gives this master his identifying name; Cf. Kleinschmidt, *Basilika San Francesco*, 2:221 ff.

60. Cimabue's *Madonna and Child* is in the right half. See appendix 1, p. 273, for a list of the subjects and their locations.

61. Replacing all the phases of the Christ's public life and mission with central images of Franciscan virtue.

62. This pairing recalls the juxtaposition of the Judas scene with the *Visitation* on the triumphal arch in the Arena Chapel; see above.

63. Recall that the first instance of this disposition was in the chancel of the Scrovegni Chapel, where the point was also to express departure from earthly life. We shall find the pattern used again in Piero della Francesca's Arezzo cycle (chap. 6).

64. Cf. Borsook, *Mural Painters*, pp. 30, 32 n. 13, who mentions only the balance on the lower floor.

65. The *Stigmatization* is one of several Franciscan scenes on the lowest registers on the west and north walls. As miracles they also subsit-tute for scenes of miracles omitted from the Christological cycle.

66. See chapter 8, for works by Pintoricchio, Filippino, Signorelli, and others.

67. Although an attribution to Jacopo di Casentino, about 1322, has been proposed by Andrew Ladis, "The Velluti Chapel at Santa Croce, Florence," *Apollo* 120 (1984): 238–45, the author and date of the frescoes are still in question.

68. This Roman shrine is dedicated to Saint Lawrence—hence the prominence of his scene, opposite the main altar, that forms part of a series of six martyrologies showing the moments of saints' deaths. Cf. Gardner, "Nicholas III's Oratory of the Sancta Sanctorum," pp. 283–94, and Wollesen, "Fresken in Sancta Sanctorum," pp. 35–84. Stephen and Lawrence died before Christ and are therefore designated as protomartyrs and often paired. They are further joined in the legend of the burial of Saint Lawrence, who is said to have moved over in his grave to make room for the body of Saint Stephen, miraculously transported from Jerusalem to Rome to join him; cf. Jacobus de Voragine, "The Invention of Saint Stephen," in *Legenda aurea: Vulgo historia lombardica dicta*, ed. Th. Graesse (1st ed., Leipzig, 1850); translated and adapted as *The Golden Legend of Jacobus de Voragine*, ed. Granger Ryan and Helmut Ripperger (1941; 2d ed. New York, 1969), p. 411. Hereafter cited as *Golden Legend*.

69. Cf. Blume, *Wandmalerei als Ordenspropaganda*; Martin Gosebruch, *Giotto und die Entwicklung des neuzeitlichen Kunstbewusstseins* (Cologne, 1962); Leonetto Tintori and Eve Borsook, *Giotto: The Peruzzi Chapel* (New York, 1965); Eve Borsook, "Giotto nelle Cappelle Bardi e Peruzzi," in *Giotto e giotteschi in*

Santa Croce (Florence, 1966); Ferdinando Bologna, *Novità su Giotto: Giotto al tempo della cappella Peruzzi* (Turin, 1969); also Julie F. Codell, "Giotto's Peruzzi Chapel Frescoes: Wealth, Patronage and the Earthly City," *Renaissance Quarterly* 41(1988): 583–613.

70. *Golden Legend*, pp. 326 ff.

71. The Evangelist's Martyrdom, as distinguished from his Death feast, is celebrated on 6 May, the day he was boiled in oil at the Latin Gate in Rome, though he did not die as a result of the treatment. This festival is not represented in the frescoes.

72. "Woman, behold thy son" (John 19:26).

73. See appendix 1, p. 274, for a list of the subjects and their locations.

74. The Baptist was transported to heaven only after Christ's own descent.

75. It has been suggested that Giotto was the actual designer of the scenes in this cycle, which do indeed recall aspects of his earlier works in their inscenation as well as their disposition. See Julian Gardner, "The Decorations of the Baroncelli Chapel in Santa Croce," *Zeitschrift für Kunstgeschichte* 34 (1971): 89–114; but see also Andrew Ladis, *Taddeo Gaddi: Critical Reappraisal and Catalogue Raisonné* (Columbia, Mo., 1982), pp. 88 ff.

76. See appendix 1, p. 274, for a list of the subjects and their locations.

77. Cf. Ladis, *Taddeo*, pp. 30 ff.

78. The scene of the *Stigmatization of Saint Francis* on the top tier of the two-light stained glass window likewise places the saint on the left, with the seraph and its searing rays coming from the right (illusrated in Ladis, *Taddeo*, p. 110, fig. 4j–1; the rest of the window is nonnarrative).

79. The chapel was painted ca. 1334–41; cf. David G. Wilkins, "Maso di Banco, a Florentine Artist of the Early Trecento" (Ph.D. diss., University of Michigan, 1969; reproduced by Garland Press, New York, 1985), pp. 1–59; see appendix 1, p. 274, for a list of the subjects and their locations. See also Borsook, *Mural Painters*, pp. 38–42, who points out the tradition that Saint Francis, when he went to Rome to petition for his rule, stayed at the Convent of Santi Quattro Coronati, where the famous chapel dedicated to Saint Sylvester is painted with the same story (1246).

80. That the question of Constantine's donation of worldly goods to the papacy is ignored in this cycle perhaps reflects an unwillingness to enter current debates on the status of Franciscan ideals of poverty. The subject of the donation is one of the points of the frescoes of Santi Quattro Coronati of Rome (see previous note); cf. John Mitchell, "St. Silvester and Constantine at the Ss. Quattro Coronati," in *Federico II e l'arte del duecento italiano*, ed. Annamaria Romanini, 2:15–32, Atti della III Settimana di studi di storia dell'arte medievale dell-'Università di Roma (Rome, 1980).

CHAPTER THREE

1. These decades bracket the devastating outbreak of bubonic plague that spread throughout Italy. For speculation about the impact of the plague on art, cf. the seminal work by Millard Meiss, *Painting in Florence and Siena after the Black Death* (Princeton, 1951); and see Henk Van Os, "The Black Death and Sienese Painting: A Problem of Interpretation," *Art History* 4(1981): 237–49, for later literature on the subject.

2. The doors were made for the main entrance on the east side of the building but were moved to the south side in the fifteenth century to make way for Ghiberti's portals. See Mariagiulia Burresi, with Antonino Caleca, *Andrea, Nino e Tommaso, scultori pisani* (Milan, 1983), pp. 72–73; see also Gert Kreytenberg, *Andrea Pisano und die toskanische Skulptur des 14. Jahrhunderts* (Munich, 1984), bibliography, pp. 417–23, and Anita F. Moskowitz, *The Sculpture of Andrea and*

Nino Pisano (New York, 1986). Ghiberti's doors are discussed below, chapter 5.

3. Cf. Guglielmo Matthiae, *Le porte bronze bizantine in Italia* (Rome, 1971); Emile Bertaux (1904), *L'art dans l'Italie meridionale*, ed. Adriano Prandi (Rome, 1978); Ursula Mende, *Die Bronzetüren des Mittelalters, 800–1200* (Munich, 1983). The disposition of scenes on early doors is sometimes problematic because they were rearranged in restoration. See especially the doors of San Paolo fuori le Mura in Rome (second half of the eleventh century, Lives of Christ and Saints Peter and Paul; Matthiae, pls. 16–48); also the doors of San Zeno in Verona (Giuseppe Trecca, *La facciata della Basilica di S. Zeno* [Verona, 1968]; the present scheme is diagrammed on pp. 18–19).

4. The extraordinary accomplishments in the compositional logic of Bonanno on the Pisan doors, as well as those he made for the Duomo of Monreale in the same period (Albert Boeckler, *Die Bronzetüren des Bonanus von Pisa und des Barisanus von Trani* (Berlin, 1953); see Mende, *Bronzetüren*, pp. 170, 173, for diagrams), are newly analyzed by John White, "The Bronze Doors at Pisa and the Development of Dramatic Narrative," *Art History* 11(1988): 158–94 (who deals with many of the problems under discussion here). It has been suggested that Andrea's commission included a mandate to study Bonanno's doors as a model; cf. Ilse Falk and Jëno Lanyi, "The Genesis of Andrea Pisano's Bronze Doors," *Art Bulletin* 25(1943): 132–53. The theory, based on a document of 1329 concerning a trip to Pisa of Piero di Iacopo, Andrea Pisano's teacher, is disputed by Ilaria Toesca, *Andrea e Nino Pisani* (Florence, 1950).

5. See appendix 1, p. 274, for a list of the subjects and their locations.

6. The visual qualities of the reliefs reverse contemporary panel painting's contrast of colored figures against gold backgrounds by showing gilded figures modeled almost in the round that spring miraculously to life against an unreal dark brown base.

7. In both subject and format, the arrangement is also reminiscent of the earlier *Saint John Frontal* (1260–70, Pinacoteca, Siena), where an enthroned figure of Saint John is flanked by three tiers of two-by-two narrative scenes reading down first the left side and then the right side; Piero Torriti, *La Pinacoteca nazionale di Siena* (Genoa, 1977–78), 1, 14:44. I have dealt with the dependence of both the altar frontal and the doors for some of their iconography on the contemporary translation of the legendary life of Saint John; Lavin, "Giovannino Battista: A Study," p. 88; Anita Moskowitz gives misinformation on this point in *Antichità Viva* 20 (1981): 28–39, which she corrects in "Note on Narrative Mode and Iconography in Andrea Pisano's Bronze Doors," in *Renaissance Studies in Honor of Craig Hugh Smyth*, ed. Andrew Morrogh et al., 2:431–64 (Florence, 1985).

8. See above, chapter 2; see also the dado tier of the Saint Martin Chapel at Assisi.

9. See below, chapter 8, discussion of the Andrea del Sarto's Lo Scalzo frescoes.

10. The extraordinary feature of John's body represented with its head (after he had been decapitated) in both these scenes, reminding the worshiper of the wholeness of John's spirit after death as he descended to limbo to await Christ's arrival and his own liberation, is repeated from the mosaic of *John's Burial* inside the Baptistry.

11. Hope, Faith, Charity, and Humility reading across both valves on the sixth tier, and Fortitude, Temperance, Justice, and Prudence on the seventh.

12. Facing the Castello; cf. Ivo Ceccarini, *Duomo di S. Gimignano: Ampliamenti e trasformazioni nei secoli XIV e XV* (Poggibonsi, 1979), esp. pp. 13 ff., 17 ff., with diagrams and documents. The building is documented as early as 1056; it was consecrated by Eugenius III in 1148; the reorientation involved building a *coro nuovo* and bringing the baptismal font inside before 1328. The present fa-

cade and other amplifications were designed in the mid-fifteenth century by Giuliano da Maiano. It is a pleasure to thank Deborah Krohn for making me aware of this information and for lending me her own copy of the Ceccarini book.

13. Cf. Gaudenz Freuler, "Lippo Memmi's New Testament Cycle in the Collegiata in San Gimignano," *Arte Cristiana* 79(1986): 93–102, with bibliography. I thank Elizabeth Beatson for this reference.

14. There is no central portal.

15. Cf. Christie K. Fengler, "Bartolomeo di Fredi's Old Testament Frescoes in S. Gimignano," *Art Bulletin* 63(1981): 374–84, who discusses the compositions' dependence on those by Taddeo Gaddi in the Campo Santo in Pisa, painted during the 1340s (although the shape of the fields differs).

16. See appendix 1, p. 275, for a list of the subjects and their locations. The scene of the *Massacre of the Innocents* is placed before the *Flight into Egypt*, one of the possible interpretations resulting from combining gospel accounts. The same sequence is found in the contemporary frescoes at the Abbey of Pomposa, as well as on the much earlier bronze doors of Monreale (by Bonanno Pisano, 1186, often said to be restored incorrectly). It is seen again in a cycle at San Francesco in Volterra (see below, chap. 4), and in the much later Christological nave cycle by Lattanzio Gambara (1567–71) in the Duomo of Parma. An alternative explanation is offered by Ruth Wilkins Sullivan, "Some Old Testament Themes on the Front Predella of Duccio's *Maestà*," *Art Bulletin* 68(1986): 597–609, esp. p. 607, who discusses the same question of order in Duccio's painting. She solves the problem by reidentifying the *Flight* as the *Return from Egypt*, which would then be in gospel order.

17. The *Annunciation*, which includes the motif of a spindle-wielding witness taken over from Giotto's scene of the *Annunciation to Saint Anne* in the Arena Chapel.

18. Again following the scheme of the Arena Chapel.

19. This figure recalls the midwife in Pietro Lorenzetti's extraordinary composition the *Birth of the Virgin*, an altarpiece made for the Cathedral of Siena in these very years: the woman's body is divided by one of the foreground architectural members. Cf. Henk Van Os, with Kees Van der Ploeg, *Sienese Altarpieces, 1215–1460: Form, Content, and Function*, vol. 1, *1215–1344* (Groningen, 1984), fig. 91, p. 80, Museo del Opera del Duomo, Siena. They differ in that the figure of the woman is perpendicular whereas Memmi's boy thrusts strongly to the right, carrying the story along.

20. See San Giovanni a Porta Latina, Rome; Sant'Angelo in Formis, and closer in date to these frescoes, Duccio's *Maestà*.

21. Millard Meiss, "The Highlands in the Lowlands: Jan van Eyck, the Master of Flemalle, and Franco-Italian Tradition," in *The Painter's Choice: Problems in the Interpretation of Renaissance Art* (New York, 1976) pp. 36–59.

22. Francesco Petrarca, *The Revolution of Cola di Rienzo*, ed. Mario E. Cosenza (New York, 1986). See also Yves Renouard, *The Avignon Papacy, 1305–1403*, trans. Denis Bethell (Hamden, Conn., 1970), pp. 44 ff., with bibliography.

23. See below, chapter 6.

24. Salvatore Ferraro, *La colonna del cereo pasquale di Gaeta* (Naples, 1905), esp. pp. 11, 12 (Life of Saint Erasmus and Life of Christ, both two-field Boustrophedons of twenty-four scenes each).

25. An astonishing strength in psychological expression and abstract values of design is noticed in many of these scenes. The variety of facial gestures and repeated diagonals of the spears in the *Kiss of Judas*, for example, drawn from earlier scenes of the same subject (on the doors of Bonanno Pisano and the Gaeta Candelabrum) are here brought to a peak of threatening force. It is the overall disposition of the narrative, however, that gives these elements of inscenation their new expressive power.

26. Deuchler, *Duccio*, with bibliography.

27. The ceiling mosaics in the main church at San Marco had been in progress since the eleventh century; cf. Demus, *Mosaics of San Marco in Venice*. Structural characteristics of this centralized building, and the approach to narrative as illustration demonstrated here, separate the mosaics of San Marco from the history we are tracing. See Weitzmann and Kessler, *Cotton Genesis*, pp. 18–20, for the dependence of the Venice compositions on manuscript illustration.

28. Rossana Tozzi, "I mosaici del Battistero di San Marco a Venezia e l'arte bizantina," *Bollettino d'Arte* 26(1933): 418–32; Rodolfo Pallucchini, *La pittura veneziana del trecento* (Venice, 1964), pp. 75–78.

29. In the barrel vault, the white-bearded God of the Old Testament surrounded by prophets is represented with the monogram of Christ; in the central dome, Christ in Glory is surrounded by figures of the apostles each performing a baptism; in the east dome before the altar, the Christ of the Second Coming is surrounded by the angelic hierarchy.

30. See appendix 1, p. 275, for a list of the subjects and their locations.

31. Of Ein-Karim, according to a Syriac apocrypha. See Lavin, "Giovannino Battista: A Supplement," p. 319, esp. n. 1.

32. Lavin, "Giovannino Battista: A Study," pp. 86 ff.; idem, "Giovannino Battista: A Supplement," p. 320.

33. Lavin, "Giovannino Battista: A Supplement," pp. 321–22.

34. Marilyn Aronberg Lavin, *Piero della Francesca's "Baptism of Christ"* (New Haven, 1981), pp. 39–57.

35. The doge Andrea Dandolo (1343–54), patron of the chapel, the cancellier grande of Venice to the left, and to the right an unknown magistrate. See the forthcoming article by Debra Pincus, "Doge Andrea Dondolo and Visible History: The San Marco Projects," in *Acts of the Conference on Art and Politics in Late Medieval and Early Renaissance Italy: 1250–1500* (Notre Dame, Ind., in press).

36. Cf. M. Restle, "Das Dekorationssystem im Westeil des Baptisteriums von San Marco zu Venedig," Festschrift für Otto Demus zum 70. Geburtstag, *Jahrbuch der Oesterreichischen Byzantinistik* 21(1972): 229–39, who points out connections with Assisi in terms of pictorial illusionism. My thanks to Debra Pincus for this reference.

37. From the *Birth*, through the *Annunciation of Death*. See appendix 1, p. 275, for a list of the subjects and their locations.

38. Dating from 1346–47, the painting was the third replacement for this image; cf. Richard Offner and Klara Steinweg, *Corpus of Florentine Painting* (Berlin, 1930), sec. 3, vol. 2, pt. 1, pl. XVIII-9. The frame Orcagna designed for the panel establishes the theme of revelation, with sculptured angels holding back stone drapes to reveal the "tabernacle of the Lord." The subject of revelation and the tabernacle within the tabernacle will be fully developed by Diane Zervos in her forthcoming monograph on the Church of Or San Michele.

39. Nancy Rash Fabbri and Nina Rutenburg, "The Tabernacle of Orsanmichele in Context," *Art Bulletin* 63(1981): 385–405; also Brendan F. Cassidy, "The *Assumption of the Virgin* on the Tabernacle of Orsanmichele," *Journal of the Warburg and Courtauld Institutes* 51(1988): 174–80. I shall discuss further Marian cycles and their disposition toward the end of this chapter.

40. Gian Lorenzo Mellini, *Altichiero e Jacopo Avanzo* (Milan, 1965). See appendix 1, p. 276, for a list of the subjects and their locations.

41. Cf. Mary D. Edwards, "The Chapel of S. Felice in Padua as *Gesamtkunstwerk*," *Journal of the Society of Architectural Historians* 47(1988): 160–72.

42. Margaret Plant, "Portraits and Politics in Late Trecento Padua: Altichiero's Frescoes in the S. Felice Chapel, S. Antonio," *Art Bulletin* 63(1981): 406–25.

43. Roughly contemporary with Altichiero's are the frescoes by Giusto di Menabuoi in the Baptistry of Padua (started in 1376). Combining Genesis stories in the dome and lives of the Baptist, Mary, and Christ (and a number of devotional images), the complicated disposition includes a Wraparound pattern for some sequences, along with a Boustrophedon on the south wall to the left of the present entrance; Sergio Bettini, *Le pitture di Giusto de' Menabuoi nel Battistero del Duomo di Padua* (Venice, 1960).

44. Fausto Piola Caselli, *La costruzione del palazzo dei papi di Avignone, 1316–1367* (Milan, 1981). Earlier standard bibliography includes Léopold Duhamel, "Les origines du palais des papes," *Congrès Archéologiques*, followed by articles published in the *Mémoires de l'Académie de Vaucluse* from 1911 to 1942; G. Mollat, *Les papes d'Avignon (1305–1378)*, 9th ed. (Paris, 1949) (with much bibliography).

45. Apparently painted last, although the dates overlap in the period 1344–49; cf. Enrico Castelnuovo, *Matteo Giovannetti al palazzo dei papi ad Avignone* (Milan, 1965); also Margaret Plant, "Fresco Painting in Avignon and Northern Italy: A Study of Some Fourteenth-Century Cycles of Saints' Lives outside Tuscany" (Ph.D. diss., University of Melbourne, 1981).

46. Daniel F. Callahan, "The Sermons of Ademar of Chabannes and the Cult of St. Martial of Limoges," *Revue Bénédictine* 86(1976): 251–95 (my thanks to Lawrence Nees for this reference). Léon Honoré Labande, *Le palais des papes et les monuments d'Avignon au XIVe siècle*, 2 vols. (Marseilles, 1925), passim.

47. When he is boiled in oil, though not killed.

48. The survival rate of medieval ceiling paintings is very low. One reason is the number of longitudinal barrel vaults replaced in Gothic rebuildings and the many Gothic vaults that were replaced or repainted in the fifteenth century through the seventeenth. A major Romanesque survivor is the French abbey church at Saint-Savin-sur-Gartemps, where ceiling decorations of the late eleventh century remain in the entryway, the barrel-vaulted nave, the transept, and the crypt; cf. Demus, *Romanesque Mural Paintings*, pls. 125–42. I shall refer to these frescoes again in chapter 8. A well-preserved Italian crypt ceiling decoration in the Cathedral of Anagni, south of Rome (cf. Miklòs Boskovits, "Gli affreschi del Duomo di Anagni: Un capitolo di pittura romana," *Paragone* 357 [1979]: 3–41), exemplifies mid-thirteenth-century groin-vault painting. Early fifteenth-century vault narratives can be seen in the apse of the Collegiata, Castiglione Olona; Maria Luisa Gatti Perer, "Historia salutis e istoria: Varianti lombarde nell'applicazione del 'De pictura' di Leon Battista Alberti," *Arte Lombarda* 80–82 (1987): 17–36, fig. 46, and in the eight-part ogival vaults with a True Cross cycle at Montegiorgio, in the province of Ascoli Piceno; Piero Mazzoni, *La leggenda della croce nell'arte* (Florence, 1913–14), pp. 117 ff.; and a sixteenth-century example is the Old Testament cycle by Guglielmo de Marcillat (1521–29) in the vaults of the Duomo of Arezzo; Angelo Tafi, *Il Duomo di Arezzo (Guida storico-artistica)* (Arezzo, 1980), no. 45, p. 55, ill. p. 20 (finished in seventeeth century). See also Margaret Plant, "The Vaults of the Chapel of Saint Martial, Palace of the Popes, Avignon: Frescoes of Matteo Giovannetti," *Source* 2(1982): 6–11, who, besides analyzing the organization of this cycle refers to a number of other fourteenth-century painted vaults.

49. See appendix 1, p. 275, for a list of the subjects and their locations.

50. Embrasures are painted in the same manner in the Saint Johns Chapel on the lower floor of the palace. This treatment had been seen in Italy just a few years earlier in the fresco of the *Annunciation* in the San Galgano Chapel, Montesiepi (Borsook, *Mural Painters*, fig. B), the frescoes at San Leonardo al Lago (Eve Borsook, "The Frescoes at San Leonardo al Lago," *Burlington Magazine* 98[1956]: 351–58), and later in the *Nativity* apse fresco by Goro Ghezzi in San Michele, Paganico, of about 1375 (Gaudenz Freuler "Die Fresken der Biagio di

Goro Ghezzi in S. Michele, in Paganico," *Mitteilungen des Kunsthistorischen Institutes in Florenz* 25[1981]: 35–58; idem, *Biagio di Goro Ghezzi a Paganico* [Florence, 1986], pp. 13 ff., 62 ff.). Some eighty years after Avignon we shall see this treatment used again by Masolino in the work he did in Castiglione Olona for Cardinal Branda. See below, chapter 5.

51. The logic of this sequence is not always appreciated; cf., e.g., Belting, "New Role of Narrative," p. 154: "The crisis of the narrative was reach when Matteo Giovannetti . . . probably realized the problems he could not solve and, in order to establish proper reading sequence, identified the scenes by" letters.

52. The building portraits are inscribed with their dedications. Other medieval territorial landscapes and architectural images that survive can be seen at Le Tre Fontane outside Rome; cf. Fernanda de' Maffei, "Riflessi dell'epopea carolingia nell'arte medievale: Il ciclo di Ezechiele e non di Carlo a Santa Maria in Cosmedin e l'Arco di Carlo Magno a Roma," in *Atti del Convegno Internazionale sul Tema: La poesia epica e la sua formazione* (Rome, 28 March–3 April 1969), pp. 351–92, Accademia Nazionale dei Lincei 367 (Rome, 1970), in the Church of Saint Demetrios in Thessaloniki (Greece; cf. Robin Cormack, "The Making of a Patron Saint: The Powers of Art and Ritual in Byzantine Thessaloniki," in *The World of Art: Themes of Unity in Diversity,* ed. Irving Lavin, Acts of the Twenty-sixth International Congress of the History of Art, Washington, D.C., 1986 (College Park, Pa., 1989), and in the Palazzo Pubblico at Siena and other trecento town halls; cf. Edna C. Southard, "The Frescoes in Siena's Palazzo Pubblico, 1285–1539" (Ph.D. diss., University of Indiana, 1978; reproduced by Garland Press, New York, 1979).

53. The method of "numbering" with letters appears to have an early medieval background. The ivory plaques on "Cathedra Petri," thought to date from the time of Charles the Bald, are numbered with letters on the back, indicating their collocation on the base of the chair; cf. Michele Maccarrone, "Le nuove ricerche sulla cattedra," *Memorie* (Atti della Pontificia Accademia Romana di Archeologia, ser. 3), 1(1975). I am indebted to Lawrence Nees for this reference. Frescoes in the churches of Santo Stefano Rotondo and Saints Nereo and Achilleo in Rome are both painted in this manner. Both are Early Christian monuments repainted during the papacies of Sixtus V and Clement VIII in the sixteenth century with the direct objective of reviving the values and forms of the primitive church (see below, chap. 9). No doubt the usage in Avignon had much the same motivation.

54. Cf. Offner and Steinweg, *Corpus of Florentine Painting,* sec. 3, vol. V.1; see also Serena Romano, "Due affreschi del Cappellone degli Spagnoli: Problemi iconologici," *Storia dell'Arte* 28(1978): 181–214; and Julian Gardner, "Andrea di Bonaiuto and the Chapterhouse Frescoes in Santa Maria Novella," *Art History* 2(1979): 107–37.

55. See appendix 1, p. 276, for a list of the subjects and their locations.

56. The Life of Saint Peter Martyr on the interior facade is a separate system, unfortunately much destroyed, meant to be related typologically to the Life of Christ; cf. the iconographical analysis of Borsook, *Mural Painters,* 49–51. See also Roberto Lunardi, *Arte e storia in Santa Maria Novella* (Florence, 1983), pp. 67–69 and bibliography.

57. From the mid-trecento until well into the fifteenth century, the huge project to decorate the burial ground known as the Campo Santo in Pisa was under way. (The building was much destroyed by bombing during World War II.) In a basically rectangular plan surrounding an open court, a number of loosely related cycles of Old and New Testament subjects move generally clockwise. Cf. Igino B. Supino, *Il Camposanto di Pisa* (Florence, 1896); Enzo Carli, *Il Campo Santo di Pisa* (Rome, 1937); Meiss, *Black Death;* Luciano Bellosi, *Buffalmacco e il trionfo della morte* (Turin, 1974); Mario Bucci and Licia Bertolini, *Camposanto*

monumentale di Pisa: Affreschi e sinopie (Pisa, 1960), see ground plan after p. 144; Belting, "New Role of Narrative." Within the large interior spaces the cycle of the Life of Saint Ranieri (Bucci, nos. 10–15) moves left-right for three fields on two superimposed tiers; the stories of Saints Efiso and Potito (Spinello Aretino, Bucci, nos. 16–21) move in a Boustrophedon, two scenes on each of two tiers; the story of Job (Bucci, nos. 22–31) is again left-right, three scenes on two tiers each. The Pietro di Puccio cycle of Creation through the Tower of Babel, on the opposite wall, has the same disposition. See below, chapter 5, for mention of later frescoes in this building.

58. During a 1961 cleaning of this chapel, it was discovered that the *stemma* of the Rinuccini family was painted in tempera over the shield of the Guidalotti. The second painter is known only as the "Master of the Rinuccini Chapel." Cf. Liana Castelfranchi-Vegas, *Giovanni da Milano*, Maestri del Colore 3 (Milan, 1965); Mina Gregori, *Giovanni da Milano alla Cappella Rinuccini*, L'Arte Racconta 30 (Milan, 1965); Richard Fremantle, *Florentine Gothic Painters, from Giotto to Masaccio: A Guide to Painting in the near Florence, 1300–1400* (London 1975), pp. 181 ff., 193 ff.

59. A nascent form of thematic balance was used by Giotto in the Peruzzi Chapel.

60. See appendix 1, p. 276, for a list of the subjects and their locations.

61. See chapter 4, discussion of the Alberti Chapel. Still to be explained is the contrast to the two biblical accounts of the number of angels present in the *Marys at the Tomb* episode. According to Matthew (28:2) and Mark (16:5), there was one angel; Luke (24:4) and John (20:12) speak of two. In the painting three angels are present.

62. To the right of the entrance to the Baroncelli Chapel; dating after 1383 and before 1395. Cf. Bruce Cole, *Agnolo Gaddi* (Oxford, 1977), pp. 9–20, 78–79, pls. 12–24. The frescoes on the bottom tier left were partially destroyed in the fifteenth century when a tomb was inserted; all the frescoes except those on the ceiling were whitewashed by the end of the seventeenth century. The chapel is now dedicated to the Holy Sacrament.

63. It is possible that it was planned even earlier by Gregory X, the first pope known to have resided in Orvieto (1273), although the French Urban IV (1262–64) had had an earlier residence; cf. Fumi, *Duomo di Orvieto*; R. Bonelli, *Il Duomo di Orvieto e l'architettura italiana del duecento trecento* (Città di Castello, 1952); cf. also John White, "The Reliefs on the Facade of the Duomo of Orvieto," *Journal of the Warburg and Courtauld Institutes* 22(1959): 254–302; Gary M. Radke, "Gothic Style at the Papal Palace in Orvieto," public talk, College Art Association Meeting, New York, 1986.

64. See above, chapter 1, note 66; also Michael D. Taylor, "The Iconography of the Facade Decoration of the Cathedral of Orvieto" (Ph.D. diss., Princeton University, 1970).

65. Restorations and changes were made by Bernardino Pintoricchio and others in the 1490s. Cf. Enzo Carli, *Il Duomo di Orvieto* (Rome, 1965), pp. 83–97, and Zimeri A. Cox, "Ugolino di Prete Ilario, Painter and Mosaicist" (Ph.D. diss., Institute of Fine Arts, New York University, 1976).

66. A brief cycle of the Virgin, contemporary or somewhat later, by Bartolo di Fredi in Sant'Agostino in San Gimignano, to the right of the apse, is similarly disposed from the bottom up (three scenes in Straight-Line Verticals) on opposing walls and emphasizes food in the scene of the *Birth of the Virgin*, with a whole chicken being delivered by a centrally placed maidservant; see Raimond Van Marle, *The Development of the Italian Schools of Painting* (The Hague, 1924), 2: 499–503, fig. 326. The chicken motif is again seen in the mosaic representation of this scene on the facade at Orvieto, also designed by Ugolino d'Ilario.

67. The upward progression harmonizes with the organization of the adja-

cent apse window, decorated with New Testament scenes by Giovanni di Bonino and dated 1334. The narrative progression is also upward in the reliefs on the four great facade pilasters of the church, created between 1310 and 1330 by the Maitani shop. The two outer piers (Old Testament subjects on the left and Last Judgment scenes on the right) are organized between the branches of espaliered climbing plants. The two inner piers (Tree of Jesse on the left and New Testament subjects on the right) emulate intertwining vines, reminiscent of the Franciscan *Albero della Vita*; cf. Ubertino da Casale, *Arbor vitae crucifixae Jesu* (Turin, 1961; written in the fourteenth century and first published in 1485).

68. *Annunciation of Death in Her Bedroom*, the *Death and Koimesis, Funeral with Falling Idols and Jew Miracle*, and the *Resurrection of Mary*.

69. Based on a famous letter attributed to him, but now believed spurious; cf. *Catholic Encyclopedia*, vol. 2 (New York, 1913), p. 6.

70. G. Pelagotti, *Il sacro cingolo Mariano in Prato fino alla traslazione del 1395* (Prato, 1895); see also Giuseppe Marchini, *La Cappella del Sacro Cingolo nel Duomo di Prato*, Edizione del Palazzo ([Prato?]:1975).

71. Cf. Cole, *Gaddi*, pp. 32–40, 87–88, who points out that the architecture was changed somewhat during construction.

72. See the description given by Mrs. [Anna Butler] Jameson, *Legends of the Madonna* (London, 1852), pp. 344–46.

73. See appendix 1, p. 277, for a listing of the subjects and their locations.

74. See Henry Maguire, *Art and Eloquence in Byzantium* (Princeton, 1981), "Antithesis," p. 61.

75. The disposition of the Dragomari story continues the left-right, top-down arrangement on the right wall, ending on a single tier above the entrance. Agnolo also painted an *Assumption with Saint Thomas* in fresco on the facade of the Prato Duomo (now lost), reemphasizing the main point of these episodes for the building and the town; cf. Cole, *Gaddi*, app. 4, doc. 28 (1394), p. 69. See below, chapter 6, for further discussion of this cult.

76. Enzo Carli, *Pittura pisana del trecento*, vol. 2 (Milan, 1961), p. 27, figs. 54–57. See appendix 1, p. 277, for a list of the subjects and their locations.

77. Marvin Eisenberg, "The First Altar-Piece for the 'Cappella de' Signori' of the Palazzo Pubblico in Siena: '. . . Tales figure sunt adeo pulcre . . . ,'" *Burlington Magazine* 123(1981): 134–47.

78. Texts by pseudo-Jerome and pseudo-Augustine, thought to be authentic until the sixteenth century. See *Catholic Encyclopedia*, vol. 2 (New York, 1913), pp. 6–7.

79. Cf. Renato Roli, "Considerazione sull'opera di Ottaviano Nelli," *Arte Antica e Moderna*, 1961, p. 122; Alessandro Buffetti-Berardi, ed., *Foligno, Bevagna, Cannara, Montefalco, Nocera Umbra, Spello, Trevi, Casa di Risparmio di Foligno, 1858–1958* (Foligno, 1958), pp. 56–59, 61 (color plate of vault).

CHAPTER FOUR

1. "Day of the Cross," 3 May 1294, Luigi Magnani, *La cronaca figurata di Giovanni Villani: Richerche sulla miniatura fiorentina del trecento* (Vatican City, 1936), book 8, chap. 7. Cf. Filippo Moisè, *S. Croce di Firenze* (Florence, 1845). An inscription with a slightly different date exists today: +.M.CC.LXXXXV.V. NONA MAII FU/IT FVDATA ISTA ECCL'IA. AD HONO/RE SCE CRVCIS & B'TI FRANCISCI:-. Paatz and Paatz, *Kirchen von Florenz*, 1:497–703, esp. p. 499.

2. Like the apse at Assisi, this one is polygonal with five facets, three of which hold stained glass windows; cf. Paatz and Paatz, *Kirchen von Florenz*, 1:521–22.

3. And forebears of the famous Leon Battista. Cf. Armando Sapori, *I libri degli Alberti del Giudice* (Milan, 1952), pp. lxxxviii–lxxxix. See

Gene Brucker, *The Civic World of Early Renaissance Florence* (Princeton, 1977), pp. 102 ff.

4. Cf. Blume, *Wandmalerei als Ordenspropaganda*, p. 99. The program of the entire church was not complete until almost two hundred years later, when Vasari rebuilt the chapels of the nave; see below, chapter 9.

5. Esther C. Quinn, *The Quest of Seth for the Oil of Life* (Chicago, 1962).

6. Amnon Linder, "The Myth of Constantine the Great in the West: Sources and Hagiographic Commemoration," *Studi Medievali*, 3d ser., 16(1975): 43–96.

7. Cf. Karl Adolf Wiegel, "Die Darstellungen der Kreuzauffindung bis zu Piero della Francesca" (Ph.D. diss., Universität Köln, 1973).

8. Or Khusrau, surnamed Paris or Parviez, who was twenty-third king of the Sassanians.

9. See references below, notes 10, 13, and 20.

10. Cf. Pierre Batiffol, *Histoire du bréviaire romain*, 3d ed. (Paris, 1911), pp. 165 ff., and Mario Righetti, *L'anno liturgico nella Storia, nella Messa, nell'Ufficio* (Milan, 1969), 2:341 ff.

11. Charles Clermont-Ganneau, "The Taking of Jerusalem by the Persians, A.D. 614," *Palestine Excavation Fund Quarterly*, 1898, pp. 43 ff.; Paul P. Peeters, "La prise de Jerusalem par les Perses," *Mélanges de l'Université Saint-Joseph* 9(1923): 7 ff.

12. Suzanne Spain Alexander, "Heraclius, Byzantine Imperial Ideology, and the David Plates," *Speculum* 52(1977): 217–37. The basic source is Angelo Pernice, *L'imperatore Eraclio, saggio di storia bizantina* (Florence, 1905).

13. Venance Grumel, "La reposition de la Vraie Croix à Jérusalem par Héraclius: Le jour et année," in *Byzantinische Forschungen*, ed. A. M. Hakkert and Peter Wirth, 1:139–49 (Amsterdam, 1966).

14. Mary Dolorosa Mannix, ed., *Oration de obitu Theodosii* (Washington, D.C., 1925), pp. 59 ff., 77 ff. (delivered on 25 Februaury A.D.395.

15. Louis Duchesne, *Origines du culte chrétien: Etude sur la liturgie latine avant Charlemagne* (Paris, 1898), p. 259.

16. Patrick J. Geary, *Furta Sacra: Thefts of Relics in the Central Middle Ages* (Princeton, 1978), pp. 65, 186. The story was later represented in a relief on the left side of the Reims facade.

17. A scholar of impressive erudition, Jacobus (born ca. 1230) was archbishop of Genoa and a close friend of Pope Nicholas IV. Immediately after his death (ca. 1298), Jacobus was venerated by a local cult; he was beatified in the early nineteenth century.

18. Starting with 30 November in the season of Advent.

19. See the *Golden Legend*, p. viii, where the point is made that the word *legenda* did not mean myth or fable in the thirteenth century but was the equivalent of *lectio*, meaning reading or lesson. For a modern evaluation of the text, see Sherry L. Reames, *The "Legenda Aurea": A Reexamination of Its Paradoxical History* (Madison, Wis., 1985); reviewed by Eugene Rice, *Renaissance Quarterly* 39(1986): 279–81. Not many post-Enlightenment critics seem to realize the historical potential of the book. On the one hand it is a handy compilation of abstruse sources presented with admirable objectivity, and on the other it is an articulation of the annual calendar (hard to come by before the printing press), often in familiar languages. See below, chapter 6, note 130, for further discussion of the character and contributions of this work.

20. Graesse ed., pp. 303–11, chap. 67, and pp. 605–11, chap 137; *Golden Legend*, pp. 269–76, 3 May, the Invention of the Holy Cross, and pp. 543–50, 14 September, the Exaltation of the Cross.

21. Cole, *Agnolo Gaddi*, pp. 26 ff., 79–80, makes these points; see also Roberto Salvini, *L'arte di Agnolo Gaddi* (Florence, 1936), pp. 84 ff.

22. Unless we have lost major examples of illustrated copies of *The Golden Legend*, which might have provided sources.

23. Andreas Stylianou and Judith Stylianou, *"In Hoc Vinces . . . , By This Conquer"* (Nicosia, 1971), pp. 18 ff.

24. Illustrations to this story are also found in World Chronicles manuscripts; for examples see Gabrielle Spiegel, *The Chronicle Tradition of Saint-Denis: A Survey* (Brookline, Mass., 1978).

25. This idea is part of a broad tradition of identifying Constantine as the Christian hero, to be discussed further below.

26. Cf. Sirarpie Der Nersessian, "The Illustrations of the Homilies of Gregory of Nazianzus, Paris Gr. 510: A Study of the Connections between Text and Images," *Dumbarton Oaks Papers* 16(1962): 197–228. Byzantine representations of the True Cross story are very rare.

27. The relics are enshrined in a pouch beneath the smaller of two tiny Byzantine triptychs. On the exterior of the wings of the smaller triptych, the centerpiece of which is a *Crucifixion*, seen when the wings are closed, is a scene of the *Annunciation*. We should remember the juxtaposition of this scene with a cycle of the True Cross in relation to Piero della Francesca's version of the story (discussed in chap. 6). The *Annunciation* is also one of the prominent scenes in that cycle, though it is not part of the canonical story.

28. Lothar II, Conrad III, and Frederick I Barbarosa (1152–90).

29. Cf. the monographic study by William Voelkle, *The Stavelot Triptych: Mosan Art and the Legend of the True Cross* (New York, 1980); this publication includes a catalog of over twenty-five small-scale illustrations of scenes from the legend in the Morgan Library. Voelkle points out that the Stavelot Triptych is the earliest surviving reliquary of the True Cross with illustrations of the legend.

30. Maxentius drowned in the Tiber while attempting to cross the bridge he himself had undermined to trap Constantine; cf. *Golden Legend*, p. 272.

31. Cf. Voelkle, *Stavelot Triptych*, figs. 25–27, for comparisons with other medieval battle scenes in illuminated manuscripts.

32. See below, note 53.

33. Cf. Wiegel, "Darstellungen der Kreuzauffindung."

34. For examples, see Millard Meiss, *French Painting in the Time of Jean de Berry* (New York, 1974), pp. 131, 217–22, figs. 488, 596.

35. See appendix 1, p. 277, for a list of the subjects and their locations.

36. See above, notes 23 and 24, and below, note 45.

37. See below for the literary source of this scene.

38. The light on all tiers, on both sides, flows from the direction of the real windows in the apse wall, an effect that by this period was not unusual. Cf. Borsook, *Mural Painters*, fig. F.

39. I have found no precedent visual examples for this scene, although the episodes are included in *The Golden Legend*. The monumentalization of this subject at this time seems related to two points. The first is purely Franciscan: to include a representation of Saint Michael, one of Saint Francis's patron. The second relates to the contemporary elaboration of the story of the lives and deaths of Adam and Eve, the *Vita Adae* and its addition to the Story of the True Cross at this period. Cf. John H. Mozley, "Documents: The 'Vita Adae,'" *Journal of Theological Studies* 30(1929): 121–49, who refers to a manuscript version in Balliol College Oxford (Ox. 228), fifteenth century, where the two legends are combined and unified. This manuscript is particularly interesting because it also contains a full text of *The Golden Legend* (fols. 11–202), the text of the Gospel of Pseudo-Matthew (fols. 206v–213v), and the text "De Inventione 3 Crucis" and the story of Constantine (fols. 74v–76v). It thus brings together several popular apocrypha in one collection. See Roger A. B. Mynors, ed., *Catalogue of the MSS of Balliol College, Oxford* (Oxford, 1963), pp. 230–31.

40. Cf. André Chastel, "Le rencontre de Salomon et de la reine de Saba dans l'iconographie médiévale," *Gazette des Beaux-Arts* 35(1949): 99–114.

41. No precedent examples.

42. No precedent examples.

43. Cf. Wiegel, "Darstellungen der Kreuzauffindung."

44. At this period the altar was placed closer to the back of the apse than one sees it today. See below chapter 9, discussion of Vasari's work in this church.

45. As in the Wessobrunner Prayer Book; cf. note 23. Another example is a breviary, Roman Office for Franciscan use, Paris, ca. 1355 (by a follower of Jean Pucelle), Morgan Library (New York), M. 75, fol. 422v (Office of 3 May); cited by Voelkle, *Stavelot Triptych*, p. 37.

46. Helena presents only half the cross, a detail transferred to her in *The Golden Legend*, where it is she who takes the other half to her waiting son in Constantinople. On the other hand, in the painting the city of Jerusalem is quite clearly reidentified as ROMA by a *titulus* held by a prophet in the frame at the right. In this way, Agnolo Gaddi establishes the adoration ritual as authentically Western.

47. The cross was probably painted in secco and has now vanished.

48. In the manner of a Resurrection scene.

49. As I have noted, this scene is not described in *The Golden Legend*; see the discussion of its poetic source below.

50. Cf. Emile Mâle's classic discussion of this window reprinted in *The Gothic Image*, pp. 347–52; Yves Delaporte and Etienne Houvet, *Les vitraux de la cathédrale de Chartres* (Chartres, 1926), p. 314; an updated but wrong-minded analysis was made by Clark Maines, "The Charlemagne Window at Chartres Cathedral: New Considerations on Text and Image," *Speculum* 52(1977): 800–823. For another interpretation, see Michael W. Cothren and Elizabeth A. R. Brown, "The Twelfth-Century Crusade Window of the Abbey of Saint-Denis," *Journal of the Warburg and Courtauld Institutes* 49(1986): 1–40. I shall discuss the content of the window further on in this chapter. Another scene of the *Battle of Heraclius* with this format is by the Master Honoré, in the Prayer Book of Philip the Fair (Paris, Lib., Bibl. Nationale, lat. 1023, Breviary, fol. 426v, 1295), where it serves as an illustration to the feast of the Exaltation.

51. This mode was probably operative in earlier cycles, such as the Peruzzi Chapel, but in the chancel of Santa Croce it became entirely explicit for the first time. It is interesting to note that just a decade earlier both feasts had been elevated to double majors, and a new office of the Exaltation had been inaugurated. Cf. Giovanni Mercati, *Operi minori*, vol. 2, Studi e Testi 77 (Vatican City, 1937), pp. 380–82. This liturgical activity was carried out by Pope Gregory XI when he journeyed from Avignon to Anagni in 1377 (letter dated 1 September 1377). Dorothy Glass helped me find this reference. The Invention feast was dropped from the Western calendar under Pope John XXIII.

52. The feast painting seems to have appeared in Byzantine art in the tenth century, when the structure of the iconostasis (screen decorated with icons separating the sanctuary from the rest of the church) reached its most elaborate form. Above isolated vertical images of Christ, Mary, and various saints was a *bema*, or lintel, on which were placed smaller rectangular panels with representations of biblical events celebrated during the liturgical year. Cf. Kurt Weitzmann, "The Narrative and Liturgical Gospel Illustrations," in *Studies in Classical and Byzantine Manuscript Illumination*, ed. Herbert L. Kessler, intro. Hugo Buchthal (Chicago, 1971), pp. 247–70, and idem, "Byzantine Miniature and Icon Painting in the Eleventh Century," ibid., pp. 271–313. See also Nikolai I. Kondakov, *The Russian Icon*, trans. Ellis H. Minns (Oxford, 1927), pp. 29–30, who reports that in modern Orthodox churches the festival icon is carried about and

then placed in a special niche during the service, after which it is returned to its place until the following year.

53. Diana M. Webb, "The Truth about Constantine: History, Hagiography and Confusion," in *Religion and Humanism*, 17:85–102, Papers of the Ecclesiastical History Society, Studies in Church History (London, 1981), esp. p. 85, makes this point. I may add, moreover, that what might be an early trecento image of the *Constantine with the Archangel Michael* in stained glass was originally included in the Velluti Chapel at the opposite end of the transept, though no cross is shown. In fact, Giuseppe Marchini calls the armed warrior "Eraclio(?) vincitore . . ."; *Il complesso monumentale di Santa Croce* (Florence, 1983), p. 311. The window on which this pair of figures forms the second tier of three was moved much later to the Bardi Chapel, where it remains; cf. Ladis, "Velluti Chapel at Santa Croce," pp. 241, 244, fig. 8.

54. See Webb, "Truth about Constantine," for a very useful historical review of opinions on Constantine's possible Arianism and on the controversial subject of his Donation through the beginning of the sixteenth century.

55. The discussion that follows should be put in the context of the long-established Florentine anti-Ghibelline sentiment and the Guelf Republicanism that was the governmental mode.

56. Richard C. Trexler, *The Spiritual Power: Republican Florence under Interdict* (Leiden, 1974), p. 4.

57. Cf. Brucker, *Civic World*, chap. 3, "Foreign Affairs: 1382–1402; Florentine Imperialism, 1382–88," pp. 102–44; the sale price of Arezzo was forty thousand florins.

58. A prominent member of the family was Benedetto Alberti, one of the men Otto della Guerra sent to negotiate peace with Gregory XI and sent to Arezzo at the time of sale. Afterward Benedetto was exiled to Genoa, from which he made a pilgrimage with his nephew Agnolo to the Holy Land. On their way back they fell ill in Rhodes and died there. The year was 1388; Benedetto's body was returned to Florence and buried in Santa Croce; *Dizionario biografico degli Italiani*, vol. 1 (Rome, 1960), pp. 686–87. The Story of the True Cross was a fitting remembrance of these events.

59. See the text and illustrations in Magnani, *Cronaca figurata*, fols. 35–44. Cf. Nicolai Rubinstein's seminal discussion of this topic, "The Beginnings of Political Thought in Florence," *Journal of the Warburg and Courtauld Institutes* 5(1942): 198–227, esp. 215 ff.

60. Gina Fasoli, "Carlo Magno nelle tradizioni storico-leggendarie Italiane," in *Karl der Grosse* (Aachen, 1961), pp. 357–63; Eugene Müntz, "La légenda de Charlemagne dans l'art du Moyen Age," *Romania* 14(n.d.): 321–42; cf. Majorie Reeves, *The Influence of Prophecy in the Later Middle Ages: A Study in Joachimism* (Oxford, 1969), pp. 324 ff., who reports on the rapid dissemination of Francophile prophecies as illustrated in Alessandro Gherardi, ed., *Diario d'anonimo Fiorentino 1358 al 1389*, Documenti di Storia Italiana 6 (Florence, 1876), pp. 389–90, and by the "mysterious" Telesphorus of Cosenza, a Francophile Joachite who reported a major vision on Easter 1386, in which the French King "Karolum" (descendant of Pepin) appears and destroys the German eagle and the antipope; the "angelic pope" crowns Karolum emperor, and together they undertake the last crusade.

61. They are fully developed by Stephen G. Nichols, Jr., *Romanesque Signs: Early Medieval Narrative and Iconography* (New Haven, 1983).

62. From Adémar de Chabanne's eleventh-century *Life of Charlemagne*; cf. Nichols, *Romanesque Signs*, pp. 66–68, 81.

63. The source is the text *Voyage de Charlemagne*, ed. Guildo Favati (Bologna, 1965), thought to be a compilation of earlier legends of a journey to Con-

stantinople and another to Jerusalem. For a recent interpretation and current bibliography, see Massimo Bonafin, "Fiaba e *chanson de geste:* Note in margine a una rilettura del *Voyage de Charlemagne,*" *Medioevo Romanzo* 9(1984):3–16.

64. *Historia tripartita,* by Cassiodorus; *Historia ecclesiastica,* by Eusebius of Caesarea; Spain, "Heraclius, Byzantine Imperial Ideology," p. 225; for the account of Charlemagne's sin, cf. the "Vita Sancti Aegidii," *Acta Sanctorum,* 9 September, pp. 299–304, and William M. Hinkle, "The Iconography of the Four Panels by the Master of Saint Giles," *Journal of the Warburg and Courtauld Institutes* 28(1965): 110–44.

65. The window of Saint Denis is lost; cf. Cothren and Brown, "Twelfth-Century Crusade Window." The reprise at Chartres (see above, note 50), surely repeats the main motifs and is equally religious in content, in contrast to what is usually said, by Mâle, Abbé Delaporte, Panofsky, and Grodecki; see Nichols, *Romanesque Signs,* p. 221 nn. 2, 5. See next note.

66. The composition of the window, to paraphrase the study of Deuchler, "Sens de la lecture," is boustrophedonic moving upward. Other parallels with elements of the myth of Constantine should be noted in the tales of the origin of the *oriflamme* (similar to the *labarum*) and in the stories of the cross that appears on Pepin's armor before battle; cf. Robert Folz, *Le souvenir et la légende de Charlemagne dans l'empire germanique médiéval; Etudes sur le culte liturgique de Charlemagne dans les églises de l'empire* (Geneva, 1973), pp. 457 ff.

67. *Carolus alter Cristus;* cf. Folz, *Souvenir et la légende de Charlemagne.* The relationship of this claim to the experience of Saint Francis less than a century later, as far as I know, has not been the subject of study.

68. On the basis of this literary tradition, the stories entered *Les grandes chroniques de France* and became part of the country's official history, as Nichols points out in *Romanesque Signs,* p. 127.

69. This source was discovered by Wiegel, "Darstellungen der Kreuzauffindung," nos. 108, 206. The passage reads: "Le nuit que cil rouva son fil / les crestïens metre a eschil, / vint li angles Nostre Signor / a nostre bon empereor, / dist li: "Eracle, esvelle toi! / Dius te mande salus par moi / si te requiert par moi un don. / Eü en as le guerredon / qu'il t'a doné sens et savoir, / honor et hautece a avoir. / Amis, ne l'oublier tu pas, / car tout est de par Dies que t'as, / Or si te mande Nostre Sire / que tu assanles ton empire / quanc'onques on puet assanler" (Gautier d'Arras, *Eracle,* ed. Guy Raynaud de Lage, Les Classiques Français du Moyen Age [Paris, 1976] p. 164, ll. 5323 ff.).

L. Renzi, *Tradizione cortese e realismo in Gautier d'Arras* (Padua, 1964), dates the poem between 1159–1184. It is described as a "religious, hagiographic" work composed in direct response to the fourth crusade. A few years later, there appeared a German version of the same story inspired by the French, by the poet Otte; cf. Winfried Frey, ed., *Eraclius/Otte* (Göppingen, 1983). Lesson 4 of the breviary reading for 14 September implies such a vision, saying that Heraclius was guided by "divine inspiration."

70. Reprint with intro. by Aurelio Rancoglia, ed., *I reali di Francia* (Rome, 1967); also Adelaide Mattaini, ed. *Romanzi dei reali di Francia,* Classici Rizzoli (Milan, 1957). I am grateful to David Quint for introducing me to this poem. See also Gerardo C. A. Ciarambino, *Carlomagno, Gano, e Orlando, in alcuni romanzi italiani del XIV e XV secolo* (Pisa, 1976) (my thanks to John d'Amico for this reference).

71. Cf. Rita Lejeune and Jacques Stiennon, *La légende de Roland dans l'art du Moyen Age* (Brussels, 1966), vols. 1 and 2.

72. Cf. Habig, *Omnibus,* Celano 2, chap. 90, p. 467, and bibliography, p. 1709; Cap Ubald d'Alençon, "De l'origine française de St. François d'Assise," *Etudes Franciscaines* 10 (1903): 449–54. See Francis's passage on Charlemagne

and his knights in the *Legend of Perugia*, sec. 72, Habig, *Omnibus*, pp. 1048–49. Cf. also *Golden Legend*, Feast of Saint Francis, 4 October, p. 597.

73. Habig, *Omnibus*, Celano 1 chap. 5, pp. 232–33; and *Major Life*, chap. 13, sec. 10, p. 735.

74. Habig, *Omnibus*, *Major Life*, chap. 13, secs. 8 ff. pp. 735–36.

75. *Circa festum Exaltationis Sanctae Crucis*, as Saint Bonaventure says (*Major Life*, chap. 13, secs. 8 ff., pp. 735–36; cited by Borsook, *Mural Painters*, p. 93). Bonaventura's version of the story changes the report of Thomas of Celano, who had implied that Francis was keeping a fast between the feast of the Assumption (15 August) and the feast of Saint Michael 29 September; Habig, *Omnibus*, Celano 2, chap. 149, p. 520). The change was part of the official shift of emphasis toward representing Francis as closer to Christ. Another step in this process was the institution of the Stigmatization of Francis as a feast, by Pope Benedict XI in 1304, to be celebrated on 17 September, near the Exaltation but not in conflict with it (now called the Commemoration of the Impression of the Holy Stigmata on the Body of Saint Francis); Luke Wadding, *Scriptores ordinis minorum quibus accesit syllabus illorum qui eodem ordine . . .* (Rome, 1654), vol. 6, sec. 14, p. 39.

An important relic of the True Cross had been brought to Tuscany two decades after the death of Saint Francis. The infamous Fra Elias Coppi of Cortona, previously a close associate of Saint Francis, was excommunicated when he went as emissary of the emperor Frederick II to the court at Constantinople. There he received a large piece of the "Constantinian cross," which he brought back to Cortona. Forgiven on his deathbed, Elias gave the relic to the monastery of San Francesco in Cortona, and later it was housed in a splendid reliquary, inscribed in Greek and Latin and adorned with figures of precious metal; cf. Anatol Frolow, *Les reliquaires de la Vraie Croix* (Paris, 1965), cat. no. 540, and Colin Eisler, "The Golden Christ of Cortona and the Man of Sorrows in Italy," *Art Bulletin* 51(1969): 107–18, 233–46 (with bibliography). Eisler also refers, p. 111, to a document of 1456 stating that a relic of the True Cross, coming from Constantinople, was placed on the altar of the Duomo in Florence, possibly from the same source as the Cortona relic.

76. Although, as we shall see, other Franciscan foundations repeated the usage, the subject was not restricted to Franciscan churches.

77. Salvini, *Gaddi*, p. 84, discusses the aesthetic aspect of the landscapes.

78. Their custodial authority also included the Church of the Nativity in Nazareth; cf. Giovanni Odoardi, "La custodia Francescana di terra santa, nel VI centenario della sua costituzione (1342–1942)," *Miscellanea Francescana* 43 (1943): 217–56. In another context, Borsook, *Mural Painters*, p. 95, suggests this connection was a motivation for Franciscan interest in the subject matter of the True Cross.

79. Cf. John W. Barker, *Manuel II Palaeologus (1391–1425)* (New Brunswick, N.J., 1969), p. 123–99.

80. Thought to have been considered classical originals by the duke, the medals were recently shown to have been designed by the Limbourg brothers soon after their work on the paintings of the *Très riches heures* was complete; cf. Mark Jones, *A Catalogue of the French Medals in the British Museum*, vol. 1, A.D. *1402–1610* (London, 1982), pp. 17–24; idem, "The First Cast Medals and the Limbourgs: The Iconography and Attribution of the Constantine and Heraclius Medals," *Art History* 2(1979): 35–44, citing also Meiss, *French Painting*, pp. 64–65, pp. 131 ff., 217–22, and Roberto Weiss, "The Medieval Medallions of Constantine and Heraclius," *Numismatic Chronicle* 3(1963): 129–44; also Stephen K. Scher, "Gothic, Renaissance, and Baroque Medals from the Museum of Fine Arts, Boston," *Medal*, no. 9, special issue (1986): 81–87.

81. There are several versions of each medal, and no two are treated exactly the same way.

82. Beginning at the top on the left: *Quest of Seth and Adam's Death, Constantine's Vision and Battle,* and *Helena Consulting with Judas and Proofing the Cross;* on the right, Heraclius's Son in Single Combat, Chosroes Enthroned and Killed, and the *Exaltation of the Cross.* See below, Piero della Francesca's version, chapter 7.

83. Leandro de Saralegui, *El Museo Provincial de Bellas Artes de San Carlos* (sala 1 and 2), Cuadernos de Arte 8 (Valencia, 1954), pp. 113–38.

84. *Diccionario de historia de España* (Madrid, 1952), 1:73–74, 2:636–38.

85. The battle of 1212 had the combined forces of Castile, Navarre, and Aragon fighting for Alfonso VIII under a crusade brief from Pope Innocent III. A cycle of the True Cross (attributed to Antoniazzo Romano about 1495–1500, disposed in the Apse pattern around the base of the semidome) in the apse at Santa Croce in Gerusalemme in Rome, commissioned by a Spanish cardinal, either Pietro Gundisalvo de Mendoza or Bernaldino Lopez de Carvajal, probably makes reference to the same Spanish feasts (cf. Saralegui, *Museo Provincial,* p. 135). Cf. Maria Ciartoso, "Note su Antoniazzo Romano, degli affreschi in Santa Croce in Gerusalemme e di due imagini votive," *L'Arte* 14(1911): 42–52; and Gregory Hedberg, "Antoniazzo Romano and His School" (Ph.D. diss., New York University, 1980), pp. 184–87, no. 43a. I owe this last reference to Jonathan Brown.

86. Cf. Corrado Ricci, *Volterra* (Bergamo, 1905), ill. pp. 148, 149; Susanne Phleger, "La Cappella della Croce nella Chiesa di S. Francesco di Volterra," *Rassegna Volterrana* (Accademia dei Sepolti), 59–60 (1983–84): 171–245.

87. Called "out and out copies" by Bruce Cole, "Three New Works by Cenni di Francesco," *Burlington Magazine* 111(1969): 83 ff.

88. See appendix 1, p. 278, for a list of the subjects and their locations.

89. The technique had been used in the sacristy, also off the right wall of the nave, in San Miniato in Florence, for the Life of Saint Benedict (1387–88) by Spinello Aretino; cf. Claudio Paolini, "Scene della vita di San Benedetto in Toscana dal XIV al XV secolo: Problemi iconografici," in *Iconografia di San Benedetto nella pittura della Toscana: Immagini e aspetti culturali fino al XVI secolo* (Florence, 1982), pp. 127–89, bibliography, p. 138.

90. Subjects, as we have seen, bracketing the glory of the Virgin (see above, Prato and Siena). In Volterra the cycle starts with the *Nativity and Adoration of Shepherds* (first bay, top tier, right wall) and continues on the three facets of the apse. The scene in the upper tier of the left bay of the apse seems to represent a throne and could be an *Adoration of the Magi* or a *Coronation,* but it is too badly damaged to judge. See appendix 1 for a list of the subjects and their locations. The *Annunciation* scene has been related to what is apparently the same subject in Piero's cycle; see below, chapter 6.

91. Long since codified in publications such as the *Biblia pauperum;* cf. Emile Mâle, *L'art religieux de la fin du Moyen Age en France: Etude sur l'iconographie du Moyen Age et sur ses sources d'inspiration,* 4th ed. (Paris, 1931), chap. 6, pp. 223–92.

92. Reminiscent of the Saint Martin's Chapel in Assisi of a hundred years earlier; see chapter 2.

93. The relationship of the subject matter to Saint Francis is made explicit in the figure of the saint receiving the Stigmata on the pilaster face between the first and second bay on the right wall; he and other Franciscan saints, Anthony of Padua and Louis of Toulouse, are on the ceiling of the second bay's vault.

94. Cf. Phleger, "Cappella," pp. 172–245, where all the relevant documents and citations concerning the chapel are brought together.

95. *Dizionario biografico degli Italiani,* vol. 29 (Rome, 1983), pp. 638 ff., 671.

96. Bruce Cole, "Masolino's True Cross Cycle in Santo Stefano, Empoli,"

Mitteilungen des Kunsthistorischen Institutes in Florenz 13(1968): 289–300; Irenio Lazzeroni, "Le sinopie degli affreschi di Masolino nella Cappella della Croce in Santo Stefano degli Agostiniani," *Bullettino Storico Empolese* 1(1957): 141–54; Ugo Procacci, *Sinopie e affresci* (Milan, 1961), p. 227; Lajos Vayer, "Problemi iconologici della pittura del quattrocento, cicli di affreschi di Masolino da Panicale," *Acta Historiae Artium* (Academiae Scientiarum Hungaricae) 31(1985): 5–30. See appendix 1 for a list of the subjects and their locations.

97. We shall see below, chapter 6 that Piero also omitted this scene.

CHAPTER FIVE

1. Cf. the thirteenth-century writings by Ludolph of Saxony, *Vita Jesu Christi redemptoris nostri ex medullis evangelicis* (Lyons, 1519), the *Meditationes Christi* by a Tuscan Franciscan (*Meditations on the Life of Christ: An Illustrated Manuscript of the Fourteenth Century,* trans. Isa Ragusa and Rosalie B. Green [Princeton, 1961]), and in passages in *The Golden Legend.* See also, from the next century, Saint Bridget of Sweden, *Revelationes* (Rome, 1628), and Saint Thomas à Kempis (1380–1471), *Opera omnia,* vols. 3 and 5, ed. M. J. Pohl (Freiburg im. Breisgau, 1902–22); Erwin Panofsky, "Imago Pietatis," in *Festschrift für Max J. Friedländer zum 60. Geburtstag* (Leipzig, 1927), pp. 261 ff., discusses this subject at length.

2. For discussion of the competition with Brunelleschi, see Richard Krautheimer, with Trude Krautheimer-Hess, *Lorenzo Ghiberti* (Princeton, 1970), pp. 44–49; see pp. 103–34 for an analysis of the doors themselves.

3. See appendix 1, p. 279, for a list of the subjects and their locations.

4. See above, chapter 2.

5. See above, chapter 3, note 4. In appraising bottom-to-top progression in narrative as "connoting the upward path of salvation," Krautheimer is led to make some brief generalizations about narrative disposition that are not borne out by statistics; cf. *Ghiberti,* p. 114.

6. Peter Partner, *The Lands of St. Peter: The Papal States of the Middle Ages and the Early Renaissance* (Berkeley, 1972).

7. Sarah Blake McHam has prepared an essay on this point: "Donatello's Tomb of Pope John XXIII," in *Life and Death in Fifteenth-Century Florence* (Durham, N.C., 1989). Cf. Horst W. Janson, *The Sculpture of Donatello* (Princeton, 1957), 2:59–65.

8. See above, chapter 1.

9. See above, chapter 1; cf. Lavin, "Giovannino Battista: Study" and "Giovannino Battista: Supplement"; also Penelope A. Dunford, "The Iconography of the Frescoes in the Oratorio di S. Giovanni at Urbino," *Journal of the Warburg and Courtauld Institutes* 36(1973): 367–73; Alberto Rossi, *I Salimbeni* (Milan, 1976), figs. 164–205, for illustrations, some in color, excluding the left wall.

10. The oratory is a rectangle without transept. See appendix 1, p. 278, for a list of the subjects and their locations.

11. Lavin, "Giovannino Battista: Study," and "Giovannino Battista: Supplement."

12. Rossi, *Salimbeni,* figs. 199–202.

13. Meiss, *Painting in Florence and Siena,* pp. 132–56.

14. Cf. Howard Saalman, *The Church of Santa Trinita in Florence* (Pittsburgh, 1966), pp. 7 ff.; and Christa Gardner von Teuffel, "Lorenzo Monaco, Filippo Lippi und Filippo Brunelleschi: Die Erfindung der Renaissancepala," *Zeitschrift für Kunstgeschichte* (1982): 1–30.

15. The organization of the side walls here forecasts a development that would flower at the end of the century when chapel walls were divided into only

two tiers and the pictorial space of each field was great expanded behind heavy architectural frames. See below, chapter 8.

16. Cf. Van Os, *Sienese Altarpieces,* passim.

17. The scenes in the predella are the *Visitation,* the *Nativity,* the *Adoration of the Magi,* and the *Flight into Egypt.* See appendix 1, p. 278, for a list of the subjects and their locations.

18. Cf. Gardner von Teuffel, "Lorenzo Monaco," fig. 5. This idea started a new trend that had its own development in chapel decoration, as we shall presently see.

19. This arrangement recalls the position of the *Assumption* on the exterior of the Cappella Tosinghi e Spinelli in Santa Croce, whose conception is attributed to Giotto, and was also associated with a Life of Mary on the interior of the chapel. See above, chapter 2.

20. Mary appeared to Pope Liberius in the fourth century during a miraculous storm and inspired him to draw the plan of the church in the snow; this event is celebrated in the feast of 6 August (Santa Maria della Neve).

21. One should recall at this chronological juncture (1423), the project to renew the Early Christian fresco cycles in San Giovanni in Laterano in Rome. It was Gentile da Fabriano's last commission; he died in 1427, and Pisanello was called in to complete the work. These painting were destroyed in the seventeenth century to make way for Borromini's new nave. Besides a drawing from Borromini's shop and the pseudohistorical painted records by Filippo Gagliardo (1650) in San Martino ai Monti in Rome (cf. Krautheimer, Corbett, and Frazer, *Corpus,* 5:1–92; see discussion by Michele Metraux, "The Iconography of San Martino ai Monti in Rome" [Ph.D diss., Boston University, 1979], pp. 91–95, 140–48), there are a few fifteenth-century sketches of particular compositions in this cycle by Pisanello and his shop; see Charles de Tolnay, "Conceptions religieuses dans la peinture de Piero della Francesca," *Arte Antica e Moderna* 23 (1963):213. The cycles represented the lives of the two Saint Johns, arranged in the Double Parallel Apse-to-Entrance pattern. That the new frescoes followed the medieval protocol is confirmed by the Borromini drawing, where it is noted that the *Visitation* (an early scene in the Baptist's story) is on the right side near the crossing pier.

22. Ghiberti's first set of doors on the Life of Christ (of course the second for the Baptistry) was installed on the east side of the building in April 1424; the contract for the "third bronze door of S. Giovanni" was dated 2 January 1425; Krautheimer with Krautheimer-Hess, *Ghiberti,* pp. 159–202.

23. Cf. ibid., pp. 159 ff., and Frederick Hartt, "*Lucerna ardens et lucens:* Il significato della Porta del Paradiso," in *Lorenzo Ghiberti nel suo tempo,* pp. 27–57, Atti del Convegno Internazionale di Studi (Florence, 1978).

24. Nonnarrative figures were removed to niches in the frames.

25. Much discussion has revolved around the switch from single to multiple episodes within a given frame, mainly concerning its implications for the chronology of execution. Although Krautheimer (*Ghiberti,* p. 197) maintains that the one monoscenic composition on the doors, the *Solomon* scene, was the last panel to be done because it achieves "a unity of narrative and design, of time and space," Pope-Hennessy ("Sixth Centenary of Ghiberti," pp. 39–105, esp. pp. 59–64) declares that the *Solomon* scene came early in the sequence because its "old style" monoscenic mode lacks the multiple *effetti* of the artist's more developed conception.

26. Ghiberti's experiment had an important effect on contemporary fresco disposition, which I shall take up in due course. For the moment it is sufficient to recall that while these reliefs were in progress, Masolino was working in Ghiberti's shop.

27. See below, chapter 6, for references explaining this typology.

28. The generations of Mary are divided thus, each group divisible by seven,

in Luke 3:23–38. Cf. for bibliography on this complicated subject *The Catholic Encyclopaedia*, vol. 6 (New York, 1909), pp. 410–11. The relation of Ghiberti's program to the generations of Mary was suggested to me by Robert Russell in a graduate seminar at Princeton University in 1983.

29. Fremantle, *Florentine Gothic Painters*, figs. 849, 852, 853; see also Stanislaw Mossakowski, "Raphael's St. Cecilia: An Iconographical Study," *Zeitschrift für Kunstgeschichte* 21(1968): 1–26.

30. The image of Saint Cecilia's elevated body with decapitated head in place is particularly arresting.

31. Vasari first speaks of the subjects he attributes to Masolino in the Life of that artist (*Vite*, 2:265) and then names the rest of the scenes in the Life of Masaccio (*Vite* 2:297 ff.), giving no indication of a topographical sequence in his description.

32. And dating the commission; cf. Borsook, *Mural Painters*, pp. 63–67, for basic bibliography up to 1980. James Beck, *Masaccio: The Documents* (Locust Valley, N.Y., 1978), pp. 19, 27, finds documentation for work only in the years 1427–28, that is, after Masolino returned from Hungary and after completion of the Pisa altarpiece. Issues of attribution were clarified largely as a result of the restoration campaign carried out in the 1980s, which also brought to light the subjects of the lost altar wall lunette level in the form of *sinopie* (underdrawings); cf. Umberto Baldini and Ornella Casazza, in several articles in *Critica d'Arte* 49, 1(1984): 65–72; 51, 11(1986): 65–84; and 53, 16(1988): 72–97. Sometime between 1435 and 1458 the altar wall was changed to accommodate a cult of the "Madonna del Popolo," with a new devotional image and a marble altar. When the altar was dismantled during the restoration campaign, it was found to have covered a fresco scene, presumably a representation of the *Crucifixion of Saint Peter* (the figure of an executioner with his genitals exposed can be recognized on the right side of the field). Also found were traces of an opening in the right wall, suggesting that a shorter composition might originally have been on that wall (perhaps representing the Fall of Simon Magus). Cf. Ugo Procacci, "La Cappella Brancacci: Vicende storiche," in *La Cappella Brancacci nella Chiesa del Carmine a Firenze*, Quaderni del Restauro 1 (Milan, 1984). More than fifty years after the cycle had been left incomplete when the artists went to Rome (where Masaccio died in 1428), Filippino Lippi was called in to repair and complete the work. Finding the lower left wall blocked out, with many heads and other portions fully painted, he filled in the missing parts. With the right wall by now closed in and the last scene of the story destroyed, he completed the cycle with great sensitivity by ending the narrative in a matching three-part composition. (Filippino, it seems, also referred to a motif of Piero della Francesca in a portion of his scene of the *Crucifixion of Peter*; see below, chap. 6.) After the church was damaged by fire in the late seventeenth century and the chapel was threatened with destruction, the lunette tier and vault were redecorated by the eighteenth-century painter Vincenzo Meucci; see Ornella Casazza, "Settecento nella Cappella Brancacci," *Critica d'Arte* 51, 11(1986): 68–72.

33. Leading the way was the study by Astrid Debold–von Kritter, *Studien zum Petruszyklus in der Brancaccikapelle* (Berlin, 1975). See also Carolyn K. Carr, "Aspects of the Iconography of Saint Peter in Medieval Art of Western Europe to the Early Thirteenth Century" (Ph.D. diss., Case Western Reserve, 1978). After discovery of the *sinopie* and the missing subjects, the interpretation was refreshed by Ornella Casazza, "Il ciclo delle storie di San Pietro e la 'Historia Salutis': Nuova lettura della Cappella Brancacci," *Critica d'Art* 51, 9(1986): 69–84.

34. Charles Hope, a late arrival to the topic of narrative cycles, lectured on this chapel (published as "Religious Narrative in Renaissance Art," *Royal Society for the Encouragement of Arts, Manufactures and Commerce Journal* 134 [1986]:

804–18) and several others, adducing the silly conclusion that Renaissance Tuscans "seem to have been quite easy going about [narrative] order" and otherwise trivializing the entire enterprise of fourteenth- and fifteenth-century public painting.

35. See appendix 1, pp. 278–79, for a list of the subjects as they are now known, and their locations on the walls.

36. This placement recalls the scene of the *Martyrdom of Saint Lucy* on the inside face of the right entrance pier of the Castellani Chapel, and presumably its partner on the left now lost, which is also an image from a narrative not developed inside the chapel.

37. Certain compositions at San Paolo have been cited as more than generic sources for frescoes in the Brancacci Chapel. Cf. Joseph Polzer, "Masaccio and the Late Antique," *Art Bulletin* 53(1971): 36–40.

38. Having been moved in the ninth century from the nave; see above, chapter 1. The rule for this placement was codified in a decree of Innocent III (early thirteenth century) requiring the head of Saint Paul to be represented to the right of Christ's body on the crucifix (in connection with the relics of the Lateran), therefore placing Saint Peter on the left, that is, to our right as we face the apse. Cf. Erwin Panofsky, *Studies in Iconography* (Princeton, 1939), p. 140, and further references cited in chapter 1, note 23.

39. Cf. above, chapter 1. The cycle is similarly placed to the right of the high altar in the Duomo of Monreale. Cf. Ernst Kitzinger, *The Mosaics of Monreale* (Palermo, 1960), pp. 14–16; also Eve Borsook, *Messages in Mosaic: The Royal Programs of Norman Sicily, 1130–1187* (Oxford, 1989).

40. The choice of this scene, recalling Giotto's *Navicella* at the Vatican, occurred almost simultaneously with that on the north doors of the Baptistry, and perhaps for similar reasons of papal solidarity; see above.

41. Now that the *Feed My Sheep* scene has been identified, it may be related to the same choice of scene in the Orlandi cycle in Grado; see above, chapter 1.

42. The complexity of the story of the *Tribute Money* is also recognized at San Piero in Grado, where it is expressed not with continuous but with polyscenic inscenation, with Saint Peter performing two actions simultaneously.

43. Cf. Peter Meller, "La Cappella Brancacci: Problemi ritrattistici ed iconografici," *Acropoli*, fasc. 3 (1960–61:) 186–227; fasc. 4 (1960–61): 273–312; Millard Meiss, "Masaccio and the Early Renaissance: The Circular Plan," in *The Renaissance and Mannerism: Studies in Western Art*, 2:123–44, Acts of the Twentieth International Congess of the History of Art (Princeton, 1963); Anthony Molho, "The Brancacci Chapel: Studies in Its Iconography and History," *Journal of the Warburg and Courtauld Institutes* 40(1977): p 50–98, where the scene is connected specifically with the contemporary debates on the institution of the Catasto tax. The reflection of a general but significant mercantile concern for morality in banking in the eyes of the church seems more pertinent.

44. There is discussion over which healing miracle is represented on the left: that of the lame man in Jerusalem (Acts 3:2–10), actually the first miracle, or that of the palsied man in Lydda (Acts 9:33–34). On the right is the *Raising of Tabitha* in Joppa (Acts 9:36–41).

45. The events celebrated by these feasts are fully described in *The Golden Legend*, pp. 330 ff. In fact, under the feast of 29 June all the episodes represented in the chapel are outlined, along with the full description of Peter's contest with Simon Magus, his arrest, and his crucifixion. The establishment of the feast of Peter's Liberation in Rome under the aegis of Pope Alexander VI is also described. Alexander himself was jailed by Quirinus and freed by an angel before he transported Peter's chain relics from Jerusalem to San Pietro in Vincoli.

46. Very little of the painting was carried out by Masaccio before his un-

timely death, probably in 1428; Vayer, "Problemi iconologici della pittura del Quattrocento."

47. See appendix 1, p. 279, for a list of the subjects and their locations.

48. Like many large-scale Crucifixions on altar walls, as in the San Felice Chapel in Padua or the Migliorati Chapel by Niccolò Gerini (ca. 1395) in San Francesco in Prato (cf. *La Cappella Migliorati: Il ciclo pittorico di Niccolò Gerini nel S. Francesco di Prato* [Prato, n.d.]), it identifies the lives of the saints on the flanking walls as imitations of the life of Christ.

49. As mentioned, Masolino was a member of Lorenzo Ghiberti's shop during the final stages of the north doors' production, and the designing period of the east doors. The pictorial technique used in San Clemente strongly reflects the thinking of the second set of doors.

50. Perhaps including Domenico Veneziano and Pisanello; cf. Hellmut Wohl, *The Paintings of Domenico Veneziano, ca. 1410–1461* (New York, 1980), pp. 42–43, pls. 89–91.

51. See appendix 1, p. 280, for a list of the subjects and their locations.

52. This precise arrangement had been used for a Life of the Baptist in the Baptistry of Parma (ca. 1160), where the arrangement also places the scene of *Christ's Baptism* over the altar. Cf. Toesca, *Battistero di Parma.*

53. That of two angels delivering the camel's hair cloak to the youthful Saint John; cf. Lavin, "Giovannino Battista: Supplement," pp. 322–23; Wohl, *Veneziano*, pp. 42–43, pls. 89–91.

54. This point was made by Maria Luisa Gatti Perer in a paper delivered at the symposium Christianity and the Renaissance, Florence, June 1985 (cf. above, chap. 3, note 50); see also Carol Pulin, "The Palaces of an Early Renaissance Humanist, Cardinal Branda Castiglione," *Arte Lombarda* 61(1982): 23–31. When Vecchietta came to Castiglione Olona a decade later (1446–48) to paint in the Branda Chapel of the Collegiata, he too followed this directive. The Life of the Virgin on the upper level, and the Lives of Saints Stephen and Lawrence below, also turn the corners and wrap around the window jambs. Cf. Henk Van Os, *Vecchietta and the Sacristy of Siena Hospital Church* (The Hague, 1974), pp. 57–61.

55. Vasari, *Vite*, 2:676–78.

56. Baldovinetti was paid in 1461 to complete Veneziano's "Marriage" scene. Cf. Wohl, *Veneziano*, pp. 17 ff., no. 86, pp. 200–207. All that remain are fragments of feet and painted marbelized panels.

57. Cf. Lunardi, *Arte e storia in Santa Maria Novella*, pp. 31–67 and bibliography.

58. See above, chapter 3.

59. Not many outdoor, monastic cycles remain intact from this time, but from the few that do, we may judge that the Chiostro Verde is rather out of the ordinary. Most cloister cycles proceed counterclockwise, perhaps relating to some religious function yet to be discovered. Cf. for example, in the nearly contemporary (1436–39) cloister of the Florentine Badia, monoscenic scenes of Saint Benedict's life fill the entire arched area of each bay and progress from right to left; cf. Alfred Neumeyer, "Die Fresken im 'Chiostro degli Aranci' der Badia Fiorentina," *Jahrbuch der Königlichen Preussischen Kunstsammlungen* 48(1927): 25–42; also Paolini, "Scene della vita di San Benedetto," bibliography p. 136. See below, chapter 8.

60. The choice of these themes is apparently quite new to this format and doubtless has implications for the Dominican order at this period. The same patriarchs appear together again on the ceiling of the Strozzi Chapel inside the church; see below, chapter 7.

61. Previewing, as it has been said, his "sculptural painting," which would in his future career fulfill the definition laid down by Alberti. Cf. Ludwig H. Hey-

denreich, *Eclosion de la Renaissance, Italie: 1400–1460* (Paris, 1972), p. 291. See below, chapter 9, for remarks on the use of the technique of green grisaille (with red touches for details) as a simulation of primitive painting to match the primitive beginnings of mankind described in the story.

62. This approach is not unrelated to Masaccio's unification of space on the altar wall at the Brancacci Chapel.

63. Luisa Vertova, *I cenacoli fiorentini* (Turin, 1965); cf. also Frederick Hartt and Gino Corti, "Andrea Castagno: Three Disputed Dates," *Art Bulletin* 48(1966): 228–33. Cf. Borsook, *Mural Painters*, pp. 87–90, for discussion and bibliography of technical and other aspects of this ensemble. See appendix 1, p. 280, for a list of the subjects and their locations.

64. Originally one entered the room from a door in the short wall opposite, and the windows were only on the wall to the right. Since the light on both tiers of the paintings comes from the right and was identified with the real source of illumination, the original effect is now destroyed.

65. As has often been pointed out, the setting for this scene is a building whose perspective construction is architecturally anomalous. Cf. Frederick Hartt, *The History of Italian Renaissance Art* (Englewood Cliffs, N.J., 1975), pp. 221–23. See also Marita Horster, *Andrea del Castagno* (Oxford, 1980), pp. 23–27, figs. 31–64.

66. In paintings by Taddeo Gaddi, Fra Angelico, and so on.

67. The *sinopia* found beneath the fresco and now set up at the opposite end of the room retains the lines of construction showing how carefully this arrangement was prepared.

68. Cf. John Pope-Hennessy, *Fra Angelico* (Ithaca, N.Y., 1974), pp. 202 ff.

69. Cf. chapter 2, note 39 above and chapter 9.

70. Antonella Greco, *La Cappella di Niccolò V del Beato Angelico* (Rome, 1980).

71. Richard Krautheimer, "Fra Angelico and—perhaps—Alberti," in *Studies in Late Medieval and Renaissance Painting in Honor of Millard Meiss*, ed. I. Lavin and J. Plummer, 1:290–96 (New York, 1977).

72. It seems to have persuaded Piero della Francesca to formulate some of his ideas in the Arezzo cycle; see below, chapter 6.

73. Antonio Boschetto, *Benozzo Gozzoli, nella Chiesa di San Francesco a Montefalco* (Milan, 1961), pp. 18–28; Silvestro Nessi, "La vita di S. Francesco dipinto da Benozzo Gozzoli a Montefalco," *Miscellanea Francescana* 61(1961): 467–92; Elisabeth Giese, *Benozzo Gozzolis Franziskuszyklus in Montefalco: Bildkomposition als Erzählung* (Frankfurt am Main, 1986).

74. See above, chapter 3, note 67.

75. Habig, *Omnibus*, Celano 2, chap. 109, p. 481.

76. In the *Legend of the Three Companions* (Habig, *Omnibus*, pp. 890–92, chapter 1.2), the pilgrim-Christ comes to the Bernardone house begging alms. The tradition that Francis was born in a stable, like Christ, seems to begin with this painting; there is a "holy site" in Assisi called "the stable where Saint Francis was born." It received written form only with the seventeenth-century publication of Luke Wadding (*Annales Minorum*; cf. Habig, *Omnibus*, "A new Fioretti: A Collection of Early Stories about Saint Francis of Assisi," pp. 1809 ff., I. Stories of the Early Years, 1, p. 1826).

77. Habig, *Omnibus*, Celano 2, chap. 90, 150, p. 483. In terms of narrative chronology on the left side of the window, tiers 1 and 2 follow a Boustrophedon moving upward. The scene is modeled on the scene of the *Meeting of Saints Peter and Paul* (called *aspasmos* or visitation, in Byzantine art) mentioned in chapter 1 and has the same religiopolitical meaning.

78. This separation of seraph and kneeling Francis into two spaces also is found on the top tier of the fourth window from the apse on the left side of the

nave of San Francesco in Assisi; the same is true on the window in Baroncelli Chapel. Such representations form precedents for Giovanni Bellini's painting, now in the Frick Museum, New York where, if the Stigmatization is represented, the assumed Seraph would have to be outside the frame.

79. Recall the triangulation in Assisi and Santa Croce in Florence.

80. The placement of this figure recalls that of God the Father in Uccello's scene of *Noah's Sacrifice,* in the Chiostro Verde, Santa Maria Novella in Florence.

81. The scenes are identified in the inscriptions.

82. The technique is used again with great power in his frescoes slightly more than a decade later in Sant'Agostino in San Gimignano, another Apse pattern moving upward. It is important to recognize the differences between these ideological cycles and his more purely theological paintings in the Medici Chapel.

In the 1470s, Gozzoli continued the decoration in the Campo Santo in Pisa (destroyed and reconstructed; cf. Bucci and Bertolini, *Camposanto monumentale,* nos. 32–58). Telling the stories of Abraham through the *Meeting of Solomon and the Queen of Sheba,* he employed a disposition that reads from the top down on two tiers, in stacks one field wide, progressing from left to right. The stories are divided into two sets of five stacks. Preceding the Old Testament sequence, a stack contained the *Annunciation* above the *Adoration of the Magi;* after the fifth stack, a *Coronation of the Virgin* was placed above a group of apostles. In both New Testament pairs, the disposition was reversed to read from bottom to top. Gozzoli thereby signaled the difference between prophecy and fulfillment in visual terms. (It would be fruitful to compare these largle-scale continuous narrative compositions with the slightly later scenes of similar subjects in the Moses and Christ cycles in the Sistine Chapel; see below, chap. 7).

CHAPTER SIX

1. Not the four tiers more usual for chancel areas; e.g. the Upper Church at Assisi; Santa Croce, Florence; Sant'Agostino Gubbio; Santa Maria Novella, Florence, and so on.

2. My concern for the True Cross cycle grew out of a long-standing interest in Piero's paintings, in particular their contributions to the transmission of new ideas through the screen of traditional iconography.

3. Decorated, as we have seen, by Agnolo Gaddi in the late fourteenth century. See above, chapter 3.

4. The original wooden pulpit was replaced in the 1430s by one of bronze made by Michelozzo and Donatello; cf. Janson, *Sculpture of Donatello,* pp. 108–18. A marble pulpit was built later in the century for showing the relic inside the church near the entrance; Eric C. Apfelstadt, "The Later Sculpture of Antonio Rossellino" (Ph.D. diss., Princeton University, 1987).

5. Moreover, the building was a *pieve,* that is, a parish church where baptisms can be performed.

6. See the monographic work by Eve Borsook, with Leonetto Tintori, "Fra Filippo Lippi and the Murals for Prato Cathedral," *Mitteilungen des Kunsthistorischen Institutes in Florenz* 19(1975): 1–148.

7. See appendix 1, p. 281, for a list of the subjects and their locations.

8. Cf. Lafontaine-Dosogne, *Iconographie de l'enfance de la vièrge.*

9. Henrik Cornell, *The Iconography of the Nativity of Christ* (Uppsala, 1924), analyses the reference to baptism expressed in such scenes of infant bathing.

10. Saint John is one of the few saints honored with a celebration of his birth (24 June) as well as his death (29 August).

11. *Golden Legend,* p. 410, explains, "The Invention of Saint Stephen took

place on the day when the church celebrates his passion (December 26); the feast was changed (from August 3) for a twofold reason. First Christ was born on earth, that man might be born in Heaven. Thus it was fitting that the heavenly birth of St. Stephen should follow upon the Nativity of Christ."

12. See Borsook with Tintori "Fra Filippo," pp. 149–80, "Conservazione, tecnica e restauro degli affreschi," for the surface losses of narrative features as well as pictorial details in this and other parts of the murals. The two scenes in the right half of the tier depend on the popular narrative tradition, ever more widely known after its arrival in Tuscany early in the fourteenth century; cf. Lavin, "Giovannino Battista: Study," and "Giovannino Battista: Supplement." John's infant years show his precocious piety as he troops daily into the forest seeking the company of nature's beasts, solitude, and communion with the spiritual world. Finally, at the age of seven, he announces to his parents that he must depart forever, to live a hermit's life of contemplation and prayer. In the fresco, his grief-stricken but stalwart parents understand his predestined mission and bid him farewell with an embrace. A second figure of young John, still clad in regular cloth garments, kneels to the left on the opposite side of a river, alluding to the Jordan. His position at the foot of a rock hill alludes to the "mount of penitence," which, according to the story, he will later climb in imitation of Christ. Cf. the similar representation in an early fourteenth-century Riminese panel in the Vatican Pinacoteca (Lavin, "Giovannino Battista: Study," fig. 10; John Pope-Hennessy, *Italian Paintings in the Robert Lehman Collection* (Metropolitan Museum of Art) (New York, 1987), part of an altarpiece by the Master of the Life of Saint John the Baptist, no. 39, pp. 86–87, pp. 288–89, fig. 26). Originally at Prato, there was an angel bringing a reed cross, above to the left where John directs his gaze (now lost). The same apocryphal legends describe John's colloquies with angels who explain his future to him; cf. Lavin, "Giovannino Battista: Supplement," figs. 2–7.

13. The "jagged fold" device for designating pictorial space as an otherworldly realm passed into Late Gothic Italian art from Byzantium and obviously was never lost. Cf. Marie Louise d'Otrange Mastai, *Illusion in Art, Trompe l'Oeil: A History of Pictorial Illusionism* (New York, 1975), pp. 62, 369; Charles de Tolnay, "Remarques sur la Sainte Anne de Léonardo," *Revue des Arts* 6(1956): 161–66.

14. Not all these scenes have been identified with certainty: as a young deacon, Stephen bids goodbye to Bishop Julian and travels to a domestic abode, perhaps that of his natural parents. There he drives away a demon from a possessed youth in chains, perhaps the changeling boy. But there are discrepancies with the written source. Cf. *Golden Legend*, 26 December, pp. 54–58.

15. Fra Filippo here exploits for new purpose the narrative extension from the side to the altar wall started by Giotto at the Arena Chapel and employed on the triumphal arch in the Castellani and Brancacci chapels, among others.

16. The corner-turning technique, in a milder form, had been used to emphasize two important scenes in the *Cycle of Queen Theodelinda* by the Zavattari, dated 1444, in the Duomo of Monza: the *Baptism of Agilulf* and his *Coronation*. In both scenes, the hands that baptize and the hands that crown move around the corners of the apse wall's center facet. See references below in this chapter, note 131. What seems to be a puzzling omission of scenes of baptism in John's story should be understood as suppression of reference to Christological scenes in favor of focus on the relics per se.

17. Died 1448; cf. Bettini and Puppi, *Chiesa degli Eremitani di Padova*, and Giuseppe Fiocco, *The Frescoes of Mantegna in the Eremitani Church, Padua* (Oxford, 1978). The church was destroyed during World War II (now reconstructed), and the frescoes are known only from photographs. See also Ronald Lightbown,

Mantegna: With a Complete Catalogue of the Paintings, Drawings, and Prints (Berkeley, 1986).

18. The main image of the altarpiece represents the Madonna Enthroned with Child; a youngish Saint John the Baptist faces them on the left; Saint Peter Martyr is next to the left, facing Saint Anthony of Padua at the left end of the row. On the right is Saint James the Greater, Saint Christopher carrying the Child and a flowering palm, turning to Saint Anthony Abbot with his bell at the right end of the row. An architectural frame with figured frieze and pediment above and predella in three compartments below completes the ensemble. Originally this altarpiece was under a fresco of the *Assumption of the Virgin* by Mantegna. The format of this fresco—a vertical rectangle taller than a single tier on the side walls—may be thought of as a precedent from for what I shall call the "expanded field;" see below, chapter 8.

19. According to the inscription in the chapel. This double dedication is one of several in church: Saints James the Lesser and Philip in the chancel; Saints Cosmas and Damian in the Sanguinacci Chapel; Saints George and James on the Dotto monument. The two saints named Anthony on Pizzolo's terra-cotta altarpiece should perhaps be thought of in this context.

20. The arrangement is reminiscent of the Baroncelli Chapel and its descendants. See appendix 1, p. 280, for a list of the subjects in the Ovetari Chapel and their locations.

21. See Francesca Flores d'Arcais, *Guariento* (Venice, 1965), pp. 63 ff. Guariento's Gothic-style frames create a further spatial subdivision between the main fields, where figures of evangelists are represented. This relationship was pointed out by Wendy J. Wegener in a seminar report presented in the spring of 1984; a number of other points in the following paragraphs draw upon Wegener's observations.

22. Richard Cocke, "Piero della Francesca and the Development of Italian Landscape Painting," *Burlington Magazine* 122(1980): 627–31, rightly claims "Bono must have known Piero's paintings in Ferrara and/or works like the St. Jerome in Berlin, dated 1450" and learned how to paint water surfaces and reflections from them.

23. Mantegna's emphasis on antique details is deeply connected to narrative itself: James was tried by Herod Agrippa in the Roman court. He was thus the first apostle to die for Christ, an event that signaled the beginning of the persecution of Christians by the Roman army.

24. See George Kaftal, *The Iconography of the Saints in Tuscan Painting* (Florence, 1952), p. 511, fig. 592.

25. Spoken as he baptizes Hermogenes; *Golden Legend*, p. 370.

26. According to the legend, the saint was decapitated with a sword. The change of weapon has been explained as a reference to the antique method used in capital punishment. With his head inserted in a rustic *ghigliottina*, held in place by two staves (one held by a soldier), Saint James lies on his stomach as the executioner stands astride, swinging the wooden mallet (*mazzo*) that will break his neck. The technique is called *mazzolare* and was still in use in the eighteenth century. The reference, among other things, is to the locale of Saint James's execution on the Capitoline Hill. Cf. Silvia Danesi Squarzina, "Eclisse del gusto cortese e nascita della cultura antiquaria: Ciriaco, Feliciano, Marcanova, Alberti," in *Da Pisanello alla nascita dei Musei Capitolini: L'antico a Roma alla vigilia del Rinascimento* (Rome, 1988), p. 29.

27. When Christopher begins his colloquy with the king of Lycia, he is told that having changed his name from "Reprobus," or the Outcast, to Christopher the bearer of Christ, he has taken a fool's name, since Christ could do naught for himself and would do naught for Christopher. Calling him a fool perhaps should

be related to the minstrel and the dwarf in type, and to the words of Saint Paul (1 Cor. 4:9–15); see below, note 107.

28. See Bettini and Puppi, *Chiesa degli Eremitani*, p. 37, fig. 13, for the painted copy of this lost scene, where all the details mentioned are reproduced.

29. The decorations, including the escutcheon of the Ovetari family, are painted as though hanging on the surface of the wall. Even the straps and hooks that hold them are rendered and are lit and shadowed in concert with the scenes they frame. Light in all the scenes is painted to coincide with the source of real light on the altar wall, and the molded frames share this feature of "realism" with the scenes.

30. The day of the Annunciation.

31. By virtue of their own life experiences, both saints became patrons of pilgrims and travelers. In the readings for the Holy Mass on 25 July the words of Saint Paul are quoted: "We are fools for Christ's sake, but are wise in Christ. (Nos stulti propter Christum, vos auten predentes in Christo," 1 Cor. 4:9–15), giving the references to fools in the Christopher story liturgical resonance.

32. Reinforcement of the ulterior argument by the Festival Mode would have been even stronger had the original plans to include scenes of the Passion of Christ on the triumphal arch of the chapel been carried out (cf. Bettini and Puppi, *Chiesa degli Eremitani*, p. 37, fig. 13).

33. His birthdate is unknown (ca. 1415–20); he died on 12 October 1492.

34. All the major monographs deal with the cycle: Roberto Longhi, *Piero della Francesca* (1927, 1945) (Milan, 1963), pp. 75–86; Bernard Berenson, *Piero della Francesca, or The Ineloquent in Art* (1950) (New York, 1954), pp. 9 ff.; Kenneth Clark, *Piero della Francesca* (1951) (London, 1969), pp. 21 ff.; Lionello Venturi, *Piero della Francesca* (Geneva, 1954), pp. 52–92; Philip Hendy, *Piero della Francesca and the Early Renaissance* (New York, 1968), pp. 81–91; Creighton Gilbert, *Change in Piero della Francesca* (Locust Valley, N.Y., 1968), pp. 75–86. Eugenio Battisti, *Piero della Francesca* (Milan, 1971), 1:132–279, 2:19–32; and Mario Salmi, *La pittura di Piero della Francesca* (Novara, 1979), pp. 62–100 ff. Other questions repeatedly discussed are the sequence of execution and the attribution of the various parts of the cycle to various assistants. Subject matter is another area of debate and will be taken up in detail below.

35. Cf. Mario Salmi, "I Bacci di Arezzo nel secolo XV e la loro cappella nella Chiesa di S. Francesco," *Rivista d'Arte* 9(1916–18): 224–37.

36. On the question of the cycle's dating, I wish to voice the opinion that though some planning may have taken place in the early 1450s, most of the painting was done after Piero's experience in 1458–59 in Rome, where, if he had not done so before, he would have seen many of the great medieval fresco cycles extant at the time. I believe, further, that the disposition at Arezzo, as usual, was fully developed before the painting began, and therefore in this context the hands and sequence of execution, much discussed in the literature, are of little interest.

37. See the discussion of the *Finding of the Cross* below. For Saint Francis in Arezzo, see Jacopo Burali, *Vite de Vescovi Aretini, 336–1638* (Arezzo, 1638), pp. 54 (55), 56, 57, 60. Twenty-five years after Francis's death, a Franciscan community settled in the environs of Arezzo, and by 1290 they were given permission to move into town and provide with land to build the present convent. Some time passed before the buildings were fully operative, but apparently already by 1298 the friars could officiate in the church. After a fire a century later (1374), a new *maggiore cappella* was complete; the roof was finished in 1377; Ubaldo Pasqui, *Documenti per la storia della città di Arezzo 1180/1337)* (Florence, 1916), 2:496–97.

38. Divided into three tiers with narrative scenes in all three tiers on the side walls and in the two lower tiers of the altar wall. See appendix 1, pp. 281, 284–

86, for a list of the scenes and their locations. There are nonnarrative, isolated figures of prophets in the lunette tier and others (fathers of the church, saints, and angels) on the inner face of the entrance arch and window jambs.

39. Chronologically, the story begins on the top tier to the right and reads right to left across the tier. It drops to the second tier and reads left to right. It moves to the altar wall, second tier on the right, and descends diagonally to the altar wall's bottom tier on the left. It then returns to the right on the bottom tier. Turning the corner and moving left to right across the bottom tier right wall, it jumps to the second tier on the left of the altar wall. After a leap to the left end of the second tier on the left wall, it reads back left to right. It descends to the bottom tier on the left and reads again left to right. The final move is to the top tier on the left wall, where the story ends with a single monoscenic episode.

40. The two top tiers confront the Tree with the Cross; the second tiers have queens as their protagonists; the third tiers show battle scenes.

41. Michel Alpatov, "Les fresques de Piero della Francesca à Arezzo: Sémantique et stilistique," *Commentari* 1(1963): 17–38. Alpatov rightly concentrated on the reciprocity of the scenes to Christological prototypes, such as the Burial of the Wood (sometimes called the Discovery of the Wood) to Christ Carrying the Cross; see below, note 69.

42. Enzo Carli, *Piero della Francesca: The Frescoes in the Church of San Francesco at Arezzo* (Milan, 1963), pp. 5 ff.; Laurie Schneider, "The Iconography of Piero della Francesca's Frescoes Illustrating the Legend of the True Cross in the Church of San Francesco in Arezzo," *Art Quarterly* 32(1969): 22–48; Michael Podro, *Piero della Francesca's Legend of the True Cross*, 55th Charleton Lecture, University of Newcastle upon Tyne (Edinburgh, 1974).

43. Maurizio Calvesi, "Sistema degli equivalenti ed equivalenze del sistema in Piero della Francesca," *Storia dell'Arte* 24–25(1975): 83–110; René Lindekens, "Analyse sémiotique d'une fresque de Piero della Francesca: La légende de la Vraie Croix," *Canadian Journal of Research in Semiotics* 4, 3(1979): 3–19 (who calls the organization axiological rather than chronological); Jonathan Goldberg, "Quattrocento Dematerialization: Some Paradoxes in a Conceptual Art," *Journal of Aesthetics and Art Criticism* 35(1976): 162 ff.; Norman Bryson, *Vision and Painting: The Logic of the Gaze* (New Haven, 1983), p. 182; *Piero: Teorico dell'arte*, ed. Omar Calabrese, Semiosis, Collana di Studi Semiotici, 1 (Rome, 1985): Louis Marin, "La théorie narrative et Piero peintre d'histoire," pp. 55–84; Daniel Arasse, "Piero della Francesca, peintre d'histoire?" pp. 85–114; Omar Calabrese, "Note su dispositive formale della Storia della vera croce di Piero della Francesca ad Arezzo," pp. 155–72; Omar Calabrese, *La macchina della pittura* (Rome, 1985).

In 1981 the Italian historian Carlo Ginzburg published a collection of studies of works by Piero della Francesca that includes this cycle (*Indagine su Piero* [Turin, 1981], pp. 15–62; English edition, *The Enigma of Piero: Piero della Francesca: The Baptism, the Arezzo Cycle, the Flagellation* [London, 1985]). His points of departure were two: the first was the declaration that, since art historians rarely know how to work with historical material, he would use his professional expertise to remedy the lack of information concerning Piero. The second was that three of Piero's major works, dating over twenty-five years, were produced under the aegis of one person (Giovanni Bacci) and motivated by another (the Greek cardinal Besarion) to promulgate a crusade against the Turks. Pursuing these ideas, Ginzburg set forth a web of historical information concerning intellectual activities in humanist circles in the mid-fifteenth century, extremely interesting in itself but not necessarily in any way connected to the paintings.

Meanwhile, in the process of doing his own research he had discovered what every art historian who works in the fifteenth century already knew, that docu-

ments concerning the Arezzo frescoes were not forthcoming. Thus forced to rely on the published work of art historians (and he took a generous helping from their plates of definitions and solutions), he chose one of the most popular interpretations of the frescoes, "the Turkish question" (see below), and set about trying to prove it (see Eve Borsook's review, *Burlington Magazine*, 125[1983]: 163–64). The result is an attractive but self-fulfilling compilation of information that does little to illuminate the visual or historical problems surrounding the work of art. Although Ginzburg's book now solemnly appears in bibliographies of Piero, one should be aware that it does not contribute to our knowledge of the history of art. For remarks on the historiographic implications of the various approaches, see David Carrier, "Piero della Francesca and His Interpreters: Is There Progress in Art History?" *History and Theory: Studies in the Philosophy of History* 26(1987): 150–65.

44. In Santa Croce in Florence, San Francesco in Volterra, and the chapel of Saint Helena in Empoli (discussed in chaps. 4 and 5), the scenes include (tiers are separated by semicolons) Quest of Seth, Planting of Branch over Adam's Body (these scenes are not represented at Empoli); Sheba's Recognition of the Wood, Solomon's Burial of the Wood; Retrieval of the Wood from the Probatic Pool, Fabrication of the Cross; Saint Helena Finding the Cross, Proofing of the Cross; Saint Helena Returning the Cross to the People of Jerusalem; Chosroes' Theft of the Cross; Chosroes Enthroned, Dream of Heraclius, Battle of Heraclius's Son and Chosroes; Execution of Chosroes, Heraclius Stopped by an Angel at the Blocked Gate, Barefoot Heraclius Brings Cross to Jerusalem.

45. Cf. Gilbert, *Change in Piero*, pp. 75–86.

46. For Piero's superior position among mathematicians of the fifteenth century, see Marshall Clagett, *Archimedes in the Middle Ages*, vol. 3, *The Medieval Archimedes in the Renaissance, 1450–1565* (Philadeophia, 1978), pp. 383 ff., esp. 399–400 and 415–16.

47. Longhi, *Piero*, pp. 121–22, makes much of this counterpoint.

48. Although the Renaissance worshiper would have seen the workings of divine proportion in these geometric shapes, for the viewer of the late nineteenth to early twentieth century the quality of abstraction made Piero seem to join the ranks of "modern" artists. See the informative article on this topic by Albert Boime, "Seurat and Piero della Francesca," *Art Bulletin* 47(1965): 265–71, and the remarks in my forthcoming monograph on Piero (scheduled for publication in 1992, the quincentenary of his death). Piero is the favorite artist of countless living painters.

49. Omitted are scenes of the Probatic Pool, Fabrication of the Cross, Helena Returning the Cross to Jerusalem, Chosroes' Theft of the Cross, Chosroes Enthroned, Dream of Heraclius, and Heraclius Stopped by an Angel.

50. Added scenes are Dying Adam's Conversation about Death*, all Constantine scenes, Judas Extracted from Dry Well, Meeting of Solomon and Sheba*, and Annunciation (* signifies unprecedented in illustrations to the Story of the True Cross).

51. See the bibliography in note 34 above, where individual scenes have been discussed and analyzed at length.

52. See the references cited in chapter 4, note 39 and Alessandro d'Ancona, ed., *La Leggenda d'Adamo ed Eva, testo inedito del secolo XIV,* Curiosità Letterarie 106 (Bologna, 1870), pp. 11–12. What may point to the source of the Latin version is an Arabic legend written by an Egyptian Christian about A.D. 750–60 and known in a later Ethiopian redaction (Sylvain Grébaut, "Littérature ethiopienne Pseudo-Clémentine: Traduction du Qalêmentos," *Revue de l'Orient Chrétien* 16(1911): 72 ff., 167 ff., 225 ff.). In chapter 5 Adam gives elaborate instructions on the subject of his death and burial; in chapter 7 he continues his disquistion with Seth, indicating that his burial is to be in the "Cave of Trea-

sures," and then gives directions on how to live. Adam next divulges the prophecy conveyed to him by God: "Luimême [God] m'a dit que, dans les jours ultérieurs, son Verbe s'incarnerait de la Vièrge (de la fille), appelée Marie; se cacherait en elle" (p. 174). This source is unique, as far as I know, in relating the story of Seth as Adam's heir to the Annunciation (see below) and has not previously been brought together with other sources of the Story of the True Cross.

53. The relationship of the lunette's foreground alignment of isocephalic figures to classical sarcophaghus reliefs should be emphasized. In fact, all the compositions of this cycle are generally arranged along the frontal plane. Individual figures, moreover, recall a variety of classical sources, such as the astonishing male nude with his back to the picture plane. This pose has often been compared to Pothos figures and other sculptures; see Gilbert, *Change in Piero*, p. 20 and n. 34; Richard Cocke, "Masaccio and the Spinario, Piero and the Pothos," *Zeitschrift für Kunstgeschichte* 43(1980): 21–32. More probable as a source are similar figures painted on vases and engraved on metal cistae. One particular example, the Ficoroni Cista (Villa Giulia, Rome; not discovered until the eighteenth century), shows two such figures; cf. Brilliant, *Visual Narratives*, p. 40, who shows that one is "contemplating the coming death of Amycus" and therefore is in a pose of mourning. Piero's connection with such material may be inferred; cf. Ubaldo Pasqui, "Pittori aretini vissuti della metà del sec. XII al 1527," *Rivista d'Arte* 10(1917): 32–87, who mentions Aretine vase makers, sons and nephews of Lazzaro Taldi (who named themselves "Vasari," including Giorgio), with whom Piero worked. But see Frank Dabell, "Domenico Veneziano in Arezzo and the Problem of Vasari's Painter Ancestor," *Burlington Magazine* 127(1985): 29–32. Cf. Michael Vickers, "Imaginary Etruscans: Changing Perceptions of Etruria since the Fifteenth Century," *Hephaistos* 7–8(1985–86): 156–57, who suggests Greek vase painting as a source for Adam's profile. The sinuous outline of Piero's figure seems to emphasize the long staff he leans on. His left hand appears under his right armpit to hold the top of the staff in a manner that attracts attention. Indeed, one version of the True Cross story includes the genesis of the staff of Moses, passed down through the ages from the time of Adam to the patriarch of Exodus. Cf., e.g., the series of sixty-four woodcuts made in Holland and published by Veldener in 1483; reproduced by John Ashton, *The Legendary History of the Cross* (London, 1887), pp. 113–76, figs. 5–9. (The iconographic importance of the staff was first observed by Kay van Valkenberg in a 1975 seminar.)

54. Not unlike the figure of Saint James in the bottom tier on the left in the Ovetari Chapel (see above).

55. Quinn, *Quest of Seth*, bibliography, pp. 165–87.

56. And therefore might be identified as Isaiah (Isaiah, chaps. 4 and 9 in particular).

57. Borsook, *Mural Painters*, p. 97.

58. Richard Morris, *Legends of the Holy Rood*, Early English Texts Society 46 (London, 1871); Cf. M. R. Bennett, "The Legend of the Green Tree and the Dry," *Archaeological Journal* 83(1926): 19–23; Rose J. Peebles, "The Dry Tree: Symbol of Death," in *Vassar Medieval Studies*, pp. 59–79 (New Haven, 1923).

59. The hymn reads, in part, "O certe necessarium Adae peccatum, quod Christi morte deletum est! O felix culpa, quae talem ac tantum meriut habere redemptorum!" Cf. Herbert Weisinger, *Tragedy and the Paradox of the Fortunate Fall* (East Lansing, Mich., 1953); also Victor Yelvertain Haines, *The Fortunate Fall of Sir Gawain: The Typology of Sir Gawain and the Green Knight* (Washington, D.C., 1982), finds the origin of the concept in Exodus, where the narrative explicitly demonstrates that one cannot return from exile without having been in exile.

60. In *Golden Legend* and in Gaddi's Santa Croce rendition, for example.

61. The composition has strong ties to Gaddi's and Masolino's prototypes.

62. André Chastel, "Rencontre de Salomon et de la reine de Saba," and idem, *Fables, formes, figures,* vol. 1 (Paris, 1978) pp. 53 ff.; James B. Pritchard, et al., eds., *Solomon and Sheba* (London, 1974).

63. "The Jews have been declared guilty. And now there is clearly signified the mystery of the church, coming together from the ends of the whole world to learn the words of the true peacemaker Solomon. The church can be seen both in the penitential initiates and in the queen of the south, zealous for wisdom. The church is a queen indeed, her kingdom rising up as one indivisible body, uniting diverse and distant peoples. Lesson 2: The meeting of Solomon and the queen of the south was a great symbol, therefore, of Christ and the church. But what we have now is greater. The former came as a figure, but now the mystery is truly fulfilled. There we had Solomon as a type, but here Christ is present in his own body." (From a homily on Luke 11, read in the Roman breviary during the first week of Lent and as the lesson for Wednesdays).

64. It is often pointed out that the ladies-in-waiting in the Meeting scene were drawn from the same cartoons as in the Veneration scene by simply reversing their design. Not pointed out is the extraordinary continuity of narrative sequence this technique produces.

65. And of the symbolic marriage; see my discussion of this subject, Lavin "Baptism," pp. 82–88.

66. These window wall episodes are usually given to Giovanni di Piamonte, one of Piero's assistants; cf. Roberto Longhi, "Genio degli Anonimi–1.0 Giovanni di Piamonte (?)," *Critica d'arte* 23, 2(1940): 97–100; also Luciano Belosi, "Giovanni di Piamonte e gli affreschi di Piero ad Arezzo," *Prospettiva* 50(1987): 15–35.

67. Hendy, *Piero,* p. 86, calls this pool "the jaws of hell."

68. Bare genitals again correspond to the gross figures in the Brancacci and Ovetari chapels.

69. The Carrying of the Cross has often been suggested here; on such visual references, see Gilbert's contributions and review of the subject: *Change in Piero,* pp. 77–82, n. 38.

70. The most important is that by Rainer Kahsnitz, "Zur Verkündigung im Zyklus der Kreuzlegende bei Piero della Francesca," in *Schülerfestgabe für Herbert von Einem,* pp. 112–37 (Bonn, 1965), on which some of the ideas expressed below depend.

71. The major precedent for the motif of the palm is the cycle of the Death of the Virgin on the *Maestà* by Duccio. The palm was already transferred to the Annunciation of the Incarnation in the fourteenth century and brought to Arezzo, where it became the preferred mode. See the discussion by Mark J. Zucker, "Parri Spinelli's Lost 'Annunciation to the Virgin' and Other Aretine *Annunciations* of the Fourteenth and Fifteenth Centuries," *Art Bulletin* 57(1975): 186–89. Let me point out that it is a misconception to think the angel of the Annunciation always brings a floral offering and that the lily is the most usual of these. During the fourteenth century Gabriel is often empty-handed, and scenes that do include flowers depict lilies, myrtle, and palm fronds in equal numbers (cf. Giacomo Prampolini, *L'Annunciazione nei pittori primitivi italiani* [Milan, 1939]). Each of these plants carries a slightly different connotation. The lily refers to Mary's virginity. The myrtle, from antiquity the symbol of marriage, in Annunciations alludes to the marriage of Christ and the church that took place at the moment of the Incarnation. (Cf. my article on this subject: Marilyn Aronberg Lavin, "The Joy of the Bridegroom's Friend: Smiling Faces in Fra Filippo, Raphael, and Leonardo," in *Art the Ape of Nature: Studies in Honor of H. W. Janson,* ed. Lucy Freedman Sandler et al., pp. 193–210 (New York, 1980). The palm is the Christian symbol of paradise, taken away when man was expelled from the

Garden and returned to Mary, first mortal without sin and the only one to be assumed into paradise directly in the flesh. When the angel gives Mary the palm at either Annunciation, it refers primarily to her role in the scheme of salvation as the key to paradise. Cf. Kahsnitz, "Zur Verkündigung," for the Ave-Eva discussion of Mary as the replacement and antidote for Eve; for the classical background of this symbolism, see Helena Fracchia Miller, "The Iconography of the Palm in Greek Art: Significance and Symbolism" (Ph.D. diss., University of California, Berkeley, 1979), "The palm and victory," pp. 35–58 (beauty, sterility, ability to resist added weight).

72. This point is made by Phleger, "Cappella della Croce," who claims that in strictest terms, therefore, the scene is not a precedent for Piero. It should be observed that the frond given to Mary in the Volterra scene matches the one planted over Adam's body in the same series (fig. 91).

73. See above, chapter 3; Maguire, *Art and Eloquence*, p. 61.

74. Cf. the Cappella del Campo, the structure added to the facade of the Palazzo Pubblico in Siena in 1348 and Michelozzo's tabernacle in Santissima Annunziata in Florence (1449–52; Ottavio Morisani, *Michelozzo Architetto* [Turin, 1951], pl. 154).

75. Carla Gottlieb, "A Sienese Annunciation and Its Fenestra Cancellata," *Gazette des Beaux-Arts* 83(1974): 89–96; she is also known as the Fenestra Coeli; cf. sermon attributed to Saint Augustine (but later), in Migne, *P. L.* 39, col. 1991, 2. The prophet at the top of this vertical zone might be identified as Ezekiel or Jeremiah for these reasons.

76. Such rings are seen in many Renaissance paintings (see, e.g., the background building in Masolino's *Acts of Peter*, on the second tier right of the Brancacci Chapel) and are still in use today on many Italian buildings. See George Goldner ("Notes on the Iconography of Piero della Francesca's *Annunciation* in Arezzo," *Art Bulletin* 56[1974]: 342–44), who along with Hartt (*Italian Art*, p. 241) identifies this object as made of rope, associating it with a noose. It is perhaps more pertinent to observe the subtle effect of the bar's shadow, which seemingly passes through the circumference of the circle, again referring to the mystical properties of the Virgin's impregnation; cf. Laurie Schneider, "Shadow Metaphors and Piero della Francesca's Arezzo *Annunciation*," *Source* 5(1985): 18–22, citing ideas of Howard McP. Davis.

77. And the single veil in the *Annunciation* in the transept of the Lower Church in Assisi. Comparably placed metal struts and rings appear in a Perugian panel of the *Annunciation* in Avignon; cf. Michel Laclotte and Elizabeth Mognetti, *Peinture italienne, Avignon, Musée du Petit Palais* (Paris, 1976), no. 293, ca. 1440.

78. (Arch. Capit. *Sinossi Paci*, n. 119); Pasqui, *Documenti per la storia*, vol. 2, no. 684, pp. 496–97, n. 1. Pasqui speculated that the altar to the left of the chancel may have been functional at this time. See Mario Salmi, "Un'antica pianta di S. Francesco in Arezzo," *Miscellanea Francescana di Storia, di Lettere, di Arti* 21(1920): 97–114, fig. 1, for the plan of San Francesco and monastery by Fra Giovanni da Pistoia (fourteenth century) showing the *tramezzo* and monks' choir in place.

79. The other saints involved (Francis, Anthony, and Clare) are (were) represented in the embrasures of the central window. Moreover, on the uppermost tier of the embrasures there are large-scale vases of flowers; the Sacred Vessel, of course, is another epithet of the Virgin.

80. See below, Saint Ambrose passage.

81. Possibly the large-scale trecento-painted *Cross* on which Saint Francis is shown kissing the feet of Christ, now in the church, or one like it.

82. See above, chapter 4.

83. Outdoing Castagno's flying athletes in Sant'Apollonia. The arrangement

of an angel flying in on high from the left was forecast in the scene *Joseph's Second Dream*, e.g., in the Baptistry of Venice (fig. 145).

84. The cross is very worn; it is perpendicular to the angel's extended hand. In fact, Piero conflates two different descriptions of the vision in the sources: one occurred in daylight when a cross inscribed *"in hoc vince"* appeared in the sky and only later that night is explained to Constantine by Christ, and another in which the nocturnal explanation is made by an angel. See Linder, "Myth of Constantine."

85. In this scene, as in all others in the chancel, light flows from the position of the real window. That the actual light is meant to represent divine illumination, however, is reinforced by the image of the Holy Spirit painted at the apex of the window embrasure. In the *Annunciation* its presence makes the Santa Casa cast a shadow toward the left on the paved floor; in the *Dream of Constantine* it brings the light that streams down toward the right from the cross.

86. A well-known image in Crucifixion scenes, e.g., the Ottonian ivory in the Metropolitan Museum, New York; cf. Adolph Goldschmidt and Kurt Weitzmann, *Die byzantineschen Elfenbeinskulpturen des X.–XIII. Jahrhunderts* (Berlin, 1934), vol. 2, pl. II, n. 6. Constantine's body also hides the vertical tent pole's contact with the horizontal, making it seem to float. All these elements are present but grounded in Agnolo Gaddi's comparable scene (fig. 86).

87. A common motif on antique sarcophaghi. Cf. also the scene of the *Death of Saint Ambrose* in the Sacrament Chapel, San Clemente, Rome, where on the platform of the saint's bed a mourning servant is seated in the same pose (fig. 146).

88. It is no mistake that the wreath-wearing pagan is directly above this scene.

89. As we have seen, earlier representations showed the battle in crusade form, as an equestrian charge; e.g., the rondel on the Stavelot Triptych (fig. 79).

90. This portion of the fresco is badly damaged. The best way to observe the composition as a whole, as well as the battle scenes on the opposite wall, is through the early nineteenth-century watercolor copies made by the German painter Johann Anton Ramboux, in the Düsseldorf Kunstmuseum (fig. 149) and reproduced in Battisti, *Piero della Francesca*, vol. 2, figs. 85, 86; see Aby Warburg, "Piero della Francescas Constantinschlacht in der aquarell Kopie des Johann Anton Ramboux," in *Gesammelte Schriften*, 1, pp. 251–54, 389–91 (Leipzig 1932), who remarked that the scene looked like a crusader battle and related it to events of 1453. See below. Also Irene Hueck, "Le copie di Johann Anton Ramboux da alcuni affreschi in Toscana ed in Umbria," *Prospectiva* 23 (1980): 2–10.

91. Cf. Erich Becker, "Konstantin der Grosse, der 'neue Moses': Die Schlacht am Pons Milvius und die Katastrophe am Schilfmeer," *Zeitschrift für Kirchengeschichte* 31(1910): 161–71.

92. See below, chapter 7.

93. Habig, *Omnibus*, Celano 1, chap. 5, pp. 232–33; and ibid., *Major Life*, chap. 13, sec. 10, p. 735.

94. One of the first authors to make this connection was Jean Babelon, "Jean Paleologus et Ponce Pilate," *Gazette des Beaux-Arts*, ser. 6, 4(1930): 365–75, who related the medal to the figure of Pilate in Piero's *Flagellation* as well. See below, note 126.

95. Joseph Gill, *The Council of Florence* (Cambridge, Mass., 1959).

96. It is so depicted on Pisanello's medal. Cf. Michael Vickers, "Some Preparatory Drawings for Pisanello's Medallion of John VIII Palaeologus," *Art Bulletin* 60(1978): 415–25, with review of the material.

97. In contrast to different styles, even specifically Jewish clothes for Old Testament scenes; observe, for example, one of the stunning women attendants

of Sheba who wears a headdress called a *cornalia* (or *cornu* or *sella*: hair gathered in two raised points on the sides, covered by a veil), which was imposed on Jewish women by the sumptuary laws of 1326 and 1434 in Augsburg and later spread throughout Europe; cf. Gabriella Ferri Piccaluga, "Ebrei nell'iconografia del '400," *Rassegna Mensile d'Israel* 52(1986): 394. On a theoretical plane, some of Piero's contemporaries believed that fifteenth-century Byzantine costumes mirrored those worn by the people of antiquity; see book 10 in Flavio Biondo's *Roma triumphans*, written in 1459 (published in Basel, 1559). Cf. my discussion of this subject in Lavin, *Flagellation*, pp. 59–62; idem, *Baptism*, pp. 62–64.

98. In the same way he alluded to the equally popular image of the emperor Sigmund with costume and facial type while "representing" Saint Sigismondo in his fresco in Rimini; cf. Marilyn Aronberg Lavin, "Piero della Francesca's Fresco of Sigismondo Pandolfo Malatesta . . . ," *Art Bulletin* 56(1974): 354–56.

99. Constantine's mother Helena learns from debates with the Jews of Jerusalem that one of their number knows the whereabouts of Christ's cross, which she has come to retrieve. This person is a certain Judas, grandson of the brother of Saint Stephen (!), who all along has been a secret Christian. When Judas refuses to divulge his knowledge, Helena has him thrown into a dry well; after seven days, he recants and is drawn out.

100. He has fallen in a dunghill.

101. See Giovanni Boccaccio, *Decameron*, intro. Vittore Branca, (Florence, 1966), 1:118, 124; see 3:966–68, bibliography of MSS and illustrations (I thank Paul Watson for his help in locating this reference). See also Vittore Branca, *Boccaccio medievale* (Florence, 1981), esp. pp. 402–3. My special gratitude goes to Professor Branca (who voiced enthusiastic agreement with my observation) for supplying me with many references and color prints of the illustrations for study.

102. There is an uncanny similarity to the scene of *Constantine's Baptism* on the Stavelot Triptych (fig. 79); the three pulley supports over a well resemble the three holy rays descending from the hand of God over the basin on the enamel rondel.

103. Or as Calvesi reads it, "Prudentius," whom he suggests is Prudentius Clement (ca. 348–405), first panegyrist of the martyrs; "Sistema degli equivalenti," p. 94. In fact Prudentius says one should inscribe the following lines under scenes from history to show the concordance of the Old Testament with the New: "Wisdom builds a temple by Solomon's obedient hands, and the queen from the south piles up a great weight of gold. The time is at hand when Christ shall build his temple in the heart of men." Cf. Paul F. Watson, "The Queen of Sheba," in *Solomon and Sheba*, ed. James B. Pritchard et al., part 2, pp. 115 ff. (London, 1974). Salmi, *Piero*, p. 79, quotes a reading by the philologist Augusto Campana as "prude[n] ti vinco" (with prudence I conquer you) and says the image alludes to the decline of Judaism. The use of *vinco* is surely a play on the word of victory inscribed on Constantine's Labarum, extraordinarily not represented in the cycle; it more than likely refers to Judas's coming victory over the devil; see below.

104. The source of the story of Habakkuk (who had planned to take food to the workers in the field and is taken to save Daniel instead) is "Bel and the Dragon," part of the Greek Book of Daniel; cf. Wilhelm Messerer, "Zu Berninis Daniel und Habakuk," *Römishe Quartalschrift* 57(1962): 292–96. In this same manner Dante was pulled from the river Lethe in purgatory (where he was cleansed before entering paradise); "La bella donna ne le braccia aprissi; abbracciommi la testa e mi sommerse. Indi mi tolse [The fair lady opened her arms, clasped my head, and dipped me under, where it behooved me to swallow of the water. Then she drew me forth]." *The Divine Comdey: Purgatory*, ed. Charles S. Singleton (Princeton, 1973), canto 31, ll. 101–3. I am again greatly indebted to

Professor Branca for this reference. The spiral-striped staff carried by the official seems to be a sign of civic authority—at least it was so interpreted by Filippino Lippi when he painted the same detail in the Brancacci Chapel (completed in 1487; cf. chap. 8, note 24). In the scene of the *Crucifixion of Peter* on the lower tier of the right wall, as the saint is hoisted into place by a pulley similar to the one painted by Piero, an armored official directs the proceedings leaning on such a staff, spiral striped this time in red and gold.

105. After the death of Bishop Macarius.

106. Both with the large-scale frescoes we have discussed and with the many illustrations in liturgical manuscripts.

107. For example, the jongleur Taillefer, who holds the horse of the messenger Turold at the Battle of Hastings in the Bayeux tapestry (cf. Rita Lejeune, "Turold dans la tapisseries de Bayeux," *Mélanges Crozet* 1(1966): 419). For a survey of such figures, see Erica Tietze-Conrat, *Dwarfs and Jesters in Art* (London, 1957).

108. Hans Swarzenski, *The Berthold Missal: The Pierpont Morgan Library MS 710 and the Scriptorium of Weingarten Abbey* (New York, 1943), fig. 106, p. 73. There appears to have been a cult of the Cross at Weingarten Abbey. "Un buffone, che era molto innamorato della contessa di Fiandre," is one of the major characters in the *Reali di Francia* (book 1; see above, chap. 4, note 70). We might assume a sequel to this line in the Sala di Costantino in the Vatican, where Grabasso Berettai, the dwarf of Ippolito de' Medici, appears in the scene of *Constantine's Vision* holding his master's Hebrew-inscribed shield; cf. Frederick Hartt, *Giulio Romano* (New Haven, 1957), vol. 1, no. 3, p. 49; vol. 2, pl. 57. See also, Rolf Quednau, *Die Sala di Costantino im Vatikanischen Palast: Zur Dekoration der beiden Medici-Päpste Leo X. und Clemens VII.* (Hildesheim, 1979), pl. 12 and p. 343.

109. See the discussion in Lavin, *Baptism*, pp. 27 ff.

110. According to one version of the legend, the cross was found at the site of a temple to Venus built by Hadrian so that, as *The Golden Legend* says, the people who came to worship Christ would worship Venus on Golgotha. The story says the temple was destroyed just before the crosses were found, and afterward Helena erected a new basillica to mark this topographical concomitance. The painted facade behind Helena may refer to the future building, for it is certainly represented in a "future" style. In fact it is a preview of Bernardo Rossellino's facade for the new cathedral in Pienza: the pedimented superstructures containing circular motives and the three-part facades with circular recesses and inlaid marble patterns are too close to be fortuitous. Designs for this church were in progress in 1459, when Piero was in Rome working at the Vatican; cf. Luciana Finelli, *L'umanesimo giovane: Bernardo Rossellino a Roma e Pienza* (Rome, 1984), and Charles R. Mack, *Pienza: The Creation of a Renaissance City* (Ithaca, N.Y., 1987). He would have had contact there with Rossellino and may even have had a hand in the designing (rather than the other way around), since in Rossellino's oeuvre the design is unique. The right-hand view of the streets of Jerusalem, lined with palaces (the front face of one intersects with the coign of the palace of the adjacent *Well* scene), is crowned by a ghostly white dome, evocative both of ancient Roman hegemony and of the future of the Italic Christian state.

111. "O Judas, what hast thou done? Thou hast acted quite differently from my Judas . . . when Judas heard the crying and shouting of Devil, he was not afraid," *Golden Legend*, p. 274. Visual expression of this episode may be seen on the predella of a polyptych by the Bolognese painter Michele di Matteo in the Accademia, Venice, dating about 1430. The predella shows Helena's mission in several scenes, with the next to the last scene showing two devils flying above the figures of Judas, holding a shovel and pointing (or blessing) with two fingers,

and Helena likewise pointing upward in disputation. Other scenes are *Helena Enters Jerusalem on Horseback, Helena Debates with the Jews, Jews Petition Judas, Helena Arrests Judas, Judas Drawn out of the Well, Judas and Helena Find the Crosses, Helena Proofs the Cross on a Young Man*, and *Devils Exorcised by Judas and Helena*; formerly in church of Santa Elena, Venice; cf. Sandra Moschini Marconi, ed., *Catalogo dell'Accademia di Venetia*, (Venice, 1955), no. 195, p. 172.

112. Habig, *Omnibus, Major Life*, chap. 6, sec. 9, pp. 677–79. The story has been identified historically with the conflict between the Bostoli family and the commune and its Podestà Giovanni Cocci da Viterbo in 1215–16, by P. Marco Renzoni, "S. Francesca ed Arezzo," *Studi Francescani* 22(1950): 129–55. Scenes of the *Cleansing of Arezzo* form part of the cycle of Francis's life in the Upper Church of Assisi (fig. 159) and in the contemporary cycle in the chancel of San Francesco in Montefalco, where its political significance is emphasized, as we have seen.

113. Habig, *Omnibus, Major Life*, chap. 3, sec. 5, p. 648. One wonders if Brother Sylvester's name was fortuitous.

114. Saint Ambrose, *Oration de obitu Theodosii*, ed. Mary Dolorosa Mannix (Washington, D.C., 1925), pp. 59 ff., 77 ff. (delivered on 25 February 395).

115. The composition, since Clark's publication, is usually compared with Roman reliefs, in particular ones on battle sarcophaghi, and said to be less grand and more chaotic and therefore more "mannerist" (or Late Antique) than Constantine's Battle in this cycle.

116. Close prototypes for this kind of battle can be found in historical chronicles, such as the astonishing manuscript description of the campaign of Heinrich VII, ca. 1350 (published by Franz-Joseph Heyen, *Kaiser Heinrichs Romfahrt* [Boppard am Rhein, 1965]); see fol. 10 (fig. 161), where the upper tier shows the Battle of Milan very much in this format, with an earlier style of armor, of course, but including the severed head on the ground. Fol. 19b depicts a battle at the Milvian bridge, the same spot as Constantine's Battle.

117. See the penetrating discussion of significant changes that occurred in historical battle pieces during the early fifteenth century in Randolph Starn and Loren Partidge, "Representing War in the Renaissance: The Shield of Paolo Uccello," *Representations* 5(1984): 32–65 (I thank Barbara Wollesen-Wisch for this reference).

118. The connection with the arch has been noticed by many authors: cf. Warburg, "Piero della Francescas Constantinschlacht," who first pointed out the relationship to the Trajanic relief on the passageway of the Arch of Constantine in Rome (the emperor on a rearing horse with fallen enemy below and the back view of the foot soldier to his right); Michael Vickers, "Theodosius, Justinian or Heraclius?" *Art Bulletin* 58(1976): 281–82, brought the fifteenth-century drawing of the equestrian statue from Constantinople into the discussion, pointing out the similarity of the feathered headpieces in the drawing and on the white-bearded equestrian in the center of this composition.

119. Piero's version of the Persian king's precious tower, with its pseudocelestial firmament, finds its source in the pavilion of the *Annunciation* by Masolino in San Clemente in Rome, where the high location also has celestial connotations. See above, chapter 5.

120. Salmi, "Bacci," and Ginzburg, *Indagini su Piero*, passim.

121. Ernst H. Kantorowicz, "The 'King's Advent' and the Enigmatic Panels in the Doors of Santa Sabina," *Art Bulletin* 26(1944): 207–31.

122. We should recall this pattern, found in the Saint Martin Chapel in Assisi and in the Cappella del Crocifisso in Volterra used horizontally across the architectural space, and seen in the Brancacci Chapel, where it was transferred, as here, to the vertical plane of the altar wall.

123. See above, chapter 2.

124. Gilbert, *Change in Piero*, among other authors, believes the composition of the lunettes were already blocked out by Lorenzo di Bicci, leaving Piero more or less burdened with simplistic arrangements and scene choices. I do not believe Piero would find it necessary to follow such constraints. On the contrary, he would have sought such a reference consciously, to pay homage to a cycle in the major Franciscan church in Tuscany and to the most authoritative prototype for his own cycle.

125. This kind of inscenation is typical of Piero, who always tells what his main point is *visually*. For the most part, his point is something extraordinary, based on tradition but going beyond to the universal realm. His grand and simple style then makes the neoteric subject appear as though it had always been that way. Cf. his painting of the *Baptism*; Lavin, *Baptism*, passim.

126. The subject of the Turkish conflict in Piero's work was carried on by Kenneth Clark (*Piero*, 1951), and further developed by Constantin Marinescu, "Echos byzantins dans l'oeuvre de Piero della Francesca," *Bulletin de la Société Nationale des Antiquaires de France*, 1958, pp. 195–96; the idea was continued by many authors in the 1960s and 1970s, and finally overexploited by Ginzburg, *Indagini*, passim.

127. The one forerunner known to me (mentioned by Kahsnitz and discussed above, chap. 4) is the small-scale Spanish altarpiece by Miguel Alcañiz. Alessandro Del Vita, "La battaglia di Anghiari rappresentata da Piero della Francesca?" *Il Vasari* 17(1959): 106–11, suggests that Piero witnessed the 1440 battle of Anghiari near the Tiber and drew on this experience for his frescoes.

Another large-scale cycle of the True Cross with two battles was created almost simultaneously with Piero's cycle in England at Stratford-upon-Avon, in the chancel of the Chapel of the Guild of the Holy Cross (built about 1450 and destroyed in 1804; before their destruction they were drawn by a Mr. Fisher and published in 1807). Their subjects were Sheba Adores Wood before Solomon; Vision of Constantine; Bloody Battle of Constantine with Maxentius; Helena's Departure for Jerusalem; Judas Released from Dry Well (a dwarf, or child, with sword and shield stands nearby); Finding of the Cross; Proofing of the Cross; Helena Exalts the Cross; Helena and Constantine Adore the Cross; Heraclius's Battle on a Bridge; Heraclius Beheads Chosroes; Heraclius Is Barred from Entering Jerusalem; and Heraclius Exalts the Cross. See Ashton, *Legendary History*, pp. lxiv–lxxiii.

128. Piero had earlier experience with this subject matter in the battle frescoes he did in the d'Este palace in Ferrara about 1450 (destroyed in 1479 or 1509; Vasari, *Vite*, 2:491). Those scenes are thought to have illustrated parts of the *Chanson de Roland* itself. More than one scholar believes they were copied on panels, one now in Baltimore and the other in London. Federico Zeri, *Paintings in the Walters Art Gallery* (Baltimore, 1976), vol. 2, no. 251, p. 373, disagrees with Martin Davies, *The Earlier Schools, National Gallery, London* (London 1961), p. 435 n. 4, who identified them as such; see also Battisti, *Piero*, 1:44 ff., 2:84, fig. 16. For a more extended study, see Jan Lauts, "Note on Piero della Francesca's Lost Ferrara Frescoes," *Burlington Magazine* 95(1953): 166; idem, "Zu Piero dei Franceschis verloren Fresken in Ferrara," *Zeitschrift für Kunstgeschichte* 10(1941–42): 67–72. Archie K. Loss, "The 'Black Figure' in the Baltimore Copy of Piero della Francesca's Lost Ferrara Frescoes," *L'Arte*, n.s., 1(1968): 98–106, (Walters Art Gallery, attr. to Dosso, fig. 1; National Gallery, London, with portrait of Leonello d'Este, fig. 6), identifies the black rider as the Saracen Marsile, "black as melted pitch," who fought Roland at Roncevaux. Cf. Meredith Jones, "The Conventional Saracen of the Songs of Geste," *Speculum* 17(1942): 201–25. George Pudelko, "The Early Works of Paolo Uccello," *Art Bulletin* 16(1934): 257 n. 36, related them to Pisanello, of course, before discovery of the Mantua frescoes. See also Salmi, *Pittura di Piero*, pp. 40–50. Cf. a

painting owned by Cardinal Francesco Barberini, 4 × 4½ *palmi*, given to Marcello Sacchetti, on 5 October 1629, a battle scene attributed to Dosso Dossi; cf. Marilyn Aronberg Lavin, *Seventeenth Century Barberini Documents and Inventories of Art* (New York, 1975), III.inv.26–31.412.

129. The fundamental work on this subject remains Raimond Van Marle, *Iconographie de l'art profane au Moyen-Age et à la Renaissance* (The Hague, 1931) (although many basic definitions would now be questioned, including that of the word profane; many of the stories are religious in content and "secular" only in detail).

130. In many ways these visual characteristics follow the structure of the poems; see Joseph Bédier, *Les légendes épiques*, 3 vols., (Paris, 1921); and Gerard J. Brault, ed., *The Song of Roland: An Analytical Edition*, 2 vols. (University Park, Pa., 1978). In his version of the Cross legend, Bishop Jacobus de Voragine, author of *The Golden Legend*, shares these characteristics, but with a fundamental contribution of his own. In compiling his account he assembled all the sources available to him and then reported on them, one by one. Footnotes had not been invented, and thus each time he moves to a new source the story begins again. For example, when he completes the tale of Seth's Quest quoting the "Gospel of Nicodemus," he says he finds more information in "still another history," where it is told that the branch given to Seth came from the very trees that caused Adam to sin. He goes on to report information from the Scholastic History, Gregory of Tours, Saint Paul, and Saint Augustine. He takes pains to point out that "we are dealing with a legend" and that some of the information is contradictory. He then cites the *Tripartite History*, the *Ecclesiatical History*, the Life of Saint Sylvester, and the Chronicle of the Popes. He thus gives three versions of Constantine's vision and later two versions of his baptism. Afterward he starts the story of Saint Helena, speaking of her origin (several different stories) religious life (Jew and then Christian, Christian before Constantine, Christian after Constantine), and so on. In what may be counted as a brilliant early attempt at scholarship, Jacobus thus scrupulously includes all aspects of the story with their sources. (These qualities are missed in the interpretation of Reames, "*Legenda Aurea*.") As a narrative, however, it has the interrupted, repetitious piling up of episodes and reversals of chronology characteristic of the literature of the time. It seems that this "gothic" literary order disturbed no one.

131. The extant examples are characteristically in northern Italy: e.g., in the Palazzo Borromeo in Milan; the Castello del Buonconsiglio and the Torre Aquila in Trento (Bishop Liechtenstein); fresco of "Otinel" formerly in the Museo Civico at Treviso, along with the Palazzo Chiaramonti in Palermo. See Eurica Cozzi, "Temi cavallereschi e profani nella cultura figurative Trevigiana dei secoli XIII e XIV," in *Tomaso da Modena*, ed. Luigi Menegazzi (Treviso, 1979), esp. pp. 44–52; also Eugenio Battisti, *Cicli pittorici storie profane*, Touring Club Italiana (Milan, 1981). Reflecting this tradition, although in an ecclesiastical setting, is the Cappella di Theodelinda in the Duomo of Monza, dated 1444; see Giuliana Algeri, *Gli Zavattari, una famiglia di pittori e la cultura tardo gotica in Lombardia* (Rome, 1981). On the essentially religious nature of the Monza cycle, see Anthony Hirschel, "Problems of Patronage at Monza: The Legend of Queen Theodelinda," *Arte Lombarda* 80–82 (1987): 105–13. For illustrations of the Sala di Pisanello see Battisti, *Cicli pittorici*, p. 82, pl. 52 (color), and Giovanni Paccagnini, *Pisanello e il ciclo cavalleresco di Mantova* (Venice, 1973); n.b. fig. 15 for a general view of the disposition; pl. XII shows an armored dwarf charging on horseback. Joanna Woods-Marsden, *The Gonzaga of Mantua and Pisanello's Arthurian Fresco* (Princeton, 1989), identifies the French Carolingian romance the frescoes illustrate. We should keep in mind the "melting" characteristic found in Masolino's work, which he often uses to illustrate apocryphal legends. The two phenomena are not unrelated.

132. For example, in 1451, when Florence was threatened by Alphonse of Aragon, Agnolo Acciaiuoli, who was sent to Paris to petition aid from René of Anjou, compared the king to Charlemagne and the other "très glorieux rois de cette très chrétienne maison ont été les fondateurs de notre ville." And the same comparison was made later for Louis XI and then Charles VIII for the same purpose of flattery. See below, notes 140–41.

133. Helene Wieruszowski, "Arezzo as a Center of Learning and Letters in the Thirteenth Century," *Traditio* 9(1953): 321–91, esp. 338 ff.; also Giovanni Moroni, *Dizionario di erudizione storico-ecclesiastica* (Venice, 1840), 3:15–18.

134. In September 1384 the popular but vicious General de Coucy made Arezzo his own. Neither town nor conqueror knew that King Louis of France had been dead for nine days; cf. Brucker, *Civic World*, pp. 102–44. See Magnani, *Cronaca figurata di Giovanni Villani*, fols. 140, 142, 148v, for illustrations of the some of the battles between the cities.

135. The first rebellion against Florence took place in 1408; the second was in 1431, under the guidance of Niccolò Piccinino. There were other rebellions in 1502 and 1529–30, but always to no avail; cf. *Enciclopedia italiana* (Rome, 1949), 4:170–71 and bibliography, p. 175.

136. For descriptions of the "Alte Valle Tiberina," see Lavin, *Baptism*, pp. 19 ff.

137. For Rome and the Divine Imperium, see the discussion of Judith P. Aikin, *The Mission of Rome in the Dramas of Daniel Casper von Lohenstein: Historical Tradegy as Prophesy and Polemics*, Stuttgarter Arbeiten zur Germanistik (Stuttgart, 1976).

138. Arezzo is one of the few Tuscan towns to make a point of dating its Catholic history exactly to the reign of Constantine. See Burali, *Vite de Vescovi Aretini*, p. 2, "SATURO PRIMO VESCOVO ANNO, CCCXXXVI, Quanto nelle arti di Pace, e di Guerra, i Toscani furono chiari fra le nationi Occidentali, tanto ancora per ogni età nello studio della Religione s'avvanzarono; Ma perche nessuna lingua ha mai taciuto simili prerogative, giudico ancor'io superfluo parlarne; solo accennar mi basta, come il popolo Aretino (parti tanto principali dell'Antica, e moderna Toscana) à nessuno degl'altri fu inferiore. . . . de' Vescovi giuderà il Beato Saturo, primo di quelli, che almeno à noi sono noti; ilquale al tempo in cui Regnava nell'Imperio il Gran Costantino, fu da San Silvestro Papa eletto Vescovo d'Arezzo, e confermato l'anno di nostra salute CCCXXXVI, e visse con poco disturbo ani X. con occasione, che ne diede detto Costantino, il quale ordinò non si perseguitasse le vera Fede di Christo, alla quale essortati gli Aretini, con spesse e ferventi orationi da esso Saturo molti crederono [Among the nations of the West, the Tuscan people in every period were as superior in the study of religion as they were in the art of war and peace. But because no one has ever doubted these achievement, it is almost superfluous to speak of them. Suffice it to say that the Aretines, be they principally ancient or modern, are inferior to no one. . . . of the bishops (of the town), the leader would be Beato Saturo, first among those known to us; he was elected bishop of Arezzo during the reign of Emperor Constantine the Great by the pope Saint Sylvester, and confirmed in the year 336. He lived ten years undisturbed owing to Constantine's order not to persecute the True Christian Faith, in which many Aretines believed, having been exhorted with strong and fervent prayers by Saturo]." Repeated by Pietro Farulli, *Annali di Arezzo in Toscana, dal suo principio fino al presente anno 1717* (Foligno, 1717), p. 263.

139. Horace, *Ars poetica*, pp. 113–34. In the fifteenth century Horace was regularly taught in schools. (Aristotle's *Poetics* had not yet been recovered, though scholars gleaned what they could about it from the Horatian sources.) The *Ars* promulgated poetry as "the great civilizing force in human history . . . and the poet, as a balanced moralist, and shrewd observer." Cf. Creighton E. Gilbert, "Antique Frameworks for Renaissance Art Theory: Alberti and Pino,"

Marsyas 3(1943–45): 87–106; John R. Spencer, "Ut Rhetorica Pictura," *Journal of the Warburg and Courtauld Institutes* 20(1957): 26–44.

140. The composition showed a new historicity, moreover, by returning to the Life of Charlemagne by Einhard for some of its facts; cf. Jacques J. Monfrin, "La figure de Charlemagne dans l'historiographie du XVe siècle," *Annuaire-Bulletin de la Société de l'Histoire de France, 1964–1965*, 1966, pp. 67–78, esp. p. 71; Daniella Gatti, *La "Vita Caroli" di Donato Acciaiuoli: La leggenda di Carlo Magno in funzione di una "historia" di gesta* (Bologna, 1981).

141. Alfonso Lazzari, *Ugolino e Michele Verino* (Turin, 1897) (reference kindly supplied by John d'Amico). Cf. further evidence of the politically motivated use of historical myth: the biography and encomium of "Carlo Magno" in the last canto of Pulci's *Morgante Maggiore*; see Constance Jordan, *Pulci's "Morgante": Poetry and History in Fifteenth-Century Florence* (Washington, D.C., 1986), p. 216 ff.; Michel Plaisance, "L'invenzione della Croce de Lorenzo (di Pierfrancesco) de' Medici (1463–1503) et le mythe du second Charlemagne," in *Culture et religion en Espagne et en Italie aux XVe et XVIe siècles*, vol. 4 (Abbeville [France], 1980), pp. 43–107 (text of the *rappresentazione*, pp. 73–104).

142. Enrico Carrara, *Da Rolando a Morgante* (Turin, 1932).

143. Rensselaer W. Lee, "Observations on the First Illustrations of Tasso's *Gerusalemme Liberata*," *Proceedings of the American Philosophical Society* 125(1981): 329–56.

144. Torquato Tasso, "Discorsi del poema eroico," in *Prose*, ed. Ettore Mazzali (Milan, 1959).

145. Francesco Bracciolini (1566–1645), secretary to Cardinal Maffeo Barberini, published the first fifteen books of his *Della Croce racquistata, poema heroico*, in 1601 and finished all thirty-five in 1611; cf. Michele Barbi, *Notizia della vita e delle opere di Francesco Bracciolini* (Florence, 1897). My thanks to Marc Fumaroli for information concerning Bracciolini.

146. Omitted are Solomon's mistake, Chosroes' blasphemy, and Heraclius's affront. Nor is there any reference to the controversies surrounding Constantine's orthodoxy (when he was baptized, and where) or questions concerning the donation (see Podro's remarks on this topic, "Legend," p. 10); cf. Webb, "Truth," who cites a 1469 letter from the Aretine abbot Francesco Aliotto to a Florentine priest praising his historicity and truthfulness as a historian and criticizing "fantastic" and "mendacious" stories such as Constantine's leprosy and baptism by Saint Sylvester as tearing "history to shreds" and being detrimental to faith. Piero includes a representation of Saint Peter Martyr on the surface of a pilaster here to intimate, nevertheless, that Constantine was not an Arian, as sometimes charged. (Saint Peter was killed by Arians as he wrote the Credo.) See Podro, "Legend," also on this point.

147. Saint Francis, "Sermones 4 de S. Francisci," in *Opera omnia*, 9:586 (Quaracchi, 1901), trans. in Eric Doyle, *The Disciple and the Master: St. Bonaventure's Sermons on St. Francis of Assisi* (Chicago, 1983), p. 87. I am grateful to Rona Goffen for making me aware of this passage.

148. The next Constantinian True Cross cycle was that done under Pope Leo X in the Vatican; cf. Quednau, *Sala di Costantino*. There the epic mode is repoliticized, the *Donation* is made the climax of the cycle, and the cycle is put in apposition to the *Coronation of Charlemagne* depicted at the opposite end of the suite of *stanze*. See the discussion of Charles L. Stinger, *The Renaissance in Rome* (Bloomington, Ind., 1985), pp. 250–54, for a history of fifteenth-century post-Valla attitudes and opinions concerning the Donation.

CHAPTER SEVEN

1. The "Cappella Magna" built under Nicholas III (1277–80) was badly in need of repair, and it is claimed that Sixtus IV stripped it down to the founda-

tions (probably in 1477; see Monfasani reference below) and built it anew. The chapel is a simple rectangle without transept, measuring 40.23 × 13.41 meters; Eugenio Battisti's idea that it had the auspicious dimensions of the Temple of Solomon ("Il significato simbolico della Cappella Sistina," *Commentari* 8(1957): 96–104, and "Roma apocalittica e il Re Salomone," in *Rinascimento e Barocco*, pp. 712–95 (Turin, 1960), has met with skepticism. There are six windows on each side wall; there were two above the altar before the restructuring of the west wall in 1536 (to make way for Michelangelo's *Last Judgment*). The chapel is roofed with a flattened barrel vault twenty-one meters high. With the high altar at the west, the liturgical orientation parallels that of the basilica of Saint Peter.

2. That the scheme of the chapel was worked out before hand to allow several artists to work together, as underscored by Ettlinger (*Sistine Chapel*, pp. 31–32), is not surprising. As our study has shown, such a procedure had to have been in use for many centuries for the patterns we have discovered to exist.

3. John Monfasani, "A Description of the Sistine Chapel under Pope Sixtus IV," *Artibus et Historiae* 7(1983): 9–18, reviews the relevant documents, concluding that the chapel was complete and in use before these dates (April–May 1482).

4. Shearman, *Raphael's Cartoons*, pp. 3–5, fig. 4, publishes a miniature showing the pre-Sixtus chapel with an *Assumption* altarpiece.

5. Lost in 1536 when the wall was rebuilt.

6. Cf. Ettlinger, *Sistine Chapel*, pp. 23–25, for historical descriptions and visual documentation of the composition; see also Pietro Scarpellini, *Perugino* (Milan, 1984), cat. no. 30 (p. 78) and fig. 40.

7. Besides evidence for Sixtus's prolonged contemplation before statues and painted images of Mary, his well-documented devotion took the form of many public acts; in 1475 he reconfirmed the feast of the Visitation; he promoted the use of the rosary; he made the Lorentian Litany of the Virgin official; he formalized the Immaculate Conception as part of the church calendar (8 December); he rebuilt and refurbished two great Roman Marian churches, Santa Maria del Popolo and Santa Maria della Pace; and he enriched and redecorated the miracle shrines of the Virgin at Genezzano and Loreto. Cf. Massimo Miglio et al., eds., *Un pontificato ed una città: Sisto IV (1471–1484)* (Vatican City, 1986).

8. See above, chapter 5. Cf. Ettlinger, *Sistine Chapel*, pp. 23–25, for precedent altarpieces painted in fresco.

9. The lunette level at the top was painted later by Michelangelo. Cf. Johannes Wilde's discussion of the decorative scheme of the chamber, "The Decoration of the Sistine Chapel," *Proceedings of the British Academy* 44(1950): 61–81.

10. The top tier presents a series of portraits of the first thirty popes, each next to a window and separated from each other by the same painted pilasters, lined up with the ones below. The bottom register is painted with fictive draperies of the same proportions as the narrative fields and framed in the same way except that the dividing pilasters stand on high bases. Two contracts (one of 27 October 1481 and the other of 17 January 1482) specify that each artist was responsible for painting the rectangular narrative field, the frame around it, the papal portraits associated with the allotted space, and the drapery below. Cf. Ettlinger, *Sistine Chapel*, pp. 23–25, pl. 44b, whose reconstruction differs from that of his predecessors.

11. See appendix 1, p. 281, for a list of the subjects and their locations.

12. Both horizontally and vertically—that is, nonnarrative standing figures superimposed above narrative scenes.

13. The major studies of the chapel are Franz Xaver Kraus, *Geschichte der christlichen Kunst*, vol. 2, part 2 (Freiburg im Breisgau, 1900), pp. 447 ff. (remarks concerning the disposition at Sant'Urbano alla Caffarella and at Santa

Maria Antiqua are inexact); Ernst Steinmann, *Die Sixtinische Kapelle*, vol. 1, *Der Bau und Schmuck der Kapelle unter Sixtus IV* (Munich, 1901), and the reviews by Joseph Sauer in *Germania* (Wissenschaftliche Beilage) 48(1901), and in *Deutsche Rundschau* 32(1906): 27–39; Ettlinger, *Sistine Chapel*; Shearman, *Raphael's Cartoons*; Deoclecio Redig de Campos, ed., *Art Treasures of the Vatican* (Englewood Cliffs, N.J., 1975), pp. 169–73, where the *tituli*, then recently recovered from under whitewash, are quoted. See next note. Cf. also the essay by John Shearman, "The Chapel of Sixtus IV," in *The Sistine Chapel: A New Light on Michelangelo; the Art, the History, and the Restoration*, ed. Carlo Pietrangeli et al., pp. 22–87 (New York, 1986). In a forthcoming monograph, *The Sistine Chapel Walls*, Carol F. Lewine will deal with aspects of the arrangement of scenes as well as choice of subjects and their liturgical significance.

14. To give only two examples, the *titulus* over the *Circumcision of Moses' Son* reads OBSERVATIO ANTIQUE REGENERATIONIS A MOISE PER CIRCONCISIONEM. On the right wall, over the *Baptism of Christ*, the *titulus* reads: INSTITUTIO NOVAE REGENERATIONIS IN BAPTISMO. Over the scenes of *Moses the Lawgiver*, the *titulus* reads: PROMULGATIO LEGIS SCRIPTAE PER MOISEM; over the *Sermon on the Mount*, the titulus reads: PROMULGATIO EVANGELICE LEGIS PER CHRISTUM. Along with the rigid formulation of the titles, forcing even the seemingly disparate compositions into pairs, the profuse use of gold for details and modeling within the figure scenes further nullifies the apparent naturalism of the style.

15. Ettlinger ultimately calls the statement a "historical and political manifesto, bringing to an end the conciliar movement"; *Sistine Chapel*, pp. 117–18. For an extended study of the history of these concepts, see Stinger, *Renaissance in Rome*, chap. 4, "The Primacy of Peter, *Princeps Apostolorum* and the *Instauration Ecclesiae Romanae*," pp. 156–234.

16. In this context, Ettlinger's generalization about disposition, to which I referred in part in thes33Introduction, is of further interest to our topic: "Beginning the narrative at the altar-wall it was customary in the Middle Ages and during the Renaissance either to work round the church and back to altar, or to proceed in a double stream along each side wall toward the entrance. The latter arrangement was the obvious choice in the case of the Sistina with the juxtaposed Moses and Christ cycles. This system . . . creates one peculiar difficulty. We automatically 'read' pictures from left to right as we do the pages of a book" (p. 35). The author then says that the "backward" reading on the left wall made it difficult to create unified space, in his opinion, one of the essential desiderata in the artistic planning of the chapel. I hope the history we have been tracing has shown the irrelevance of such a remark.

17. Such as the apse end of the Arena and the Castellani chapels and the facade end of the Upper Church at Assisi.

18. Upper Church, Assisi, upper two tiers, Santa Maria in Vescovio, and so on.

19. San Giovanni in Laterano perhaps also had this disposition.

20. There may have been more: cf. the mosaic Life of Samson on the floor of the basilica of Misis; Ernst Kitzinger, "Observations on the Samson Floor at Mopseuistia," *Dumbarton Oaks Papers* 27(1973): 133 ff. See also the ninth-century monastery church of Saint John, Müstair in Graubünden (Grisons), Switzerland, where the lengthy Story of David appears on the inside facade, interposed between the two halves of the Life of Christ on the side walls; cf. Cwi, "Study in Carolingian Political Theology," pp. 117–28. For color plates, see also Marèse Sennhauser-Girard, "Carolingian and Romanesque Treasures: The Paintings in the Abbey Church of Müstair," *Swissair Gazette* 8(1986): 28–37. The cycle in Santa Maria in Cosmedin in Rome, dated 1120–23, is now identified on the basis of seventeenth-century drawings as scenes from the life of the

Old Testament prophet Ezekiel (cf. Maffei, "Riflessi dell'Epopea Carolingia nell'Arte Medieval," pp. 351–92. A trecento instance of a prolonged Life of the Old Testament Joseph (thirteen scenes) is found on the second tier of the Florentine Baptistry; see above, chapter 1.

21. Moses scenes were included on the Old Testament sides of both Old Saint Peter's and Saint Paul's; scenes of the plagues in Egypt and other episodes were shown in at least eleven separate compositions. Individual Moses scenes played roles in the early typological cycles, e.g., in San Giovanni in Laterano and in the aisle of Sant'Angelo in Formis and at Monreale; a limited number of episodes from his life are included on Ghiberti's second set of doors.

22. Not to be forgotten are the other near-contemporary representations of the Moses story, for example, in the Gianfigliazzi Chapel in Santa Trinita, Florence (cf. Ruth W. Kennedy, *Alessio Baldovinetti* [New Haven, 1938], pp. 172 ff.) and the major narrative compositions (now lost) on the Life of Moses in the Old Testament cycle by Benozzo Gozzoli in the Campo Santo in Pisa (the Crossing of the Red Sea, Moses with the Laws, Story of Corah, Rod of Aaron, Serpent of Bronze, Death of Aaron, Death of Moses), most of which were painted before the Sistina; see references in chapter 5, note 82.

23. See above, chapter 1, for references and Ettlinger, *Sistine Chapel*, pp. 44 ff.

24. One other Franciscan had been elected to the papacy between Nicholas and Sixtus, namely Alexander V, who reigned only ten months during the Great Schism and died in 1410 before ever reaching Rome.

25. Francesco della Rovere began his Franciscan career at the age of nine. After an excellent education in philosophy and theology, he had risen to be general of the order (1464, Perugia); a trip to Assisi is documented in August 1476, where he celebrated the feast of Saint Francis and venerated his relics with great devotion. Cf. Luke Wadding, *Annales minorum*, 14:145 ff.; Ludwig Pastor, *History of the Popes* (Saint Louis, Mo., 1989), 4:289 and notes. As pope, he remained very partial to the order, canonizing, on 14 April 1482, Saint Bonaventure and the Minorites martyred in Morocco; cf. Pastor, *Popes*, pp. 201–10. A hundred years later the next Franciscan pope, Sixtus V, took the same name and made the ultimate personal connection with the church by choosing it as the place of his funerary chapel (see below, chap. 9).

26. In examples by Ghiberti, Fra Angelico, Gozzoli, or Piero.

27. Only the *Institution of the Eucharist*, by Cosimo Rosselli, is set within an architectural structure. See discussion below.

28. Which have been described in similar terms by Kitzinger, *Byzantine Art*, pp. 72 ff. (above, chap. 1, note 10).

29. So Ettlinger observed (*Sistine Chapel*, pp. 41–42). This author's attempt to show a consistent three-part massing of forms as a basic design principle in each field is neither successful nor pertinent.

30. This unusual scene of *Michael Defending the Body of Moses*, not incidentally, ensures the inclusion of representations of all three of Saint Francis's saintly patrons. After Mary and Saint Peter, "he was particularly devoted to Saint Michael the Archangel because it is his task to bring souls before God." Habig, *Omnibus, Major Life*, chap. 9, sec. 3, p. 699.

31. The scenes on the entrance wall, originally by Signorelli and probably Rosselli, were repainted in the sixteenth century by Arrigo Fiammingo and Matteo da Lecce.

32. "When you, dearest Brethren, receive this letter, imitate the people of Israel as they wept over their great leaders, Moses and Aaron. We may permit our tears to flow freely—we who have lost the consolation of such a father!" Habig, *Omnibus*, Letter of Brother Elias, p. 1959.

33. These points are made by Fleming in *From Bonaventure to Bellini*, pp. 46

ff. Fleming refers to the well-documented study by Sophronius Clasen, "Franziskus, der neue Moses," *Wissenschaft und Weisheit* 24(1961): 200–208.

34. Habig, *Omnibus*, Bonaventure, *Minor Life*, chap. 6, sec. 4, p. 823; as Fleming points out (*From Bonaventure to Bellini*, p. 48), these lines are read as the sixth lesson for the feast of the Stigmata in the Roman breviary.

35. Ubertino da Casale, *Arbor vitae crucifixae Jesu* (Turin, 1961), 3, 3, f.k ii^r. Cf. Fleming, *From Bonaventure to Bellini*, p. 57.

36. The inscription reads in translation, "Let no man take the honor unto himself, but he that is called by God, as Aaron was"; see Fleming, *From Bonaventure to Bellini*, pp. 99 ff., for discussion of Francis's identification with Aaron. Ronald Lightbown, *Sandro Botticelli: Life and Work* (Berkeley, 1978), pp. 59–61, observed that the original quotation (Heb. 5:4) is changed here from a statement to a command. The *tituli* of these scenes are: left side, "Conturbatio Moisi Legis Scriptae Latoris"; right side, "Conturbatio Iesu Christi Legis Latoris."

37. Sauer (review of Steinmann) was the first to define this threefold function; Ettlinger, *Sistine Chapel*, pp. 66–69; also pp. 112 ff., 117.

38. Fleming, *From Bonaventure to Bellini*, pp. 19, 162–63.

39. Saint Francis was Francesco della Rovere's patron, along with the Virgin Mary. Not three months after I finished the text to this chapter, I had the pleasure of reading Rona Goffen, "Friar Sixtus IV and the Sistine Chapel," *Renaissance Quarterly* 39 (1986): 218–63, in which, by quite another route, the author reaches the same basic conclusion. See her concise yet detailed analysis of the Franciscan content in each composition. See also Frederick Hartt, "*Lignum Vitae in Medio Paradisi:* The Stanza d'Eliodoro and the Sistine Ceiling," *Art Bulletin* 32(1950): 131–34, for discussion of the Franciscan character of many symbols from both Sixtus's and Julius II's campaigns in the chapel.

40. On 4 September 1483; cf. Pastor, *Popes*, 4:394, and Goffen, "Friar Sixtus," pp. 231–32 n. 53.

41. When the Florentines turned against Gregory XI and toward the Avignon papacy; see above, chapter 4. It is said the Sixtus was behind the Pazzi revolt of 1478; his war with Florence began in July of that year. There followed a papal interdict, and fighting continued until 3 December 1480. In spite of help from Louis XI of France, Florence lost and peace was officially concluded in December 1482. In honor of this event, the pope initiated the rebuilding of a Roman church, renaming it Santa Maria della Pace (Pastor, *Popes*, pp. 300–330).

42. The tapestries later designed by Raphael and placed over the fictive hangings below the narrative scenes followed the disposition of the frescoes, with matching cycles, of Saints Peter and Paul. Starting with one unit from each on the altar wall, they continued on the side walls toward the main entrance. The Saint Peter scenes were on the right, Saint Paul on the left. This placement is fully discussed by Shearman, *Raphael's Cartoons*, pp. 38–44, who cites the comments of Paris di Grassis and the traditional requirement that Paul (of the tribe of Benjamin, *filius dexterae*) be represented on the right (facing the nave) of the crucifix on the altar. This arrangement puts Peter on the right facing toward the altar and may have had a bearing on the tradition I have noted that places Saint Peter cycles to the right of the altar and in the right transept. See above, chapter 5.

43. Vasari, *Vite*, 3:189, is actually criticizing Rosselli for succumbing to the pope's questionable taste. Since he uses the same anecdote to describe the taste of Julius II as unsatisfactory when speaking to Michelangelo, we may take Vasari's remarks as serving a role other than reportage.

44. This composition is discussed by Sandström, *Levels*, pp. 49–50, and related to that of Castagno's *Last Supper* in Florence (see above); in his chapter on Rosselli's *Institution of the Eucharist*, pp. 413–22, Steinmann claims that these three scenes were added on the orders of Pope Sixtus himself. Cf. Goffen, "Friar

Sixtus," pp. 257–58, for discussion of the number symbolism in these constructions.

45. The saga of the Sassetti commission has been well studied; after a disagreement with the Dominicans at Santa Maria Novella, Francesco bought new space in Santa Trinita (between 1478 and 1480). There he found an ambient already dedicated to his patron, Francis of Assisi, whose life he wished to have represented. (Santa Trinita was at this time an abbey church of the Vallombrosians, whose sympathies toward the Franciscans were expressed by their adopting the Franciscan habit, omitting only the cord worn as a belt.) Borsook, *Mural Painters*, pp. 117–22; Eve Borsook and Johannes Offerhaus, *Francesco Sassetti and Ghirlandaio at Santa Trinita Florence: History and Legend in a Renaissance Chapel* (Doornspijk, 1981); Peter Porçal, "La Cappella Sassetti in Santa Trinita a Firence: Osservazioni sull'iconographia," *Antichità Viva* 23(1984): 26–36.

46. Aby Warburg, "Francesco Sassettis Letztwillige Verfügung (1907)," in *Gesammelte Schriften*, 1:127–58, 353–65 (Leipzig, 1932), translated in *La rinascita del paganesimo antico* (Florence, 1966); Fritz Saxl, "The Classical Inscription in Renaissance Art and Politics," *Journal of the Warburg and Courtauld Institutes* 4(1941): 19–46, esp. 27–29.

47. Use of the exterior facade of a chapel as a field for narrative is reminiscent of the Bartolini Chapel across the transept. See below for another relationship to the same chapel.

48. Cf. *Golden Legend*, p. 49.

49. Cf. Iris Origo, *The World of San Bernardino* (London, 1960), with bibliography.

50. The vista down the sweep of the hill is squeezed together vertically, with the huge dome of the Pantheon throbbing above the Church of San Marco, Old Saint Peter's above the Pantheon, and the spiral column of Trajan only slightly to the right thereof.

51. See appendix 1, pp. 281–82, for a list of the subjects and their locations.

52. See above, chapter 1. For discussion of the individual scenes and illustrations, cf. Borsook and Offerhaus, *Sassetti*, pp. 27–33.

53. One Franciscan text speaks of Bernardone's rage and says that he beat Francis and put him in chains; Habig, *Omnibus, Minor Life*, chap. 1, sec. 7, pp. 796–97.

54. Habig, *Omnibus*, Bonaventura, *Major Life*, pt. 2, chap. 2, sec. 4, p. 755.

55. Ibid.

56. The miracle is commonly misnamed for the Spini family, whose palace appears in the painting.

57. Current studies show that the architectural backdrop identified the city of Florence as the new Rome, city of peace following the end of the conflict with the papacy and the imminent arrival of the Golden Age. See Borsook and Offerhaus, *Sassetti*, pp. 44, 49–50, who also discuss the famous portraits in the foreground of this scene.

58. Cf. the detailed analysis of the altarpiece in ibid, pp. 33 ff., where the reciprocity between the Eucharistic themes in the panel, the scenes above, and the Bernardine trigram in the entrance arch fresco are pointed out; see also Porçal, "Cappella," on this topic. A passage from Porçal's text, incidentally, demonstrates how little understood the concept of "visual order" remains: "La storia della resurrezione del bambino che fu infine scelta rappresenta un miracolo eseguito dal santo dopo la sua morte e viene stranamente dipinta tra le scene della vita di Francesco, *contro ogni regola* che avrebbe voluto che la scena apparisse dopo quella del funerale del santo [The story of the resurrection of the little boy finally chosen represents a miracle carried out by the saint after his death and is strangely placed among the scenes of Saint Francis's life, *against every rule* that should have the scene appear after the funeral of the saint]." However, this au-

thor could not miss the significance of the displacement and adds new substance to the phenomenon in the currency of his argument, saying: "Probabilmente si può ricercare la spiegazione di questa dispozione anancronistica nella volontà di raffigurare il miracolo proprio sopra l'altare associandolo alle tre annunciazioni dell'incarnazione nell'intento di enfatizzare la forza della religione cristiana 'post eventu incarnationis' [Probably one can find an explanation of this anachronistic disposition in the desire to represent the miracle exactly over the altar, associating it to the three annunciations for the purpose of emphasizing the power of the Christian religion 'post eventu incarnationis']."

59. See chapter 8.

60. And Jews, exemplified by a statue of David on a column painted on the pilaster to the left of the chapel's entrance; cf. Borsook and Offerhaus, *Sassetti*, pp. 49–50. Syncretism between classical rationalism, Hebrew monotheism, and the Christian faith is a major element in the thematic unity of the chapel.

61. Planning for this juxtaposition perhaps motivated the chronology's downward progression, in contrast to the organization of Gozzoli's fairly recent Life of Francis in Montefalco, which moves upward. See above, chapter 6.

62. One of the first instances of a revival type of formula that would soon become common.

63. The interweaving of themes and patterns has other ramifications that further unify the disposition. The two episodes on the left wall both have landscapes with recognizable cities in the background. The two dramatic scenes on the right are set in monumental open pavilions. Thematically they are each other's opposites: in the *Trial by Fire*, the "infidel" refuses to be moved (cf. Porçal, "Cappella," on the subject of the "Great Conjunction"). In the *Funeral of Saint Francis* the "doubter is convinced"; cf. Habig, *Omnibus, Major Life*, chap. 15, sec. 4, p. 743. Both scenes pay homage to the classic compositions of Giotto in the Bardi Chapel, adding many contemporary characters. The great change in the last scene is that the "doubter" now stands behind the bier and is part of a deeply moving configuration of three men, resembling a *meterza* composition of highly emotive figures.

64. Cf. Warburg, "Francesco," and Borsook and Offerhaus, *Sassetti*, passim.

65. After the failure of many branch banks in Milan, Avignon, Bruges, and London during 1478–80; Lorenzo "stands by" Francesco in the *Rule* scene.

66. The consolatory aspect of this fresco should be related to that of the *Flagellation* by Piero della Francesco; cf. Lavin, *Flagellation*, pp. 70, 99n. 43.

67. Borsook and Offerhaus, *Sassetti*, pp. 52 ff.

68. Charles T. Davis, "Topographical and Historical Propaganda in Early Florentine Chronicles and in Villani," *Medioeva e Rinasciemento, Annuario* 2(1988): 33–51. See also chapter 4.

69. See above, chapters 4 and 6.

70. Borsook and Offerhaus, *Sassetti*, p. 21.

71. *Dizionario della lingua italiana* (Florence: 1975), Sansoni, s.v. "Corso, edilizia."

72. *Bibliotheca sanctorum*, vol. 2, cols. 1294–1321. The trigram was first used as a sign of peace in 1257; it had been placed on the facade of Santa Trinita, where it remained until the sixteenth-century restoration; cf. Borsook and Offerhaus, *Sassetti*, n. 102. Ghirlandaio further identified the symbol with the kneeling Virgin in the altarpiece below by repeating its stippled gold rays and flames in the circle of Mary's halo.

73. Using ambient frames to indicate the levels of reality is reminiscent of the technique used in the Ovetari Chapel in Padua; see above, chapter 6.

74. Borsook and Offerhaus, *Sassetti*, pp. 14–15.

75. But see below, note 79. The area had been decorated by Orcagna about 1348 with a cycle of the Life of the Virgin; by the early fifteenth century it was

in poor condition but, according to Vasari, visible enough to have had some effect on the replacements; see *Vite*, 3:260–61: "Logò Giovanni a Domenico questa opera con le storie medesime che erano dipinte prima." James Wood Brown, *The Dominican Church of Santa Maria Novella* (Edinburgh, 1902); Hans Dietrich Grounau, *Andrea Orcagna und Nardo di Cione* (Berlin 1937); see also Patricia Simons, "Patronage in the Tornaquinci Chapel, Santa Maria Novella, Florence," in *Patronage, Art, and Society in Renaissance Italy,* ed. F. W. Kent and Patricia Simons with J. C. Eade, pp. 221–50 (Oxford, 1987). Giuseppe Marchini, "The Frescoes in the Choir of Santa Maria Novella," *Burlington Magazine* 95(1953): 320–30, who wrote just after the frescoes were cleaned, and whose main point was to attribute particular areas to specific individuals in Ghirlandaio's shop (including the young Michelangelo), said the frescoes were done at the "moment in Quattrocento painting in which all the principal conquests of the early Florentine Renaissance are taken into account and made use of." Like so many authors, he is unaware of the issue of disposition, where the real contribution of these frescoes lies.

76. Gerald S. Davies, *Ghirlandaio* (New York, 1909), pp. 103–30, app. VI, pp. 170–72. Signed on 1 September 1485, with work beginning in May 1486, completion was to be in four years' time.

77. See appendix 1, p. 282, for a list of the subjects and their locations.

78. This subject, like the *Visitation* in the John cycle, connects Mary and Saint Elizabeth, who both participated in both events. See Lavin, "Giovannino Battista: Supplement," pp. 319–20.

79. See references in Simons, "Tornaquinci Chapel," p. 235 n. 45. The child was born 11 October 1487.

80. The *Annunciation,* as we have seen, appeared on triumphal arches throughout the Middle Ages; *Saint John Entering the Desert* is placed in the identical position on the altar wall of the Castellani Chapel (see above, chapter 3).

81. This formulation was made by Adrian Randolph in a seminar report, Princeton University, fall term, 1986. Randolph also suggested that since these scenes were private experiences, they could not hold contemporary participants and therefore were more conveniently placed on the altar wall. A similar suggestion was made by Hope, "Religious Narrative in Renaissance Art," pp. 804–18.

82. Remember that the *tramezzo* (choir screen; see note 85) was still in place at this date, limiting visibility; cf. Marcia Hall, "The *Ponte* in S. Maria Novella," *Journal of the Warburg and Courtauld Institutes* 37(1974):157–73.

83. The organization of the altar wall also reads from the bottom up. The first tier shows the donors kneeling in prayer, Francesca Pitti on the right, Giovanni Tornabuoni on the left. The third tier up contains two scenes from the life of the major Dominican saint after Dominic, Saint Peter Martyr: *Peter Burning Heretical Books* and the *Martyrdom of Peter* (cf. *Golden Legend* under 29 April, pp. 247–59). These scenes express Dominican fears of ancient texts and might be seen in relation to the classical allusions in the Sassetti Chapel. The lunette area above shows heavenly hierarchies, kneeling saints, Old Testament prophets above, musical angels and then, crowning the top in the highest region, the *Coronation of the Virgin.* The scenes in the stained-glass window, also designed by Ghirlandaio (1492), place the Assumption of the Virgin at the top of the window, just below the painted Coronation. On the second tier of the window is a scene of the Purification of the Virgin, salvaged from the original program of the side wall, and below the Miracle of Snow, or the Founding of Santa Maria Maggiore in Rome.

84. San Bernardino da Siena had traveled extensively in this region, founding communities and spreading his preaching techniques. His method of preaching involved the use of a wooden plaque carved with his trigram to assist his listen-

ers, as he said, in spiritual concentration, emotion, and devotion. Cf. Origo, *World of San Bernardino*, pp. 14–16.

85. The *tramezzo* is the feature in monastic churches ministering to the laity that closes off the monks' choir from the rest of the nave. They were mostly destroyed in the churches of central Italy.

86. At Ivrea (Church of San Bernardino by Martino Spanzotti), Varallo (Santa Maria delle Grazie, by Gaudenzio Ferrari, 1486), Caravaggio (San Bernardino, by Fermo Stella, ca. 1510), and Borno (Chiesa dell'Annunciata, artist unknown), and with variations, Lugano (Santa Maria degli Angeli, Bernardino Luini, 1520–25), to mention only a few. See Alessandro Nova, "I tramezzi in Lombardia fra XV e XVI secolo: Scene della Passione e devozione francescana," in *Il Francescanesimo in Lombardia: Storia e arte*, pp. 197–216 (Milan, 1983), pls. 83, 84, 85, 88; see below for further discussion of the Luini fresco.

87. Philip McMahon, *Leonardo's Treatise on Painting (Codex Urbinas Latinus 1270)*, trans. and annotated (Princeton, 1956), vol. 1, part 2 ("The Composition of Narrative Painting"), pp. 106–12, fols. 38v–44, nos. 256–74; no. 265, p. 109, "Why Depicting Rows of Figures One Above the Other Is a Method of Working to Be Avoided" (Perche i capitoli delle figure l'uno sopra l'altro e'opera da fugire): "Questo universale uso il quale si fa pei pittori nelle faccie delle capelle e' molto da essere ragionevolmente Biasimato impero che fanno l'una storia in un piano col suo paese et edifici poi s'alzono un altro grado e fanno una storia e variano il punto dal primo e poi la terza e alla quarta in modo che una facciata sine de fatta con quattro punti la quale e' somma stoltitia di simili maestri, noi sapiamo ch'el punto e' posto a l'ochio del riguardatore della storia." And further to this point: ibid. ("Expression of the Face," fol. 108, no. 418, p. 155): "And your narrative paintings should not show one figure above the other with different horizons on the same wall, so that the painting seems to portray a shop with merchandise for sale in rectangular drawers" (e' che le tue storie non sieno l'una sopra de l'altra in una medesima pariete co[n] diversi orizzonti chella paia una botega di merciaio cole sue cassette fatte a'quadretti). From his phraseology, we may surmise that Leonardo expected the story to start at the bottom of a wall and progress upward. His statements, in this context, take on new, if oblique, historical resonance in recognizing, although with disapproval, Renaissance fresco arrangements as having a conceptual basis. He was perhaps the first to articulate the possibility of alternative solutions.

88. Stemming from Aristotle in the first instance and Vitruvius in the second, these ideas had been reemphasized by Alberti in 1436 in his own highly influential architectural treatise and had so passed on to Leonardo.

89. Cf. Borsook, *Mural Painters*, p. xliii, for a discussion of the antipathy between solid wall surfaces and the new perspective style.

90. McMahon, *Treatise*, chap. 265.

91. Luini, along with the other painters in Leonardo's Milanese circle, probably heard the master discourse at length if he did not actually read his notes.

92. Cf. Luca Beltrami, *Luini, 1512–1532* (Milan, 1911), figs. on pp. 475, 478, 484, 486–88.

93. Ernst H. Gombrich, *Means and Ends: Reflections on the History of Fresco Painting*, Walter Neurath Memorial Lecture (London, 1976) pp. 35 ff.

94. Alessandro Marabottini, *Polidoro da Caravaggio* (Rome, 1969), pp. 135 ff.; color photos in Lanfranco Ravelli, *Polidoro Caldara da Caravaggio* (Bergamo, 1978), pls. XI, XII. See also Diega Giunta, "La presenza di S. Caterina di Siena in Roma, cenni storico-iconografici," *Urbe* 42(1979): 38–47, who identifies one of the scenes as "Saint Catherine Mediating between Urban VI and the Romans."

1. The commission was perhaps completed by 1485. Cf. Enzo Carli, *Il Pintoricchio* (Milan, 1960), pp. 23–29, pls. 23–38; a brief biographical account of Bufalini is found in Clara Gennaro, "Bufalini, Niccolò dei (Nicolaus de Castello)," in *Dizionario biografico degli Italiani*, 14:802–3 (Rome, 1972). Cf. also Sandström, *Levels*, pp. 41–56. I have been unable to consult Priscilla Albright, "Pintoricchio's Frescoes in the San Bernardino Chapel in Santa Maria in Aracoeli, Rome" (Ph.D. diss., University of California, Berkeley, 1980).

2. As in the contemporary Sassetti Chapel, the decoration rests on a unified dado that circles the entire chapel (painted with red and yellow geometric patterns alternating with the Bernardine trigram). All these architectural members are decorated primarily in blue and white with elaborate moldings and classical grotesques. Sandström has referred to this arrangement as "false architecture" and discussed the innovation at length, saying that Pintoricchio here "abolished the boundary between figurative and decorative painting" (*Levels*, pp. 42 ff.); this author is primarily concerned with the interrelation between pictorial space and the real world and methods of "interpenetration" of the two. He points to the Early Christian pilasters of Santa Maria in Aracoeli itself as sources for Pintoricchio's classicizing motifs; p. 36 n. 12, p. 84 n. 4. These motifs and many other aspects of the architectural structures have been associated with the discovery of the Golden House of Nero; cf. Nicole Dacos, *La découverte de la Domus Aurea et la formation des grotesques à la Renaissance* (London, 1969).

3. Sandström, *Levels*, pp. 42 ff., 49–50.

4. Trecento ancestors of the Expanded Field can be seen the Veluti and Pulci Beraldi chapels in Santa Croce, Florence, where each side wall has only one unified scene. Besides the enlarged fields of the Bartolini Chapel in Santa Trinita, Florence, mentioned above, perhaps even more pertinent were Ercole de' Roberti's frescoes in the Garganelli Chapel, San Pietro, Bologna (destroyed in the early seventeenth century). Also painted in the early 1480s, the side walls seem to have featured single, monumental scenes: the *Crucifixion* on the left and the *Dormition of the Virgin* on the right. See Luisa Ciammitti, *Tre artisti nella Bologna dei Bentivoglio* (Bologna, 1985); and Joseph Manca, "Ercole de' Roberti's Garganelli Chapel Frescoes: A Reconstruction and Analysis," *Zeitschrift für Kunstgeschichte* 49(1986): 147–64.

The phenomenon in fresco painting should be considered in relation to developments in the format of altarpieces. In the 1460s and 1470s, in Tuscany and the Veneto, a similar expansion can be seen in what has been called the "lunette altarpiece," that is, a spatially unified central panel crowned with a lunette-shaped top; Henk W. Van Os, "The Sienese Lunette Altarpiece," public lecture, "Symposium, Painting in Renaissance Siena," Metropolitan Museum of Art, New York, 20 January 1989.

5. The unified format also recalls to some extent earlier large-scale Crucifixion scenes that fill the wall behind the altar, e.g., the Oratorio di San Giovanni Battista in Urbino, or the sacristy in San Francesco in Prato. The latter example, because of the proportions of the scenes and the division into two tiers on the side walls, foreshadows the development we are discussing; cf. Van Marle, *Development of the Italian Schools of Painting*, vol. 3, figs. 350–51. Equally relevant is the tall, uninterrupted vertical field over the altar of the Ovetari Chapel, discussed above, chapter 6.

6. This narrative technique is very innovative and deserves fuller study than can be given here. See below for references to Bernardino's sermons.

7. See Oswald Goetz, *Der Feigenbaum in der religiösen Kunst des Abendlandes* (Berlin, 1965).

8. The Italian name refers to the plant's cowl-shaped leaf; cf. Salvatore Battaglia, *Grande dizionario della lingua italiana* (Turin, 1961), 1:658.

9. Piero Bargellini, ed., *San Bernardino da Siena: Le prediche volgari* (Milan, 1937), 39:893–919.

10. Bernardino kneels at the foot of a heavy architectural support, from the top of which a putto surveys the scene. He holds a *scudo* with the Bufalini arms (a buffalo head with a rose between the horns). The motif confirms the family's dedication to the saint.

11. Origo, *World*, p. 73.

12. Coinciding with the dado level on the right wall.

13. Similar to the same scene in the Sassetti Chapel, with Alverna shown as a populated monadnoch in the background.

14. Origo, *World*, p. 233.

15. Cf. Origo, *World*, pp. 159–81, esp. 176.

16. S.v. "Luoghi deputati," *Enciclopedia dello spettacolo*, (Rome, 1975), vol. 6, cols. 1739–41; Sandström *Levels*, p. 54, sees the theatrical aspect of this scene but related it to the form of the perspective stage set, which, however, developed somewhat later. Cf. Hans Heinrich Borcherdi, *Das europäische Theater im Mittelalter und in der Renaissance* (Leipzig, 1935), pp. 140 ff.

17. For example, a stillborn infant revived; Cola, the blind man from Rocca Marsicana, whose sight was restored; cf. George Kaftal, *Iconography of the Saints in Central and South Italian Schools of Painting* (Florence, 1965), 55:195–218.

18. Origo, *World*, pp. 248–50.

19. See above, chapter 2.

20. Origo, *World*, pp. 131–58, 198–99.

21. Based on John 17:6. The identification was pointed out by Kaftal long ago, *Saints*, 55:195–218.

22. Cf. Edwin Hall and Horst Uhr, "'Aureola super Auream': Crowns and Related Symbols of Special Distinction for Saints in Late Gothic and Renaissance Iconography," *Art Bulletin* 67(1985): 567–603, esp. 574.

23. Late in his career (1503–8), Pintoricchio was to employ the same format for a secular cycle, the Life of Aneas Silvius Piccolomini (Pius II), in the Piccolomini Library, Cathedral of Siena, where the biographical narrative is heroicized in a series of semicircular-topped, unified vertical fields, progressing left to right around the rectangular chamber.

24. 1488–93. After Filippino had completed his work in the Brancacci Chapel, in Florence, probably in 1487, he received a commission from Filippo Strozzi for a cycle in Santa Maria Novella. Having barely begun, in August 1488, he departed for Rome to work for Carafa and remained almost five years. Cf. Alfred Scharf, *Filippino Lippi* (Vienna, 1935), pp. 32 ff.; also Carlo Bertelli, "Il restauro della Cappella Carafa in S. Maria sopra Minerva a Roma," *Bollettino dell'Istituto Centrale del Restauro*, 1965, pp. 145–95.

25. Also like the Sassetti Chapel, the webs of the cross vault contain images of four sibyls with tituli, each accompanied by an angel.

26. Cf. Gail L. Geiger, "Filippino Lippi's Carafa 'Annunciation': Theology, Artistic Conventions, and Patronage," *Art Bulletin* 63(1981): 62–75, and the same author's *Filippino Lippi's Carafa Chapel: Renaissance Art in Rome* (Kirksville, Mo., 1986).

27. This relationship has been thoroughly discussed by Sandström, *Levels*, pp. 55 ff.

28. Geiger, as above, note 26.

29. For the figure of Saint Thomas, cf. the discussion of Hall and Uhr, "'Aureola super Auream,'" pp. 566–603, esp. pp. 593–94.

30. In his account of the chapel, Vasari speaks first of the left wall, which he says had a *Triumph of Virtues over Vices* (Psychomachia); *Vite*, 3:468–69. Although he does not say so specifically, this Triumph must have been in the lower,

larger field, where it would have balanced the Triumph of Saint Thomas. Vasari does not say what was depicted on the lunette level. The wall was destroyed in the sixteenth century to make way for the tomb of Pope Urban VII.

31. Not finished until 1502. Cf. John Russell Sale, "The Strozzi Chapel by Filippino Lippi in Santa Maria Novella" (Ph.D. diss., University of Pennsylvania, 1976, reproduced by Garland Press, 1979); see also Sandström, *Levels*, p. 57.

32. Sale, *Strozzi*, pp. 258 ff., discusses fully the relation of the chapel to the Bufalini and Carafa chapels.

33. The chapel in Santa Maria Novella, which had been owned most recently by Bono di Giovanni Boni, had been dedicated to Saint John the Evangelist, and Strozzi did not attempt to change the dedication when he purchased the property; cf. ibid., pp. 103–8, esp. n. 19.

34. The feast of the Martyrdom of Saint John the Evangelist on the left (6 May), and the Martyrdom of Saint Philip on the right (1 May); cf. *Golden Legend*, pp. 58 ff., 276 ff., 326.

35. Dacos, *Grotesques*, pp. 69 ff., followed by Sale, *Strozzi*, pp. 231 ff., suggests that Filippino visited Padua in 1489.

36. The relation the Mantegna fresco has to the altar table and frontal before it is repeated here with one major exception. Strozzi's tomb is placed in a position of honor at the center of the base of the altar wall; cf. David Friedman, "The Burial Chapel of Filippo Strozzi in S. Maria Novella in Florence," *L'Arte* 9(1970): 109–31.

37. Sale, *Strozzi*, pp. 305 ff.

38. In the tradition of the Arena Chapel, the transept of the Lower Church at Assisi, and Piero della Francesca's cycle at Arezzo.

39. *Saint John the Evangelist Raising Drusiana* and *Saint Philip Quelling the Dragon before the Statue of Mars.*

40. John's martyrdom is celebrated, as I have noted (chap. 6), on the day he was put in boiling oil on the Via Latina in Rome, although he survived this torture and lived on for many years.

41. A similar method was used on the ceiling in the Gianfigliazzi Chapel started by Alessio Baldovinetti in 1471, with different Old Testament characters (Noah [destroyed], Abraham, Moses, and David) but in the same chronological sequence (a Zigzag starting over the altar wall, right wall, left wall, ending over the entrance); cf. Kennedy, *Alessio Baldovinetti*, pp. 172–78.

42. Moreover, there are surely allusions to the patrimonial concerns of the Dominican order expressed earlier in the subject matter of the cloisters of Santa Maria Novella. Cf. discussion above.

43. Such walls usually supported groined vaults and were treated as a single unit. Gombrich, *Means and Ends*, pp. 45–48, notices this fact. A forerunner of the lunette-shaped field may be seen in the apse at San Leonardo al Lago (about 1350–60), where the three monoscenic episodes entirely fill lunette-topped wall spaces of the sides as well as the altar wall (Borsook, "San Leonardo"), and again in the topical frescoes in the *pellegrinaio* in the Hospital of Siena, painted by Domenico di Bartolo and Vecchietta between 1437 and 1443; cf. Daniela Galavotti, "Gli affreschi quattrocenteschi della sala del Pellegrinaio nello Spedale di Santa Maria della Scala in Siena," *Storia dell'Arte* 13(1972): 5–42.

44. Carli, *Pintoricchio*, pp. 61–63; see also Konrad Oberhuber, "Raphael and Pintoricchio," in *Raphael before Rome: A Symposium*, ed. James Beck, 17:155–74, Studies in the History of Art, National Gallery (Washington, D.C., 1985). Although it is not certain, the donor may have been Rodolfo Baglione, 1447–1501.

45. On the ceiling, following both the Carafa and the Strozzi chapels, four sibyls are painted on the webs of the vault.

46. Called also the "Cappella Nuova"; for Saint Brixio, see *Golden Legend*, pp. 674–75.

47. 1447–49; cf. Pope-Hennessy, *Fra Angelico*, pp. 189 ff.

48. He seems to have enlarged the dado to nearly two-thirds the height of the wall, placing there the famous literary figures in their enframing grotesques, currently being studied by Rose Marie San Juan, "The Function of Antique Ornament in Luca Signorelli's Fresco Decoration for the Chapel of San Brizio," in *The Roman Tradition in Wall Decoration*, vol. 12 of *Canadian Art Review* (Quebec, 1985), pp. 235–42, and Johathan B. Riess, "Signorelli's Dante Illustrations in Orvieto Cathedral: Narrative Structure, Iconography, and Historical Context," College Art Association Annual Meeting, Boston, 1987, Abstracts, p. 65.

49. Cf. André Chastel, "L'Apocalypse en 1500: La fresque de l'Antéchrist à la chapelle Saint-Brice à Orvieto," in *Humanisme et Renaissance*, 14:124–40 (Paris, 1952), who discusses traditional prophecies and the reference to Savonarola as the false prophet; see also Stanley Meltzoff, *Botticelli, Signorelli and Savonarola: "Theologica Poetica" and Painting from Boccaccio to Poliziano* (Florence, 1987), pp. 302–56 (the narrative movement indicated in the diagram modified after the *Guida d'Italia*, used on p. 285, is backward). This sequence is narrative in neither the chronological nor the theological sense. For this discussion, however, I have assumed a progression from evil and damnation to celestial rewards.

50. Including some of the same motifs.

51. See appendix 1, p. 282, for a list of the subjects and their locations.

52. The light in the Antichrist scene on the same wall flows from the same source.

53. See Paolini, "Scene della vita di San Benedetto." The Story of the True Cross in San Francesco, Volterra (see above, chap. 4), likewise gives a view from the door, beginning opposite the entrance from the nave, moving boustrophedonically across two walls, and ending below the starting point for the same reason.

54. Cf. Otto E. Neugebauer, *A History of Ancient Mathematical Astronomy* (New York, 1975), part 3, book 6, "Planetary Motion," p. 1088, and figs. 155 (Saturn) and 156 (Jupiter).

55. The basic reference is Aby Warburg, "Italienische Kunst und internationale Astrologie," in *Gesammelte Schriften*, vol. 2 (Leipzig, 1932) pp. 459–81, 627–44; for a series of color illustrations, see Battisti, *Cicli pittorici*, pls. 60–67. See Ranieri Varese, "Schifanoia: Francesco del Cossa or Giuseppe Mazzolani?" *Critica d'Arte* 52(1987): 22–32, and Christen Lippincott, "The Narrative Structure of the *Salone dei Mesi* in the Palazzo Schifanoia and the Study of Latin Grammar in Fifteenth-Century Ferrara," College Art Association Annual Meeting, Boston, 1987, Abstracts, p. 66. It is perhaps not without significance that the four painted stucco narrative rondels by Donatello in the Old Sacristy, San Lorenzo, Florence, are disposed counterclockwise, starting of the right of the altar. As is well known, over the altar is a large-scale astrological chart plotting an important Medici horoscope. The counterclockwise reading of the narrative would therefore repeat the movement of the planets represented; cf. *Donatello e la Sagrestia Vecchia di San Lorenzo: Temi, studi, proposte di un cantiere di restauro* (Florence, 1986); Isabella Lapi Ballerini, "L'emisfero celeste della Sagrestia Vecchia: Rediconti da un giornale di restauro," pp. 75–85 (English translation "Donatello at Close Range," *Burlington Magazine* 129[1987]: 51–52). See other examples in Gioio Mori, "Arte e astrologia," *Art Dossier* 10(1987). See also the passage concerning the right-left organization of Botticelli's *Primavera*, as reflecting astrological movement in Charles Dempsey, "The Sources of Botticelli's *Primavera*," *Journal of the Warburg and Courtauld Institutes* 31(1968): 266–67.

56. A unique result of the specific arrangement—starting in the first field on

the left and rotating right to left—was the positioning of all the heavenly scenes to the right of the figure of Christ on the ceiling.

57. In precisely the same time frame (1498–99), we find Signorelli again using the full lunette mode for his commission at the Benedictine monastery of Monte Olivetto (Siena), for the Life of Saint Benedict on the walls of the cloister. These semicircular fields above a dado correspond to the bays of the cloister, however, and are much smaller in scale than chapel lunettes. Cf. Enzo Carli, *L'abbazia di Monteolivetto* (Milan, 1961), pp. 23–46.

58. Segnatura, 1508–11; Eliodoro, 1512–14; Incendio, 1514–17 (see Pier Luigi De Vecchi, *Raffaello: La Pittura* [Florence, 1981], pp. 32–57, 245–46, 247–48, 250–51, bibl. pp. 232–37; Redig de Campos, *Raphaels Fresken in den Stanzen*); Costantino 1519–24, 1585 (the latter has rectangular fields; see Quednau reference, chap. 6). Loren Partridge and Randolph Starn, *A Renaissance Likeness: Art and Culture in Raphael's "Julius II"* (Berkeley, 1980), p. 72, notice that the scenes in the Stanza d'Eliodoro circle the room counterclockwise. See also *Raffaello a Roma: Il convengno del 1983*, Bibliotheca Hertziana, Musei Vaticani (Rome, 1986), pp. 45–116, 159–88, 245–55 (several authors); esp. Arnold Nesselrath, "La progettazione della 'Incoronazione di Carlomagno,'" pp. 173–82, who discusses the political implications for Leo X and Francis I of the evocations of Leo III and IV and Charlemagne in the Coronation scene.

59. 1508–12. Cf. Charles De Tolnay, *Michelangelo: The Sistine Ceiling* (Princeton 1959); for reports on the work in progress during the cleaning of the 1980s, see Carlo Pietrangeli et al., eds., *The Sistine Chapel, a New Light on Michelangelo: The Art, the History, and the Restoration* (New York, 1986).

60. We have just seen that the progress on Fra Angelico's ceiling in Orvieto, though not narrative, is Apse-to-Entrance.

61. Such an abbreviated Genesis cycle, with the scenes of Creation reduced from the canonical seven, in the Apse-to-Entrance disposition, finds ample precedence not only in Old Saint Peter's and Saint Paul's, but in their progeny in the Upper Church at Assisi, the Florentine Baptistry, Santa Maria in Vescovio, and so on. The Ancestors Michelangelo depicted on the lunette level (originally) all around the chapel followed the same arrangement as the First Popes sequence immediately below: from apse to entrance, moving boustrophedonically across the chapel and back, bay by bay. It seems helpful in digesting some of Michelangelo's awesome stylistic innovations to keep in mind his profound respect for the traditions to which he was heir.

62. Esther Gordon Dotson, "An Augustinian Interpretation of Michelangelo's Sistine Ceiling," *Art Bulletin* 61(1979): 232–34, discussion and notes.

63. Cf. Dotson, "Augustinian Interpretation," pp. 418–20; also Malcolm Bull, "The Iconography of the Sistine Chapel Ceiling," *Burlington Magazine* 130(1988): 601.

64. This solution is still seen, for example, in the Arena Chapel and in the chapter house at San Francesco in Pisa; *La chiesa monumentale di San Francesco* (Pisa, n.d.). It is not entirely clear what the ceiling looked like when Michelangelo began; Ettlinger, *Sistine Chapel*, pp. 15–16.

65. George Gaillard, *Les fresques de Saint-Savin* (Paris, 1944).

66. The chronology moves down to the "second" tier for two episodes at the beginning, causing the last branch of the narrative to begin in the third position; see below.

67. The same is true of the transverse vault in the entrance of the Venice Baptistry and in the fifteenth-century mosaics by Mantegna and Michele Giambono in the Chapel of the Madonna dei Mascoli inside San Marco itself (1443); see above, chapter 3, and Hartt, *History of Renaissance Art*, p. 200, fig. 266.

68. Cf. Enzo Carli, *Gli affreschi di Belverde* (Florence, 1977), pp. 17–18, pls. 60–78.

69. Above, chapter 4.

70. Cf. Tafi, *Duomo di Arezzo*, no. 45, p. 55, ill. p. 20; Liana Cheney, "Marcillat's Ceiling Decoration," public talk, Southeastern College Art Conference, Annual Meeting, New Orleans, 1985.

71. Before taking this step, the artist apparently considered an alternative approach, current in Tuscany and Lazio at the time, of implanting a long rectangle on the vault surface to be divided into a grid of geometric compartments, arranged in decorative and symmetrical patterns, some of which held narrative episodes. Cf. the discussion of Juergen Schulz, *Venetian Painted Ceilings of the Renaissance* (Berkeley, 1968), pp. 3–58, where the "Roman" schemes are considered as background for the development of the flat *soffitti Veneziani*. Michelangelo's preliminary organizational sketches for the ceiling are newly studied by Fabrizio Mancinelli and Kathleen Weil-Garris Brandt, "The Early Projects for Michelangelo's Sistine Ceiling: Their Practical and Artistic Consequence, I and II," in *Michelangelo Drawings: A Symposium*, National Gallery of Art (Washington, D.C., 1988).

72. See Shearman in *Sistine Chapel*, "The Chapel of Sixtus IV," esp. pp. 34–36, for processional and liturgical practice in the chapel. The west entrance was somewhat changed in 1536; see above, chapter 7.

73. The relation between disposition and orientation was to become, in the course of the sixteenth century, a major issue for ceilings decorated with scenes in small compartments and with larger *quadri riportati*, which proliferated during this period. See again Schulz, *Venetian Painted Ceilings*; though problems of disposition and orientation are not discussed, the plates and figures faithfully reproduce and reconstruct both elements for many Venetian ceilings. This tradition was carried forward in Naples, where many such ceilings from the later sixteenth century remain intact. For example, at Santa Maria la Nova (a collaborative work on the Life and Theology of Mary by Francesco Curia, Francesco Imparato, and many others, dating 1598–1600) four large Marian scenes are placed down the center of the ceiling, oriented toward the altar end or toward the main entrance in a surprising sequence that makes the spectator turn front to back several times. The ceiling of San Gregorio Armeno, decorated between 1580 and 1582 under the direction of the northern painter Teodoro di Errico, has a ceiling divided into large square compartments with central *quadri* representing individual saints. In the corners of the squares are circular narrative scenes, all oriented toward the center of the square. In terms of their disposition, these scenes vary from the Wraparound that circulates clockwise, the Counterclockwise Wraparound, and includes one Cat's Cradle pattern; cf. Carmela Vargas, *San Gregorio Armeno, Napoli* (Naples, 1988). In the Gesù Nuovo, constructed 1584–1601 and decorated over the next hundred years (works from Giovanni Lanfranco to Paolo De Matteis), the organization of the ceiling decorated with *quadri riportati* is unified toward a single point of viewing. All the scenes are oriented toward a spot directly under the center of the dome. Standing in place, the spectator rotates to see four different sequences, each occupying an arm of the Greek cross plan. I have not yet studied these Neapolitan ceilings in detail or entered them into the database.

74. See above, chapter 6.

75. See above, chapters 1 and 7.

CHAPTER NINE

1. Henry J. Schroeder, trans., *Canons and Decrees of the Council of Trent* (Saint Louis, 1941); see also Marcia B. Hall, *Renovation and Counter-Reformation: Vasari and Duke Cosimo in Sta Maria Novella and Sta Croce, 1565–1577* (Oxford, 1979), pp. 55 ff.

2. See below, note 76, for brief descriptions of two seventeenth-century examples.

3. For which the original variables matched the categories I had programmed into the computer.

4. The Old Testament narrative covers three sides of the cloister, ending at the facade of the "Spanish Chapel."

5. Paolini, "Scene della vita di San Benedetto," bibliography, p. 138. The cycle runs around the court (starting in the east arm) from left to right.

6. Attributed to Giovanni di Consalvo, 1436–39, with later additions by Bronzino; Procacci, *Sinopie e affreschi*, pp. 27–28.

7. In the fourth bay, with continuous episodes of *Benedict in Ecstasy* and *Benedict Tempted*; cf. Craig Hugh Smyth, "Bronzino's Earliest Works," *Art Bulletin* 31(1949): 184 ff., fig. 3, and Andrea Emiliani, *Il Bronzino* (Milan, 1960), p. 62, pls. 1–3.

8. Xavier Barbier de Montault, "Peintures claustrales des monastères de Rome," *Revue de l'Art Chrétien* 4(1860): 71–89; also Luigi Huetter and Emilio Lavagnino, *S. Onofrio* (Rome, 1951).

9. Nicola Spinosa, ed., *Guida sacra della città di Napoli* (Naples, 1985), giornata 4, pp. 74–76; Dario Nicolella, *I cento chiostri di Napoli* (Naples, 1986), pp. 78–86, fig. 81.

10. Cf. Janet Cox Rearick, *The Drawings of Pontormo* (Cambridge, Mass., 1964), pp. 213–26.

11. A preparatory drawing exists for a *Nailing to the Cross* (cf. ibid.), but none for a *Crucifixion*. Therefore the question remains open. See next note.

12. We have literary evidence describing the meditative element in a cycle in the now lost Dominican cloister of Santa Maria sopra Minerva. Painted by Fra Angelico, Melozzo, or Antoniazzo Romano between 1445 and 1468, the cycle was commissioned by Cardinal Torquemada and decorated with thirty-four scenes (from Genesis, the Life of Christ, and some devotional scenes). It is said to have illustrated a *Meditation* composed by the cardinal, with explicative epigrams from the meditation itself written out on the scenes. Unfortunately the disposition of the cycle is not recorded; cf. Heinz Zirnbauer, ed., *Johannes de Turrecremata, "Meditationes," Faksimile-Ausgabe Erstdrucks von 1467*, Stadtbibliothek Nürnberg, (Wiesbaden, 1968); cf. also Luigi di Gregori, *Del Chiostro della Minerva* (Florence, 1927). Whether the counterclockwise reading direction in cloisters had any relation to the astrological tradition mentioned above, I am unable to say.

13. Cf. Ignacio L. Moreno, "Pontormo's Passion Cycle at the Certosa del Galluzzo," *Art Bulletin* 63(1981): 308–12, who suggests that the Crucifixion was omitted in the cycle but was present in the monumental cross placed over the well in the burial courtyard, a typical feature of every Carthusian monastery.

14. See above, chapter 4.

15. John Henderson, "Lay Penitential Confraternities in Quattrocento Florence," conference lecture, Christianity and the Renaissance, Florence, June 1985, dealt with the function of these early organizations.

16. Howard Collins, "Major Narrative Paintings by Jacopo Bellini," *Art Bulletin* 14(1982): 466–72, who claims that two paintings in the Galleria Sabauda, Turin, and two in a private collection are part of what was the cycle in the Sala Maggiore of the Scuola Grande di San Giovanni Evangelista in the 1450s. The attribution and analysis is disputed by Jürg Meyer zur Capellen, *Gentile Bellini* (Stuttgart, 1985), pp. 156, 160; this reference was provided by Patricia Fortini Brown.

17. Peter Humfrey, "The Life of St. Jerome Cycle from the Scuola di San Gerolamo in Cannaregio," *Arte Veneta* 34(1985): 41–46. One of the few discussions of the architecture of the *scuole* is found in Philip L. Sohm, "The Scuola

Grande di San Marco, 1473–1550: The Architecture of a Venetian Lay Confraternity" (Ph.D. diss., Johns Hopkins University, 1978; reproduced by Garland Press, New York, 1982).

18. Cf. Rodolfo Pallucchini, *Vittore Carpaccio: Le storie di Sant'Orsola* (Milan, 1958), and Francesco Valcanover, "Le storie di Sant'Orsola di Vittore Carpaccio dopo il recente restauro," *Adunanza Solenne 1986* (Istituto Veneto di Scienze, Lettere ed Arti) 144(1985–86): 10–34.

19. Antonio Morassi, *Tiziano: Gli affreschi* (New York, 1964), pp. 14–15. See next note.

20. And in the still later cycles in the Scuola Grande di San Marco cycle by Tintoretto (1548 +) and the Scuola di San Rocco (cycle again by Tintoretto, 1564–77).

21. Patricia Fortini Brown, "Painting and History in Renaissance Venice," *Art History* (1984): 263–94, and idem, *Venetian Narrative Painting in the Age of Carpaccio* (New Haven, 1988), discusses Venetian *historia* mostly from the latter point of view; see the catalog, pp. 258–98, for a review of information concerning reconstruction of the original sequence of the cycles up to 1530.

22. See below, note 67.

23. Cf. Linda Caron, "The Oratorio of San Bernardino, Siena," College Art Association Annual Meeting, Boston, 1987, Abstracts, p. 74.

24. Because the *portacroce* went barefoot in processions. The property of the company runs between the Via Cavour and the Via San Gallo.

25. At nearly the same moment he began to work in another courtyard, that of Santissimi Annunziata in Florence. Started about 1460–62 with Baldovinetti's *Nativity*, the organization of episodes painted by Franciabigio, Pontormo, and Rosso il Fiorentino in the next century was not designed to create an organized cycle.

26. John Shearman, "The Chiostro dello Scalzo," *Mitteilungen des Kunsthistorischen Institutes in Florenz* (1960): 207–20; Sydney J. Freedberg, *Andrea del Sarto* (Cambridge, Mass., 1963), 2:9 ff.; John Shearman, *Andrea del Sarto* (Oxford, 1965), pp. 294 ff.; Borsook, *Mural Painters*, pp. 127–31. All these authors offer dates, painting sequence, and attributions. Generally it is agreed that Andrea started with the *Baptism of Christ,* painted the central part of John's life before his departure, and finished the saint's later life and early childhood, in that order, after his return from France. No one has speculated on the possible relation between the narrative sequence and the development of Andrea's style.

27. Also like some other earlier cloisters, the painting is done in grisaille or, better in this case, a rather rich monochrome of golds and grays. Many suggestions have been made to explain this choice, such as following Alberti's rule to keep a close approximation to sculpture or restricting the color to allude to the penitential nature of the setting. These points of view are summarized by Borsook, *Mural Painters*, p. 128. I suggest that the technique used in this context follows Pliny, who claims that painting began when an artist drew around a shadow and thus made the first monochrome. Pliny, *The Elder Pliny's Chapters on the History of Art*, trans. K. Jex-Blake (London, 1896), book 45, "Painting," para. 1, pp. 84–85, "Omnes umbra hominis lineis circumducta, itaque primam talem." By identifying the technique with primitive time, the subject is thereby identified with primitive Christianity. The grisailles (mainly in gold tones) used for painted plaques on the dado level in the Vatican *stanze*, between the scenes in the Oratory of San Giovanni Decollato, and below the scenes in the nave of Santa Prassede in Rome, all bear historical scenes relevant to the episodes in the main fields.

28. The macabre motifs used in the areas above the cornice reflect the function of the confraternity in caring for the indigent dead and dying.

29. See appendix 1, p. 283, for a list of the subjects and their locations.

30. Franciabigio represented the *Blessing of John and Farewell to His Parents* and *John's Departure for the Wilderness*, shown in continuous narrative through the doorway. In this setting the scenes are a kind of urbanized version of the episodes in Fra Filippo Lippi's Prato frescoes; see above, chapter 6.

31. This approach is the same as the one Pisano used on the fourteenth-century bronze doors of the Florentine Baptistry; see above, chapter 3. In the frescoes, a second figure of Christ is seen in the left background of the *Preaching* scene, expressing in visual terms John's words, "and I knew him not."

32. The planning of the Lo Scalzo paintings must have taken place at the same moment Michelangelo was working on the Sistine ceiling, where, as we have seen, the same concept is used.

33. The biblical accounts say that John was baptizing at the Jordan both before and after Christ's appearance.

34. Started in 1536, work continued until 1553; the painters were Jacopino del Conte, who did the lion's share: the *Annunciation*, the *Young Saint John Preaching in the Wilderness*, the *Baptism of Christ*, and the *Deposition* altarpiece; Francesco Salviati: the *Birth of the Baptist*, redone in 1551, and with an assistant, the *Decollation*; and Battista Franco: the *Arrest of the Baptist* (fig. 199).

35. This relationship is studied by Rolf Keller, *Das Oratorio von S. Giovanni Decollato in Rom* (Neuchatel, 1976), and Jean S. Weisz, *Pitturae Misericordia: The Oratory of S. Giovanni Decollato in Rome* (Ann Arbor, Mich., 1984). On the Roman oratories and their administration, see Alessandro Zuccari, "La politica culturale dell'Oratorio Romano nella seconda metà del cinquecento," *Storia dell'Arte* 41(1981): 77–112.

36. Compare an earlier rendering by Signorelli (1494) in his *Martyrdom of Saint Catherine*, a predella of the Sienese Bichi altarpiece; see Keith Christiansen et al., *Painting in Renaissance Siena, 1420–1500* (New York, 1988), pp. 342–43 (by Laurence B. Kanter).

37. Painted in 1555, after Daniele da Volterra failed to produce his promised altarpiece.

38. Cf. Jean S. Weisz, "Salvation through Death: Jacopino del Conte's Altarpiece in the Oratory of S. Giovanni Decollato," *Art History* 6(1983): 395–405.

39. Cf. Richard Krautheimer's remarks on conceptions of "copies" in the Middle Ages in "An Introduction to an 'Iconography' of Medieval Architecture," *Journal of the Warburg and Courtauld Institutes* 5(1942): 1–33; see also the reference to Steven Ostrow, dissertation, note 75 below, where the relationship between mannerist style and Early Christian revival is discussed at length.

40. Alessandra Molfino, *L'Oratorio del Gonfalone* (Rome, 1964).

41. The artists included Pedro de Rubiales, Luzio Romano, Jacopo Bertoja, Livio Agresti, Marcantonio del Forno, Raffaellino da Reggio, Matteo da Lecce, and Cesare Nebbia; see Barbara L. Wollesen-Wisch, "The Archiconfraternità del Gonfalone and Its Oratory in Rome: Art and Counter-Reformation Spiritual Values" (Ph.D. diss., University of California, Berkeley, 1985).

42. Josephine Von Henneberg, *L'Oratorio dell'Arciconfraternità del Santissimo Crocifisso di San Marcello* (Rome, 1974).

43. See appendix 1, p. 283, for a list of the subjects and their locations.

44. Vasari, *Vite*, proemio, 1:215–44.

45. Such structures are sometimes known in English as "rood screens"; in common Italian parlance the *tramezzo* was also called the *ponte*.

46. Space on this structure was used for chapels and burial vaults; it was cluttered with escutcheons and emblems, painted and sculptured altarpieces, epitaphs, cenotaphs, and mottoes of all kinds.

47. Hall, *Renovation*; Marcia B. Hall, "The Tramezzo in Sta Croce Reconstructed," *Art Bulletin* 56(1974): 325 ff.

48. The chapel owners included the Serristori, Cavalcanti, Pazzi, Corsi, Zati,

Buonaroti, Alamanneschi, Dini, Zanchini (these last two were owners earlier than the project), Verrazzano, Medici, Berti, Guidacci, Asini, and Biffoli. The one family that lost out was the Alberti, patrons of the chancel area for generations, with eleven tombs in the choir. When these tombs were destroyed in 1566 the Alberti sued but lost, and their rights were ceded.

49. Santi di Tito, Minga, Barbiere, Coppi, Naldini, and a bit later Cigoli; Hall, *Renovation,* chap. 2 and pp. 122–51.

50. Finished by Johann Bilivert in the early seventeenth century (originally this scene was to have been a *Last Supper*).

51. The tenth, the sixth, and the eighth to be painted.

52. The ninth, the third, and the twelfth to be painted.

53. It is said that the program had to work its way around two previously built chapels on the interior facade of the church, with representations of the *Deposition* by Salviati (1548) on the left and the *Descent into Limbo* by Bronzino (1552) on the right. Hall claims (*Renovation,* chap. 2 and pp. 122–51) that these subjects "create a mild anachronism in the sequence; the Limbo scene should logically follow the Entombment." Actually there is no Entombment in the cycle (it is a Laying on the Ground, the moment in real time after the Deposition). In fact, the two facade paintings (now removed) formed a pair of themselves. The *Deposition,* compositionally a Boustrophedon thrusting toward the right, has a light flow from left to right. In a complementary way, in the *Limbo* scene, Christ turns toward the left, and the light flows from right to left.

54. Actually the first in the series to be painted (1568).

55. The Risoliti Chapel in the adjacent space of the transept had an altarpiece of the Trinity, painted by Girolamo Macchietti in 1575 (lost), and was not actually part of the Vasari project; cf. Hall, *Renovation,* chap. 2 and pp. 122–51.

56. The concept of using narrative subjects on separate, coordinated altarpieces to form a cycle was operative at least as early as the 1330s in Siena, where five altarpieces were planned to form a sequence on the Life of the Virgin in the crossing of the Duomo; see Van Os, with Van der Ploeg, *Sienese Altarpieces.* Others have been hypothesized; Lotte Brand Philip, public lecture, "Bosch Altarpiece Cycles," Institute for Advanced Study, Princeton, 1981 (not published).

57. "Which is not so much dramatized as diagrammed, to the arcane iconography" (Hall, *Renovation*). Even in their own day much was written about the appropriateness of these paintings in terms of their style and iconography. Raffaello Borghini, author of *Il Riposo* (Florence, 1584), criticized them in relation to religious criteria and aesthetic requirements for having too much *grazia,* for being anachronistic, and for combining narrative and doctrine. What these writers lack is the historical perspective that puts the works into the context of a long development. As devotional images with narrative subjects, the altarpieces find their place in an important but little studied trend that may be observed first in Tuscany and by the mid-fifteenth century also in northern Italy and the Veneto—the emergence of narrative as a subject for devotional images. In a series of graduate seminars (at Princeton University and the University of Maryland), my students and I began what is still an incomplete survey of this topic in fourteenth- to sixteenth-century Italian painting. I hope that the material thus brought together, plus more data yet to be gathered, will soon be placed in a computer database for further study. Not infrequently, the appearance of a particular subject accompanied establishment of a feast for more than local devotion, and I have made bold to suggest the terms "Western Feast Painting" as appropriate for such paintings; cf. my *Baptism,* pp. 107, 123 n. 1. However, by the early years of the sixteenth century, hallmark scenes epitomizing events in the church calendar had all been found suitable for separate representation and veneration. The artistic transformation signaling this function in a given composition involved blocking lateral movement and bringing the figures into bal-

anced, frontal poses arranged in static symmetry. Emotional expression is calmed to the universal and venerable. Retaining palpability and naturalism, the characters are physically idealized and morally aggrandized. Often sainted beings or other persons of superior spirituality are represented in the composition to demonstrate correct methods of contemplation for the worshiper to follow.

58. First on the left in Santa Maria in Aracoeli, Rome; cf. Johanna E. L. Heideman, *Cinquecento Chapel Decorations in S. Maria in Aracoeli in Rome* (Amsterdam, 1982), pp. 9–39, 1551–54, by Francesco Pichi.

59. Ibid., pp. 41–50.

60. See above, the discussion of the implications of the changing shapes of painting fields.

61. A special feast day dedicated to the rosary (7 October) had recently been established for the universal church following the victory over the Turks at Lepanto in 1571, under Pope Gregory XIII.

62. Cf. Piero Giacomo Bacci, *Vita di S. Filippo Neri* (1745), ed. Ferrante (Rome, 1855), p. 62; Louis Ponelle and Louis Bordet, *Saint Philip Neri and the Roman Society of His Times (1515–1595)* (London, 1932), and Mary Ann Graeve, "The Stone of Unction in Caravaggio's Painting for the Chiesa Nuova," *Art Bulletin* 40(1958): 223–38.

63. The cycle, which took more than twenty years to complete, includes (from the right) the *Annunciation* by Passignano, the *Visitation* by Barocci, the *Nativity* by Durante Alberti, the *Adoration of the Magi* by Cesare Nebbia, and the *Presentation of the Virgin* by Cavaliere d'Arpino (lost) at the entrance on the left; the *Crucifixion* by Scipione Pulzone, Caravaggio's *Entombment* (chapel dedicated to the Pietà), today in the Pinacoteca Vaticana; the *Ascension* by Girolamo Muziano, the *Pentecost* by Vincenzo Fiammingo (Vincent Adriancz), the *Assumption of the Virgin* by Aurelio Lomi, and finally the *Coronation of the Virgin* by Cavaliere d'Arpino (1593); cf. Eugénie Strong, *La Chiesa Nuova*, Società Editrice d'Arte Illustrata (Rome, 1923), and note 62.

64. Born in Florence (1515) and trained by the Dominicans of San Marco, San Filippo was instructed in this devotion from early childhood.

65. See Graeve, "Stone," p. 234, for a discussion of this practice and the discrepancy between the fifteen mysteries of the rosary and smaller number of altars in the Chiesa Nuova.

66. Cf. *Catholic Encyclopedia* (New York, 1912), s.v. "Rosary."

67. The altar-cycle technique was appearing in Venice close to this same time; cf. chapter 7 and above. Peter Humfrey is at present studying what he calls the "coordinated altarpiece" in Counter-Reformation Venice, starting with the system in the Capuchin Church of the Redentore, designed by Palladio in 1577–88 (consecrated 1592) and commissioned by a state committee. The disposition there is a Wraparound that starts on the right at the entrance end and moves counterclockwise; *Nativity*, Bassano; *Baptism of Christ*, Veronese; *Flagellation*, Tintoretto, on the right; sculptured crucifix on the altar; *Entombment*, Paolo Giovane; *Resurrection*, Bassano; and finally *Ascension*, Tintoretto, at the entrance end on the left. Public lecture, 1 December 1986, Princeton University. Howard Hibbard's study of the conceptual organization of altar and chapel dedications in the Gesù ("*Ut Picturae Sermones*: The First Painted Decorations of the Gesù," in *Baroque Art: The Jesuit Contribution*, ed. Rudolf Wittkower and Irma B. Jaffe [New York, 1972], pp. 29–50) shows the use of the familiar cross-nave pairing in a new form. Rather than being based in narrative cycles, the chapels are decorated thematically, in what can be called narrative clusters, and are connected to the major devotional statements at the high altar and in the transept arms. This thematic organization again moves the possibilities of narrative disposition into physical environments substantially different from the ones used to

structure my database, and therefore it will have to be studied in the next phase of the survey. See below, The Computer Database.

68. The altar was dedicated to the sacrament; the relics included the table of the Last Supper, columns from the Temple of Solomon, and earth from the hill of Golgotha, brought back from Jerusalem by Saint Helena.

69. Assisted by Cesare Nebbia and other members of his highly skilled professional staff of decorators. The Lateran transept and the entire enterprise of the commission is the subject of a Ph.D. dissertation by Jack Freiberg, "The Lateran and Clement VIII" (New York University, 1988). My observations have benefited greatly from information Freiberg shared with me.

70. It seems that the Counterclockwise Wraparound pattern immediately became a new protocol, for it appears in a number of other churches decorated or redecorated during Clement's reign, as at San Cesareo (1600–1601) on the Via Appia (cf. Alexandra Herz, "Cardinal Cesare Baronio's Restoration of SS. Nereo ed Achilleo and S. Cesareo de' Appia," *Art Bulletin* 70[1988]: 590–620), and Santa Prassede (a Passion cycle painted by Baldassare Croce, Cesare Rossetti, Agostino Ciampelli, and others; cf. Carla Faldi Guglielmi, *Basilica di S. Prassede* [Bologna, n.d.], bibliography, p. 2).

71. The same tapestry conceit was used in the prototype in the Vatican *stanze*.

72. The use of this symbol should be related to that in the Oratory of the Cross (see above, this chapter).

73. Kneeling before Saint Sylvester, Constantine presides over a gift-giving ceremony.

74. Proving the "primacy of Christ's special seat on earth"; cf. Freiberg, "Lateran," chap. 4, nn. 146 ff.

75. Many ancient cycles throughout Rome were refreshed or replaced at this time, and in several cases where old ones were lost or lacking, new ones harking back to the venerated prototypes were executed. Sixtus V, the Franciscan who made a point of returning to Santa Maria Maggiore for his mortuary chapel, saw to it that the nave decoration was carried out under one of his cardinals, the archpriest Domenico Pinelli, 1590–93; cf. Steven F. Ostrow, "The Sistine Chapel at S. Maria Maggiore: Sixtus V and the Art of the Counter Reformation" (Ph.D diss., Princeton University, 1987). Pinelli sponsored another team of painters to do a cycle on the tier above the Early Christian mosaics (which Pinelli also had restored): Orazio Gentileschi, Giovanni Battisti Ricci, Andrea Lilio, Ferrari Fenzoni, Ventura Salimbeni, later Baldassare Croce (1614) (and Aureliano Milani, eighteenth century). I am grateful to Ostrow for making this information available to me (1985). Combining the Lives of Mary and Christ, the sequence wraps around starting at the altar end of the right wall and proceeding left to right all the way around the long nave, including the interior facade wall. With the Double-Parallel Apse-to-Entrance disposition of the Old Testament mosaics, the new cycle creates an interlocking system that brings relationships full circle by recalling the disposition in the nave of the Upper Church at Assisi. The difference here is of course that in contrast to traditional arrangements, the New Testament appears above, rather than under, the Old. This innovation takes advantage of the miniature scale of the mosaics, making them footnote commentaries on the Christological scenes above (see chap. 1).

At least two Early Christian churches redone in this period have scenes labeled with letters: Saints Nereo and Achilleo, on the Via Appia (Herz, "Baronio's Restoration," and the martyrologies in Santo Stefano Rotondo, perhaps reflecting an early form of didactic instruction. Cf. Zuccari, "Politica culturale dell'Oratorio romano," pp. 97 ff.

76. The seventeenth-century development that took place in this domain has never been considered. However, even a brief glance indicates how useful such

an investigation would be. For a portion of the ceiling decoration of the apse of San Andrea della Valle in Rome, painted by Domenichino, 1622–27, two parts of the Life of Saint Andrew are disposed in an interlock of the Apse pattern and the Straight-Line Vertical. The *Baptist Revealing Christ to Saints Andrew and Peter* is placed on the intrados of the triumphal arch, oriented toward the worshiper standing in the nave. The *Calling of Saints Andrew and Peter* is the next scene down, directly below in the central segment of the semidome. The *Flagellation of Saint Andrew* appears at the same height on the left and is paired with *Saint Andrew Adoring the Cross on the Way to His Death* on the right. Together the two sequences intersect in a manner not unlike that in the Sassetti Chapel (see chap. 7 above) except that here the episodes appear as *quadri riportati,* placed in a dome, with major decorative forms between them. The arrangement binds the beginning of the apostle's Christian life together with his sacrifice in martyrdom. His final *Glory* appears in a separate rondel at the apex of this arrangement in the center of the semidome, where his rising body is seen *di sotto in sù,* as if moving toward the heavenly sphere above the building. Cf. Richard E. Spear, *Domenichino* (New Haven, 1982), cat. no. 88, pp. 242 ff., figs. 285, 286, 293, 294, 295. A quarter of a century later (1647–51), Bernini used narrative disposition to express a number of ideas in the Cornaro Chapel in Santa Maria della Vittoria. Four episodes from the Life of Saint Teresa are placed on the lower vault surface of the side and altar walls. The chronological arrangement starts to the left of the window on the altar wall (*Teresa and Her Brother as Children Seek Martyrdom*) and moves to the right (*Teresa Flagellates Herself with Keys before a Vision of Christ*). It then moves to the left side wall where *Christ Crowns Teresa for Her Good Offices,* and finally to the right side wall where *Christ Marries Teresa with a Nail.* The disposition is thus two left-right pairs that move from back to front. The result is that youthful scenes of physical ardor are placed on the altar wall, and the two scenes in which Christ honors Teresa for her spiritual achievements are paired on the side walls. Aside from the evident ideological basis for his arrangement of the narrative, Bernini strongly emphasizes its ulterior meaning in two ways. To remove all vestiges of realism from the narrative, he covers the scenes from Teresa's life in unrealistic, ethereal gold and then physically covers the total image with the stucco cloud that descends from above as a heavenly apparition. Cf. Irving Lavin, *Bernini and the Unity of the Visual Arts* (New York, 1980), pp. 129–33.

THE COMPUTER DATABASE: NARRART DATA

1. I soon came to realize that each time an art historian shows two slides together and makes a comparison one is dealing with statistics, whether one knows it or not.

2. One byte is the same as one character or letter on a computer screen.

3. The electrical signals (positive/negative, or 1/0) in a computer program are conventionally designated as 1/2 and yes/no.

4. The basic SAS system provides tools for information storage and retrieval; data modification and programming; report writing; statistical analysis; and file handling. Cf. *SAS User's Guide: Basics* (1982), SAS Institute, Inc., Box 8000, Cary, N.C. 27511. SAS can be run on a variety of hardware types and is currently in use internationally.

5. There can be as many as ninety-nine versions of the same type of record, giving great flexibility to the amount of information the database can ultimately receive.

6. A list of all the codes used in the database is found in appendix 1.

7. City and church codes are listed alphabetically in appendix 1.

8. The coding for these units is given in appendix 1.

9. A thesaurus of titles has been drawn up both for consistency and for use in statistical sorting with SAS.

10. The first of these numbers defines the "narrative mode" of the scene in the following manner: 1 = monoscenic (one representation of a figure performing one narrative action); 2 = polyscenic (one representation of a figure performing more than one narrative action); 3 = continuous (more than one representation of a figure in a given framed painting field); 4 = nonnarrative, devotional image.

11. The full coding of these numbers is found in appendix 1.

12. See below, "Using the SAS Program."

13. The "naturalistic" arrangement of light flow is generally associated with developments in the sixteenth century and later. But see Borsook, *Mural Painters*, fig. F, the study by Paul Hills, *The Light of Early Italian Painting* (New Haven, 1987), and Julia I. Miller, "Symbolic Light in Giotto and the Early Quattrocento in Florence," *Source* 5(1985): 7–13.

14. These statistics find their counterpart, interestingly enough, in Cennino Cennini's *Libro dell'Arte*, ed. Daniel V. Thompson, Jr. (New Haven, 1932), a handbook for craftsmen written between 1396 (the death of Cennino's master Agnolo Gaddi) and 1437 (a dated manuscript version of the book). Chapter 9 (p. 6) tells painters how to achieve relief when drawing or copying in a chapel: Cennino says to do it according to the arrangement of the windows found in these places ("Secondo l'ordine delle finestre chettruovi ne' detti luoghi, che t'anno addare la luce. E chosi, seguitando a luce da qual mano sia, da' el tuo rilievo e lo schuro, secondo la ragion detta"). He goes on to say that if it happens that the light shines through the center straight ahead ("o vero in maesta"), apply your relief in the same way. The passage thus also corroborates the terms I chose to decribe the elements of light flow in the database. I am grateful to Rona Goffen for leading me to this passage.

15. Art historians will recognize in these results a suggestive correlation with the observations of Millard Meiss concerning the relation of certain developments in Tuscan painting style to the bubonic plague, which reached a high point in 1348; *Painting in Florence and Siena after the Black Death* (Princeton, 1951). The nature of this apparent correlation would form part of such a study.

Bibliography

Aikin, Judith P. *The Mission of Rome in the Dramas of Daniel Casper von Lohenstein: Historical Tragedy as Prophesy and Polemics.* Stuttgarter Arbeiten zur Germanistik 21. Stuttgart, 1976.

Algeri, Giuliana. *Gli Zavattari, una famiglia di pittori e la cultura tardo gotica in Lombardia.* Rome, 1981.

Alpatoff, Michel. "The Parallelism of Giotto's Paduan Frescoes." *Art Bulletin* 29(1947): 149–54.

Alpatov, Michel. "Les fresques de Piero della Francesca à Arezzo: Sémantique et stilistique." *Commentari* 1(1963): 17–38.

Ancona, Allessandro d', ed. *La leggenda d'Adamo ed Evo, testo inedito del secolo XIV.* Curiosità letterarie 106. Bologna, 1870.

Ashton, John. *The Legendary History of the Cross.* London, 1887.

Babelon, Jean. "Jean Paleologus et Ponce Pilate." *Gazette des Beaux-Arts,* ser. 6, 4(1930): 365–75.

Bacci, Pier Giacomo. *Vita di S. Filippo Neri* (1745). Ed. Ferrante. Rome, 1855.

Baldini, Umberto. *Le crucifix de Cimabue.* Vienna, 1982.

Baldini, Umberto, and Ornella Casazza. *Critica d'Arte.* 49, 1(1984): 65–72; 51, 11(1986): 65–84; 53, 16(1988): 72–97.

Baldini, Umberto, et al., eds. *Il complesso monumentale di Santa Croce: La basilica, le cappelle, i chiostri, il museo.* Florence, 1983.

Ballerini, Isabella Lapi. "L'emisfero celeste della Sagrestia Vecchia: Rediconti da un giornale di restauro," pp. 75–85 (English translation "Donatello at Close Range," *Burlington Magazine* 129 [1987]: 51–52).

Bargellini, Piero, ed. *San Bernardino da Siena: Le prediche volgari.* Milan, 1937.

Barker, John W.. *Manuel II Palaeologus (1391–1425).* New Brunswick, N.J., 1969.

Batiffol, Pierre. *Histoire du bréviaire romain.* 3d ed. Paris, 1911.

Battaglia, Salvatore. *Grande dizionario della lingua italiana.* Turin, 1961.

Battisti, Eugenio. *Cicli pittorici storie profane.* Touring Club Italiana. Milan, 1981.

———. *Cimabue.* Milan, 1963.

———. *Il crocifisso di Cimabue in Santa Croce.* Milan, 1967.

———. "Roma apocalittica e il Re Salomone." In *Rinascimento e Barocco,* 712–95. Turin, 1960.

———. "Il significato simbolico della Cappella Sistina." *Commentari* 8(1957): 96–104.

———. *Piero della Francesca.* Milan, 1971.

Baxandall, Michael. *Giotto and the Orators.* Oxford, 1971.

Beck, James. *Masaccio: The Documents.* Locust Valley, N.Y., 1978.

Béidier, Joseph. *Les légendes épiques.* 3 vols. Paris, 1921.

Bellosi, Luciano. *Buffalmacco e il trionfo della morte.* Turin, 1974.

Belting, Hans. *Die Oberkirche von San Francesco in Assisi.* Berlin, 1977.

Beltrami, Luca. *Luini, 1512–1532.* Milan, 1911.

Bennett, M. R. "The Legend of the Green Tree and the Dry." *Archaeological Journal* 83 (1926): 19–23.

Bennett, V., and R. Winch. *The Assumption of Our Lady and Catholic Theology.* London, 1950.

Berenson, Bernard. *Piero della Francesca, or The Ineloquent in Art.* New York, 1954. Originally published 1950.

Bertaux, Emile. *L'art dans l'Italie meridionale.* Ed. Adriano Prandi. Rome, 1978. Originally published 1904.

Bertelli, Carlo. "Il restauro della Cappella Carafa in S. Maria sopra Minerva a Roma." *Bollettino dell'Istituto Centrale del Restauro,* 1965, pp. 145–95.

Bettini, Sergio. *Le pitture di Giusto di Menabuoi nel Battistero del Duomo di Padua.* Venice, 1960.

Bettini, Sergio, and Leonello Puppi. *Le Chiesa degli Eremitani di Padova.* Vicenza, 1970.

Beven, Edwyn. *Holy Images.* London, 1940.

Bibliotheca sanctorum. Rome: Grottaferrata di Roma, 1967.

Biondo, Flavio. *Roma triumphans.* Basel, 1559. Originally published 1459.

Blair, Hugh. *Lectures on Rhetoric.* Brooklyn, N.Y., 1812. Originally published 1783.

Blume, Dieter. *Wandmalerei als Ordenspropaganda, Bildprogramme im Chorbereich franziskanischer Konvente italiens bis zur Mitte des 14. Jahrhunderts.* Heidelberger Kunstgeschichtliche 17. Worms, 1983.

Boeckler, Albert. *Die Bronzetüren des Bonanus von Pisa und des Barisanus von Trani.* Berlin, 1953.

Boime, Albert. "Seurat and Piero della Francesca." *Art Bulletin* 47(1965): 265–71.

Bologna, Ferdinando. *Gli affreschi di Simone Martini ad Assisi.* Milan, 1965.

———. *Novità su Giotto: Giotto al tempo della cappella Peruzzi.* Turin, 1969.

Bonelli, R. *Il Duomo di Orvieto e l'architettura italiana del duecento trecento.* Città di Castello, 1952.

Borcherdi, Hans Heinrich. *Das europäische Theater im Mittelalter und in der Renaissance.* Leipzig, 1935.

Borsook, Eve. "The Frescoes at San Leonardo al Lago." *Burlington Magazine* 98(1956): 351–58.

———. "Giotto nelle Cappelle Bardi e Peruzzi." In *Giotto e giotteschi in Santa Croce.* Florence, 1966.

———. *The Mural Painters of Tuscany, from Cimabue to Andrea del Sarto.* Oxford, 1980. Originally published 1960.

———. "Notizie su due cappelle in Santa Croce a Firenze." *Rivista d'Arte* 36(1961–62): 98–106.

Borsook, Eve, and Johannes Offerhaus. *Francesco Sassetti and Ghirlandaio at Santa Trinita Florence: History and Legend in a Renaissance Chapel.* Doornspijk, 1981.

Borsook, Eve, with Leonetto Tintori. "Fra Filippo Lippi and the Murals for Prato Cathedral." *Mitteilungen des Kunsthistorischen Institutes in Florenz* 19(1975).

Boschetto, Antonio. *Benozzo Gozzoli, nella chiesa di San Francesco a Montefalco.* Milan, 1961.

Boskovits, Miklòs. "Gli affreschi del Duomo di Anagni: Un capitolo di pittura romana." *Paragone* 357 (1979): 3–41.

Branca, Vittore. *Boccaccio medievale*. Florence, 1981.

Brancaloni, Leoni. *L'arte francescana nella vita e nella storia de settecento anni*. Todi, 1924.

Brault, Gerard J., ed. *The Song of Roland: An Analytical Edition*. 2 vols. University Park, Pa., 1978.

Brenk, Beat. *Die frühchristlichen Mosaiken in S. Maria Maggiore zu Rom*. Wiesbaden, 1975.

———. "Müstair and Artistic Centers in Italy: Milan, Verona and Rome." Paper presented at symposium on Italian Church Decoration of the Middle Ages and Early Renaissance: The Problem of Regional Traditions, Johns Hopkins University, Florence, March 1987.

Brilliant, Richard. *Visual Narratives: Storytelling in Etruscan and Roman Art*. Ithaca, N.Y., 1984.

Brink, C. O. *Horace on Poetry*. Vol. 1 (1963), vol. 2 (1971).

Brink, Joel. "Sts Martin and Francis: Sources and Meaning in Simone Martini's Montefiore Chapel." In *Renaissance Studies in Honor of Craig Hugh Smyth*, ed. Andrew Morrogh et al., 2:79–96. Florence, 1985.

Brown, James Wood. *The Dominican Church of Santa Maria Novella*. Edinburgh, 1902.

Brown, Patricia Fortini. "Painting and History in Renaissance Venice." *Art History* 7 (1984): 263–94.

———. *Venetian Narrative Painting in the Age of Carpaccio*. New Haven, 1988.

Brown, Raphael. *Our Lady and St. Francis: All the Earliest Texts*. Chicago, 1954.

Brucker, Gene. *The Civic World of Early Renaissance Florence*. Princeton, 1977.

Brunacci, Aldo. *Leggende e culto di S. Rufino in Assisi*. Perugia, 1955.

Bryson, Norman. *Vision and Painting: The Logic of the Gaze*. New Haven, 1983.

Bucci, Mario, and Licia Bertolini. *Camposanto monumentale di Pisa: Affreschi e sinopie*. Pisa, 1960.

Bull, Malcolm. "The Iconography of the Sistine Chapel Ceiling." *Burlington Magazine* 130 (1988): 601 ff.

Burali, Jacopo. *Vite de Vescovi Aretini, 336–1638*. Arezzo, 1638.

Burresi, Mariagiulia, with Antonino Caleca. *Andrea, Nino e Tommaso, scultori pisani*. Milan, 1983.

Busuioceanu, Alexandru. "Un ciclo di affreschi del secolo XI: s. Urbano alla Caffarella." *Ephemeris Dacoromana* 2 (1924).

Calabrese, Omar. "Note sul dispositivo formale della 'Storia della Vera Croce' di Piero della Francesca ad Arezzo." In *La macchina della pittura: Pratiche teoriche della rappresentazione figurative fra Rinascimento e Barocco*, pp. 241–63. Biblioteca di Cultura Moderna Laterza 917. Rome, 1985.

Callahan, Daniel F. "The Sermons of Ademar of Chabannes and the Cult of St. Martial of Limoges." *Revue Bénédictine* 86 (1976): 251–95.

Calvesi, Maurizio. "Sistema degli equivalenti ed equivalenze del sistema in Piero della Francesca." *Storia dell'Arte* 24–25 (1975): 83–110.

Campagnola, Stanislao da. *L'angelo del sesto sigillo et l'"Alter christus": Genesi e sviluppo di due temi francescani nei secoli XIII–XIV*. Rome, 1971.

Cannon, Joanna. "Dating the Frescoes by the Maestro di S. Francesco at Assisi." *Burlington Magazine* 124 (1982): 65–69.

Carli, Enzo. *Gli affreschi di Belverde*. Florence, 1977.

———. *Il Campo Santo di Pisa*. Rome, 1937.

———. *Il Duomo di Orvieto*. Rome, 1965.

———. *Piero della Francesca: The Frescoes in the Church of San Francesco at Arezzo*. Milan, 1963.

———. *Il Pintoricchio*. Milan, 1960.

———. *Pittura pisana del trecento*. Vol. 2. Milan, 1961.

Carr, Carolyn K. "Aspects of the Iconography of Saint Peter in Medieval Art of Western Europe to the Early Thirteenth Century." Ph.D. diss., Case Western Reserve, 1978.

Carrier, David. "Piero della Francesca and His Interpreters: Is There Progress in Art History?" *History and Theory: Studies in the Philosophy of History* 26 (1987): 150–65.

Casazza, Ornella. "Il ciclo delle storie di San Pietro e la 'Historia Salutis': Nuova lettura della Cappella Brancacci." *Critica d'Arte* 51, 9(1986): 69–84.

Caselli, Fausto Piola. *La costruzione del palazzo dei papi di Avignone, 1316–1367.* Milan, 1981.

Cassidy, Brendan F. "The Tabernacle of Orcagna in the Church of Orsanmichele in Florence." Ph.D. diss., University of Cambridge, 1983.

Castelfranchi-Vegas, Liana. *Giovanni da Milano.* Maestri del Colore, 3. Milan, 1965.

Castelnuovo, Enrico. *Matteo Giovannetti al palazzo dei papi ad Avignone.* Milan, 1965.

Ceccarini, Ivo. *Duomo di S. Gimignano: Ampliamenti e trasformazioni nei secoli XIV e XV.* Poggibonsi, 1979.

Chastel, André. "L'Apocalypse en 1500: La fresque de l'Antéchrist à la chapelle Saint-Brice à Orvieto." In *Humanisme et Renaissance,* 14: 124–40. Paris, 1952.

———. *Fables, formes, figures.* Vol. 1. Paris, 1978.

———. "Le rencontre de Salomon et de la reine de Saba dans l'iconographie médiévale." *Gazette des Beaux-Arts* 35 (1949): 99–114.

Ciammitti, Luisa. *Tre artisti nella Bologna dei Bentivoglio.* Bologna, 1985.

Ciarambino, Gerardo C. A. *Carlomagno, Gano, e Orlando, in alcuni romanzi italiani del XIV e XV secolo.* Pisa, 1976.

Ciartoso, Maria. "Note su Antoniazzo Romano, degli affreschi in Santa Croce in Gerusalemme e di due imagini votive." *L'Arte* 14 (1911): 42–52.

Clagett, Marshall. *Archimedes in the Middle Ages.* Vol. 3. *The Medieval Archimedes in the Renaissance, 1450–1565.* Philadelphia, 1978.

Clark, Kenneth. *Piero della Francesca.* London, 1969. Originally published 1951.

Clasen, Sophronius. "Franziskus, der neue Moses." *Wissenschaft und Weisheit* 24 (1961): 200–208.

Clermont-Ganneau, Charles. "The Taking of Jerusalem by the Persians, A.D. 614." *Palestine Excavation Fund Quarterly,* 1898, pp. 43 ff.

Cocke, Richard. "Masaccio and the Spinario, Piero and the Pothos." *Zeitschrift für Kunstgeschichte* 43 (1980): 21–32.

———. "Piero della Francesca and the Development of Italian Landscape Painting." *Burlington Magazine* 122 (1980): 627–31.

Cole, Bruce. *Agnolo Gaddi.* Oxford, 1977.

———. "Masolino's True Cross Cycle in Santo Stefano, Empoli." *Mitteilungen des Kunsthistorischen Institutes in Florenz* 13 (1968): 289–300.

———. "Three New Works by Cenni di Francesco." *Burlington Magazine* 111 (1969): 83 ff.

Collins, Howard. "Major Narrative Paintings by Jacopo Bellini." *Art Bulletin* 14 (1982): 466–72.

Cornell, Henrik. *The Iconography of the Nativity of Christ.* Uppsala, 1924.

Cothren, Michael W., and Elizabeth A. R. Brown. "The Twelfth-Century Crusade Window of the Abbey of Saint-Denis." *Journal of the Warburg and Courtauld Institutes* 49 (1986): 1–40.

Cox, Zimeri. "Ugolino di Prete Ilario, Painter and Mosaicist," Ph.D. diss., Institute of Fine Arts, New York University, 1976.

Cozzi, Eurica. "Temi cavallereschi e profani nella cultura figurative Trevigiana

dei secoli XIII e XIV." In *Tomaso da Modena,* ed. Luigi Menegazzi. Treviso, 1979.

Cwi, Joan S. "A Study in Carolingian Political Theology: The David Cycle at St. John, Müstair." In *Riforma religiosa e arti nell'Epoca Carolingia,* ed. Alfred A. Schmid, pp. 117–28. Atti del XXIVe Congresso Internazionale di Storia dell'Arte 1979. Bologna, 1983.

d'Otrange Mastai, Marie Louise. *Illusion in Art, Trompe l'Oeil: A History of Pictorial Illusionism.* New York, 1975.

Dabell, Frank. "Domenico Veneziano in Arezzo and the Problem of Vasari's Painter Ancestor." *Burlington Magazine* 127(1985): 29–32.

Dacos, Nicole. *La découverte de la Domus Aurea et la formation des grotesques à la Renaissance.* London, 1969.

Davis, Charles T. "Topographical and Historical Propaganda in Early Florentine Chronicles and in Villani." *Medioevo e Rinascimento, Annuario* 2(1988): 33–51.

Davis-Weyer, Cäcilia. *Early Medieval Art, 300–1150.* Englewood Cliffs, N.J., 1971.

De Campos, Deoclecio Redig, ed. *Art Treasures of the Vatican.* Englewood Cliffs, N.J., 1975.

Deckers, Johannes G. "Die Wandmalerei des tetrarchischen Lagerheiligtums im Ammon-Tempel von Luxor." *Römische Quartalschrift für Christliche Altertumskunde und Kirchengeschichte* 68(1973): 1 ff.

Deichmann, Friedrich Wilhelm. *Ravenna: Hauptstadt des spätantiken Abendlandes.* Vol. 1. *Geschichte und Monumente.* Wiesbaden, 1969. Vol. 2. *Kommentar.* Wiesbaden, 1974. Vol. 3. *Frühchristliche Bauten und Mosaiken von Ravenna,* 2d ed. Wiesbaden, n.d.

Delaporte, Yves, and Etienne Houvet. *Les vitraux de la cathédrale de Chartres.* Chartres, 1926.

Del Vita, Alessandro. "La battaglia di Anghiari rappresentata da Piero della Francesca?" *Il Vasari* 17(1959): 106–11.

Demus, Otto. *Byzantine Mosaic Decoration.* New Rochelle, N.Y., 1976.

———. *The Mosaics of San Marco in Venice.* Vol. 4. Chicago, 1984.

———. *Romanesque Mural Painting.* Trans. Mary Whittall. London, 1970.

Denny, Don. "The Annunciation from the Right: From Early Christian Times to the Sixteenth Century." Ph.D. diss., New York University, 1965. Reproduced by Garland Press, New York, 1977.

Der Nersessian, Sirarpie. "The Illustrations of the Homilies of Gregory of Nazianzus, Paris Gr. 510: A Study of the Connections between Text and Images." *Dumbarton Oaks Papers* 16 (1962): 197–228.

De Tolnay, Charles. "Conceptions religieuses dans la peinture de Piero della Francesca." *Arte Antica e Moderna* 23(1963): 205–41.

———. *Michelangelo: The Sistine Ceiling.* Princeton, 1959.

———. "Remarques sur la Sainte Anne de Léonardo." *Revue des Artes* 6(1956): 161–66.

Deuchler, Florens. *Duccio.* Milan, 1984.

———. "Le sense de la lecture, à propos du boustrophedon." In *Etudes d'art médiéval offertes à Louis Grodecki,* ed. Sumner McK. Crosby et al., 251–58. Paris, 1981.

Diringer, David. *The Illuminated Book: Its History and Production.* New York, 1967.

Dizionario della lingua italiana. Florence: Sansoni, 1975.

Dotson, Esther Gordon, "An Augustinian Interpretation of Michelangelo's Sistine Ceiling." *Art Bulletin* 61(1979): 223–56, 405–49.

Duchesne, Louis. *Origines du culte chrétien: Etude sur la liturgie latine avant Charlemagne.* Paris, 1898.

Durandus of Mende. *Rationale divinorum officiorum.* Trans. J. M. Neale and B. Webb as *The Symbolism of Churches and Church Ornaments.* Leeds, 1843. Originally published 1568.

Eberlein, Johann Konrad. *Apparitio Regis—Revelatio Veritatis.* Wiesbaden, 1982.

———. "The Curtain in Raphael's Sistine Madonna." *Art Bulletin* 65(1983): 61–77.

———. Letter to the Editor. *Art Bulletin* 66(1984): 330–31.

Edwards, Mary D. "The Chapel of S. Felice in Padua as *Gesamtkunstwerk.*" *Journal of the Society of Architectural Historians* 47(1988): 160–72.

Eisenberg, Marvin. "The First Altar-Piece for the 'Cappella de' Signori' of the Palazzo Pubblico in Siena: '. . . Tales figure sunt adeo pulcre. . . .'" *Burlington Magazine* 123(1981): 134–47.

Eisler, Colin. "The Golden Christ of Cortona and the Man of Sorrows in Italy." *Art Bulletin* 51(1969): 107–18, 233–46.

Eleen, Luba. "The Frescoes from the Life of St. Paul in San Paolo fuori le Mura in Rome: Early Christian or Medieval?" In *The Roman Tradition in Wall Decoration,* vol. 12 of *Canadian Art Review,* pp. 251–59. Quebec, 1985.

Emiliani, Andrea. *Il Bronzino.* Milan, 1960.

Enciclopedia dello spettacolo. Vol. 6. Rome, 1975.

Ettlinger, L. D. *The Sistine Chapel before Michelangelo: Religious Imagery and Papal Primacy.* Oxford, 1965.

Fabbri, Nancy Rash, and Nina Rutenburg. "The Tabernacle of Orsanmichele in Context." *Art Bulletin* 63(1981): 385–405.

Fagiolo, Marcello. "Chiesa Celeste, Chiesa Umana, Chiesa di Pietra." *Chiese e Cattedrali* (Touring Club Italiano), 1978, 47–49.

Falk, Ilse, and Jëno Lanyi. "The Genesis of Andrea Pisano's Bronze Doors." *Art Bulletin* 25(1943): 132–53.

Farulli, Pietro. *Annali di Arezzo in Toscana, dal suo principio fino al presente anno 1717.* Foligno, 1717.

Fengler, Christie K. "Bartolomeo di Fredi's Old Testament Frescoes in S. Gimignano." *Art Bulletin* 63(1981): 374–84.

Ferraro, Salvatore. *La colonna del cereo pasquale di Gaeta.* Naples, 1905.

Finelli, Luciana. *L'umanesimo giovane: Bernardo Rossellino a Roma e Pienza.* Rome, 1984.

Fiocco, Giuseppe. *The Frescoes of Mantegna in the Eremitani Church, Padua.* Oxford, 1978.

Fleming, John V. *From Bonaventure to Bellini: An Essay in Franciscan Exegesis.* Princeton, 1982.

Flores d'Arcais, Francesca. *Guariento.* Venice, 1965.

Folz, Robert. *Le souvenir et la légende de Charlemagne dans l'empire germanique médiéval: Etudes sur le culte liturgique de Charlemagne dans les églises de l'empire.* Geneva, 1973.

Freedberg. Sydney J. *Andrea del Sarto.* Cambridge, Mass., 1963.

Freiberg, Jack. "The Lateran and Clement VIII." Ph.D. diss., New York University, 1988.

Fremantle, Richard. *Florentine Gothic Painters, from Giotto to Masaccio: A Guide to Painting in and near Florence, 1300–1400.* London, 1975.

Freuler, Gaudenz. *Biagio di Goro Ghezzi a Paganico.* Florence, 1986.

———. "Die Fresken der Biagio di Goro Ghezzi in S. Michele, in Paganico." *Mitteilungen des Kunsthistorischen Institutes in Florenz* 25(1981): 35–58.

———. "Lippo Memmi's New Testament Cycle in the Collegiata in San Gimignano." *Arte Cristiana* 79(1986): 93–102.

Friedman, David. "The Burial Chapel of Filippo Strozzi in S. Maria Novella in Florence." *L'Arte* 9(1970): 109–31.

Frolow, Anatol. *Les reliquaires de la Vraie Croix*. Paris, 1965.

Fry, Roger. *Vision and Design*. New York, 1921.

Fumi, Luigi. *Il duomo di Orvieto e i suoi restauri*. Rome, 1891.

Gaillard, George. *Les fresques de Saint-Savin*. Paris, 1944.

Garber, Josef. *Wirkungen der frühchristlichen Gemäldezyklen der alten Peters- und Pauls basilika in Rom*. Berlin, 1918.

Gardner, Julian. "Andrea di Bonaiuto and the Chapterhouse Frescoes in Santa Maria Novella." *Art History* 2(1979): 107–37.

———. "The Decorations of the Baroncelli Chapel in Santa Croce." *Zeitschrift für Kunstgeschichte* 34(1971): 89–114.

———. "Nicholas III's Oratory of the Sancta Sanctorum and Its Decoration." *Burlington Magazine* 115(1973): 283–94.

———. "Pope Nicolas IV and the Decoration of Santa Maria Maggiore." *Zeitschrift für Kunstgeschichte* 36(1973): 1–50.

Gardner von Teuffel, Christa. "Lorenzo Monaco, Filippo Lippi und Filippo Brunelleschi: Die Erfindung der Renaissancepala." *Zeitschrift für Kunstgeschichte* 45(1982): 1–30.

Gasparotto, Cesira. "Critica della cronologia tradizionale della Cappella degli Scrovegni." *Padova e la Sua Provincia* 12, 10(1966): 3–9; 12, 11(1966):3–12.

Gaston, Robert W. "Studies in the Early Christian 'Tituli' of Wall Decoration in the Latin West (The Tituli of St. Paulinus of Nola)." Ph.D. diss., University of London, 1969.

Gatti, Daniella. *La "Vita Caroli" di Donato Acciaiuoli: La leggenda di Carlo Magno in funzione di una "historia" di gesta*. Bologna, 1981.

Gatti Perer, Maria Luisa. "Historia salutis e istoria: Varianti lombarde nell'applicazione del 'De pictura' di Leon Battista Alberti." *Arte Lombarda* 80–82(1987): 17–36.

Geary, Patrick J. *Furta Sacra: Thefts of Relics in the Central Middle Ages*. Princeton, 1978.

Geiger, Gail L. "Filippino Lippi's Carafa 'Annunication': Theology, Artistic Conventions, and Patronage." *Art Bulletin* 63(1981): 62–75.

———. *Filippino Lippi's Carafa Chapel: Renaissance Art in Rome*. Kirksville, Mo., 1986.

Genette, Gérard. *Narrative Discourse*. Oxford, 1972.

Gennaro, Clara. "Bufalini, Niccolò dei (Nicolaus de Castello)." In *Dizionario biografico degli Italiani*, 14: 802–3. Rome, 1972.

Gilbert, Creighton E. "Antique Frameworks for Renaissance Art Theory: Alberti and Pino." *Marsyas* 3(1943–45): 87–106.

———. *Change in Piero della Francesca*. Locust Valley, N.Y., 1968.

Gill, Joseph. *The Council of Florence*. Cambridge, 1959.

Ginzburg, Carlo. *Indagine su Piero*. Turin, 1981. Translated as *The Enigma of Piero: Piero della Francesca: The Baptism, the Arezzo Cycle, the Flagellation*. London, 1985 (reviewed by Eve Borsook, *Burlington Magazine* 125[1983]: 163–64).

Giunta, Diega. "La presenza di S. Caterina di Siena in Roma, cenni storico-iconografici." *Urbe* 42(1979): 38–47.

Glass, Dorothy. "Papal Patronage in the Early Twelfth Century: Notes on the Iconography of Cosmatesque Pavements." *Journal of the Warburg and Courtauld Institutes* 32(1969): 386–90.

———. *Studies on Cosmatesque Pavements*. BAR Intern Series 82. Oxford, 1980.

Gnudi, Cesare. *Giotto*. Milan, 1958.

Goetz, Oswald. *Der Feigenbaum in der religiösen Kunst des Abendlandes*. Berlin, 1965.

Goffen, Rona. "Friar Sixtus IV and the Sistine Chapel." *Renaissance Quarterly* 39(1986): 218–63.

—————. *Piety and Patronage in Renaissance Venice: Bellini, Titian, and Franciscans.* New Haven, 1986.

—————. *Spirituality in Conflict: Saint Francis and Giotto's Bardi Chapel.* University Park, Pa., 1988.

Goldberg, Jonathan. "Quattrocento Dematerialization: Some Paradoxes in a Conceptual Art." *Journal of Aesthetics and Art Criticism* 35(1976): 153–68.

Goldner, George. "Notes on the Iconography of Piero della Francesca's *Annunciation* in Arezzo." *Art Bulletin* 56(1974): 342–44.

Goldschmidt, Adolph, and Kurt Weitzmann. *Die byzantineschen Elfenbeinskulpturen des X.–XIII. Jahrhunderts.* Berlin, 1934.

Gombrich, Ernst H. *Means and Ends: Reflections on the History of Fresco Painting.* Walter Neurath Memorial Lecture. London, 1976.

Gosebruch, Martin. *Giotto und die Entwicklung des neuzeitlichen Kunstbewusstseins.* Cologne, 1962.

Gottlieb, Carla. "A Sienese Annunciation and Its Fenestra Cancellata." *Gazette des Beaux-Arts* 83(1974): 89–96.

Graeve, Mary Anne. "The Stone of Unction in Caravaggio's Painting for the Chiesa Nuova." *Art Bulletin* 40(1958): 223–38.

Grébaut, Sylvain. "Littérature ethiopienne Pseudo-Clémentine: Traduction du Qalêmentos." *Revue de l'Orient Chrétien* 16(1911): 72 ff., 167 ff., 225 ff.

Greco, Antonella. *La Cappella di Niccolò V del Beato Angelico.* Rome, 1980.

Green, Rosalie B., and Isa Ragusa, trans. *Meditations on the Life of Christ: An Illustrated Manuscript of the Fourteenth Century (Meditationes Christi,* by a Tuscan Franciscan). Princeton, 1961.

Gregori, Luigi di. *Del Chiostro della Minerva.* Florence, 1927.

Gregori, Mina. *Giovanni da Milano alla Cappella Rinuccini.* L'Arte Racconta 30. Milan, 1965.

Grimaldi, Giacomo. *Descrizione della basilica antica di S. Pietro in Vaticano, Codice Barberini Latino 2733.* Ed. Reto Niggl. Codices ex Vaticanis Selecti 32. Vatican City, 1972.

Groenewegen-Frankfort, Henrietta A. *Arrest and Movement: An Essay on Space and Time in the Representational Art of the Ancient Near East.* Chicago, 1951.

Grounau, Hans Dietrich. *Andrea Orcagna und Nardo di Cione.* Berlin, 1937.

Grumel, Venance. "La reposition de la Vraie Croix à Jérusalem par Héraclius: Le jour et année." In *Byzantinische Forschungen,* ed. A. M. Hakkert and Peter Wirth, 1:139–49. Amsterdam, 1966.

Guglielmi, Carla Faldi. *Basilica di S. Prassede.* Bologna, n.d.

Gy-Wilde, Julie. "Die Stellung der 'Himmelfahrt Maria' und der 'Stigmatisation des Hl. Franziskus' in Giottos Werk: Giotto-Studien." *Wiener Jahrbuch für Kunstgeschichte* 7(1930): 45–94.

Habig, Marion A., ed. *St. Francis of Assisi, Writings and Early Biographies: English Omnibus of the Sources for the Life of St. Francis.* Chicago, 1983.

Hahn, Cynthia. "Narrative and Liturgy in the Earliest Illustrated Lives of the Saints." Ph.D. diss., Johns Hopkins University, 1982.

Haines, Victor Yelvertain. *The Fortunate Fall of Sir Gawain: The Typology of Sir Gawain and the Green Knight.* Washington, D.C., 1982.

Hall, Edwin, and Horst Uhr. "'Aureola super Auream': Crowns and Related Symbols of Special Distinction for Saints in Late Gothic and Renaissance Iconography." *Art Bulletin* 67(1985): 567–603.

Hall, Marcia B. "The *Ponte* in S. Maria Novella." *Journal of the Warburg and Courtauld Institutes* 37(1974):157–73.

—————. *Renovation and Counter-Reformation: Vasari and Duke Cosimo in Sta Maria Novella and Sta Croce, 1565–1577.* Oxford, 1979.

————. "The Tramezzo in Sta Croce Reconstructed." *Art Bulletin* 56(1974): 325–41.

Hanfmann, George M. A. "Narration in Greek Art." In *Narration in Ancient Art: A Symposium*, ed. Carl Hermann Kraeling et al. (1957). Reprinted in *American Journal of Archaeology* 61(1961): 43–91.

Hartt, Frederick. *Giulio Romano*. New Haven, 1957.

————. *The History of Italian Renaissance Art*. Englewood Cliffs, N.J., 1975.

————. "*Lignum Vitae in Medio Paradisi:* The Stanza d'Eliodoro and the Sistine Ceiling." *Art Bulletin* 32(1950): 115–45.

————. "*Lucerna ardens et lucens:* Il significato della Porta del Paradiso." In *Lorenzo Ghiberti nel suo tempo*, pp. 27–57. Atti del Convegno Internazionale di Studi. Florence, 1978.

Hartt, Frederick, and Gino Corti. "Andrea Castagno: Three Disputed Dates." *Art Bulletin* 48(1966): 228–33.

Hatfield, Rab. "The Compagnia de' Magi." *Journal of the Warburg and Courtauld Institutes* 33(1970): 107–61.

Hedberg, Gergory. "Antoniazzo Romano and His School." Ph.D. diss., New York University, 1980.

Heideman, Johanna E. L. *Cinequecento Chapel Decorations in S. Maria in Aracoeli in Rome*. Amsterdam, 1982.

Hendy, Philip. *Piero della Francesca and the Early Renaissance*. New York, 1968.

Henkels, H. "Remarks on the Late Thirteenth-Century Apse Mosaic in Santa Maria Maggiore." *Simiolus* 4(1971): 128–49.

Herz, Alexandra. "Cardinal Cesare Baronio's Restoration of SS. Nereo ed Achilleo and S. Cesareo de' Appia." *Art Bulletin* 70(1988): 590–620.

Hetherington, Paul. *Pietro Cavallini: A Study in the Art of Late Medieval Rome*. London, 1979.

Heydenreich, Ludwig H. *Eclosion de la Renaissance, Italie: 1400–1460*. Paris, 1972.

Heyen, Franz-Joseph. *Kaiser Heinrichs Romfahrt*. Boppard am Rhein, 1965.

Hibbard, Howard. "*Ut Picturae Sermones:* The First Painted Decorations of the Gesù." In *Baroque Art: The Jesuit Contribution*, ed. Rudolf Wittkower and Irma B. Jaffe, pp. 29–50. New York, 1972.

Hills, Paul. *The Light of Early Italian Painting*. New Haven, 1987.

Hirn, Yiro. *The Sacred Shrine*. London, 1912.

Hirschel, Anthony. "Problems of Patronage at Monza: The Legend of Queen Theodelinda." *Arte Lombarda* 80–82(1987): 105–13.

Hoch, Adrian S. "St. Martin of Tours: His Transformation into a Chivalric Hero and Franciscan Ideal." *Zeitischrift für Kunstgeschichte* 50(1987): 471–82.

Höger, Annegret. "Studien zur Entstehung der Familien Kapelle und zu Familienkapellen und -altären des Trecento in Florentiner Kirchen." Ph.D. diss., Universität, Bonn, 1976.

Hope, Charles. "Religious Narrative in Renaissance Art." *Royal Society for the Encouragement of Arts, Manufactures and Commerce Journal* 134(1986): 804–18.

Horace [Quintus Horatius Flaccus]. *Arts poetica*. Ed. Charles D. N. Costa. Boston, 1973.

Horn, Walter. "Das Florentiner Baptisterium." *Mitteilungen des Kunsthistorischen Institutes in Florenz* 5(1938).

Horster, Marita. *Andrea del Castagno*. Oxford, 1980.

Hueck, Irene. "Cimabue und das Bildprogramm der Oberkirche von San Francesco in Assisi." *Mitteilungen des Kunsthistorischen Institutes in Florenz* 25(1981): 280–324.

————. "Le copie di Johann Anton Ramboux da alcuni affreschi in Toscana ed in Umbria." *Prospettiva* 23(1980): 2–10.

———. *Das Programm der Kuppelmosaiken im Florentiner Baptisterium.* Mondorf, 1962.

———. "Zu Enrico Scrovegnis Veränderungen der Arenakapella." *Mitteilungen des Kunsthistorichen Institutes in Florenz* 17(1973): 277–94.

Huetter, Luigi, and Emilio Lavagnino. *S. Onofrio.* Rome, 1951.

Humfrey, Peter. "The Life of St. Jerome Cycle from the Scuola di San Gerolamo in Cannaregio." *Arte Veneta* 34(1985): 41–46.

Jacobus de Voragine. *Legenda aurea: Vulgo historia lombardica dicta.* Ed. Th. Graesse, 1st ed., Leipzig, 1850. Translated and adapted as *The Golden Legend of Jacobus de Voragine,* ed. Granger Ryan and Helmut Ripperger, 1941. 2d ed. New York, 1969.

Jameson, Mrs. [Anna Butler]. *Legends of the Madonna.* London, 1852.

Janson, Horst W. *The Sculpture of Donatello.* Princeton, 1957.

Jeffery, Lillian H. *The Local Scripts of Archaic Greece.* Oxford, 1961.

Jones, Mark. *A Catalogue of the French Medals in the British Museum.* Vol. 1. *A.D. 1402–1610.* London, 1982.

———. "The First Cast Medals and the Limbourgs: The Iconography and Attribution of the Constantine and Heraclius Medals." *Art History* 2(1979): 35–44.

Jones, Meredith. "The Conventional Saracen of the Songs of Geste." *Speculum* 17(1942): 201–25.

Jordan, Constance. *Pulci's "Morgante": Poetry and History in Fifteenth-Century Florence.* Washington, D.C., 1986.

Jugie, Martin. *Le mort e l'assomption de la sainte Vièrge.* Studi e Testi 114. Vatican City, 1944.

Kaftal, George. *Iconography of the Saints in Central and South Italian Schools of Painting.* Florence, 1965.

———. *The Iconography of the Saints in Tuscan Painting.* Florence, 1952.

Kahsnitz, Rainer. "Zur Verkündigung im Zyklus der Kreuzlegende bei Piero della Francesca." In *Schülerfestgabe für Herbert von Einem,* pp. 112–37. Bonn, 1965.

Kalavrezou-Maxeiner, Ioli. "The Imperial Chamber at Luxor." *Dumbarton Oaks Papers* 29(1975): 227 ff.

Kantorowicz, Ernst H. "The 'King's Advent' and the Enigmatic Panels in the Doors of Santa Sabina." *Art Bulletin* 26(1944): 208–31.

Karpp, Heinrich, ed. *Die frühchristlichen und mittelalterlichen Mosaiken in Santa Maria Maggiore zu Rom.* Baden-Baden, 1966.

Keller, Rolf. *Das Oratorio von S. Giovanni Decollato in Rom.* Neuchatel, 1976.

Kemp, Wolfgang, *"Sermo Corporeus": Die Erzählung der mittelalterlichen Glasfenster.* Munich, 1987.

Kennedy, Ruth W. *Alessio Baldovinetti.* New Haven, 1938.

Kent, F. W., Patricia Simons, and J. C. Eade, eds. *Patronage, Art, and Society in Renaissance Italy.* Oxford, 1987.

Kessler, Herbert L. "The Meeting of Peter and Paul in Rome: The Emblematic Narrative of Spiritual Brotherhood." In *Studies in Art and Archaeology in Honor of Ernst Kitzinger on His Seventy-fifth Birthday. Dumbarton Oaks Papers* 41(1987): 265–75.

———. "Pictorial Narrative and Church Mission in Sixth-Century Gaul." In *Pictorial Narrative,* pp. 75–91.

———. "Pictures as Scripture in Fifth-Century Churches." *Studia Artium Orientalis et Occidentalis* 2(1985): 17–31.

Kirsch, Edith W. "An Early Reliquary of the Holy Nail in Milan." *Mitteilungen des Kunsthistorischen Institutes in Florenz* 30(1986): 569–76.

Kitzinger, Ernst. "The Arts as Aspects of a Renaissance, Rome and Italy." In

Renaissance and Renewal in the Twelfth Century, ed. R. L. Benson and Giles
 Constable, pp. 637–70. Cambridge, 1982.

————. *Byzantine Art in the Making: Main Lines of Stylistic Development in
 Mediterranean Art, Third–Seventh Century.* Cambridge, Mass., 1977.

————. "Christian Imagery: Growth and Impact." In *The Age of Spirituality:
 Late Antique and Early Christian Art, Third to Seventh Century,* ed. Kurt
 Weitzmann et al., pp. 141–63. New York, 1980.

————. *The Mosaics of Monreale.* Palermo, 1960.

————. "Observations on the Samson Floor at Mopseuistia." *Dumbarton Oaks
 Papers* 27(1973): 133 ff.

————. "The Role of Miniature Painting in Mural Decoration." In *The Place of
 Book Illumination in Byzantine Art,* ed. Kurt Weitzmann et al., pp. 99–142.
 Princeton, 1975.

Kleinschmidt, Beda. *Die basilika San Francesco in Assisi.* Berlin, 1915–28.

Kondakov, Nikolai I. *The Russian Icon.* Trans. Ellis H. Minns. Oxford, 1927.

Kraeling, Carl Hermann, et al., eds. "Narration in Ancient Art: A Symposium."
 American Journal of Archaeology 61(1961): 43–91.

Kraus, Franz Xaver. *Geschichte der christlichen Kunst.* Vol. 2, part 2. Freiburg im
 Breisgau, 1900.

————. "Die Wandgemälde von Sant'Angelo in Formis." *Jahrbuch der Preus-
 sischen Kunstsammlungen* 14(1893): 3–21, 84–100.

Krautheimer, Richard. "The Architecture of Sixtus III: A Fifth-Century Renas-
 cence?" In *De Artibus Opuscula XL: Essays in Honor of Erwin Panofsky,* pp.
 291 ff. New York, 1961.

————. *Early Christian and Byzantine Architecture.* Harmondsworth, 1965.

————. "Fra Angelico and—Perhaps—Alberti." In *Studies in Late Medieval and
 Renaissance Painting in Honor of Millard Meiss,* ed. I. Lavin and J. Plummer,
 1:290–96. New York, 1977.

————. "An Introduction to an 'Iconography' of Medieval Architecture." *Journal
 of the Warburg and Courtauld Institutes* 5(1942): 1–33.

————. *Rome: Profile of a City, 312–1308.* Princeton, 1980.

————. *Studies in Early Christian, Medieval, and Renaissance Art.* New York,
 1969.

Krautheimer, Richard, Spencer Corbett, and Alfred K. Frazer. *Corpus Basilica-
 rum Christianarum Romae: The Early Christian Basilicas of Rome (IV–IX
 Cent.).* Vols. 1–5. Vatican City, 1977.

Krautheimer, Richard, with Trude Krautheimer-Hess. *Lorenzo Ghiberti.* Prince-
 ton, 1970. Originally published 1956.

Kreytenberg, Gert. *Andrea Pisano und die toskanische Skulptur des 14. Jahrhun-
 derts.* Munich, 1984.

Kritter, Astrid Debold-von. *Studien zum Petruszyklus in der Brancaccikapelle.*
 Berlin, 1975.

Kuhn, Rudolf. *Mittelitalienische Freskenzyklen, 1300–1500: Zur erzählenden
 Malerei.* Munich, 1984.

Labande, Léon Honoré. *Le palais des papes et les monuments d'Avignon au XIVe
 siècle.* 2 vols. Marseilles, 1925.

Laclotte, Michel, and Elizabeth Mognetti. *Peinture italienne, Avignon, Musée du
 Petit Palais.* Paris, 1976.

Ladis, Andrew. "The Legend of Giotto's Wit and the Arena Chapel." *Art Bulletin*
 68(1986): 580–96.

————. *Taddeo Gaddi: Critical Reappraisal and Catalogue Raisonné.* Columbia,
 Mo., 1982.

————. "The Velluti Chapel at Santa Croce, Florence." *Apollo* 120(1984): 238–
 45.

Lafontaine-Dosogne, Jacqueline. *Iconographie de l'enfance de la Vièrge dans l'empire byzantin et en occident.* Mémoires de l'Académie Royale de Belgique, Classe des Beaux-Arts 11. Brussels, 1964.

Lasko, Peter. *Ars Sacra, 800–1200.* Baltimore, 1972.

Lauts, Jan. "Note on Piero della Francesca's Lost Ferrara Frescoes." *Burlington Magazine* 95(1953): 166.

———. "Zu Piero dei Franceschis verloren Fresken in Ferrara." *Zeitschrift für Kunstgeschichte* 10(1941–42): 67–72.

Lavin, Irving. *Bernini and the Unity of the Visual Arts.* New York, 1980.

Lavin, Marilyn Aronberg. "Computers and Art History: Piero della Francesca and the Problem of Visual Order." *New Literary History* 20, 2(1988–89): 1–22.

———. "Computers and the Private Scholar." *AICARC,* 14–15, 25–26(1986/87): 54–55.

———. "Giovannino Battista: A Study in Renaissance Religious Symbolism." *Art Bulletin* 37(1955): 85–101.

———. "Giovannino Battista: A Supplement." *Art Bulletin* 43(1961): 319–26.

———. "Italian Narrative Fresco Cycles." In *Automatic Processing of Art History Data and Documents (September 24–27, Pisa, 1984): Papers,* ed. Laura Corti, 2, 48:387–401. Florence, 1984.

———. "The Joy of the Bridegroom's Friend: Smiling Faces in Fra Filippo, Raphael, and Leonardo." In *Art the Ape of Nature: Studies in Honor of H. W. Janson,* ed. Lucy Freedman Sandler et al., pp. 193–210. New York, 1980.

———. "Monumental Narrative Cycles." In *Census: Computerization in the History of Art,* ed. Laura Corti, Scoula Normale Superiore, Pisa (Italy), and the J. Paul Getty Trust, 1, 142: 343–44. Los Angeles, 1984.

———. "Patterns of Arrangement in Italian Fresco Cycles: A Computer Database." In *The Roman Tradition in Wall Decoration,* vol. 12 of *Canadian Art Review,* pp. 209–14. Quebec, 1985.

———. *Piero della Francesca: The Flagellation.* New York, 1972.

———. *Piero della Francesca's "Baptism of Christ."* New Haven, 1981.

Lazzari, Alfonso. *Ugolino e Michele Verino.* Turin, 1897.

Lazzeroni, Irenio. "Le sinopie degli affreschi di Masolino nella Cappella della Croce in Santo Stefano degli Agostiniani." *Bulletino Storico Empolese* 1(1957): 141–54.

Lee, Rensselaer W. "Observations on the First Illustrations of Tasso's *Gerusalemme Liberata.*" *Proceedings of the American Philosophical Society* 125(1981): 329–56.

Lejeune, Rita. "Turold dans la tapisseries de Bayeux." *Mélanges Crozet* 1(1966): 419.

Lejeune, Rita, and Jacques Stiennon. *La légende de Roland dans l'art du Moyen Age.* Brussels, 1966.

Leveto-Jabr, Paula. "Carbon-14 Dating of Wood from the East Apse of Santa Maria at Castel Seprio." *Gesta* 26(1987): 17–18.

Lightbown, Ronald. *Mantegna: With a Complete Catalogue of the Paintings, Drawings, and Prints.* Berkeley, 1986.

———. *Sandro Botticelli: Life and Work.* Berkeley, 1978.

Lindekens, René. "Analyse sémiotique d'une fresque de Piero della Francesca: La légende de la Vraie Croix." *Canadian Journal of Research in Semiotics* 4, 3(1979): 3–19.

Linder, Amnon. "The Myth of Constantine the Great in the West: Sources and Hagiographic Commemoration." *Studi Medievali,* 3d ser., 16(1975): 43–96.

Lisner, Margrit. "Farbgebung und Farbikonographie in Giottos Arenafresken." *Mitteilungen des Kunsthistorischen Institutes in Florenz* 29(1985): 1–69.

Longhi, Roberto. "Genio degli Anonimi–1.o Giovanni di Piamonte (?)." *Critica d'Arte* 23, 2(1940): 97–100.

———. *Piero della Francesca*. Milan, 1963. Originally published 1927.

Loss, Archie K. "The 'Black Figure' in the Baltimore Copy of Piero della Francesca's Lost Ferrara Frescoes." *L'Arte*, n.s., 1(1968): 98–106.

Lubac, Henri de. *The Splendour of the Church*. Trans. Michael Mason. New York, 1956.

Ludolph of Saxony. *Vita Jesu Christi redemptoris nostri ex medullis evangelicis*. Lyons, 1519.

Lunardi, Roberto. *Arte e storia in Santa Maria Novella*. Florence, 1983.

Maccarrone, Michele. "Le nuove ricerche sulla cattedra." *Memorie* (Atti della Pontificia Accademia Romana di Archeologia, ser. 3), 1(1975).

McHam, Sarah Blake. "Donatello's Tomb of Pope John XXIII." In *Life and Death in Fifteenth-Century Florence*. Durham, N.C., 1989.

Mack, Charles R. *Pienza: The Creation of a Renaissance City*. Ithaca, N.Y., 1987.

McMahon, Philip. *Leonardo's Treatise on Painting (Codex Urbinas Latinus 1270)*. Trans. and annotated. Princeton, 1956.

Maffei, Fernanda de'. "Riflessi dell'epopea carolingia nell'arte medievale: Il ciclo di Ezechiele e non di Carlo a Santa Maria in Cosmedin e l'Arco di Carlo Magno a Roma." In *Atti del Convegno Internazionale sul Tema: La poesia epica e la sua formazione* (Rome, 28 March–3 April 1969, pp. 351–92. Accademia Nazionale dei Lincei 367. Rome, 1970.

Maginnis, Hayden B. J. "The Passion Cycle in the Lower Church of San Francesco, Assisi: The Technical Evidence." *Zeitschrift für Kunstgeschichte* 39(1976): 193–208.

———. "Pietro Lorenzetti: a Chronology." *Art Bulletin* 66(1984): 183–211.

———. "Pietro Lorenzetti and the Assisi Passion Cycle." Ph.D. diss., Princeton University, 1975.

Magnani, Luigi. *La cronaca figurata di Giovanni Villani: Ricerche sulla miniatura fiorentina del trecento*. Vatican City, 1936.

Maguire, Henry. *Art and Eloquence in Byzantium*. Princeton, 1981.

Maines, Clark. "The Charlemagne Window at Chartres Cathedral: New Considerations on Text and Image." *Speculum* 52(1977): 800–823.

Mâle, Emile. *L'art religieux de la fin du Moyen Age en France: Etude sur l'iconographie du Moyen Age et sur ses sources d'inspiration*. 4th ed. Paris, 1931.

———. *The Gothic Image: Religious Art in France of the Thirteenth Century*. Trans. Dora Nussey. New York, 1972. Originally published 1913.

Manca, Joseph. "Ercole de' Roberti's Garganelli Chapel Frescoes: A Reconstruction and Analysis." *Zeitschrift für Kunstgeschichte* 49(1986): 147–64.

Marabottini, Alessandro. *Polidoro da Caravaggio*. Rome, 1969.

Marchini, Giuseppe. "The Frescoes in the Choir of Santa Maria Novella." *Burlington Magazine* 95(1953): 320–30.

———. "Gli affreschi perduti di Giotto in una cappella di S. Croce." *Rivista d'Arte* 20(1938): 215–41.

Marconi, Sandra Moschini, ed. *Catalogo dell'Accademia di Venetia*. Venice, 1955.

Mathews, Thomas F. *The Early Churches of Constantinople*. University Park, Pa., 1971.

Mattaini, Adelaide, ed. *Romanzi dei Reali di Francia*. Classici Rizzoli. Milan, 1957.

Matthiae, Guglielmo. *Pittura romana del medioevo*. Rome, 1966.

———. *Le porte bronze bizantine in Italia*. Rome, 1971.

Mazzoni, Piero, *La leggenda della croce nell'arte*. Florence, 1913–14.

Meiss, Millard. *French Painting in the Time of Jean de Berry*. New York, 1974.

———. "The Highlands in the Lowlands: Jan van Eyck, the Master of Flemalle,

and Franco-Italian Tradition." In *The Painter's Choice: Problems in the Interpretation of Renaissance Art*. New York, 1976.

———. "Masaccio and the Early Renaissance: The Circular Plan." In *The Renaissance and Mannerism: Studies in Western Art*. 2: 123–44. Acts of the Twentieth International Congress of the History of Art. Princeton, 1963.

———. *Painting in Florence and Siena after the Black Death*. Princeton, 1951.

Meller, Peter. "La Cappella Brancacci: Problemi ritrattistici ed iconografici." *Acropoli*, fasc. 3, (1960–61): 186–227; fasc. 4 (1960–61): 273–312.

Mellini, Gian Lorenzo. *Altichiero e Jacopo Avanzo*. Milan, 1965.

Meltzoff, Stanley. *Botticelli, Signorelli and Savonarola: "Theologica Poetica" and Painting from Boccaccio to Poliziano*. Florence, 1987.

Mende, Ursula. *Die Bronzetüren des Mittelalters, 800–1200*. Munich, 1983.

Mercati, Giovanni. *Operi minori*. Vol. 2. Studi e Testi 77. Vatican City, 1937.

Messerer, Wilhelm. "Zu Berninis Daniel und Habakuk." *Römishe Quartalschrift* 57(1962): 292–96.

Metraux, Michele. "The Iconography of San Martino ai Monti in Rome." Ph.D. diss., Boston University, 1979.

Meyer zur Capellen, Jürg. *Gentile Bellini*. Stuttgart, 1985.

Meyvaert, Paul. "An Apocalypse Panel on the Ruthwell Cross." *Medieval and Renaissance Studies* (Duke University), 1982, pp. 3–32.

Miglio, Massimo, et al., eds. *Un pontificato ed una città: Sisto IV (1471–1484)*. Vatican City, 1986.

Miller, Helena Fracchia. "The Iconography of the Palm in Greek Art: Significance and Symbolism." Ph.D. diss., University of California, Berkeley, 1979.

Miller, Julia I. "Symbolic Light in Giotto and the Early Quattrocento in Florence." *Source* 5(1985): 7–13.

Mitchell, Charles. "The Imagery of the Upper Church at Assisi." In *Giotto e il suo tempo: Atti del congresso internazionale per la celebrazione del VII. centenario della nascita di Giotto*, pp. 113–34. Rome, 1971.

Mitchell, John. "St. Silvester and Constantine at the Ss. Quattro Coronati." In *Federico II e l'arte del duecento italiano*, ed. Annamaria Romanini, 2:15–32. Atti della III Settimana di studi di storia dell'arte medievale dell'Università di Roma. Rome 1980.

Moisè, Filippo. *S. Croce di Firenze*. Florence, 1845.

Molfino, Alessandra. *L'Oratorio del Gonfalone*. Rome, 1964.

Molho, Anthony. "The Brancacci Chapel: Studies in Its Iconography and History." *Journal of the Warburg and Courtauld Institutes* 40(1977): 50–98.

Mollat, G. *Les papes d'Avignon (1305–1378)*. 9th ed. Paris, 1949.

Monfasani, John. "A Description of the Sistine Chapel under Pope Sixtus IV." *Artibus et Historiae* 7(1983): 9–18.

Monfrin, Jacques J. "La figure de Charlemagne dans l'historiographie du XVe siècle." *Annuaire-Bulletin de la Société de l'Histoire de France, 1964–1965*, 1966, 67–78.

Montagu, Jennifer. *Alessandro Algardi*. New Haven, 1985.

Montault, Xavier Barbier de. "Peintures claustrales des monastères de Rome." *Revue de l'Art Chrétien* 4(1860): 71–89.

Moppert- Schmidt, Anita. *Die Fresken von S. Angelo in Formis*. Zurich. 1967.

Morassi, Antonio. *Tiziano: Gli affreschi*. New York, 1964.

Moreno, Ignacio L. "Pontormo's Passion Cycle at the Certosa del Galluzzo." *Art Bulletin* 63(1981): 308–12.

Mori, Gioio. "Arte e astrologia." *Art Dossier* 10(1987).

Morisani, Ottavio. *Gli affreschi di Sant'Angelo in Formis*. Cava dei Tirreni, 1962.

———. *Michelozzo Architetto*. Turin, 1951.

Moroni, Giovanni. *Dizionario di erudizione storico-ecclesiastica*. Venice, 1840.

Morris, Richard. *Legends of the Holy Rood*. Early English Texts Society 46 London, 1871.

Moskowitz, Anita F. *The Sculpture of Andrea and Nino Pisano*. New York, 1986.

Mossakowski, Stanislaw. "Raphael's St. Cecilia: An Iconographical Study." *Zeitschrift für Kunstgeschichte* 21(1968): 1–26.

Mozley, John H. "Documents: the 'Vita Adae.'" *Journal of Theological Studies* 30(1929): 121–49.

Mynors, Roger A. B., ed. *Catalogue of the MSS of Balliol College, Oxford*. Oxford, 1963.

Naples. *Guida Sacra della città di Napoli*. Ed. Nicola Spinosa. Naples, 1985.

Nessi, Silvestro. *La Basilica di S. Francesco in Assisi e la sua documentazione storica*. Assisi, 1982.

———. "La vita di S. Francesco dipinto da Benozzo Gozzoli a Montefalco." *Miscellanea Francescana* 61(1961): 467–92.

Nestori, Aldo. *Repertorio topografico delle pitture delle catacombe romane*. Roma Sotterranea Cristiana 5. Vatican City, 1975.

Neugebauer, Otto E. *A History of Ancient Mathematical Astronomy*. New York, 1975.

Neumeyer, Alfred. "Die Fresken im 'Chiostro degli Aranci' der Badia Fiorentina." *Jahrbuch der Königlichen Preussischen Kunstsammlungen* 48(1927).

Nichols, Stephen G., Jr. *Romanesque Signs: Early Medieval Narrative and Iconography*. New Haven, 1983.

Nicolella, Dario. *I cento chiostri di Napoli*. Naples, 1986.

Nordhagen, Per Jonas. *The Frescoes of John VII (A.D. 705–707) in S. Maria Antiqua in Rome*. Acta ad Archaeologiam et Axtium Historiam Pertinentia 3. Rome, 1968.

———. "John VII's *Adoration of the Cross* in S. Maria Antiqua." *Journal of the Warburg and Courtauld Institutes* 30(1967): 388 ff.

Nova, Alessandro. "I tramezzi in Lombardia fra XV e XVI secolo: Scene della Passione e devozione francescana." In *Il Francescanesimo in Lombardia: Storia e arte*, pp. 197–216. Milan, 1983.

Odoardi, Giovanni. "La custodia Francescana di Terra Santa, nel VI centenario della sua costituzione (1342–1942)." *Miscellanea Francescana* 43(1943): 217–56.

Oertel, Robert. *Early Italian Painting to 1400*. London, 1968.

Offner, Richard, and Klara Steinweg. *Corpus of Florentine Painting*. Berlin, 1930.

Origo, Iris. *The World of San Bernardino*. London, 1960.

Ostrow, Steven F. "The Sistine Chapel at S. Maria Maggiore: Sixtus V and the Art of the Counter Reformation." Ph.D. diss., Princeton University, 1987.

Paatz, Walter, and Elizabeth Paatz. *Die Kirchen von Florenz*. Frankfurt am Main, 1955.

Paccagnini, Giovanni. *Pisanello e il ciclo cavalleresco di Mantova*. Venice, 1973.

Pächt, Otto. *The Rise of Pictorial Narrative in Twelfth-Century England*. Oxford, 1962.

Pallucchini, Rodolfo. *La pittura veneziana del trecento*. Venice, 1964.

———. *Vittore Carpaccio: Le storie di Sant'Orsola*. Milan, 1958.

Panofsky, Erwin. "Imago Pietatis." In *Festschrift für Max J. Friedländer zum 60. Geburtstag*. Leipzig, 1927.

———. *Studies in Iconography*. Princeton, 1939.

Paolini, Claudio. "Scene della vita di San Benedetto in Toscana dal XIV al XV secolo: Problemi iconografici." In *Iconografia di San Benedetto nella pittura della Toscana: Immagini e aspetti culturali fino al XVI secolo*. Florence, 1982.

Partner, Peter. *The Lands of St. Peter: The Papal States of the Middle Ages and the Renaissance*. Berkeley, 1972.

Partridge, Loren, and Randolph Starn. *A Renaissance Likeness: Art and Culture in Raphael's "Julius II,"* Berkeley, 1980.

Pasqui, Ubaldo, *Documenti per la storia della città di Arezzo (1180/1337).* Florence, 1916.

———. "Pittori aretini vissuti della metà del sec. XII al 1527." *Rivista d'Arte* 10(1917): 32–87.

Pastor, Ludwig. *History of the Popes.* Saint Louis, 1989.

Peebles, Rose J. "The Dry Tree: Symbol of Death." In *Vassar Medieval Studies,* pp. 59–79. New Haven, 1923.

Peeters, Paul P. "La prise de Jerusalem par les Perses." *Mélanges de l'Université Saint-Joseph* 9(1923): 7 ff.

Pelagotti, G. *Il sacro cingolo mariano in Prato fino alla traslazione del 1395.* Prato, 1895.

Pernice, Angelo. *L'imperatore Eraclio, saggio di storia bizantina.* Florence, 1905.

Petrarca, Francesco. *The Revolution of Cola di Rienzo.* Ed. Mario E. Cosenza. New York, 1986.

Phleger, Susanne. "La Cappella della Croce nella Chiesa di S. Francesco di Volterra." *Rassegna Volterrana* (Accademia dei Sepolti), 59–60 (1983–84): 171–245.

Pictorial Narrative in Antiquity and the Middle Ages, ed. Herbert L. Kessler and Marianna Shreve Simpson. Vol. 14 of *Studies in the History of Art.* Center for Advanced Study in the Visual Arts Symposium Series 4. Washington, D.C., 1985.

Piero: Teorico dell'arte, ed. Omar Calabrese. Semiosis, Collana di Studi Semiotici l. Rome, 1985.

Pietralunga, Ludovigo da. *Descrizione della Basilica di S. Francesco e di altri santuari di Assisi.* Commen. Pietro Scarpellini. Treviso, 1982.

Pietrangeli, Carlo, et al., eds. *Sistine Chapel, a New Light on Michelangelo: The Art, the History, and the Restoration.* New York, 1986.

Plaissance, Michel. *Culture et religion en Espagne et en Italie aux XVe et XVIe siècles.* Vol. 4. Abbeville (France), 1980.

Plant, Margaret. "Fresco Painting in Avignon and Northern Italy: A Study of Some Fourteenth-Century Cycles of Saints' Lives outside Tuscany." Ph.D. diss., University of Melbourne, 1981.

———. "Portraits and Politics in Late Trecento Padua: Altichiero's Frescoes in the S. Felice Chapel, S. Antonio." *Art Bulletin* 63(1981): 406–25.

———. "The Vaults of the Chapel of Saint Martial, Palace of the Popes, Avignon: Frescoes of Matteo Giovannetti." *Source* 2(1982): 6–11.

Pliny. *The Elder Pliny's Chapters on the History of Art.* Trans. K. Jex-Blake. London, 1896.

Podro, Michael. *Piero della Francesca's Legend of the True Cross.* 55th Charleton Lecture, University of Newcastle upon Tyne. Edinburgh, 1974.

Poeschke, Joachim, with Stefan Diller, Luigi Artini, and P. Gerhard Ruf. *Die Kirche San Francesco in Assisi und ihre Wandmalereien.* Munich, 1985.

Polzer, Joseph. "Masaccio and the Late Antique." *Art Bulletin* 53(1971): 36–40.

Ponelle, Louis, and Louis Bordet. *Saint Philip Neri and the Roman Society of His Times (1515–1595).* London, 1932.

Pope-Hennessy, John. *Fra Angelico.* Ithaca, N.Y., 1974.

———. *Italian Paintings in the Robert Lehman Collection* (Metropolitan Museum of Art). New York, 1987.

———. *The Portrait in the Renaissance.* New York, 1966.

———. "The Sixth Centenary of Ghiberti." In *The Study and Criticism of Italian Sculpture,* pp. 39–70. New York, 1980.

Porçal, Peter. "La Cappella Sassetti in Santa Trinita a Firence: Osservazioni sull'iconographia." *Antichità Viva* 23(1984): 26–36.

Poseq, Avigdor W. D. "The Lunette: A Study in the Role of the Arch-Outlined Format in the Design and Content of Italian Murals of the Renaissance." Ph.D. diss., Hebrew University, Jerusalem, 1974.

Prampolini, Giacomo. *L'Annunciazione nei pittori primitivi italiani*. Milan, 1939.

Pritchard, James B., et al., eds. *Solomon and Sheba*. London, 1974.

Procacci, Ugo. *Sinopie e affreschi*. Milan, 1960.

Pudelko, George. "The Early Works of Paolo Uccello." *Art Bulletin* 16(1934): 257 ff.

Pulin, Carol. "The Palaces of an Early Renaissance Humanist, Cardinal Branda Castiglione." *Arte Lombarda* 61(1982).

Quednau, Rolf. *Die Sala di Costantino im Vatikanischen Palast: Zur Dekoration der beiden Medici-Päpste Leo X. und Clemens VII*. Hildesheim, 1979.

Quinn, Esther C. *The Quest of Seth for the Oil of Life*. Chicago, 1962.

Raffaello a Roma: Il convengno del 1983. Bibliotheca Hertziana, Musei Vaticani. Rome, 1986.

Rancoglia, Aurelio, ed. *I reali di Francia*. Rome, 1967.

Ravelli, Lanfranco. *Polidoro Caldara da Caravaggio*. Bergamo, 1978.

Reames, Sherry L. *The "Legenda Aurea": A Reexamination of Its Paradoxical History*. Madison, Wis., 1985. Reviewed by Eugene Rice, *Renaissance Quarterly* 39(1986): 279–81.

Rearick, Janet Cox. *The Drawings of Pontormo*. Cambridge, Mass., 1964.

Redig de Campos, Deoclecio. *Raphaels Fresken in den Stanzen*. Stuttgart, 1984.

Renouard, Yves. *The Avignon Papacy, 1305–1403*. Trans. Denis Bethell. Hamden, Conn., 1970.

Renzi, L. *Tradizione cortese e realismo in Gautier d'Arras*. Padua, 1964.

Renzoni, Marco P. "S. Francesca ed Arezzo." *Studi Francescani* 22(1950): 129–55.

Restle, M. "Das Dekorationssystem im Westeil des Baptisteriums von San Marco zu Venedig." Festschrift für Otto Demus zum 70. Geburtstag. *Jahrbuch der Oesterreichischen Byzantinistik* 21(1972): 229–39.

Ricci, Corrado. *Volterra*. Bergamo, 1905.

Righetti, Mario. *L'anno liturgico nella Storia, nella Messa, nell'Ufficio*. Milan, 1969.

Robert, Carl. "Die Entwicklung des griechischen Mythos in Kunst und Poesie." In *Bild und Lied: Archaeologische Beitrage zur Geschichte der griechischen Heldensage*. Berlin, 1881.

Rocchi, Giuseppe. *La Basilica di San Francesco ad Assisi: Interpretazione e relievo*. Florence, 1982.

———. "La più antica pittura nella Basilica di S. Francesco ad Assisi." In *The Roman Tradition in Wall Decoration*, vol. 12 of *Canadian Art Review*, pp. 169–74. Quebec, 1985.

Roli, Renato. "Considerazione sull'opera di Ottaviano Nelli." *Arte Antica e Moderna*, 1961, p. 122.

Romano, Serena. "Due affreschi del Cappellone degli Spagnoli: Problemi iconologici." *Storia dell'Arte* 28(1978): 181–214.

Rossi, Alberto. *I Salimbeni*. Milan, 1976.

Ruf, Gerhard. *Christ ist erstanden: Eine Betrachtung der Bildes des rechten Chorfenters der Oberkirche von S. Francesco in Assisi*. Basel, 1983.

———. *Das Grab des hl. Franziskus: Die Fresken der Unterkirke von Assisi*. Freiburg im Breisgau, 1981.

Saalman, Howard. *The Church of Santa Trinita in Florence*. Pittsburgh, 1966.

Saint Abrose. *Oration de Obitu Theodosii*. Ed. Mary Dolorosa Mannix. Washington, D.C., 1925.

Saint Bridget of Sweden. *Revelationes*. Rome, 1628.

Saint Francis. "Sermones 4 de S. Francisci." In *Opera omnia*, 9:586. Quaracchi,

1901. Translated in Eric Doyle, *The Disciple and the Master: St. Bonaventure's Sermons on St. Francis of Assisi*. Chicago, 1983.

Saint Thomas à Kempis. *Opera omnia*. Vols. 3 and 5. Ed. M. J. Pohl. Freiburg im Breisgau, 1902–22.

Sale, John Russell. "The Strozzi Chapel by Filippino Lippi in Santa Maria Novella." Ph.D. diss., University of Pennsylvania, 1976. Reproduced by Garland Press, New York, 1979.

Salmi, Mario. *L'Abbazia di Pomposa*. Milan, 1966.

———. "Un'antica pianta di S. Francesco in Arezzo." *Miscellanea Francescana di Storia, di Lettere, di Arti* 21(1920): 97–114.

———. "I Bacci di Arezzo nel secolo XV e la loro cappella nella Chiesa di S. Francesco." *Rivista d'Arte* 9(1916–18): 224–37.

———. *La pittura di Piero della Francesca*. Novara, 1979.

Salvini, Roberto. *L'arte di Agnolo Gaddi*. Florence, 1936.

San Bernardino da Siena. *Le Prediche Volgari*. Ed. Piero Bargellini. Milan, 1937.

Sandström, Sven, *Levels of Unreality: Studies in Structure and Construction in Italian Mural Painting during the Renaissance*. Uppsala, 1963.

San Juan, Rose Marie. "The Function of Antique Ornament in Luca Signorelli's Fresco Decoration for the Chapel of San Brizio." In *The Roman Tradition of Wall Decoration*, vol. 12 of *Canadian Art Review*, pp. 235–42. Quebec, 1985.

Sapori, Armando. *I libri degli Alberti del Giudice*. Milan, 1952.

Saralegui, Leandro de. *El Museo Provincial de Bellas Artes de San Carlos (sala 1 and 2)*. Cuadernos de Arte 8. Valencia, 1954.

Saxl, Franz. "The Classical Inscription in Renaissance Art and Politics." *Journal of the Warburg and Courtauld Institutes* 4(1941): 19–46.

Scarpellini, Pietro. *Perugino*. Milan, 1984.

Scharf, Alfred. *Filippino Lippi*. Vienna, 1935.

Schiller, Gertrude. *Iconography of Christian Art*. 2 vols. Trans. Janet Seligman. London, 1972.

———. *Ikonographie der Christlichen Kunst*. 4 vols. Kassel, 1976.

Schlegel, Ursula. "Zum Bilderprogramm der Arena Kapelle." *Zeitschrift für Kunstgeschichte* 20(1957): 125–46.

Schlunk, Helmut, and Theodor Hauschild. "Informe preliminar sobre los trabajos realizados en Centcelles." *Excavaciones Arqueologicas en España* 18(1962).

Schneider, Laurie, "The Iconography of Piero della Francesca's Frescoes Illustrating the Legend of the True Cross in the Church of San Francesco in Arezzo." *Art Quarterly* 32(1969): 22–48.

———. , ed. *Giotto in Perspective*. New York, 1974.

Schroeder, Henry J., trans. *Canons and Decrees of the Council of Trent*. Saint Louis, 1941.

Schulz, Juergen. *Venetian Painted Ceilings of the Renaissance*. Berkeley, 1968.

Shearman, John K. G. *Andrea del Sarto*. Oxford, 1965.

———. "The Chapel of Sixtus IV." In *The Sistine Chapel: A New Light on Michelangelo; the Art, the History, and the Restoration*, ed. Carlo Pietrangeli et al., pp. 22–87. New York, 1986.

———. "The Chiostro dello Scalzo." *Mitteilungen des Kunsthistorischen Institutes in Florenz* 9(1960): 207–20.

———. *Raphael's Cartoons in the Collection of Her Majesty the Queen and the Tapestries for the Sistine Chapel*. London, 1972.

Simons, Patricia. "Patronage in the Tornaquinci Chapel, Santa Maria Novella, Florence." In *Patronage, Art, and Society in Renaissance Italy*, ed. F. W. Kent and Patricia Simons with J. C. Eade, pp. 221–50. Oxford, 1987.

Smart, Alastair. *The Assisi Problem and the Art of Giotto: A Study of the Legend of St. Francis in the Upper Church of San Francesco, Assisi*. Oxford, 1971.

Smyth, Craig Hugh. "Bronzino's Earliest Works." *Art Bulletin* 31(1949): 184 ff.

Sohm, Philip L. "The Scuola Grande di San Marco, 1473–1550: The Architecture of a Venetian Lay Confraternity." Ph.D. diss., Johns Hopkins University, 1978. Reproduced by Garland Press, New York, 1982.

Souriau, Etienne. "Time in the Plastic Arts." *Journal of Aesthetics and Art Criticism* 7(1949): 294–307.

Southard, Edna C. "The Frescoes in Siena's Palazzo Pubblico, 1285–1539." Ph.D. diss., University of Indiana, 1978. Reproduced by Garland Press, New York, 1979.

Spain, Suzanne Alexander. "Heraclius, Byzantine Imperial Ideology, and the David Plates." *Speculum* 52(1977): 217–37.

Spear, Richard E. *Dominichino*. New Haven, 1982.

Spencer, John R. "Ut Rhetorica Pictura." *Journal of the Warburg and Courtauld Institutes* 20(1957): 26–44.

Spiazza, Anna Maria. "'Giotto a Padova': Studi sullo stato di Conservazione della Cappella degli Scrovegni in Padova." *Bollettino d'Arte*, ser. 2, 63(1978; published 1982).

Starn, Randolph, and Loren Partidge. "Representing War in the Renaissance: The Shield of Paolo Uccello." *Representations* 5(1984): 32–65.

Steinmann, Ernst. *Die Sixtinische Kapelle*. Vol. 1. *Der Bau und Schmuck der Kapelle unter Sixtus IV.* Munich, 1901. Reviewed by Joseph Sauer in *Germania* (Wissenschaftliche Beilage) 48(1901), and in *Deutsche Rundschau* 32(1906): 27–39.

Stinger, Charles L. *The Renaissance in Rome*. Bloomington, Ind., 1985.

Strong, Eugénie. *La Chiesa Nuova*. Società Editrice d'Arte Illustrata. Rome, 1923.

Stubblebine, James H. *Assisi and the Rise of Vernacular Art*. New York, 1985.

Stylianou, Andreas, and Judith Stylianou. "*In Hoc Vinces . . . , By This Conquer.*" Nicosia, 1971.

Sullivan, Ruth Wilkins. "Some Old Testament Themes on the Front Predella of Duccio's *Maestà*." *Art Bulletin* 68(1986): 597–609.

Supino, Igino B. *Il Camposanto di Pisa*. Florence, 1896.

Swarzenski, Hans. *The Berthold Missal: The Pierpont Morgan Library MS 710 and the Scriptorium of Weingarten Abbey*. New York, 1943.

Tafi, Angelo. *Il Duomo di Arezzo (Guida storico-artistica)*. Arezzo, 1980.

Taft, Robert F. *The Great Entrance . . . the Rite of the Liturgy of St. John Chrysostom*. Rome, 1975.

Tasso, Torquato. "Discorsi del poema eroico." In *Prose*. Ed. Ettore Mazzali. Milan, 1959.

Texte et image: Actes du Colloque International de Chantilly (13–15 October, 1982). Centre de Recherches de l'Université de Paris 10. Paris, 1984.

Tietze-Conrat, Erica. *Dwarfs and Jesters in Art*. London, 1957.

Tintori, Leonetto, and Eve Borsook. *Giotto: The Peruzzi Chapel*. New York, 1965.

Tintori, Leonetto, and Millard Meiss. *The Painting of the Life of St. Francis in Assisi, with Notes on the Arena Chapel*. 3d ed. New York, 1967.

Toesca, Ilaria. *Andrea e Nino Pisani*. Florence, 1950.

Toesca, Pietro. *Il Battistero di Parma*. Milan, 1960.

Tomei, Alessandro. "Il ciclo vetero e neotestamentario di S. Maria in Vescovio." In *Roma Anno 1300*, pp. 355–66. Rome, 1983.

Torriti, Piero. *La Pinacoteca nazionale di Siena*. Genoa, 1977–78.

Tozzi, Rossana. "I mosaici del Battistero di San Marco a Venezia e l'arte bizantina." *Bollettino d'Arte* 26(1933): 418–32.

Trecca, Giuseppe. *La facciata della Basilica di S. Zeno*. Verona, 1968.

Tronzo, William. "The Prestige of Saint Peter's: Observations on the Function

of Monumental Narrative Cycles in Italy." In *Pictorial Narrative*, pp. 93–112.

——. *The Via Latina Catacomb: Imitation and Discontinuity in Fourth-Century Roman Painting*. University Park, Pa., 1986.

Ubald d'Alençon, Cap. "De l'origine française de St. François d'Assise." *Etudes Françiscaines* 10(1903): 449–54.

Ubertino da Casale. *Arbor vitae crucifixae Jesu*. Turin, 1961. Originally published 1485.

Valcanover, Francesco. "Le storie di Sant'Orsola di Vittore Carpaccio dopo il recente restauro." *Adunanza Solenne 1986* (Istituto Veneto di Scienze, Lettere ed Arti) 144(1985–86): 10–34.

Van Dijk, S. J. P., and J. Hazelden Walker. *The Origins of the Modern Roman Liturgy: The Liturgy of the Papal Court and the Franciscan Order in the Thirteenth Century*. Westminster, Md., 1960.

Van Marle, Raimond. *The Development of the Italian Schools of Painting*. The Hague, 1924.

——. *Iconographie de l'art profane au Moyen-Age et à la Renaissance*. The Hague, 1931.

Van Os, Henk. "The Black Death and Sienese Painting: A Problem of Interpretation." *Art History* 4(1981): 237–49.

——. "St. Francis of Assisi as a Second Christ in Early Italian Painting." *Simiolus* 7(1974): 115–32.

——. *Vecchietta and the Sacristy of Siena Hospital Church*. The Hague, 1974.

Van Os, Henk, with Kees Van der Ploeg. *Sienese Altarpieces, 1215–1460: Form, Content, and Function*. Groningen, 1984.

Vargas, Carmela. *San Gregorio Armeno, Napoli*. Naples, 1988.

Vasari, Giorgio. *Le vite de' Più Eccellenti pittori, scultori ed architettori*. Ed. Gaetano Milanese. Milan, 1878.

Vayer, Lajos. "Problemi iconologici della pittura del quattrocento; cicli di affreschi di Masolino da Panicale." *Acta Historiae Artium* (Academiae Scientiarum Hungaricae) 31(1985): 5–30.

Venturi, Lionello. *Piero della Francesca*. Geneva, 1954.

Vertova, Luisa. *I cenacoli fiorentini*. Turin, 1965.

Vickers, Michael. "Imaginary Etruscans: Changing Perceptions of Etruria since the Fifteenth Century." *Hephaistos* 7–8(1985–86): 156–57.

——. "Some Preparatory Drawings for Pisanello's Medallion of John VIII Palaeologus." *Art Bulletin* 60(1978): 415–25.

——. "Theodosius, Justinian or Heraclius?" *Art Bulletin* 58(1976): 281–82.

Voelkle, William. *The Stavelot Triptych: Mosan Art and the Legend of the True Cross*. New York, 1980.

Volpe, Carlo. "La formazione di Giotto nella cultura di Assisi." In *Giotto e i Giotteschi in Assisi*, intro. Giuseppe Palumbo. Rome, 1969.

Von Henneberg, Josephine. *L'Oratorio dell'Arciconfraternità del Santissimo Crocifisso di San Marcello*. Rome, 1974.

Von Simson, Otto. *Sacred Fortress: Byzantine Art and Statecraft in Ravenna*. Chicago, 1948.

Voragine. See Jacobus de Voragine.

Wadding, Luke. *Scriptores ordinis minorum quibus accesit syllabus illorum qui eodem ordine . . .* Vol. 6. Rome, 1654.

Waetzoldt, Stephan. *Die Kopien des 17. Jahrhunderts nach Mosaiken und Wandmalereien in Rom*. Vienna, 1964.

Walsh, Barbara B. "Giotto's 'Visions' of Brother Agostino and the Bishop of Assisi, Bardi Chapel, S. Croce, Florence." *Art Bulletin* 62(1980): 20–23.

Warburg, Aby. "Francesco Sassettis Letztwillige Verfügung (1907)." In *Gesammelte Schriften*, 1:127–58, 353–65. Leipzig, 1932. Translated in *La rinascita del paganesimo antico*. Florence, 1966.

————. "Italienische Kunst und internationale Astrologie." In *Gesammelte Schriften*, 2:459–82, 627–44. Leipzig, 1932.

————. "Piero della Francescas Constantinschlacht in der aquarell Kopie des Johann Anton Ramboux." In *Gesammelte Schriften*, 1:251–54, 389–91. Leipzig, 1932.

Webb, Diana M. "The Truth about Constantine: History, Hagiography and Confusion." In *Religion and Humanism*, 17:85–102. Papers of the Ecclesiastical History Society, Studies in Church History. London, 1981.

Weil-Garris, Kathleen, and John D'Amico. "The Renaissance Cardinal's Ideal Palace: A Chapter from Cortese's *De Cardinalatu*." In *Studies in Italian Art and Architecture, Fifteenth through Eighteenth Centuries*, ed. Henry A. Millon, pp. 45–123. Cambridge, Mass., 1980.

Weisinger, Herbert. *Tragedy and the Paradox of the Fortunate Fall*. East Lansing, Mich., 1953.

Weiss, Roberto. "The Medieval Medallions of Constantine and Heraclius." *Numismatic Chronicle* 3(1963): 129–44.

Weisz, Jean S. *Pitturae Misericordia: The Oratory of S. Giovanni Decollato in Rome*. Ann Arbor, Mich., 1984.

Weitzmann, Kurt. *The Fresco Cycle in Santa Maria in Castelseprio*. Princeton, 1951.

————. *Illustration in Roll and Codex*. Princeton, 1947.

————. "The Narrative and Liturgical Gospel Illustrations" and "Byzantine Miniature and Icon Painting in the Eleventh Century." In *Studies in Classical and Byzantine Manuscript Illumination*, ed. Herbert L. Kessler, intro. Hugo Buchthal, pp. 247–313. Chicago, 1971.

Weitzmann, Kurt, and Herbert L. Kessler. *The Cotton Genesis: British Library, Codex Cotton Otho B VI*. Princeton, 1986.

Wellen, G. A. *Theotokos: Eine ikonographische Abhandlung über das Gottesmutterbild in frühchristlicher Zeit*. Utrecht, 1960.

White, John. "Cavallini and the Lost Frescoes of S. Paolo." *Journal of the Warburg and Courtauld Institutes* 19(1956): 84 ff.

————. "Cimabue and Assisi: Working Methods and Art Historical Consequence." *Art History* 4(1981): 355–83.

————. "The Reliefs on the Facade of the Duomo of Orvieto." *Journal of the Warburg and Courtauld Institutes* 22(1959): 254–302.

Wickoff, Franz. *Die "Wiener Genesis."* Vienna, 1895. Translated by E. Strong as *Roman Art: Some of Its Principles and Their Application to Early Christian Painting*. New York, 1900.

Wiegel, Karl Adolf. "Die Darstellungen der Kreuzauffindung bis zu Piero della Francesca." Ph.D. diss., Universität Köln, 1973.

Wieruszowski, Helene. "Arezzo as a Center of Learning and Letters in the Thirteenth Century." *Traditio* 9(1953): 321–91.

Wilde, Johannes. "The Decoration of the Sistine Chapel." *Proceedings of the British Academy* 44(1950): 61–81.

Wilkins, David G. "Maso di Banco, a Florentine Artist of the Early Trecento." Ph.D. diss., University of Michigan, 1969. Reproduced by Garland Press, New York, 1985.

————. Review of James Stubblebine, *Giotto and the Arena Chapel Frescoes. Art Quarterly* 34(1971): 114.

Wilson, H. A., ed. *Gelasian Sacramentary: Liber Sacramentorum Romanae Ecclesiae*. Oxford, 1894.

Wohl, Hellmut. *The Paintings of Domenico Veneziano, ca. 1410–1461*. New York, 1980.

Wollesen, Jens T. "Die Fresken in Sancta Sanctorum." *Römisches Jahrbuch für Kunstgeschichte* 19(1981): 35–84.

————. *Die Fresken von San Piero in Grado bei Pisa.* Bad Oeynhausen, 1977.

Wollesen-Wisch, Barbara L. "The Archiconfraternità del Gonfalone and Its Oratory in Rome: Art and Counter-Reformation Spiritual Values." Ph.D. diss., University of California, Berkeley, 1985.

Woods-Marsden, Joanna. *The Gonzaga of Mantua and Pisanello's Arthurian Fresco.* Princeton, 1989.

Zanocco, Rizieri. "L'Annunciazione all'Arena di Padova (1305–1309)." *Rivista d'Arte* 19(1937): 370–73.

Zeri, Federico. *Paintings in the Walters Art Gallery.* Baltimore, 1976.

Zirnbauer, Heinz, ed. *Johannes de Turrecremata, "Meditationes," Faksimile-Ausgabe Erstdrucks von 1467.* Stadtbibliothek Nürnberg. Wiesbaden, 1968.

Zuccari, Alessandro. "La politica culturale dell'Oratorio Romano nella seconda metà del cinquecento." *Storia dell'Arte* 41(1981): 77–112.

Zucker, Mark J. "Parri Spinelli's Lost 'Annunciation to the Virgin' and Other Aretine *Annunciations* of the Fourteenth and Fifteenth Centuries." *Art Bulletin* 57(1975): 186–89.

Photographic Credits

Artale, Florence: pls. 10, 11
Arte Grafici, Bergamo: figs. 91, 92, 126, 127 (negatives destroyed during World
 War II)
Biblioteca Apostolica Vaticana: fig. 74
Biblioteca Hertziana, Rome: fig. 208
Bibliothèque Nationale, Paris: fig. 78
Vittore Branca: fig. 155
Caisse Nationale des Monuments Historiques et des Sites, Paris: figs. 59–61
 (© Arch. Phot. Paris/SPADEM)
De Antonis Fotografo, Rome: pl. 24
Stefan Diller, Kreuzbergst: figs. 11, 32
Fratelli Alinari, Florence: figs. 3, 14, 15, 18, 20, 24, 28, 29, 33, 36–38, 40, 44,
 46, 50, 51, 54, 55–57, 64–67, 73, 80–87, 93–95, 99, 112, 113, 117, 135, 136,
 142, 151, 154, 159, 163, 169, 170, 173, 176, 192, 195, 206
Galleria degli Uffizi, Florence: fig. 2
Grafisches Sammlung, Kunstmuseum Düsseldorf: fig. 149
Instituto Centrale per il Catalogo e la Documentazione, Rome: figs. 1, 9, 10,
 21, 22, 34, 35, 68, 69, 100–103, 114–16, 133, 134, 146, 162, 165, 166, 174,
 175, 177–81, 185–91, 198–203, 207
Kunsthistorisches Institut, Florence: figs. 12, 13, 17, 19
Hayden Maginnis: fig. 39
Mostra di Federico Barocci, Bologna: fig. 205
Musée du Louvre, Paris: figs. 88, 89
Musei Vaticani: figs. 122–25, 164
Museo Civico, Padua: fig. 58
Museo Provincial de Bellas Artes de San Carlos, Valencia: fig. 90
Parrocchia di San Giovanni Battista Museo del Duomo, Monza: fig. 27
Pierpont Morgan Library, New York: figs. 79, 157
SCALA/Art Resource, New York: pls. 1–9, 14–23, figs. 16, 25, 26, 137
Soprintendenza per i Beni Ambientali Architettonici, Artistici e Storici, Archivio
 Fotografico, Sezione Beni Artistici e Storici, Arezzo: figs. 140, 143, 147, 148
Soprintendenza per i Beni Artistici e Storici, Gabinetto Fotografico, Florence:
 pls. 12, 13 (photography supplied by Antonio Quattrone, courtesy of Oli-
 vetti), figs. 11, 23, 30, 31, 41–43, 45, 47–49, 52, 53, 62, 63, 70–72, 75, 76,
 96–98, 104–11, 118, 119, 121, 128–32, 138, 139, 141, 144, 150, 152, 153,
 156, 158, 160, 167, 168, 171, 172, 182–84, 193, 194, 196, 197, 204
Staatsarchiv, Koblenz: fig. 161
Staatsbibliothek, Munich: fig. 77

Index

Assissi, San Francesco (*continued*) Chapel, 311n.58; Saint John the Baptist Chapel, 311n.58; Saint Martin Chapel (Montefiore), 55–59, 313n.8, 326n.92, 345n.122, figs. 11, 34, 35, diag. 15; Saint Mary Magdalene Chapel, 53–54, 59, 66, 78, 308n.29, 310n.45, figs. 32, 33, diag. 14; transept (Life of Christ), 61–63, pl. 7, figs. 36–40

—Upper church: apse (Life of Mary), 30–31, 149–52, 204–7, figs. 12, 13, diag. 7; nave (Genesis, Lives of Christ and Francis), 36–39, figs. 18–20, 159, diag. 10; transept (Fall of the Angels and Life of Peter), 33, 52, pl. 3, figs. 16, 17

Assumption: doctrine of, 31, 94, 195; feast of (15 August), 153, 195, 308n.37

Astrology (zodiacal movement), 232, 361n.54, 55

Asuino da Forlì, 160

Augustine, Saint, Life of: Gubbio, San Agostino, chancel, app. 2; San Gimignano, San Agostino, chancel, 161

Augustine, Saint, pseudo-, 319n.78

Augustinian Hermits of Padua, 306n.1

Augustus, 204

Avignon, 59, 85

Avignon, papal palace, Tour Saint Jean

—Lower Chapel (Lives of two Saint Johns), 85; reference to Lateran, 85, fig. 59

—Upper Chapel (Life of Saint Martial), 83–88, 142; reference to, 93, 236, figs. 60, 61

Bacci, Giovanni, 337n.43

Bacci family, 167, 188, 194

Baglione, Rodolfo, 360n.44

Baglione family, 215

Bajazet, Emir, 113

Baldovinetti, Alessio, 142–43, 331n.56, 360n.41, 365n.25

Bandelli, Vincenzo, 200

Baptism, 82, 333n.9

Barberini, Andrea da. *See* Andrea da Barberini

Barberini, Cardinal Francesco, 347n.128

Barberini, Cardinal Maffeo. *See* Urban VIII

Barbiere, Alessandro, 253

Barna da Siena, 74. *See also* Memmi, Lippo

Barocci, Federico, 255, 368n.63

Bartolo di Fredi, 74, 318n.66

Basil I, 103

Bassano (Jacopo da Ponte), 368n.67

Bastiani, Lazzaro, 244

Battle scenes: crusade form, 342n.89; two, 114, 191; types of, 345.117

Bayeux Tapestry, 344n.107

Beccafumi, Domenico, 244

Bellini, Gentile, 244

Bellini, Giovanni, 244, 333n.78

Bellini, Jacopo, 244

Belt. *See Cingolo*

Belverde (Città di Pieve), Franciscan friary, Oratorio della Maddalena, 236

Benedict, Saint, Life of

—Florence: Badia, cloister, 241, 331n.59; San Miniato ai Monte, sacristy, 231, 326n.89

—Monte Oliveto, monastery church, cloister, 241

Benedict XI, 325n.75

Berettai, Grabasso (dwarf), 344n.108

Bernardino, Saint, da Siena (Bernardino Albizzeschi), 218, 221; Life of, Rome, Santa Maria in Aracoeli, Bufalini Chapel, 215–22; as peacemaker, 221; portrait of, 221; preaching method, 212; sermons of, 218, 220; trigram (YHS), 203, 354n.58, 355n.72, 358n.2

Bernardone, Pietro (father of Saint Francis), 112, 354n.52

Bernardone house, 332n.76

Bernini, Gianlorenzo, 370n.76

Berry, Jean, duke of, 113

Bertoja, Jacopo, 366n.41

Besarion, Cardinal, 337n.43

Bicci di Lorenzo, 167

Bilivert, Johann, 367n.50

Boccaccio, *Decameron*, 181–82, fig. 155

Bologna, San Pietro, Garganelli Chapel, 358n.4

Bonaventure, Saint, 31; canonization of, 200; *Legenda maior*, 38, 112, 193–94, 199, 303n.59, 303n.66, 309n.40, 325n.75

Bono da Ferrara, 160, 335n.22

Bono di Giovanni Boni, 360n.33

Borghini, Raffaello, 367n.57

Borghini, Vincenzo, 253

Borno, Chiesa dell'Annunciata, 357n.86

Borromeo, San Carlo, 307n.15

Borromini, Francesco, 25, 328n.21

Bostoli family (Arezzo), 345n.112

Botticelli, Sandro, 195

Bottom-to-top progression, 327n.5

Boustrophedony, 153, 309nn.42, 43. *See also* Patterns of disposition

Bracciolini, Francesco, 193, 349n.145

Bramante, Donato, 299n.23

Branda Castiglione, Cardinal, 138–42, 316n.50

Breviary, reading, 241, 245

Bricks, 206; wall, 146

Bridget, Saint, vision of, 229–30

Bronze doors, 71–74, 313n.3

Bronzino, Agnolo, 241

Brunelleschi, Filippo, 327n.2

Bruni, Leonardo, 128

Bubonic plague, 312n.1, 371n.15

Bufalini, Niccolò, 215

Bufalini family, 221

Buffoons. *See* Dwarfs

Buonconsiglio, Castello del, 347n.131

Byzantine: mural decoration, 298n.3; pastophoria, 308n.26

Byzantium: patriarch of, 303n.58

Capital punishment, antique method, 335n.26

Capitoline Hill, 203, 335n.26

Carafa, Cardinal Olivero, 222–23

Caravaggio, Michelangelo Merisi da, 368n.63

Caravaggio, Polidoro da, 214

Caravaggio, San Bernardino, 357n.86

Carliade (Ugolino Vernio), 193

Carpaccio, Vittore, 244

Carthusian order, 241, 364n.13

Cassiodorus, 324n.64

Castagno, Andrea del, 142–43, 145–46, 341n.83

Castiglione Olona, collegiata and baptistry, 140–42, 316nn.48, 50, 331n.54, pl. 14, fig. 117

Catacombs, 298n.2

Catasto tax, 330n.43

Catherine, Saint, Life of (Rome): San Clemente, Branda Chapel, 139; San Silvestro al Quirinale, 214

Cavallini, Pietro, 24, 31–32, 33, 300n.23, 305n.95

Cecilia, Saint, Life of, Florence, Santa Maria del Carmine, sacristy, 131–33

Ceiling decoration. *See* Painting fields

Cenni di Francesco di Ser Cenno, 115–17

Cennino Cennini, 371n.14

Centcelles (Spain), 305n.89

Chalivoy-Milon, 307n.21

Chanson de Roland, 111, 193, 346n.128

Chanson tradition, 193

Chapels, private ownership of, 308n.31

Charlemagne, myth of: canonized, 111; coronation, 110; incest, 111; journeys to East, 324n.63; king of France, 110, 111, 119; "Pius Aenea," 193; "Second," 349n.141

Charles V, 111

Charles VI, 113

Charles VII, 348n.132

Charles VIII, 193

Charles of Durazzo, 110

Chartres, cathedral: "Charlemagne window," 78, 106, 322n.50, 323nn.65, 66; Sylvester window, 111